SPHINX · FINE · ART

Edward Strachan · Roy Bolton

One Hundred Old Master Paintings

125 Kensington Church Street
London W8 7LP • United Kingdom
Tel: +44 20 7313 8040 • Fax: +44 20 7229 3259
info@sphinxfineart.com
www.sphinxfineart.com

SPHINX BOOKS

125 Kensington Church Street
London W8 7LP
www.sphinxfineart.com

First published in the UK by
SPHINX BOOKS 2009
Copyright text © Sphinx Books 2009

A copy of the British Library Cataloguing in
Publication Data is available from the British Library

ISBN 978-1-907200-01-4

Printed and bound in the UK by BAS Fine Art Printers

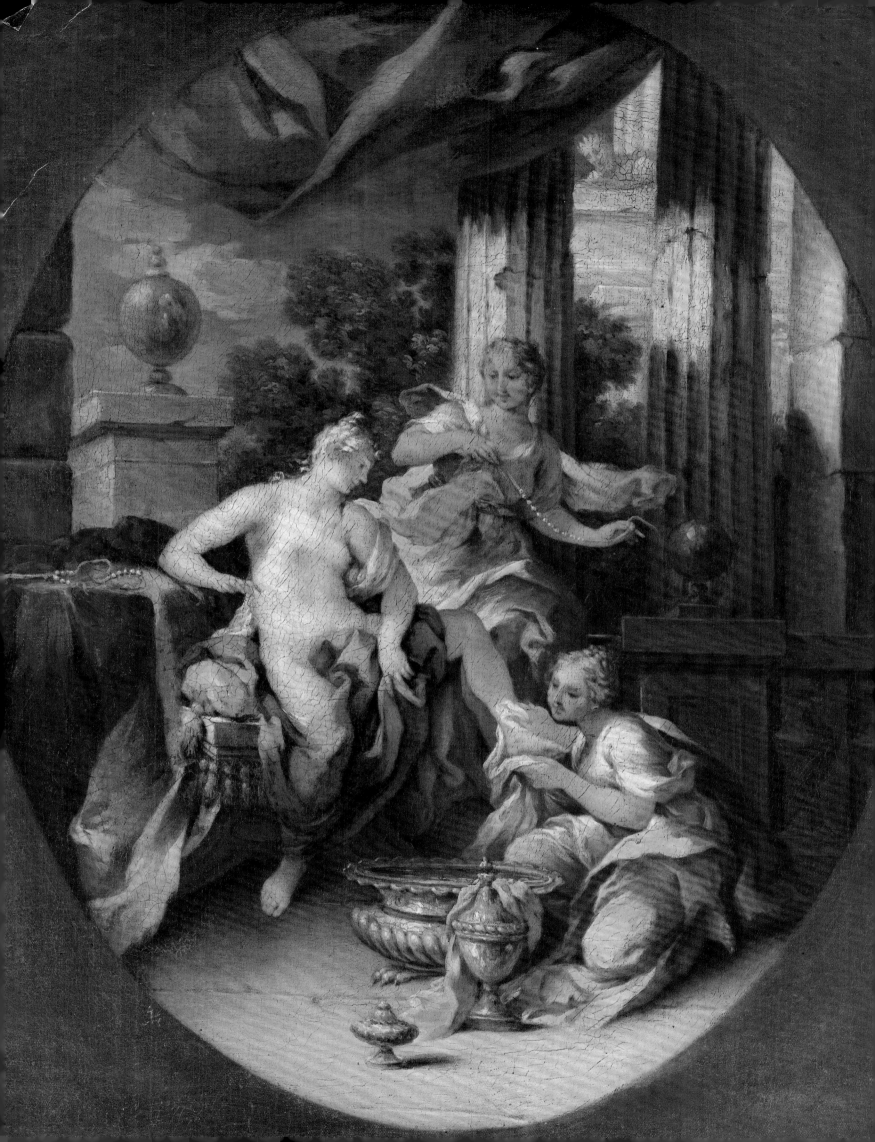

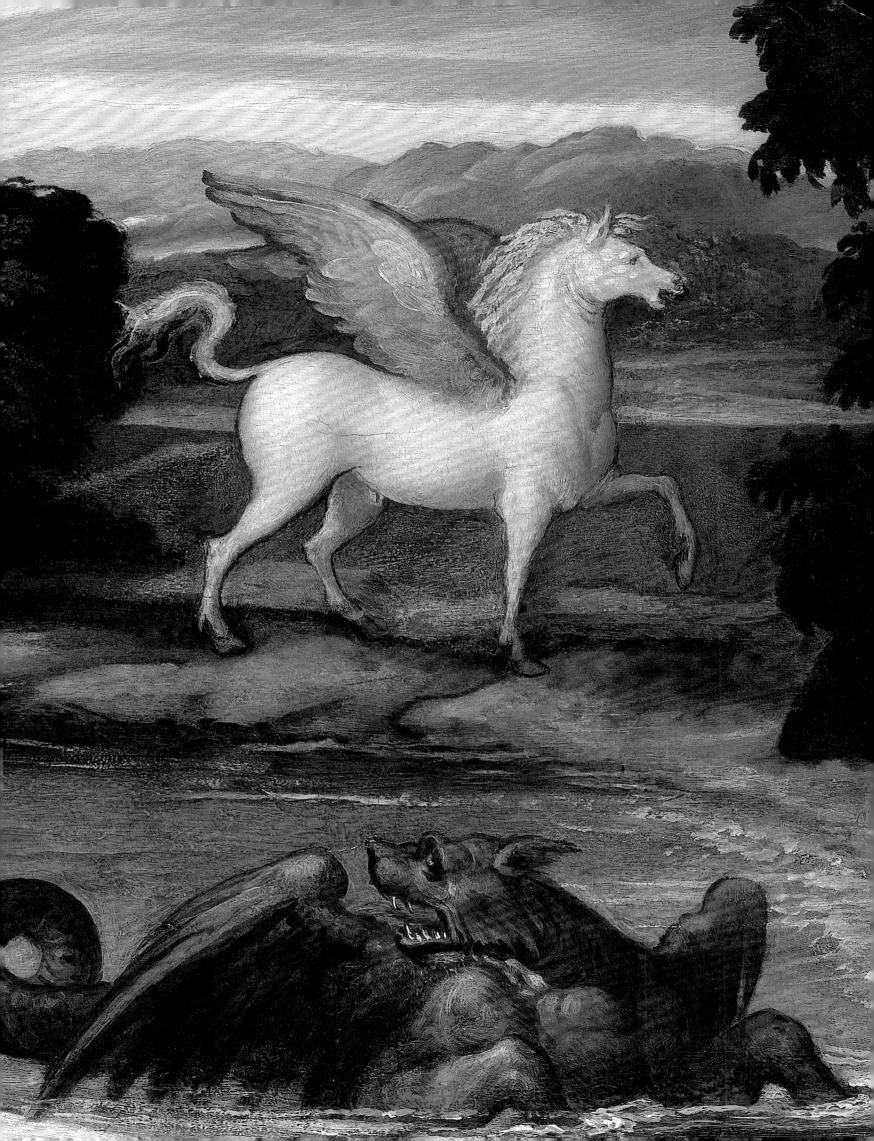

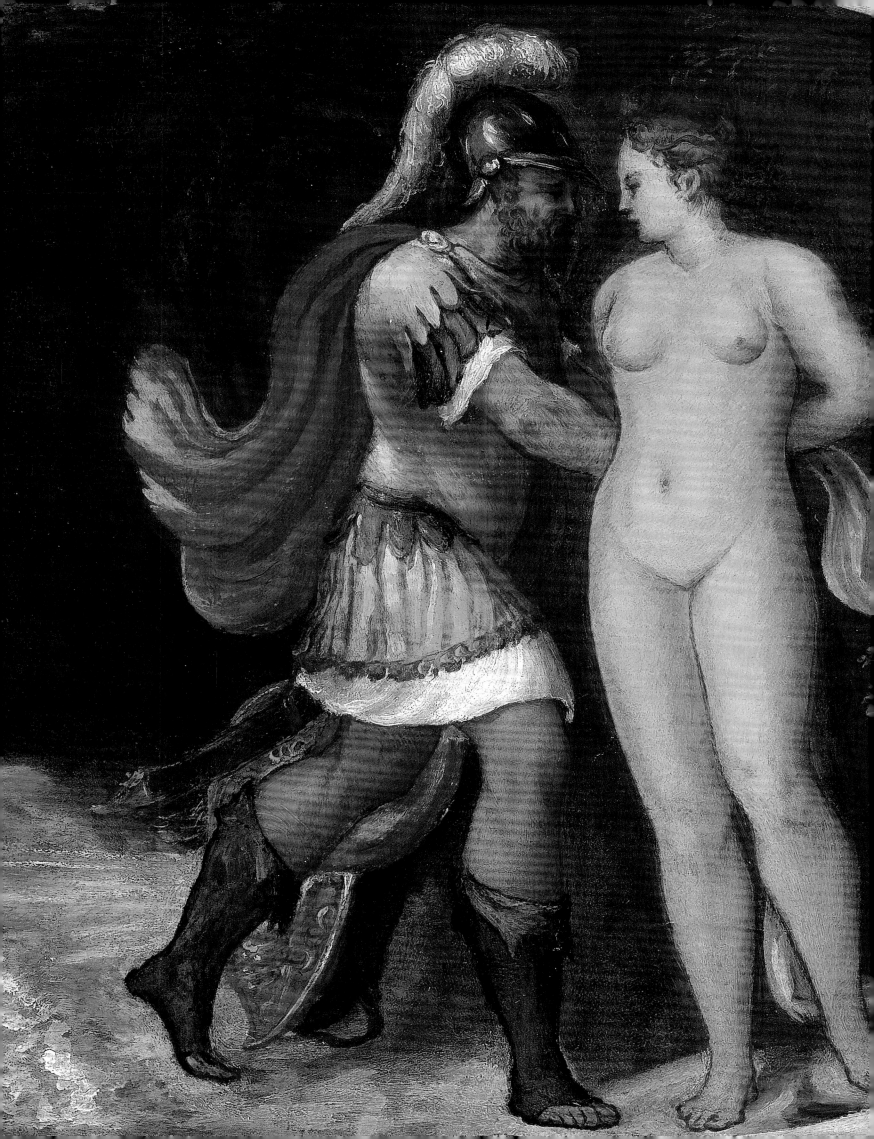

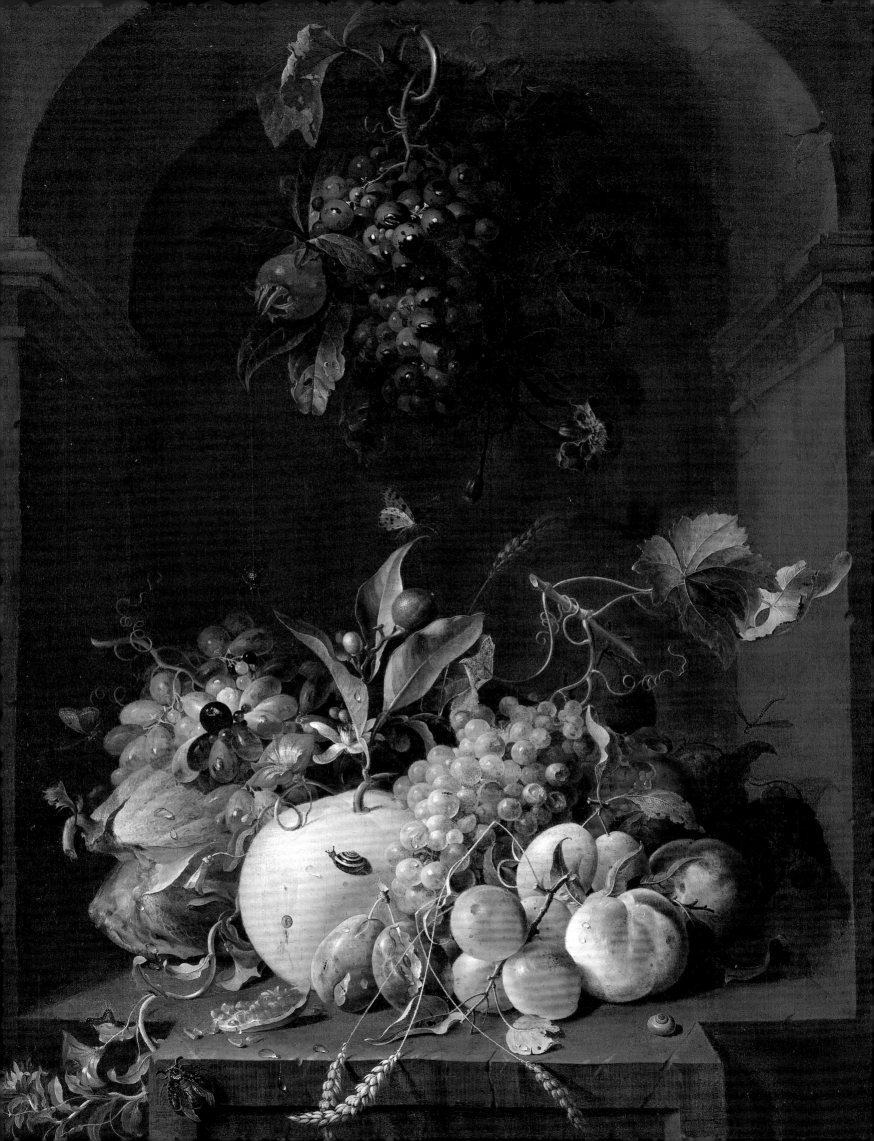

INTRODUCTION

WITH THE INAUGURAL YEAR OF MASTER paintings week coinciding with the annual success of Master Drawings London, we felt it right to mark the moment with a full catalogue of works for our participation in both events. With this in mind we have brought together some of the gallery's most interesting pictures for *One Hundred Old Master Paintings* and *Fifty Old Master Drawings*, printed together in this publication.

Following on from Sphinx's three previous exhibitions, *Russia & Europe in the Nineteenth Century, Russian Orientalism: Central Asia & the Caucasus* and *Constantinople: Views of Nineteenth Century Istanbul* we are now very pleased to be starting our programme of exhibiting strong selections of Old Master pictures. With so much of the gallery's expertise firmly rooted in Old Masters, it is very exciting for Sphinx to be able to share some of our research and paintings, especially at such an interesting time for this area within the art market. As the economic issues that currently surround the contemporary art world refocus interest onto our historic area of collecting, proving the strength of an area seemingly impervious to the winds of change that effect the less established areas of art, it is a fortuitous time for events such as Master Paintings Week and Master Drawings London. The strength, in both the increasing value of historic art and of collectors' discernment, is a heartening aspect of the renewed drive of so many now collecting primarily within this category. With this fresh impetus from both established and new collectors the world of Old Masters seems to be in its ascendancy for headline writers, investors and collectors alike.

Drawing on our friends and clients from both the Russian and Old Master areas we hope to continue the cross-pollination of buyers in both of these fields; bringing Russian paintings into the mainstream for western collectors and Old Masters back into the heart of collections within Russia. With this in mind we are currently working on our exhibition, *The Russian Collection: Old Masters* which will focus on the artists and collectors who are represented within the Hermitage, St. Petersburg. The accompanying catalogue will be published to coincide with our exhibition opening over the next Old Master and Russian art weeks in London.

Through our exhibitions so far, we have attempted to delineate the shared influences and progression of movements within European paintings east and west, as well as to comment on the varied nature of Orientalism. Within this publication we have brought together complementary paintings that are both individually beautiful as well as being solid examples from their respective times, regions and artists from over the last 500 years.

Arranged by region and date the exhibition moves from early Flemish works, such as the *Adoration of the Magi* of *c.*1520, through the early seventeenth century with a summer harvesting scene by Abel Grimmer, to the beginning of the eighteenth century with a pair of works by Joseph van Aken. The Italians are well represented by Tosini, Raibolini, Schiavone, Sassoferrato, Carlone, the Guardi family, Solimena, Pellegrini and Maggiotto. There are too many notable works to mention here so I do hope you will find reading the text which accompanies each painting enjoyable and informative.

The gallery space that we have created in West London to house some of the collection in dedicated exhibitions such as this one, is spread over three floors and we do welcome you to visit at any time. We always have a selection of works on display that do not fall within the scope of the exhibitions we hold. The collection as a whole can be viewed on our website, as can the printed catalogues either in their on-line format or by requesting a bound copy from the gallery.

We are most grateful for the recently shared expertise of Cornelis Bart, Jean-Pierre Cuzin, Everett Fahy, Dr. Sturla Gudlaugsson, Dr. Georges Keyes, M. Nicolas Lesur, Dr. Julia Marciari-Alexander, Jan de Maere, Fred Meijer, Dr. Mitchell Merling, Dr. Ludwig Meyer, Prof. Lino Moretti, Dr. Mary Newcombe Schleier, Dr. Martin Postle, Graham Reynolds, Dimitri Salmon, Prof. Giancarlo Sestieri, Prof. Dario Succi, and Dr. Alexander Wied, the attributions from whom have allowed the gallery to present such an impressive body of works in this volume.

Roy Bolton

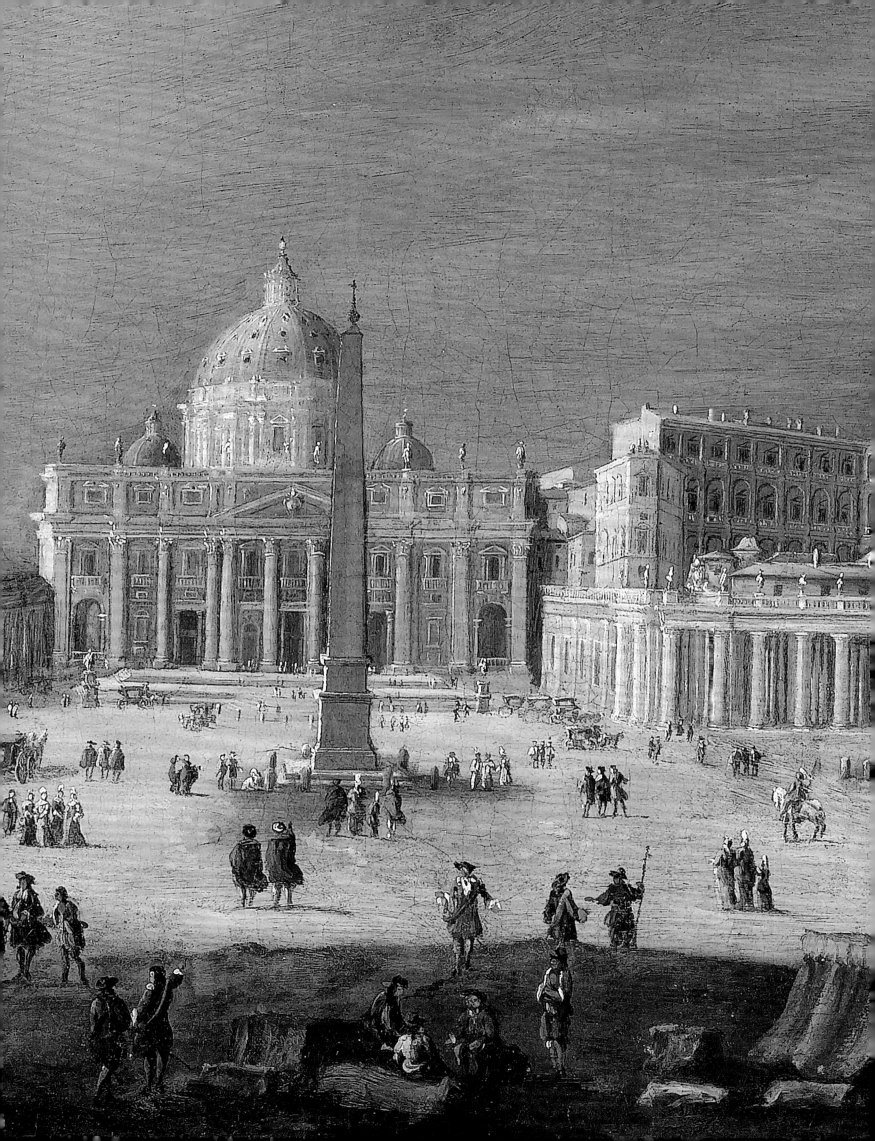

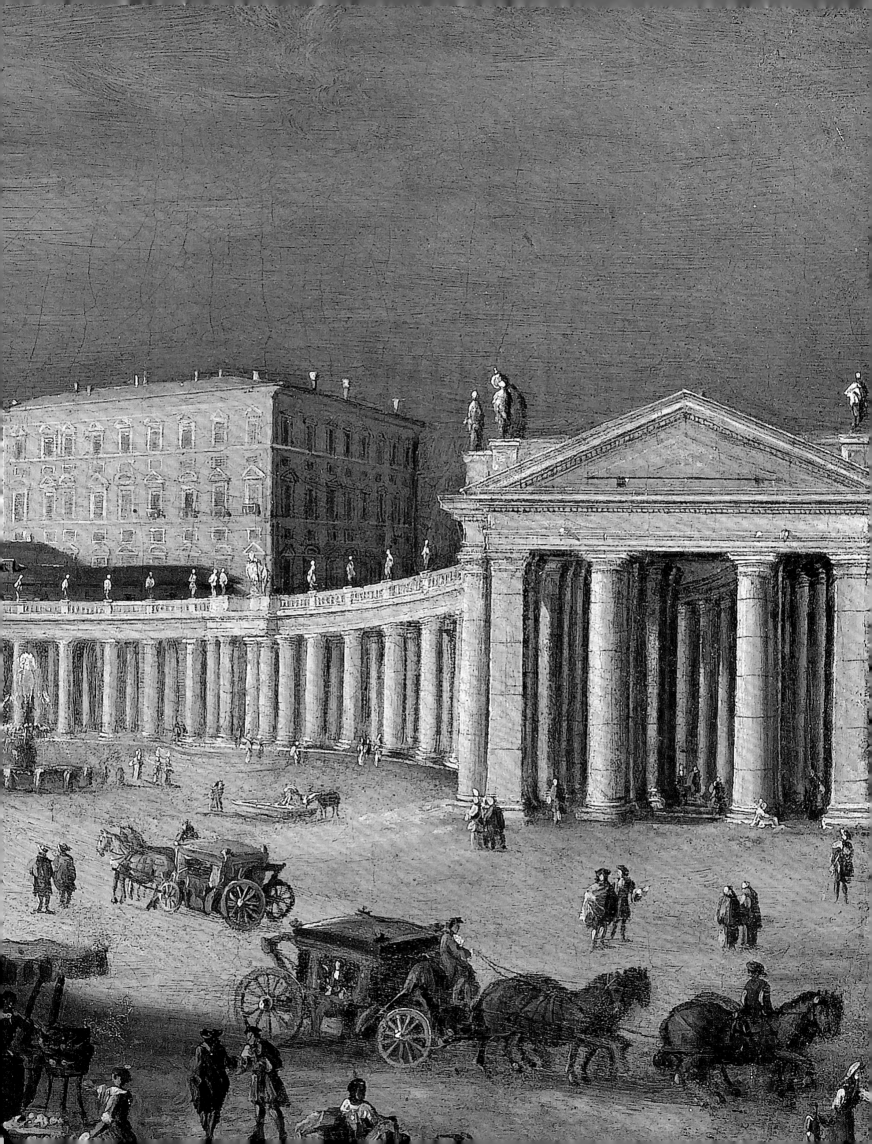

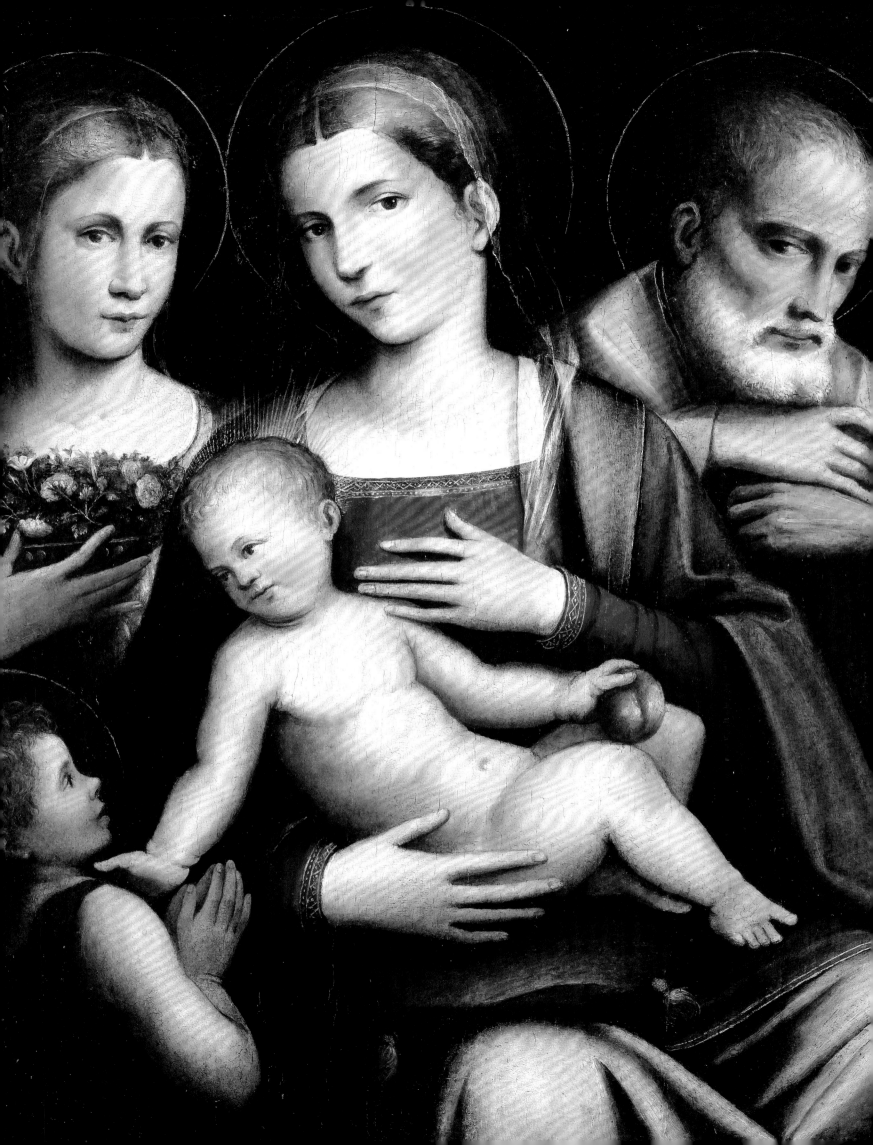

SPHINX · FINE · ART

Edward Strachan · Roy Bolton

CONTENTS

No. 37	**Cornelis Jonson van Ceulen** *(London 1593 - Utrecht 1661)*	*Portrait of Thomas Cletcher, Half-Length*
No. 38	**Attributed to the Monogrammist HVT** *(Active in the Netherlands during the seventeenth century)*	*Portrait of a Bearded Man, Half Length, Wearing a Black Tunic and Hat*
No. 39	**Attributed to Daniël de Koninck** *(Amsterdam 1668 - England, after 1720)*	*Portrait of a Man, Half-Length, Wearing a Plumed Turban and Gold Embroidered Red Cloak with a White Shawl*
No. 40	**Jacob Willemsz. De Wet I** *(Haarlem c.1610 - Haarlem c.1675)*	*The Idolatry of Solomon*
No. 41	**Maerten Stoop** *(Rotterdam 1620 - Utrecht 1647)*	*A Card Game in a Courtyard*
No. 42	**Willem de Poorter** *(Haarlem 1608 - 1648)*	*Croesus Shows Solon his Wealth*
No. 43	**Hendrick Bloemaert** *(Utrecht c.1601 - Utrecht 1672)*	*Artemisia in Mourning*
No. 44	**Jan de Bray** *(Haarlem c.1627 - Haarlem 1697)*	*The Adoration of the Magi*
No. 45	**Jan de Bray** *(Haarlem c.1627 - Haarlem 1697)*	*Bacchus*
No. 46	**Attributed to Jacob van Loo** *(Sluis, nr. Bruges 1614 - Paris 1670)*	*Portrait of William II of Orange-Nassau (1626-1650) as a Child, Head and Shoulders, Holding a Feathered Cap*
No. 47	**Otto Marseus van Schrieck** *(Nijnegen 1619/20 (?) - Amsterdam 1678)*	*A Forest Floor Still-Life with Various Fungi, Thistles, an Aspic Viper, a Sand Lizard, a Tree Frog and Two Moths*
No. 48	**Elias van den Broeck** *(Antwerp 1650 - Amsterdam 1708)*	*A Forest Floor Landscape with a Thistle, Fungi, Moths, a Lizard and Snakes*
No. 49	**Willem Kalf** *(Rotterdam 1619 - Amsterdam1693)*	*A Woman Pulling Water from a Well, A Pile of Vegetables at her Feet*
No. 50	**Palamedes Palamedesz., called Stevens Stevaerts** *(London 1607 - Delft 1638)*	*A Cavalry Skirmish*
No. 51	**Jacob van der Croos** *(active in Amsterdam c.1630/6 - after 1691)*	*River Landscape*
No. 52	**Pieter de Molijn** *(London 1595 - Haarlem 1661)*	*A Hilly Landscape with Wanderers at the Foot of a Castle Ruin*
No. 53	**Cornelis Gerritsz. Decker** *(Haarlem 1620 - Haarlem 1678)*	*Landscape with a Village Road and Figures Conversing in the Right Foreground & Landscape with a Farmyard and Figure Drawing water from a Well, other Figures Conversing Nearby*
No. 54	**Roelof Jansz. van Vries** *(Haarlem 1630 - Amsterdam after 1681)*	*A Landscape with a Figure on a Path and a Bleaching Field Beyond*
No. 55	**Frederik de Moucheron** *(Emden 1633 - Amsterdam 1686)*	*A Wooded River Landscape with a Traveller on a Track*
No. 56	**Frederick de Moucheron and Adriaen van de Velde** *(Emden 1633 - Amsterdam 1686)* *(Amsterdam 1636 - Amsterdam 1672)*	*A Hawking Party at the Foot of an Ornamental Staircase, with a Mountainous Landscape Beyond*
No. 57	**Johannes Lingelbach** *(Frankfurt am Main 1622 - Amsterdam 1674)*	*Peasants Resting Before an Inn*
No. 58	**Reinier Nooms, called Zeeman** *(Amsterdam 1623 - Amsterdam 1664)*	*Shipping before a Mediterranean Coast with a Fortified Town near a Cliff*

No. 59	**Thomas Heeremans** *(Haarlem 1641 - Haarlem 1697)*	*A River Landscape with Figures outside a Tavern and Yachts Moored alongside Houses*
No.60	**Jan Abrahamsz Beerstraten** *(Amsterdam 1622 - Amsterdam 1666)*	*A Mediterranean Harbour with Men-o' War, Shipping and Merchants on a Quay by a Tower*
No. 61	**Ludolph Backhuysen** *(Emden 1631 - Amsterdam 1708)*	*Shipping by the Dutch Coast*
No. 62	**Dionijs Verburgh** *(Rotterdam c.1655 - 1722)*	*A Town in a Hilly Landscape with a River and Several Figures*
No. 63	**Matthias Withoos** *(Amersfoort 1627 - Hoorn 1703)*	*Capriccio of the Forum, Rome, with the Arch of Constantine and the Coliseum in the Background*
No. 64	**Jan Siberechts** *(Antwerp c.1627 - London 1703)*	*A Horse-Drawn Cart with Two Women Travelling down a Flooded Road at the Edge of a Wood*
No. 65	**Salomon Rombouts** *(active Haarlem 1652 - Florence 1710)*	*A Torrent in a Scandinavian Landscape, a House Beyond*
No. 66	**Jan Frans van Bloemen, called Orizzonte** *(Antwerp 1662 - Rome 1749)*	*The Flight into Egypt* *& The Rest on the Flight to Egypt*
No. 67	**Gerard Hoet** *(Zaltbommel 1648 - The Hague 1733)*	*A Mythological Scene with Prisoners Kneeling Before a Queen*
No. 68	**Gerard Hoet** *(Zaltbommel 1648 - The Hague 1733)*	*Paris Presenting Helen to the Court of King Priam*
No. 69	**Pieter Gallis** *(1633 - Hoorn 1697)*	*A Swag of Flowers Hanging in a Niche, with Gooseberries, Strawberries, Roses, Plums, an Iris, a Daisy and a Spider*
No. 70	**Coenraet Roepel** *(The Hague 1678 - The Hague 1748)*	*Still Life of Grapes, Melons, Peaches, Plums and other Fruit with Morning Glory and Shafts of Wheat in a Stone Niche, with a Bunch of Grapes and Medlars Hanging Above*
No. 71	**Henri Gascars** *(Paris 1635 - Rome 1701)*	*Portrait of a Lady, Seated Three-Quarter-Length, in a White and Gold Gown with a Blue Robe, a Garden Beyond*
No. 72	**Sir Joshua Reynolds, P.R.A.** *(Plympton, Devon 1723 - London 1793)*	*Portrait of a Lady, Bust-Length, with Earrings, Unfinished*
No. 73	**John Hoppner** *(London 1758 - London 1810)*	*Portrait of the Right Honourable William Pitt the Younger (1759-1806), Three-Quarter-Length, in a Black Coat, Standing before a Column and Gold Brocade Drape*
No. 74	**William Hamilton** *(London 1751 - London 1801)*	*Calypso Receiving Telemachus and Mentor in the Grotto*
No. 75	**Francis Wheatley, R.A.** *(London 1747 - London 1801)*	*A Market Scene*
No. 76	**William James** *(active 1730 - 1780)*	*View of the Thames at Westminster*
No. 77	**Daniel Turner** *(active 1782 - 1817)*	*View on the Thames with Blackfriars Bridge and St. Paul's Cathedral Beyond*
No. 78	**Attributed to Richard Wilson, R.A.** *(Penegoes 1713 - Colomendy 1782)*	*A River Landscape with Figures Dancing in the Foreground, Mountains Beyond*
No. 79	**Thomas Luny** *(London 1759 - Teignmouth 1837)*	*Ships in a Harbour with Fisherfolk in the Foreground*

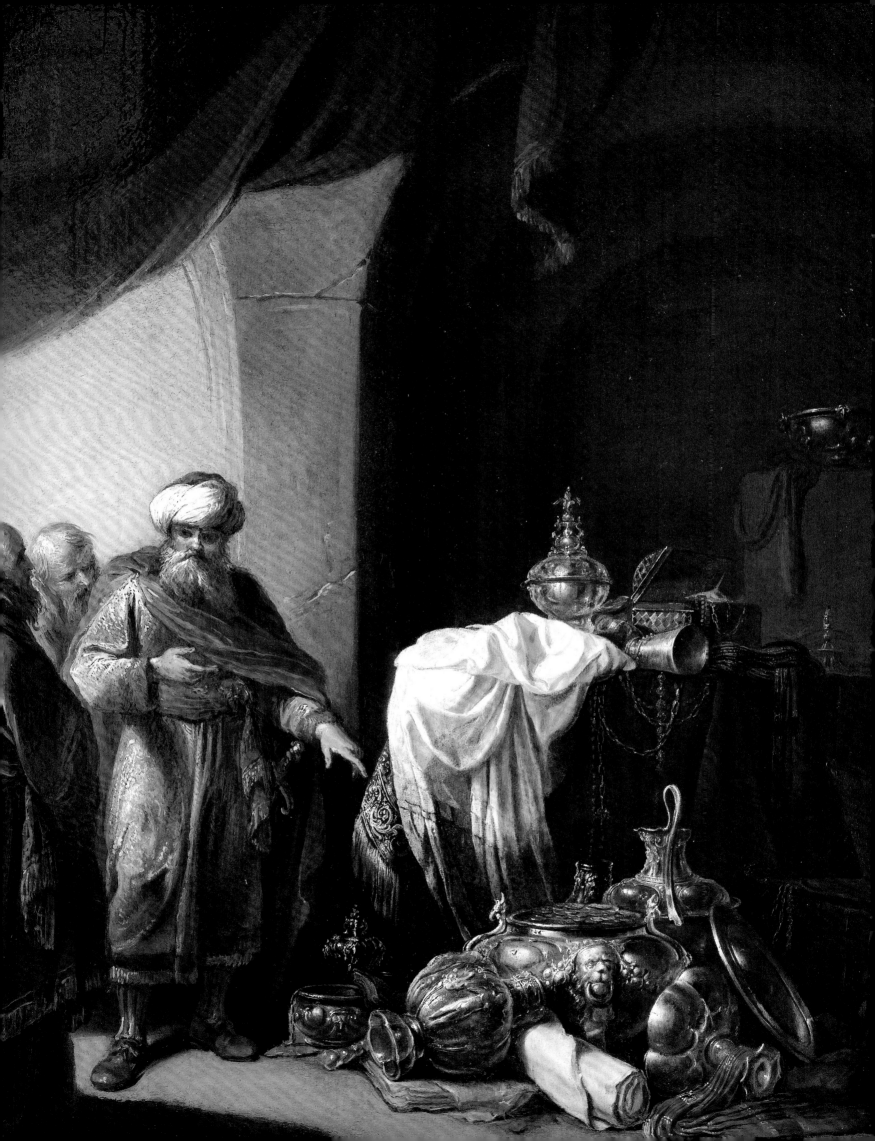

CATALOGUE OF PAINTINGS

ANTWERP SCHOOL, c.1520-1530

The Adoration of the Magi

oil on panel
80 x 56.5 cm (31½ x 22¼ in)

Provenance: Sotheby's Monaco, 31 June 1995, as Studio of Jan de Beer;
Private Collection, Germany.

T*HE ADORATION OF THE MAGI* PRESENTS THE ceremonial gift-giving of the three Magi within a resplendent and ornate portico; only the tethered donkey and bull in the background allude to the traditional stable setting. Central in the composition, a youthful Virgin cradles the infant Christ on her lap. At their feet, an elaborate gold crown attached to a wide-brimmed red hat has been placed. Clearly it has been removed by the kneeling magus, stooped in veneration, while offering a beautiful gold coffer to the Christ child. This bearded, kneeling magus wears a lavish mantle lined with ermine, indicating his royal status.

To the left of the Holy Family stands a second, more youthful, Magus. He too has removed his crown, though he still wears a golden turban alluding to his eastern homeland. His dress is elaborate and sumptuous; the blue and yellow stripes of his hose are echoed in the fractured tile floor below. The third Magus raises his crown in deference as he kneels to the floor. He is holding an intricately fashioned vessel, the base of which is nestled in the soft pink fabric draped loosely around his shoulders. Behind the Virgin and Child, the figure of St. Joseph is seen. Dressed in a simple, though vibrant, flowing red tunic he clasps a straw hat to his chest, while two servants wait in the doorway on the right.

Antwerp School,
c.1520-1530,
The Adoration of the Magi
(Detail)

The background offers a fascinating insight into the narrative of the Adoration. Through the far right window, two camels can be seen being loaded ready for travel. The central window leads the viewer's eye to a train of men making their way gaily through the streets of Bethlehem, many armed and holding spears. Several figures are seen wearing turbans suggesting that they are part of the three Magi's military entourage.

The Adoration of the Magi is an exceptional example of 'Antwerp Mannerism'; a stylistic term coined in 1915 by the German art historian Max Friedländer in his article 'Die Antwerpener Manieristen von 1520'.[1] This style of painting flourished during the period of *c.*1500 to 1530, and the theme of the Adoration of the Magi was the most popular subject matter of the Antwerp Mannerists (see figs. 1, 2 and 4).[2] The present work is one of several versions created and intended for sale on the open art market and for export to southern Europe. *The Adoration of the Magi* is

Antwerp School, *c.*1520-1530, *The Adoration of the Magi* (Detail)

[1] M. J. Friedländer: Die Antwerpener Manieristen von 1520, *Jb. Kön. -Preuss Kstsamml.*, xxxvi (1915), pp. 65-91; subsequent publications in 1921, 1933 and 1937. The term 'Antwerp Mannerism' is now felt to be somewhat unsatisfactory and several attempts have since been made to refine the definition.
[2] John Oliver Hand and Martha Wolff, *Early Netherlandish Painting*, Cambridge, 1986, p. 122.

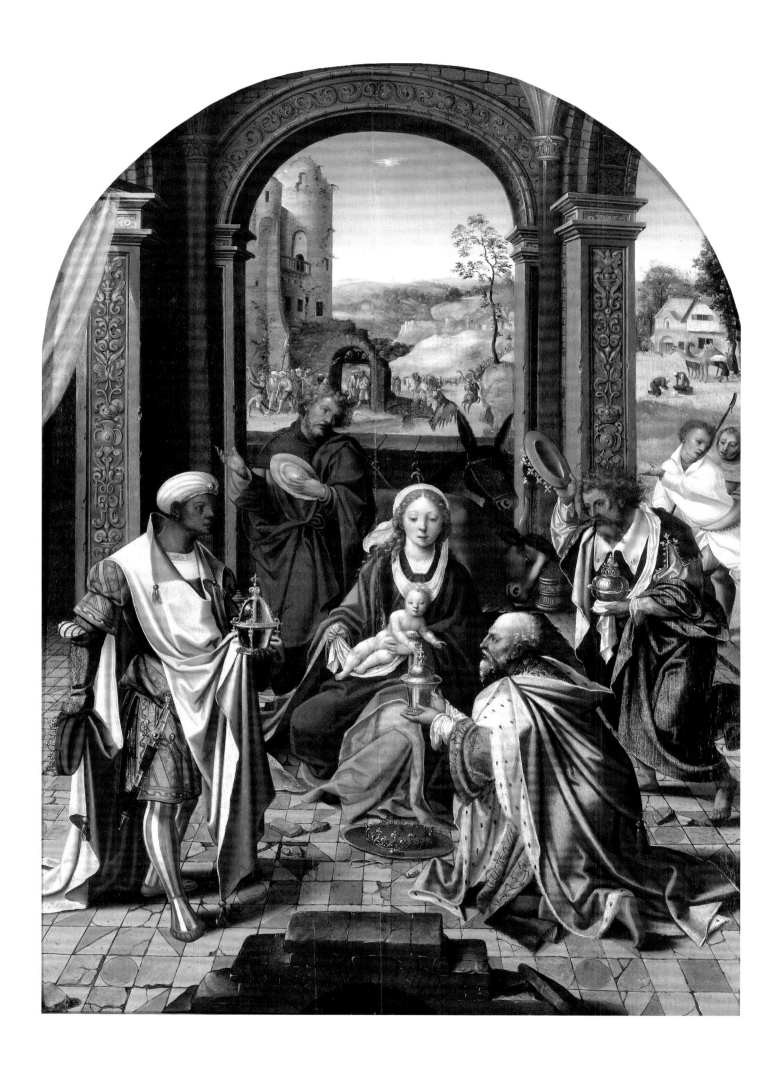

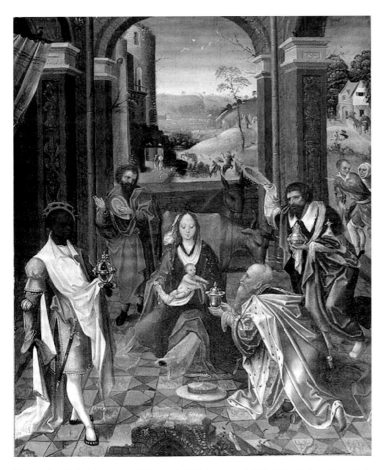

Netherlandish (Antwerp Mannerist) Painter, *c*.1520, *The Adoration of the Magi*, The Metropolitan Museum of Art, New York (Figure 1)

known in at least four other versions: in the Szépmüvészeti Múzeum, Budapest, the Staatliche Kunsthalle, Karlsruhe, The Metropolitan Museum of Art, New York (fig. 1) and in the Johnson collection, Philadelphia Museum of Art (fig. 2). In his 1915 article Friedländer proposed that the Philadelphia version, attributed to an anonymous master active in Antwerp

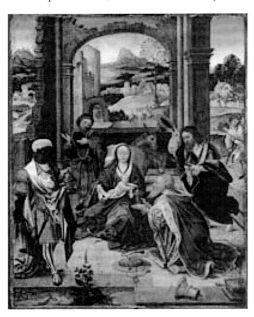

Netherlandish (Antwerp Mannerist) Painter, *c*.1515-1525, *The Adoration of the Magi*, Philadelphia Museum of Art, Johnson Collection (Figure 2)

Antwerp School, *c*.1520-1530, *The Adoration of the Magi* (Detail)

during the first quarter of the sixteenth century, was the most convincing prototype for the subsequent versions.

Like all of the versions, the present work is characterised by a grand, classical architectural setting, exotic oriental costumes, dramatic gestures between the protagonists and a sumptuous, (sometimes jarring,) colour scheme. The opulent gifts presented by the Magi reflect the current designs of elaborate objects imported into and produced in Antwerp, the centre of trade and commerce in the sixteenth-century Netherlands.

Compositionally and structurally, the present work is almost identical to the Metropolitan Museum and Philadelphia versions. Common to all three are the placement of the central figure group and interaction of the magi. However, there are subtle differences which set them apart.[3] On closer inspection of the Virgin's head, for example, one can see the works differ somewhat. In the Metropolitan Museum version, the Virgin's face is more elongated with a pinkish tone and appears almost idealised, see fig. 3, whereas in the present work, the Virgin is shown to be much closer in appearance to the infant Jesus and her face is softer and more rounded. Moreover, the background activity and landscape differ in all of the works. Where elements may remain the same, for example the jumping horses in the Metropolitan Museum of Art version and the present example, there are also enough variations to distinguish between each painting. As none of the works are attributed to particular artists it is difficult to know whether they were completed by the same hand, or by different artists active in Antwerp, as collaboration appears to have been common. However, it is clear that they were produced, possibly using the Philadelphia prototype as a guide, to supply popular iconography to a voracious public who particularly favoured this subject matter.

Distinct from Italian Mannerism, Northern European Mannerism and, in particular, 'Antwerp Mannerism' was essentially an expression of late Gothic art, which was characterised by its unique stylistic and

[3] There is also slight variation in the size of composition; while the present work measures 80 x 56.5 cm (31½ x 22¼ in), the Metropolitan Museum and Philadelphia versions are similarly sized at 68.9 x 54.6 cm (27⅛ x 21 ½ in) and 70.2 x 54 cm (27⅝ x 21¼ in).

Netherlandish (Antwerp
Mannerist) Painter, *c*.1520,
The Adoration of the Magi,
The Metropolitan Museum of Art,
New York
(Detail)
(Figure 3)

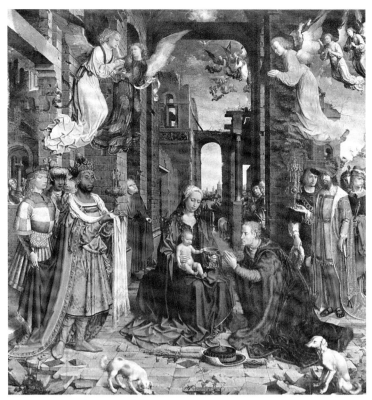

Jan Gossart, *Adoration of the Magi*, *c*.1510-15,
National Gallery, London (Figure 4)

thematic traits[4]. In his seminal study, Friedländer attempted to impose order upon a large extant body of anonymous Antwerp paintings (and some drawings) that had been erroneously gathered under the name of Herri met de Bles (born *c*.1510), after an *Adoration of the Magi* (now in the Alte Pinakothek, Munich) bearing a false Bles signature. Though many of the works remained unattributed, Friedländer was able to identify some of the common anonymous masters, such as Master of the Antwerp Adoration (Alte Pinakothek, Munich) and Master of the von Groote Adoration. The principle recognisable artist working in this tradition is Jan de Beer (*c*.1475-1528), though Friedländer also included Adriaen van Overbeke (fl. *c*.1508-29), the early work of Jan Gossart (*c*.1478-1532) (fig. 4) and the putative *oeuvre* of Jan Wellens de Cock (*c*.1490-1527) as part of 'Antwerp Mannerism'.

Antwerp had emerged as the economic capital of Northern Europe at the beginning of the sixteenth century due to its rich trade and cultural contacts. The city attracted hundreds of artists who joined the local painters' Guild of St. Luke and established successful workshops. Though stylistic characteristics naturally differed from artist to artist, there are some common features found in the Antwerp Mannerist *oeuvre*. These include exaggerated dramatic gestures and dramatic figural arrangements; flamboyant costumes; vivid, sometimes abrasive colouristic effects; the fantastical; architecture which freely combines Gothic and Renaissance elements and demonstrative technical virtuosity (fig. 4). Another characteristic of 'Antwerp Mannerism' is the marked tendency towards repetition. Inspired by the demand for a recognisable product, or 'manner', Antwerp painters developed a repertoire of stock motifs, compositions, and themes, of which the present work is an excellent example.

[4] Though many of the early sixteenth-century Mannerists were based in Antwerp, where the movement was most clearly defined, other centres in France, Germany, and the southern and northern Netherlands were important for the transmission and divergence of the style.

However, it is the devotional character and reworked religious iconography of 'Antwerp Mannerism' in the early sixteenth century that is perhaps its most consistent feature. Though Mannerist paintings appeared before the Reformation in 1517, their composition and focus complemented the personal form of religious expression that the Protestants encouraged. The intercession of the holy figures was particularly emphasised, for example.- As a movement, this branch of Northern Mannerism was relatively short-lived, dying out by the fourth decade of the 1500s, but it was echoed in some of the trends explored by Netherlandish artists around the turn of the following century.

Antwerp School,
c.1520-1530,
*The Adoration of the
Magi* (Detail)

ANTWERP SCHOOL, SEVENTEENTH CENTURY

An Ebony, Ivory, Tortoiseshell, Painted and Ebonised Cabinet on a Stand

open: 185 x 171 x 77.8 cm (72¾ x 67 ¼ x 30 ⅝ in)
closed: 155 x 92 x 41.8 cm (61 x 36 ¼ x 16 ⅜ in)

The rectangular lifting top fitted with a panelled mirror, above two panelled doors, enclosing a fitted interior with ten drawers, surrounding a central panel hinged door opening to reveal a recessed absidal interior with a chequered floor and mirrored sides with later grotto work on the walls, on a later ebonised stand with spiral twisted column supports; the panels painted with landscapes by an artist of the Antwerp School.

Provenance: Envenet, Parpeville, Aisne (according to an old label inside).

THIS WELL PRESERVED AND CHARMINGLY DEC-orated cabinet is an excellent example of the highly skilled cabinetry that flourished in seventeenth-century Antwerp.

Cabinets originated in the late fifteenth century in Italy as the demand of wealthy scholars and patrons grew for a place in which they could display curiosities or hoard confidential documents. As a form of furniture, they developed in the seventeenth century into far more monumental, decorative items. They either stood alone or were set upon carefully fashioned stands. Almost invariably, however, due to the sheer weight of the cabinets, the original stands did not endure the test of time.

The type of woods used and their decorative purpose in cabinet-making varied greatly. Ebony, despite or perhaps because of its extraordinary rarity and the challenges that accompanied any fashioning owing to its hardness, was highly prized.

In this present example, the carved borders of the eight drawers and the frames of the interior panel paintings are all made from ebony. Often in lieu of ebony it became customary to imitate the wood. Writing later in the eighteenth century, the great furniture maker, Thomas Sheraton revealed, 'pear tree and other close-grainwoods have sometimes passed for ebony by staining them black. This some do by a few washes of a hot decoction of galls and when dry, adding writing ink, polishing it with a stiff brush and a little hot wax.'[1]

This seventeenth century cabinet bears striking similarities to a cabinet from the same period that is now housed in the Victoria and Albert Museum (fig. 1). It has the same number of drawers and panel paintings, and in construction the two are almost identical. In keeping with the fashion for decorating the interiors of seventeenth-century cabinets, the eight drawers, central cupboard and the panels behind the two main doors are painted in both cabinets. In our present example, hunting and courtship appear to be recurrent themes, and both subjects were likely to appeal to the original owner of the cabinet. It is possible that the patron commissioned the scenes specifically as the featured architecture could have personal

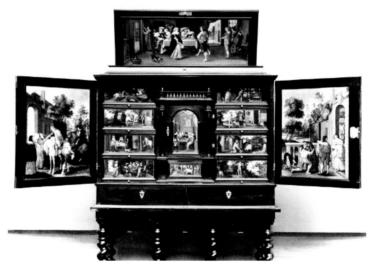

Seventeenth-Century Antwerp Cabinet,
Victoria and Albert Museum, London (Figure 1)

significance. Alternatively, given the intimate nature of some of the scenes and the courtly iconography, it may be that it was commissioned for a lady of some standing.

It would appear that the same man is represented in at least three of these internal scenes. In all, he is splendidly attired in a vivid scarlet cloak, high leather hunting-boots and sporting an ostrich feather-plumed hat and he is shown to be heartily enjoying his various outdoor pursuits. In the right-hand panel painting, he triumphantly fells a giant stag plunging his glittering sword vertically into the pitiful beast (fig. 2). Two dogs yap excitedly at their quarry, and the face of a black dog can be seen as it paws impatiently at the stag's neck.

[1] Ed. Walker, A. *The Encyclopedia of Wood* (1989), pp. 160-161.

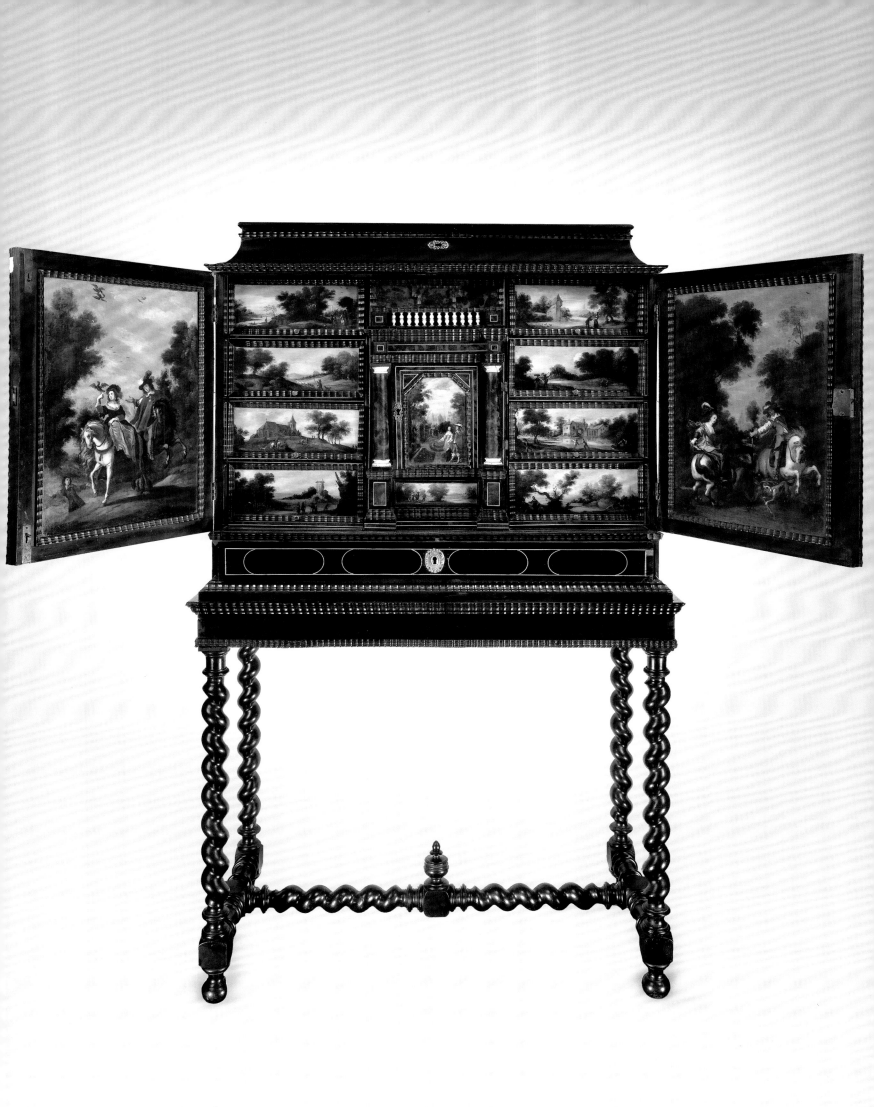

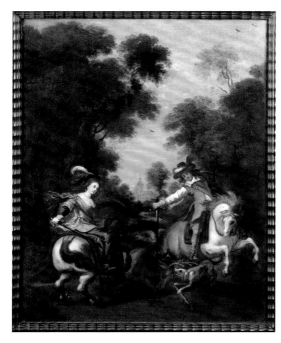

Antwerp School, Seventeenth Century *An Ebony, Ivory, Tortoiseshell, Painted and Ebonised Cabinet on a Stand* (Detail) (Figure 2)

The man's female companion looks on in quiet amusement though she too has her own sword and seems fully complicit in her suitor's favourite sport. In the sumptuousness of her dress she easily matches her partner with an equally exquisite and lavish costume. She is dressed in deep cerulean clasped with an emerald brooch. A fine, gold over-garment and a pink cloak are flung carelessly from her shoulder. A beautifully detailed pearl choker adorns her neck and she too wears a red ostrich feather in her hat.

Whilst this is ostensibly a hunting scene, it is permeated with a distinctly erotic overtone as the woman's revealing attire intimates. In fact, the twining of love and the thrill of the hunt has been exploited by authors and artists for centuries since classical times. Ovid, in his mischievous love poetry as well as in his *Metamorphoses* frequently made the link. The memorable story of Daphne and Apollo in the first book of the poet's epic, records that, on seeing the nymph hunting, Apollo was overcome with lust for her

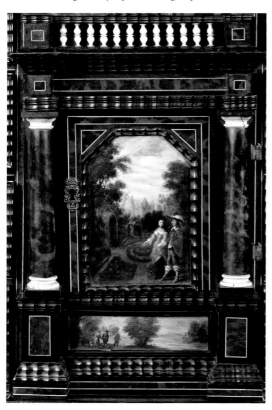

Antwerp School, Seventeenth Century *An Ebony, Ivory, Tortoiseshell, Painted and Ebonised Cabinet on a Stand* (Detail) (Figure 3)

beauty. The same is true in the story of Circe and Picus in which Circe became infatuated with the shepherd as she spied him hunting.[2] Shakespeare's *Venus and Adonis* also makes this connection as the poet opens with the line: 'Hunting he loved, but love he laughed to scorn…'.

Elegant tortoise-shell columns flank the central panel, which evokes an idyllic atmosphere as a young man and woman take a leisurely stroll in the manicured gardens of the castle in the distance (fig. 3). The haze of pink that envelops the castle suggests that it is early evening. The artist's use of light in a number of these panel paintings sensitively conveys early morning or dusk and the miniature nature of these compositions endows the scenes with a far greater intimacy. In this central panel, for instance, an almost imperceptible group of four men stand huddled behind the well-dressed couple. Their very presence is enough to intrude on the couple's seemingly private encounter.

The use of the physical structure of the furniture to convey this intimacy is exemplified in the picture secreted behind the door of this central panel picture (fig. 4). Evidently solely for the private consumption of the owner of this piece, the painting depicts two figures kissing in a close embrace. This harmonious scene is set in a bucolic idyll with sheep grazing in the distance and a blue tinged mountain range looming benignly on the horizon.

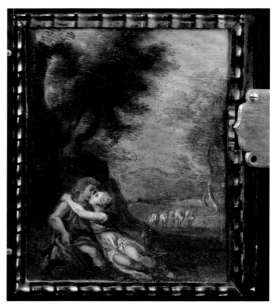

Antwerp School, Seventeenth Century *An Ebony, Ivory, Tortoiseshell, Painted and Ebonised Cabinet on a Stand* (Detail) (Figure 4)

The scene is perhaps set at dusk and the bare arms and legs of the maiden as she draws her lover close to her confirm its overtly amorous nature.

Antwerp replaced Bruges as the main trading centre of the Low Countries in *c.* 1500. Its artistic importance in the seventeenth century was cemented by the works of Peter Paul Rubens (1577-1640) and Jacob Jordaens (1593-1678), and the influence of Anthony van Dyck (1599-1641), which made Antwerp the centre of the Flemish Baroque art. Antwerp was also renowned as a great publishing centre and producer of musical instruments such as harpsichords.

The city produced a number of skilled cabinet makers, many of whom travelled across Europe to practise their craft. One example is the Dutch or Flemish born Gerrit Jensen (*c.*1680-1715) who was recorded as a cabinet-maker to the English crown. Stylistically his work exerted an important influence on English furniture makers. Working with different materials, such as tortoise-shell and brass, and employing new techniques, Jensen and others from the Low Counties brought English cabinet making up to a high standard.

[2] Ovid, *Metamorphoses*, Book XIV.
[3] Edwards, C. *Eighteenth Century Furniture* pp. 34

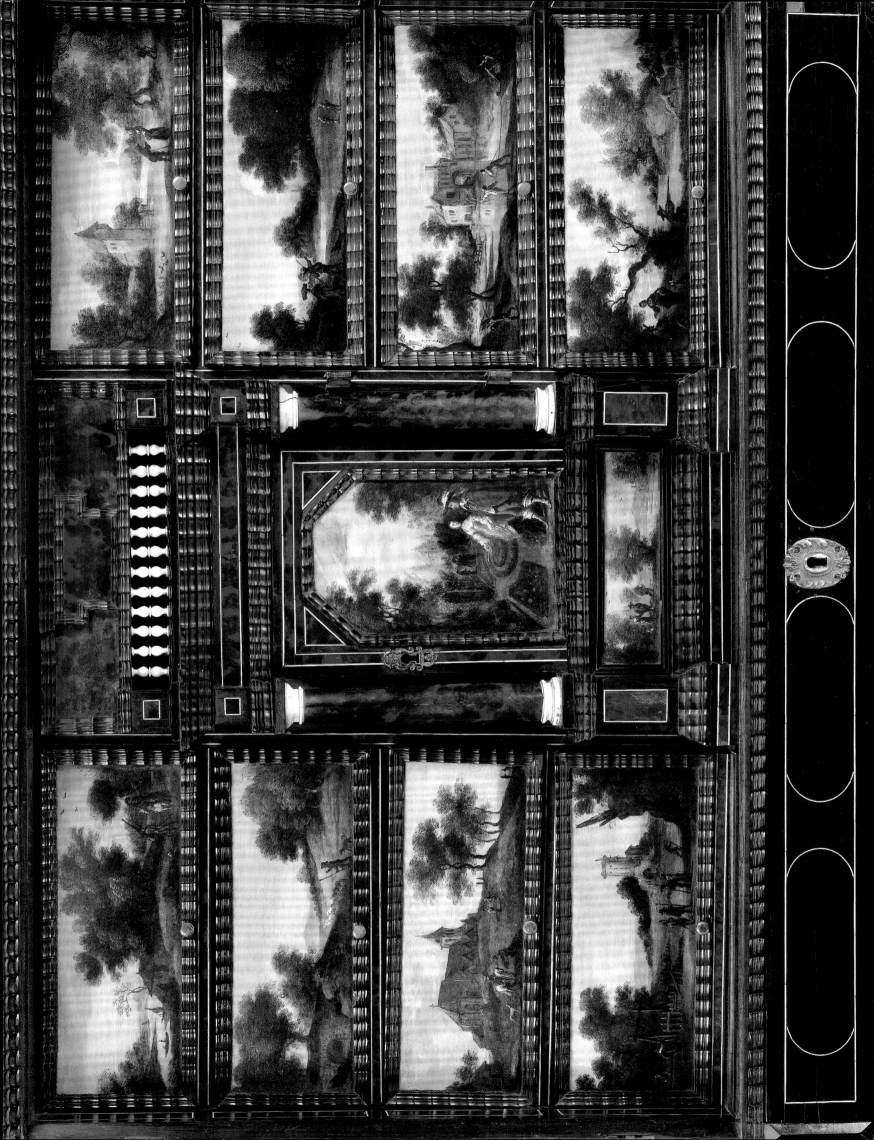

SCHOOL OF LIÈGE, SIXTEENTH CENTURY

The Intoxication of Bacchus

oil on panel
83 x 68.4 cm (32¼ x 26¾ in)

THIS COMPLEX AND REMARKABLE COMPOSITION, with its rich palette and exquisite detailing, shows the Roman god Bacchus at the height of inebriation, an empty wine bowl dangling from his hand. Scarcely able to stand, he is helped up onto a long-suffering donkey by two of his companions. The immense effort required to hoist the unruly god onto the animal is displayed in the concentrated pose of the man in the scarlet cloak. All three wear wreaths of vine leaves typically associated with these celebrations of Bacchic rites. The delicately silvered edges of the leaves and the fluttering tendrils that unfurl from their crowns are characteristic of Flemish realism. A broad canopy of vine leaves trails over an archway, highlighting even further the incongruity of a mythological scene depicted in an otherwise intensely Netherlandish setting with the minutely detailed town bathed in a blue haze in the far distance.

The unsettling contrast is made even more acute by the blend of illusion and reality. Two *putti* with lurid red and aquamarine wings, that resemble parrots' feathers, frolic in the foreground as a goat stumbles through a hoop that they hold. Goats were commonly associated with Bacchus. The historian Pausanias offers a tantalising hint as to the connection: 'On the market-place is a votive offering, a bronze she-goat for the most part covered with gold. The following is the reason why it has

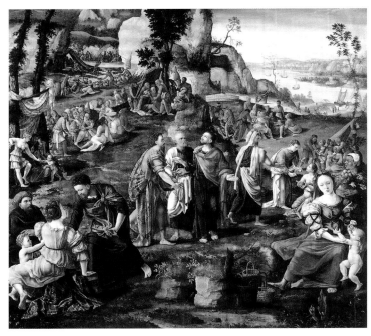

Lambert Lombard, *The Miracle of the Loaves and Fishes*, Rockox House, Antwerp (Figure 1)

received honours among the Phliasians. The constellation which they call 'the Goat', on its rising, causes continual damage to the vines. In order that they may suffer nothing unpleasant from it, the Phliasians pay honours to the bronze goat on the market-place and adorn the image with gold.'[1]

Other animalistic elements include a panther skulking in the far right-hand foreground, its paw adjacent to the foot of the scarlet-cloaked member of Bacchus' entourage. Equally alarming is the depiction of the man on the most extreme left-hand of the work. He is contorted in a bizarrely foreshortened pose as one arm stretches out of the painting with the winding coils of a green serpent wrapped around it. The creature's menacing face is complete with beady eyes and fangs. With his other hand, the figure greedily lunges for a bunch of glossy grapes proffered

School of Liège,
Sixteenth Century,
The Intoxication of Bacchus
(Detail)

[1] *Pausanias* II.13.6.

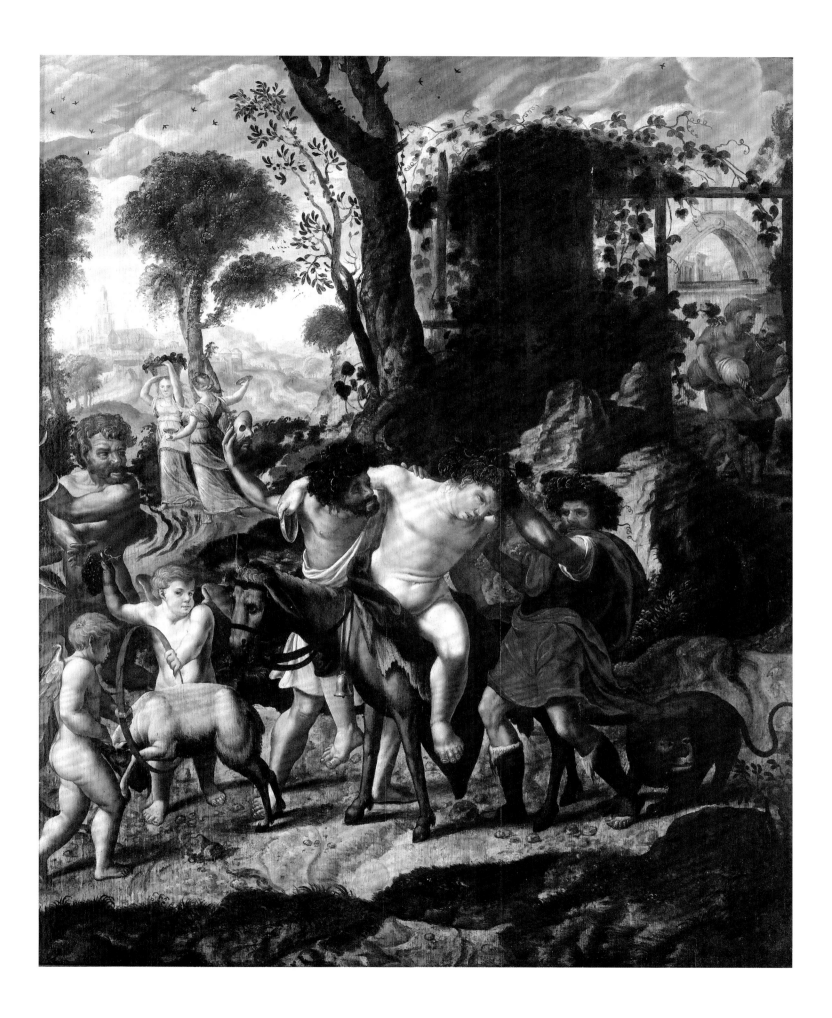

School of Liège, Sixteenth Century, *The Intoxication of Bacchus* (Detail)

by one of the curiously un-childlike cherubs. It is possible that his legs, which are obscured, are those of a goat and he could be represented as a satyr. His expression is fixed firmly on the figure that dominates the central space of the painting and takes with him the eye of the viewer.

Bacchus, god of many things including wine, agriculture and the theatre, had his Greek counterpart in the form of the awesome god Dionysus. He is popularly held to be the offspring of Zeus and Semele. Zeus' eternally jealous wife Hera discovered his betrayal and wrought her characteristic revenge on her husband's hapless mistress. Appearing in the guise of an old woman, Hera befriended Semele and it was not long before the young girl boasted to the seemingly benign old woman that Zeus was her lover. The crafty Hera began to plant seeds of doubt in Semele's mind as to Zeus' true identity and taunted her with the proposition that if Zeus did truly love her, he would grant her request that he appear to her in his true form. Semele did as Hera had advised and demanded that Zeus appear to her in his usual form. Zeus, filled with panic, flatly refused but was compelled to grant her request as he had sworn a solemn oath to her, before he knew what the request would be. When the mighty god appeared, enrobed in flames and clutching his thunderbolts, Semele was

School of Liège, Sixteenth Century, *The Intoxication of Bacchus* (Detail)

burned alive. Zeus managed to rescue the foetal Dionysus and sewed him into his thigh until he was ready to be born. The miraculous nature of Dionysus' birth led him to become the focus of worship of innumerable cults.

It is thought that the cult of the Roman Bacchus was imported from Etruria in *c*.200BC. Bacchus' own festival, the *Liberalia* was celebrated in March. These festivals or *bacchanalia* as they became known, were regarded as utterly notorious, so much so that a famous decree of the Roman senate in 186BC banned them throughout Rome except by special dispensation, as it was reported that political conspiracies were being hatched under the cloak of religion. Bacchus, like the Greek Dionysus, is associated with female followers known as *maenads*. He was also usually accompanied by Silenus, his old friend and faithful companion. The sons of Silenus were Bacchus' satyrs. Silenus has been described as the oldest, wisest and most drunken of Bacchus' followers. Interestingly in literature and in art, it is Silenus rather than Bacchus who is depicted atop an ass. In Titian's (*c*.1485/90-1576) *Bacchus and Ariadne* (National Gallery, London), for instance, a drunken Silenus can be seen in the background half asleep on a donkey. In Book IV of Ovid's *Metamorphoses* the following is embedded in a dramatic narrative of the rites of Bacchus: 'You yoke together two lynxes with bright rein decorating their necks, Bacchantes and Satyrs follow you, and that drunken old man, Silenus, who supports his stumbling body with his staff, and clings precariously to his bent-backed mule. Wherever you go the shouts of youths ring out, and the chorus of female voices, hands beating on tambourines, the clash of cymbals, and the shrill piping of the flute.'[2]

The festivals of Bacchus, the essence of which is depicted here in *The Intoxication of Bacchus*, involved a mixture of comedy and tragedy. The tragic actor, or *bacchant,* wore high-soled hunting boots made from goatskin called buskins. The man to the right of Bacchus appears to be wearing these. His other companion, if he were to represent comedy, would wear soft sandals made of fawn skin. However, his bare feet provide enough of a contrast. A figure in this painting also appears to be holding a mask, paying homage to Bacchus' position as a patron of the theatre. The mask was used in Dionysian masquerades to represent the incarnate god. The *bacchant* who wore the mask became himself the mask or earthly representative, on stage, of the god Bacchus.

This sixteenth-century painting is intriguing on a number of levels not least on account of its subject matter. Large-scale mythological portrayals, whilst eminently popular amongst Italian Renaissance artists, held far less appeal for the Netherlandish painters whose strong commitment to realism inevitably curtailed these compositions which were based largely on imagination. In many ways this present depiction of Bacchus, in a distinctly Netherlandish environment, is similar to contemporary artists' evocations of religious subject matter. Renditions of the Madonna and Child in clearly domestic environments, which avoided the stylised figures of their Italian counterparts, were peculiarly Netherlandish. Similarly here, the cherubs have adult faces with childlike bodies. The architecture on the far right of the work resembles Albrecht Dürer's (1471-1528) architectural paintings. The two pairings of women and men on either side of the gnarled tree trunk look like peasants going about their daily business. On closer inspection, however, they are directly participating in the rites of Bacchus. The men pour wine from a large wineskin, whilst one woman carries a basket of grapes on her head. Her companion, arms akimbo, holds two golden wine cups. The way that she holds them is also suggestive of the cymbals used to celebrate Bacchic rites.

[2] Ovid, *Metamorphoses* IV. 27-30.

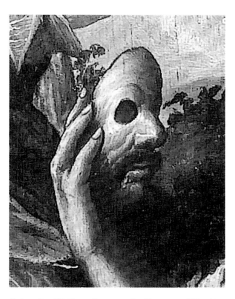

School of Liège, Sixteenth Century, *The Intoxication of Bacchus* (Detail)

The dominant feature of the tree, that effectively separates the painting into a work of two halves, is covered with twining ivy which was another distinctive attribute of Bacchus. The ivy, like the grapes and wine cups that are abundantly detailed, is a mild intoxicant as well as being symbolic of everlasting life. Consequently, many ancient depictions of Bacchus often show him with grapes and ivy together. The tree may also represent the *thyrsus* or staff that the god commonly held and which was topped with a pine cone. Bacchus' wand was inherently phallic and represented the life force or virility that he symbolised.

The inspiration to attempt mythological subject matter may have stemmed from the invention of printing. Before the prevalence of printed material, scholars and other learned men had been dependent on copyists for their versions of classical texts and the Bible. With the advent of printing, these texts became more widespread, thus granting artists in the Netherlands access to such subject matter. Dr. Whinney notes that Flemish artists, whilst they did not show any distinct appreciation for the High Renaissance style in Italy, did demonstrate a new interest in representing classical subjects, particularly those that required the use of the nude.[3] The careful modelling of the cherubs' bodies, as well as Bacchus' with his portly belly, demonstrates a keen interest in the representation of the human form in an innovative way.

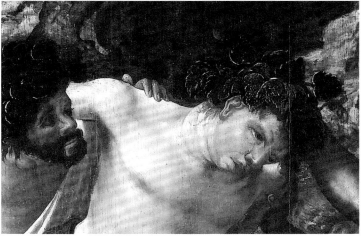

School of Liège, Sixteenth Century, *The Intoxication of Bacchus* (Detail)

One of the leading proponents of this fusion of Northern and Italian Renaissance was the Liège artist, Lambert Lombard (1505-1566) who, in *c.*1538, founded the first northern academy of art, based on Italian equivalents he had noted on his travels. Lombard belonged to a generation of Flemish artists who sought to revive Flemish painting by looking back to the art of antiquity and the Italian Renaissance. A journey to Rome in 1538 allowed him to formally study antique works as well as those of Raphael (1483-1520) and Michelangelo (1475-1564). Whilst there, he came into contact with Francesco Salviati (1510-1563) and Baccio Bandinelli (1493-1560). Lombard also travelled to Germany where he absorbed much from the study of grave reliefs. A large proportion of his work incorporates motifs and ideas from Italian prints but the forms, technique and marked taste for pictorial narrative derive from Antwerp Mannerism. Lombard embraced subject matter from classical literature as well as from the New Testament which was highly unusual at the time. In both, the influence of antique statuary is clearly identifiable as are Raphael's cartoons of the Acts of the Apostles. Lombard's humanist tendencies, which encompassed the study of ancient history, mythography, archaeology and ancient religions, fed into his

Lambert Lombard, *The Vestal Virgin Claudia Quinta Draws the Boat from Cybele*, The Church of St. Armand, Stokrooie, Belgium (Figure 2)

choice of subject matter. Scarcely any of his paintings survive today although his, *Miracle of the Loaves and the Fishes* and *The Vestal Virgin Claudia Quinta Draws the Boat from Cybele* bear both the hallmarks of his own artistic style as well as some comparative points with the present work (figs. 1 and 2). The finely detailed landscapes that can be glimpsed in the distance, a haze of grey and blue, the intensely crowded compositions and the vivid colouring of both works are all identifiable aspects of *The Intoxication of Bacchus*.

During the twelfth century, Liège was one of the most prolific artistic centres of Western Europe noted particularly for its illuminated manuscripts, sculpture and metalwork. After an interim period of decline, the region re-emerged in the early sixteenth century to absorb the precepts of the Italian Renaissance. *The Intoxication of Bacchus* dating from this period clearly displays the combination of Northern and Italian Renaissance styles peculiar to the Liège School of artists.

[3] Whinney, M., *Early Flemish Painting*, 1968, p. 122.

ABEL GRIMMER

(Antwerp 1570 - Antwerp 1618)

An Allegory of Summer

oil on panel
28.7 x 39.3 cm (11¼ x 15½ in)

Provenance: Anonymous sale, New York, Sotheby's, 13 October, 1989, lot 51;
with Richard Green, London;
Dimitri Mavrommatis.

Literature: R. de Bertier de Sauvigny, *Jacob et Abel Grimmer*, Belgium 1991, p. 268, no. 28, reproduced in a colour plate 95.

SEEKING SHADE FROM THE FIERCE SUMMER SUN, A group of harvesters recline under the boughs of a tree sharing a simple meal of bread and cheese. The whole scene bustles with activity as a number of labourers still toil in the field beyond, gathering the carefully scythed corn into neat stooks. Men, women and children all lend a hand giving a sense of dynamic community to the work. A little child dressed in a white smock can be seen wrestling with a bundle of corn far too big for her to manage. Another young child sits in the shade, his back to the viewer as he thirstily drinks from the bowl of milk that has been set upon a spotless, white table cloth. In bare feet a man and a woman frame the activity of the harvesters' merry picnic; the woman bending forward to eat while the man leans back to drain a flagon of ale. With their hats and scythes cast aside for the brief respite provided by their meal, this group stands in contrast to the hard work still going on behind them. A little dog mischievously sniffs the picnic basket next to his unsuspecting owners, who are oblivious to everything except resting their weary limbs and sating their hunger. This imbues the ritual of the harvest with a sense of light hearted realism.

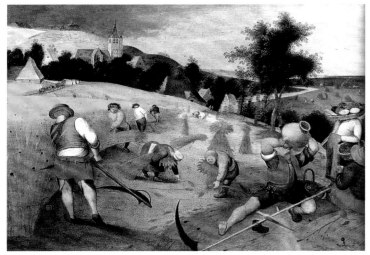

Abel Grimmer, *Summer*, 1607, Koninklijk Museum, Antwerp (Figure 2)

In the composition of *An Allegory of Summer*, Abel Grimmer creates an almost pictorial narrative aided by a subtle yet highly effective use of light and shade. In the left foreground, a shepherd dressed in a loose red tunic and virtually obscured by the shade of a tall oak idly tends his flock as they amble unhurriedly down the brilliantly sun-lit path. Three sheep pause at the bottom leading the eye at once to the relaxed picnic of the tired labourers. The stooks and the precise line resulting from the harvesters' toil lead the eye further back into the recesses of the composition, to the horse-drawn cart and a cluster of paler silhouettes of the same foreground stooks. Two farmsteads stand at the edge of the field, while beyond, blue-green woods line the horizon. In the very far distance a shimmering church spire can be seen, the creamy clouds tinged with pink vividly conjuring up the reality of the searing heat and windlessness of a perfect summer's day.

Grimmer is known principally for his numerous small-scale paintings of country scenes, sometimes with biblical themes. Often his works form part of a series of the four seasons or the months of the year and no doubt this present work followed the same format. A complete series of the

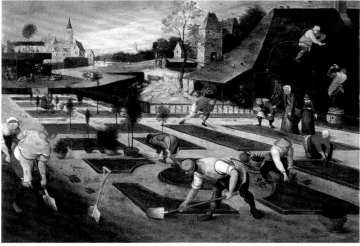

Abel Grimmer, *Spring*, 1607, Koninklijk Museum, Antwerp (Figure 1)

four seasons is held in the Koninklijk Museum, Antwerp, two of which, *Spring* and *Summer*, are detailed here (figs. 1 & 2). As Reine Berthier de Sauvigny has suggested, Grimmer's *An Allegory of Summer* can perhaps be linked to *The Month of May*[1] which is of approximately the same dimensions and stylistically highly similar.[2] It is also possible that this panel was painted as a single month and incorporated into a series of the full twelve months of the year. While the majority of these series are now dispersed, Berthier de Sauvigny identifies one complete set of twelve that was last recorded in Belgium.

The origins of the Flemish tradition of landscape painting on panel, as exemplified by Grimmer's *An Allegory of Summer*, can be traced back to the miniature paintings of medieval manuscript illumination. The celebrated *Très Riches Heures de Duc de Berry* (c.1411-1416, Musée Condé, Chantilly, France) illustrated by the Limbourg brothers, provides a supreme example of such craftsmanship. It depicts the labours of the months within detailed, naturalistic landscapes for the first time in the history of art (fig. 3).

The same type of calendar decoration was taken up once more in Netherlandish art with the *Da Costa Book of Hours* (c.1515, Pierpont

Abel Grimmer, *An Allegory of Summer* (Detail)

Morgan Library, New York) by the native Bruges artist, Simon Bening (1483/4-1561).[1] The importance of the innovations heralded by manuscript illumination in the northern Netherlands was not lost on Grimmer given that, in a fashion similar to the Limbourg brothers' illustration of July, see fig. 3, he too includes landscape, architecture and a highly accurate iconography of the seasons. In *An Allegory of Summer with Three Signs of the Zodiac* (fig. 5), the season is made recognisable by the weather and the activities of the figures depicted. The signs of the zodiac in the sky also identify the time of year. Signs of the zodiac are rare in Grimmer's work and do not feature in *An Allegory of Summer*. Their inclusion in *An Allegory of Summer with Three Signs of the Zodiac*, however, demonstrates his clear knowledge of the traditions and techniques of manuscript illumination.

An equally, if not more, important influence upon Grimmer's works came from his predecessor and compatriot, Pieter Brueghel the Elder (c.1525-c.1569). Figure 4 is one of six panels by Brueghel the Elder designed for the home of the wealthy Antwerp merchant Niclaes Jongelinck. The series, which represented the seasons or times of the year, included six works, five of which survive.[4] Brueghel's unique sensitivity to rendering nature in all her glory marked a clear departure from his predecessors since he favoured suppressing the religious associations of earlier depictions of the seasons in favour of an unidealised vision of landscape.

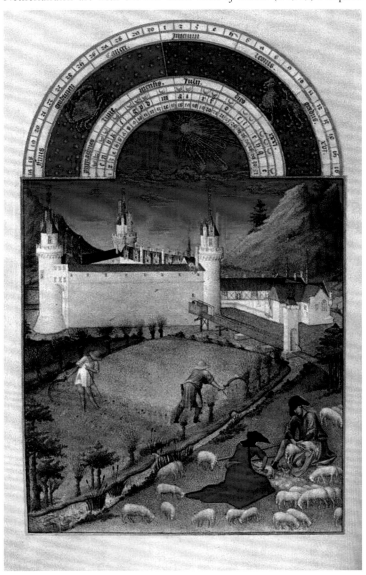

Limbourg Brothers *Les très riches heures du Duc de Berry: Juillet (July)*, 1412-16, Musée Condé, Chantilly (Figure 3)

[1] With Galerie R. Finck, Brussels.

[2] See literature: R. Berhier de Sauvigny, p. 264, no. 9, fig. 136.

[3] A. van Suchtelen, *Holland Frozen in Time, The Dutch Winter Landscape in the Golden Age*, Exhib. Cat., The Mauritshuis, The Hague, 24 November 2001-25 February 2002, Waanders, p. 37.

[4] The other four are: *Gloomy Day, Return of the Herd, Hunters in the Snow* (all Vienna, Kunsthistorisches Museum), and *Haymaking* (Nelahozeves, Czech Republic, Roudnice Lobkowicz Collection).

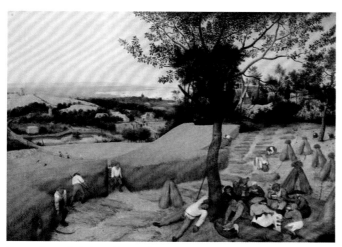

Pieter Brueghel the Elder, *The Harvesters*, 1565,
The Metropolitan Museum of Art, New York (Figure 4)

Abel Grimmer, *An Allegory of Summer with Three Signs of the Zodiac: A Wooded Landscape with Peasants Shearing Sheep and Harvesting Corn*, Private Collection (Figure 5)

Brueghel's *The Harvesters* probably represented the months of August and September in the context of the series. It shows a partially cut and stacked field of corn, while in the foreground a number of peasants pause to picnic in the relative shade of a pear tree. Work continues around them as a couple gathers wheat into bundles, three men cut stalks with scythes, and several women make their way through the wheat field with stacks of grain over their shoulders. The vast panorama across the rest of the composition reveals that Brueghel's emphasis is not on the labours that mark the time of the year, but on the atmosphere and transformation of the landscape itself.

Grimmer's *An Allegory of Summer* has much in common with Brueghel's exquisitely naturalistic setting of the same subject matter. In both, tired peasants can be seen resting from the summer heat under the shade of a tree while others continue toiling in the field behind. The strikingly similar poses of the exhausted labourers, their legs splayed out in weary abandon is of particular note in both works. The linearity of Brueghel's cornfield is also a point of comparison. In terms of its rigid line and methodical composition, Grimmer borrows aspects of Brueghel's style. In a number of other ways, however, Grimmer's *An Allegory of Summer* is highly individual. The graphic, detailed treatment of the features in the foreground of the work, such as the twisted tree trunk, dark foliage, sheep and undulating path, are distinctively his own.

There is a typically schematised quality to Grimmer's treatment of colour and composition in the painting with bands of brighter areas juxtaposed with darker ones. The bright sunlit path of the foreground is set against dark foliage just as the shimmering golden cornfield is bordered by the deep blue-green woods on the horizon. Scarcely perceptible flecks of white on the foliage of the distant trees lend them a silvery quality which contrasts with the warm green, brown and ochre tones of the foreground foliage. The artist's progressive use of cooler, blue-green hues as the scene recedes into the distance derives from the tradition of atmospheric perspective prevalent in Flemish landscape painting, which was introduced by Joachim Patenir (c.1475/1480-1524). Not only does this technique serve to lend

the work a greater depth, it also keenly evokes a palpable atmosphere of a tranquil summer's day.

Grimmer was the son of his painter father, Jacob (1525/6-before 1590) whom the art historian Giorgio Vasari (1511-1574) considered one of the finest landscapists of his time and of whom van Mander made the claim that he knew of no other artist who was so 'outstandingly skilled in landscapes'.[5] Jacob Grimmer was one of the first Netherlandish artists to break with the tradition of the mountain landscape pioneered by Patenir. Instead he depicted broad landscapes of the Flemish countryside, as exemplified in his *Four Seasons* of 1575 which were executed ten years after Brueghel's six panels of the months (fig. 6). Although Grimmer's *An Allegory of Summer* is akin to his father's *Four Seasons* both in its naturalism and close observation of nature, it is also individual in style and distinct from Jacob Grimmer's panels.

Born in 1570, Grimmer became a master in the Antwerp Guild of St. Luke in 1592. His paintings owe much to his father's style as well as to Brueghel the Elder, as discussed above. Grimmer often copied prints engraved by Pieter van der Heyden (c.1530-1572) after designs by Brueghel and the artist Hans Bol (1534-1593).[6] His series of the *Twelve Months* (1592, Montfaucon-en-Velay, Haute-Loire, Chapelle Nôtre-Dame), for instance, are exact copies of Adriaen Collaert's prints after Bol.[7] While he also painted church interiors and other architecturally inspired pieces, Grimmer is perhaps best known for his depictions of peasants at work or leisure in the outdoors as in *An Allegory of Summer*.

[5] Vasari, G., *Vite*, 1550, ed. Milanesi, G., 1878-1885, vii, p. 586

[6] The series of engravings by P. Van der Heyden after Pieter Breughel the Elder and Hans Bol are at the Rijksmuseum, Amsterdam. Reproduced in A. van Suchtelen, *Holland Frozen in Time, The Dutch Winter Landscape in the Golden Age*, pp. 42-44.

[7] Hollstein: Dutch and Flemish, iv. no's. 523-34 (published by Hans van Luyck, fl. c.1580-85, in 1585).

Jacob Grimmer, *Spring*, Museum of Fine Arts, Budapest (Figure 6)

PAUL VAN SOMER

(Antwerp c.1576 - London 1621)

Portrait of a Gentleman, Three-Quarter-Length, in a Black Doublet with a Medallion on a Gold Chain,
a Sword in his Left Hand, a Letter in his Right

inscribed and dated 'AETATIS. SUAE 39. ANNO. 1.60.6.' (upper right)
oil on canvas
99.7 x 73.7 cm (39¼ x 29 in)

Provenance: Anonymous sale, Christie's, London, 20 December 1906, Lot 157 (6 gns. to Gurney);
anonymous sale, Sotheby's, London, 18 October 1995, Lot 51.

THE BULKY FRAME OF THE GENTLEMAN DEPICTED in Paul van Somer's portrait is positioned squarely in the centre of the canvas, giving him a proud and defiant air that suits his stern facial expression. One of his hands is pushed to the forefront of the composition holding a letter and the other prominently displays a sword, indicating his strength and valour. The man's status and authority is confirmed by the three loops of heavy gold chain hanging from his neck holding a medallion with the profile portrait of Archduke Matthias of Austria (1557-1619), who reigned as King of Hungary from 1608 to 1619, King of Bohemia from 1611 to 1617 and as Holy Roman Emperor from 1612 to 1619. The bestowing of Matthias' favour on the present sitter was clearly an event worth commemorating in a portrait; particularly notable as the work is dated 1606, the date of the Peace of Vienna between Archduke Matthias and István Bocskai, Prince of Transylvania.

Portrait of a Gentleman, Three-Quarter-Length, in a Black Doublet with a Medallion on a Gold Chain, a Sword in his Left Hand, a Letter in his Right, adheres to a conventional format particularly in the sitter's hieratic pose against a plain dark background, with the coat of arms of the Ströling family in the upper left and an inscription in the right. The gentleman's stance is rigid; his face, however, is painted in a naturalistic style, breathing life into the portrait and offering the viewer a sense of the sitter's character. The details of the gentleman's lace collar and cuffs, pinked and patterned doublet sleeves and decorative sword scabbard are especially finely rendered.

Van Somer's talent for depicting character as well as intricacies of costume is similarly reflected in his portrait of *Lady Elizabeth Grey, Countess of Kent*, in the Tate Gallery, London (fig. 1). The portrait dates to *c.*1619 and van Somer's style has evolved slightly from the present picture, allowing for a more relaxed image, greater background detail and three-dimensionality. The parallels are still apparent however, as Lady Grey is depicted three-quarter-length, like the gentleman in the present portrait, and like him has one hand resting on a table while the other holds a fan, an attribute of femininity and gentility, just as the sword is of masculinity. Although Lady Grey's clothing is predominately black as in the present painting, the sartorial detail captured by van Somer, is luxurious and fine. While at the English court, van Somer's work, such as *Lady Elizabeth Grey, Countess of Kent*, shows stylistic links with that of Robert Peake (c.1551-1619) and Marcus Gheeraerts II (1561-1635/6), although it was grounded in the more prosaic style of early seventeenth-century Antwerp painting.

Van Somer received his initial training in Antwerp and may have been a pupil of the Flemish painter Philip Lisaert (fl.1530-1588) who taught his older brother Berneart van Somer (before 1575-1612). After travelling extensively through Europe, van Somer is thought to have arrived in England *c.*1616. At this time, Henry, Prince of Wales, was a great patron of the arts and together with his mother, Anne of Denmark, arbitrated taste and helped to redefine the early seventeenth-century artistic sense. Van Somer rapidly became a favourite artist of Queen Anne and possibly even her official painter. After his death, van Somer's wife continued to receive substantial payment from the court for his work. Van Somer's success in establishing royal patronage may have paved the way for his fellow countrymen such as Sir Anthony van Dyck (1599-1641) to achieve such prominence in the English court in succeeding generations.

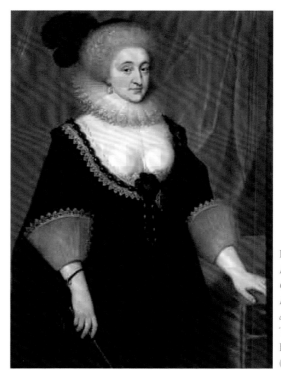

Paul van Somer,
Lady Elizabeth
Gray, Countess of
Kent,
*c.*1619,
Tate Gallery,
London
(Figure 1)

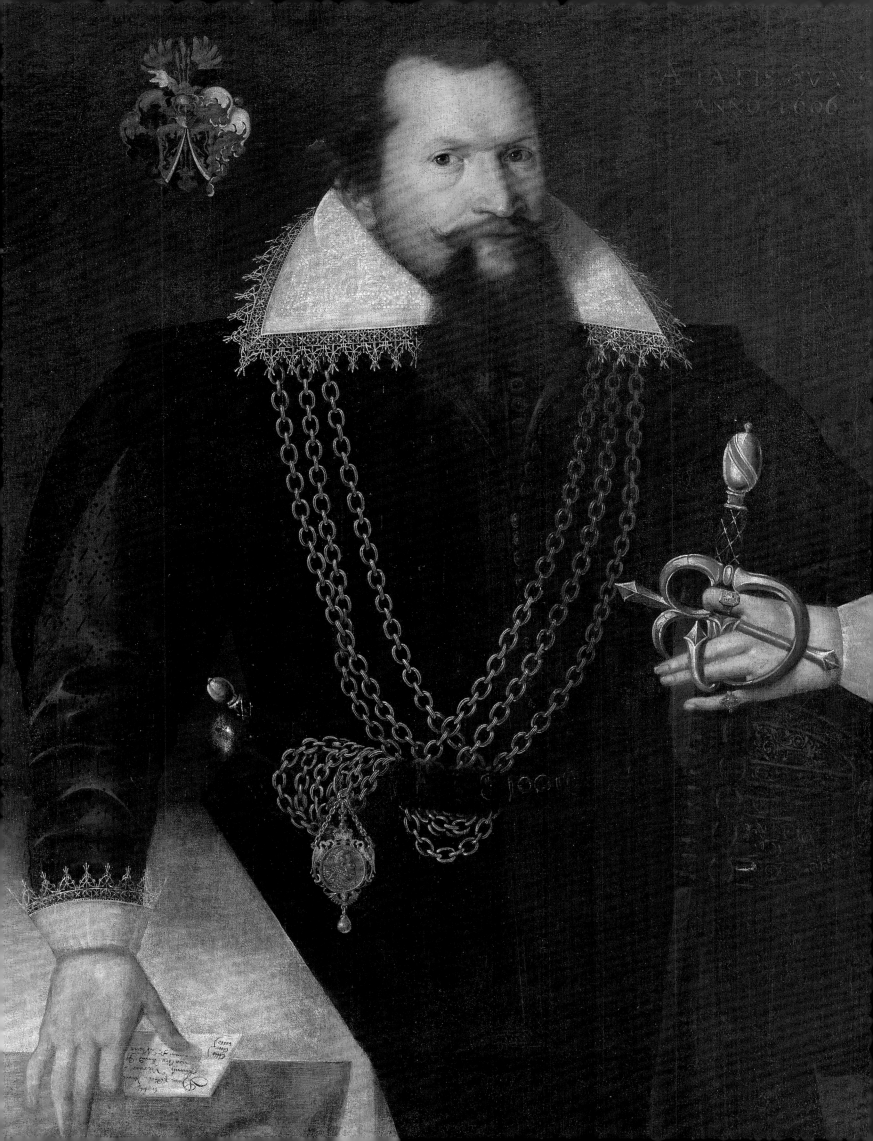

ÆTATIS SVÆ
ANNO 1606

FOLLOWER OF
JAN MASSYS

(Antwerp c.1509 - Antwerp c.1575)

The Penitent Magdalene

oil on panel
74.2 x 102.2 cm (29¼ x 40¼ in)

THE PENITENT MAGDALENE IS A PARTICULARLY intimate representation of Mary Magdalene set amidst a dense, sinewy forest. She prays intently to an illustrated holy book, a vase and a wooden crucifix placed nearby. She appears to have stopped on a country track, the continuation of which can be seen in the right background, as it continues up towards a mystical citadel or geomorphic structure.

The composition of *The Penitent Magdalene*, a work by a follower of Jan Massys, displays many characteristics found in Flemish painting of the mid-sixteenth century. The theme and general conception can be traced to Massys and his workshop, however, the elongated proportions and the heavier, somewhat triangular face, could be attributed to the influence of the more progressive Flemish painter Frans Floris (Frans Floris (1519/20-1570) (fig. 1). The depiction of the partially clad Magdalene kneeling in a landscape was widespread in this period but here the artist introduces an unusual element by creating a view through the grotto behind the saint's head. A similar but not identical device can be found in the work of another contemporary, Maarten de Vos (1532-1603), known through an engraving by Antonie Wierix.[1]

Jan Massys, *David and Bathsheba*, 1562, Musée du Louvre, Paris (Figure 2)

Massys, son of Quentin Massys (1466-1530), was a master of the Guild of St. Luke in Antwerp. After being exiled from the Brabant in 1544 for his heretical sympathies, it is thought that Massys went to France, possibly Fontainebleu, as well as Germany and Italy around 1549. He returned to Antwerp in 1555, and it was during his second Antwerp period (1555-1578) that he was most productive. Throughout his career he worked in a traditional style, often influenced by the works of his father, in particular his satirical genre scenes. Massys' output focused on a small number of popular subjects, which he often repeated: the Virgin and Child, St. Jerome and Mary Magdalene. However, Massys is best known for his depictions of the female nude and frequently used Old Testament, allegorical and mythological subjects to incorporate the female form (fig. 2).

Frans Floris, *The Judgement of Paris, c.* 1550s, The Hermitage, St. Petersburg, Collection of Peter Weiner, Leningrad, 1925 (Figure 1)

[1] See Hollstein, *Dutch and Flemish Etchings, Engravings and Woodcuts, 1450-1700,* vol. 44, Maarten de Vos. no. 1119, reproduced vol. 46, pl. 100.

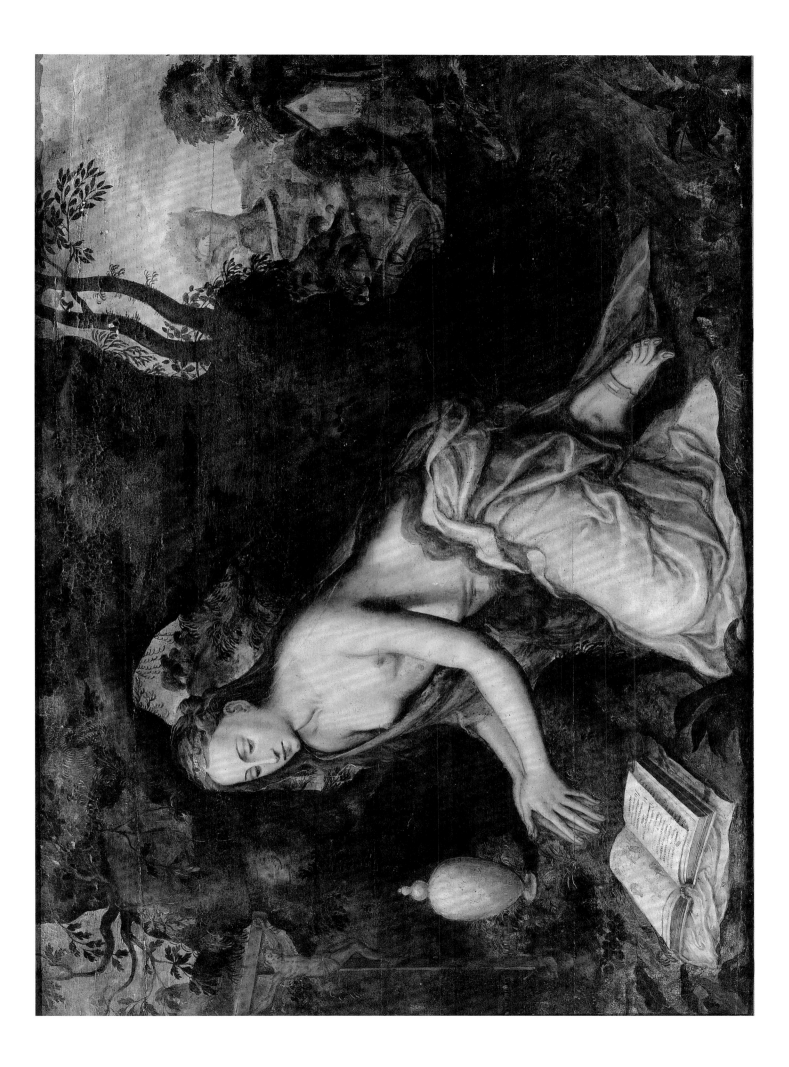

FREDERICK VAN VALCKENBORCH

(Antwerp 1566 - Nuremberg 1623)

The Fire of Troy

oil on copper
17.5 x 27 cm (6⅞ x 10⅝ in)

Provenance: former Private Collection, Germany.

'Who could unfold the horrors of that night? Who could speak of such slaughter? Who could weep tears to match that suffering? It was the fall of an ancient city that had long ruled an empire.'
 - Virgil, *The Aeneid*, II, 361-363

THIS WORK BY FREDERICK VAN VALCKENBORCH shows the terrifying turmoil created during the sacking of the ancient city of Troy. After ten years of fighting, the Trojan War ended with Odysseus' famous wooden horse, inside of which a group of Greek soldiers had hidden themselves whilst the rest of their comrades pretended to sail home, leaving the horse as a gift to the goddess Athena. The Trojans, believing that the Greeks had finally abandoned their long siege, triumphantly dragged the horse inside their city's walls. Later that night the hidden Greek soldiers crept out of the horse's belly, opened the city gates to the rest of their army, and sacked the city.

Frederick van Valckenborch, *The Fire of Troy* (Detail)

Van Valckenborch has depicted the carnage of the attack as the Greeks slaughter the fleeing Trojans and torch the city. In the foreground, a group of Greek soldiers attack Trojan women and children. The victims' faces are ghostly white, which makes them stand out against the prevailing darkness of the scene, thus highlighting their terror and anguish. Many of the women, who have placed themselves between their children and the soldiers, fling their arms out in despair, which emphasises their helplessness as they have nothing with which to protect themselves. In stark contrast, the Greek soldiers are armed with swords and shields and their grim faces are clouded in shadow, making them all the more formidable. Details, such as the soldier calling over his shoulder for reinforcements, emphasise the savage mercilessness of the Greeks toward the helpless Trojans.

The foreground group of figures seems almost disconnected from the rest of the picture. Van Valckenborch has created the impression that this detailed section is a small snapshot of the melee below, that the violence seen is being replicated many times throughout the scene behind it. A panoramic view of the scene reveals many of the city's buildings smouldering in the distance, thick smoke billowing into the black sky. The background glows with a bright, white light suggesting the strength and magnitude of the fire. However, the overwhelming visual drama comes from the surging crowds that dominate the composition. Figures are often indicated in the dense crowds by little more than a black mark of paint, yet despite this lack of detail there is a very real sense of the crowd's movement across the picture. Scattered amongst the black marks are splashes of colour that suggest the presence of Greek soldiers, for instance small patches of red echo the cloak of one of the foreground soldiers. In the distant background one can see the wooden horse: its solidity in stark contrast to the rush of movement and commotion surrounding it.

Kerstiaen de Keuninck, *Fire of Troy*,
The Hermitage, St. Petersburg, collection of P. P. Durnovo, 1925 (Figure 1)

It is interesting to compare the present work to a depiction of the fall of Troy by van Valckenborch's contemporary Kerstiaen de Keuninck (after 1560-c.1632/3) (see Inventory) (fig. 1). Whereas van Valckenborch has portrayed a heaving mass of bodies, de Keuninck's figures are more individualised and distributed more sparingly. The foreground shows figures caught up in the chaos. On the left-hand side, a Trojan emerges from an archway pursued by a heavily armed Greek. Another invader steals a pack from the dead body beside him. A mother and child sit helplessly on the steps, praying for deliverance. There are also the instantly recognisable figures of Aeneas carrying his father Anchises on his back. Though less crowded in composition, de Keuninck's work is comparable to the present work as the action in the foreground presents a crystallised snapshot of events throughout the vast scene. Both paintings are illuminated by the bright light of the raging fire, although de Keuninck's palette is dominated by glowing reds and oranges, where van Valckenborch uses a vibrant white to illuminate his scene.

In terms of composition, *The Fire of Troy* is comparable to other works by van Valckenborch, such as *The Building of the Tower of Babel* (fig. 2). In the foreground of this work we can see the ancient monarch Nimrod sitting atop a makeshift throne surrounded by his advisors. The group are perched on a craggy cliff in much the same way as the foreground figures in *The Fire of Troy* are raised above the main body of the scene. However, once more

Frederick van Valckenborch, *Shipwreck of Aeneas, c.*1603,
Museum Boijmans van Beuningen, Rotterdam (Figure 3)

the foreground group seem somewhat disconnected from the rest of the painting, in this case as if a portrait of Nimrod has merely been set against the background, rather than being fully integrated into it. Both *The Fire of Troy* and *The Building of the Tower of Babe*l are typical of late Mannerism. A feature of this style is the novel treatment of a foreground which functions independently of its background.

One of the key elements of *The Fire of Troy* is the depiction of the fire itself. Rather than a study of the flames, van Valckenborch chooses to give a distanced impression of the thick smoke, the intense bright light given off by the fire, and the panic that it causes amongst the crowd. A number of his paintings, such as *Shipwreck of Aeneas* (Museum Boijmans van Beuningen, Rotterdam), *Pilgrim by a Country Chapel, Approaching Thunderstorm* (Museum of Fine Arts, Budapest)and *Burning Town* (National Gallery, Prague), reveal van Valckenborch's interest in depicting the forces of nature. In the *Shipwreck of Aeneas* as in *The Fire of Troy*, we see cowering helpless figures amidst a black night illuminated by an intense natural light, the brightness of which reflects the power of nature (fig. 3). In many of van Valckenborch's works, a smooth and flowing brush technique combined with a violent contrast between light and dark, creates a dynamic, almost visionary quality.

The events surrounding the Trojan War and its protagonists clearly fascinated van Valckenborch. He painted a number of different scenes

Frederick van Valckenborch, *The Building of the Tower of Babel*,
Kunsthistorisches Museum, Vienna (Figure 2)

featuring the sack of Troy and the ensuing fate of Aeneas, the Trojan prince chronicled by Virgil in *The Aeneid*, who escaped from the burning city and whose descendants founded Rome. As well as *The Fire of Troy* and *Shipwreck of Aeneas*, he painted several other paintings based on the same theme, such as *Aeneas and Anchises fleeing Troy* (Private Collection). Aeneas, carrying his father on his back, is tucked away on the far right-hand side of the painting so that, despite its title, the focus of the painting is not on the fleeing figures. Instead, like in *The Fire of Troy*, this is an image of chaos and carnage surrounding the fall of the city.

However, as well as the historical paintings discussed above, van Valckenborch was also a painter of landscapes, for example the Rijksmuseum's *Mountainous Landscape* (see catalogue no. 8, fig.1). Despite the change of subject illustrated in van Valckenborch's mountainous river landscapes still share many characteristics with his historical paintings, such as *The Fire of Troy*. For example, both works contain evidence of man's violence. In the bottom left-hand corner of *Mountainous Landscape* helpless peasants are being attacked by bandits. The victims' goods have been scattered over the path. The old lady leans forward offering a ring to her attacker who looms over the helpless, wizened old man, his sword held high, ready to strike.

Frederick van Valckenborch, *The Birth of Christ*,
Kunstmuseum, Basel (Figure 4)

This aggressive attack on the defenceless is reminiscent of the attack on the women and children in the foreground of *The Fire of Troy*. The untamed, mountainous nature of the landscape reflects the danger it holds and the presence of a gallows merely reinforces this impression.

Van Valckenborch's *The Birth of Christ* also shares many of the qualities evident in much of his output, including *The Fire of Troy* (fig. 4). In a manner reminiscent of the present work, the key figures are placed on the left-hand side of the foreground and are illuminated against the darkness. The slightly elevated position of this foreground group enables a more comprehensive view of a background that plunges deep into the composition. Again, the foreground feels disconnected to the landscape beyond, an effect heightened by van Valckenborch's use of contrasting palettes. The dramatic *chiaroscuro* of the foreground and the spectacular night sky gives *The Birth of Christ* a theatricality that as much a feature in *The Fire of Troy*.

Van Valckenborch came from a Flemish family of artists that included fourteen known painters, the most notable of whom were his father, Marten van Valckenborch I (1534-1612), his uncle Lucas van Valckenborch I (after 1535-1597) (see Inventory) and his brother Gillis van Valckenborch (1570-1622). His first training was probably in Antwerp, possibly from Marten. However, since his early figures are quite distinct from those of Marten, it is possible that he could have studied landscape painting with his father, whilst also working with another Antwerp figure painter. Jacob de Backer (c.1555-c.1585) (see Inventory) has been suggested as a possible alternative teacher, a reasonable theory when one compares van Valckenborch's painting of the *Last Judgement* (Alte Pinakothek, Munich) with Jacob de Backer's version of the same theme (Antwerp, Koninklijk Museum voor Schone Kunsten). In both works, the compositional structure and the representation of the figures invite comparison, especially in their rounded bodies and oval faces, their gestures and stances. However, despite the obvious influence of de Backer's work on that of van Valckenborch, there is no evidence to suggest that their relationship was that of master and pupil.

It seems that van Valckenborch may have spent time in Italy with his brother Gillis, which would explain the Italian influence evident in his work. In any case, he had returned to Frankfurt by the beginning of 1597, where he became a citizen. It seems that once in Frankfurt he quickly married, for on 23 April 1598, twin sons, Frederik and Wilhelm, were baptised. Van Valckenborch later had two more sons, Moritz and Nicolaus, both of

whom became painters. In 1602, van Valckenborch left Frankfurt to settle in Nuremberg and in 1607 he received a commission from Archduke Maximilian for a copy of Albrecht Dürer's (1471-1528) *Assumption of the Virgin*, on which he was assisted by the Nuremberg painter Paul Juvenel (1579-1643). In 1612 van Valckenborch was commissioned by the Nuremberg authorities to design an arch for the triumphal entry of Archduke Matthias (see catalogue no. 5 for a fuller discussion of Archduke Matthias.)

Van Valckenborch's relative obscurity can be partially explained by the fact that only a small number of his paintings are signed or monogrammed. Much of his work is characterised by violent contrasts between light and dark, such as those in *The Fire of Troy* and by animated forms that give a dynamic, and occasionally threatening, mood to the paintings, as in *Mountainous Landscape*.

In contrast to the theatricality and dynamism of his paintings, many of van Valckenborch's drawings seem to demonstrate a desire to depict a more realistic vision of nature. Most belong to the so-called 'Travelling Sketchbook', which was originally attributed to Lucas van Valckenborch when in the collection of the Archduke Frederick of Austria; the book was subsequently broken up and its contents dispersed. Most of the sketches within were produced during the last years of the sixteenth century, when the artist was travelling in the Alps and the Danube area. They are generally characterised by an objective description of nature and topographical accuracy. The difference between these drawings and van Valckenborch's late Mannerist works is most marked in the handling of space. The impulse towards topographical accuracy compelled van Valckenborch to create serene and simple scenes, which provide a more coherent evocation of space than many of his painted works. Van Valckenborch is thus an artist of contrasting styles: during the period defined by his late Mannerist style he produced vividly imagined and contrived effects, whilst in his travel drawings he aimed for an unadorned realism. Faggin called him, justifiably, an artistic genius, one of the most temperamental personalities of the transitional period from Mannerism to Baroque, an artist with a fertile imagination an excellent draughtsman of the human figure, and an exceptional landscape artist.

Dr. Alexander Wied has confirmed the attribution of *The Fire of Troy* to Frederick van Valckenborch (1993).

Frederick van Valckenborch, *The Fire of Troy* (Detail)

FREDERICK VAN VALCKENBORCH

(Antwerp 1566 - Nuremberg 1623)

A Mountainous River Landscape with a Chapel and a Tavern, with Fishermen Nearby

oil on canvas
130.8 x 192 cm (51½ x 75½ in)

THIS DYNAMIC AND LARGE COMPOSITION, DEPICT-ting a chapel set against an imposing bluff, displays marked contrasts between light and dark, which along with the exaggerated interplay of forms, and the animated figures in the foreground, are characteristic of Frederick van Valckenborch's unique style and reveal the influences of late Mannerism. The image hovers between a naturalistic and contrived depiction of a landscape, and the gesturing of the figures and the ominously dark and wild cliffs topped by precarious looking ruins add an element of eccentricity and whimsicality to the composition.

The present work is divided into two parts: the foreground with the chapel and the Swan Inn, and the background, a seemingly inaccessible area with two fortifications at its summit. The presence of a rickety bridge on the left of the painting suggests that there is a way to access the upper reaches of the mountain; it is, however, cut off by the edge of the canvas and does not lead anywhere identifiable. This distinction between the foreground and background of the composition and their independence from one another is again characteristic of the late Mannerist style and van Valckenborch's work in general. He displays a clear inclination towards depicting mountainous landscapes, another example of which is in the Rijksmuseum, Amsterdam (fig. 1), and features a similarly craggy overgrown rock formation and dramatic contrasts between light and dark. The figures in the bottom left of the Rijksmuseum painting are shown attacking each other, and although fighting, their expressive gesturing is much like that of the fishermen and other characters in the present picture. Another similar large-scale landscape, featuring a chapel set before a fortified bluff with similar groups of revellers and fishermen in the foreground, was sold at Sotheby's New Bond Street, 17 December 1998, lot 48.

The chapel, bathed in sunlight, is the focal point of the present work. A bearded monk, with a rosary in one hand and a cane in the other leaves the chapel. The other prominent feature of the village is the tavern where figures are carousing outside, and their jollity and indulgence in corporeal pleasures stands in contrast to the solitary image of the monk with an empty chapel behind him. While tavern business thrives, the centre of the village's spiritual life has been neglected as indicated by the chapel's physical state of disrepair. This juxtaposition may indicate a moralising message in the painting.

Van Valckenborch was the son of the landscape painter Marten van Valckenborch I (1534-1612), from whom he may have received some initial training. His figure painting, however, even in early works, is markedly different from his father's style, which has prompted a theory that he may also have worked with an Antwerp figure painter. It has been suggested that the structure of van Valckenborch's compositions and his depiction of figures, particularly in their rounded forms and gestures, are closest to the

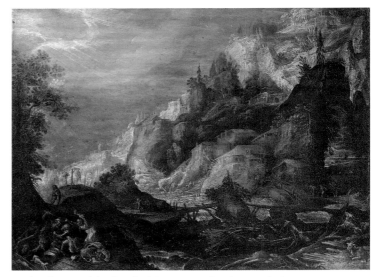

Frederick van Valckenborch, *Mountainous Landscape*, 1605, Rijksmuseum, Amsterdam (Figure 1)

work of Flemish painter Jacob de Backer (*c.*1555-*c.*1585) (see Inventory).[1] In the 1590s, van Valckenborch may have travelled to Italy with his brother Gillis, a suggestion supported by the existence of a drawing by Gillis with the inscription and date 'Roma 1595', and also by the Italian influences present in the work of both artists. Van Valckenborch moved to Frankfurt and became a citizen there in 1597. He had four sons, two of whom became painters. Only a small number of van Valckenborch's existing works are signed or monogrammed. They could, however, be described as signed in the palette on account of his distinctive style. His paintings, characterised by extremes between light and dark and fantastical elements are in contrast to his drawings, which treat landscapes in a far more naturalistic and topographically accurate manner. Van Valckenborch's dual talent for depicting people and landscapes and portraying his subjects with vigorous imagination or intent realism has led scholars such as G. T. Faggin to justifiably describe him as an artistic genius[2].

A Mountainous River Landscape with a Chapel and a Tavern, with Fishermen Nearby has been confirmed by Dr. Alexander Wied as being painted by van Valckenborch.

[1] T. Gerszi: 'Quelques problèmes que pose l'art du paysage de Frederik van Valckenborch', *Bulletin du Musée hongrois des beaux arts*, xlii (1974), pp. 63-89.
[2] G. T. Faggin: 'De gebroeders Frederik en Gillis van Valckenborch', *Bulletin: Museum Boymans-van Beuningen*, xiv (1963), pp. 2-14.

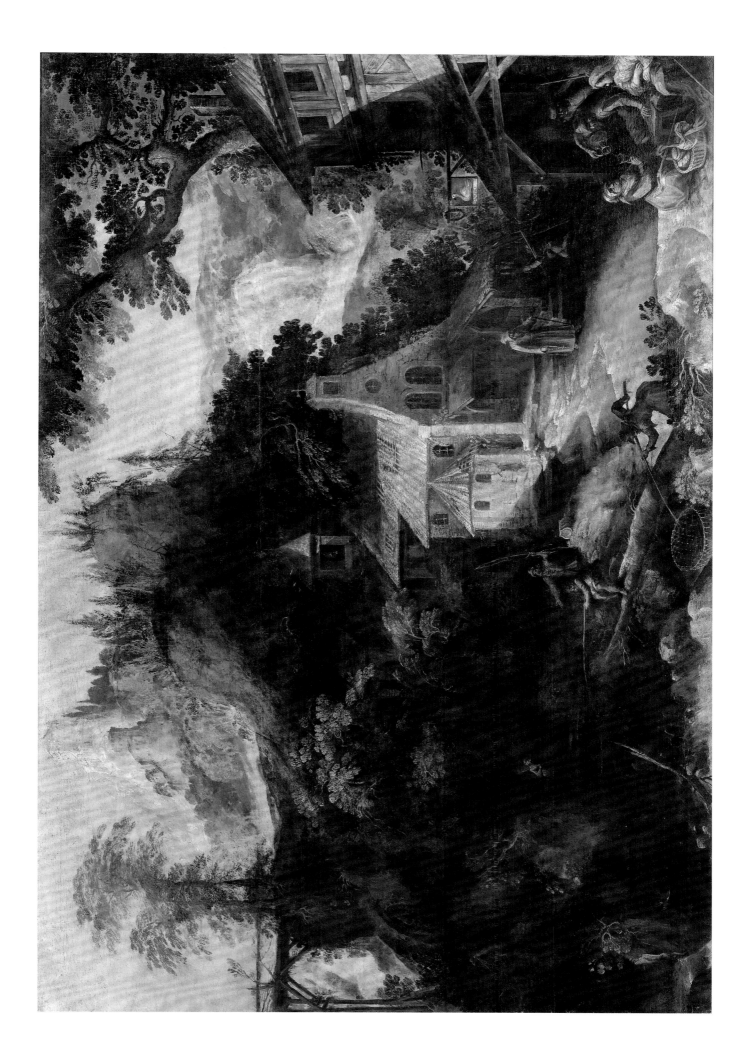

PAUWELS CASTEELS

(Active in Antwerp c.1649 - 1677)

The Battle of Milvian Bridge

signed 'PAVWELS CASSTEELS' (lower centre)
oil on canvas
85.1 x 213.2 cm (33½ x 83⅞ in)

P AUWELS CASTEELS, IN THIS AMBITIOUS COMP-osition, merges two genres highly favoured by Flemish painters of the seventeenth century: landscape and historical subject matter. In *The Battle of Milvian Bridge*, hoards of soldiers on horseback charge into battle over hilly terrain with their raised standards billowing out behind them. This seemingly infinite army of men is, however, merely a backdrop for the main focus of the scene, the Emperor Constantine I. Mounted on a magnificent white steed, the emperor is shown looking heavenwards, almost certainly represented at the moment that he experienced his famous vision which encouraged him to fight under a Christian god.

The Battle of Milvian Bridge took place in October 312 AD between the two Roman emperors, Constantine and Maxentius. Following decisive fighting, Constantine was victorious and the unfortunate Maxentius drowned in the River Tiber while making a desperate bid to flee. Shortly afterwards, a victorious Constantine established himself as sole emperor and celebrated his great dynastic success with the building of his triumphal arch which still stands in Rome today (fig. 1). On the eve of the battle, as the two ancient annalists Eusebius of Caesarea and Lactantius record, Constantine and his soldiers experienced a vision from God promising victory if they painted a sign of the cross on their shields. The two

Giulio Romano after Raphael, *The Battle of Milvian Bridge*,
The Vatican Rooms, Rome (Detail) (Figure 2)

sources offer up conflicting versions of the event. Eusebius tells that when Constantine looked up at the sun, a cross of light appeared, with the words in Greek: *in this sign conquer.*

Lactantius, on the other hand, reports that God appeared to the emperor in a dream and commanded that he 'delineate heavenly signs on the shields of his soldiers'.[1] Casteels presents an altogether more subtle version of the Holy Spirit to which Constantine's outstretched arm motions. In a style beloved of Italian Renaissance artists, Casteels uses rays of light from behind a cloud to signify the presence of God.

Casteels' fondness for battle scenes can be seen in a reprise of the subject matter towards the end of his life in *The Battle between King John Sobieski III and the Turks*. The popularity of the story of Constantine's vision makes it the subject of numerous other renditions including versions by Giulio Romano (1599-1546) (fig. 2).

The painting is illustrated in detail on opposite page and in full overleaf.

Photograph of the bas relief panel depicting the Battle of Milvian Bridge, The Arch of Constantine, Rome (Figure 1)

[1] Lactantius, *De Mortibus persecutorum*, 44,5.

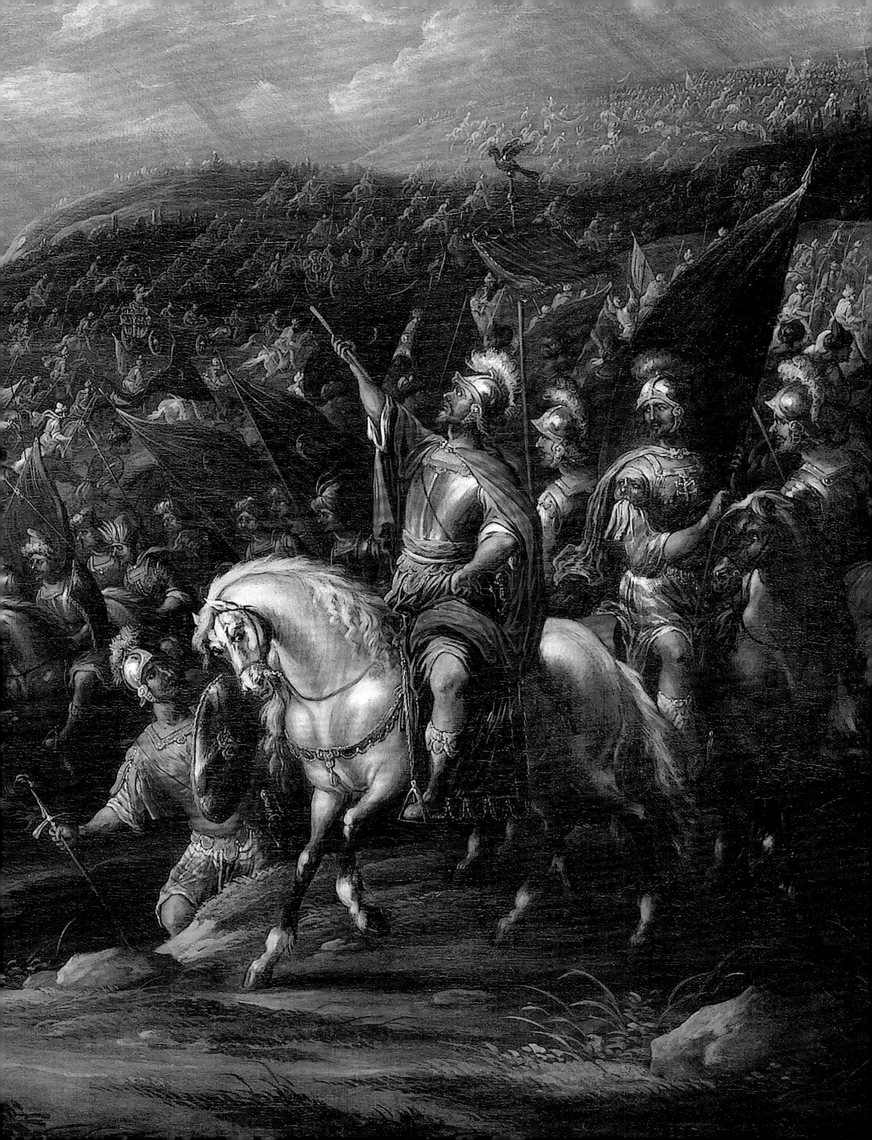

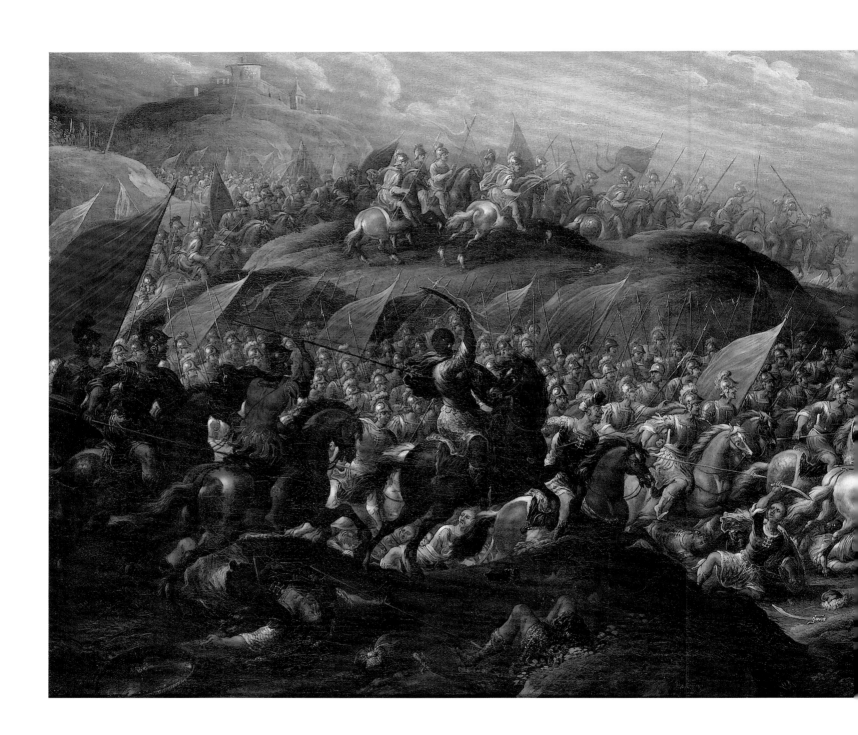

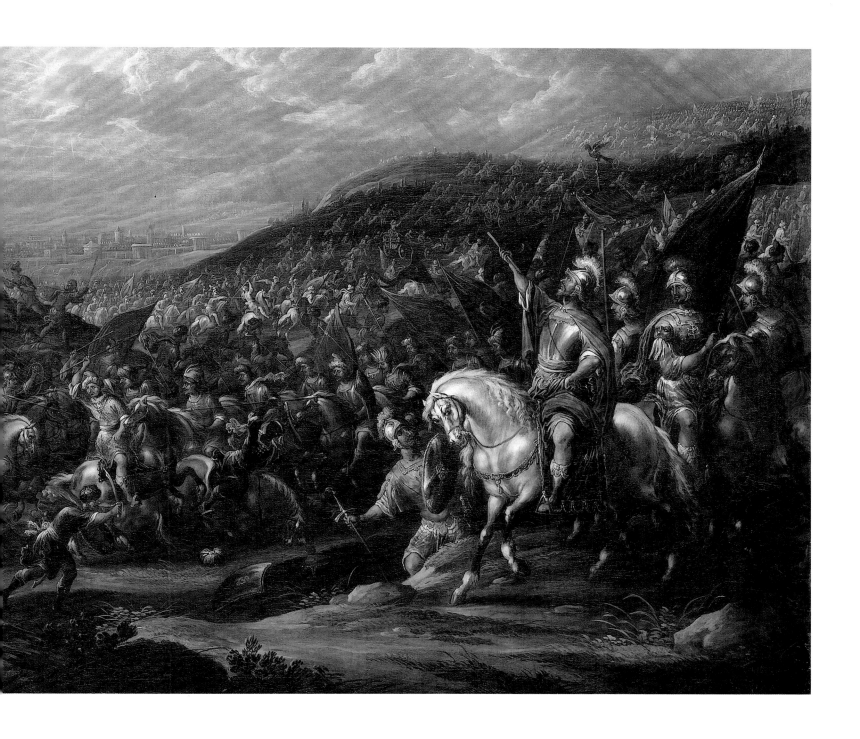

LORENZO A. CASTRO

(London, active 1672 - 1686)

An English Man-O'War Running into a Crowded Continental Port

signed 'L A Castro F' (lower right)
oil on canvas
71.8 x 111.1 cm (28¼ x 43¾ in)

LORENZO A. CASTRO'S PAINTING SHOWS AN ENGLISH man-o'war entering an anonymous port. The sea is dark and choppy and storm clouds hover overhead, crowding out the bright sky on the right-hand side of the work. The tricky conditions have resulted in many of the figures in the painting struggling to control their boats. In the foreground, a man tries to push his rowing boat away from the rocks as his companions row desperately against the waves. Their efforts are echoed by the frenzied activity that takes place on the man-o'war, where the sails are being lowered and the ship is being prepared to enter the port. In the background is the port itself, where numerous other large vessels are already anchored. On the right of the composition a ship has been dragged ashore and its crew have built a fire; behind, an abandoned ship has fallen on its side.

A man-o'war was the most powerful type of armed ship from the sixteenth to the nineteenth centuries, identifiable by its heavy cannons. They were propelled primarily by sails, unlike a galley which was moved forward primarily by oars. The extensive decoration on the stern of the ship is typical of a man-o'war, making them easily recognisable, and the English Navy often found it difficult to disguise them because of the profusion of carved works. In fact, 'it seems to have been the rule that any ship built for the Navy in the seventeenth century was heavily ornamented'.[1]

Although traditionally presumed to be a *capriccio*, *An English Man-O'War Running into a Crowded Continental Port* is made all the more intriguing by the flags flying from the mastheads of the incoming English ship. Instead of the usual jacks of the period, the vessel is wearing what are termed 'the "Stuart" colours', and although it remains unclear precisely what these striped flags denoted, it is possible that they alluded to an allegiance to the Stuart Kings of England in general, and to James II in particular, after his enforced abdication in favour of William III and Queen Mary.

Castro was primarily a maritime painter, and his work within this genre was quite diverse. *The Battle of Actium, 2ⁿᵈ September 31 BC* provides us with a particularly contrasting work to *An English Man-O'War Running into a Crowded Continental Port*, not only in terms of subject matter, but also in composition and mood. Rather than a traditional marine landscape with a study of weather conditions, the work is more typical of history painting, with its focus on the frenzied battle. Castro's *A Galley off a Mediterranean Port,* however, contains many of the elements present in the present work not least in the close and detailed study of a large ship, which acts as the focus for the work (fig. 1). Again this port is crowded with ships and, as well as the numerous and diverse sized vessels, details of human activity in the port are also depicted. Dark clouds are encroaching on the bright blue sky, a contrast that Castro employs in both works.

Castro was born in Antwerp, of Portuguese-Jewish descent. It was here that he received his early training, possibly from his father Sebastian, being recorded in 1664 as a member of the Antwerp Guild of St. Luke. He travelled extensively to Lisbon, Genoa, Sicily and Malta, and his work certainly reflects a knowledge of Mediterranean regions, although many of the elements of his landscapes have a northern character. He appears to have settled in England between 1672 and 1686, although a Lawrence Castro is recorded there as late as 1695. In England, he painted Mediterranean scenes for a specific market and many of his works are held in English private and public collections. In style, Castro excelled in depicting figures and was indeed an accomplished portrait painter. As is evident in *An English Man-O'War Running into a Crowded Continental Port,* Castro used the contrast between light and dark to intensify his scenes.

Castro's work was heavily informed by the maritime paintings of the Willaerts family. Abraham Willaerts' (*c.*1603-1669) *A French Galley and Dutch Men-of-War off a Port* (National Maritime Museum, London) has similar concerns to the present work. Again, the location is an imaginary one, although the exotic appearance of the castle in the background is suggestive of a Mediterranean harbour. Willaerts achieves a successful balance between the detailed depiction of a range of vessels, and the varied and hectic human activity that takes place on the quay. Similarly, in the present work, Castro realizes a harmonious balance of dramatic landscape, the meticulous rendering of vessels, and scenes of human activity.

Lorenzo A. Castro, *A Galley off a Mediterranean Port, c.*1672-1686, National Maritime Museum, London (Figure 1)

[1] L. G. Carr Laughton, *Old Ship Figure-Heads and Sterns*, Courier Dove Publications, 2001.

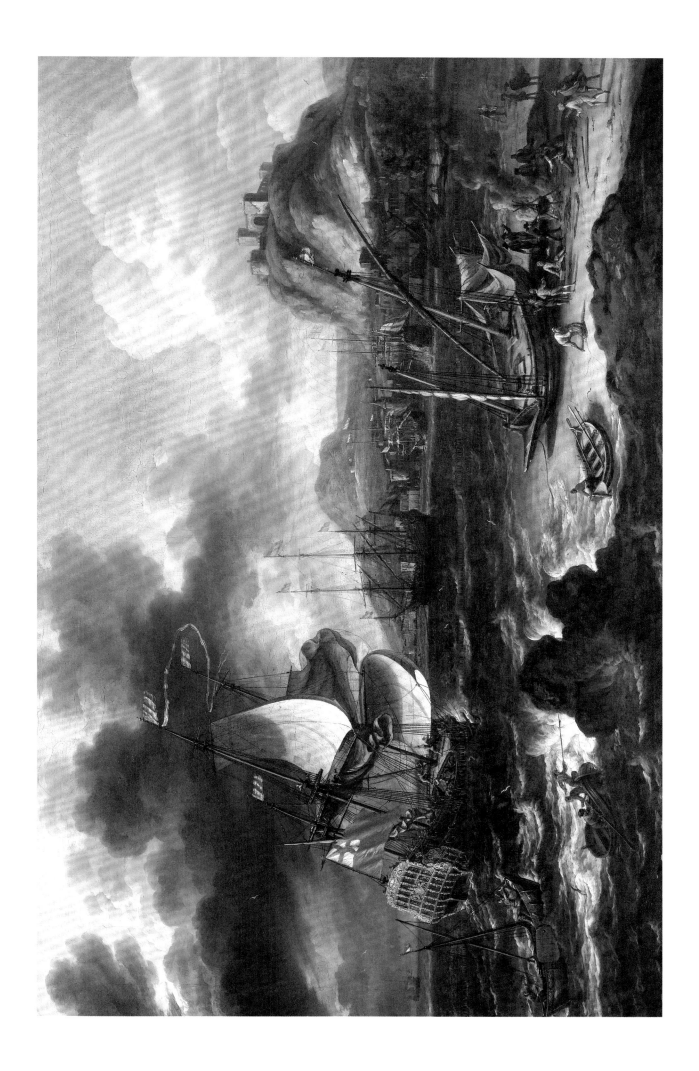

PHILIPPE DE MOMPER

(Antwerp 1598 - Amsterdam 1675)

A Village Scene by a River, said to be Treviso

oil on oak panel
47.4 x 77.9 cm (18⅝ x 30¾ in)

Provenance: Anonymous sale, Amsterdam, Mak van Waay, 1946;
with Galerie Robert Finck, Brussels, 1964;
Possibly anonymous sale, Munich, Weinmüller, 20-21 May 1970, lot 13 (according to K. Ertz, under Literature);
Anonymous sale, Munich, Neumeister, 20-21 May 1970, lot 602 (according to K. Ertz, op. cit.);
Anonymous sale ('The Property of a Gentleman'), London, Christie's, 26 November 1971, lot 52, as Joos de Momper.

Exhibitions: Brussels, Galerie Robert Finck, 26 September - 18 October 1964, no. 43, reproduced in the catalogue.

Literature: K. Ertz, *Josse de Momper the Younger*, Freren 1986, p. 641, cat. no. A119, reproduced on p. 415, fig. 529 (as Philippe de Momper).

THE QUAINT RIVERSIDE SCENE DEPICTED HERE by Philippe de Momper is thought to be a view of Treviso, in the Veneto region of northern Italy. The bustling activity is centred on what could be the Riviera Santa Margherita, one of the main waterways running through Treviso and the site where *barconi* arriving from Venice offloaded their goods and passengers. A photograph of Treviso today shows a view of the Santa Margherita river, see fig. 1, with the characteristic towers, archways and stone embankments that are present in *A Village Scene by a River, said to be Treviso*. De Momper also depicts the pitched tile roofs and wooden shuttered windows of the buildings along the riverfront, although he gives them a distinctly Netherlandish aspect.

In the foreground of the picture, vessels carrying timber and merchandise are moored near to the bank and labourers heave baskets and sacks to and fro. A few figures, a dog and two donkeys make their way along a path weaving around a tower. Treviso was heavily fortified during Venetian occupation from the fourteenth to eighteenth centuries, a sign of which may be the

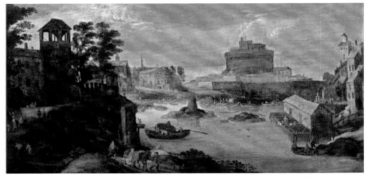

Philippe de Momper, *Rome: A View of the Castel Sant'Angelo, the Ponte D'Angelo and the Tiber*, Private Collection (Figure 2)

imposing structure of the tower, and perhaps also the remains of the bridge behind it, which is portrayed in a neglected and overgrown state. The placid river extends towards the horizon, passing by a dense forest of trees on one side and a multitude of closely packed houses on the other. The expansive sky above balances the composition, giving the scene a sense of calm and continuity.

De Momper is known to have visited Rome with Jan Breughel the Younger (1601-1678) (see Inventory) in *c.*1634-1636, where he painted a view of the Castel Sant'Angelo see fig. 2, and it seems probable that he would also have visited northern Italy. His depiction of Rome, although incorporating one of the city's most distinctive landmarks, gives the impression that it could be a northern European view in terms of its colouring and crowded architecture, which is similar to that of *A Village Scene by a River, said to be Treviso*.

De Momper is documented as living in Amsterdam from 1649 where he remained until his death, and is buried in the Nieuwe Kerk. He was a merchant as well as an artist, which may explain why images of trade and the working world feature prominently in the present painting.

Riviera Santa Margherita, Treviso (Figure 1)

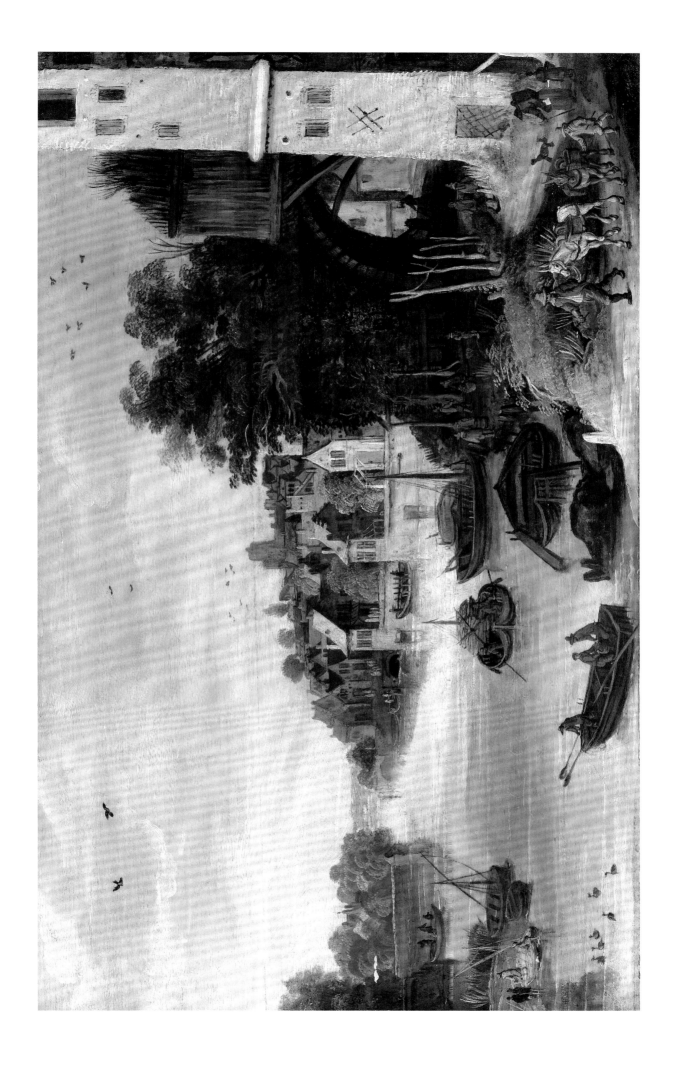

JOSEPH VAN AKEN

(Antwerp? c.1699 - London 1749)

A Vegetable Seller and his Son Offering Wares to a Lady and a Cleric by a Statue of Bacchus

&

A Vegetable and Fruit Market by a Statue of Venus, with a Town by a River Beyond

oil on canvas, a pair
75.6 x 63.5 cm (29¾ x 25 in)

Provenance: Wilton Gallery, London, 1951;
W. R. Jeudwine collection, London.

IN *A VEGETABLE SELLER AND HIS SON OFFERING WARES TO a Lady and a Cleric by a Statue of Bacchus* a vegetable seller is trying to convince an elegant young lady to buy some of his marrows. The lady turns away, seemingly uninterested, and the cleric, who is accompanying her on a walk, directs her attention to the size of the vegetable. Standing over the figures is a statue of the Roman god Bacchus. This statue helps contribute to the Italianate feel of an landscape, in which the figures are standing. The wind-swept tree to Bacchus' right suggests there is a strong bluster blowing through the landscape, yet there is little other indication of this apart from the dark, overcast sky, and the lady who has removed her hat. The other figures seem unaffected, and the river is positively calm.

The accompanying work, *A Vegetable and Fruit Market by a Statue of Venus, with a Town by a River Beyond,* is set in a very similar, though brighter, landscape. Greater emphasis is placed on the classical aspects of the landscape, for as well as the statue, which in this case is of Venus, the market is positioned alongside a classical building, and a circular portico is also discernable in the distant town. In the centre of the painting, a lady places her order with a crouching vendor whose produce includes cabbages, cauliflowers and artichokes. On the left-hand side, another seller weighs some cherries, and sitting under the statue a figure rests with a pipe in hand.

The two paintings share many characteristics which unite them as a pair, the most obvious being the landscape in which they are set. Both paintings are similar in subject matter, and touch on the contrast between the social classes. This is particularly apparent in *A Vegetable Seller and his Son Offering Wares to a Lady and a Cleric by a Statue of Bacchus*, where the vivid colours of the lady's fine clothing are contrasted with the dirty, muted red of the vendor's tatty and torn coat. Other details, such as the prominent classical statues, provide a visual link between the two scenes, as does the presence of a dog seen vigorously scratching himself in *A Vegetable Seller and his Son Offering Wares to a Lady and a Cleric by a Statue of Bacchus* and growling menacingly in *A Vegetable and Fruit Market by a Statue of Venus, with a Town by a River Beyond*.

The subject matter of these two paintings recurs throughout van Aken's *oeuvre.* He dedicated a number of his works to views of Covent Garden, which at the time was the biggest market in London, an example of which is his *Old Covent Garden*, (fig.1). Although this bustling urban scene stands in stark contrast to the peaceful landscapes mentioned so far, the interaction between figures, typified in the present works, is replicated many times and on a far greater scale in *Old Covent Garden*. The figures seen in one work would not seem out of place in another, and it is merely the setting that appears markedly different. In the foreground of *Old Covent Garden,* the vivid colour of the lady's red cloak makes her stand out against the predominantly sombre palette of the painting. The luxurious nature of her clothing, in comparison to the surrounding figures, draws attention to her social status, as does the servant standing behind, carrying her shopping. On the right-hand side of the painting there is a growling dog, which is almost identical to the one in *A Vegetable and Fruit Market by a Statue of Venus, with a Town by a River Beyond*. This repetition of certain motifs is fairly common in van Aken's work, for example, a statue of Bacchus also appears in the background of an *An English Family at Tea* in the Tate, London, (fig. 2).

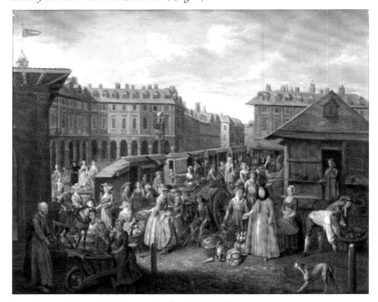

Joseph van Aken, *Old Covent Garden*, 1725-1730, Government Art Collection, UK (Figure 1)

Joseph van Aken, *A Vegetable Seller and his Son Offering Wares to a Lady and a Cleric by a Statue of Bacchus* (Detail)

Joseph van Aken, *A Vegetable and Fruit Market by a Statue of Venus, with a Town by a River Beyond* (Detail)

Van Aken began his career in Antwerp where he painted genre scenes in the Flemish tradition. He arrived in London with his brothers around 1720 and continued to produce genre paintings as well as conversation pieces. His *Old Covent Garden* and *The Old Stocks Market* (*c.*1740, Bank of England, London) show his adaptation of this genre tradition to contemporary London scenes, and the several versions of these works attest to their popularity. Van Aken also painted portraits, and his conversation pieces such as *An English Family at Tea*, betray a French influence in their lively brushwork and informal compositions.

In the 1730s and 1740s, on account of his talent in rendering materials such as satin, velvet and gold lace, van Aken abandoned independent work, taking up employment as a drapery painter for other artists. He worked for many leading portrait painters of the day, including Joseph Highmore (1692-1780), Thomas Hudson (?1701-1779), George Knapton (1698-1778), Arthur Pond (1701-1758), Allan Ramsay (1713-1784) and Joseph Wright of Derby (1734-1797). Usually, these artists painted only the face of the sitter, leaving van Aken to fill in the rest of the composition. Some of these artists often relied heavily upon his judgement, an example being Winstanley, who painted his faces on a piece of cloth which van Aken would then paste onto a larger canvas, arranging the composition himself. However, others, such as Ramsay, sent him drawings and instructions suggesting postures and draperies. In 1737, the English writer and engraver, George Vertue (1684-1756), remarked that van Aken had lately excelled in painting 'particularly the postures for painters of portraits who send their

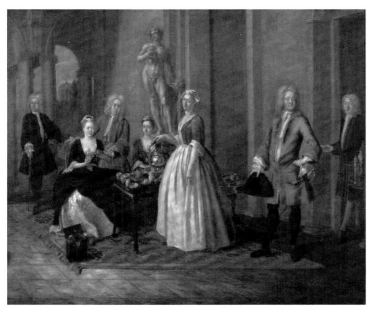

Joseph van Aken, *An English Family at Tea*, *c.*1720, The Tate, London (Figure 2)

pictures when they have done the faces to be dressed and decorated by him'.[1] Van Aken was especially known for his costumes, which were inspired by those in Anthony van Dyck's (1599-1641) paintings, as well as being derived from Peter Paul Rubens' (1577-1640) portrait of *Hélène Fourment* (Museu Calouste Gulbenkian, Lisbon). One highly fashionable composition, closely modelled on *Hélène Fourment*, was used by Ramsay, Hudson and Wright several times, but it has been demonstrated that the design originated with van Aken. On the work of English portraitists, Vertue remarked 'it's very difficult to know one hand from another', such was van Aken's popularity.[2] Horace Walpole also remarked. 'Almost every painter's works were painted by van Aken'.[3] Van Aken's output was so prolific that it has led some to comment that English portraiture in the age of Joshua Reynolds (1723-1792) (see Inventory) would not have existed without him. Artists, to an extent, made their reputations on his ability, as his elegant poses and sumptuous draperies attracted patronage. In 1745, his services were solicited by John Robinson, a portrait painter from Bath, but van Aken's other employers were so jealous of his ability that they threatened to withdraw offers of employment if he agreed to work for Robinson. He received a similar threat when he was offered work by the popular portrait painter Jean-Baptiste van Loo (1684-1745) (see Inventory). Such extreme reactions are a useful gauge of van Aken's popularity at the time, as well as a reflection of his discreet input into the works of important artists. Paintings such as *A Vegetable Seller and his Son Offering Wares to a Lady and a Cleric by a Statue of Bacchus* or *An English Family at Tea*, exemplify the qualities that made his work a success. Both paintings depict a range of different draperies and garments belonging to rich and poor, male and female, all of which are invariably brilliantly painted.

In 1748, van Aken travelled to France with a number of artists, including William Hogarth (1697-1764) and Hudson, and then by himself to the Netherlands. It was on this trip that, while sketching in Calais, Hogarth was arrested as a spy and on his return immediately began his famous painting *O the Roast Beef of Old England* (or *Calais Gate*, Tate, London).

Hogarth commemorated van Aken's death in 1749 with a caricature depicting the disconsolate portrait painters lamenting at his funeral, and Ramsay and Hudson were joint executors of his will.[4] Van Aken's younger brother, Alexander van Aken, was also a drapery painter and was employed by Hudson after Joseph's death. Another brother, Arnold, was also an artist, but his output was limited to small conversation pieces and a series of engravings of fish.

[1] R. Edwards, 'The Conversation Pictures of Joseph van Aken', *Apollo*, XXIII, 1936, p. 80.

[2] 'The Note-books of George Vertue', *Walpole Soc.*, xxii, 1934, p. 117.

[3] Ellis Waterhouse, *The Dictionary of British 18th Century Painters in Oils and Crayons*, 1981, p.377

[4] Edwards, p. 81.

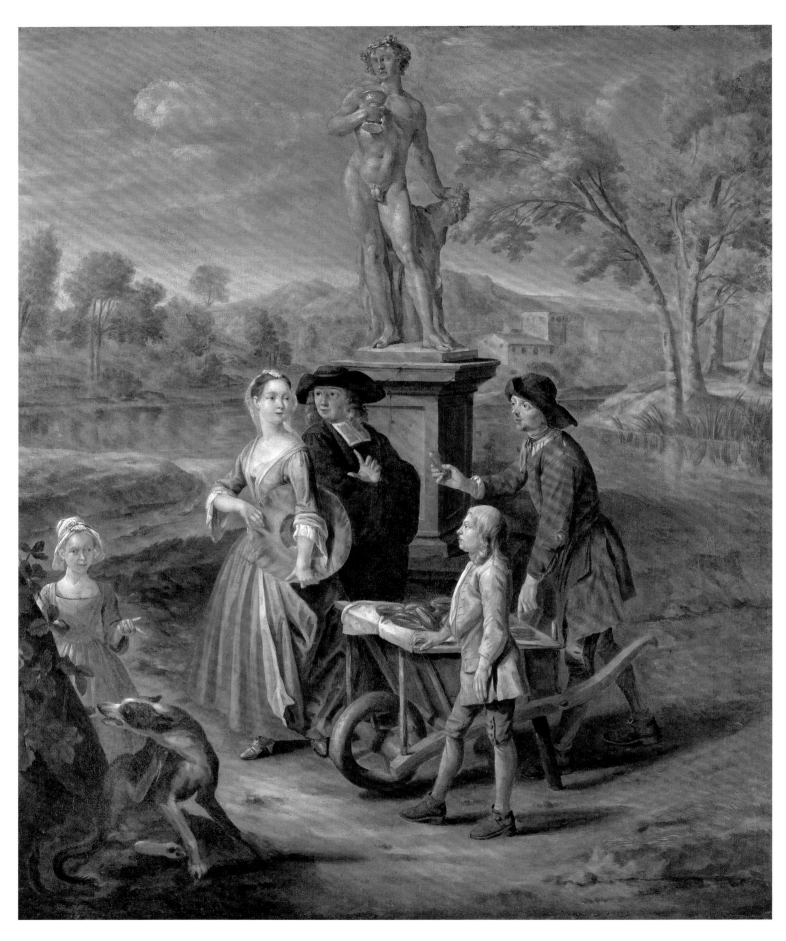

Joseph van Aken, *A Vegetable Seller and his Son Offering Wares to a Lady and a Cleric by a Statue of Bacchus*

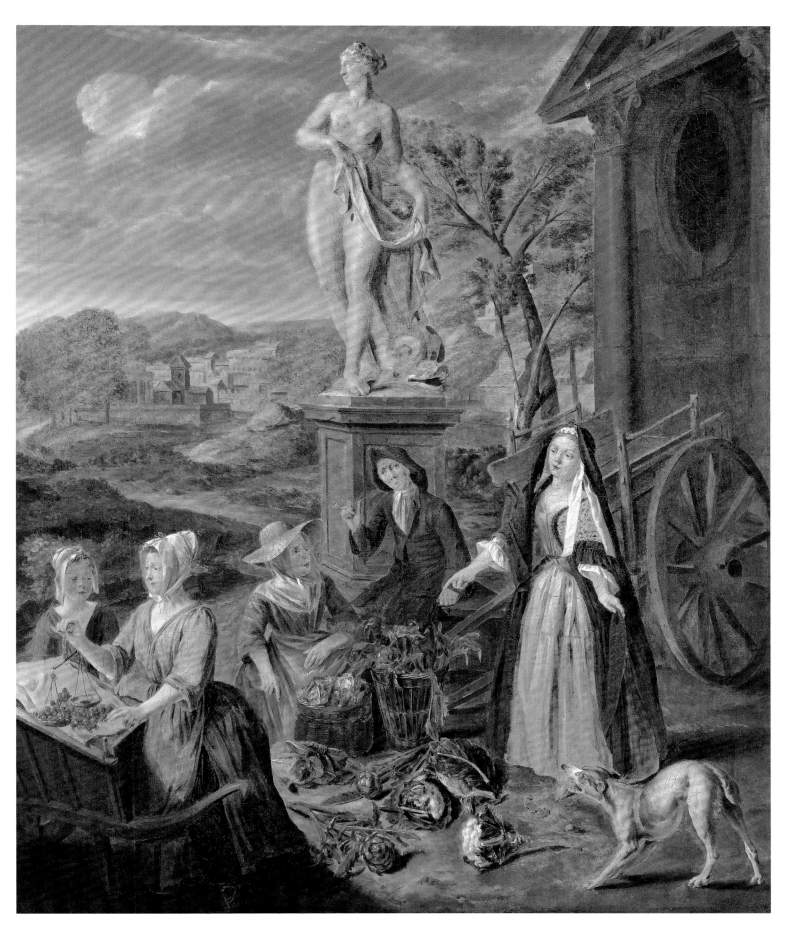

Joseph van Aken, *A Vegetable and Fruit Market by a Statue of Venus, with a Town by a River Beyond*

MICHELE TOSINI, CALLED MICHELE DI RIDOLFO DEL GHIRLANDAIO

(Florence 1503 - Florence 1577)

An Allegory of Fortitude

oil on panel
73 x 54.7 cm (28¾ x 21½ in)

Provenance: John Giles, Albion Street, London;
his sale, London, Christie's, February 2, 1881,
lot 635 (as Andrea del Sarto), for 3,312 pounds, where acquired by the great-grandfather of a private collector;
by whom sold ('The Property of a Gentleman'), London, Sotheby's, December 11, 1996, lot 34 (where the image was reversed in the catalogue);
anonymous sale, New York, Sotheby's, January 22, 2004, lot 15.

THIS COMPELLINGLY BEAUTIFUL BUST-LENGTH painting of a woman in classical costume is most likely an allegory of Fortitude, one of the four cardinal virtues as defined in Greek philosophy. She is identified by her two most common attributes, the column which she grasps with both hands, and the lion, whose head is emblazoned on a decorative clasp at her chest. The figure's strength of character is evident and her monumentality is heightened by the manner in which she dominates the space within the panel.

In his representation of Fortitude, Michele Tosini, called Michele di Ridolfo del Ghirlandaio, followed the Renaissance iconography developed by artists such as Paolo Uccello (*c.*1397-1475) and Sandro Botticelli (1444/5-1510) in depicting her as a woman holding a fragment of a column. Botticelli's *Allegory of Fortitude* painted in 1469 for the Court of the Mercanzia in Florence, showing Fortitude enthroned and grasping a miniature column, was much praised and no doubt would have influenced generations of Florentine artists such as Tosini. The seven virtues, comprised of the theological virtues of faith, hope and charity and the cardinal virtues of prudence, justice, temperance and fortitude, were a popular theme in Christian art and were most often personified by female figures. Around 1570, Tosini painted *Charity*, the most significant of the theological virtues, as a mother nursing and caring for her children, a work that is now housed in the National Gallery, London (fig. 1).

An Allegory of Fortitude relates to a number of bust-length female portraits that Tosini executed, all of which are on panels of a similar size, and are indebted to the example of Giorgio Vasari (1511-1574). The idealised women in each are generally posed turned to the right against a plain background and take up most of the panel, giving them an imposing immediacy. Particularly notable paintings in this group are *Lucretia* and *Leda* in the Galleria Borghese, Rome, and other examples can be found in private collections. *Venus Victrix* in the National Museum in Krakow (fig. 2), another version of which is titled *Portrait of a Young Woman* in the Galleria dell'Accademia in Florence, is presented in a slightly different manner to the rest of the group but nevertheless

Michele Tosini, *Charity,* c.1570, National Gallery, London (Figure 1)

maintains striking parallels with the present work. *Venus Victrix*, or 'Venus the Victorious', depicts a military aspect of the goddess, which was adopted from the eastern concept of a goddess of war and translated from Greek to Roman mythology. She is bare-breasted and turned almost in full profile with a richly decorated fanciful costume and an ornate headdress. Although her classicised features, pale complexion touched with pink and golden ringlets suggest idealised beauty, her proud and resolute pose, her exotic headdress and

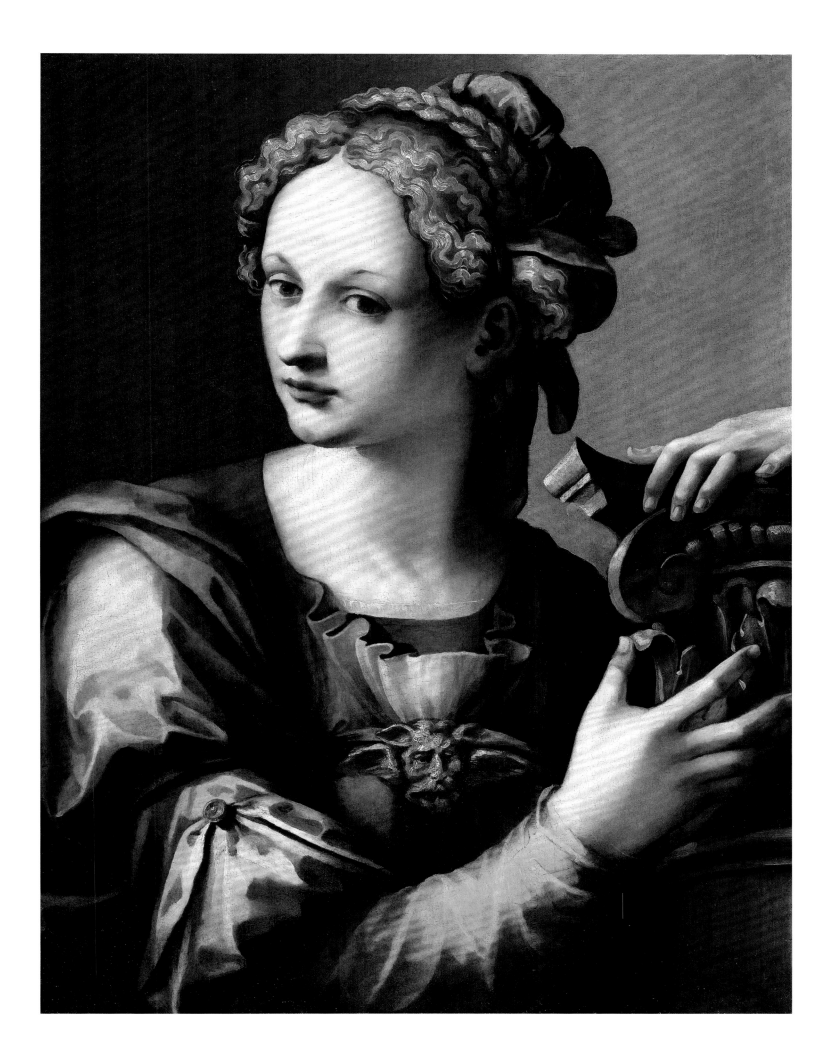

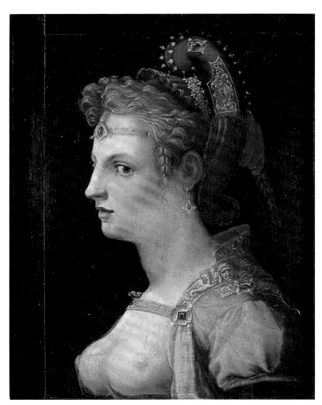

Michele Tosini, *Venus Victrix*, National Museum, Krakow (Figure 2)

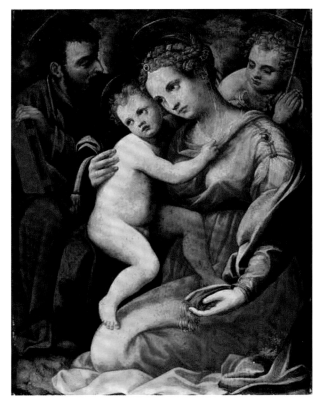

Michele Tosini, *The Holy Family with the Infant Saint John the Baptist*, Private Collection (Figure 3)

the emblems depicting fantastical creatures at her shoulder give her the air of a warrior. In this blending of physical charm with a bold and resolute manner, the *Venus Victrix*, like Fortitude, asserts herself as a powerful and intimidating presence. Both paintings have a strikingly enigmatic quality, accentuated in the colouring, distinctive dress and imperious expressions of the female figures.

The embellishment of Fortitude's costume and hair style in the present work and that of *Venus Victrix* recurs in Tosini's images of women, whether allegorical, mythological or religious in subject matter. His painting of *The Holy Family with the Infant Saint John the Baptist* in a private collection, see fig. 3 reveals the great care taken in portraying the Virgin's intricately bound hair adorned with jewels and the decorative shoulders of her dress, giving her a more fashionable air than would normally be associated with depictions of the mother of Christ. This preoccupation with ornamentation is similarly evident in Tosini's painting of *Saint Catherine of Alexandria*, whose garments and headdress are of exceptional quality and rich in detail (fig. 4). The metalwork details in the clasp of Saint Catherine's cloak and her armband, headpiece and necklace are stiking and reminiscent of the ornament depicting a lion's head that is prominently positioned at Fortitude's breast in the present work.

The headdresses that Tosini chose for his female subjects were very likely inspired by Michelangelo's (1475-1564) studies of fantastically decorated heads, designs which Tosini may have had first-hand knowledge of, or seen in engravings. *Ideal Head of a Woman* in The British Museum, see fig. 5, is an example of a head study by Michelangelo that displays an ostentatious and peculiarly complex hairstyle, which has much in common with those worn by *Venus Victrix* and *Charity*. The woman's braids in Michelangelo's study resemble those of Fortitude in the present painting, the Virgin in *The Holy Family with the Infant Saint John the Baptist* and *Saint Catherine of Alexandria*.

Tosini's paintings are indebted to Michelangelo's example, not only in the hairstyles of his female figures but also in their classicised and slightly masculinised facial features. *Lucretia*, see fig. 6, which has parallels to the present work in its size and idealised female type, has facial features that, like those of Fortitude, closely resemble Michelangelo's *Ideal Head of a Woman*. Lucretia's appearance also reveals the effects of Mannerism, a movement that Tosini was initially slow to accept but began experimenting with in his paintings of the 1540s. Late in his career, Tosini drew particular inspiration

from the works of the Roman Mannerist Francesco Salviati (1510-1563), renowned for his painterly fluidity and elegance, artificiality and complexity. These aspects are evident in Tosini's paintings of long-necked and tranquil beauties, among which *An Allegory of Fortitude* is particularly striking in its harmonious colouring and the other-worldly grace and serenity of the female figure. The painting can be seen to unite the influences that contributed to Tosini's artistic success, borrowing elements from Michelangelo, Salviati and Raphael (1483-1520), whom Tosini would have known through his

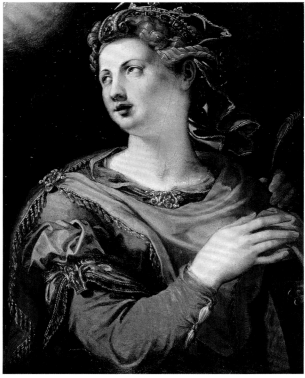

Michele Tosini, *Saint Catherine of Alexandria*, Private Collection (Figure 4)

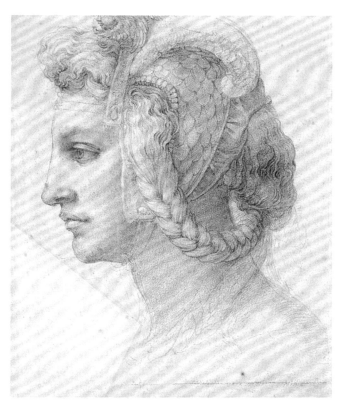

Michelangelo, *Ideal Head of a Woman, c.*1525-1528,
The British Museum, London (Figure 5)

teacher Ridolfo Ghirlandaio (1483-1561), once a student of the Umbrian master. There is, however, also a marked originality in compositionand costume detailin the present work that is unique to Tosini.

Tosini's *Saint Mary Magdalene,* see fig. 7, is a further fine example in the group of bust-length paintings of female figures that *An Allegory of Fortitude* belongs to. As in *Saint Catherine of Alexandria* and the present work, the attribute most associated with the woman is displayed on the right of the painting, in this case an ointment jar signifies the Magdalene. Her hair, centrally

Michele Tosini, *Lucretia,* Private Collection (Figure 6)

Michele Tosini, *Saint Mary Magdalene,* Private Collection (Figure 7)

parted and bound in a red cloth. is much like that of Fortitude and her facial features are almost identical. Her tranquillity of expression is typical of Tosini's female types regardless of their situation; even Lucretia, in preparing to stab herself, appears cool and unruffled by the dramatic tension of the moment. Despite their apparent inertness, each woman displays a powerful presence and self-confidence, nowhere more exemplified than in *An Allegory of Fortitude*, an exceptionally refined example of Tosini's painterly style.

Tosini studied initially with Lorenzo di Credi (1459-1537) and Antonio del Ceraiolo (fl. 1520-1538) before entering the workshop of the prominent Florentine painter Ghirlandaio, whose name he adopted. By 1525, the two artists had developed a close relationship and collaborated frequently.[1] Tosini was an accomplished portraitist as well as a religious and allegorical painter, and his portraits have on occasion been mistaken for those of Agnolo Bronzino (1503-1572), the master of sixteenth-century Florentine portraiture. Tosini achieved renown in his time and worked at the centre of Medician culture, evidenced by his commission to paint a portrait of Cosimo de'Medici. In 1563, he assisted Vasari with the formation of the Accademia del Disegno and subsequently worked with him in decorating the frescos for the Salone dei Cinquecento in the Palazzo Vecchio, Florence. Through Vasari's example, Tosini began adopting elements of Michelangelo's work as has been revealed in the paintings discussed here. Tosini's major commissions in his later years included the fresco decoration of three city gates of Florence, the altar in the Chapel at the Villa Caserotta, near San Casciano Val di Pesa, and the paintings on the back and sides of the tabernacle of the high altar of Santa Maria della Quercia, Viterbo. After Ghirlandaio's retirement, Tosini became head of his workshop, which was one of the largest and most productive in Florence.[2] Tosini's students included Stoldo Lorenzi (1534-1583), Girolamo Macchietti (1535-1592) and Bernardino Poccetti (1548-1612).

[1] For the relationship between Tosini and Ghirlandaio, see David Franklin, 'Towards a New Chronology for Ridolfo Ghirlandaio and Michele Tosini', *Burlington Magazine* 40 (1998), pp. 445-56.
[2] H. J. Hornik: 'Michele Tosini: The Artist, The Oeuvre and The Testament', *Continuity, Innovation and Connoisseurship: Old Master Paintings at the Palmer Museum of Art* (exh. cat., ed. M. J. Harris; University Park, PA, 2003), pp. 22-37

SCHOOL OF FERRARA, SIXTEENTH CENTURY

The Madonna and Child with Saint Catherine,

Saint Sebastian and Mary Magdalene

bears an indistinct signature and date 'Pet.s Ioas / 1450' (lower left)
oil on panel
52 x 41 cm (20½ x 16⅛ in)

Provenance: The Vanderbilt Collection, Chicago, until *c.* 1980;
German Private Collection.

THE MADONNA AND CHILD WITH SAINT CATHERINE, *Saint Sebastian and Mary Magdalene* presents the holy group in the vibrant, elegant Renaissance dress of sixteenth-century Italy. In the centre, the Madonna is swathed in sumptuous red and blue fabric, her hair delicately dressed and pinned. She holds the infant Jesus tenderly in her lap, and Saints Catherine and Mary Magdalene are nearby on the right. St. Catherine, kneeling in profile, holds her hand to delicately touch the foot of the infant Jesus, while in her left hand she clutches a fragment of a wheel and a palm leaf, alluding to her martyrdom. Standing above her is Mary Magdalene, identified by the jar of oil she holds in her hand. On the left, St. Sebastian, who is bare to the waist, is recognised by the arrow wound protruding from his right breast. Behind the head of St. Sebastian, one can see a distant town with a citadel rising majestically above.

Although the artist of the present work is unknown, the painterly style and rendered features of the figure group is associated with work produced in Ferrara in the sixteenth century. Ferrara was a centre of rich artistic production throughout the Renaissance, which was cultivated by the ruling d'Este family. Patronage was particularly prevalent after Ercole d'Este I became Duke in 1470, and the family remained in power until Alfonso II died without an heir in 1597. Historically, the great period of Ferrarese art production is considered to have coincided with the d'Este ascent in the fifteenth and sixteenth centuries.

Artists such as Nicolò Pisano (1470-?1538), Dosso Dossi (*c.*1486-1541/2) and Benvenuto Tisi, il Garofalo (1481-1559) were employed by the d'Este court to produce opulent religious and classical works for their noble patrons. The evolution of the Ferrarese school style of painting appears to blend influences from Mantua, Venice, Lombardy, Florence and particularly neighbouring Bologna. Much of the local collections, like those of the Gonzaga family in Mantua, were dispersed with the end of the d'Este line in 1598.

The Madonna and Child with Saint Catherine, Saint Sebastian and Mary Magdalene has a particularly interesting provenance as it was held within the Vanderbilt Collection until *c.*1980. The Vanderbilts were a prominent Dutch-American family who amassed considerable wealth in the nineteenth century from their successful railroad and shipping empires. The affluence of the family is considered to epitomise the 'Gilded Age' of nineteenth-century industrial America.

In particular, William H Vanderbilt (1821-1885), was an avid art enthusiast who favoured collecting Old Masters. In 1878 Vanderbilt built a mansion on Fifth Avenue and began accruing, what was at the time, one of the world's highest valued private art collections. During his lifetime he acquired over two hundred paintings, many of which he displayed in his palatial New York townhouse.

[1] A list School of Ferrara painters in Camillo Laderchi's 1856 artist biography, includes Girolamo da Carpi (*c.*1501-?1556), Lorenzo Costa (*c.*1460-1535), Dosso Dossi, Garofalo, Ludovico Mazzolino (*c.*1480-after 27 Sep 1528) and Ortolano (fl. *c.*1500-after 1527).

GIACOMO RAIBOLINI, CALLED GIACOMO FRANCIA

(Bologna 1486 - Bologna 1557)

The Holy Family with the Infant Saint John the Baptist and Saint Elizabeth

oil on panel
68 x 56.5 cm (25¾ x 22¼ in)

IN THIS PANEL PAINTING, GIACOMO RAIBOLINI, CALLED Giacomo Francia, combines the monumental grace of Raphael (1483-1520) with the gentle religiosity and archaic style of his father, Francesco Francia, il Francia (*c.*1450-1517). In executing *The Holy Family with the Infant Saint John the Baptist and Saint Elizabeth*, Raibolini demonstrates the technical accomplishment and softly modelled figures that characterise his father's work. Both father and son were trained as goldsmiths and the precision and skill gained from the trade is evident in their highly detailed painting style. In contrast to his father's consistently traditional and formal approach, Raibolini tends to treat his subjects in a more dynamic and lucid manner. The figures in the present painting are elegant as well as fully engaging and modern in their presentation, indicating the influence of Raphael. The painting, due to its size and format, was possibly commissioned by a private patron as a devotional image. It fulfils its purpose with refinement and delicacy.

The figures in the present work are harmoniously grouped, emanating serenity and contentment. The contrasting colours of their garments are rich without being excessive and their positioning is intimate whilst maintaining the formality appropriate to their ranks within the religious hierarchy. The Virgin is particularly striking in her noble bearing and dreamy countenance. She dominates the scene, wearing a red dress, with arabesque gold trimming, a green mantle, and a nearly transparent veil. She holds the infant Christ seated on a red velvet cushion. Christ reaches out his hand in a welcoming gesture to the young John the Baptist, who is clad in a camel hair tunic in anticipation of his future spent as a hermit in the desert. In his other hand he holds a peach, the symbol of salvation and truth. To the right of the Virgin stands Joseph clad in a gold mantle. To her left is St. Elizabeth, John the Baptist's mother and the Virgin's older kinswoman, who bears white carnations, which were introduced to Europe in the Middle Ages and symbolised the eye of God from which nothing could escape. According to legend, when Mary saw Christ carrying the cross, she wept, and carnations grew where her tears fell. The flower appears in a number of paintings of the Mother and Child, particularly in Renaissance iconography.

Another painting by Raibolini, *The Mystic Marriage of Saint Catherine*, reveals a composition similar to the present one in which the Virgin and Child are again flanked by two saints (fig. 1). The Virgin's classicised features, graceful pose and long elegant fingers are reminiscent of the present work. Christ's body is of similar proportions, looking remarkably naturalistic and child-like with rounded limbs and a plump face. Joseph is once again placed

Giacomo Raibolini, called Giacomo Francia, *The Mystic Marriage of Saint Catherine*, Private Collection (Figure 1)

on the right of the composition, witnessing the tender scene. St. Catherine of Alexandria stands on the left of Mary, holding the martyr's palm. Her hand is outstretched to allow the infant Christ to place a ring on her finger. The ring symbolises their 'mystic marriage', which according to the 'Golden Legend', was foreseen in a vision by St. Catherine following her conversion to Christianity.

Like Raibolini, his father, il Francia, was best known for his intimate Madonnas, although he also painted a number of complex large-scale

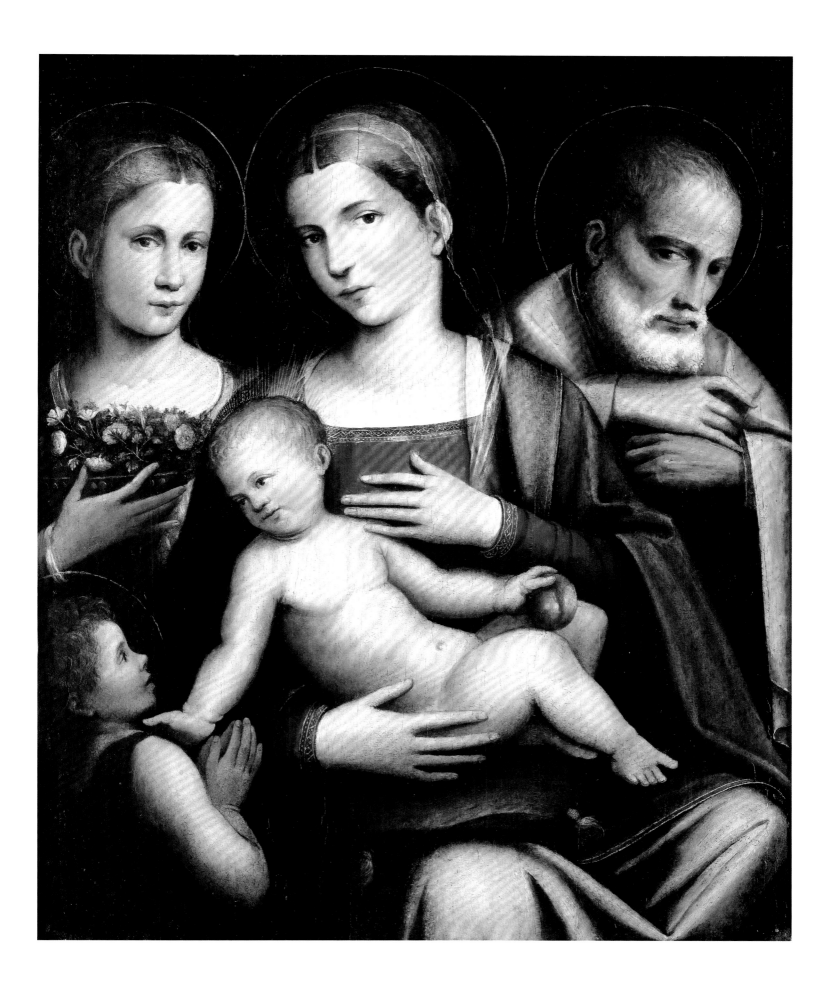

Francesco Raibolini, il Francia, and Giacomo Raibolini, called Giacomi Francia, *Madonna and Child with St Catherine of Alexandria*, c.1510-1515, Private Collection (Figure 2)

altarpieces with the Virgin and Child enthroned and surrounded by monumental architecture, saints and angels. A painting of the *Madonna and Child with St. Catherine of Alexandria*, see fig. 2, that is thought to have been painted by il Francia, with help from his son reveals how closely Raibolini modelled his own work on his father's compositions. The physiognomy and modelling of the figures is exceptionally similar to that of the present painting, and the faces are particularly sweet and softly rounded. In *Madonna and Child with St. Catherine of Alexandria*, as in the present work, the training of both father and son as goldsmiths is most evident in the enamel-like finish of the work and the delicate details, particularly in the border of St. Catherine's garments, the scalloped edge of the Madonna's veil, and the leaves of the trees in the background.

Given that Raibolini was an assistant in his father's studio for such a long period of time, it is not surprising that il Francia's work was a source of great influence. Indeed, throughout his career, Raibolini remained faithful to his father's style. Il Francia's manner of painting, passed down to his son, seems to derive in many respects from the Umbrian master Perugino (c.1450-1523), whose Madonnas have a particularly dream-like, almost wistful quality. Perugino's constant preoccupation in achieving harmony and balance in his works as well as light effects, are concerns that are also illustrated in il

[1] Larousse *Dictionary of Painters*, Book Club Associates, London, 1981, p. 315.
[2] *The Concise Oxford Dictionary of Art and Artists*, ed. Ian Chilvers, Oxford University Press, Oxford, 2003, p. 219.
[3] Karl Ludwig Gallwitz, *The Handbook of Italian Renaissance Painters*, Prestel Verlag, Munich, 1999, p. 154.
[4] Giorgio Vasari, *Vite*, 1550, rev. 2/1568, ed. G. Milanesi.

Francia and Raibolini's work.[1] Il Francia was certainly aware of Perugino's brilliant pupil, Raphael, who painted numerous Virgin and Child images, many based on Perugino's prototypes. Although il Francia may have tried to imbue his paintings with Raphaelesque grace, his work is adamantly traditional and it does not seem that he responded in any significant way to the younger artist's innovations. Although he was a commercially successful artist, painting pleasing pictures for his clientele, apparently he was aware of his shortcomings, as according to Vasari, 'Francia died of "grief" after seeing Raphael's *St Cecilia* [Pinacoteca Nazionale, Bologna] which made his own paintings look hopelessly old-fashioned.'[2] Raibolini, perhaps because he was of a younger, less conservative generation, showed more of a leaning towards emulating Raphael. *The Holy Family with the Infant Saint John the Baptist and Saint Elizabeth*, although very similar in composition to many of Il Francia's paintings, gives the figures a greater monumentality and grace that is more suggestive of Raphael.

Lorenzo Costa (c.1460-1535), who on moving to Bologna c.1483, began closely collaborating with il Francia, can be considered another influence on both father and son. The beauty of Costa's facial types and soft, atmospheric manner of painting is clearly translated into both il Francia and Raibolini's work. Yet another artist who reached the height of his career in Bologna, and may have been a member of il Francia's prosperous workshop, was Bartolomeo Ramenghi, il Bagnacavallo (1484-1542) who is considered a protagonist of so-called Bolognese Raphaelism.[3] Il Bagnacavallo, according to Vasari, was in Rome during Raphael's sojourn there from 1508 to 1520.[4] He produced his principal works in Bologna between 1520 and 1530, which were very much styled after Raphael and it seems likely that, either in il Francia's workshop or afterwards, he would have been acquainted with Raibolini.

A painting by Raibolini of the Madonna and Child, see fig. 3, this time depicted without accompanying figures, is perhaps most revealing of his father's influence as it resembles the fine detail and smoothness of *Madonna*

Giacomo Raibolini, called Giacomo Francia, *The Madonna and Child, Seen through a Feigned Window*, Private Collection (Figure 3)

Giacomo Raibolini, called Giacomo Francia, *Sacra Famiglia*, Private Collection (Figure 4)

and Child with St. Catherine of Alexandria. The countryside displayed in the background is closely observed and brings to mind landscapes found in Flemish art. This influence may have been transmitted by Perugino, who also sometimes included misty northern-looking scenery in his religious compositions, as in *The Crucifixion with the Virgin, Saint John, Saint Jerome, and Saint Mary Magdalene* (National Gallery, Washington).[5]

Raibolini's ability to convey softness and refinement is exemplified in his painting *Sacra Famiglia*, which is not symmetrical like most of his works and incorporates three figures (fig. 4). The gentle tilt of the Madonna's head, her languorous gaze, the rounded forms of the infant and softly modelled drapery reveal the extent to which Raibolini was inspired by elder masters Perugino and Costa, and the youthful genius of Raphael. There is more fluidity and liveliness to *Sacra Famiglia* than in *Madonna and Child with St. Catherine of Alexandria*, which is dominated by il Francia's hand and overall, a more conservative approach. The inclusion of a landscape in the background is reminiscent of the earlier work, whereas the present painting and *The Mystic Marriage of Saint Catherine* both have plain dark backgrounds against which the figures are dramatically silhouetted.

Raibolini and his younger brother Giulio Francia were both trained by their father in the family business of painting and goldsmithing. On il

[5] Larousse *Dictionary of Painters*, Book Club Associates, London, 1981, p. 315.

[6] Nicosetta Roio: 'Giacomo e Giulio Raibolini detti i Francia', *Pittura bolognese del cinquecento*, ed. V. Fortunati Pietrantonio, Bologna, 1986, pp. 29–57.

Francia's death in 1517, they took over the workshop, jointly painting a number of altarpieces, identifiable by the initials 'I. I.', which stood for their latinised names Iacobus and Iulius. Raibolini's earliest known work, the *Virgin in Glory with Saints Peter, Mary Magdalene, Francis, Martha and Six Nuns* (Pinocateca Nazionale, Bologna), was painted after 1515 and signed by both brothers. In the 1520s, Raibolini most likely travelled to Florence and to Rome where he would have been exposed to wider artistic influences, and his paintings from this decade indicate that he had reached his full artistic maturity. Around 1530, Giacomo and Giulio painted an altarpiece depicting *Saint Frediano with Saints James, Lucy, Ursula and a Blessed Person* (Pinacoteca Nazionale, Bologna), which repeats the compositional structure of Raphael's *St. Cecilia in Ecstasy*, the painting that earlier had such an emotional effect on il Francia. During this period, his paintings also reveal the inspiration of Parmigianino (1503-1540), who spent the years 1527 to 1530 in Bologna, making it possible that Raibolini may have come into direct contact with the artist during this time.

By the mid to late 1530s, Raibolini seems to have abandoned his most experimental phase in which he was open to the influences of dominant artistic trends. He spent the remainder of his career re-working existing compositions in a more traditional manner, similar to that of his father. This was perhaps a consequence of the spread of the more difficult Mannerist style, which he was unprepared to adopt.[6] His later works most often take the form of the Madonna with Child, based on the centralised Raphaelesque type, surrounded by saints, as in *The Holy Family with the Infant Saint John the Baptist and Saint Elizabeth*. As well as altarpieces, Raibolini executed a number of smaller panels for private patrons and female convents, of which the present picture may be an example. Though a prolific artist, many of Raibolini's works no longer exist and are only known through documentary sources.

Giacomo Raibolini, called Giacomo Francia, *The Holy Family with the Infant Saint John the Baptist and Saint Elizabeth* (Detail)

ANDREA MELDOLLA, CALLED SCHIAVONE

(Zara, now Zadar 1510 - Venice 1563)

Perseus and Andromeda

oil on panel, with *trompe l'oeil* shaped corners
24.9 x 49.8 cm (9¾ x 19⅝ in)

Provenance: Anonymous sale, New York, Sotheby's, 20 May 1993, lot 11.

Attributed to Andrea Schiavone, *Two Mythological Figures*, probably *c.*1548-1550, National Gallery, London (Figure 1)

PERSEUS AND ANDROMEDA PRESENTS A ROMANTIC and heroic mythological rescue. The story, taken from Greek mythology, tells us of Andromeda, the daughter of an Ethiopian king, who had been chained to a rock and offered as a sacrifice to a sea monster. The myth relates that Perseus, who had happened upon the pitiful figure, first thought Andromeda to be a statue due to her porcelain white skin. On realising her plight Perseus slew the monster, released her from captivity and the couple fell in love and were married.

In Renaissance and modern interpretations, Perseus is shown flying to her rescue on the winged horse Pegasus. The present work represents all of these elements within an oval composition. On the right, the nude Andromeda is unshackled by Perseus while the sea monster, unaware of her rescue, languishes nearby in the water. In the background Pegasus waits patiently, his rainbow coloured wings raised. The composition is set within an oval, and the *trompe l'oeil* shaped corners would suggest that this painting once formed part of a larger complex, perhaps a *cassone*-shaped panel, which may have been dismantled later. When the painting was sold in 1993, it was extremely dirty and the corners had been painted over.

Cassoni (*cassone* in the singular) were Italian boxes or chests, often decorated with carving, gilding and painted panels. During the Renaissance, they were frequently made in pairs or groups of three, and were included as part of a wedding dowry since the bride would receive a *cassone* from her family on marriage. Such marital associations meant that the pictorial narratives often illustrated acts of heroism or love, such as in the present work. The National Gallery, London holds another *cassone* panel attributed to Schiavone, showing two mythological figures embracing, possibly Jupiter and Callisto (fig. 1).

Born in Zara (now Zadar) on the Dalmatian Coast in 1510, Schiavone was essentially a self-taught artist, copying from the drawings of Parmigianino (1503-1540). By the late 1530s, Schiavone had established himself as an artist working in Venice, though his first surviving paintings and etchings date from *c.*1538-1540. These early works show the influence of Parmigianino and the Central Italian Mannerists in terms of figure and composition, whilst also retaining the *colore* and painterly style associated with Venetian art of the period. Schiavone was also a proficient fresco painter who applied the medium in a

particularly impressionist manner and his works 'shocked some contemporaries and stimulated others'.[1] Later in his career he influenced the works of aspiring Venetian artists such as Jacopo Bassano (*c.*1510-1592) and Jacopo Tintoretto (1519-1594), particularly through his introduction of Mannerist painting methods to Venetian circles and his innovative 'impressionist' works executed on a large-scale.

[1] In 1548, Pietro Aretino reported to Schiavone that Titian was amazed 'at the technique you demonstrate in setting down the sketches of stories.'

SANTE CREARA

(Verona c.1572 - Verona c.1620)

The Flagellation

oil on slate
29.5 x 24.2 cm (11⅝ x 9½ in)

S ANTE CREARA'S RENDITION OF *THE FLAGELLATION* shows his masterful handling of *chiaroscuro*. Central to the composition, Christ's body radiates a crisp, white light while on either side of him, encased in darkness, two servants of Pontius Pilate administer the lashes. To the right a male figure wields a whipping device; the straps, caught mid-air, subtly catch the light emanating from the figure of Christ. Standing to the right of Christ another tormentor grips a bundle of birch sticks menacingly with both hands. At the foot of Christ a sensually dressed female figure, her left breast slightly exposed, kneels while holding a burning torch; apparently to provide light for the two persecutors to carry out their violent task. In the bottom-right corner, the crown of thorns worn by Christ before his crucifixion is visible. Creara may have included this symbolic item to allude to the following scene in the Passion of Christ.

The Flagellation of Christ was a particularly popular subject in sixteenth and seventeenth-century religious painting. As part of the Passion cycle, it depicts the moment when Christ, at the request of Pontius Pilate, is flogged before his crucifixion. Unusually, the present work does not depict Christ

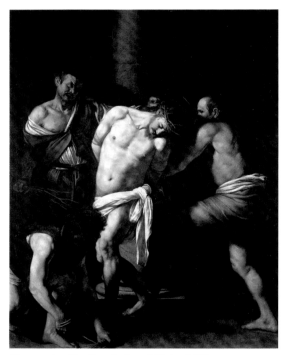

Caravaggio, *The Flagellation of Christ*, 1607, Museo Nazionale di Capodimonte, Naples (Figure 2)

Felice Riccio, *St Margaret of Antioch*, Private Collection (Figure 1)

tied to a column during his ordeal, an item which is often included in artistic representations of this scene.

The subtle use of light within darkness by Creara shows clear links to the master of *chiaroscuro*, the contemporary artist Caravaggio (1571-1610), as well as to the work of Creara's teacher, Felice Riccio (1542-1605), known as il Brusasorci (fig.1). This use of *chiaroscuro* became a popular effect during the sixteenth century, in both Mannerist and in Baroque art. Artists such as Jacopo Tintoretto (1519-1594) and Paolo Veronese (1528-1588) chose this effect to exaggerate and emphasise divine light radiating from reverential subjects, such as in *The Flagellation*. Dark subjects dramatically lit by a shaft of light from a single source was a compositional device developed by, amongst others, Caravaggio who was seminal in developing the style of tenebrism where dramatic *chiaroscuro* would become a dominant stylistic device. Figure 2 shows Caravaggio's interpretation of the same subject matter executed in 1607.[1]

[1] Caravaggio also painted another version of the Flagellation of Christ in 1607, *Christ at the Column*, now in the Musée des Beaux Arts, Rouen.

(Actual Size)

GIOVANNI BALDUCCI

(Florence 1560 - Naples 1603)

The Penitent Magdalene in a Landscape

oil on panel
133 x 96 cm (52¼ x 37¾ in)

Provenance: Private Collection, Belgium.

GIOVANNI BALDUCCI'S *THE PENITENT MAGDALENE in a Landscape* kneels on the grass, her hands held together in prayer. Mary Magdalene, after being redeemed of her sins by Jesus, and following His resurrection, spent the rest of her life in solitary atonement, the period of her life depicted in the present work. She has always been a popular subject for painters as she was revered as the woman closest to Jesus, and for the decorative and salacious qualities of her representation. In Balducci's work she is turning to look up at the archangel Gabriel, who is descending from heaven out of a golden cloud. On the right-hand side of the painting is a bible and crucifix to aid her in her contemplation. She is nude, apart from the large pink cloak which partially covers her, her long hair falling down to her thighs. In the background is a landscape with a river, town and distant mountains. The rich pink of Magdalene's cloak and bible stands out against the soft blues and greens of the landscape and help focus our attention on the image of penance.

The Penitent Magdalene in a Landscape is an emotional image but one which nevertheless contains an element of restraint in the figure of Mary. This approach is similar to that which Balducci employs in *The Penance of Charles Martel* in the Royal Collection (fig. 1). The central figure may clasp his hands to his chest, but there is no force to his actions. The grief depicted through the figures of Charles Martel and Mary Magdalene is not overstated; their poses and actions concur with the narrative, with both maintaining their self-control. As a result

Balducci has portrayed exquisite nude figures who clearly and concisely convey the narrative of the paintings. Their emotions are evident but these feelings do not impinge on the beauty of the figures, the figure of Mary Magdalene for example recalling the highly stylised stillness of Netherlandish nudes, such as Lucas Cranach the Younger's (1515-1586) *Adam and Eve*.

Balducci was trained by Giovanni Battista Naldini (*c.*1537-1591), who was influenced by Giorgio Vasari (1511-1574) and late Florentine Mannerism. Naldini's *Bathsheba* shows the influence that his work had on Balducci (fig. 2). Once again the focus is on the female nude. In fact, in addition to Bathsheba, Naldini has depicted her four attendants in a variety of poses, so the painting is very much a study of the female form. David is a mere detail in the background. The painting also demonstrates the same soft, rich colouring that Balducci uses in *The Penitent Magdalene in a Landscape*.

In 1589 Balducci worked on the decoration of Florence Cathedral for the wedding of Ferdinand I de' Medici, Grand Duke of Tuscany. From 1588 to 1590 he painted one of his finest works, a cycle of scenes from the *Life of Christ*, in the Oratory of the Pretoni in Florence for Cardinal Alessandro de' Medici. Balducci also went to Rome as part of the entourage of the cardinal, (later Pope Leo XI), and is recorded there in 1594. He also executed a number of works in Naples, where he later died, including the frescoes in the cloister of S. Maria del Carmine.

We are grateful to Mr Everett Fahy of the Metropolitan Museum of Art, New York, for confirming the attribution to Balducci

Giovanni Balducci,
The Penance of Charles Martel,
*c.*1592-1596,
The Royal Collection
(Figure 1)

Giovanni Battista
Naldini,
Bathsheba,
The Hermitage,
St. Petersburg
(Figure 2)

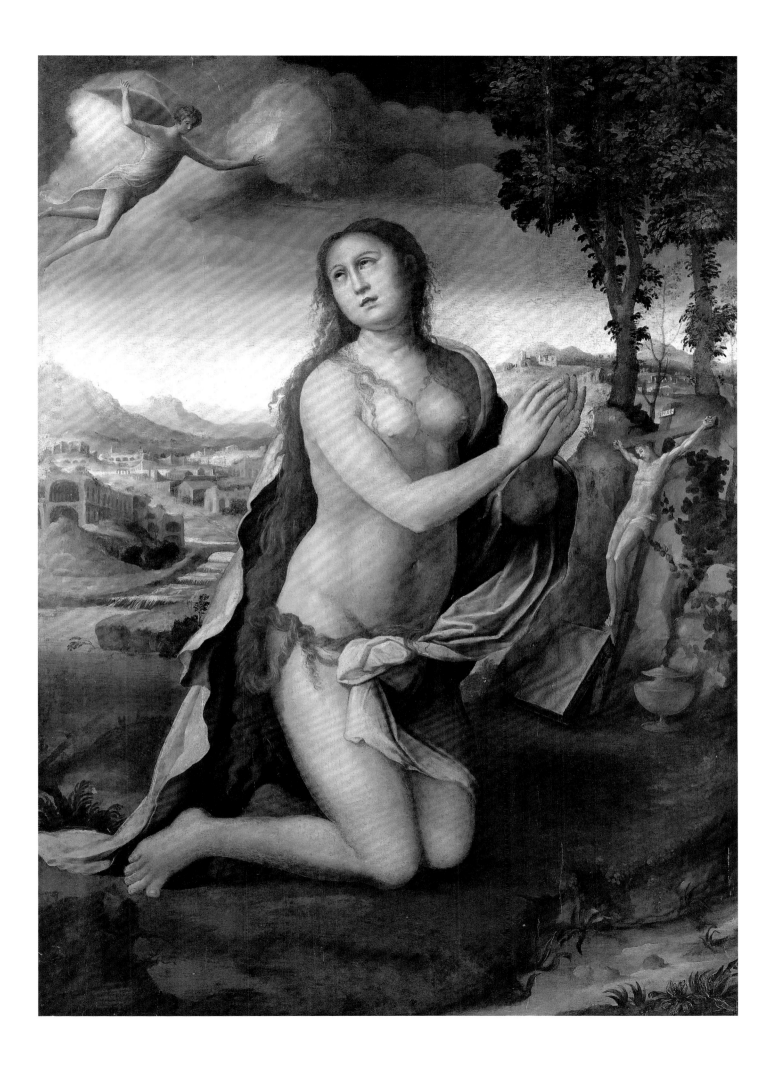

ATTRIBUTED TO
ANTONIO TEMPESTA

(Florence 1555 - Rome 1630)

The Stoning of Saint Stephen

oil on marble
37.4 x 53 cm (14¾ x 20⅞ in)

Provenance: Galerie Reynald Liron-Péan, Deauville.

THE SUMPTUOUS GOLDEN, JEWEL-LIKE COLOUR scheme of *The Stoning of Saint Stephen* is superbly complemented by the marble upon which it is painted. The natural colour variations, patterns and veins found in the marble are picked out in the walls of the architecture, craggy landscape and heavenly sky, providing a unique ocular experience for the viewer.

The present work, attributed to Antonio Tempesta, shows the stoning, or martyrdom, of Saint Stephen. The Acts of the Apostles (6:1-8:2) tells how Stephen was tried for blasphemy for spreading the word of Jesus and was stoned to death in *c.*34/35 AD by an enraged mob whose actions were encouraged by Saul of Tarsus (later to become St. Paul). In the centre of the composition, the kneeling figure of St. Stephen can be seen; his palms facing upward in serene protestation.[1] Surrounding him are three male figures in the process of hurling stones, while other figures nearby casually watch the activity unfold. In the sky above, the resplendent figure of Christ wears a billowing red cloak and clutches a crucifix, while to his right the delicately sketched figure of God holding a large orb is visible.

The technique of painting on stone was fashionable in Italy from the early sixteenth century until the middle of the seventeenth century. The prevalence of quarried marble on the Italian coast made it a readily available, though unusual, surface for paint. By the 1590s paintings on copper, stone, lapis lazuli and alabaster amongst other materials had gained prominent positions in Italian collections as they displayed refinement, delicacy and an exceptional artistic skill. Tempesta was one of the artists at the forefront of this varied media experimentation and his works were distributed amongst connoisseurs in Rome, often encased in elaborate enamel frames. Another example of Tempesta's delicate works on stone is now held in the Galleria Sabauda in Turin (fig. 1).

Tempesta was an Italian painter and engraver whose *oeuvre* fused the styles of Baroque Rome and the artistic culture of Antwerp.[2] He enrolled in the Accademia del Disegno in Florence on 8 December 1576 where he was a pupil of Santi di Tito (1536-1602) and Joannes Stradanus (1523-1605). It was with Stradanus that Tempesta worked under Giorgio Vasari (1511-1574) on the interior decoration of the Palazzo Vecchio in Florence. He later relocated to Rome where, alongside Matthijs Bril (1550-1583), he was commissioned by Pope Gregory XIII to produce the *Transfer of the Relics of St Gregory of Nazianzus* (1572) and other religious scenes in the loggias on the third floor of the Vatican Palace. He received other papal fresco commissions, notably for the interior of the chapel at S.S. Primus Felicianus in Rome. He also produced over one thousand engraved prints and book illustrations which were widely circulated during his lifetime and which were used as models by other artists.[3] Tempesta became a member of the Accademia dei Virtuosi al Pantheon in Rome in 1611 and of the Accademia di San Luca in Rome by 1623.

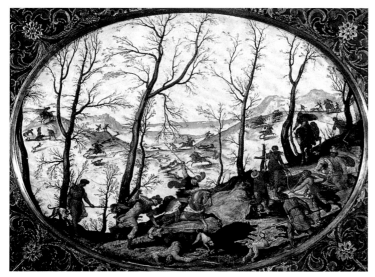

Antonio Tempesta, *The Death of Adonis, c.*1593, oil on stone, Galleria Sabauda, Turin (Figure 1)

[1] St. Stephen was the first deacon and the first martyr and, as in the present work, is usually depicted wearing a dalmatic (a wide sleeved tunic) - a recognisable attribute of his office.

[2] Silvia Danesi Squarzina, "The Collections of Cardinal Benedetto Giustiniani. Part II" *The Burlington Magazine* 140 (February 1998: 102-118) particularly p. 110, note 43.

[3] Tempesta's engraving of the French King Henry IV on horseback (1593) served as a model for portraits of Henry by numerous artists, including Jacques Callot (1592-1635), Peter Paul Rubens (1577-1640) and Diego Velázquez (1599-1660).

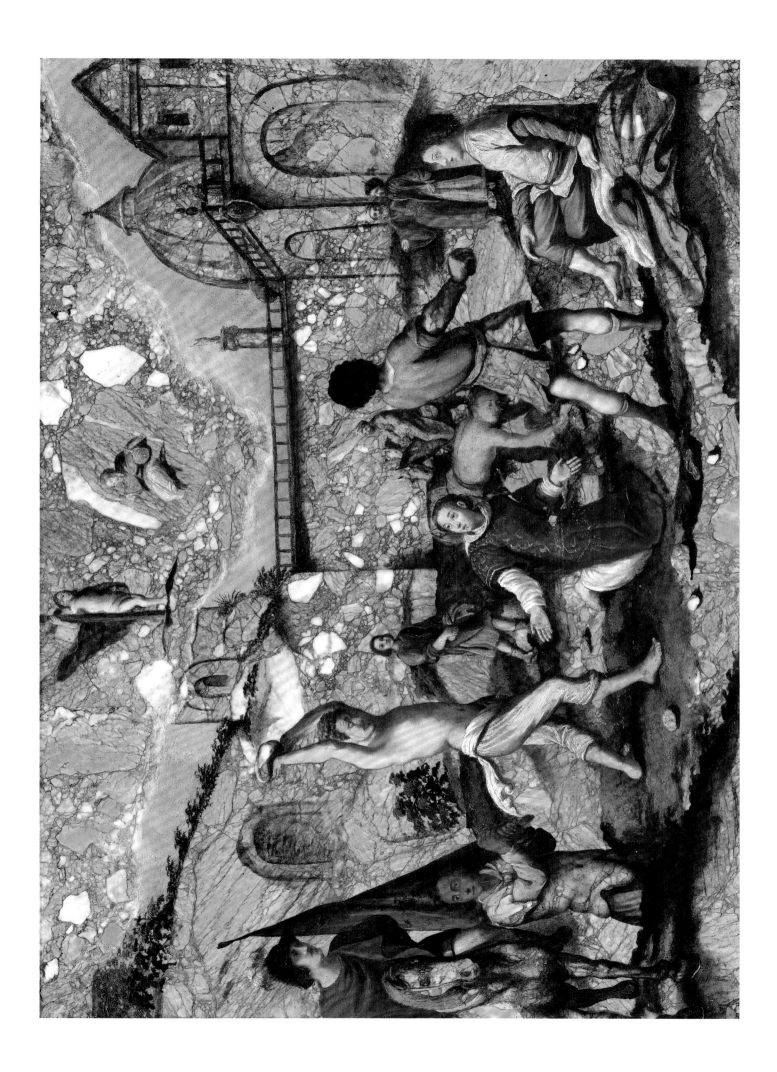

FLORENTINE SCHOOL, SEVENTEENTH CENTURY

A Portrait of a Noblewoman with a Lace Collar

oil on canvas
42 x 32.3 cm (16½ x 12¾ in)

I N *A PORTRAIT OF A NOBLEWOMAN WITH A LACE COLLAR,* an attractive, youthful, noblewoman, painted against a stark background, stares calmly out at the viewer. This bust-length portrait tells the viewer that we are looking at a lady of some standing. Her magnificently opulent collar dominates the painting due, not only to its size, but also because of the elaborate lace detailing. The spider's web of intricate swirls and patterns are loosely painted in white and grey. The delicate brushwork helps to create the fragile nature of lace.

The noblewoman's face is an idealised one, soft and without blemish. The muted red of her lips and cheeks bring touches of colour to her pale complexion. She looks directly out at the viewer, not aggressively but certainly with the understated authority and confidence of an important woman. In her carefully styled auburn hair is a star shaped broach and two other pieces of jewellery and from her left ear hangs a large pearl earring.

The portrait has been painted for the most part in a restricted and subdued palette of greens, browns and reds. This, together with the lack of strong, precise line, unifies the whole work and blurs the boundaries between the different parts of the painting, a technique which is especially effective in capturing the layers of the collar.

This portrait is dominated by the statement of sophistication and class, which is made by the exquisite collar, elegant headdress and carefully coiffured hair, and this focus on the elaborate costume of the sitter is very much a feature of the portraiture of the period. For example Santi di Tito's

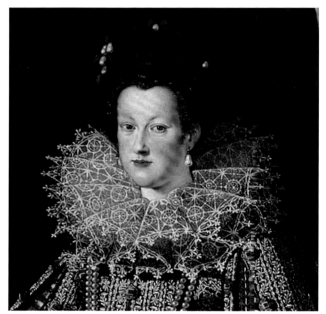

Santi di Tito, *Portrait of Maria de' Medici, c.*1601, Palazzo Pitti, Florence (Figure 1) (Detail)

(1536-1602) *Portrait of Maria de' Medici* is a brilliant depiction of sumptuous materials and textures (fig. 1). The style and fashions evident in de' Medici's head and shoulders are comparable to those that are such a crucial part of *A Portrait of a Noblewoman with a Lace Collar.* Both figures have finely painted, intricately patterned and almost transparent collars. Like the woman in the present work, de' Medici has a similarly pale complexion, animated by the red hue of her cheeks and lips. Both women have thick hair which is tightly pulled back and styled in a manner according to contemporary fashion. De' Medici's headdress is more elaborate than the one in the present work, but they are both made up of similar jewellery, which is echoed by the single pearl earrings both women wear. As daughter to the Grand Duke of Tuscany, de' Medici would have been at the forefront of Florentine fashionable society and clearly this is the sort of status which would have been suggested to a contemporary viewer of *A Portrait of a Noblewoman with Lace Collar.* For an artist this type of costume and style obviously provided an appealing challenge due to the variety of materials, so that the delicacy of the lace is contrasted with the glint of light off jewellery.

Florentine School, *A Portrait of a Noblewoman with a Lace Collar* (Detail)

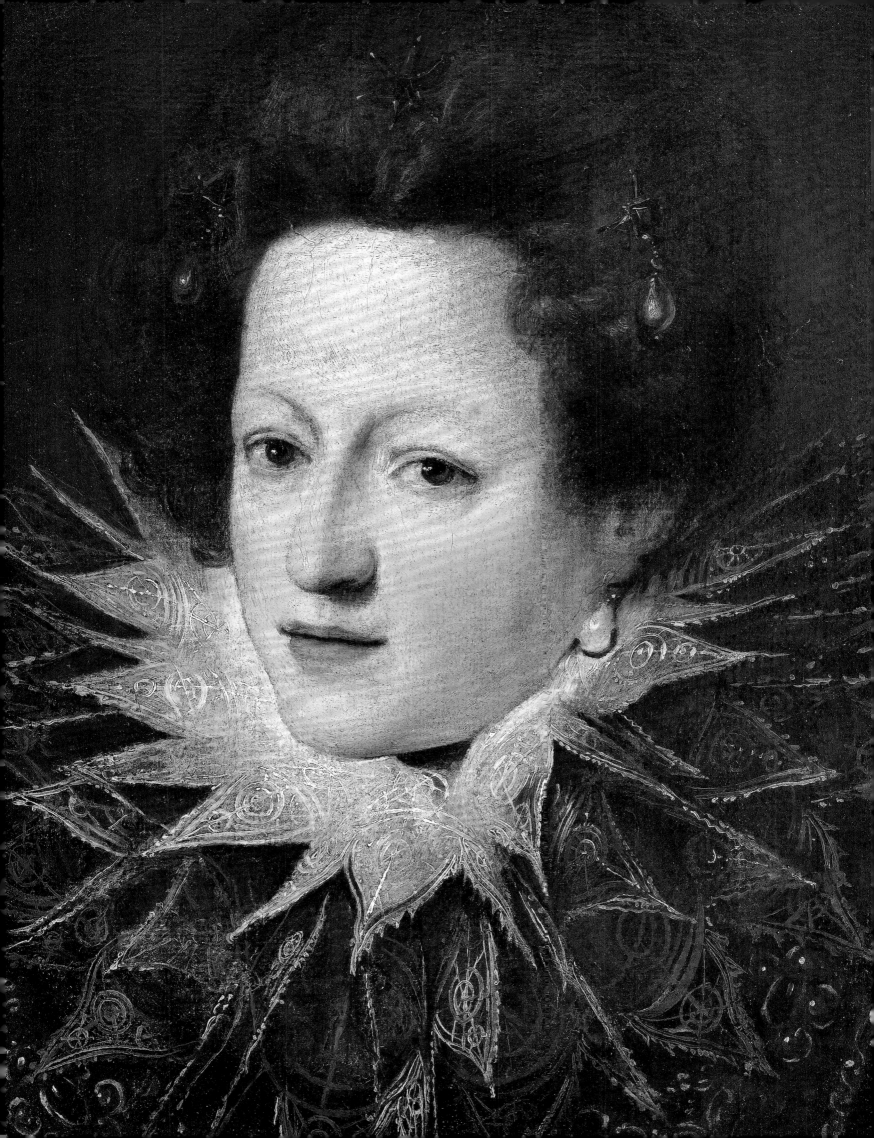

EMILIAN SCHOOL, LATE SIXTEENTH CENTURY

Portrait of Hernán Cortés (Ferdinandus Cortesius)

inscribed 'FERDINANVS CORTESIVS' (upper edge)
oil on canvas
64.8 x 50.2 cm (25½ x 19¾ in)

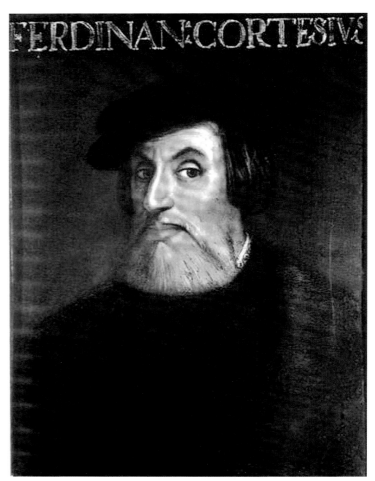

Cristofano di Papi dell'Altissimo, *Portrait of Hernando Cortes*, 1552, Uffizi Gallery, Florence (Figure 1)

THE PROUD AND IMPERIOUS GENTLEMAN DEPicted in this late sixteenth-century portrait is Hernán Cortés (1485-1547), a Spanish conquistador famed for his explorations of Mexico and defeat of the Aztec empire. He is dressed primarily in black, giving him an austere appearance, which is slightly softened by the rich fur collar of his cloak. Cortés' considerable girth fills much of the canvas and the strong lines of his face and ample facial hair contribute to his imposing presence.

Portrait of Hernán Cortés (Ferdinandus Cortesius) may relate to a lost portrait of the conquistador, which was one of four hundred portraits depicting eminent Europeans, amassed by Paolo Giovio (1483-1552) for his villa-museum in Borgovico, near Como. Although Giovio's collection no longer remains, as in time the pieces were destroyed or dispersed, the subjects are known today through painted copies commissioned by Cosimo I de'Medici. The painting of Cortés was copied by Christofano di Papi dell'Altissimo (fl.1552-d.1605), a pupil of Agnolo Bronzino (1503-1572) and Jacopo da Pontormo (1494-1556), in 1552, and is now in the Uffizi (fig. 1). The copy has notable similarities with the present work in that the sitter's Latin name is inscribed along the upper edge and he is depicted in an identical fashion, wearing a black doublet, fur lined cloak and soft crowned hat. Although the compositional resemblance is evident, the virtuosity and expressiveness of *Portrait of Hernán Cortés (Ferdinandus Cortesius)* far outshines the copy.

Cortés was born in the Spanish city of Medellín in 1485 and in his youth decided to seek his fortune in the New World. His travels began at the age of eighteen when he sailed to the island of Hispaniola in the West Indies and later participated in the Spanish conquest of Cuba in 1511. He became Mayor of Santiago de Cuba but, dissatisfied with a sedentary lifestyle, in 1519 he led an expedition to Mexico, which was ruled by the Aztec emperor, Montezuma II. On arriving in Mexico, Cortés made his way inland to the Aztec capital city, Tenochtitlán, befriending the indigenous population along the way to aid in the Aztec defeat. Although his first attempt to capture Tenochtitlán was foiled, Cortés returned to the capital in 1521, which finally fell after a three month siege. He was rewarded with the title of Marqués del Valle de Oaxaca. His explorations continued over the following years and he made several more journeys to Central America, before finally settling in Spain in 1541. Cortés was famed as much for the great riches that he plundered from Mexico as for his military conquests. Due to Cortés' controversial undertakings and the scarcity of reliable sources about him, historians have long found it difficult to assert anything concrete about his personality or motives. The present work appears to provide as useful an account as any about the nature of his character, which from the way he commands the viewer's attention, was clearly strong, authoritative and determined.

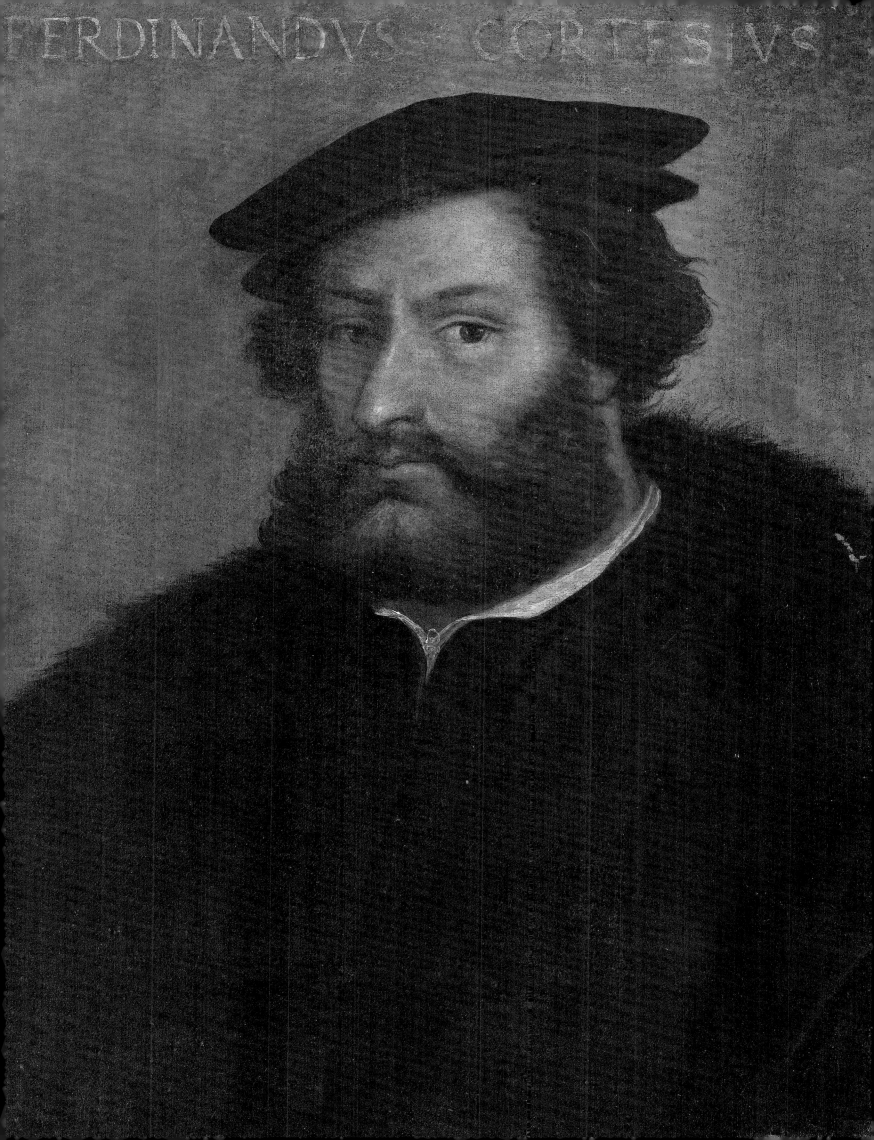

FERDINANDVS · CORTESIVS

JACOPO VIGNALI

(Pratovecchio 1592 - Florence 1664)

The Archangel Michael

oil on canvas
115.1 x 87.6 cm (45¼ x 34½ in)

JACOPO VIGNALI'S PAINTING OF *THE ARCHANGEL Michael* brilliantly evokes the strength and authority of his subject, the field commander of the Army of God, as well as emphasising his beauty and youth. Vignali's naturalistic style, dramatic use of *chiaroscuro* and elegance in balancing colour and design is true to the Florentine Baroque tradition.

The archangel wears a lustrous blue tunic, evoking Roman armour and accordingly great heroism, with tasselled shoulders and a neckline embroidered in gold. An ornate plumed helmet adorns his head. The costume presents the perfect opportunity for Vignali to showcase his talent in depicting rich materials and a variety of textures and tones. Michael holds two of his attributes, the scales used to judge men's souls, and the red banner, a reminder of his secondary role, popularised in late medieval imagery, as a knight and slayer of dragons.

The majority of Vignali's work was devoted to images of saints designed for ecclesiastical commissions, and the Archangel Michael figures prominently. In the church of S.S. Michele e Gaetano, Florence, a painting by Vignali of the archangel freeing souls from purgatory reveals him in his role as liberator, judging the good from the bad, and leading them before the tribunal of God (fig.1). Although a complex composition featuring several figures, the representation of Michael is remarkably similar to the present painting. He, like the angels accompanying him, is sensually depicted as a young man with abundantly curly hair, full lips, bright eyes and a pure complexion. He wears a blue tunic embroidered in gold and carries a banner. The interplay of light and shadow is prominent in both paintings, and in the version in the church of S.S. Michele e Gaetano it is heightened by the thunderous clouds overhead and the fiery furnace from which desperate men are being saved. The present painting offers a more personal and psychological portrayal of Michael, capturing him in an unsuspecting moment from a close vantage point. As he locks gaze with the viewer, one detects a softer human side to the archangel and in his disarming expression there is a note of vulnerability that contradicts his fearsome power.

Vignali was a precocious artist and at an early age entered the studio of Matteo Rosselli (1578-1650) in Florence. In 1616, he was admitted to the Academia del Disegno in Florence and became an academician in 1622. In the 1620s, his works developed a new boldness in their use of colour, lighting and expression, moving away from the influence of Rosselli. As well as being an easel painter, Vignali also contributed to fresco cycles and ceiling decorations for patrons including the Medici family. He took inspiration from a variety of fellow Italian artists as his career progressed, including Orazio Gentileschi (1562-1639), Filippo Napoletano (*c.*1587-1629), Rutilio Manetti (1571-1639), Guercino (1591-1666), Francesco Curradi

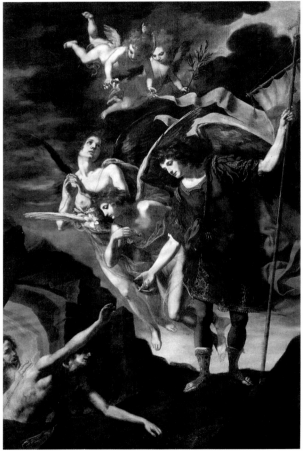

Jacopo Vignali, *Liberation of Souls from Purgatory,* 1642, S.S. Michele e Gaetano, Florence (Figure 1)

(1570-1661) and Giovanni Lanfranco (1582-1647). The early 1630s were a particularly productive period for Vignali and in 1632 he painted his first commission for the church of S.S. Michele e Gaetano, painting the ceiling frescoes, two lunettes and a lateral composition for the Bonsi Chapel. In the 1640s, his works took on a greater monumentality, evidenced by works such as *Liberation from Souls of Purgatory* (fig. 1). Later in the decade, his compositions became increasingly dark and meditative, often depicting scenes of death or martyrdom. Vignali had several pupils, the most successful among them was Carlo Dolci (1616-1687), who adopted and enhanced the ardent religiosity of his master's works to great effect.

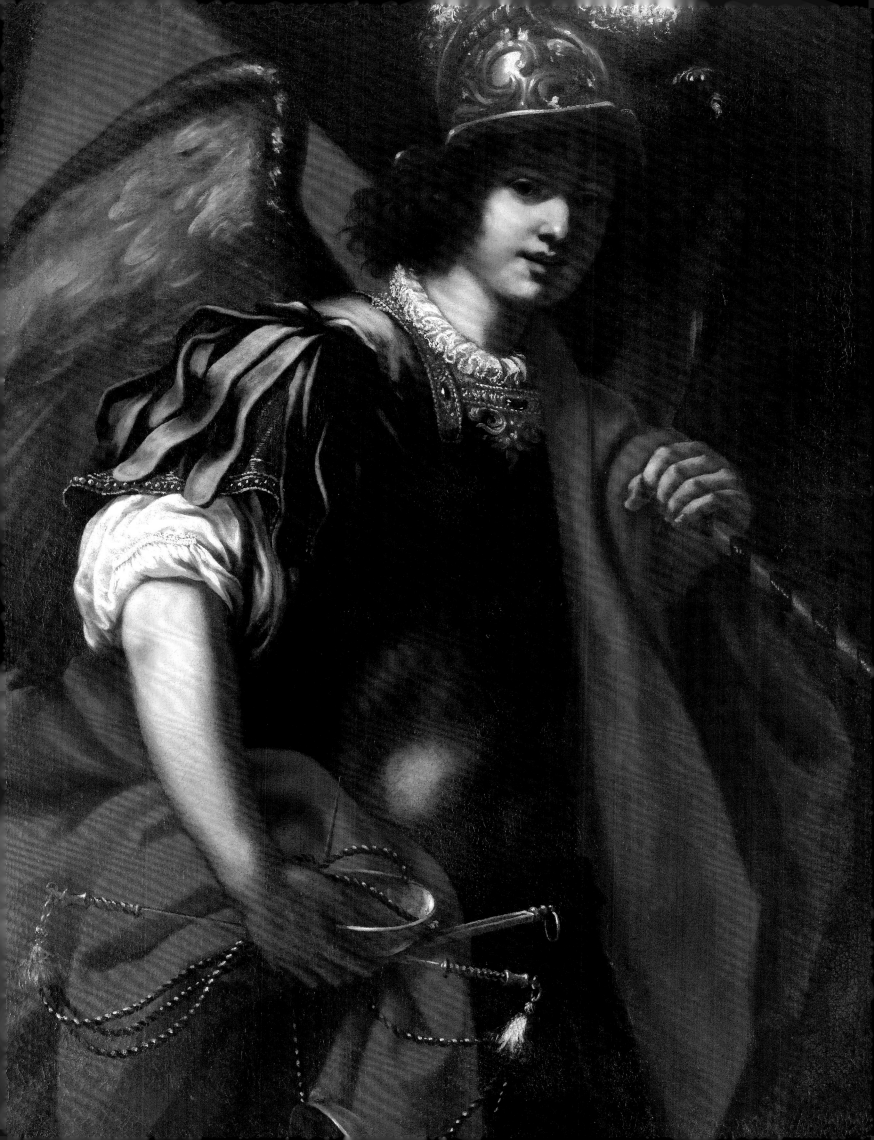

GIOVANNI BATTISTA SALVI, IL SASSOFERRATO

(Sassoferrato 1609 - Rome 1685)

Madonna at Prayer

oil on canvas
74.6 x 60.9 cm (29⅜ x 24 in)

Provenance: Private Collection, Sweden;
with Derek Johns Ltd., London.

OTHER THAN A FEW PUBLIC COMMISSIONS GIOvanni Battista Salvi, il Sassoferrato, painted mainly small devotional pictures for private clients and the Madonna at prayer was one of his most popular subjects. Like the Florentine artist Carlo Dolci (1616-1686), Salvi seems to have concentrated on producing multiple versions of this devotional image to meet an ever increasing demand fuelled by the fervent Marian cult of the counterreformation. The 'Madonna at Prayer' was produced in various formats by Salvi: half-length, as seen in the present example; with the Madonna's eyes raised in prayer (e.g. Fondazione Sgarbi-Cavallini, Ferrara); a cropped image focusing on the Madonna's head (National Museum of Fine Arts, Stockholm); and, demonstrating the influence of Albrecht Dürer (1471-1528) on his work, (*Virgin and Child with Half a Pear,* Kunsthistorisches Museum, Vienna) with the Madonna wearing a northern headdress (e.g. Galleria Nazionale dell'Umbria, Perugia,). The influence of Guido Reni (1575-1642), for example in the composition, delicate colouring and emotional subtlety of Salvi's work, is evident from Reni's *Madonna of the Annunciation* (fig. 1). All Salvi's known images of the Madonna are now thought to have been catalogued and reveal a consistently high quality in execution.

Salvi was known by the name of his birth town, Sassoferrato, in the Marche area of central Italy. He was primarily active in nearby Urbino and other central Italian cities and was first apprenticed under his father, the painter Tarquinio Salvi. Later whilst in Naples, though the dates are undocumented, he spent a good while as the pupil of the Bolognese artist Domenico Zampieri (1581-1642), known as Domenichino, who had previously worked as the main apprentice of Annibale Carraci (1560-1609). Salvi was also greatly influenced by two other pupils of Carracci, Francesco Albani (1578-1660) and Reni.

The precise draughtsmanship and choice of colouring alongside the sweet and *quattrocentesque* style of Salvi's devotional work, unlike his more progressive Baroque contemporaries, led many eighteenth and nineteenth century historians to believe Salvi was a contemporary of Raphael (1483-1520) and his tutor Perugino (*c.*1445-1523). In 1641, Salvi was working in Rome having received the commission to fresco the sacristy of San Francesco di Paolo, and in 1643 he was commissioned to paint a canvas for the Chapel of Santa Caterina in Santa Sabina to replace a lost work of Raphael. Salvi's resulting work, the *Madonna of the Rosary,* still *in situ,* is perhaps his best known and most celebrated work and demonstrates his painstaking craftsmanship and skilful use of brilliant colour. He produced few other altarpieces or large compositions, preferring to work on a smaller scale, mostly on sacred subjects, although he did occasionally paint mythological scenes. Salvi's *Virgin Mary* now at the National Gallery, London, is one of his later works (fig. 2). From 1650 until his death little is known of Salvi's activity.

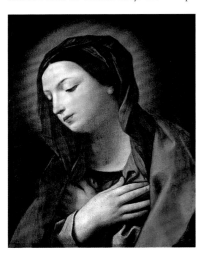

Guido Reni,
Madonna of the Annunciation
(date unknown),
Landesmuseum, Oldenburg
(Figure 1)

Sassoferrato,
Virgin Mary,
*c.*1640-50,
National Gallery, London
(Figure 2)

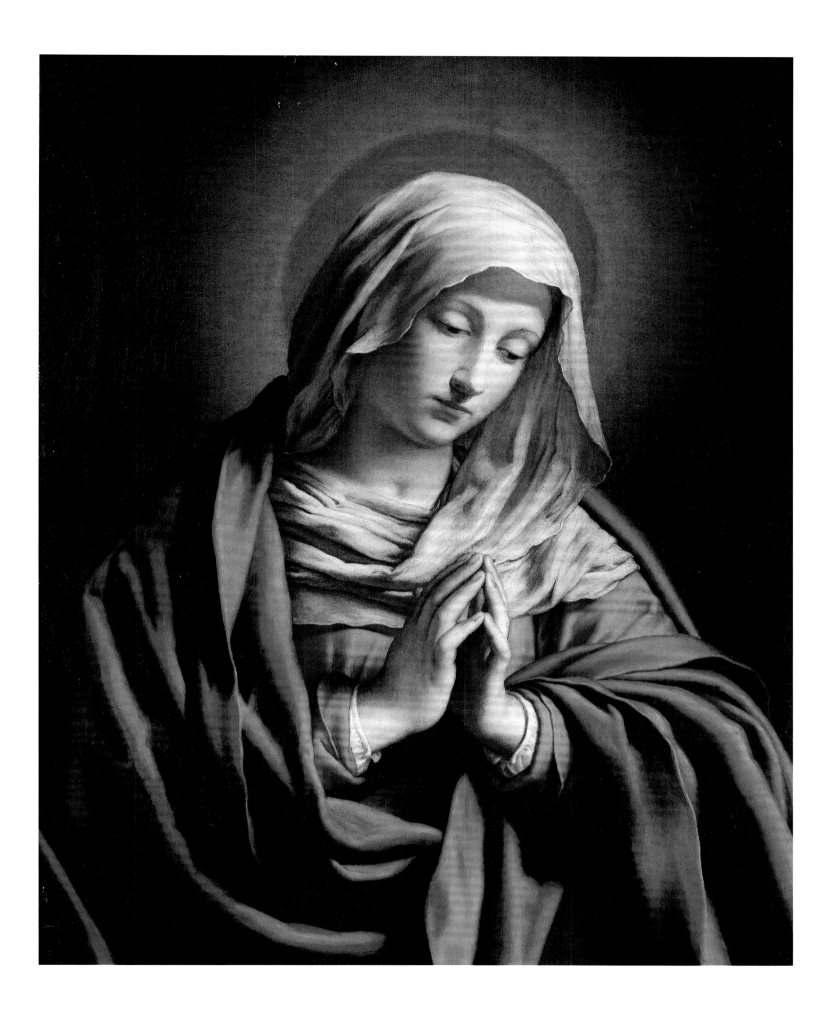

GIOVANNI ANDREA CARLONE

(Genoa 1639 - Genoa 1697)

The Sacrifice of Iphigenia

oil on canvas
115 x 166.5 cm (45¼ x 65½ in)

Provenance: Possibly in the collection of Don Miguel Martinez de Pinillos y Saenz de Velasco during the early nineteenth century,
but probably acquired by his son Don Antonio Martinez de Pinillos (1865-1923), Cadiz;
by direct descent to his daughter Doña Carmen Martinez de Pinillos, Cadiz;
thence by family descent to the previous owners.

IN A SCENE CHARGED WITH POWERFUL DRAMA, GIO-vanni Andrea Carlone captures in glorious detail the point at which Agamemnon had intended to sacrifice his daughter Iphigenia to the goddess Artemis. Iphigenia was the eldest born of Agamemnon and his wife Clytemnestra and her name translates literally as 'strong born'. Numerous myths abound in the classical tradition as to the exact reason for the goddess' wrath. The most commonly held version, however, and the one adopted by the fifth-century playwright Sophocles in his play *Electra*, suggests that Agamemnon provoked Artemis' fury after killing a sacred deer in her hallowed groves. In retaliation, Artemis sent down stormy winds to forestall Agamemnon's long-awaited siege of Troy. Each time he attempted to set sail, Agamemnon found himself unable to do so. In perplexity, he turned to the seer Calchas, pictured here on the far left and clad in white and proffering a bowl. The prophet divined that Agamemnon had offended the goddess of hunting and counselled that the only way to appease her was to sacrifice his own daughter, Iphigenia. At the eleventh hour, Artemis took pity on the

Giovanni Andrea Carlone, *The Fall of Phaethon*, Private Collection (Figure 2)

hapless Iphigenia. In Carlone's evocative *The Sacrifice of Iphigenia*, the goddess obscures the scene with cloud and snatches her from the sacrificial altar leaving in her place a deer.

A majestic Artemis - Diana in Roman nomenclature - is made instantly recognisable by the accoutrements of her favoured pastime: a quiver of arrows and a hunting spear which are set at her left hand side. In her right hand she wields a deadly golden bow though this time it is used to transform the original human sacrifice into an animal one. The luminous sparks from her bow crackle with life and imbue the painting with movement. It seems only fitting that the goddess of hunting is flanked on her other side by what appears to be a young bear cub who peeps over the cloud she has conjured up to veil onlookers in confusion. Artemis' association with bears is recorded in a number of ancient sources, though here its presence could also refer to the myth of the unfortunate nymph Callisto who was turned into a bear by Hera. In order to please the Queen of the gods some have suggested that Artemis shot the

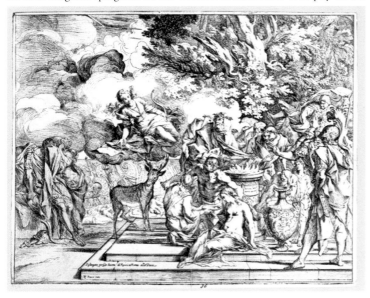

Pietro Testa, *The Sacrifice of Iphigenia, c.*1640-1642 (Figure 1)

Giovanni Andrea Carlone, *The Sacrifice of Iphigenia* (Detail)

metamorphosed Callisto who in her former life was also one of her followers. In the Greco-Roman pantheon, Artemis' other spheres of influence included the moon revealed by the crescent adorning the gold band that crowns her forehead.

In its composition, the scene is dominated by Artemis and Iphigenia's father, Agamemnon, King of Argos. Cloaked in dazzling vermillion and richly wrought greaves, the king looks fearfully up at a stern Artemis. Carlone's masterful use of perspective ensures that the confusion engendered in Agamemnon and his companions is palpable for his daughter is shielded from him by the mighty goddess. Nor can the stag yet be seen from behind the cloud the goddess has

Giovanni Andrea Carlone, *The Sacrifice of Iphigenia* (Detail)

created. In the bottom left hand corner of the group's arrangement, completing the diagonal line of Agamemnon and Artemis, a muscular figure caught in full motion reaches up to the departing figure of Iphigenia. Grasping a lethal knife, it seems likely that the grisly task of executing Iphigenia would have fallen to him. The composition is beautifully balanced with the group of three figures, including Calchas, gazing in bewilderment at the altar. In the bottom right quadrant, a mother and child, and a handsomely dressed soldier avert their eyes in anticipation of Iphigenia's gruesome death. A bizarre image to the left of the mother's outstretched hand shows a man clinging to a fantastical figure.

The myth of Iphigenia fascinated artists and writers alike from Sophocles, Euripides and Aeschylus to Goethe and Racine. In the realm of art, the etching with drypoint of Pietro Testa (1611-1650), see fig. 1, seems to have been influenced by Gianbattista Tiepolo's (1696-1770) rendition of *The Sacrifice of Iphigenia* at Villa Valmarana in Vicenza.

This work as a whole is a superb example of the high Baroque style which Carlone adopted in a number of his other pieces, *The Fall of Phaethon*, being another prime example (fig. 2). His exquisite use of *chiaroscuro* to model his groups of figures, notable in both works, and in particular in the figure of the executioner, owe much to the painterly style of Carlo Maratti (1625-1713), under whom he studied whilst in Rome. An aesthetic integral to the Baroque style shines out of Carlone's version of Agamemnon's sacrifice. The supremacy of emotional expression to artists of this period is reflected in Carlone's decision to render the scene at the exact moment when Artemis is spiriting Iphigenia away, or as Phaethon falls from the sky. Carlone's works simmer with energy and bear all the hallmarks of a Baroque artist's attempts to transport their viewers to a higher emotional plane. From the late sixteenth century onwards, arousing the viewer's passions through concentrated detailing of their subjects' expressions, facial or gesticulative, became hugely important for the artist. The expressive resonances that Carlone creates in *The Sacrifice of Iphigenia* largely through use of his figures' hands, are astonishing. Iphigenia's helpless plight is underlined by her despairing hand gesture while Artemis' disdainful authority is embodied in her resolutely held bow. In pity, the plumed soldier seated to Agamemnon's left puts his hand over his heart, and in frustration, as his victim escapes, the executioner reaches up to the departing figure of Iphigenia.

Giovanni Andrea Carlone, *Aurora*, c.1678,
The National Gallery of Slovenia, Ljubljana, (Figure 3)

a clear signal of his importance in Roman artistic circles, Carlone became a member of the Accademia di San Luca. Towards the end of his life, the artist worked with his brother, Niccolò, in their native Genoa, frescoing two rooms in the Palazzo Rosso with an *Allegory of the Arts and the Age of Mankind* (1691-1692).

Carlone's nomadic lifestyle permeated his output. His paintings from Perugia and Foglino have much in common with the Umbrian artists. In contrast, his Roman works underline the profound influence of Maratti on his artistic development. The Genoese frescoes that he completed with Niccolò hark back to the style of his father and his famous contemporary Pietro da Cortona (1596-1669). Yet he unites this with the High Baroque art of Gaulli and Maratti. By the close of the century, the artists of the Casa Piola had absorbed this high Baroque style, certainly in part due to Carlone's work.

A word on provenance: Carlone's *The Sacrifice of Iphigenia*, once formed part of the collection of the Martinez Pinillos family, who resided in Cadiz until the end of the nineteenth century. The family, of aristocratic lineage, descend from the Counts of Villanova. They moved to Cadiz in 1835, where they founded the navigation company Pinillos. The original founder of the company was Don Miguel Martinez de Pinillos y Saenz de Velasco, who was an avid collector and philanthropist. Under the direction of his son Don Antonio, the family business prospered further, and as a result of the contacts made through the various trade routes, their collection of art also grew. In particular, given the strong connections with the ports of Naples and Genoa, the collection featured the names of the most important and influential artists from these cities, *The Sacrifice of Iphigenia*, by the Genoese Carlone, being one such fine example.

We are grateful to Dr. Mary Newcome Schleier for proposing the attribution to Giovanni Andrea Carlone following first hand inspection of the painting.

Giovanni Andrea Carlone, *The Sacrifice of Iphigenia* (Detail)

One work of Carlone that has much in common with *The Sacrifice of Iphigenia* is his evocation of the goddess of the Dawn, (fig. 3). One of his more mature works, it is based on Guido Reni's (1575-1642) *Aurora* which is housed in the Casino Rospiglioso, Palazzo Pallavicini in Rome and forms part of a ceiling decoration. The little *putto* accompanying a radiant Aurora strongly resembles the young infant nestling in his mother's lap in the bottom right-hand corner of the present painting. The brooding backdrop to both subjects is also a distinctive trait of Carlone's *oeuvre*, though the attractively realistic luminosity of Aurora's female form would seem slightly incongruous in his more ambitious *The Sacrifice of Iphigenia*.

In terms of the depiction of his human figures, Carlone rarely positions them to face the viewer directly. Both Aurora and the goddess Artemis avoid the viewer's gaze by turning sideways, lending a dramatic intensity to the pictorial narrative. The realistic folds of drapery in both paintings emphasise Carlone's skill at combining a more naturalistic feel - displayed also in his rendition of the flowers held by Aurora - with the majesty of Italian Baroque painting.

Carlone learnt much from his father, Giovanni Battista Carlone (1603-1684) who was also a distinguished painter. Subsequently, however, his extensive travels throughout Italy, first to Rome, left a great mark on his painting style. In Rome, he made contact with Giovanni Battista Gaulli (1639-1709) who is credited with influencing his early ornamental style. In the 1660s, Carlone worked in Perugia, painting the frescoes in the church of S. Filippo Neri, and with Gaulli, he worked on frescoes in Il Gesù in Rome, painting a fresco of the life of St. Francis. The following decade saw him travelling to key art centres of many Italian territories: Naples, Messina and Palermo and from there to Venice, Padua, Ferrara, Bologna, Modena, Parma and Piacenza. In 1675, in

VENETIAN SCHOOL, EIGHTEENTH CENTURY

Study of a Turkish Archer, Bust-Length

monogrammed and dated 'f.l. 76' (upper right)
oil on panel
22.3 x 17.3 cm (8¾ x 6⅞ in)

ADELICATE FEATHER PINNED ATOP A TURBAN AND the faint outline of a bow identifies this striking figure as a Turkish archer. His dark eyes are cast aside as he gazes intently at something outside the picture plane. Evidently a sketch, the artist had primarily focused on the expression, and rendering, of the facial features and headwear. With delicate, light brushstrokes the wispy beard, moustache and ruddy colouring of the archer are picked out using a limited palette of brown, red and cream. Light gently falls on the wrapped turban, catching the shiny surface of the cabochon jewel and feather, as well as the surrounding material, suggesting it is made of silk. Less attention has been given to the simple tunic the archer wears, which subtly blends in with the muted brown background.

As with previous centuries, painting production in eighteenth-century Venice was often focused around family-run workshops. The most important were those of Sebastiano Ricci (1659-1734) and his nephew Marco (1676-1730), Giambattista Tiepolo (1696-1770) (see catalogue no. 113) and his sons Giandomenico (1696-1770) and Lorenzo (1736-1776), Canaletto (1697-1768) and his nephew Bernardo Bellotto (1721-1780), and Domenico Guardi (1678-1716) with his sons Giantonio (1699-1760) (see catalogue no. 26) and Francesco (1712-1793) (see catalogue no. 27).

Although *Study of a Turkish Archer* is attributed to an anonymous eighteenth-century Venetian artist, it displays strong stylistic similarities in terms of light brushwork and execution to the work of Giantonio Guardi. Guardi was familiar with Turkish subject matter as among his important

Venetian School, Eighteenth Century, *Study of a Turkish Archer, Bust Length* (Detail)

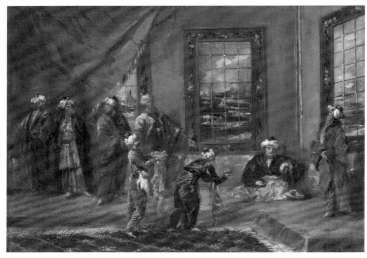

Giantonio Guardi, *The Sultan Receives a Delegation*, 1742-1743, Private Collection (Figure 1)

As a vital trading point between East and West, Venice had long-standing associations with the Byzantine and, later, Ottoman Empires, both politically and commercially, and Venetian artists were fascinated by the exoticism of their near eastern neighbours. Artists such as Gentile Bellini (*c.*1429-1507) worked in the Ottoman court for the Sultan, firmly establishing the artistic connection between Turkish culture and the Venetian school of painting. 'Orientalism' in Venice was based on direct contact with the Islamic world, which brought new technological, artistic, and intellectual information to the Republic.

patrons was the German aristocrat and collector Johann Matthias von der Schulenburg (1661-1747) who retired in Venice having fought with the Imperial and Venetian armies against the Turks. It is possible that the cultural legacy of this military service led him to commission Guardi to create a series of Turkish-inspired interiors as easel pictures for private decoration (fig. 1).[1]

[1] A long series of small scenes of *Turkish Life*, commissioned by von der Schulenburg are said to have been forty-three in number, according to Guardi's inventory of 1741, although only twenty-one are now known.

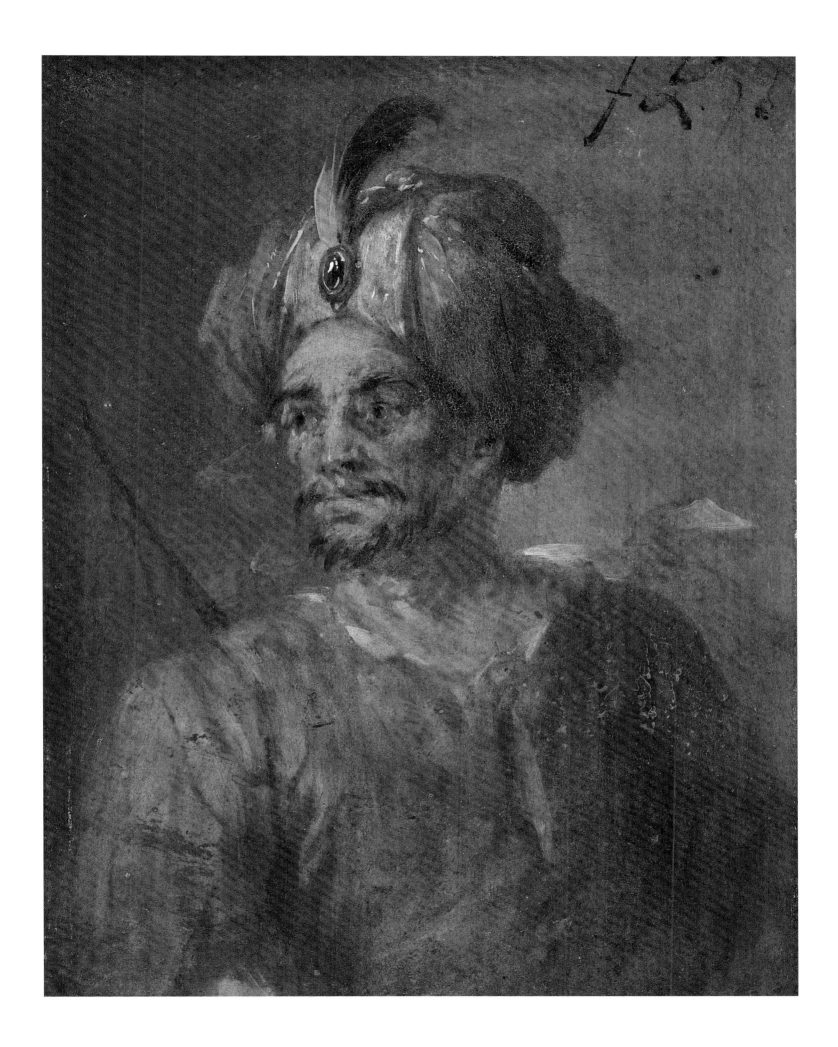

GIANANTONIO GUARDI

(Vienna 1699 - Venice 1760)

The Flight into Egypt

oil on canvas
75 x 60.5 cm (29½ x 23¾ in)

THIS MASTERLY CANVAS, RECENTLY ATTRIBUTED to Gianantonio Guardi by Dr. Mitchell Merling, depicts Mary and the infant Jesus on a donkey, accompanied by Joseph, as they escape at night to Egypt from the child's birthplace, Bethlehem in Judea.

Dusk is approaching. The Holy Family in the foreground make their way towards the viewer in the last of the evening light, leaving behind them the humble dwellings of Bethlehem. The youthful Mary, seated side-saddle on a donkey and clad in a blue cloak, gazes down upon the pink-fleshed infant cradled in her arms, a faint golden glow encircling their heads. The elderly Joseph, wearing an expression of consternation, also regards the child as he makes his way by foot beside them, carrying the family's belongings on his staff. In spite of her trying circumstances, the Virgin is graceful and composed in her bearing. The last of the sun's rays glance off the trunk of a slim, lofty tree behind Mary, and flicker

Gianantonio Guardi, *The Flight into Egypt* (Detail)

gold in the delicately described foliage. The glinting golds of the tree are complemented by the rich golden hues of Joseph's thick cloak. In the sky, a creamy, radiant cloud, painted with thick highlights, stands out against the burgeoning darkness. Turbulent brush strokes in the clouded sky, worked quickly onto the rough canvas, suggest an impending storm, creating an atmosphere of foreboding - appropriate for the dark events to come. Bowing its head, the donkey picks its way along the bumpy track, bearing a lantern to guide the family through the night.

The events preceding the flight to Egypt are recounted in the gospels. After Jesus' birth, the Magi, or three Wise Men, came from the East to Jerusalem, asking: 'Where is the one who has been born king of the Jews? We saw his star in the East and have come to worship him.'[1] King Herod of Judea was troubled when he heard this, and gathered all the chief priests together to ask them where it was foretold that the Messiah would be born. On discovering that Jesus was to be born in Bethlehem, he called the Magi to him, telling them to find the child in Bethlehem and then to report to him, so that he might also go and worship the child. The Magi were overjoyed to see that the star that they had followed from the East stopped above the place where the child was: 'On coming to the house, they saw the child with his mother Mary, and they bowed down and worshipped him. Then they opened their treasures and presented him with gifts of gold and of frankincense and of myrrh.'[2] After being warned in a dream, the Magi did not return to Herod, but returned to their country by another route.

The story of the flight into Egypt is told in the gospel of Matthew. After the departure of the Magi, Joseph was also warned about the evil

[1] Matthew 2, verses 1-2.
[2] Matthew 2, verse 11.
[3] Matthew 2, verses 13-15.

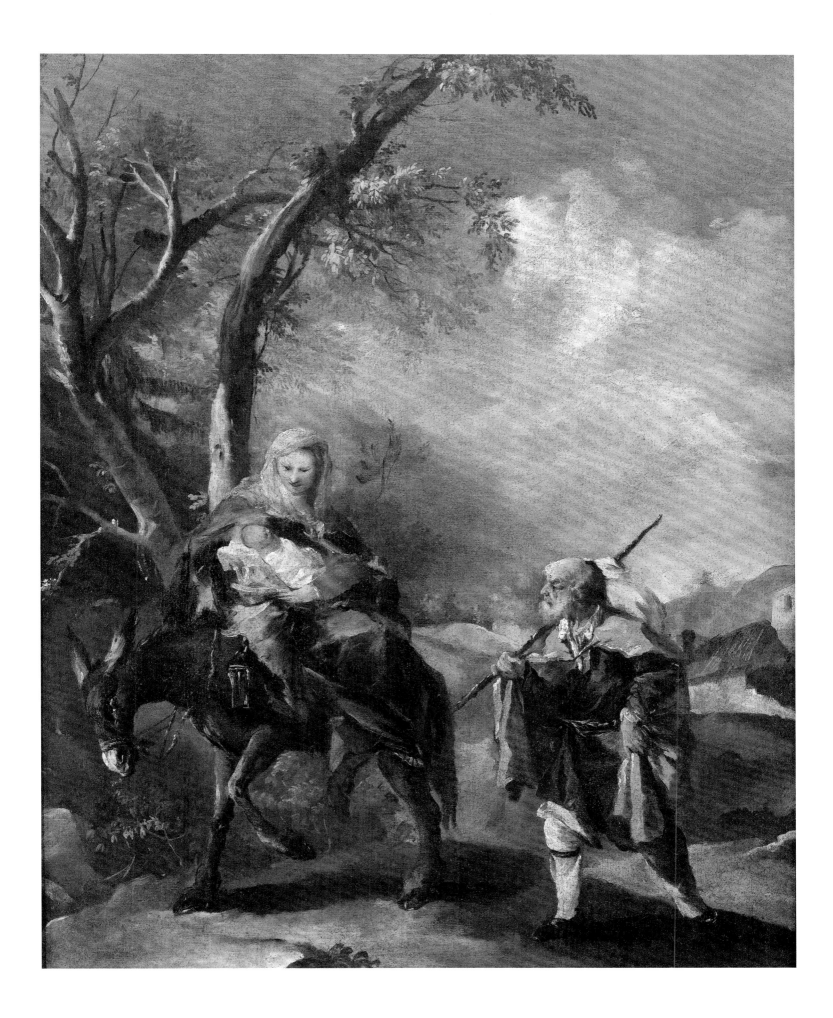

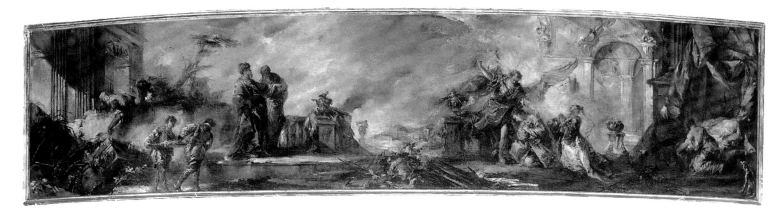

Gianantonio Guardi, *The Marriage of Tobias, c.*1750, from the Organ Parapet, Church of the Angelo Raffaele, Venice (Figure 1)

intentions of King Herod: 'An angel of the lord appeared to Joseph in a dream, "Get up", he said, "take the child and his mother and escape to Egypt. Stay there until I tell you, for Herod is going to search for the child to kill him." So he got up, took the child and his mother during the night and left for Egypt, where he stayed until the death of Herod.'[3] In this way the child was spared his life: Herod, on realising that he had been deceived by the Magi, was furious, and ordered all male children of two years and younger to be killed in the vicinity of Bethlehem. It was only following Herod's death that Joseph and his family were instructed by the angel to return to Israel, where they settled in Nazareth.[4]

Guardi, historically eclipsed by his more famous brother Francesco (1712-1793), has been in the latter part of the twentieth century re-established as a master of the Rococo in his own right. With its rich colour harmonies and swift, animated brushwork, *The Flight into Egypt* is a prime example of Guardi's painterly virtuosity. Figures and landscape unite in complementary harmonies of blues, yellow ochres and earth hues, against which the vivid red of the Virgin's sleeve prominently stands out.

The faces and drapery around the Virgin and Child are conjured with quick and summary brushstrokes. Like his brother-in-law Giambattista

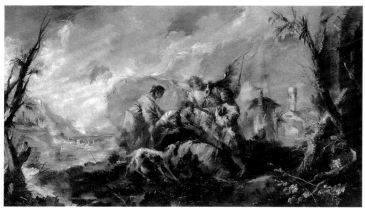

Giantonio Guardi, *The Healing of Tobias' Father, c.*1750, from the Organ Parapet, Church of the Angelo Raffaele, Venice (Figure 2)

Tiepolo (1696-1770), Guardi believed that finished paintings should not have an over-studied appearance, belying the preparation that lay behind them.[5] *The Flight into Egypt*, with its poetic evocation of landscape and its supreme painterly qualities, is an important example of Guardi's mature Rococo style. Moreover, its brilliant colour harmonies evoke the traditional primacy of *colore* in Venetian painting.

While the holy familys present a picture of ordinary humanity, heightened by the prosaic qualities of the donkey, rough path and the modest dwellings of Bethlehem, the more flamboyant treatment of Mary and Joseph lends them a simultaneous air of nobility. The high status of St. Joseph, cast in the Counter-Reformation as the father of the Terrestrial Trinity, is illustrated by *The Death of Joseph*, one of the two only known signed paintings by Guardi.

The Guardi family originated in the province of the Trentino, and belonged to the Imperial nobility, having been given a patent by Emperor Ferdinand III in 1643. Members of the Guardi family held ecclesiastical and military positions in the region, and patronised their painter relations.[6]

Guardi is presumed to have become the head of the studio of his father, Domenico Guardi (1678-1716), in Venice, at the age of seventeen. However, it is thought that he did not train with his father, a painter of the late Baroque. Shortly after his father's death, the artist is documented in Vienna in 1719, his subject matter and style showing Austrian influences at this time.[7] (His sister Cecilia married Tiepolo in the same year.)

From the age of thirty-one, Guardi had established a workshop which produced copies of sixteenth and seventeenth century Venetian masters, including Titian (1485/9-1576), Tintoretto (1518-1594), and Sebastiano Ricci (1659-1734), for the Field Marshal of the Venetian armies, the

[4] Matthew 2, verses 19-23.

[5] see Mitchell Merling, *The Brothers Guardi,* chapter X of *The Glory of Venice Art in the Eighteenth Century,* Exhibition Catalogue, Royal Academy of Arts, London, 15 September to 14 December 1994, and National Gallery of Art, Washington, 29 January to 23 April 1995, p. 300.

[6] Merling, ibid., p. 452.

[7] Merling, op. cit., p. 452.

German Graf Johann Matthias von der Schulenburg, as well as copies of portraits of the ruling families of Europe. The Marshal's patronage lasted until his death, in 1747. Guardi maintained close ties with Trentino however, executing important works there, such as the three lunettes, *The Sacrilegious Communion, The Washing of the Disciples' Feet* and *The Vision of St. Francis* as well as a small altarpiece, the *Virgin and Child with Four Saints,* all commissioned by his uncle, the priest Pietro Antonio Guardi, for the family parish church of Vigo d'Anaunia in 1738 (all *in situ*). The workshop employed many assistants within the family, including Guardi's brother Francesco, as well as another brother, Nicolò (1715-1786), whose individual work has not been identified.[8]

As a result of this studio collaboration, there has been much dispute about the authorship of many works which have been connected to the Guardi studio. While in the past Guardi scholars were inclined to attribute the best of the Guardi works to Francesco, the reputation of Gianantonio has been re-instated in the latter half of the twentieth century, through documentary evidence linking him to important works. Gianantonio is most renowned for his remarkable series of paintings of *c.*1750 decorating the Organ Parapet, Church of the Angelo Raffaele, Venice, some of the most original works of that date (figs. 1 and 2).[9] With their flickering qualities of the brush and boldness in composition, the frescos rank as one of the greatest works of the Venetian Rococo, anticipating the manner of Francesco's style a long while after Gianantonio's death.

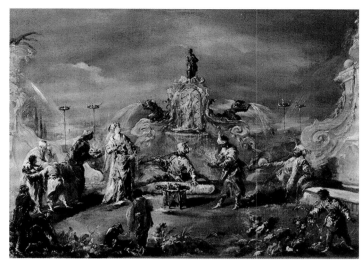

As well as the paintings executed for the church at Vigo d'Anaunia, other altarpieces which remain in the churches for which they were executed are now attributed to Gianantonio, as head of the studio (on the basis of records and scholarly opinion.) These include Guardi's most important and innovative altarpiece, the *Madonna of the Rosary (The Pala di Belvedere)* of *c.*1746, executed for the Belvedere parish church (fig. 3). Further documentation links Guardi to an altarpiece at Cerete Basso (1754), in the Bergamasque Alps (*in situ*) and to *The Vision of St. Giovanni di Matha* (1750), which remains in the parish church of Pasiano di Pordenone, near Udine. Since many of Guardi's works painted for the provincial aristocratic patrons inherited from his father remained in out of the way locations, the artist was consequently forgotten by official histories of Venetian art, in spite of the fact that he was made a founder member of the Venetian Academy.[10] This explains in part the reasons for the artist's neglected reputation in the two centuries following his death.

The Marshal's most significant commission to the Guardi is the series of forty-three small paintings based on engravings after Jean-Baptiste van Mour's (1671-1737) scenes of *Turkish Life,* probably to decorate one of his rooms *A La Turque.*[11] Four masterly scenes from the series by Guardi were discovered in the early 1970s. Supreme painterly examples such as *The Garden of the Serraglio* of *c.*1740-1745 (Thyssen-Bornemisza Collection, Madrid) however, are not copies after van Mour,[12] but is rather of Guardi's own invention, showing him to be in the words of the scholar Morassi: 'one of the most important innovators of the Venetian Settecento'[13] (fig. 4).

Gianantonio Guardi, *The Angel Appears to Tobias, c.*1750, from the Organ Parapet, Church of the Angelo Raffaele, Venice (Figure 3)

[8] Merling, ibid.

[9] See Merling, ibid, p. 293.

[10] See Merling, op cit, p. 294.

[11] Merling, op cit, p. 297.

[12] Merling, ibid.

[13] A. Morassi: 'Four Newly Discovered Turkish Scenes by Antonio Guardi', *Apollo,* xcix (April 1974), pp. 274-8.

GIACOMO GUARDI
AND FRANCESCO GUARDI

(Venice 1764 - Venice 1835)
(Venice 1712 - Venice 1793)

A View of the Venetian Lagoon with the Island of San Giacomo di Paludo

inscribed on the reverse in an old hand, possibly the artist's own: 'di S. Jacopo di Paludo di Venez[ia]'
oil on panel
17.3 x 25 cm (6¾ x 9⅞ in)

Provenance: Sir Thomas Fermor-Hesketh, 1st Baron Hesketh (1881-1944), Rufford Hall, Ormskirk, Lancashire in August 1917;
Thence by family descent to the previous owner.

Literature: Anon. compiler, Specification of Pictures and Furniture belonging to T. Fermor-Hesketh Esq., at Rufford Hall, Ormskirk, Lancashire, August 1st 1917, 'Two ditto by Guardi (very small) £200'.

THIS BEAUTIFULLY SERENE DEPICTION OF THE Island of San Giacomo in Paludo is, according to Professor Dario Succi, principally the work of Giacomo Guardi with the hand of Giacomo's father, Francesco Guardi, discernable in parts of the staffage. The painting is executed in the style of Francesco and demonstrates the great influence Giacomo took from his father. The flat glossiness of the lagoon, the sketchiness of the buildings, the spirited brush strokes and the impressionistic feel of the paintwork resemble Francesco's work. His characteristic style, known as *pittura di tocco*, was loose and informal, consisting of small dotting and quick strokes of the brush. This style, adopted by Giacomo, differed vastly from the linear, architecturally accurate approach of artists such as Canaletto (1697-1768), and gives the viewer a unique impression of life on the Venetian waterways.

The dominant feature of the painting is the church and convent of San Giacomo di Paludo, both of which were demolished in 1810. The church's steeple surmounted by a cross stands boldly delineated against the warmth of the sky, whilst gondolas pass by on the murky waters, one about to dock by a wooden jetty that leads to the entrance of the church. The view is based upon Antonio Visentini's (1688-1782) engraving of the same site, one of twenty islands featured in the *Isolario Veneto*.[1]

The island takes its name from the church that once stood there, and is today known as San Giacomo in Paludo, and is located in the Venetian lagoon, between the islands of Murano and Madonna del Monte (fig.1). The island's name translates to 'St. James in the Marsh', an appropriate name considering the church's watery foundations. In 1046, the island was

Photograph of San Giacomo in Paludo (Figure 1)

given to Giovanni Trono of Mazzorbo for the purpose of building a monastery dedicated to San Giacomo Maggiore, which was to serve as a stopping point for pilgrims. In 1238, the convent was passed on to Cistercian nuns who inhabited it until 1440, after which they moved to the Santa Margherita Abbey in Torcello. In 1546, the church complex was temporarily converted into a

[1] A second edition was published in 1777 by Teodoro Vero.

(Actual Size)

Giacomo Guardi, *View of the Piazza San Marco, Venice,*
The Courtauld Gallery, London (Figure 2)

hospice, after which it was inherited by a Franciscan order. Despite its regular use and maintenance, the banks of the island increasingly eroded causing the buildings to decay. During the Napoleonic occupation of Venice, religious orders were suppressed, and the monastery, like many others, was demolished. From that point it was used as a military outpost, after which time the island became a munitions depot and in the nineteenth century, the Austrians, and then Italians, built a rampart on the site from which they controlled the navigation in the north Laguna. Today it lies in partial ruin.

Giacomo was primarily a painter in gouache, only occasionally venturing into oil painting. *View of the Piazza San Marco, Venice* in The Courtauld Gallery, see fig. 2, is an example of his work in gouache, whereas *View of the Isola di San Michele in Venice* in the Rijksmuseum, see fig. 3, like the present work, is a rare example of a composition in oil. The size of the panel in the Rijksmuseum is 14 x 21.5 cm, slightly smaller than the present painting, and both are typical of Giacomo's minute jewel-like works.

What is evident in *A View of the Venetian Lagoon with the Island of San Giacomo di Paludo*, is how Giacomo appears to approach oil painting in a similar manner to painting with gouache or bodycolour, applying the pigment in as few layers as possible, which when translated into oils, endows the composition with a loose and fluid finish.

Elements of both the present painting and *View of the Isola di San Michele in Venice* display characteristics associated with watercolour. The

Giacomo Guardi, *View of the Isola di San Michele in Venice,*
Rijksmuseum, Amsterdam (Figure 3)

uniformity of colour and tone in both paintings gives the impression that they were created with a wash. Areas of the composition are blurred and blended in a manner reminiscent of wet on wet watercolour painting, while other details, such as the sky, are more delineated and formed using a drier brush. Giacomo also employs methods such as scratching out, which is primarily associated with works on paper.

Giacomo's interest in the contrast between light and shadow is evident throughout his *oeuvre* and gives his compositions a strong sense of form, compensating lesser embellished works. Although the architectural details in his gouaches, see fig. 2, are bold and outlined in black ink, these details are mostly omitted in his oil paintings. Instead of appearing bland and

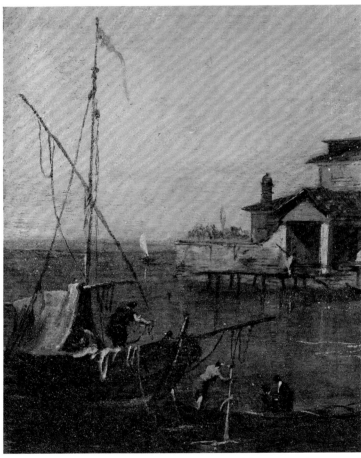

Giacomo Guardi and Francesco Guardi, *A View of the Venetian Lagoon with the Island of San Jacopo di Paludo* (Detail)

featureless on account of this economy of colour and line, however the architecture is dynamic and expressive, and the reflection of the buildings in the murky water is just hinted at in order to give the composition greater depth. In both the present painting and the Rijksmuseum example, the opacity of the lagoon, as well as the overcast sky, adds to the mystery and romanticism of the Venetian view.

The figures in Giacomo's oil compositions, made up of dashes and dots of paint, are striking in their simplicity and barely indicate details of clothing or hairstyle. This pared down approach allows the viewer to appreciate the entirety of the composition without focusing on the figures, as they are successfully integrated with the other elements of the painting instead of competing with them.

In *A View of the Venetian Lagoon with the Island of San Giacomo di Paludo*, the staffage, which is thought to have been painted by Francesco,

reveals the great range of expression and movement that can be conveyed with a bare minimum of delineation or variation in colour. The sparing use of white to heighten selected parts of the staffage, such as the oars of the gondoliers who gently navigate their gondolas and more utilitarian *traghetti* through the lagoon, is particularly effective. This method is replicated in Francesco's painting *View of the Island of San Giorgio Maggiore* in the Hermitage, which is a larger and more highly finished composition, depicting a busy scene on the lagoon and the grander and more elaborate building complex of San Giorgio Maggiore (fig. 4). Certain elements of the painting, however, particularly the way in which the vessels are depicted, and the posture and movements of the gondoliers are very similar to the present image, as is the presence of a fishing boat in the left of the panel, whose mast echoes the vertical line of the bell tower.

Giacomo Guardi, *A View of the Venetian Lagoon with the Island of San Jacopo di Paludo* (Detail)

Both Giacomo and Francesco's style contrasts greatly with that of other prominent Venetian artists, such as Canaletto, who was noted for his precisely depicted views of Venice, which were painted for the tourist market and found particular favour amongst English collectors. They often record lavish Venetian public ceremonies such as *Reception of the French Ambassador in Venice* in the Hermitage, see fig. 5, which is a riot of colour and splendour, in contrast to the more subdued style of the Guardi family. The meticulously painted gondolas in the foreground of Canaletto's painting, their oarsmen and the figures crowding around the Doge's palace, of which every architectural detail is indicated, differ greatly from the impressionistic style of the present painting. *A View of the Venetian Lagoon with the Island of San Giacomo di Paludo* depicts its subject matter with vagueness instead of painstaking precision, yet manages in a few hasty brush strokes to convey the essence of the scene.

Giacomo was born in Venice in 1764, and was the son of Francesco, and grandson of Domenico Guardi (1678-1716), who founded the family workshop of *veduta* painting in Venice. The golden age of *vedutismo*, the art of painting Italian views of cities, towns, and villages, began in the

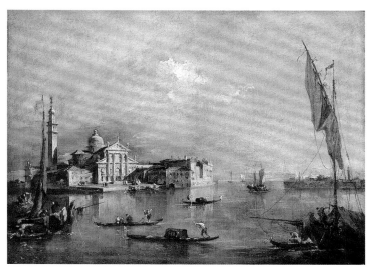

Francesco Guardi, *View of the Island of San Giorgio Maggiore*, The Hermitage, St. Petersburg, acquired from the State Museum of New Western Art, Moscow, 1927, formerly in the collection of Princes Yusupov (Figure 4)

eighteenth century and the paintings produced were especially popular with travellers on the Grand Tour.

The business was inherited by Francesco and his older brother, Giovanni Antonio (Gianantonio) Guardi (1699-1760) (see cat. no. 28), one of the founders of the Venetian Academy. Francesco, now recognised as the last of the great Venetian *vedutisti*, spent many years working alongside Gianantonio painting altarpieces, and only began specialising in Venetian views around 1760. Though Francesco's style was initially influenced by the other great Venetian *veduta* painter, Canaletto, he was also influenced by another Venetian painter, Luca Carlevaris (1663-1730), who may have been a teacher of Canaletto. Francesco's cityscapes evolved to embrace a more free-handed style which created atmospheric effect.

Giacomo studied with his father and from *c.*1780 onwards painted numerous views of his native city, which were considerably influenced both in subject and style by his father. His paintings capture the picturesque beauty and atmospheric drama of Venice in an imaginative and distinctive fashion. Collectively, the Guardi family are often said to be the last true painters of the Venetian School in its classical form.

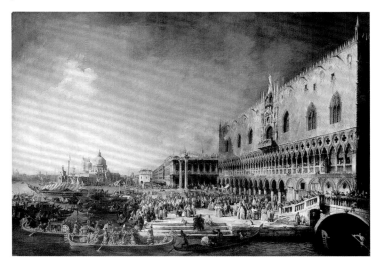

Canaletto, *Reception of the French Ambassador in Venice*, 1726/27, The Hermitage, St. Petersburg (Figure 5)

CIRCLE OF
GASPAR VAN WITTEL, CALLED VANVITELLI

(Amersfoort 1652 / 3 - Rome 1736)

A View of St. Peter's Basilica, Rome

oil on canvas
27 x 65 cm (10⅝ x 25⅝ in)

VIEW OF ST. PETER'S BASILICA, ROME, ATTRIBUTED to the circle of Gaspar van Wittel, called Vanvitelli, offers a stunning panorama of the distinctive piazza, as well as an excellent record of the dress and activities of early eighteenth-century visitors to the site. The attention to detail is extraordinary, revealing intricacies in the decoration of the church's façade and the gestures and movements of the men, women and children strolling through the grounds. A cross-section of Roman society is represented, from aristocrats to beggars, monks to street vendors, and in examining the painting, the viewer feels genuinely transported back in time.

The view and perspective is similar in style to several paintings of St. Peter's Basilica executed by Vanvitelli himself, one of which is illustrated in figure 1. Vanvitelli's *vedute* of Rome were innovative in that they accurately documented modern aspects of the city, unlike those of his many predecessors, who focused solely on the city's antique splendour or painted generic Italianate scenes.

Prior to Vanvitelli, artists such as Viviano Codazzi (*c.*1604-1670) and the German Johann Wilhelm Baur (1607-1642) were producing stylistically similar vistas of Rome. Codazzi, who was mainly active in Rome, was the foremost architectural painter of his generation. He depicted St. Peter's *c.*1630, which shows the site before Gianlorenzo Bernini's (1598-1680) colonnade was built, and offers an interesting comparative view to the present work (fig. 2). Baur instead specialised in miniature views of the city and developed the

Viviano Codazzi, *St. Peter's, Rome, c.*1630, Museo del Prado, Madrid (Figure 2)

veduta ideate, which combined observed details with the artist's imagination. The present work, however, appears to display a highly realistic view, precisely recording architectural features and the Roman populace.

Vanvitelli was a Dutch painter and draughtsman who trained in the workshop of Matthias Withoos (1627-1703) (see catalogue no. 63) in Amersfoort before venturing to Rome, where his presence was first recorded in 1675. Apart from visits to Lombardy and Naples, he spent the remainder of his life in Rome, devoting himself to topographical views of the city, showing it not only as the site of ancient ruins but also of modern creations such as St. Peter's Basilica. In the rare instances that he painted more conventional images of Roman ruins, he did so from different and novel viewpoints. His style was well-established by the 1690s, and his principles in composition and perspective remained constant throughout the rest of his career, with only the subject matter changing. He was careful to represent his architectural subjects accurately, from a point of view that corresponded with that of the spectator. In his studio, Vanvitelli often produced multiple versions of a single view based on drawings that he had executed on site.

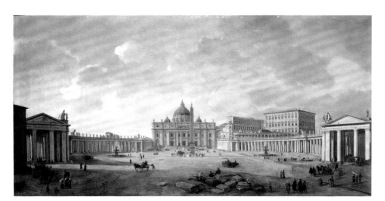

Gaspar van Wittel, called Vanvitelli, *View of Piazza San Pietro, Rome*, Private Collection (Figure 1)

NORTH ITALIAN SCHOOL, EARLY EIGHTEENTH CENTURY

A Capriccio of Roman Ruins with Monks;

&

A Capriccio of Roman Ruins with an Equestrian Statue

oil on canvas, a pair
123.8 x 162 cm (48¾ x 63¾ in) each

Literature: F. Arisi, *Gian Paolo Panini e i fasti della Roma del '700*, Rome, 1986, p. 221, nos. 7 - 8, illustrated, as early Panini; D. Marshall, 'The Architectural Picture in 1700: The Paintings of Alberto Carlieri (1672-*c*.1720), Pupil of Andrea Pozzo', *Artibus et Historiae*, 50, XXV, 2004, p.120, as 'Not Panini, near Carlieri'.

DURING THE EARLY PART OF THE EIGHTEENTH century the *capricci* emerged as a mature art form, the architectural fantasy serving as an ideal creative outlet for artists. This pair of paintings are indicative of the genre during that period. *A Capriccio of Roman Ruins with Monks* is a dramatic image of crumbling Doric architecture. Chipped columns rise up and out of the picture, dwarfing the figures below, and a huge archway frames the background. On the right-hand side there are two monks, one of whom is engrossed in a book whilst his companion reads the inscription of the monument under which they stand. On the right-hand side two exotically dressed figures are having an intense discussion. In the background an impoverished man, slumped asleep on the ground, is contrasted with a dashing horseman, who gallops out of sight. Our eye is led from figure to figure, as the painting recedes. They animate, and draw attention to, the architectural spaces which they occupy.

A Capriccio of Roman Ruins with an Equestrian Statue is in a similar setting of Roman ruins, although in this work the composition is much more spacious, with a sense of openness and a deeper internal recession. On the left-hand side is a dramatic equestrian statue, which shows a horse rearing up on its hind legs as two kneeling figures cower below. Once again, contrasting figures are scattered throughout the scene. A man in a red tunic drags a cart through the ruins and in this cart sits a legless man; the scruffy poverty of this unusual pair is contrasted with the young, elegant and well-dressed couple who stand in the shadows of the building.

Both scenes are imbued with a heavy sense of decaying antiquity. The architecture is worn and chipped by the passing of time and in *A Capriccio of Roman Ruins with an Equestrian Statue* the huge capital of a column lies forlornly on its side. In both paintings much of the neglected architecture is overgrown with creeping foliage and in the foreground of

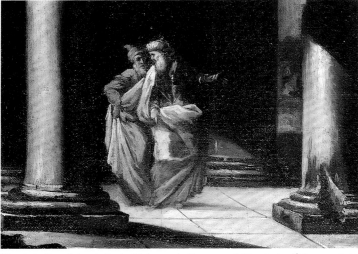

North Italian School, Early Eighteenth Century, *A Capriccio of Roman Ruins with Monks* (Detail)

North Italian School, Early Eighteenth Century, *A Capriccio of Roman Ruins with an Equestrian Statue* (Detail)

Giovanni Paolo Panini, *Capriccio of the Roman Forum*, 1741,
Yale University Art Gallery (Figure 1)

Alberto Carlieri *Capriccio with Classical Ruins and a Scene of the Healing of a
Blind Man*, The Municipal Galleries at Palazzo Ciacchi, Urbino (Figure 2)

A Capriccio of Roman Ruins with Monks, a gnarled tree grows amongst the ancient structures. This feeling is heightened by the classical dress of some of the figures detailed.

One of the most distinctive features of this pair is the dramatic use of *chiaroscuro*. Both paintings are lit by bright sunshine, which makes the contrasting shadow more intense. This is particularly notable in the case of *A Capriccio of Roman Ruins with Monks,* where, on the right-hand side, a thick beam of shadow slices through the bright scene. The painting anticipates the dramatic swathes of light and dark that were to characterise the *capricci* of Giovanni Battista Piranesi (1720-1778), who fully realised the genre as a vehicle for his creativity. The stark light effects give the paintings a sense of theatricality, which is heightened by some of the dynamic or unusual characters. The nature of these *capricci* allowed artists to indulge their artistic imaginations and produce these vibrant scenes.

Many artists produced numerous *capricci* which featured Roman ruins. A number of these paintings took the form of decorative compositions recording groups of the principal monuments seen on the Grand Tour in order to satisfy the demands of visitors, especially the *milordi Inglesi*. Giovanni Paolo Panini (1691-1765) was the leading practitioner of this. His *Capriccio of the Roman Forum* is typical of the way in which he painted recognisable buildings or archaeological monuments, rearranged in juxtapositions not designed to be topographically accurate (fig. 1). The basis of this work is a view of the Roman Forum seen from the west and various landmarks are visible, such as the ruins of the Arch of Titus and the Temples of Castor and Pollux, Saturn and the Divine Vespasian. Interspersed with these buildings are numerous figures and fragments of classical sculpture from various Roman collections. Whereas in this work many of the features are recognisable, in the present works are purely products of the imagination, nevertheless, the three paintings have significant parallels. Bathed in the same warm Italian sunshine these works have a similar sense of nostalgia for ancient times, focusing on the classical architecture, which is massive and imposing despite its crumbling state. Although playing a secondary role, details such as the figures or sculptures

demand attention from the viewer. They proliferate throughout the works and serve to animate these dramatic landscapes. The figures in Panini's work admire the ruins or are engaged in discussion, and are reminiscent of some of the figures in the illustrated pair, although none of Panini's figures are quite as dramatic as the speeding, swerving horseman, for instance.

Panini and other artists often painted works that were products of pure architectural fantasy, with no recognisable landmarks. The present works are examples of this, as is Alberto Carlieri's (1672-c.1720) *Capriccio with Classical Ruins and a Scene of the Healing of a Blind Man* (fig. 2). In Carlieri's work the central group of figures obviously recalls the story of Jesus healing the blind but the landscape in which they stand is certainly not the road to Jericho. Instead the setting is lush and green, it does not have the same dry and dusty atmosphere that features in the present works or in Panini's work. On the left-hand side is a similar, majestic, classical ruin of the kind that have characterised the previous paintings. The top of the Corinthian architecture is overgrown, making it reminiscent of *A Capriccio of Roman Ruins with Monks,* and the piles of rubble contribute further to the air of antiquity. Carlieri also uses strong contrasts of light and dark. Swathes of sunshine cut across shadow, so that the heads of the central figures are illuminated despite standing on shady grass. The effect is, however, not quite as striking or dramatic as it is in *A Capriccio of Roman Ruins with Monks* as Carlieri uses a softer light.

As shown by comparisons with the work of two of the leading exponents of the *capricci* genre in the early eighteenth century, Panini and Carlieri, the present unattributed pair are very much reflective of that style of painting. These paintings demonstrate a similar understanding of architectural language and an atmosphere of dilapidated yet majestic antiquity, which recurs throughout the work of artists such as Panini and Carlieri. The use of figures to animate the scene and the way their interaction with the setting enhances the architecture is also very much a feature of *capricci* of the Roman Forum. Equally, the more animated figures in the pair of paintings recall the drama of the healing of the blind man in Carlieri's work, drama which is enhanced by a similar use of contrasts of light for theatrical effect.

North Italian School, Early Eighteenth Century, *A Capriccio of Roman Ruins with Monks*

North Italian School, Early Eighteenth Century, *A Capriccio of Roman Ruins with an Equestrian Statue*

FRANCESCO SOLIMENA

(Canale di Serino 1657 - Barra, Napoli 1747)

St. Anne and the Virgin

oil on copper
35.2 x 31.7 cm (13⅞ x 12¼ in)

FRANCESCO SOLIMENA'S DEPICTION OF SAINTS ANNE and Joachim with the Virgin Mary expertly conveys familial affection and piety. The intimacy of the mother and child is evident as the father fondly looks on from a slight distance. According to the legend of the Virgin's parentage, Joachim and Anne were a devout couple who were barren and approaching old age. After years of prayer, they were rewarded for their faith by the miraculous conception of Mary, their only child. In return, Anne promised to offer her daughter in service to the Temple in Jerusalem. *St. Anne and the Virgin* may depict the moment when the Virgin, aged three, took leave of her parents to go to Jerusalem.

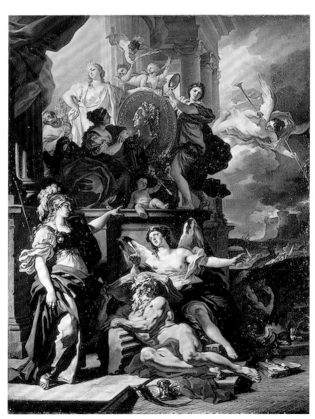

Francesco Solimena, *Allegory of Rule*,
The Hermitage, St. Petersburg (Figure 1)

St. Anne wears a subtle green dress with voluminous sleeves and an expansive blue mantle. She is the picture of modesty and the colours of her garments complement the gold of the cloth draped over her head, giving her an earthy, maternal charm. As she is usually clad in a red mantle, the choice of blue for St. Anne is unusual. Its pale hue however does not compete with the royal blue of her daughter's mantle, the colour traditionally associated with the Virgin Mary. Underneath her blue mantle, the young Mary wears a simple white dress, symbolising purity, and clearly classically inspired, as is her hairstyle. She clasps her hands and raises them upwards as she looks into her mother's eyes. Behind the pair, St. Joachim philosophically rests his head on his fist, holding a scroll in the other hand.

St Anne and the Virgin has been examined by Professor Nicola Spinosa, who has proposed that it is an example of Solimena's early work. The artist's attention is focused on the clarity of design and expression, derived from artists such as Annibale Carracci, Domenichino and Raphael. Great importance is placed on the gestures of the figures and sharpness of line. The harmony and tranquillity of the composition is in contrast to Solimena's later work, which is marked by dramatic *chiaroscuro* and complexity. Both styles, however, are rooted in classicism.

Solimena's painting *Allegory of Rule* (fig. 1), part of the Stroganoff Collection in the Hermitage, is typical of his mature style, invoking the full theatricality of the Baroque style, with liberal employment of light and shade, action and expression. *Allegory of Rule* featured in the Hermitage's exhibition *The Stroganoffs: Art Patrons and Collectors* (2003-04), accompanied by other paintings of outstanding quality. One of the exhibition's themes focused on the Stroganoff family's enduring love of classical antiquity, and one can image that Solimena's work would have been particularly appealing because of its classical derivation.

Born in Canale di Serino and taught by his father in the naturalist tradition, Solimena was a prolific artist, who created frescoes, mythological scenes, portraits and religious paintings. He moved to Naples in 1674 where he studied the masterpieces of high Baroque art. After building his reputation with a number of religious and secular commissions, Solimena became the dominant figure in the Neopolitan school of painting in the first half of the eighteenth century. Although he spent the majority of his life in Naples, he became a highly influential artist throughout Europe. Solimena acquired great wealth, established his own academy, and was in constant demand by royal patrons, including Charles III of Spain, Prince Eugene of Savoy and Louis XIV of France.

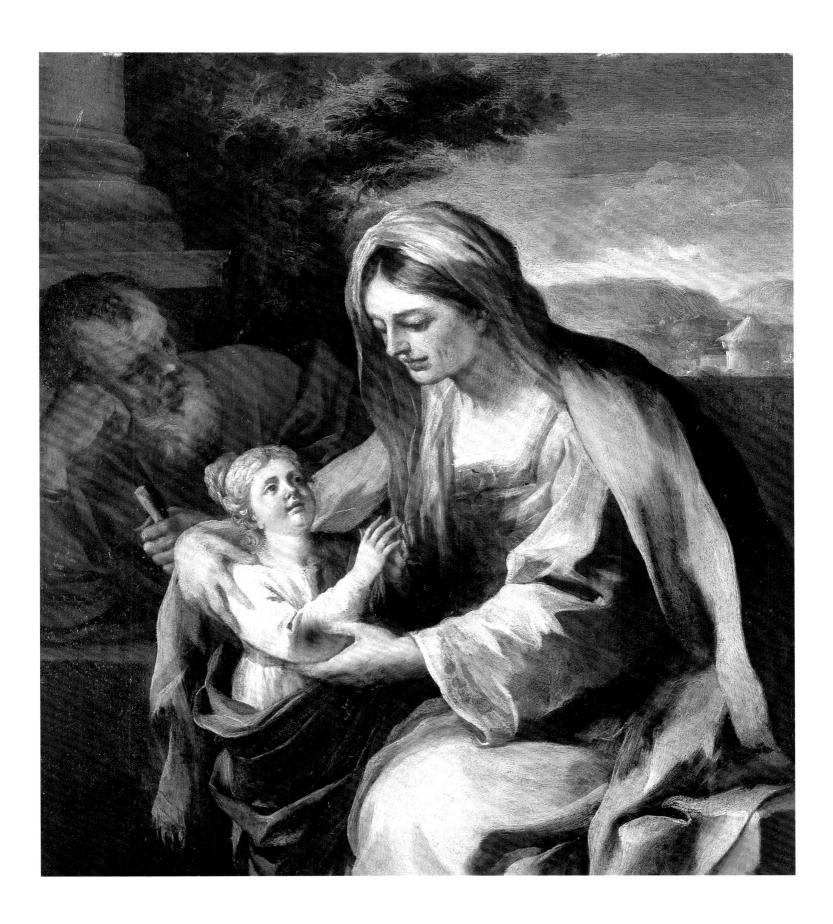

GIOVANNI ANTONIO PELLEGRINI

(Venice 1675 - Venice 1741)

Young Hannibal Swears Enmity to Rome

oil on canvas
71 x 94 cm (27⅞ x 37 in)

Provenance: Ruggero Sonino, Venice;
Anonymous sale, London, Christie's, April 24, 1981, Lot 98.

Exhibited: London, Matthiesen Fine Art Ltd., *The Settecento 1700-1800*, 1987, no. 10, pl. 5.

Literature: R. Pallucchini, 'Novita 'ed appunti per Giovanni Antonio Pellegrini', in *Pantheon*, vol. XVIII, 1960, pp. 247-248, reproduced;
G. Knox, *Antonio Pellegrini*, Oxford 1995, p. 239, cat. no. P. 169.

THE SCENE DEPICTED HERE IN ALL ITS GLORIOUS drama is of the great Carthaginian general and tactician, Hannibal, swearing eternal enmity to Rome, his bitterest foe. In a manner reminiscent of caravagesque painters, the figures that make up this scene of dramatic action are illuminated by a shaft of ethereal light beaming down on them. The main figure, Hannibal's father Hamilcar, is decked out in a brilliant crimson cloak and a bejewelled headpiece as worn by the Phoenicians. A pyramidal composition which includes another soldier with his back to the viewer and the frightened Hannibal, whose hand his father firmly clasps, highlights further the intense and concentrated expression on the old general's face. Hannibal is depicted with long hair in the conventional style and wears a pale blue cloak which he gathers about himself with his spare hand. Hannibal's upraised profile is a recurring theme in Giovanni Antonio Pellegrini's painting appearing in, for instance, *Angelica and Medor* (Narford Hall, Norfolk, England) and *The Happy Return* (Alte Pinakotthek Depot, Munich). R. Palluchini dates this work to *c.* 1731, and another version of this subject and its pendant, the *Sacrifice of Polyxena*, form over doors in the Antechamber of the Würzburg Residenz, Germany, dated 1722.

A further example of dramatic composition that exploits antique subject matter is illustrated in Pellegrini's *Achilles Discovered with the Daughters of Lycomedes* (fig. 1). The viewer is instantly struck by the turbaned figure with his back turned. In *Young Hannibal Swears Enmity to Rome*, that posture is adopted by a heavily armed soldier. Similarly, where the frightened maiden points her sword within piercing distance of the man's face, Pellegrini's arrangement of his figures' arms in *Young Hannibal Swears Enmity to Rome* creates the same frantic sense of movement and drama. His ability to pictorially outline his figures' clothes is one of his great skills. In both works, the careful modelling of the folds of drapery to outline the bodies beneath achieves an undeniable realism in spite of the fictitious subject matter (at least in *Achilles Discovered with the Daughters of Lycomedes*).

The vivid cloaks of the three protagonists in *Young Hannibal Swears*

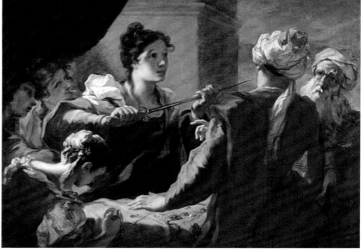

Giovanni Antonio Pellegrini, *Achilles Discovered with the Daughters of Lycomedes*, The Spencer Museum of Art, Kansas (Figure 1)

Enmity to Rome, lend the scene a theatrical undertone. There is a great deal of space around them with virtually nothing to detract from the supreme drama of the moment rendered. The three elderly men in the background behind the young Hannibal's shoulder serve to highlight the contrast between the extreme youth of Hamilcar's son as well as lending gravity to the scene by virtue of their age. The foreboding face of the nearest elder is matched by the seriousness of Hamilcar's. The perspective accomplished by painting the three in an arched recess and having the third elder straining to see from his distant vantage point, focuses all the more on Hamilcar, the central figure of the scene. Further stylistic comparatives with the present work can be identified in another history painting by Pellegrini, *Mucius Scaevola before Porsenna* (fig. 2). Scaevola appears very similar in dress to the soldier who

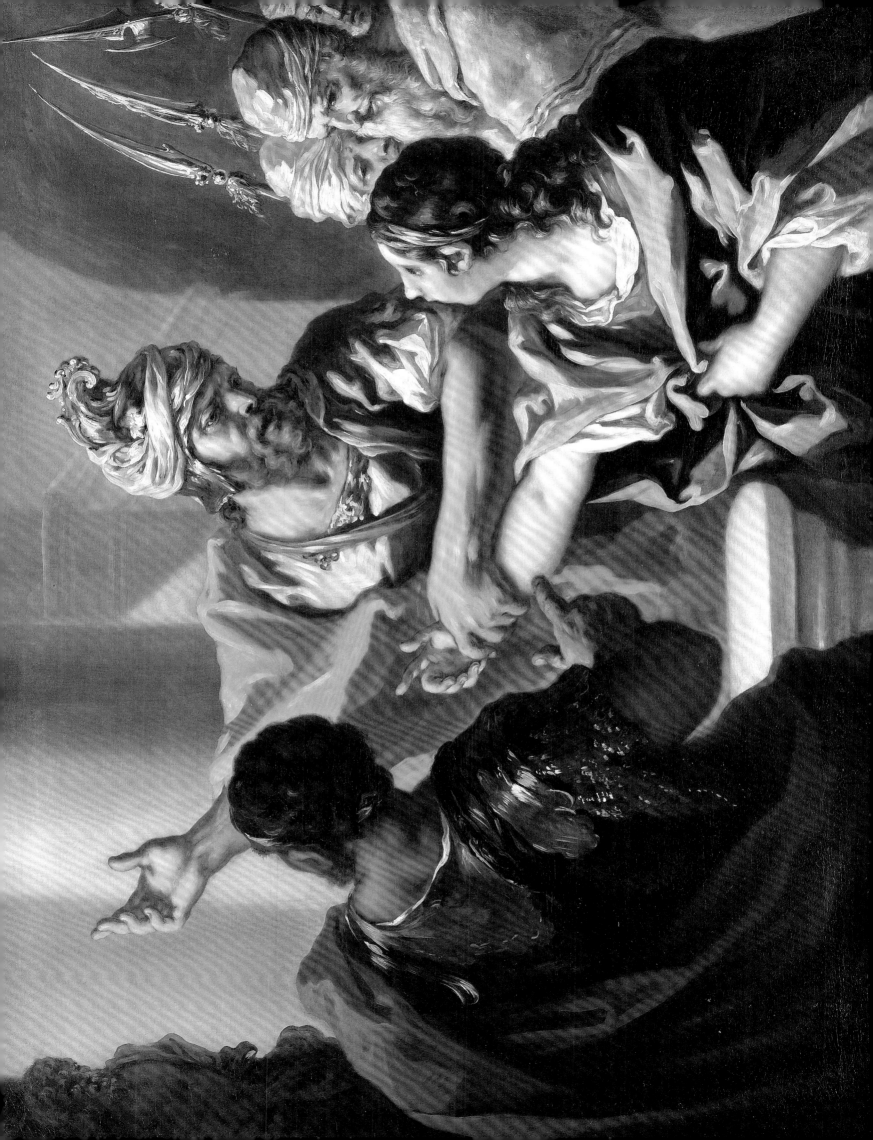

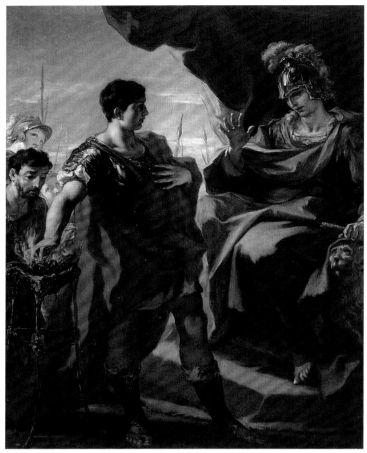

turns away from the viewer in *Young Hannibal Swears Enmity to Rome*. In this mature work, Pellegrini blends the neo fifteenth-century style of Sebastiano Ricci (1659-1734) (see Inventory) with the *chiaroscuro* effects of Luca Giordano (1634-1705).

The subject matter of this work, *Young Hannibal Swears Enmity to Rome*, concerns the period of bitter fighting between Rome and Carthage during a series of wars from the middle of the third century to the mid-second century BC. Known as The Punic Wars, they ended with a decisive vanquishing of Carthage that allowed Rome to emerge as the pre-eminent Mediterranean imperial power. One of the key players in the history of the Punic Wars was General Hannibal of Phoenician Carthage. Hannibal was the son of an equally prominent Carthaginian commander and tactician during the First Punic War, Hamilcar Barca. Pellegrini captures the moment in which the young Hannibal was compelled by his father to swear eternal enmity to Rome. According to the ancient historians Polybius and Livy, Hannibal said much later that when he came upon his father preparing for battle and begged to go with him, Hamilcar agreed but only on the condition that he swear for as long as he lived never to cede to Rome. There is another account of Hannibal's father taking his young son up to a sacrificial chamber and setting him over a fire until he made the eternal promise. From the death of his father in 229 BC until his own, Hannibal's life was one of constant struggle against the Roman Republic. Hannibal came within a whisker of erasing the emerging Roman Empire from the history books in the course of the Second Punic War (218-202 BC).

The genre in which Pellegrini excelled, as exemplified by *Young Hannibal Swears Enmity to Rome*, was history painting. A Renaissance treatise by Alberti used the word *istoria* in 1435 to describe a narrative picture with many figures. The phrase was more frequently associated with classical subject matter and largely because of the sheer number of figures in their compositions, works of this type were seen as the most demanding and exalted types of painting. Typically, this style of artistry dictated that the characters should be as near

life size as possible and ought to be studied from an individual model. One only has to look at the detailed expressions on the faces of the characters in the present picture to see this clearly. History painting coincided with the rise of naturalism which had begun in Northern Europe but during the sixteenth century it began to be felt in Rome. Overall, history painting in the earlier eighteenth century was transformed by Rococo taste into the prettiness relayed by the peripatetic Venetians, Pellegrini and the Ricci and Tiepolo families as well as François Lemoyne (1688-1737) and his pupil François Boucher (1703-1770). In England a keen advocate of history painting was Sir Joshua Reynolds (1723-1792) (see cat. no. 71). In his *Discourses,* delivered to members of the Royal Academy, he continually propounded the study of Old Masters of the Roman and Bolognese schools and of the use of subjects from Greek and Roman history.

Pellegrini (fig. 3), together with Ricci and Jacopo Amigoni (c.1685-1752), was one of the finest Venetian history painters of his day. Credited with seamlessly melding the Renaissance style promoted by Paulo Veronese (1528-1588) with the Baroque of Pietro da Cortona (1596-1569) and Giordano, Pellegrini enjoyed great popularity amongst the European aristocracy. He travelled widely around Europe executing elegant commissions to decorate the palatial residences of the wealthy upper classes.

Having trained under P. Pagani (1661-1716) in Venice, Pellegrini was invited to England in 1708 by the British ambassador to Venice, Charles Montagu. Whilst there he decorated the stairwell of Montagu's London home in Arlington Street, which has since been destroyed. The following year, Pellegrini, along with Marco Ricci (1676-1730) who had also been invited over to England by the ambassador, painted the set designs for Alessandro Scarlatti's opera, *Pirro e Demetrio* and for Giovanni Bononcini's *Camilla*. That same year he received a commission from Charles, the 3rd Earl of Carlisle to paint the cupola, staircases and entrance hall of Vanburgh's magnificent Castle Howard in North Yorkshire which was largely destroyed by fire in 1941. Employing the fashionable genre of mythological and allegorical paintings, Pellegrini created

a dramatic version of the *Fall of Phaethon* for the cupola and used the walls for allegorical settings. Following his success at Castle Howard, Pellegrini was also called upon to decorate another of Charles Montagu's residences, Kimbolton Castle. He adorned the walls with *The Triumph of a Roman Emperor* and a rendition of *Minerva* on the ceiling. *Minerva* includes a portrait of the patron upheld by *putti*. Again, the light and radiant colours are indebted to Veronese; the scene of musicians playing a fanfare, painted in a triangular area, is brilliantly accomplished, both as an independent work and as part of the whole. Both of these frescoes represent his most important surviving British achievement with a spaciousness of design and a radiance of colour that anticipates Giambattista Tiepolo (1695-1770).

Other large-scale projects undertaken whilst in England include a series of mythological canvases originally intended for Burlington House, London, which hang now in Narford Hall, Norfolk. Pellegrini worked with his fellow countryman Sebastiano Ricci on this commission and together they produced *Diana and her Nymphs Bathing* (fig. 4).

Pellegrini was particularly successful in England and through his acquaintance with Sir Godfrey Kneller he assisted in the foundation of Kneller's Academy in London in 1711 and also became a director. Pellegrini even submitted designs for the dome of the new St. Paul's Cathedral and his design is said to have been Sir Christopher Wren's (1632-1723) preferred choice. In the end Pellegrini was pipped to the post by the English painter Sir James Thornhill (1675-1734) who received the commission instead. This anecdote in itself goes some way to demonstrate the great esteem in which

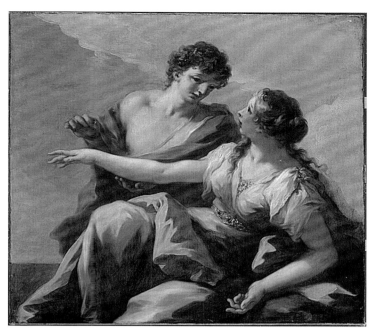

horizontal device (fig. 5).

In 1735, he was paid for the delivery of an altarpiece, St. Catherine, for the Santo in Padua, which is now in the library of the Santo. Pellegrini had an important collection of Dutch art, which, after his death, was acquired by the English consul Vivian Smith. His work was widely influential and played an important role in the formative years of Tiepolo (see cat. no. 113) and Giovanni Antonio Guardi (see cat. no. 28).

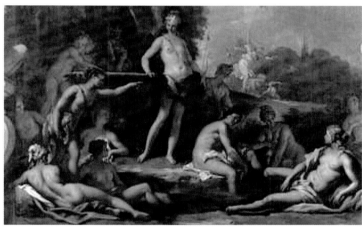

Giovanni Antonio Pellegrini and Sebastiano Ricci, *Diana and her Nymphs Bathing*, 1713-1715, Narford Hall, Norfolk, (Detail from the side wall of the main staircase) (Figure 4)

Pellegrini was held. His rivals for the St. Paul's commission included some of the greatest European artists of the day: Juan-Baptiste Catenaro, Pierre Berchet and Louis Laguerre (1663-1721) were among his competitors. According to the writer and antiquarian George Vertue, Sebastiano Ricci on finding out that the commission had been awarded to Thornhill, 'left England once and for all when he found it was resolved that Mr. Thornhill shou'd paint the Cupolo of St. Paul's.'

Pellegrini left England in 1713. Subsequently he was employed by Johann Wilhelm, Elector of the Palatinate in Düsseldorf for whom he painted *The Fall of the Giants* and *The Fall of Phaethon* to adorn the stairwell of the Elector's Schloss Bensberg. He also completed a series of allegorical canvases to celebrate the Elector's rule. These are commonly regarded as the apex of his achievement as a history painter. Pellegrini worked all over Europe, in Antwerp, The Hague, Würzburg, Dresden, Mannheim and Vienna. Following this extensive travelling, Pellegrini finally settled in Venice for the remaining years of his life.

In Venice, Pellegrini executed commissions in and around the city and it is believed that he painted *Bacchus and Ariadne* here, which although simpler in composition than *Young Hannibal Swears Enmity to Rome*, uses a similar

Giovanni Pellegrini *Young Hannibal Swears Enmity to Rome* (Detail)

MICHELE ROCCA

(Parma c.1666 - Venice, after1751)

David and Bathsheba

oil on canvas, in a painted oval
47.5 x 37.7 cm (18½ x 15¼ in)

Provenance: with Colnaghi, London;
with Agnews, London;
Lord and Lady Illiffe of Basildon Park.

THE WARM, PASTEL PALETTE, RICH PAINTERLY effects, graceful sense of movement and the coquettish display of the women in *David and Bathsheba* are typical of Michele Rocca's work and indicate that his painting, although grounded in the Baroque tradition, resonated more with the emerging French Rococo movement. The size of the composition and its decorative appeal are also characteristic of Rocca's small-scale cabinet pictures of mythological and biblical scenes that gave him his reputation as a *petit maître* in eighteenth-century Rome.

The scene illustrates a biblical passage from the second book of Samuel in which 'David arose from off his bed, and walked upon the roof of the king's house: and from the roof he saw a woman washing herself; and the woman was very beautiful to look upon' (11:2). In the upper right of the composition, King David can be seen spying on Bathsheba from his balcony. The nude Bathsheba, clutching provocatively at a piece of blue drapery, is unaware of his covetous gaze or the events soon to befall her. Two attendants flutter around, one holding a string of pearls to adorn her mistress while the other bathes her feet. Bathsheba, with pale soft skin, a voluptuous figure and fair hair, is the picture of feminine allure. According to the biblical narrative Bathsheba's beauty compelled David to summon her to him, and after learning she was the wife of Uriah, the Hittite, David ordered him to be killed so he was free to marry her. Their first child died in infancy as retribution for their sins; their second child, however, was Solomon who became the third king of Israel. The setting for such a consequential scene of seduction is appropriately romantic, featuring classical columns, ornaments and lavish drapery.

The sensuality of *David and Bathsheba* is typical of Rocca's work, whether the subject is biblical or pagan. This is evident in his painting, *Offering to Jupiter*, in which naked women and *putti* frolic on a hillside near a statue of Jupiter seated on a plinth (fig. 1). The sky is of the same rich blue hue as the present painting and is dotted with puffy white clouds. The poses and gestures of the figures are elegant and languorous and the softly modelled pale pink flesh of the women in repose is equally as suggestive as that of Bathsheba.

According to Nicola Pio's *Vite* of 1724, Rocca left his native city of Parma to travel to Rome in 1682 and study under Ciro Ferri (?1634-1689).[1] He then returned to Parma where he absorbed the influence of Correggio (?1489-1534). By 1695, he had returned to Rome and he began painting altarpieces. He was elected to the Congregazione dei Virtuosi al Pantheon in 1710 and in the same year painted his best known paintings, *Toilet of Venus* and *The Finding of Moses*, both small-scale fashionably elegant works that are indicative of the

Rococo style. Despite the Rococo influence, Rocca's cosmopolitan style owed much to his Roman colleagues and he particularly emulated Sebastiano Conca (1680-1764) (see cat. no. 34 and Inventory), which makes their work often difficult to distinguish between. Benedetto Luti (1666-1724) (see Inventory) also provided inspiration for Rocca and may have introduced him to French painters working in Rome. In 1727 Rocca was given an official post at the Accademia di S. Luca in Rome. One of his last known pictures, *Bathsheba in the Bath*, dates to 1729 and is in the Schloss Wilhelmshöhe Kassel, Germany.

We are grateful to Professor Giancarlo Sestier for confirming the attribution of this painting.

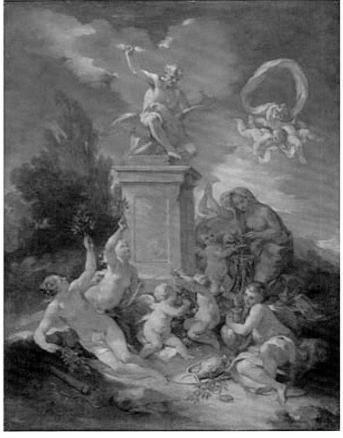

Michele Rocca, *Offering to Jupiter*,
Government Art Collection, U.K. (Figure 1)

[1] N. Pio: *Vite* (1724); ed. C. Enggass and R. Enggass (1977), p. 153.

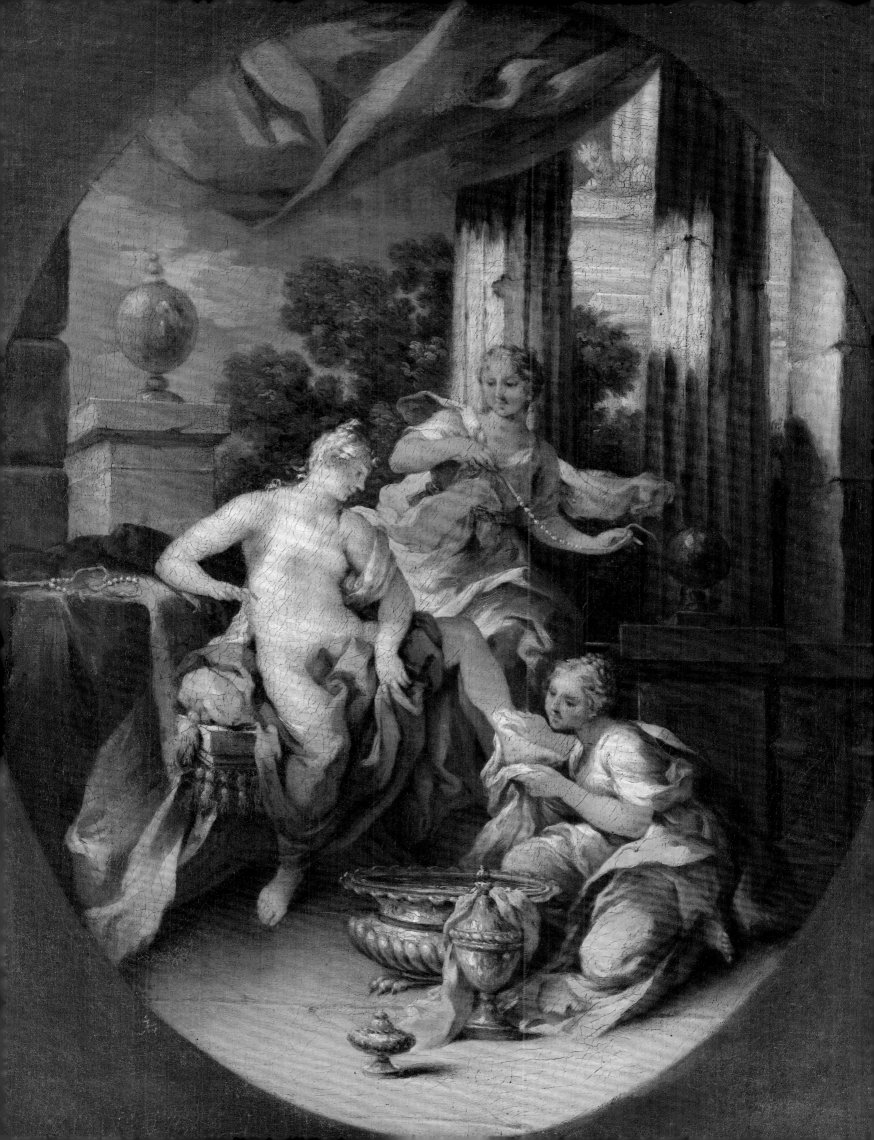

ATTRIBUTED TO

SEBASTIANO CONCA

(Gaeta 1680 - Naples 1764)

Esther and Ahasuerus

oil on canvas
84 x 109 cm (33 x 43 in)

THIS DRAMATIC REPRESENTATION OF THE BIBLICAL passage in which Esther seeks an audience with King Ahasuerus, in order to rescue the Jewish people from perishing at the hands of his evil vizier Haman, shows the beautiful new queen swooning in the presence of her lord. Esther has risked her life by approaching Ahasuerus, who has the power to condemn to death anyone who enters the throne room unannounced; the tension brought about by her daring action is evident in the painting. As Esther falls into the arms of her handmaidens, overcome by emotion, the bewildered king rushes to her aid. His page boy leaps after him to hold up his cloak. The rustling drapery and fluid movements of the figures vividly animate the composition.

Esther and Ahasuerus is attributed to Sebastiano Conca, one of the most successful painters working in Rome in the first half of the eighteenth century. He completed numerous altarpieces and frescoes, and his easel paintings were highly sought after by collectors throughout Europe. Conca's work is grounded in the late Baroque style, and the grandeur of this period can be felt in *Esther and Ahasuerus*. Conca was additionally influenced by the academic style of Carlo Maratti (1625-1713), one of the last great Italian artists to paint in the classical tradition that had originated with Raphael (1483-1520). Both Maratti and Conca's refined and elegant works anticipated the Rococo and neo-Classical movements, a hint of which is evident in *Esther and Ahasuerus* and further developed in paintings such as *Rape of Europa* (fig. 1). Here, the lyricism and sensuality of Conca's style fits the mythological subject matter. The bare-breasted Europa and her lovely female attendants are surrounded by frolicking *putti* in a romantic pastoral setting. The scene stands in contrast to the present work, which reflects the gravity of its subject through expression and costume, including the majestic swathe of drapery hanging on the left of the composition. A solid column stands in the centre of the painting, enhancing its monumentality, and classical statuary is partly visible in the niche on the wall and adorning the fountain in the palace grounds. Although differing in mood and content, both works exhibit Conca's characteristically spontaneous brushwork, heightened dramatic sense and vibrant use of colour.

Conca was the pupil of Francesco Solimena (1657-1747) (see Inventory), probably entering his studio in Naples at the age of thirteen. In 1706, Conca moved to Rome where he remained for forty-five years and began to move away from the influence of Solimena, to embrace the art of Michelangelo,

Raphael and the Carracci. Conca quickly attracted numerous ecclesiastic and aristocratic patrons, painting altarpieces for the Church of S. Clemente and S. Giovanni Laterano in Rome, frescoing the vault of S. Cecilia in Trastevere and decorating the Palazzo de Carolis. He worked for the Piedmontese royal house of Savoy, executing paintings for the royal hunting lodge, the Venaria Reale, and for the Palazzo Reale in Turin. The Duke of Parma was so impressed with Conca's talent, he gave him a studio in the Palazzo Farnese, Rome, where Conca established his Accademia del Nudo. Distinguished artists such as Pompeo Girolamo Batoni (1708-1787), Corrado Giaquinto (1703-1766) and Anton Raphael Mengs (1728-1779) attended the academy. The 1730s were Conca's most prolific and successful years, in which his altarpieces were sought after throughout Italy and his easel paintings attracted the attention of Italians and tourists alike. He moved to Naples around 1752 where he was entrusted with important decorative commissions, including the frescoes in S. Chiara and five canvases for the Palatina Chapel at Caserta. Sebastiano's younger brother, Francesco (b.1698), was also a painter, as was his cousin Giovanni (b.1698). Giovanni's son, Tommaso (1734 - 1822) was a prominent artist, best known for his decoration of the Villa Borghese, Rome.

Sebastiano Conca, *Rape of Europa*, Private Collection (Figure 1)

DOMENICO MAGGIOTTO

(Venice 1712 - Venice 1794)

Portrait of a Girl with a Dog

oil on canvas
73 x 56.5 cm (28¾ x 22¼ in)

THIS DELICATE AND SENSUOUS PORTRAIT BY Domencio Maggiotto of a young woman offering a treat to her dog gives the impression that one is viewing a private scene in which the subject is unaware that she is being observed. The girl's bodice has partially slipped off her shoulder, revealing an expanse of creamy white flesh and a careless attitude in dress that further conveys the intimacy of the scene. The painting has a dreamy quality accentuated by the soft colour palette and sensitive moulding of the sitter's features. Her gaze is directed outside of the picture indicating her thoughts are elsewhere as she absent-mindedly strokes her dog with one hand while holding its reward just out of reach in the other.

Maggiotto's technique of representing figures was adopted from his teacher Giovanni Battista Piazzetta (1682-1754), whose best-known painting, *Fortune Teller*, in the Accademia, Venice, depicts the protagonist

Domenico Maggiotto, *The Young Fruitgirl*,
Rijksmuseum, Amsterdam (Figure 1)

coyly glancing downwards and away like the present sitter. Piazzetta's characteristically limited colour scheme and prominent use of *chiaroscuro*, also clearly influenced his pupil's work. The distinctive handling of paint in depicting the girl's dress and blue wrap in the present painting is replicated in a work by Maggiotto in the Rijksmuseum, Amsterdam, which portrays a fruit seller holding a basket of apples while conversing with a young man (fig. 1). The two compositions are similar in format, both being half-length and focusing on a young woman posed against a plain dark background. The shadowing in the Rijksmuseum image is particularly caravagesque, giving the two figures a swarthy appearance reminiscent of Michael Sweerts (1618-1664), in comparison to the glowing complexion of the sitter in the present painting.

Portrait of a Girl with a Dog appears to be less a conventional portrait than a study of facial type and expression and an exploration of the play of light on the girl's skin and clothing. In this way, it may have been intended as an artistic exercise and investigation into human nature, in the style of Rembrandt van Rijn's (1606-1669) *tronies*. Rembrandt was particularly esteemed in eighteenth-century Venice, and if Maggiotto was not directly influenced by his work, he may have been aware of it through his association with the painter Giuseppe Nogari (1699-1766) who painted in a similar style. Maggiotto is known to have executed paintings solely intended as character types as he contributed to a group of thirty such images that were commissioned from leading Venetian artists by the Visconti family. These studies of personality types were hugely popular at the time, and formed a significant part of eighteenth-century figurative painting, although they were given minor status within the traditional classifications of painting.

Maggiotto studied under Piazzetta from the age of ten and assisted in his studio until Piazzetta's death in 1754, a long association that no doubt explains the parallels identifiable in their work. During this period, Maggiotto mainly executed genre scenes and collaborated on Piazzetta's large scale historical and religious works. Piazzetta was particularly well known for his drawings of half-length figures and heads documenting the common people of Venice, works which played a prominent part in elevating the status of drawing to an independent art form. Maggiotto imitated his master by producing a number of drawings in coloured chalks, which were very much works of art in themselves, rather than simply preparatory studies. In the years following Piazzetta's death, Maggiotto employed an eclectic range of styles and began painting altarpieces, although he continued to do his best work in smaller formats. In 1756, he was elected to the Accademia di Belle Arti, Venice, after which his work took on a more classicising style and he ventured into moralising and historical narratives in addition to his regular output of genre scenes. Maggiotto was also a noted restorer of paintings.

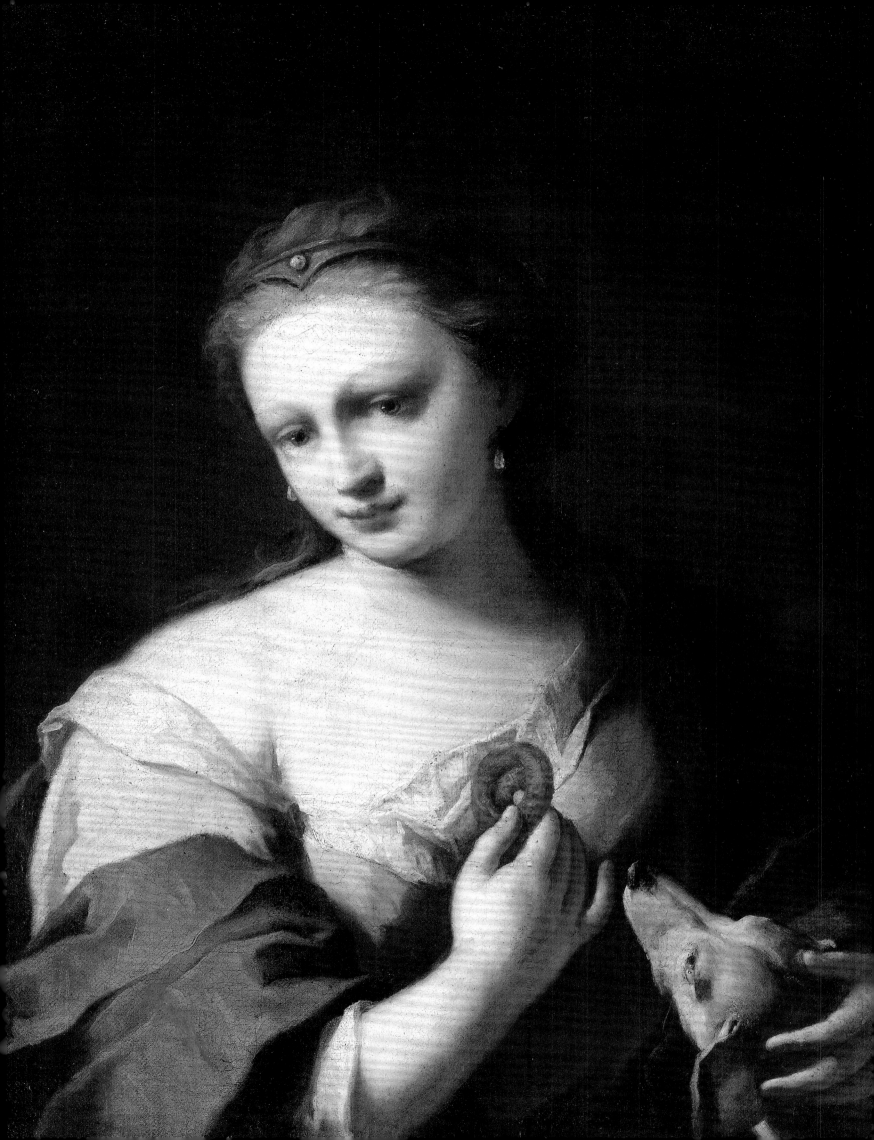

ATTRIBUTED TO

GOVERT JANSZ, CALLED MIJNHEER

(Amsterdam 1578 - Amsterdam, after 1619)

Earth: Elegant Figures at a Vegetable and Cattle Market;

&

Fire: Soldiers Assembled around a Carriage with Cannons Firing

oil on panel, a pair
24.7 x 29.8 cm (9¾ x 11¾ in) each

EARTH: ELEGANT FIGURES AT A VEGETABLE AND CATTLE *Market* shows a large market bustling with mercantile activity, in which the viewer is given the impression of the crowd stretching far back into the distance. Several figures in the foreground stand out from the mass of people, such as the boy dragging a heavily laden sled, whilst a dog scampers ahead. On the right-hand side a large woman is bent over as she strains to lift a wide basket filled with fresh produce, whilst other women carefully balance the baskets on their heads. In the centre of the composition two scrawny cows are arranged in such a way that we can see them from all angles. The same effect is achieved with two of the women, and we are given a complete view of their elaborate costumes that include a long huke, bongrace and pompon; a fashionable style at the time. There was a growing taste for market scenes in seventeenth-century Dutch painting, of which the present work can be considered an early example.[1]

The accompanying oil, *Fire: Soldiers Assembled around a Carriage with Cannons Firing* is less densely populated, though the same technique of individualising certain foreground figures against a less discernable crowd is applied successfully. A soldier is in the process of firing a cannon, which simultaneously emits thick black smoke and a flash of light that briefly illuminates the group in the darkness of the night. Some of the soldiers huddle together and watch this demonstration, their cloaks pulled close as they wrap up against the night chill. On the left-hand side, the various instruments used to fire a cannon are visible, including the sponge, cannon-balls and carriage to transport these massive weapons.

Jan van de Velde II, *Ignis, c.*1620, The New York Public Library (Figure 2)

The present pair of paintings illustrate two of the classical elements: earth and fire. In *Earth,* the market is shown as an important part of peoples' lives as they are dependant on the earth's produce, which is depicted in detail. In *Fire,* the bright light of the shot illuminates the black night and draws attention to the considerable energy and power of fire. The remaining two elements, air and water, were offered at Christie's, Amsterdam (16th November 2006, lot 53), and the identical size of the panels and stylistic similarities suggest that these paintings complete the series. The present compositions were based on Jan van de Velde II's (*c.*1593-1641) engravings of the four elements, see figs. 1 and 2, which were in turn executed after designs by the Dutch Baroque painter Willem Buytewech (*c.*1591-1624).[2] The original compositions have taken the traditional, allegorical subject of the four elements and depicted them within plausible Dutch settings thus presenting a visual record of daily life.

Mijnheer is believed to have died in Amsterdam sometime after 1619. The uncertainty of precise death dates for Mijnheer and precise dates for the execution of van de Velde's prints, dated to *c.*1620, would support the belief that the present works were painted after the prints, and at the end of Mijnheer's life.

Jan van de Velde II, *Terra, c.*1620, The New York Public Library (Figure 1)

[1] Linda Stone-Ferrier, 'Gabriel Metsu's Vegetable Market at Amsterdam: Seventeenth-Century Dutch Market Paintings and Horiculture' in *The Art Bulletin*, Vol. 71, No. 3 (Sep., 1989), pp. 428-452.

[2] see F. W. H. Hollstein, *Dutch & Flemish Etchings, Engravings and Woodcuts*, XXXIV, pp. 16-7, nos. 18 and 20.

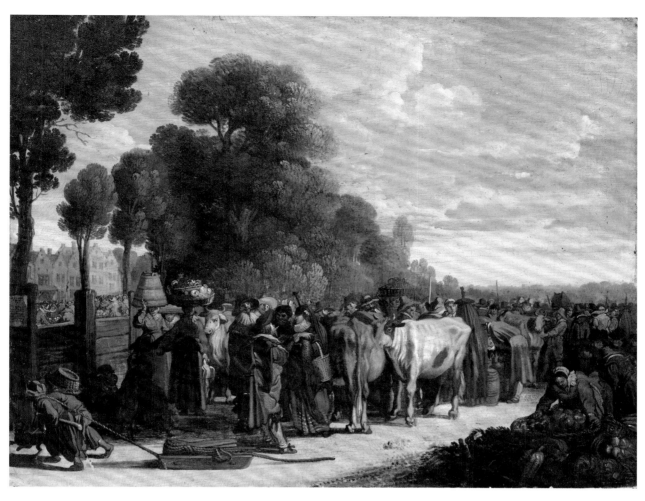

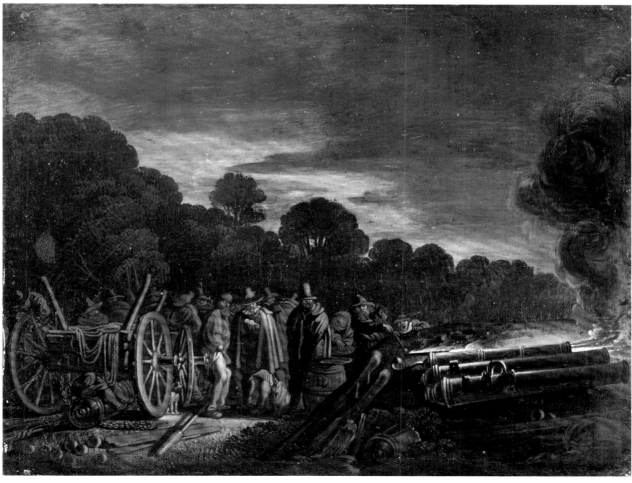

AMBROSIUS BOSSCHAERT II

(Arnemuiden 1609 - Utrecht 1645)

Peaches, Grapes, a Pear and White Currants in a Wan-li Kraak Porcelain Dish,

with Shells, a Lizard and a Butterfly on a Ledge

oil on panel
15 x 18 in (38 x 45⅝ cm)

Provenance: Anonymous sale: Sotheby's, London, 5 July, 1989, lot 36, as Bartolomeus Assteyn,
where acquired by the previous private collector

Ambrosius Bosschaert II, *Peaches, Grapes, a Pear and White Currants in a Wan-Li Kraak Porcelain Dish with Shells, a Lizard and a Butterfly on a Ledge* (Detail)

FORMERLY ATTRIBUTED TO BARTOLOMEUS ASSTEYN (1607-1667), whose early style was strongly influenced by the Bosschaert family, this painting has recently been recognised by Fred Meijer of the Rijksbureau voor Kunsthistorische Documentarie (RKD), The Hague, as the work of Ambrosius Bosschaert II. Meijer, on first-hand inspection of the painting, has suggested a date in the 1630s when the artist was active in Utrecht. Bosschaert II moved there in 1628 and evolved a style founded upon the tuition he received from his father, Ambrosius Bosschaert I (1573-1621), and the works of his uncle, Balthasar van der Ast (1573-1621). Indeed the influence of the latter is strikingly evident in the present work and comparable to other still lifes by Bosschaert II of the same period (fig. 1). Meijer's dating would make the present picture one of Bosschaert II's later works, a number of which are characterised by a more spacious and asymmetrical composition.

The artistic concept underpinning this sensuous melee of fruit, exotic shells, minutely detailed insects and an inquisitive lizard, was one widely indulged in by Dutch artists of the seventeenth century. Particularly popular

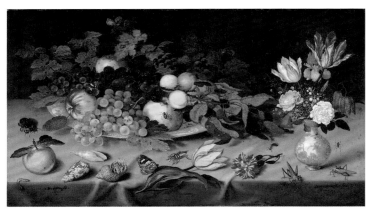

Ambrosius Bosschaert II, *Still Life with Fruit and Flowers c.1620-1*, Rijksmuseum, Amsterdam (Figure 1)

in the Northern Netherlands was a distinct category of still life painting called the *vanitas*. *Vanitas* paintings dwelt on the brevity and insignificance of man's earthly life, urging him to secure his entry to eternal life thereafter by righteous Christian conduct. The viewer is also meant to reflect upon the inevitability of death and the futility of worldly ambitions, especially the accumulation of riches and the greedy striving for power. This category of still life painting takes its name from the Latin of *Ecclesiastes* 1:2: 'Vanity of vanities, saith the Preacher...all is vanity'.[1]

In his *Tradition and Expression on Western Still Lifes,* Ernst Gombrich explained that the still life as a formal category owes its success to the fact that 'it has never cut itself loose from an immediate appeal to the five senses'.[2] In this humble genre it is the 'sensuous appeal of food and glitter' that matters. Gombrich here refers to the mystery of a still life, an illusion

[1] Langmuir, E. *The National Gallery Companion Guide*, 1994, p. 249.
[2] Ernst Gombrich, 'Tradition and Expression on Western Still Lifes,' in *Burlington Magazine* CIII, 1961, p. 180.

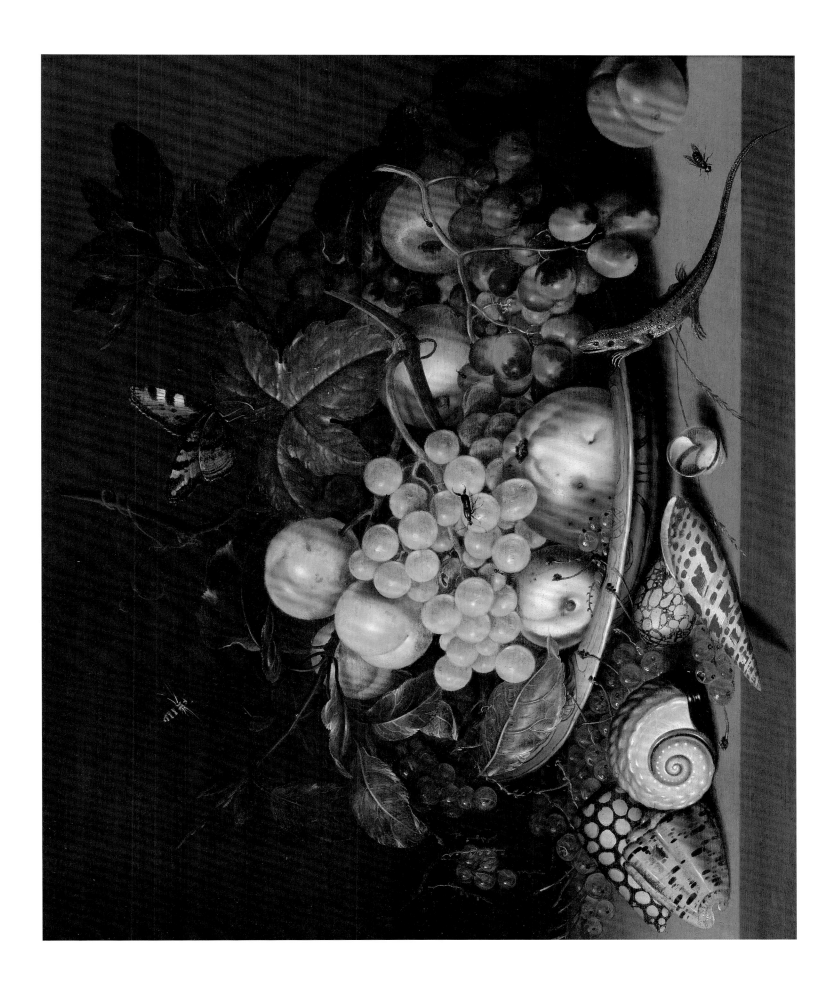

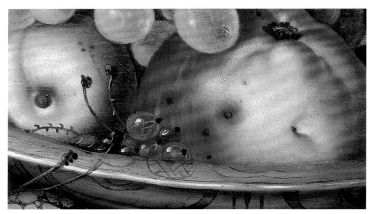

Ambrosius Bosschaert II, *Peaches, Grapes, a Pear and White Currants in a Wan-Li Kraak Porcelain Dish, with Shells, a Lizard and a Butterfly on a Ledge* (Detail)

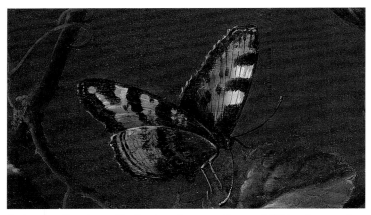

Ambrosius Bosschaert II, *Peaches, Grapes, a Pear and White Currants in a Wan-Li Kraak Porcelain Dish, with Shells, a Lizard and a Butterfly on a Ledge* (Detail)

beneath whose naturalistic rendering of familiar objects there seems to lurk an elusive, enigmatic quality. Dutch and Flemish painting of the seventeenth century can be considered the golden age of still life as a genre. Central to the movement was the work of the Bosschaert dynasty. Bosschaert I, a key figure in establishing Dutch realism in his flower paintings, had three sons of whom Ambrosius Bosschaert II was the eldest.

Gombrich's comment on the illusion created by many Dutch still lifes was another equally important driving force behind such paintings. Artists attempted to deceive their viewer through such a masterful command of their skills at depicting nature in all its glory, that illusion equalled reality. The *trompe l'oeil*, or 'deceit of the eye', evolved in the latter half of the century with dead game pieces, but even in compositions of fruit and flowers, the attempt to imitate the riches of nature is unmistakable. The glassy, almost edible white currants in the present work are prime example of this craftsmanship.

Interpreting symbolism in still life paintings of this period is fraught with difficulty particularly since objects would invariably have had different associations for audiences across the centuries. Nonetheless, Bosschaert II's pictures are marked by their strong religious message. His *Bowl of Fruit with a Siegburg Beaker* can be interpreted as an allusion to the fall of mankind, the Crucifixion and the Redemption. The caution with which items in these *vanitas* paintings are ascribed symbols is understandable. However, they cannot be viewed divorced from their historical context. Once the Council of Trent (1545-1563) had forbidden religious imagery in its traditional format,

the hidden messages perhaps concealed by Bosschaert II's lizard and butterfly may have taken on more significance to seventeenth-century viewers.

The objects in the present work have been allocated various symbolic meanings: the butterflies have been interpreted as souls, butterflies being symbolically equivalent to a bird in a religious painting. A fly can also be seen, which in Bosschaert II's time had long been regarded as a disseminator of disease. In a transferred sense it can be said to represent an equivalent of sin, and was probably introduced into the painting with this significance in mind. An earwig can be spied, boldly scuttling over a green grape in the foreground. Earwigs were commonly believed throughout much of Europe to possess deadly qualities.

The beautifully realistic lizard, as well as providing an artistic challenge to reproduce so vividly, also serves as a reminder of the serpent in the Garden of Eden as the lizard, along with snakes, is one of the abominations of the Old Testament: 'And every creeping thing that creeps on the earth shall be an abomination...whatever crawls on its belly, whatever goes on all fours, or whatever has been many feet among all the creeping things that creep on the earth...'[3] In the present painting, the ears of corn that curl delicately over the ledge next to the lizard could also be biblically inspired as a reminder of the resurrection. Similarly, the peaches and grapes could be interpreted as much more than mere fruit with peaches and pears commonly replacing the apple that presaged the downfall of Adam and Eve in the Garden of Eden. The grapes naturally recollect the blood of Christ, and indeed the corn could be said to

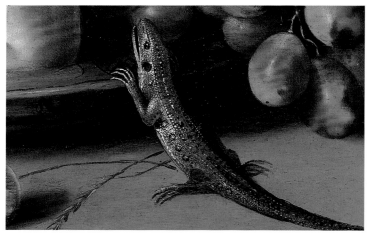

Ambrosius Bosschaert II, *Peaches, Grapes, a Pear and White Currants in a Wan-Li Kraak Porcelain Dish, with Shells, a Lizard and a Butterfly on a Ledge* (Detail)

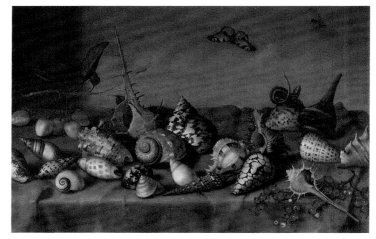

Balthasar van der Ast, *Still Life with Shells*, Museum Boymans-van Beuningen, Rotterdam (Figure 2)

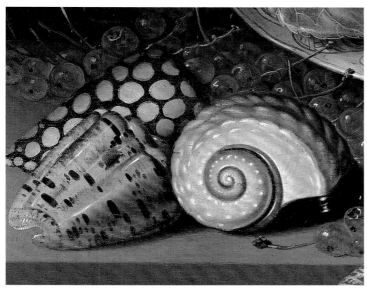

Ambrosius Bosschaert II, *Peaches, Grapes, a Pear and White Currants in a Wan-Li Kraak Porcelain Dish with Shells, a Lizard and a Butterfly on a Ledge* (Detail)

Ambrosius Bosschaert II, *Peaches, Grapes, a Pear and White Currants in a Wan-Li Kraak Porcelain Dish with Shells, a Lizard and a Butterfly on a Ledge* (Detail)

Gallery, The Hague). His later works, as this still life testifies, moved away from the high viewpoint and more rigid composition of his younger days. These works also reveal the influence of his brother, evident both in the choice of format and in a preference for blue and yellow, as well as in the darker background and more compactly organised still life arrangements. Examples of these later compositions include *Flowers in a Glass Vase* (Utrecht, Centraal Museum), see fig. 3, and *Fruits and Parrots* (The Hague, Verspreide Rijkscollectie) both dating from 1635.

allude to the ritual of the Eucharist where wine and bread represent the body and blood of Christ.

From the beginning of the seventeenth century, exotic shells were cherished objects and admired for their lustrous sheen and variety of shapes. Collectors spent considerable sums of money on prized specimens which consequently were highly prestigious acquisitions. In still lifes, therefore, they may often be interpreted as *vanitas* symbols. Van der Ast's carefully arranged variety of shells (fig. 2) conformed to a newer type of still life arrangement, in which the objects are displayed while laid out on a table which takes up more than half of the picture space[4]. Shells also held particular appeal for a nation governed by the sea. Equally, however, when opened they suggested *vanitas* and all its overtones of brevity. Like fruit or flowers that have been plucked from their branches and are hence already dead, so too were the shells plucked from the sea, the hollow remnants of past lives.

Historians have suggested that fruit pieces only qualify as 'sumptuous' still lifes if the fruit is displayed in a valuable container since fruit, in itself, does not reflect wealth, although many varieties that are common today were expensive luxuries at the time. In light of this, it is interesting that the selected container is a Wan-Li Kraak dish. At the end of the Ming dynasty, a new style of blue and white export porcelain was made in vast quantities at provincial kilns in Jingdezhen, Jiangxi province during the Wanli reign (1563-1620). They were imported by the Portuguese in their 'carrack' ships, hence the name 'Wan-Li Kraak'.

The vine leaves, too, are self-evidently transitory, and artists, including Bosschaert II in this painting, showed leaves and fruit eaten by insects and caterpillars representing man trapped in his humble, earthly life awaiting the transformation to butterfly. This motif is traditionally associated with the soul as it is freed to fly upwards to the heavens.

Bosschaert II's work has generally only been recognised since 1935 when Piet de Boer succeeded in differentiating his works from pictures by his father and his brother Abraham. The first period of his creative output falls between 1626 and 1635. His flower pieces from this time are viewed from above and have a low vanishing point. He often includes exotic accessories and shells in his paintings. One example is *Bouquet with Frog and Lizard* (now in the Nystad

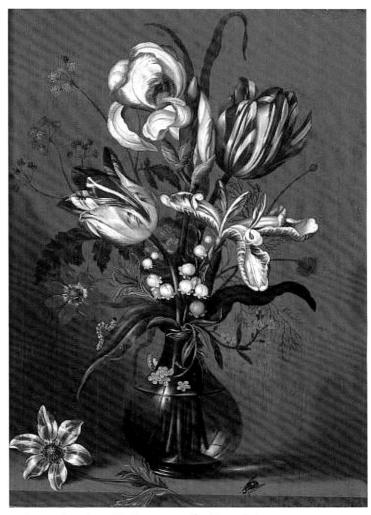

Ambrosius Bosschaert II, *Flowers in a Glass Vase*, 1635, Utrecht, Centraal Museum (Figure 3)

[3] *Leviticus* 11:41-42.
[4] Fuchs, R. H. *Dutch Painting*, 1978, p. 111.

CORNELIS JONSON VAN CEULEN

(London 1593 - Utrecht 1661)

Portrait of Thomas Cletcher, Half-Length

oil on canvas
79.7 x 64.1 cm (31⅜ x 25¼ in)

Provenance: Nicolle Collection, Copenhagen.

Exhibited: Copenhagen, Danish Museum of Fine Art, Autumn 1920, no. 64 as 'Bartholomeus van der Helst'.

Literature: K. Madsen, *Catalogue of a Collection of Paintings Exhibited in the Danish Museum of Fine Art,* Copenhagen, 1920, pp. 112-3, no. 64, as 'Bartholomeus van der Helst'.

THIS PORTRAIT OF THE JEWELLER AND GOLD-smith Thomas Cletcher (1598-1666) can be dated to around 1660 and comprises part of the output originating from Cornelis Jonson van Ceulen's later Dutch period. His paintings from these decades are considered to be among his finest, characterised by an elegance reminiscent of Anthony van Dyck (1599-1641), coupled with an expert rendering of physiognomy and facial expression. The sitter can be seen here with a cheerfully enigmatic look upon his face. The simplicity of his costume and pose focus the attention fully on his skilfully depicted features: a refined Roman nose and beard worn after the fashion of the time. A discreet gold ring sits on the fourth finger of his left hand alluding to his trade as a successful goldsmith and jeweller.

Despite the conservative nature of Cletcher's pose, the liveliness of his expression makes him appear relaxed yet subtly commanding. The conventional pyramidal shape of his body, interrupted by the inclusion of his hand for expressive purposes, exemplifies van Ceulen's careful meticulousness which can also be seen in his portrayal of Apolonius Veth two decades earlier (fig. 1). The contrast between the two portraits is revealing: both undeniably exhibit an extraordinary attention to detail as well as a very human empathy with the sitter. Yet, this present portrait seems far more confident in its use of colour and tonality for the modelling of Cletcher's face. The overall result is an assured and life-like composition.

Van Ceulen would have known Thomas Cletcher through Daniel Mijtens (*c*.1590-*c*.1647), a Dutch artist active in England with whom he worked. In his early career, van Ceulen often produced exacting copies of works by other artists among them, Mijtens' celebrated portrait of Charles I (1629; Metropolitan Museum of Art). Mijtens had married Cletcher's sister, Gratia and his portrait of his brother-in-law in The Hague's Gemeentemuseum confirms the identity of the sitter in the present painting. Van Ceulen may also have known Cletcher through connections in his own family. In his *Anecdotes of Painting in England*, of 1762, Horace Walpole notes that one of the artist's sisters was married to Nicholas Russell or Roussel, of Bruges, who was the jeweller to Kings James and Charles I.

Van Ceulen was born in London after his parents had fled their native Netherlands to avoid religious persecution. He was a highly successful portraitist who came into his own when he returned to the Northern Netherlands at the outbreak of the English Civil War in 1643 and he lived there until his death in 1661.

We are grateful to Sturla Gudlaugsson and Fred Meijer of the Rijksbureau Kunsthistorische Documentatie for their attribution of the painting to van Ceulen and their identification of the sitter as Thomas Cletcher.

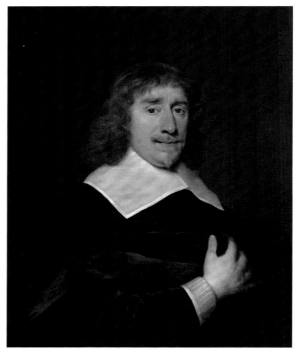

Cornelis Jonson van Ceulen, *Apolonius Veth*, 1644, The Tate Gallery, London (Figure 1)

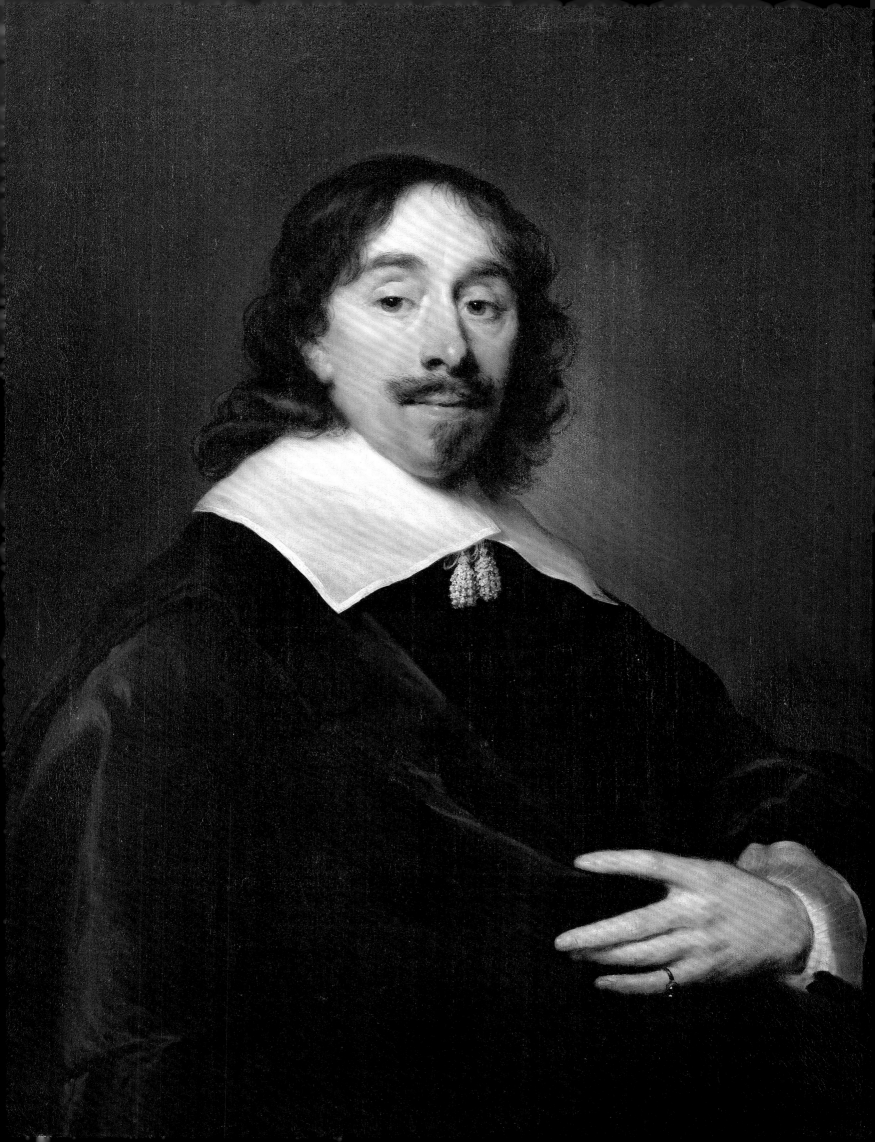

ATTRIBUTED TO

THE MONOGRAMMIST HVT

(active in the Netherlands during the seventeenth century)

Portrait of a Bearded Man, Half-Length, Wearing a Black Tunic and Hat

oil on canvas
74 x 58.7 cm (29⅛ x 23⅛ in)

THIS ARRESTINGLY SOULFUL PORTRAIT OF AN elderly bearded man is attributed to the Monogrammist HVT, and is comparable to a similar composition of the same sitter by a pupil of Rembrandt van Rijn (1606-1669).[1] The sitter's grave demeanour and the prominent cross hanging around his neck signal his religious devotion, and the details of his costume suggest that he is a cleric of eastern origin.

The man's hat is of particular note as it is distinctively Russian in style. It seems that Rembrandt's pupils, as well as the master himself, delighted in portraying sitters in exotic headwear to seventeenth-century Dutch eyes, accustomed to seeing gentleman in structured, brimmed hats, such representations would have appeared unusual and foreign. The hat is similar in design to one worn by a sitter in a painting that was originally conceived as a self-portrait, executed by Rembrandt in 1634, and then retouched by one of his pupils soon after completion, in order to resemble an aristocratic Russian (fig. 1). Researchers believe that the addition of the extravagant accessories would have made the painting more commercial as it would have appealed to the contemporary taste for extraordinary fashions.[2]

The prominence of fur in *Portrait of a Bearded Man, Half- Length, Wearing a Black Tunic and Hat* has a further Russian connection as Amsterdam dominated trade with Russia during this period, with sable being the most precious of imports. In Rembrandt's *Portrait of Nicolaes Ruts*, painted in 1631, the sitter, a merchant looking for self-promotion, is swathed in sable in allusion to his trade with Russia (fig. 2). This luxury fabric was intended to elevate him in the eyes of viewers, and Simon Schama suggests that the commission may

Rembrandt van Rijn,
Portrait of Nicolaes Ruts,
1631,
The Frick Collection,
New York
(Figure 2)

have intentionally coincided with the arrival of a Muscovite embassy in Holland at the end of 1631, indicating that Ruts was hoping to impress the embassy and thereby gain a business advantage.[3] The fur worn by the present sitter enhances his stateliness, and the cross at his neck, and rope tied around his waist, combined with the solemnity of his bearing, give him an unmistakably patriarchal appearance.

A decade after Rembrandt's death, Sandrart recorded that he had 'countless distinguished children for instruction and learning, of whom every single one paid him one hundred guilders annually'.[4] Rembrandt's large studio was run in an unconventional and informal manner; he sometimes signed his pupil's paintings and they occasionally reworked his compositions as demonstrated by figure 1. The names of twenty of Rembrandt's pupils are recorded by Sandrart and other sources, however, the records of the Amsterdam Guild of St. Luke have been lost, and sadly it is therefore impossible to ascertain the complete list.

Rembrandt van Rijn and pupil, *Self-Portrait*, Private Collection (Figure 1)

[1] A similar signed composition depicting the same sitter by a pupil of Rembrandt in the Museum Narodowe, Warsaw, is identified by Werner Sumowski as the Monogrammist HVT. See W. Sumowski, *Gemälde der Rembrandt-Schüler*, Landau/Pfalz 1983, vol. VI, p. 4004, cat. no. 1389.

[2] The portrait was restored to its original state by the Rembrandt Research Project, revealing the original self portrait underneath, and sold at Sotheby's in 2003 for nearly seven million pounds.

[3] Simon Schama, *Rembrandt's Eyes*, London, Penguin Books, 1999, p.336.

[4] Joachim von Sandrart, Teutsche Academie, Nürnberg, 1679.

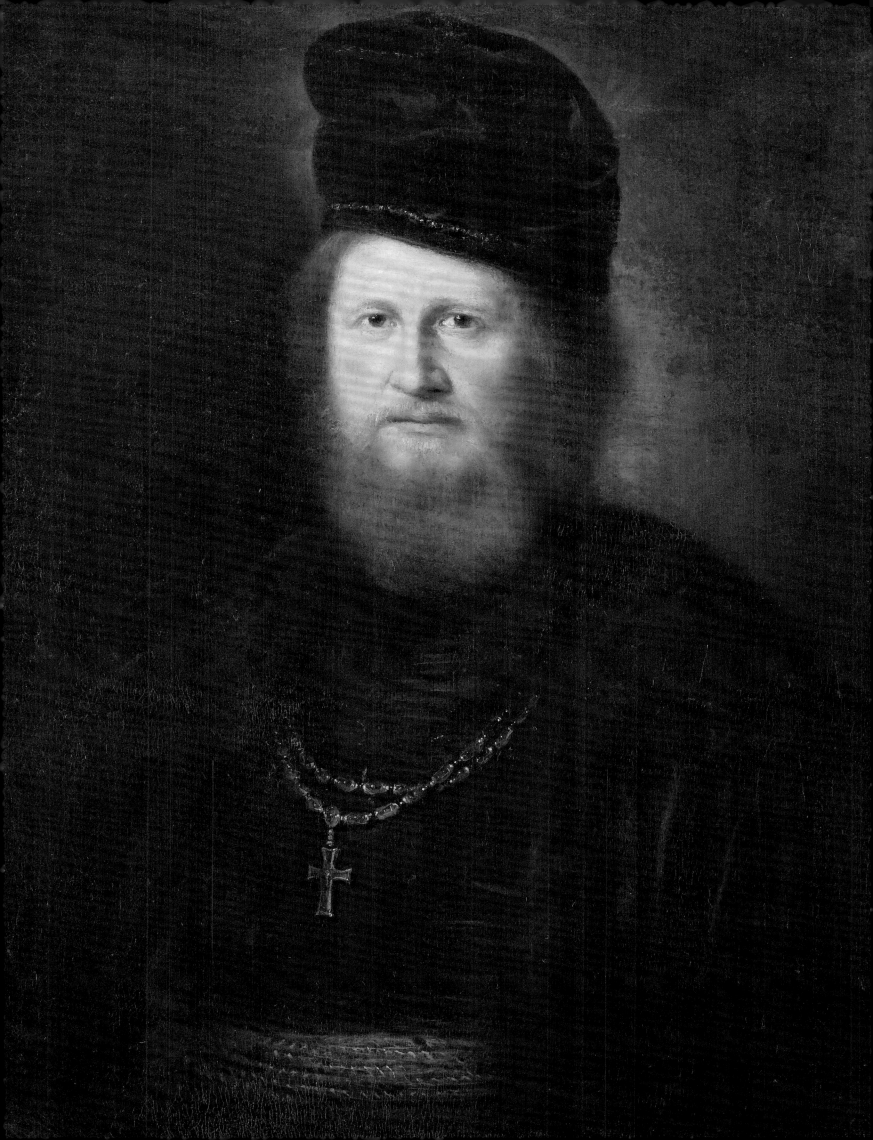

ATTRIBUTED TO
DANIËL DE KONINCK

(Amsterdam 1668 - England, after 1720)

Portrait of a Man, Half-Length, Wearing a Plumed Turban and

Gold Embroidered Red Cloak with a White Shawl

oil on canvas
64.5 x 51.5 cm (25¼ x 20¼ in)

Provenance: In the family of the previous owner since at least 1910.

THIS STRIKING PORTRAIT, ATTRIBUTED TO DANIËL de Koninck, exemplifies the seventeenth-century fashion for romanticising sitters by depicting them in eastern dress. The costume detail is very fine and rich, giving the man a theatrical air, while his face, pierced by soulful eyes, is depicted with great realism. He wears a large ostentatious turban that sparkles in the light with a feather pinned by a jewelled broach. The sheen of his headdress is matched by a white scarf wrapped around his neck. His red cloak is embroidered in gold, and two strands of jewels adorn his chest. The ensemble is not one that would be worn every day, and gives the impression of a studio costume.

Depictions of gentlemen dressed in exotic finery with turbans evidently made up a significant portion of de Koninck's *oeuvre* with several existing paintings by him that are similar to the present attributed work. *Portrait of a Man Wearing a Plumed Turban*, portrays a more mature gentleman wearing an equally prominent turban with a feather and a scarf wrapped around his neck in similar fashion to the present sitter (fig. 1). His sombre expression and the plain background against which he is posed, as in the present painting, stands in contrast to the frivolity and opulence of his dress.

In his 'orientalised' portraits, de Koninck appears to take inspiration from Rembrandt van Rijn (1606-1669), who devoted much of his production to *tronies*, depictions of an opportunity for the single figures in historical, oriental or imaginary costumes. These were more artist to demonstrate his skill in representing exotic garments, facial types and lighting effects, than conventional portraits. Rembrandt's *A Young Man Wearing a Turban* in the Royal Collection, see fig. 2, depicts the sitter wearing a modest turban, less flamboyant than the ones discussed thus far, but otherwise the painting is strikingly similar in composition and style to the present work. The sitter is painted bust-length, turned to the right, and wears a lustrous darkly coloured turban and gown and a long jewelled chain around his neck, clearly setting the precedent that de Koninck would follow. It has been suggested that Philips Koninck (1619-1688), Daniël's uncle, may have been one of Rembrandt's pupils, a connection that could have also influenced Daniël.

The de Konincks were a Dutch family of painters, draughtsmen and printmakers spanning several generations, although the relationships between the individual family members are unclear. Little is known about Daniël's life except that he studied under another uncle, Jacob de Koninck (c.1612-1690), from 3 September 1682. A record states that on 3 August 1690, Daniël paid off his apprenticeship fee 'to my Uncle Jacob de Koninck, Painter in Copenhagen'. Soon afterwards, he moved to Oxford and by 1720 he was living in London, where it seems he built up a considerable reputation as a portrait painter.

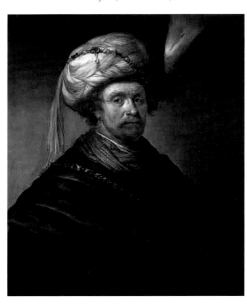

Daniël de Koninck,
Portrait of a Man Wearing a Plumed Turban,
Private Collection
(Figure 1)

Rembrandt van Rijn,
A Young Man Wearing a Turban,
1631,
The Royal Collection
(Figure 2)

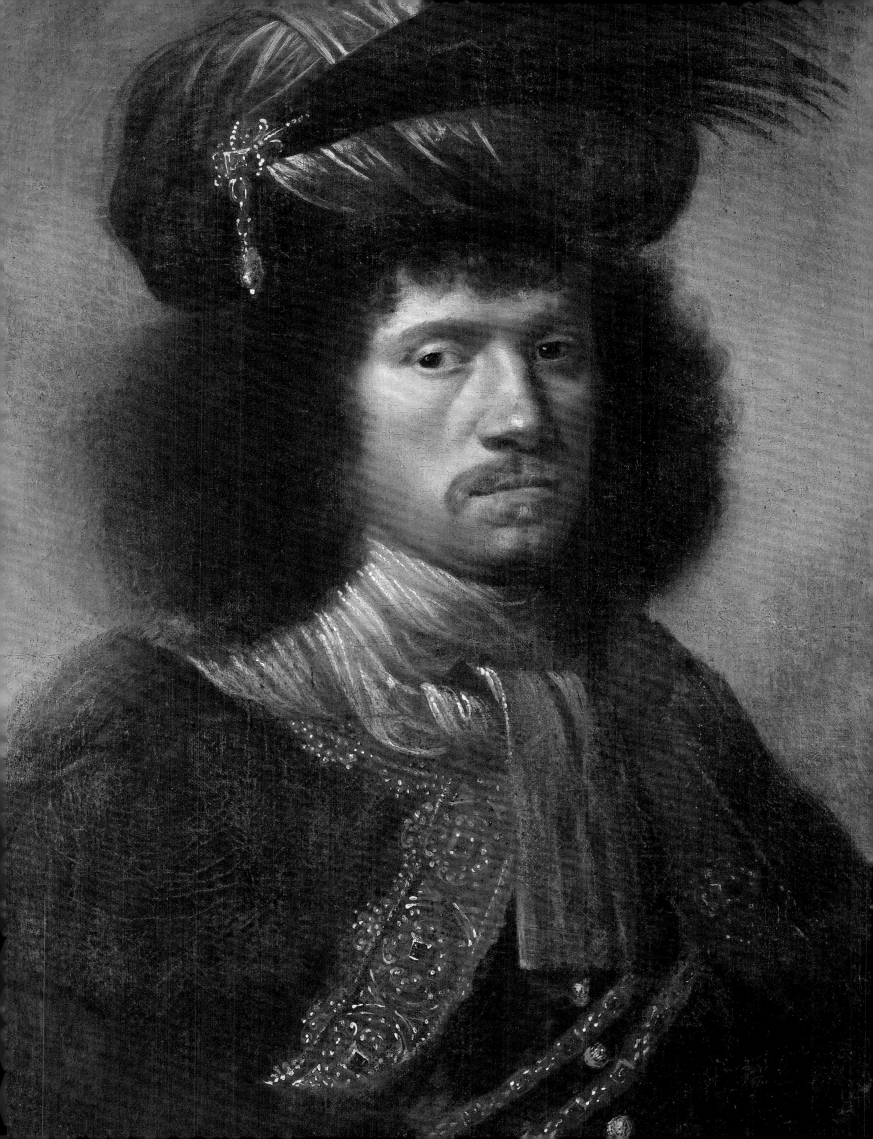

JACOB WILLEMSZ. DE WET I

(Haarlem c. 1610 - Haarlem c. 1675)

The Idolatry of Solomon

signed with monogram 'J.D.W.' (lower right edge)
oil on panel
54 x 73.5 cm (21¼ x 29 in)

SUMPTUOUS IN ITS DETAIL AND DRAMATIC IN ITS lighting effects, *The Idolatry of Solomon* by Jacob Willemsz. de Wet the Elder, illustrates the splendour of King Solomon's court and the ostentatiousness of his pagan worship. The drama of the scene is heightened by the grandiose architecture and swathes of drapery in the background, and the emotive gestures of Solomon and his retinue. The altar, made entirely of gold, and the excesses of wealth on display, speak of the king's prosperity but also the depravity that would be his ruin. Solomon's idolatry was the subject of frequent depiction in seventeenth-century northern European artwork, as to the Protestant eye it was regarded as having parallels with the Catholic Church's use of religious imagery.

The Old Testament relates that Solomon, son of David and King of Israel, prayed to God and was granted wisdom and the ability to judge good from evil. The fame of Solomon's wealth, intelligence and piety travelled far, even enticing the Queen of Sheba to visit him with gifts and praise for his deity. During his reign, Solomon expanded the kingdom, built the Temple in Jerusalem and constructed his own large palace, Fort Millo. His habit of taking multiple foreign wives, seven hundred in total, as well as three hundred

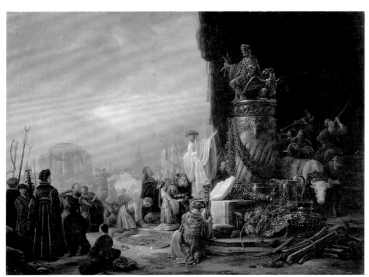

Jacob Willemsz. de Wet the Elder, *Paul and Barnabas at Lystra*,
The Ashmolean Museum of Art and Archaeology, Oxford (Figure 1)

concubines, led to his eventual fall from grace. His wives encouraged him to worship their pagan gods, and he built temples and offered sacrifices in their honour, acts that incensed God's wrath and led to the destruction of his kingdom.

In de Wet's composition, Solomon, wearing a cloak lined in ermine and embroidered with gold, is depicted in a trance-like state as he rocks back on his knees and looks up to a statue of a seated pagan deity. Behind him stands a richly dressed woman with an exotic feathered headdress, presumably one of Solomon's wives instructing him in the worship of idols. An elderly, heavily bearded priest wearing a wreath on his head stands between Solomon and a large text that is propped up on the altar. Surrounding them are participants and on-lookers, one dressed as the goddess Diana with a crescent moon in her headdress. Another holds a sculpture, perhaps an offering to be placed with the plates and urns assembled at the foot of the altar. In the background, a group of musicians raise their horns and trumpets, and one can imagine that the combination of music, flickering candle light and the heady smell of burning incense would have created quite a spectacle.

The subject of idolatry is returned to in de Wet's painting *Paul and Barnabas at Lystra*, in the Ashmolean, Oxford (fig. 1). The painting illustrates the biblical account of the people of Lystra mistaking Paul and Barnabas for gods after Paul healed a cripple. They offer adulation in a grand and extravagant style, wreathing an altar and adorning it with numerous offerings. Many of the iconographical elements of the present painting are repeated here: the altar topped with a statue of a deity, the prayer book leaned up against it, the musicians gathered in the background and the priest clothed in a white robe with a wreath around his head. *Paul and Barnabas at Lystra*, perhaps because of its outdoors setting and relative lightness in palette, has a more innocent and light-hearted tone than *The Idolatry of Solomon*, which is darkly provocative.

De Wet's *oeuvre* was primarily devoted to biblical and mythological subjects. His early work has parallels with the work of Jan Pynas (1581/2-1631) and Pieter Lastman (1583-1633), whereas his paintings from the 1630s suggest the influence of Rembrandt van Rijn (1606-1669). The emotional content and *chiaroscuro* in his compositions may indicate that he studied or had contact with Rembrandt. De Wet's later work shifts emphasis from the figures to the landscape and tends to resemble that of Benjamin Gerritsz Cuyp (1612-1652) (see Inventory). De Wet was a prolific draughtsman and many of his sketchbooks exist, some of which list the name of his pupils, including Paulus Potter and his own son, Jacob de Wet the Younger.

MAERTEN STOOP

(Rotterdam 1620 - Utrecht 1647)

A Card Game in a Courtyard

signed 'MSt..p' (lower left)
oil on panel, oval, stamped on the reverse with the panel maker's mark 'SvM' (in monogram)
46 x 62.6 cm (18⅛ x 24¼ in)

Provenance: M. & G. Segal, Basel, 1980.

THIS FINELY DETAILED AND ENGAGING PAINTING is a rare work by Maerten Stoop, an artist whose surviving works are sadly limited by the brevity of his career. Stoop specialised in genre painting and in particular guardroom subjects, portraying off-duty officers in scenes of relaxation and merriment, of which *A Card Game in a Courtyard* is an exceptionally fine example.

Guardroom subjects were initially popularised in German prints of the sixteenth century and in the large-scale figure scenes of Utrecht painters in the beginning of the seventeenth century.[1] In 1621, the Twelve Year Truce ended and fighting between the Dutch and Spanish resumed until the Treaty of Münster in 1648, when the Dutch gained their independence. The eighty year struggle made soldiers, mercenaries and members of the civic guard, male citizens who paid dues and had the right to carry firearms, rcognisable figures in Dutch seventeenth-century life and consequently the subject of paintings by Stoop and a number of his contemporaries. The buyers of guardroom paintings would have been predominantly from prosperous northern cities, which had not been directly affected by the warfare gripping the rest of the Netherlands, but would nevertheless have been interested in depictions of military life.

A Card Game in a Courtyard presents a scene in which a conspicuously well dressed woman plays a game of cards with two soldiers in a courtyard. The figures are bathed in an intensely bright light, in contrast to their surroundings, which reflects off the woman's white dress and pale skin. The company are assembled in a makeshift fashion, seated around a drum instead of a card table, and strewn about them, amongst the dirt and hay of the ground, are garments and pieces of armour that have been casually cast aside. They sit on a platform raised above the rest of the courtyard floor, on the edge of which a small dog stands alert. He faces towards a large archway on the left, through which a soldier in a brown cloak, plumed hat, blue breeches and floppy boots pensively strolls. His face is downcast in shadow

[1] Wayne Franits, *Dutch Seventeenth-Century Genre Painting*, New Haven and London 2004, pp.60-63.

Maerten Stoop, *A Card Game in a Courtyard* (Detail)

and he is seemingly oblivious to the rollicking entertainment being had by the card players. Behind him, two other soldiers, clad in blue and brown, are shown relaxing and whiling away the afternoon.

The three card players in the centre of the scene are shown reacting to the arrival of a gentleman who enters the courtyard from a side door. One of the seated soldiers flamboyantly doffs his hat while the other one peeks at the lady's cards, as she exposes in a moment of distraction. Not only the presence of the female, but also her inviting gaze, casual pose and revealing body language, with one arm outstretched, dangling a locket on a chain as if to lure the visitor into the game, suggests that she is likely to be of dubious virtue. It would appear that her jewellery is being used as the stakes for the game, and the locket will soon join the pearl necklace that has already been surrendered and lies on the drum. Luxuriously clad in a white silk dress, embroidered with gold and tied at the waist with a peach coloured sash,

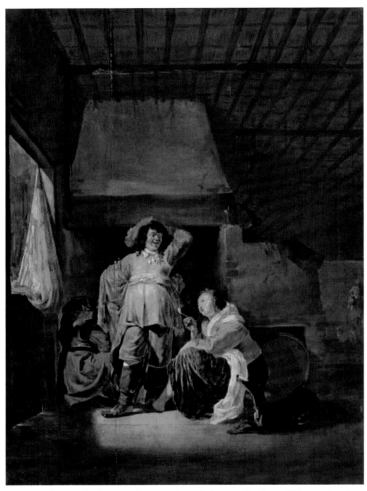

Maerten Stoop, *An Interior Scene with an Officer and a Seated Woman Smoking a Pipe*, Private Collection (Figure 1)

Maerten Stoop, *A Card Game in a Courtyard* (Detail)

the lady appears not to mind risking her valuables. The man seated across from her is dressed in a dishevelled, cavalier manner, with his bare knee showing from between his breeches and hose and his coat carelessly flung behind him. He wears a buff doublet with slashed sleeves, and a shirt with a large soft collar. His relaxed and informal appearance suggests he has been off duty for a length of time, in contrast to his comrade who is entering from outside, dressed in a voluminous blue cloak with boots pulled up well above the knee for warmth.

The low vantage point from which Stoop depicts *A Card Game in a Courtyard* shortens and exaggerates the already rotund bodies of his subjects. Their plump faces are portrayed tilted either up or down, emphasising the folds under their chins and the roundness of their cheeks, giving them a jovial and naturalistic appearance. These techniques are used repeatedly by Stoop to portray soldiers and their companions thus lending them an unpretentious charm and approachability. In another painting by Stoop, *An Interior Scene with an Officer and a Seated Woman Smoking a Pipe*, the figures are grouped in a corner of a room by the fireplace (fig. 1). A large part of the composition, as in the present painting, is taken up detailing the spartan interior with its plain brown walls. The depiction of the ceiling's rafters stretching across the room suggests that the artist is painting the scene from a seated position on the floor much like the figures in the present painting. In Stoop's pictures, there is a noticeable lack of furniture and the figures are resourceful with the objects around them.

In *An Interior Scene with an Officer and a Seated Woman Smoking a Pipe*,

the swaggering officer figures most prominently, wearing a pink doublet and breeches and matching cloak, with a buff jerkin jauntily tied at his waist with a sash. He stands with one arm on his hip and the other raised behind his head. He has a pleasantly jovial demeanour and appears to joke with the woman seated near him. She stares vacantly out of the window while holding a pipe. Similarly, in the present picture, the subjects are shown passing the time and whether in their quarters or camped in a courtyard, they are trying to divert themselves while off duty.

A combination of cheerfully rotund figures and meticulous attention to detail defines Stoop's work. In *A Card Game in a Courtyard*, his depiction of even the smallest item is exact and the play of light on each one gives it added dimension, from the locket held out in the woman's hand to the locks on the open trunk at her side. Stoop's ability to render the texture of different surfaces makes the objects appear tangible. The sartorial detail is equally impressive, with each fold of the lady's dress and each button and loop of the soldier's coat convincingly painted so as to immediately engage the viewer's eye.

Stoop's powers of observation are matched by his sense of humour, which is evident in his painting *An Officer in Billeted Quarters*, in the Rijksmuseum (fig. 2). The officer, revealed in a state of undress, smoking a pipe, is nonchalant and self-absorbed. He absent-mindedly lifts one of his legs so that a boy can remove his boot and in the meantime fails to notice the woman in the corner of the room rifling through his belongings. She glances cursorily towards him while leaning over the open trunk but the officer is turned away, seemingly lost in

Maerten Stoop, *An Officer in Billeted Quarters*,
Rijksmuseum, Amsterdam (Figure 2)

Maerten Stoop, *A Card Game in a Courtyard* (Detail)

contemplation of the curls of smoke swirling from his pipe. His surroundings are in a state of neglect, with the rough wooden beams of the ceiling and the brickwork of the walls exposed, and his clothing and personal belongings flung carelessly about. The disarray and chaos of the soldier's quarters, like that of the courtyard in the present painting, clearly delighted Stoop and he portrayed his subjects' surroundings as vividly as he did their dress and character. Interior views also gave Stoop an opportunity to demonstrate his handling of perspective, which was clearly of particular importance in *A Card Game in a Courtyard*, as the doorways to the right and left of the central group and the vista through to a secondary room give the composition a greater depth and enhance the illusion of space.

Stoop was a contemporary of Nicolaes Knupfer (*c.*1609-1655), a German painter who depicted genre and narrative scenes set in Utrecht, and Jacob Duck (*c.*1600-1667) who, like Stoop, specialised in guardroom pictures. Duck's painting, *Interior with Soldiers and Women*, exemplifies the subject matter that characterised his work (fig. 3). Like Stoop, Duck employed a relatively monotone palette, heightened only by the addition of a brightly coloured sash or garment, in this case the vivid pink of one on the soldier's hose, casually unrolled. The soldiers wear buff jerkins or doublets from which their white shirt sleeves show, and plumed hats. They present themselves in a confidently casual manner similar to that of the men in *A Card Game in a Courtyard* or *An Interior Scene with an Officer and a Seated Woman Smoking a Pipe*. Discarded guns and pieces of armour are scattered around the room, as well as a bass viol, which is propped up against the wall. The inclusion of a musical instrument as a motif in painting, could be interpreted as a commentary on the harmonies of sexual attraction. The teasing tension and flirtatiousness between the sexes is evident, as in *A Card Game in a Courtyard*.

Stoop was the son of the stained-glass artist Willem Jansz. Stoop (fl. 1633-44) and the brother of Dirck Stoop (1610-1686), who specialised in Italianate landscapes with hunting parties, views of ports, cavalry scenes and history paintings. It is thought that Maerten was an apprentice in the Utrecht Guild of St. Luke in 1638, which explains the similarities between his *oeuvre* and that of Knupfer and Duck. Biographical details about the artist, however, are even more scarce than examples of his work.

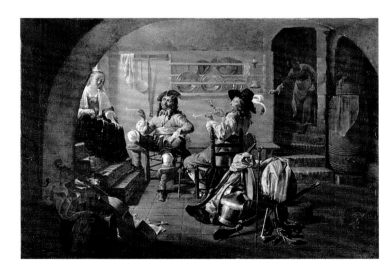

Jacob Duck, *Interior with Soldiers and Women*,
*c.*1650, the J. Paul Getty Museum, Los Angeles (Figure 3)

WILLEM DE POORTER

(Haarlem 1608 - after 1648)

Croesus Shows Solon his Wealth

oil on panel
47.2 x 37.2 cm (18⅝ x 14⅝ in)

Provenance: D. Alazraki; New York, 2000;
Maastricht. TEFAF, 2000

Exhibited: Athens, National Gallery, *Greek Gods and Heros in the Age of Rembrandt and Rubens,* 28 September, 2000 to 8 January, 2001, no. 59.

Literature: Paarlberg, S., *Greek Gods and Heros in the Age of Rembrandt and Rubens,* no. 59, with illustration.

'Croesus broke in angrily, "What, stranger of Athens, is my happiness, then, so utterly set at nought by thee, that thou dost not even put me on a level with private men?"

"Oh! Croesus," replied the other, "thou askedst a question concerning the condition of man, of one who knows that the power above us is full of jealousy, and fond of troubling our lot. A long life gives one to witness much, and experience much oneself, that one would not choose...I see that thou art wonderfully rich, and art the lord of many nations; but with respect to that whereon thou questionest me, I have no answer to give, until I hear that thou hast closed thy life happily. For assuredly he who possesses great store of riches is no nearer happiness than he who has what suffices for his daily needs, unless it so hap that luck attend upon him, and so he continue in the enjoyment of all his good things to the end of life. For many of the wealthiest men have been unfavoured of fortune, and many whose means were moderate have had excellent luck."' [1]

THIS INTRICATE JEWEL-LIKE PAINTING BY WILLEM de Poorter illustrates a conversation between Croesus, King of Lydia, and the Athenian statesman Solon (638-558 BC), narrated by Herodotus. The fabulously wealthy Croesus, after inviting the visiting statesman to view his riches, asked Solon who he deemed to be the world's happiest person. Instead of giving Croesus the answer he sought, Solon told him that happiness could only truly be judged at the end of a life and described three men, none of whom were kings, who he considered to have been the happiest. Tellus of Athens was the first, having led a full life and died in battle with honours. Cleobis and Bito came a close second, dying peacefully in their sleep as a result of their mother beseeching the goddess Juno to bestow on them the highest blessing attainable by mortals.

Croesus, left discontented after Solon's departure, was afterwards punished by the gods for daring to presume himself the happiest of men. The price was his son's accidental murder and his wife's suicide at the fall of Sardis. Croesus' empire was defeated by the Persians in *c.*547 BC, and thus his story is presented as a moralistic exemplum of the fickleness of fate.

Illuminated by a horizontal beam of light from the left of the composition, the figure of Croesus in *Croesus Shows Solon his Wealth* is

regal in bearing and richly clad. He wears a gold robe that glints in the light and a red cloak slung over his shoulders. A fringed sash is knotted at his waist and a sword, with an ornately wrought handle, can be seen at his side. Adorning his head is a turban of red and white cloth, giving him an oriental, rather than Hellenic, air. Croesus gestures dramatically towards his riches, which sparkle with brilliance, and looks demandingly at Solon. Solon stands back in the shadows as he surveys the scene with a grave

Willem de Poorter, *Croesus Shows Solon his Wealth* (Detail)

[1] Herodotus, The History of Herodotus, George Rawlinson, tr., vol. 1, Book 1, New York, D. Appleton and Company, 1885.

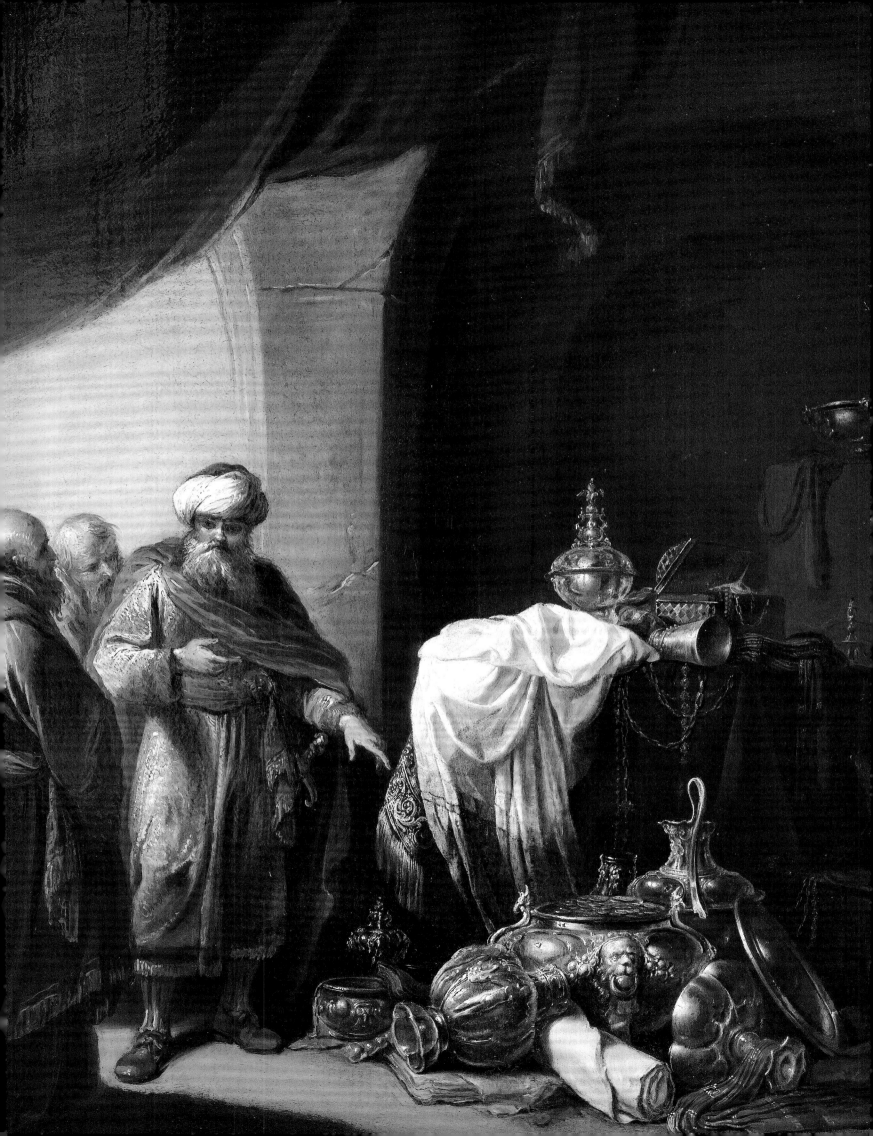

expression on his face. His sombre clothing and bare head create a stark contrast to the attire of his host and indicate his wisdom and humility, qualities which, like happiness, cannot be acquired with wealth.

Between the king and sage, a third man can be seen straining his neck to glimpse the splendour on display. A variety of vessels and urns, all elaborately embellished and shining with gold, lie scattered on the floor and on a table covered in dark red velvet. The casual manner in which the items are assembled, many leaning on their side, suggest they were tossed there with little thought and comprise only a fraction of Croesus' wealth. A burnished urn and an open chest, from which jewels spill out, sit on the table, as well as a heap of colourful drapery and an ornately embroidered rug. Each luxurious item is surpassed by the next and at the base of the table a large pot overflows with gold coins. The immensity of the king's fortune and its conspicuous display is both alluring and repulsive, and reflects the ambivalent attitude towards wealth and consumption found in many of de Poorter's works. These same contradictions were generally present in seventeenth-century Dutch society, where the restraints of Calvinist inhibition were matched by unprecedented fortune, the availability of foreign goods and mass consumption. In *The Art of the Dutch Republic 1585-1718*, Mariët Westermann describes the Dutch mentality, 'which revelled in prosperity yet was anxious about the moral consequences of wealth; a constellation of beliefs that celebrated Dutch enterprise but obsessively acknowledged its dependence on God's benevolence'.[2]

De Poorter's painting of *The Idolatry of King Solomon* in the Rijksmuseum, Amsterdam, see fig. 1, like *Croesus Shows Solon his Wealth*, illustrates a moralising story that was particularly popular in seventeenth-century Dutch society.[3] The downfall of Solomon, resulting from his

worship of idols is not dissimilar to Croesus' decline after daring to believe his riches would make him the happiest man in the world. In *The Idolatry of King Solomon*, the king, in an opulent green and gold robe, kneels before an altar covered in flames. His exotically dressed foreign wife stands at his side encouraging him to worship her pagan deities, represented by the statue of Venus above. Idolatry, like gold and riches, is portrayed as a seducer of men, and reflects the Protestant disapproval of the Catholic Church's use of religious imagery at this time.

In both images de Poorter masterfully expresses drama and narrative through lighting effects. He uses spot lighting, in the manner of Rembrandt van Rijn (1606-1669), to draw attention to his subjects and also reveals the influence of Leonard Bramer (1596-1674) in his theatrical highlighting of key features of the painting. De Poorter's use of *impasto* in white and pale yellow to define and enhance the surfaces of the gold vessels and Croesus' garments give the present work added texture and differentiation. Croesus in the present painting is bathed in light, as is Solomon in *The Idolatry of Solomon*, who is illuminated by a shaft of light coming from an upper window. This same style of lighting is evident in *An Allegorical Subject (The Just Ruler)* in the National Gallery, London (fig. 2). The figure in the painting, who may be Merit in the guise of the just ruler, stands directly in the path of a beam of light, which glances off his armour. The contrast between light and dark is at its strongest here,

[2] Mariët Westermann, *The Art of the Dutch Republic 1585-1718*, The Orion Publishing Group, London, 1996.
[3] A painting by Jacob Willemszoon de Wet I of the same subject is also illustrated in this catalogue, see cat. no. 41.

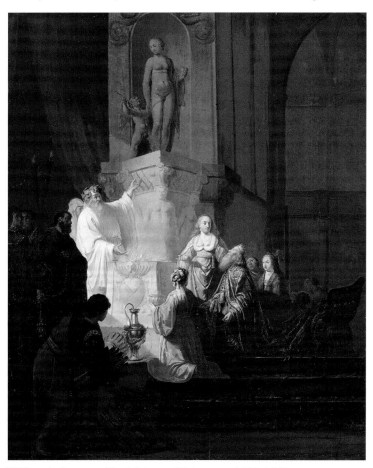

Willem de Poorter, *The Healing of the Blind Tobit*,
Private Collection (Figure 3)

Willem de Poorter, *Croesus Shows Solon his Wealth* (Detail)

with the majority of the picture opaque and shadowy while the figure stands out. The actual source of illumination, hinted at in these paintings is revealed in another work by de Poorter. *The Healing of the Blind Tobit* (fig. 3). Here the light issues from an open window and sweeps over the figures grouped around Tobit and past them to the still life of bowls and jugs in the far right of the composition.

In addition to bathing his paintings in dramatic Rembrandtesque illumination, de Poorter also delighted in representing the subtle play

Willem de Poorter, *Vanitas Still Life*, 1636,
Herzog Anton Ulrich-Museum, Braunschweig (Figure 4)

of light on different objects and substances. In *Croesus Shows Solon his Wealth*, he expertly depicts reflections on a variety of surfaces, from the smooth roundness of the urn sitting on the table, to the matte roll of paper lying on the ground and to the richly textured garments worn by Croesus.

De Poorter achieved similar effects with his depictions of burnished armour, which he often incorporated into narrative and allegorical scenes, as in *An Allegorical Subject (The Just Ruler)*, or his still lifes. *Vanitas Still Life* in the Herzog Anton Ulrich-Museum, Braunschweig, is made up of pieces of armour assembled on a stone ledge with drapery and a skull (fig. 4). The pile of armour echoes the mass of gold and riches in *Croesus Shows Solon his Wealth* and the combination of diagonally jutting objects and curving forms captures the powerful impact of light. The orange, white and blue of the fabrics may represent a flag or banner and allude to political affairs at the time of painting, as de Poorter executed several similar still lifes with armour during the mid 1630s, at the height of the Eighty Years War. The skull is symbolic of the mortality of man and the vanity, or futility, of earthly goods and pursuits, a theme that could be applied equally to the king's accumulation of fortune in *Croesus Shows Solon his Wealth*.

De Poorter's first works were recorded in Haarlem in 1631. In 1634, he was registered as a master painter and in the following year, Pieter Casteleijn was named as his pupil. Pieter Abrams Poorter and Claes Coenraets were also apprenticed under de Poorter later on in his career. The archives of the Haarlem Guild of St. Luke mention de Poorter for the last time in 1645, the year that he moved to Wijk bij Heusden. It is thought that he may have studied under Rembrandt, along with his fellow townsman Jacob de Wet (see cat. no. 41). De Poorter's small scale biblical and historical compositions are so markedly similar to Rembrandt's paintings of the same subjects from *c.*1630 that the hands of the two artists are often confused. De Poorter did on occasion copy paintings by Rembrandt, such as his *Presentation in the Temple* of 1631. If he were a pupil of Rembrandt, it seems likely that he received his training in the master's Leiden workshop, as Rembrandt's move to Amsterdam in 1631 coincided with de Poorter's first known work painted in Haarlem. In Leiden, he would have come into contact with Gerrit Dou (1613-1675) who worked there from 1628, and who reasserted the traditional Netherlandish concern for meticulous craftsmanship by establishing a school for fine painters. Fine painting, as well as dramatic lighting and a preference for still lifes, whether as the subject of a composition or incorporated into a historical narrative, characterise de Poorter's work.

HENDRICK BLOEMAERT

(Utrecht c. 1601 - Utrecht 1672)

Artemisia in Mourning

signed 'Henr: Bloemaert f.' (lower left)
oil on canvas
65.5 x 177.3 cm (25¾ x 69¾ in)

Provenance: Acquired privately in London *c.*1900, and thence by descent to the previous owner.

Literature: M. G. Roethlisberger, *Abraham Bloemaert and his Sons*, The Netherlands, 1993, I, pp. 471-2, no. H64; II, fig. H66.

THIS PAINTING BY HENDRICK BLOEMAERT IS A powerful and emotive image of grief. Artemisia II of Caria was a woman associated with extraordinary mourning. After the death of her husband and brother King Mausolus, she devoted the remaining two years of her life, during which time she also ruled Caria, to grieving him and to preserving his memory in perpetuity. During these two years of pining, from 352 to 350 BC, she is reputed to have mixed Mausolus' ashes in her daily drink, persuaded the most eminent Greek rhetoricians to praise him in their oratory and constructed a monument to his memory at Halicarnassus (present day Bodrum, Turkey). So splendid and majestic was the tomb of Mausolus, that Antipater of Sidon listed it as one of the Seven Wonders of the Ancient World, and it provides the etymology for the word 'mausoleum.'

In *Artemisia in Mourning,* Bloemaert shows the queen kneeling before the enormous golden urn containing the ashes of her late husband. The opulence of the urn and the fresh garland of flowers draped on it suggest the devotion and regard that Mausolus inspired. Next to Artemisia is a priest who swings the thurible full of burning incense over the urn. This is presumably part of the ceremony that takes place before the ashes are placed in the queen's cup, which she holds in her left hand ready to drink from. She holds her right hand to her breast whilst looking to the heavens, caught up in her memories of Mausolus. The small dog is a symbol of love and fidelity, and emphasises the message of continued loyalty on the part of Mausolus' grieving widow. The rest of the scene depicts courtiers who display a variety of reactions to the queen's grief - some of the men on the right-hand side look on admiringly at Artemisia's devotion, as do her young attendants. However, three kneeling women whisper to each other in an almost disbelieving fashion. The three older, standing figures on the left hold an impromptu conference, their faces etched with concern for their leader. The muted grey palette of the background wall and the urn's raised platform reinforce the sombre mood of the painting.

Bloemaert was the eldest son of the hugely successful painter, Abraham Bloemaert (1566-1651) (see Inventory). Hendrick was trained by his father, and this early influence significantly influenced his style and future career. This is clearly illustrated by a comparison of *Artemisia in Mourning* to a work of Abraham's, such as *The Emmaus Disciples* (fig. 1). Abraham's mature work was Caravaggesque in style and paintings such as *The Emmaus Disciples* are marked by intense lighting and dramatic *chiaroscuro*. The careful, often playful, use of light - a key aspect of Abraham's work - is also present in *Artemisia in Mourning*. In both works the only light source seems to emanate from a candle, yet the contrasts between light and dark are powerful. Furthermore, both works focus on the heavy emotional content. In Abraham's work we see the startled reactions of the two disciples as they suddenly realise that the man, to whom they have been talking for some time, is in fact the resurrected Christ. Their expressions are accentuated by that of the servant who is oblivious to the cause of their surprise.

Hendrick is the best known and most accomplished painter of Abraham's sons and, despite his father's enormous artistic influence, was the only painter to continue to work in the master's mature manner. However, later in his career he started to move away from the style associated with Abraham and adopted a more classical approach, as was practised in Utrecht, Haarlem and at Court in the mid to latter part of the seventeenth century.

Abraham Bloemaert, *The Emmaus Disciples*, 1622,
Musées Royaux des Beaux-Arts, Brussels (Figure 1)

The painting is illustrated in detail on opposite page and in full overleaf.

JAN DE BRAY

(Haarlem c.1627 - Haarlem 1697)

The Adoration of the Magi

indistinctly signed and possibly dated (lower right, to the right of the kneeling king's crown)
oil on oak panel
71 x 55 cm (28 x 21½ in)

Provenance: Anonymous sale, Amsterdam, de Winter & Yver, 8 September, 1773, lot 34 (apparently as Salomon de Bray),
to J. van der Hoogt (according to Hofstede de Groot, cited by von Moltke under Literature);
possibly anonymous sale, Amsterdam, 1 October, 1778, Ploos v. A. & Yver, lot 35 (as Salomon de Bray), to Delfos for 25 Guilders;
Johannes van Bergen van der Gryp, Malucca and Leiden, His deceased sale, Soeterwoude, A. Delfos, 25 June 1784, lot 12 (as Jacob de Bray);
anonymous sale, London, Christie's, 29 November, 1946, lot 137 (as G. van den Eeckhout), to Agnew's;
with Thomas Agnew & Sons Ltd., London, 1949, from whom acquired by John Vaughan-Morgan, later Lord Reigate;
thence by family descent; Sold, London, Sotheby's July 7, 2005 lot 14;
with Otto Naumann.

Literature: Probably J.W. von Moltke, 'Salomon de Bray' in *Marburger Jahrbuch für Kunstwissenschaft*,
vols. 11-12, 1938-9, p. 382, no. 34 (recording the 1773 sale; as Salomon de Bray);
J.W. von Moltke, 'Jan de Bray', in *Marburger Jahrbuch für Kunstwissenschaft*, vols. 11-12. 1938-9, p. 466, no. 14
(recording the van Bergen van der Gryp sale; as 'Jan de Bray');
A. van Suchtelen, 'De aanbidding der herders door J. de Bray', in *Mauritshuis in Focus*, vol. 10, 1997, pp. 14-16, also footnote 4;
J. Giltaij, in *Dutch Classicism in Seventeenth Century Painting*, exhibition catalogue,
Rotterdam 1999, p. 303, under cat. no. 59, reproduced fig. 9b (as whereabouts unknown);
P. Lammerstse, *Painting Family: The de Brays*, exhibition catalogue, Haarlem (Frans Hals Meseum)
and London (Dulwich Picture Gallery) 2008, p. 104, illus. no. 37b.

THE ADORATION OF THE MAGI PRESENTS A POISED and mature interpretation of the popular iconography of the Nativity of Jesus. Centrally seated, the Virgin Mary tenderly cradles the infant baby who is seated on her lap and nestled in amongst a crisp white cloth. In the centre one of the three Magi kneels closely to the Virgin and Child and presents a slightly opened gold jar. His elaborate turban, topped with a gold crown, rests on the floor to the right and references his exotic homeland. His lengthy cream train is carried by a young pageboy who peers at the viewer directly on the left. The central three figures are gently illuminated by a soft light, allowing the viewer to sense the intimacy of the gift offering.

Kneeling closely behind are the two remaining biblical Magi. One wears a fur mantle, and in his hand clutches a decorative silver incense burner, presumably containing either the frankincense or myrrh. The other, his gift concealed, wears a red cloak and gazes intently at the infant Jesus. In the background, several armed soldiers and a plumed horse, representative of the Magi's entourage, watch the activity unfolding inside the stable. The simple,

Jan de Bray, *The Adoration of the Magi* (Detail)

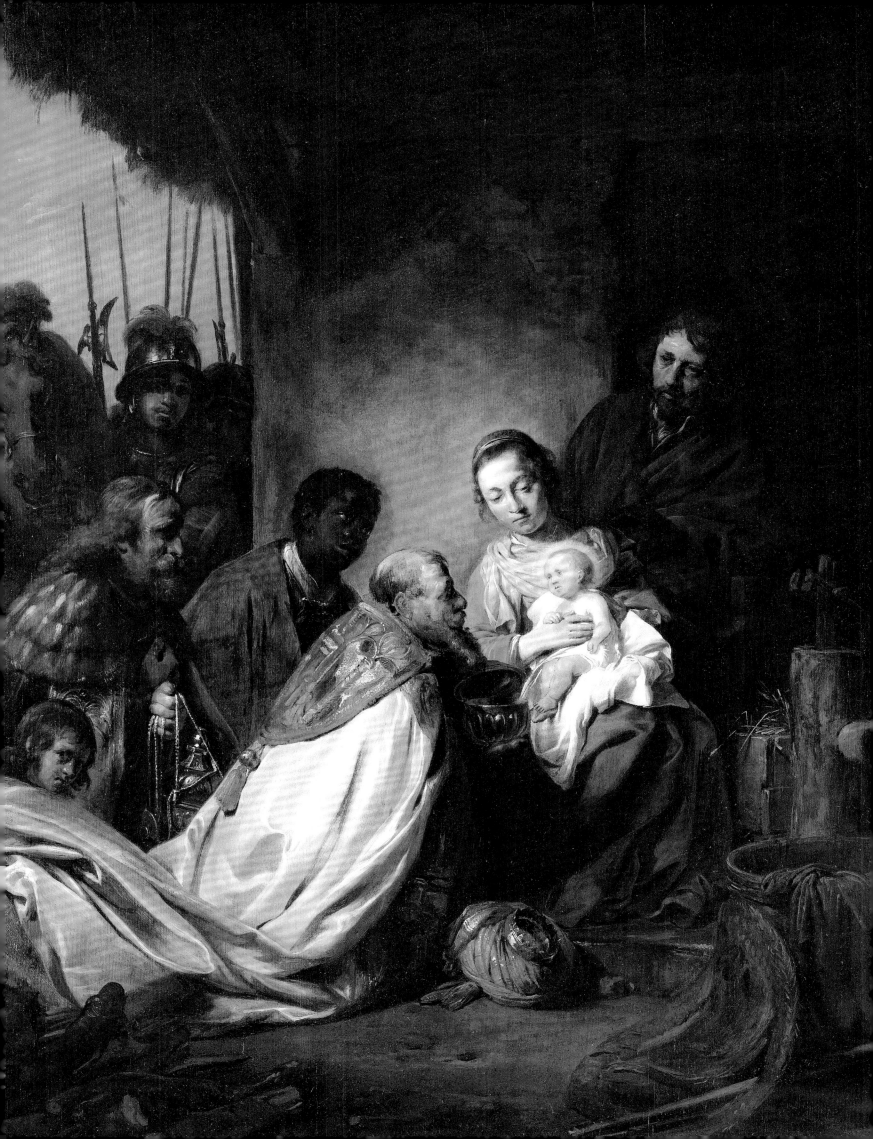

Jan de Bray, *The Adoration of the Magi* (Detail)

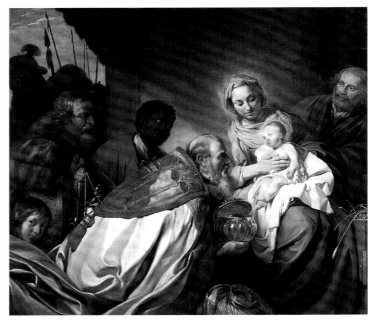

Jan de Bray, *Adoration of the Magi*, 1674, Historisches Museum, Bamberg (Figure 1)

rustic interior depicted is in keeping with the traditional stable believed to have housed the Adoration of the Magi; for example, the stack of logs on the left foreground and the wooden beamed ceiling. In the right foreground there is an open barrel with material slung over the side, and the stick that lies below suggests that this equipment is used for washing. Standing behind the Virgin on the right is the bearded figure of Joseph. With his left arm he leans on wooden machinery, which possibly refers to his *métier* as a carpenter.

Jan de Bray, *The Adoration of the Magi* (Detail)

As the recent exhibition catalogue, *Painting Family: The de Brays* (see lit.) discusses, 'Jan de Bray was one of a large family of painters living and working in Haarlem; his father, Salomon, was a successful artist, as were two of Jan's brothers, Dirck and Joseph. The family worked together very closely, studying each other's paintings, sharing advice, and maintaining an archive of the workshop's production. A feature of this studio practice was that Jan and the other de Brays regularly made drawn copies of the paintings produced in the family workshop, drawings that served not only as archival records, but also as *prospecti* for future clients who might want to commission similar paintings.'

Painted in 1658, *The Adoration of the Magi* and the drawing made after it is an example of this practice in the family workshop. De Bray returned to the subject of the Adoration once again in 1674. Most likely using the preparatory drawing from the present work, he completed the larger canvas, which is now in the Historisches Museum, Bamberg (fig. 1).[1]

The Bamberg picture depicts the Adoration from a somewhat closer viewpoint with almost exactly the same central figure grouping as the present work, and displays a more expertly designed and neater composition. Though the two works are virtually identical, the face of the Virgin is notably different. In the present work she appears youthful, almost girlish, with softened curls and subtly coloured cheeks, whereas in the Bamberg picture the Virgin is depicted as older and the rendering of her facial features and gaze towards the infant Jesus references the work of Leonardo da Vinci (1452-1519). Furthermore, in the Bamberg version she wears a yellow scarf wrapped around her head and neck, whereas in the present work it hangs loosely around her neck.

Paintings by Salomon de Bray (1597-1664) and his son Jan have often been confused in the literature. The confusion originates in descriptions in old sale catalogues: for example the present picture appears to be the one sold as Salomon de Bray in 1773, and can be identified with greater certainty as the one sold as by 'Jacob de Bray', dated 1658, in the van Bergen van der Gryp sale in 1784. Von Moltke therefore listed what was probably the same picture in his *catalogue raisonnés* of both artists. To further muddle the situation, the

[1] De Bray also completed a similar scene depicting the Adoration of the Shepherds in 1665, now held in the Mauritshuis Royal Picture Gallery, The Hague.

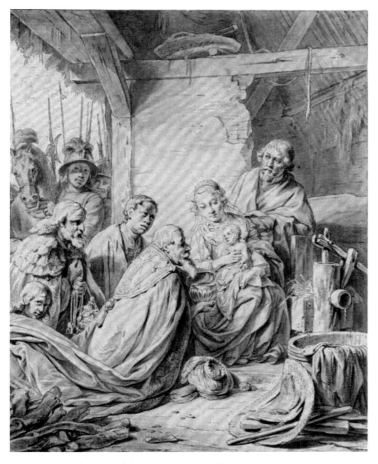

Jan de Bray, *Adoration of the Magi*, Private collection, (Figure 2)

present picture was sold at Christie's in 1946 with an attribution to Gerbrand van den Eeckhout. A photograph at the Rijksbureau voor Kunsthistoriche Documentatie in The Hague records subsequent attributions: to Jan de Bray made by Horst Gerson; and to Salomon de Bray by Albert Blankert. The question was resolved with finality when the connection between the painting and Jan de Bray's signed drawing was published by Ariane van Suchtelen in 1997 (fig. 2).

Jan de Bray, *Leading Members of the Haarlem Guild of St Luke*, 1675, Rijksmuseum, Amsterdam (Figure 3)

Jan de Bray, *The Adoration of the Magi* (Detail)

De Bray worked in Haarlem for virtually the whole of his career, except for the period 1686-1688, when he lived in Amsterdam where he helped to design a freshwater reservoir. As in Utrecht, most of the Haarlem painters remained Catholic unlike their Protestant counterparts in Amsterdam. After training with his father, de Bray began working as a portrait painter in Haarlem in 1650, an activity he continued for the next forty years. Between 1667 and 1684 he served on the committee for the Haarlem Guild of St. Luke, whose leading members he portrayed in a picture dated 1675 - *Leading Members of the Haarlem Guild of St Luke*, see fig.3, which includes a self-portrait (Jan is seen standing and drawing on the left). He married three times, in 1668, 1670 and 1672. His first two wives died a year after their marriage, his third two years afterwards, and in each case the death was followed by disputes over the inheritance. De Bray's bankruptcy of 1689 may have been a result of one of the lawsuits. He was sixty-two at the time, and from then onwards he seems to have lost his artistic drive, crushed by the financial blow and the consequent loss of social position.

As a key figure in Dutch Classicism of the seventeenth century, de Bray, like his contemporaries, drew inspiration from the same ancient writers and sources as the Italian artists of the fifteenth century. Working in the classical tradition, these artists emphasised harmony, proportion and balance in their compositions in order to present an idealised beauty.

Jan de Bray, *The Adoration of the Magi* (Detail)

JAN DE BRAY

(Haarlem c.1627 - Haarlem 1697)

Bacchus

oil on panel
23.2 x 18.1 cm (9⅛ x 7⅛ in)

BACCHUS, OR DIONYSUS IN GREEK MYTHOLOGY, IS presented as a youthful male in this portrait by Jan de Bray. His luxuriant hair falls on his shoulders and a length of ivy is wrapped loosely around the crown of his head. His cheeks and lips are softly tinged pink and his young age is evident in the wispy beard and moustache he appears to be growing. His eyes are cast outside the picture space, perhaps indicating his intoxication, as he looks longingly at something unbeknown to the viewer.

Bacchus was the god of wine and drunken revelry, as well as inspirer of ritual madness and ecstasy. He was a major figure in Greek and Roman mythology and was one of the twelve Olympians. In Greek popular culture he was believed to preside over regular Dionysiac festivals, which were characterised by ritual license and revelry, including the reversal of social roles, cross-dressing by boys and men, drunkenness, widespread boisterousness and obscenity. This tradition was introduced in Ancient Rome as *Bacchanalia* in *c.*200 BC Initially only attended by women, these louche social gatherings gradually allowed the admittance of men. However, the rapid spread of the cult and suspicion that crime and political conspiracies were being discussed during these nocturnal meetings lead to the Senate decree in 186 BC, which suppressed these gatherings except in special circumstances.

No other deity is more frequently represented in ancient art than Dionysus or Bacchus. However, Bacchus and the subject of the Bacchanal were also richly represented in Renaissance and Baroque art as part of a voracious taste for pagan and classical iconography. Artists such as Caravaggio (1571-1610), and Rubens (1577-1640) indulged with considerable artistic licence when depicting the wild and mystic figure of Bacchus, and the extravagant ceremonies associated with this pagan god of excess.[1]

Jan de Bray was a Dutch artist who spent virtually all of his life and career working in Haarlem, and was the city's most important painter during the second half of the seventeenth century. He was a highly regarded portraitist, and over half of his output consists of individual portraits. De Bray is also known for his historical painting and portraits, or *portrait historié*.[2] Works of this type portrayed individuals in the guise of figures

Jan de Bray, *The de Bray Family (The Banquet of Antony and Cleopatra)*, 1669, Currier Gallery of Art, Manchester, New Hampshire (Figure 1)

from the Bible, mythology, or ancient history and thus drew comparisons between the virtues of the sitters and the historical personalities. The sitters were contemporary individuals, patrons, and often members of the de Bray family and loved ones; one example of this hybridised *oeuvre* is a portrait of his extended family in the setting of the banquet of Anthony and Cleopatra (fig.1). It is also possible that the young man depicted in *Bacchus* was a person well known to de Bray, whom he then used as a model to represent the classical god.

[1] Rubens' interpretation *The Bacchanal, c.*1618, is now held in the Pushkin Museum, Moscow.

[2] Among his finest works are two versions of the *Banquet of Cleopatra* (1652, Royal Collection; 1669, Currier Museum of Art, New Hampshire).

(Actual Size)

ATTRIBUTED TO

JACOB VAN LOO

(Sluis, nr. Bruges 1614 - Paris 1670)

Portrait of William II of Orange-Nassau (1626-1650) as a Child,

Head and Shoulders, Holding a Feathered Cap

oil on canvas
40.5 x 32.5 cm (15⅞ x 12¾ in)

Provenance: Purchased in the 1960s;
thence by descent to the previous owners.

THIS ENCHANTING STUDY OF WILLIAM II OF ORANGE-Nassau as a boy is strikingly spontaneous and informal in its approach, particularly for an image of a future ruler. The painting's soft focus, harmonious application of colour and gentle, sometimes impressionistic brushwork give it a dreamy quality. William's blue eyes pierce through the canvas, however, reminding the viewer that the subject is a lively, spirited boy. The portrait clearly takes inspiration from Sir Anthony van Dyck (1519-1641), in style and expression, portraying the sitter's sense of character and as well as idealised grace and beauty.

William II was the son of Frederik Hendrik of Orange, the Stadholder or steward of the United Provinces. On 2 May 1641, at the age of fifteen, William married Mary Henrietta Stuart, the Princess Royal and eldest daughter of King Charles I and Henrietta Maria. Van Dyck's portrait commemorating their betrothal, see fig. 1, reveals William looking slightly self-conscious in his finery in comparison to the present portrait. The contrast between the adolescent aware of his future responsibilities and the child enjoying his freedom is evident. William acceded to the stadholderate in 1647, and proved himself a determined and ambitious leader. He was instrumental in arranging the restoration of his brother-in-law Charles II

to the throne of England. William died in 1650, the official cause being smallpox, although there was a rumour of poisoning. He did not live to see the birth of his son, later William III, King of England, and left Mary widowed at the age of nineteen.

The present work, which may be a portrait in its own right or a fragment from a larger composition is attributed to Jacob van Loo. Van Loo initially trained with his father Jan van Loo (b.1585). From 1642 he lived and worked in Amsterdam, where by the 1650s he was one of the city's most highly regarded painters, along with Rembrandt (1606-1669), Bartholomeus van der Helst (1613-1670) and Ferdinand Bol (1616-1680). Van Loo gained great renown for his group scenes of men and women, which provided inspiration for late works by Johannes Vermeer (1632-1675) as well as being precursors to the fashionable conversation pieces of the eighteenth century. An example is the *Concert*, in the Hermitage, which is an engaging and graceful depiction of a lady and gentleman seated with three musicians (fig. 2). In addition to such scenes, van Loo was also known for his portraits of both groups and individuals. In 1660, van Loo was forced to flee Amsterdam on a charge of manslaughter and settled in Paris, where he was accepted to the Académie Royale de Peinture et de Sculpture.

Sir Anthony van Dyck,
William II, Prince of Orange and Princess Henrietta Mary Stuart, daughter of Charles I of England,
1641,
Rijksmuseum, Amsterdam
(Figure 1)

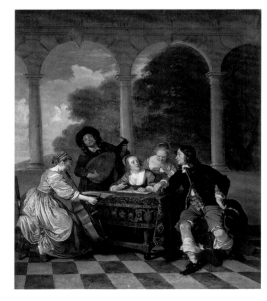

Jacob van Loo,
Concert,
early 1650s,
The Hermitage,
St. Petersburg,
(Figure 2)

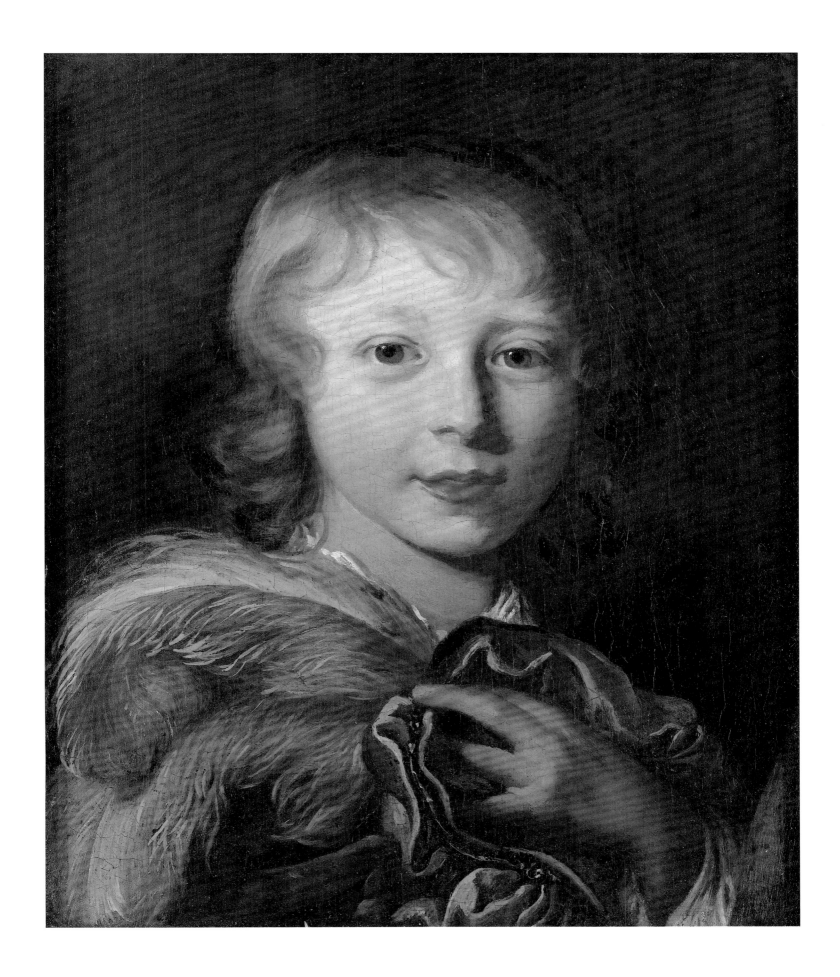

OTTO MARSEUS VAN SCHRIECK

(Nijnegen 1619/20? - Amsterdam 1678)

A Forest Floor Still-Life with Various Fungi, Thistles, an Aspic Viper, a Sand Lizard, a Tree Frog and Two Moths

signed and dated 'O/MARSEUS. 1660' (lower centre)
oil on canvas
51.5 x 42 cm (20¼ x 16½ in)

Provenance: Private Collection, Germany.

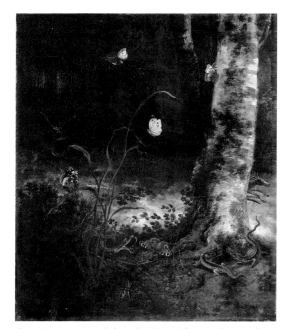

A FOREST FLOOR STILL-LIFE WITH VARIOUS FUNGI, *Thistles, an Aspic Viper, a Sand Lizard, a Tree Frog and Two Moths* is an exemplary work by the still-life painter Otto Marseus van Schrieck. Van Schrieck depicts a dark, dank forest floor, on which lives a range of different plants, fungi and animals. It is a relatively foreboding scene due to the gloom, and the underlying threat associated with aspects such as the fungi or the viper. The snake, emerging from the shadows of the undergrowth, is about to attack the frog. Its mouth is open, prepared to bite, and its wide eyes are fixed on its prey, which has its back turned, unaware of the imminent danger. The overwhelming darkness of the painting is illuminated somewhat by a gentle light which highlights the colour of the fungi and moths. In the background, the lush green of a grassy clearing can be made out, contrasting with the overgrown darkness of the foreground.

From 1663 onwards, van Schrieck, a painter, botanist and entomologist, specialised in painting these type of forest floor still-lifes, *A Forest Floor with a Snake, Lizards, Butterflies and Other Insects*, being a further example of this

Otto Marseus van Schrieck, *Forest Floor with a Snake, Lizards, Butterflies and other Insects*, Rijksmuseum, Amsterdam (Figure 1)

Otto Marseus van Schrieck, *A Forest Floor Still-Life with Various Fungi, Thistles, an Aspic Viper, a Sand Lizard, a Tree Frog and Two Moths* (Detail)

subject matter (fig.1). Both paintings feel as if they are set in a hidden-away corner of a forest, untouched by humans, and the isolation and darkness create a sinister feeling. Again, in the Rijksmuseum work, the familiar scene of a snake on the point of attacking its prey, which this time is a red butterfly is repeated. Van Schrieck, however, also includes another conflict in this painting, for at the foot of the tree two lizards circle each other ready to fight, the one on the right on the verge of pouncing. Images such as this, or of a snake eating a butterfly, or the depiction of the decay of the forest floor, are believed to allude to the transience of life. It is a recurrent theme throughout van Schrieck's work, portraying nature in such an unsettling way, contrasted with what is often the serenity of the landscape located in the background. Even in paintings such as the Fitzwilliam Museum's *Still-Life with Flowers*, where the focus is centred on a specific plant, rather than on the wider forest floor, the plant will inevitably be dead and drooping, and often will contain details of animal violence.

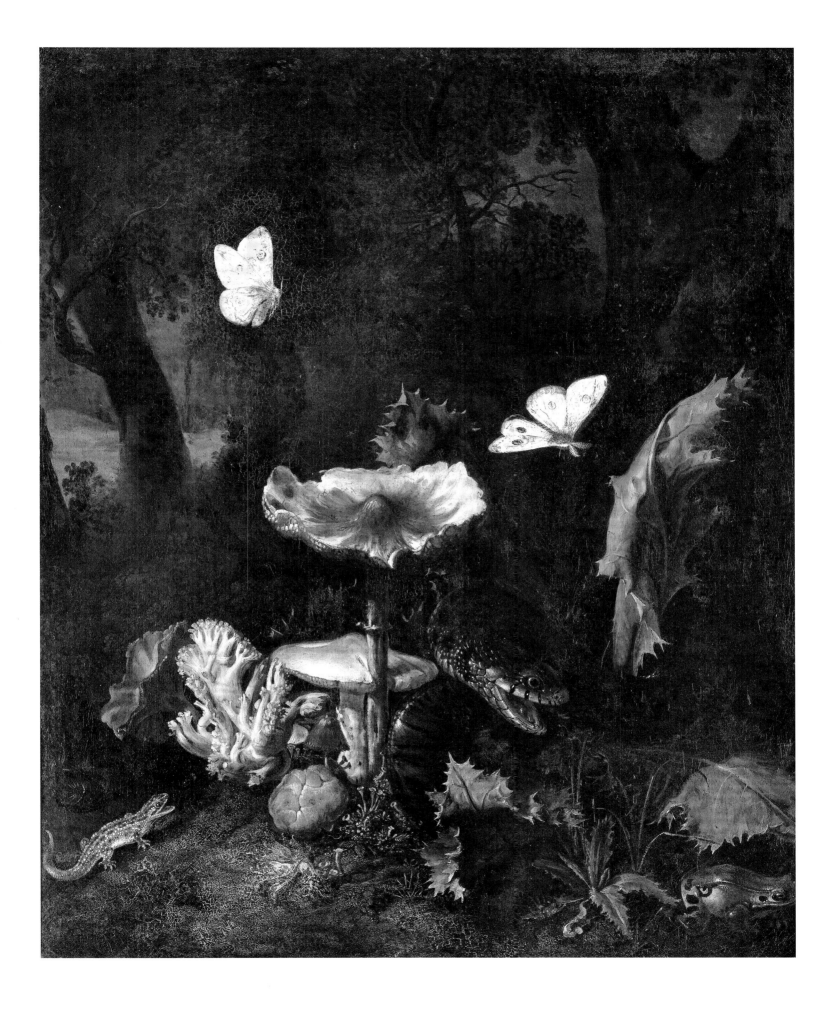

Otto Marseus van Schrieck, *A Forest Floor Still-Life with Various Fungi, Thistles, an Aspic Viper, a Sand Lizard, a Snail, a Tree Frog and Two Moths* (Detail)

Maria Sibylla Merian, Plate from *Metamorphosis Insectorum Surinamensium*, 1705 (Figure 2)

Looking at his work as a whole it is clear that van Schrieck was fascinated by the animals which he painted and their behaviour. According to his widow, as recorded by Arnold Houbraken, the author of *De Groote Schouburgh der Nederlantsche Konstschilders en Schilderessen (The Great Theatre of Dutch Painters)*, van Schrieck knew the habits of these creatures very well and is known to have bred snakes, lizards and insects himself. It therefore seems that many of the detailed flora and fauna contained in his paintings were based on careful study of the various animals, insects and plants he discovered and kept in his own garden, a 'watery' domain near Diemen.[1] Early on in his career, when he lived in Italy, van Schrieck was a member of the *Schildersbent*. This was a fraternal organisation dedicated to social fellowship and mutual assistance, founded in about 1620 by a number of Dutch and Flemish artists living in Rome. Although the society may not have contributed much to his scientific development, it is interesting to note that, according to Houbraken, it was here that van Schrieck received the nickname *Snuffelaer*. He was given the name, meaning a ferreter or scrounger, 'omdat hij allerwegen naar vreemd gekleurde of gespikkelde slangen, hagedissen, rupsen, spinnen, flintertjes en vreemde gewassen en kruiden omsnuffelde' ('because he was all about after strangely coloured and speckled snakes, lizards, caterpillars, spiders, butterflies and strange plants and herbs').[2] This early interest in the smaller forms of nature was to dominate his painting throughout his career.

Although his subject matter may have been unusual in its specialist nature, van Schrieck's work does reflect Dutch artistic culture in the seventeenth century, in that it is significantly informed by science. The practice of observing and then recording and registering results through pictures and texts, was fostered in even the most basic of schools, and consequently this culture was reflected in art. Several artists did engage in their own scientific experiments, and their interest is evident in their work, on esuch example being Jacques de

Gheyn II (1565-1629). De Gheyn was known for his delicate watercolour studies of insects and flowers, which he often produced for private study and specific patrons, such as the Holy Roman Emperor Rudolf II. Equally, many institutions, such as the botanical gardens at Leiden and Amsterdam, and the East and West Indies Companies, published scientific texts which were often illustrated by talented artists, such as Maria Sibylla Merian (1647-1717). Published in 1705 her *Metamorphosis Insectorum Surinamensium* presented her keen researches into plants and insects (fig. 2). The impressive plates were based on painstaking observations, many of them made with a magnifying glass. She published them with detailed descriptions, which were written with help from the director of the botanical gardens in Amsterdam. It is not difficult to imagine how the work of van Schrieck, with its acute study of animal interaction and the decay of nature, emerged from this scientific cultural backdrop.

Van Schrieck's work is also a product of the conditions of the Dutch art market at the time. Art was a booming industry in the Netherlands, often taking place on the level of arts and crafts, rather than as 'fine art' in the

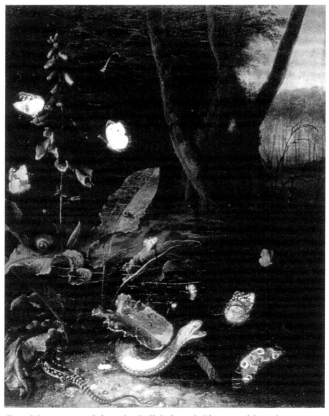

Otto Marseus van Schrieck, *Still-Life with Plants and Reptiles*, 1667, Kunstsammlung der Universität, Göttingen (Figure 3)

[1] see A. van der Willigen & F.G. Meijer, *A Dictionary of Dutch and Flemish Still-life Painters Working in Oils, 1525-1725*, Leiden 2003, p. 139.
[2] see A. Houbraken, *De Groote Schouburgh der Nederlantsche Konstschilders en Schilderessen...*, The Hague 1753, vol. I, p. 358.

modern sense of the term. Works of art were made for a market, as opposed to just being made on commission. One of the results of this was that painters had to strive hard to find a specific niche for themselves in so competitive a market. As a result, not only did many of them specialise in a specific genre, such as history or portrait painting, but often they specialised within that genre. The landscape painter Aert van der Neer (1603-1677) (see inventory), for example, invariably imbued his works with unconventional light effects. This specialisation did mean that the resultant work was often of a high quality and it is clear that van Schrieck's still-lifes were in part a product of this.

Van Schrieck's paintings also betray an unusual working technique, with some of his paintings characterised by the presence of various organisms, which he would apply directly onto the canvas. For example, in his *Still-Life with Plants and Reptiles* van Schrieck used real butterfly wings to make an impression into the paint in order to achieve lifelike texture and he also implanted at least one leg of a fly onto the canvas (fig. 3).

According to Houbraken, van Schrieck travelled to Italy in the early stages of his career and stayed in Florence and Rome with Matthias Withoos (1627-1703) (see cat. no. 63) and Willem van Aelst (1627-after 1687), the latter being his pupil at the time. Houbraken remarks that van Aelst 'carried out many pranks' in the company of van Schrieck. In Italy he was patronised by, amongst others, Ferdinando II de'Medici, Grand Duke of Tuscany. Samuel Hoogstraten claimed that he met van Schrieck in Rome as late as 1652. About 1657 he returned with van Aelst to Amsterdam, where he had a small property and was married on the 25 April 1664.

Van Schrieck developed the 'Forest Floor still-life', depicting the flora, moss and fungi with reptiles, butterflies and snails in their natural habitat with extreme precision, and was one of the first painters to specialise in this subgenre. He returned to Amsterdam in 1657 where he established a successful studio, specialising in still-life. He was much admired in his own lifetime, and his work was greatly sought after. His paintings also had a notable influence on a number of artists, including the Italian Paolo Porpora (1617-1670-80) and Schrieck's distinguished pupil, Rachel Ruysch (1664-1750). Ruysch's forest still-life *Flowers on a Tree Trunk*, provides a particularly good example of the

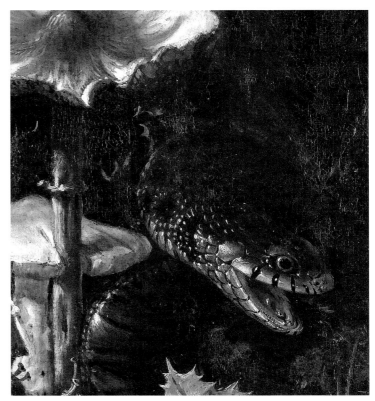

Otto Marseus van Schrieck, *A Forest Floor Still-Life with Various Fungi, Thistles, an Aspic Viper, a Sand Lizard, a Snail, a Tree Frog and Two Moth*s (Detail)

extent to which she was influenced by van Schrieck (fig.4). As in van Schrieck's still-lifes, we are presented with a dark undergrowth, from which a dried stump with knotholes surrounded by toadstools and moss emerges. Winding around the dead tree's trunk are brightly coloured flowers of all kinds, including roses, lilies and bindweed. They have a luminous quality which seems to emanate from within. Insects, reptiles, to fight one another, and collectively they destroy the plant-life. On the left of the composition a toad and a small snake attack each other, and on the right, another toad is trying to hold a small lizard in check.

The work of van Schrieck occupies a special place among Dutch still-life painters. He was as interested in representing the interactive behaviour of animals as he was their external appearance: thus a snake trying to catch a butterfly, or two lizards attacking each other. By expressing the violence of these animals, the artist's paintings underline the transitory, fragile and precarious side of life. His compositions almost always have a narrative quality to them, whether light and pleasant, as in the *Forest Floor with a Snake and a Butterfly* (Fondation Custodia, Institute Néelandais, Paris), or in a more threatening manner, as in *A Forest Floor Still-Life with Various Fungi, Thistles, an Aspic Viper, a Sand Lizard, a Snail, a Tree Frog and Two Moths*. However, although the world represented in van Schrieck's paintings reflects the zoological and botanical interests of a well-versed science amateur, this world is still not free from religious associations. Indeed, it is the religious meaning which seems to have determined the selection and composition of the animals and plants. The snake, the toad and the lizard are the 'unclean animals', with the serpent being regarded as an incarnation of evil, and as such, was a favourite subject to represnt pictorially. The strong presence of death and decay in van Shrieck's work create an effect of drama, mild horror and fascination.

An inventory of the contents of van Schrieck's house was made in July 1678, shortly after his death, in which more than three hundred paintings were listed. Besides his own paintings, there were works by Cornelis van Poelenburch (1595-1667) (see Inventory), Simon de Vlieger (1600-1653) (see Inventory), Ludolf Bakhuyzen (1631-1708) (see cat. no. 61), Jan Wijnants (c.1635-1684), Lucas van Leyden (c.1494-1533) and van Aelst.

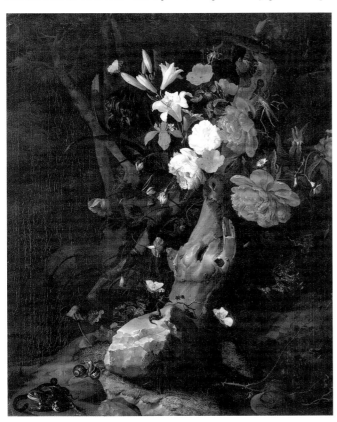

Rachel Ruysch, *Flowers on a Tree Trunk*, Staatliche Museen, Kassel (Figure 4)

ELIAS VAN DEN BROECK

(Antwerp 1650 - Amsterdam 1708)

A Forest Floor Landscape with a Thistle, Fungi, Moths, a Lizard and Snakes

oil on canvas
37.4 x 29.9 cm (14¾ x 11¾ in)

A FOREST FLOOR LANDSCAPE WITH A THISTLE, FUNGI, *Moths, a Lizard and Snakes* is a fine example of Elias van den Broeck's characteristic still life paintings of insects, reptiles and amphibians set amidst the flora of a forest floor. The work reveals van den Broeck's expertise in combining scientific accuracy in observation with a harmonious balance of colour and composition, narrative and symbolism.

The arresting image of two snakes attacking each other, one opening its jaws to swallow the other, dominates the painting. They are intertwined around a thistle, at the base of which a menacing clump of fungi grows. A lizard creeps along the mossy ground and several butterflies flutter about, mostly congregating near the central purple flower of the thistle. The plant is spot lit and around it a dense forest recedes into the darkness. The composition is very similar to a painting by van den Broeck in the Ashmolean Museum, Oxford, which is also centred on a flowering thistle plant with butterflies hovering and fungi growing nearby (fig. 1). The snake in this image has reared up ready to lunge at a grasshopper. A snail slimes its way along the ground and another settles on a leaf, while a mouse shelters in the foliage.

A Forest Floor Landscape with a Thistle, Fungi, Moths, a Lizard and Snakes, like most of van den Broeck's paintings, has a definite narrative element, provided in this case by the interaction between the two snakes. The image reveals as much of an interest in representing the ways animals behave as recording their appearance. It is probable that van den Broeck's selection of reptiles and plants was not made merely out of zoological and botanical interest, but because of their symbolic and religious associations. The lizard and snakes are the 'abominations' of the Old Testament: 'And every creeping thing that creeps on the earth shall be an abomination...Whatever crawls on its belly, whatever goes on all fours, or whatever has many feet among all creeping things that creep on the earth'.[1] The snake has the added ignominy of being the recipient of God's curse after the Fall of Man: 'cursed are you among all animals and among all wild creatures; upon your belly you shall go, and dust you shall eat all the days of your life'.[2] The thistle also has religious connotations, its spines being linked to Christ's crown of thorns and therefore his suffering, sin and sorrow. The profusion of butterflies gives the painting a hopeful and redeeming note, not only in their brightness and beauty but also as Christian symbols of the resurrection.

The subgenre of reptile, insect and plant paintings, that the current work fits into, was developed by Otto Marseus van Schrieck (see catalogue no. 47). In order to achieve greater realism, van Schrieck sometimes made an impression of the wings of butterflies and other insects into the paint, or attached them to the canvas. This was a technique also adopted by van den Broeck, to enhance the beauty and permanence of his creations; however, in almost all cases the wings have disappeared and been painted in by a later hand.[3]

Van den Broeck was born in Antwerp, and moved at an early age to Amsterdam, where he was apprenticed to a goldsmith in 1665. He also studied under Cornelis Kick, a still-life painter, until 1669, after which he became a studio assistant to Jan Davidsz. de Heem (1606-1634), one of the most influential exponents of seventeenth-century Netherlandish still life painting. It seems that van den Broeck followed de Heem when he returned to Antwerp in 1672, and a year later became a member of the guild there. In 1685 he returned to Amsterdam, where he settled permanently.

The present work has been examined and authenticated by Fred Meijer of the Rijksbureau voor Kunsthistoriche Documentatie.

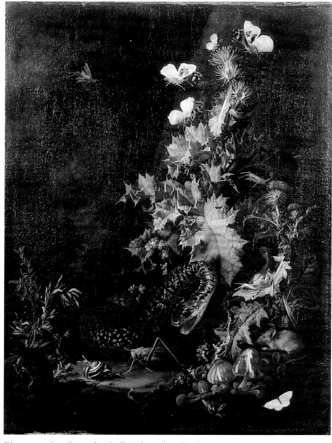

Elias van den Broeck, *Still Life with a Snake*,
The Ashmolean Museum, Oxford (Figure 1)

[1] Leviticus 11:41-42
[2] Genesis 3:14
[3] F. Meyer, 'Philip van Kouwenbergh', *Oud Holland*, LII, 1980, p. 320.

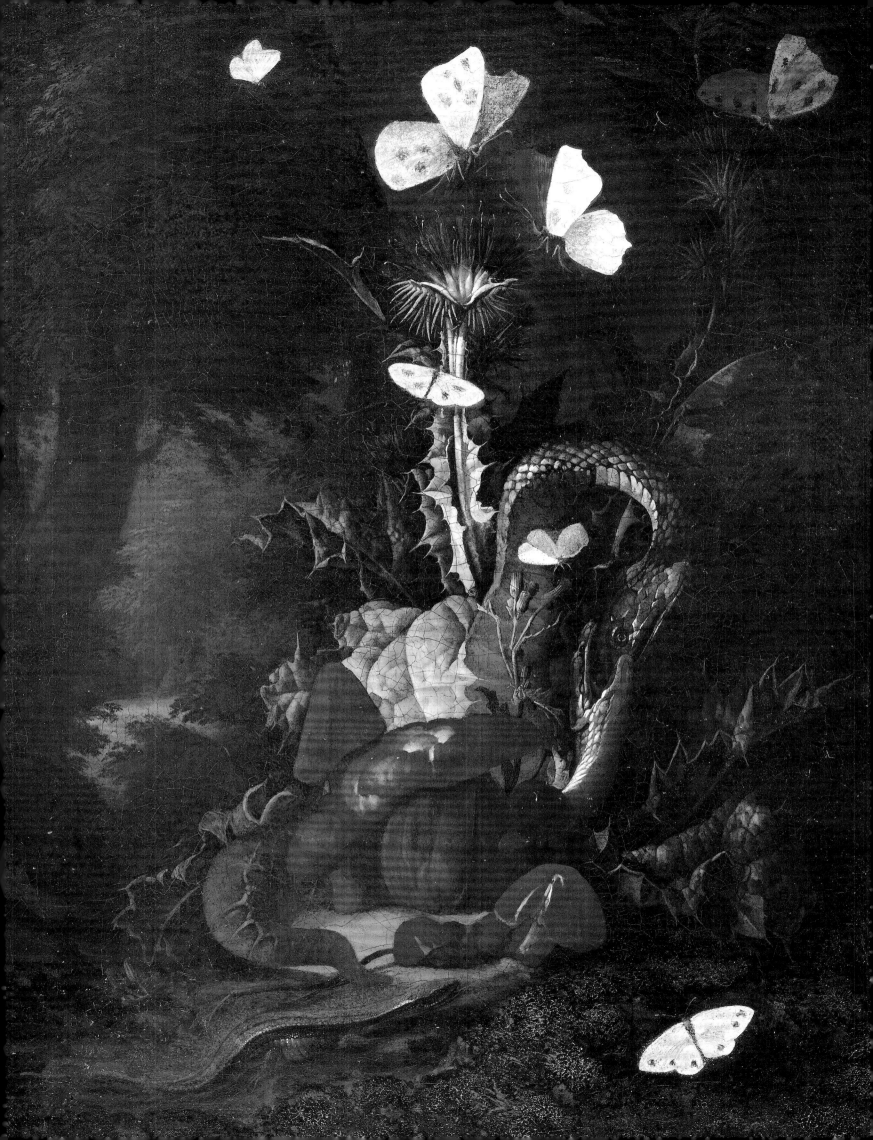

WILLEM KALF

(Rotterdam 1619 - Amsterdam 1693)

A Woman Pulling Water from a Well, a Pile of Vegetables at her Feet

oil on copper
26.6 x 22.2 cm (10½ x 8¾ in)

THE PRESENT WORK MOST PROBABLY RELATES to Willem Kalf's early Paris period when he characteristically painted rustic scenes, combining still lifes of pots, pans, vegetables and fruit with figures of peasants, set within an interior or outdoor surrounding, as seen in a very similar work, *Peasant Interior with Woman at a Well* (fig. 1). As is evident in Kalf's *A Woman Pulling Water from a Well, a Pile of Vegetables at her Feet*, the work is dominated by the still life arrangement in the foreground, as was typical of his rustic interiors. By comparing the present work with one of Kalf's still lifes, such as *Dessert,* in the Hermitage, see fig.2, many parallels can be drawn.

vegetables and pots are carefully positioned; Kalf captures the light in an instantly recognisable way, masterfully capturing the curved shapes of the copper pots, carefully observing their colour and the way the light gleams off their reflective surfaces, using tight brushstrokes to create the effect. By comparison, the brushstrokes applied to the figure of the woman are loose and appear to have been applied quickly.

Kalf was devoted to the still life genre, helping to raise the profile of still life painting to the same level as portraiture and figurative works, with G. de Lairesse noting in 1707, 'in his still lifes, the famous Kalf surpassed all the others.' Born into a prosperous family in Rotterdam, his father was a cloth merchant. Between 1642 and 1645 Kalf sojourned in Paris, where he spent

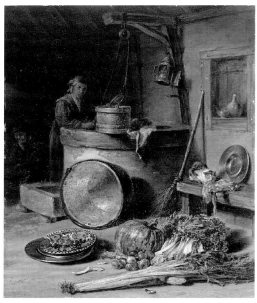

Willem Kalf, *Peasant Interior with Woman at a Well,*
*c.*1642-1643, Saint Louis Art Museum, Missouri (Figure 1)

Willem Kalf, *Dessert,* 1653/1654,
The Hermitage, St. Petersburg (Figure 2)

Compositionally, Kalf applies the same methodology to this rustic scene as he does to the still life. Each element is carefully arranged within the scene with considerable attention, and conceived in such a way as to create a harmonious balance. The use of a deep, dark background is also a common device which he employs in his still lifes, offsetting the main objects, and a well thought out colour scheme in both works helps to lead our eye from object to object.

However, it is in the depiction of the large copper pots and vegetables in the lower right of *A Woman Pulling Water from a Well, a Pile of Vegetables at her Feet,* that Kalf's mastery in rendering surface texture truly comes to the fore. Treating this area of the painting as though it were a still life, the

time in the circle of the Flemish artists in Saint-Germain-des-Prés, and it is here that his artistic career began to take shape, with his work appealing greatly to both art dealers and collectors. Kalf developed the *banketje* 'little banquet pieces' into a new and popular form of sumptuous and ornate still lifes known as *pronkstilleven*, which in Dutch means 'opulent still life painting'. In 1645 Kalf returned to the Netherlands where he made a very comfortable living by selling his paintings to wealthy clients, and later on he made the transition into an art collecting and dealing.

We are grateful to Fred G. Meijer, who confirms the attribution of the present work to Kalf.

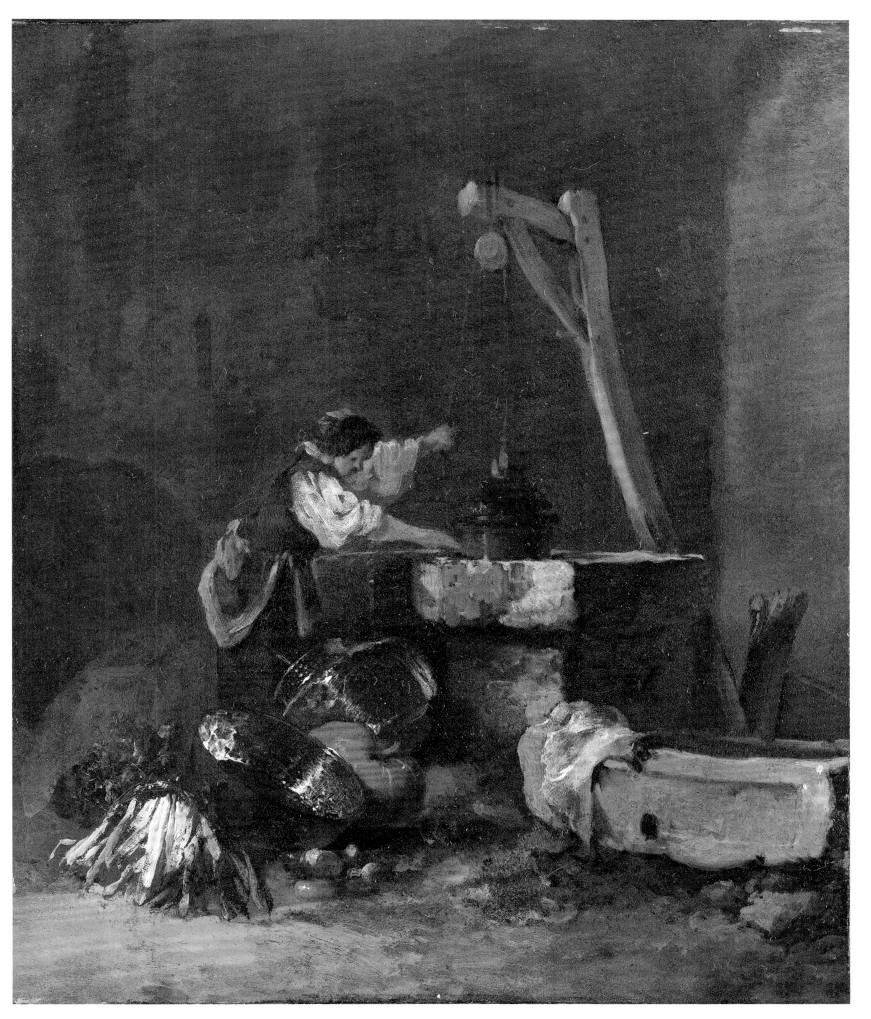

(Actual Size)

PALAMEDES PALAMEDESZ., CALLED STEVENS STEVAERTS

(London 1607 - Delft 1638)

A Cavalry Skirmish

oil on panel
49.4 x 85.4 cm (19½ x 33⅝ in)

I N THIS SCENE, PALAMEDES PALAMEDESZ. HAS DEPICTED a violent and frenzied battle. The battle is made up of a series of cavalry soldiers engaged in single duels, some have their swords drawn whilst others exchange pistol fire. In the centre of the painting is a detailed depiction of one of these clashes between two soldiers. The figure on the rearing, white horse fires down at his enemy. The shot man reels with the force of the bullet, his sword is useless as his steed slides along the ground. This creates an eye-catching contrast between the dominant and the fallen horses. Behind the two central figures, a melee of fighters in which multiple individual battles take place and the occasional detail, such as the flash of gunpowder or the thrust of a sword, can be made out. On the left-hand side of the painting, a man crawls away from the skirmish, his musket thrown from his grasp, and he is obviously struggling for breath. He has been knocked from his horse, which lies injured behind him, a small splash of blood below its belly. In the background a smaller group of fighters who have broken apart from the main battle can be seen.

The composition is almost identical to another of Palamedesz.'s paintings, *Cavalry Battle* (fig. 1). There is the same central clash projecting from the throng of battle, from which the same figures and poses can be discerned. Palamedesz. was a specialist in painting military encampments and battle scenes and there are many recurring themes and motifs that appear in his work, in particular the image of a prominent, white rearing horse. It is unusual,

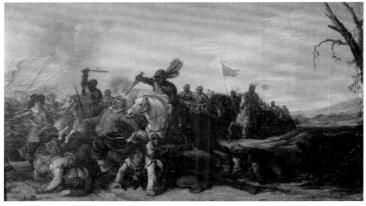

Esaias van de Velde, *Battle*, National Gallery of Armenia, Yerevan (Figure 2)

however, for Palamedesz. to have painted two compositions quite so similar. In both paintings, as is characteristic of the battle paintings in which Palamedesz. specialised, the scenes include no identifiable individuals or parties. This stands in marked contrast to the sixteenth-century tradition of battle pictures in Italy and Germany, where a greater emphasis is given to the heroism of specific soldiers and military leaders.

Palamedesz.'s paintings of cavalry battles are clearly related to the work of the Haarlem painter Esaias van de Velde (1587-1630) (see catalogue no. 137). In *Battle* van de Velde has presented detailed depictions of a few figures, set against the great indiscernible throng of the battle behind, a technique Palamedesz. has also used (fig. 2). Again there is a contrast between dominance and helplessness and an interest in the dramatic sights of battle. The dark anonymity of the armoured cavalry soldiers however, gives van de Velde's painting a sinister feel. Rather than an evenly matched battle, the scene appears to represent merciless carnage.

Palamedesz. was a Dutch painter and the younger brother and pupil of Anthonie Palamedesz. (1601-1673). He was born in London, where his father, a gem cutter, was in the service of King James I, although the family was originally from Delft. After the family returned to Delft, Palamedesz joined the Guild of St. Luke in 1627 and he can be considered part of the group of immigrants who revitalised the artistic climate of the city, along with figures such as his brother, Frans Spierincx (c.1550-1630) or Hans Jordaens I (c.1555-1630). He married the daughter of a wealthy Delft family in 1630 and the couple had four children. In 1631 Palamedesz. is recorded in Antwerp, where he had his portrait painted by Anthony van Dyck (1599-1641). He died in Delft and was buried there.

Palamedes Palamedesz., *Cavalry Battle*, 1626-1628,
Stockholms Universitet Konstsamling, Stockholm (Figure 1)

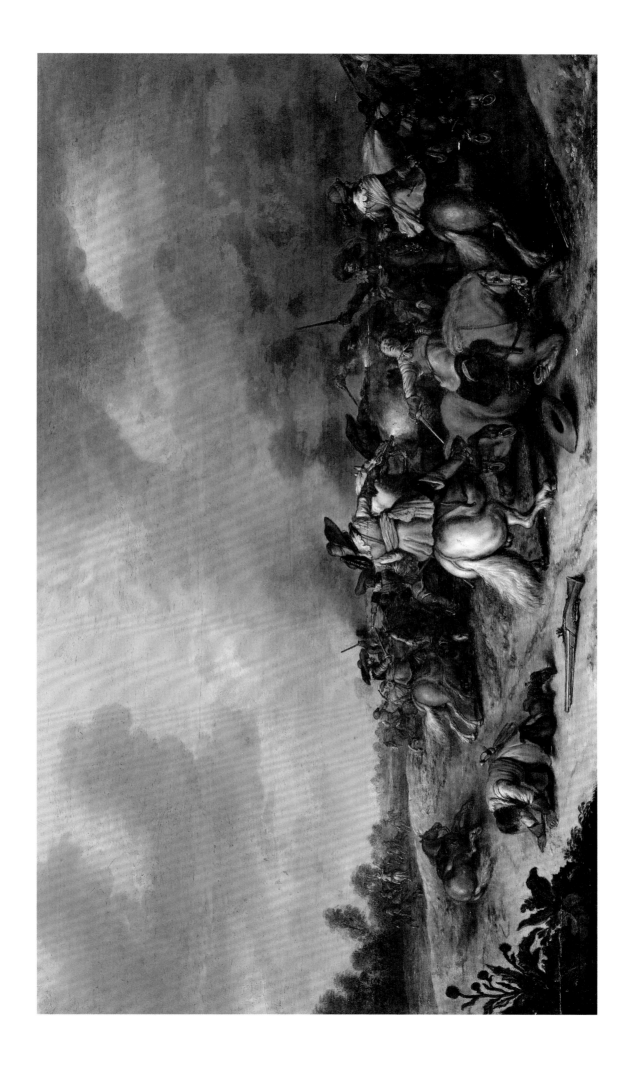

JACOB VAN DER CROOS

(active in Amsterdam c. 1630/6 - after 1691)

River Landscape

oil on panel
68 x 97.2 cm (26¾ x 38½ in)

Provenance: Duc de Trévise, France.

J ACOB VAN DER CROOS' *RIVER LANDSCAPE* EXUDES calm and tranquillity. A group of men are relaxing by the bank of a wide river. As our eye is led into the picture by the angle of the river, a town becomes visible, the spire of a church rising above the trees helping to draw the viewer's attention towards it. Details such as the windmill, continue to draw the eye towards the hazy distance, and evoke the vastness of the landscape and the length of the river which runs through it. The scene is dominated by the sky above, which van der Croos devotes at least three quarters of the picture to. He is not tempted to portray a dramatic sky with extreme weather to show off his painterly skills; rather, he depicts a cool summer's day with a few puffy clouds drifting in the sky. It seems more an attempt by van der Croos to capture the still and tranquil atmosphere of the scene. The only detail that disrupts the calm is the small figure of a hunter who sits in a boat, shooting at the scattering birds.

Although it depicts a recognisable place, van der Croos' *A View of Rijswijk Castle* has a similar focus to *River Landscape* (fig. 1). The emphasis of both works is on the impression of a vast and peaceful landscape, rather than a topographical view. The faint outline of a church spire highlights the scale of the landscape, and in the foreground the two anonymous figures create a sense of quiet isolation.

Van der Croos' painting is very much in the style of seventeenth-century Dutch landscape painting. For example, if we compare *River Landscape* to

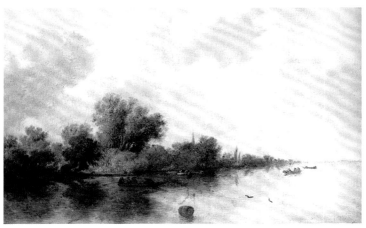

Salomon van Ruysdael's (1600/3-1670) (see inventory) *River Scene* of 1632, there are several noteable similarities (fig. 2). Again there is a sense of the water drifting away into an endless distance, although van Ruysdael accentuates this effect still further by omitting to paint the riverbank on the right-hand side of the scene. Van Ruysdael employs an almost monochrome palette, helping to fuse together the sky and water, which, according to R. H. Fuchs, 'makes this calm picture into a harmony of air and water in which the shore, gently receding until it is lost to the eye, delineates a deep, wide space'.[1] The tranquillity of the scene is reminiscent of the mood in van der Croos' work, and is a recurrent theme throughout Dutch landscape painting of the period.

River Landscape also shows the influence of another great seventeenth-century Dutch landscape painter, Jan van Goyen (1596-1656) (see catalogue no. 135), whose work also had a notable effect on that of van der Croos' cousin A. J. van der Croos, who is considered to be one of the most faithful followers of van Goyen's work. In his work of the 1630s, van Goyen produced simple landscapes showing dunes and rivers in brown and green tones, which achieve an impression of depth with the help of diagonals. Van Goyen's unity of composition and his approach towards depicting nature in a realistic fashion are also evident in van der Croos' work.

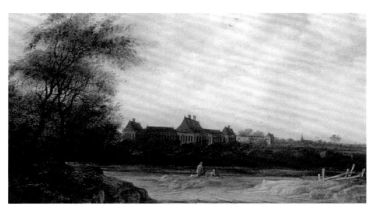

Jacob van der Croos, *A View of Rijswijk Castle*, Private Collection (Figure 1)

[1] R. H. Fuchs, *Dutch Painting*, London, 1978, p. 114.

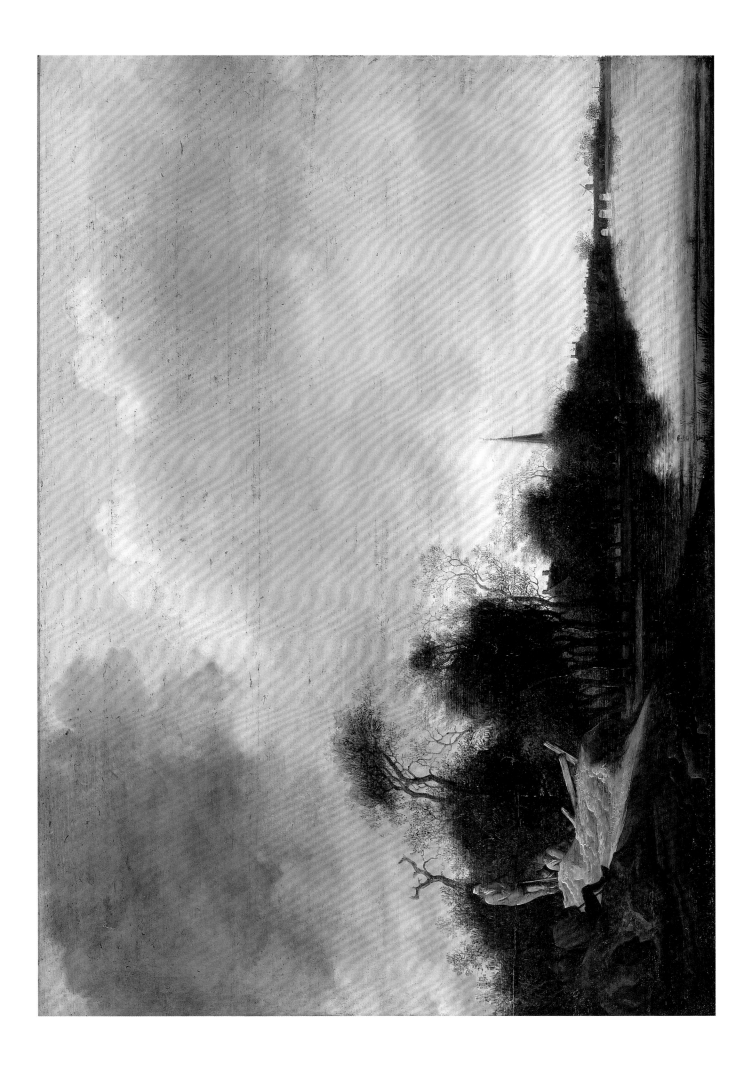

PIETER DE MOLIJN

(London 1595 - Haarlem 1661)

A Hilly Landscape with Wanderers at the Foot of a Castle Ruin

signed with monogram 'P M' (lower right)
oil on panel
32.3 x 49.4 cm (12¾ x 19½ in)

A SERENE COUNTRYSIDE IS LAID OUT BENEATH A SOFT suffusion of luminous dusky light. The stark and imposing aspect of the castle ruins commands the eye and simultaneously draws the perspective upwards and down, towards the extreme bottom right-hand corner of the composition, creating a vast space. The two walkers and a little grey dog are almost obscured by the overhang and Pieter de Molijn's uniform use of colour. In the middle ground on the far left, a delicate church spire intersects with the horizon leading the eye upwards in a bold diagonal to the castle atop its rocky outcrop. As in a number of Dutch landscapes, the presence of human beings and manmade artefacts in the untamed wilderness of nature, displays a characteristic engagement with the widely debated question of how best to represent nature in art.

De Molijn was a celebrated Dutch painter, draughtsman and etcher as his exquisite drawings attest. It is not known when he moved to Holland but in 1616, he entered the Guild of St. Luke in Haarlem where he immediately came under the influence of the great landscape innovator, Esaias van de Velde (1587-1630) (see catalogue no. 137) and his pupil, Jan van Goyen (1596-1656) (see catalogue nos. 134 and 135) who were both in Haarlem for a

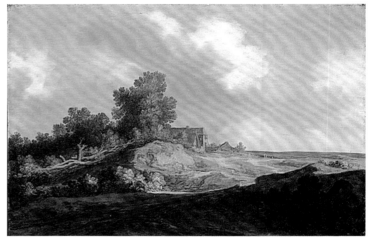

Pieter de Molijn, *Landscape with a Cottage*, 1629,
The Metropolitan Museum of Art, New York (Figure 2)

short period after de Molijn's arrival. Works by de Molijn and van Goyen represent the pinnacle of realism in Dutch landscape art (fig. 1). Replacing the ornate foliage and severe highlights of their Mannerist predecessors, the Dutch ushered in a new and more naturalistic style.

De Molijn's most prolific and inventive phase was in the 1620s when he elected not to divide his landscapes into distinct realms as had been previously practiced. This can be seen clearly in *Landscape with a Cottage* (fig. 2). Here he exploits to maximum effect the large areas of light and shadow; yet he manages to unify them into a harmonious whole with a skilful use of prominent diagonals that lead the eye into the wide expanse of cloudy sky. In comparing de Molijn's work to that of his mentor, van de Velde, his composition exudes movement. In both *A Hilly Landscape with Wanderers at the Foot of a Castle Ruin* and *Landscape with a Cottage*, there is a distinct contrast established by the dense trees in one half and the low sunlight that catches on the sandy dune.

De Molijn's work encompassed elements both of fantasy and reality. One of his main contributions, so ably demonstrated in this present work, was the sensitive and energetically observed way in which he depicted contemporary rural life of the Netherlands and its inhabitants. In his own day de Molijn was appreciated as an outstanding artist. More recently, though, he is recognised as one of the leading figures of early seventeenth-century Dutch landscape art.

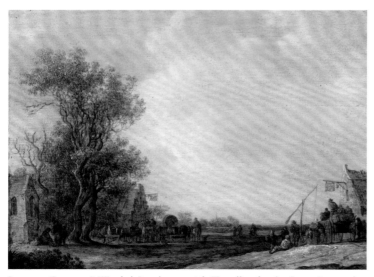

Jan van Goyen, *A Wooded Landscape with Travellers by the Swan Inn and at another Inn Opposite*, 1649, Sphinx Fine Art, London (Figure 1)

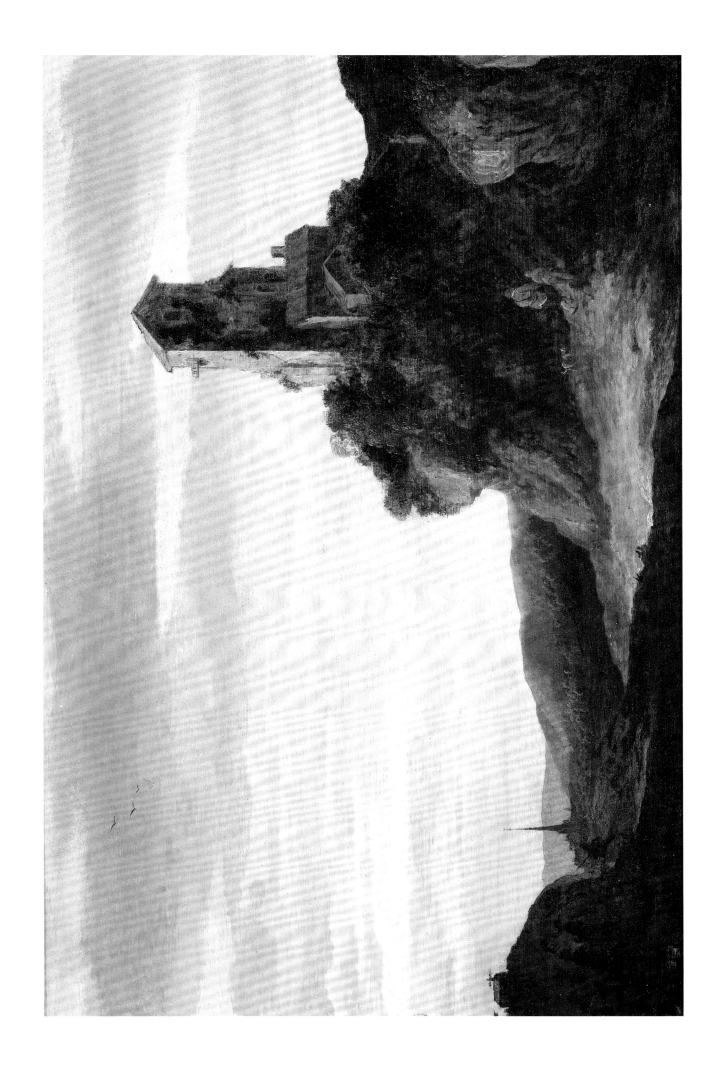

CORNELIS GERRITSZ. DECKER

(Haarlem 1620 - Haarlem 1678)

Landscape with a Village Road and Figures Conversing in the Right Foreground

&

Landscape with a Farmyard and Figure Drawing Water from a Well, other Figures Conversing Nearby

the latter signed 'C. Deck..r' (lower left on the well)
oil on canvas, a pair
83.5 x 107 cm (33 x 42 in) each

Provenance: with W. Boswell & Sons, Norwich (according to labels on the reverse);
anonymous sale ("The Property of a Lady"), October 12, 1983, lot 63;
anonymous sale, New York, Christie's, January 15, 1985, lot 49;
Private collection.

STATELY OAKS AND BROODING SKIES DOMINATE Cornelis Gerritsz Decker's fine pair of landscapes. In *Landscape with a Village Road and Figures Conversing in the Right Foreground*, a dense growth of trees encroaches on the village, already obscuring a cottage nestled in its midst. The trees are slightly starker in *Landscape with a Farmyard and Figure Drawing Water from a Well, other Figures Conversing Nearby* although they still appear to strain at their roots in an effort to command the scene. In both paintings, Decker imbues the oaks with strong personalities. The activities of the villagers and farm workers, and the placing of the other elements in each composition seem to revolve around the imposing presence of these mighty trees. The sky, likewise, has a forceful role in each painting. The lowness of the horizon and vastness of the sky dotted with expressive clouds, gives the landscapes added tension and drama.

The first of the present pair reveals strong contrasts in tonality between the darkness of the trees and the lightness of the sky and path, against which the figures stand out. The few villagers who find their way into the scene are concentrated in the lower right portion of the canvas. Two men converse near a rickety fence, one sitting and the other standing and leaning on his cane. A well dressed gentleman, in contrast to the humble rural dwellers, stands further along the path and behind him a man on a horse stops outside the village inn. A solitary idler pauses on the bridge.

Decker gives what would otherwise be a mundane portrayal of quiet village life a heightened sense of intrigue in his masterful contrasts between light and dark, shadow and illumination. There is an air of mystery in the way the top of the peaked roof of a cottage can just be made out amongst the dense foliage of the trees on the left. In the foreground, a ramshackle gate stands unhinged. This area of the composition is heavily obscured by the trees and shrubs growing there and the cottage appears completely inaccessible.

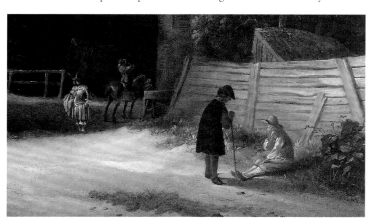

Cornelis Gerritsz Decker, *Landscape with a Village Road and Figures Conversing in the Right Foreground* (Detail)

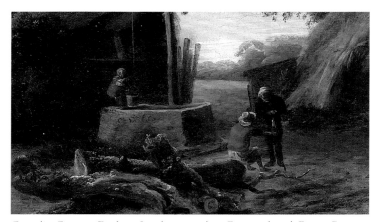

Cornelis Gerritsz Decker, *Landscape with a Farmyard and Figure Drawing Water from a Well, other Figures Conversing Nearby* (Detail)

Cornelis Gerritsz Decker, *A Wooded River Landscape with a Woman Looking out over the Water, a Horseman with his Dog and another Figure Beyond*, Private Collection (Figure 1)

Decker seems to delight in depicting peculiar houses and asymmetrical structures within his idyllic countryside scenes. A dilapidated hut, with a thatched roof that leans sharply to the ground on one side, stands in the middle of the second painting in the present pair. On the right, a crude fence has been erected with a number of roughly hewn planks protruding in different directions. These peculiar constructions are not only points of interest in the painting but also display Decker's technical skill in representing angle and perspective. They also allow for the painterly rendition of a variety of textures and materials, which is similarly exemplified in Decker's painting *A Wooded River Landscape with a Woman Looking out over the Water, a Horseman with his Dog and another Figure Beyond* (fig. 1). Here, a woman leans against a railing attached to a rough and gnarled tree trunk that curves towards a small incongruous looking outbuilding erected on the bank. A combination of planks and twigs are nailed haphazardly on top of one another to stabilise the structure, which stands on two precarious stilts reaching into the water. Whether such structures were common in rural areas at the time, or whether Decker exaggerated them simply to enhance the rustic charm of his works, the result is nonetheless very effective.

The focus of human activity in the second from the present pair of works is around the well on the left of the scene, where a man fills a bucket with water. A labourer sits nearby with his arm outstretched for his companion to bandage it. Presumably he has been injured while cutting the logs that lie scattered around the farmyard. In the image of the fallen tree trunks, it is difficult to recognise the grandeur of the living ones that predominantly command the composition. The oak trees lean at different

angles, their foliage creating dense dark patches outlined against the sky. Again, what could be a commonplace scene is given an added dimension by the strong character of the trees.

A Cottage among Trees on the Bank of a Stream by Decker in the National Gallery, London, is similar to the present pair of pictures in its spirit and monumentality (fig. 2). The view is of a cottage tucked away on a riverbank surrounded by trees. There is little activity and no great variation in colouring, yet the scene commands attention, in large part because of the dramatically twisted trunks of the trees and their distinctive craggy branches. Also notable is Decker's extensive employment of shadowing and his expansive and imposing sky. As with the present paintings, the depth and tonality of the composition is striking.

Decker was a pupil of Jacob van Ruisdael (1628/9-1682), one of the principal exponents of Dutch landscape painting in the second half of the seventeenth century. Van Ruisdael helped to revolutionise landscape painting, moving it away from the 'tonal phase' (c.1620-c.1650), associated with the preceding generation of artists such as van Ruisdael's uncle, Salomon van Ruysdael (?1600/03-1670) (see Inventory). Decker's naturalistic countryside scenes, distinctive colour palette and the solidity of his trees are clearly inspired by van Ruisdael, who was an innovator in his treatment of trees in particular, giving them important functions in the landscape rather than a purely decorative significance.

Decker was also influenced by Jan Wijnants (c.1635-1684) and Philips Wouwerman (1619-1668) (see Inventory for both). Wijnants adopted many of the compositional strategies of van Ruisdael's forest pictures of the mid-1650s, prominently positioning stark tree-trunks as well as dense clumps of foliage in his paintings. The majority of his works relegate buildings and staffage to the middle distance rather than making them the focus of the picture, in a manner that resembles the pair of paintings seen here, and Decker's work in general. The landscape paintings of Wouwerman from the 1650s, which also emphasise broad expanses of mainly horizontal landscapes with heightened colour, have discernible parallels with Decker's paintings. Although Decker is a somewhat obscure figure in that we know very little of his life, the accomplished artistry evident in the works examined here indicate that he deserves particular recognition within the Haarlem school of landscape painters.

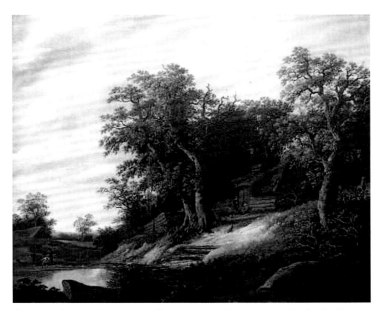

Cornelis Gerritsz Decker, *A Cottage among Trees on the Bank of a Stream*, 1669, National Gallery, London (Figure 2)

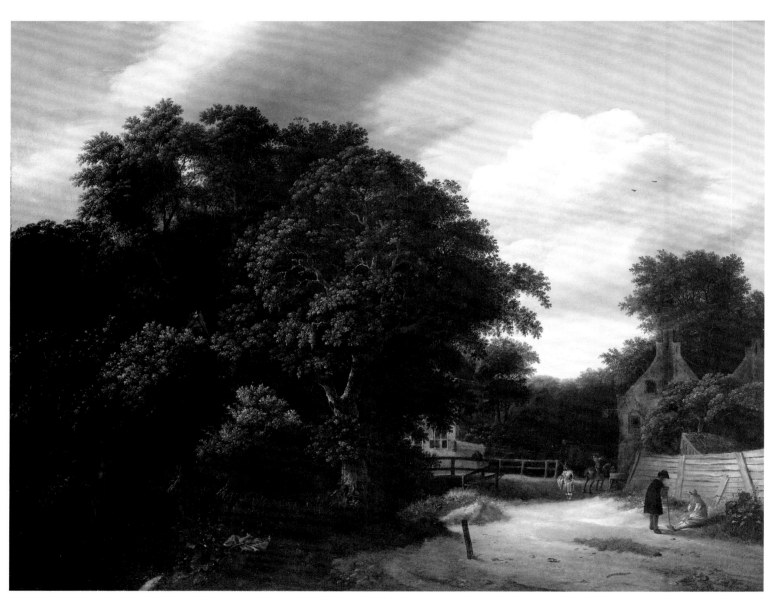

Cornelis Gerritsz Decker, *Landscape with a Village Road and Figures Conversing in the Right Foreground*

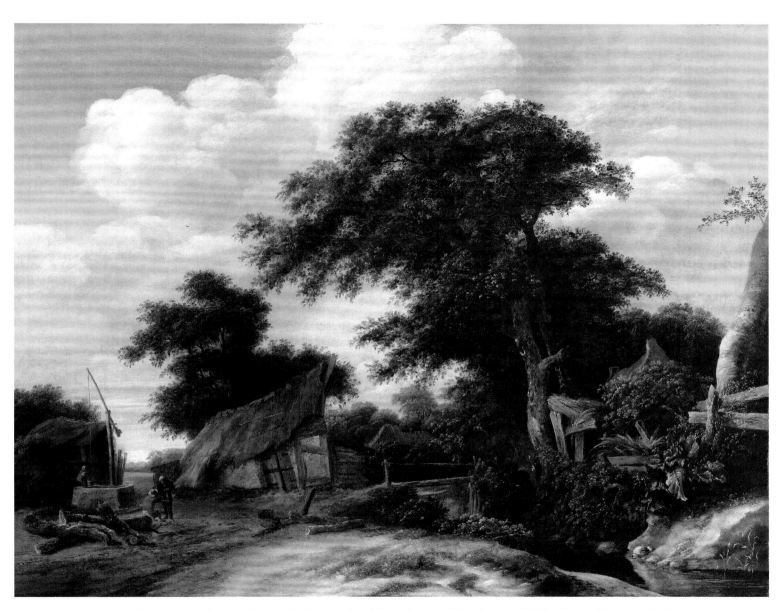

Cornelis Gerritsz Decker, *Landscape with a Farmyard and Figure Drawing Water from a Well, other Figures Conversing Nearby*

ROELOF JANSZ. VAN VRIES

(Haarlem 1630 - Amsterdam after 1681)

A Landscape with a Figure on a Path and a Bleaching Field Beyond

bears a signature 'Hobbema' (lower right)
oil on panel
41.8 x 62.6 cm (16½ x 24⅝ in)

Provenance: with Duits, London, late 1950s, when acquired by the previous owner, a nobleman, as Meindert Hobbema.

IN THIS WORK ROELOF JANSZ. VAN VRIES PRESENTS US with an exquisite Dutch village scene. A figure walks along a hilly path in the foreground. Beyond, some of the village's buildings are visible, built around a field in which several large white pieces of cloth have been laid out to dry in the warm sunlight which illuminates the whole painting.

In the seventeenth century, Holland had a virtual monopoly on cotton bleaching, and bleachers played a crucial role in the textile industry. Having been dyed through a variety of methods, the cloth was spread out on the grass of a bleach field, or on a frame supported by tenter posts, to dry and bleach in the sunshine in a process known as crofting. When it was dry, the cloth would be soaked in sour milk for several days, washed and crofted again. This whole process was repeated several times until the cloth had acquired the requisite degree of whiteness. While the cloth was spread out drying it was vulnerable to theft but the penalty for stealing cloth in this way was severe and often resulted in execution.

Van Vries was not the only artist who portrayed this important aspect of Dutch life. Jacob van Ruisdael (1628/9-1682), van Vries' tutor, painted several images of the bleaching fields around Haarlem, such as *View of Haarlem*, where the bleaching fields are painted in the foreground, the city visible in the distant background (fig. 1). Haarlem played an especially prominent role in the bleaching industry because of the access to clean water from the surrounding dunes, and it was here that van Vries, like van Ruisdael, lived and worked. Despite the shared subject matter, the two paintings are very different. Whereas van Ruisdael's *View of Haarlem* depicts an extensive, widened view of a typically

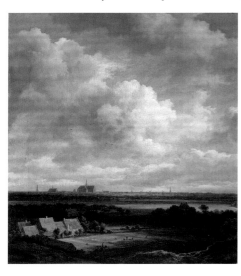

Jacob van Ruisdael, *View of Haarlem*, c.1670, Rijksmuseum, Amsterdam (Figure 1)

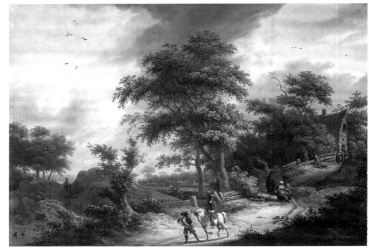

Roelof Van Vries, *Landscape with Falconer*, Rijksmuseum, Amsterdam (Figure 2)

flat, Dutch landscape, van Vries' *A Landscape with a Figure on a Path and a Bleaching Field Beyond* is a more intimate and detailed view.

A Landscape with a Figure on a Path and a Bleaching Field Beyond is fairly typical of van Vries' work. His *Landscape with Falconer*, in the Rijksmuseum, equally invites us to experience a different facet of Dutch life (fig.2). The Rijksmuseum work presents us with an undulating verdant landscape within which a nobleman, led by his falconer, trots along majestically on his way to hunt. At the top of the hill, some figures mill around outside an inn, whilst further down the path a family group takes rest on a fallen log. The anonymity of the peasants within *Landscape with Falconer* recall those in the present work. It is however the rendering of foliage, characterised by the greatest precision, and the dominant, dramatic and powerful presence of the trees and lush foliage that unite these two works, both of which exemplify van Vries' *oeuvre*. Both paintings present us with small corners of rural life, focusing in and concentrating on the landscape, and are contextualized by the human activity that takes place within them.

Van Vries was a pupil of van Ruisdael and his work was clearly influence by the paintings of his master, as well as that of Isaac van Ostade (1621-1649). However, a few of his works are more reminiscent of the style of Meindert Hobbema (1638-1709), which may account for the previous incorrect attribution to Hobbema and added signature in the present work. Van Vries entered the Leiden Guild of Saint Luke in 1653 and that of Haarlem in 1657, although the last reference to him is in Amsterdam in 1681.

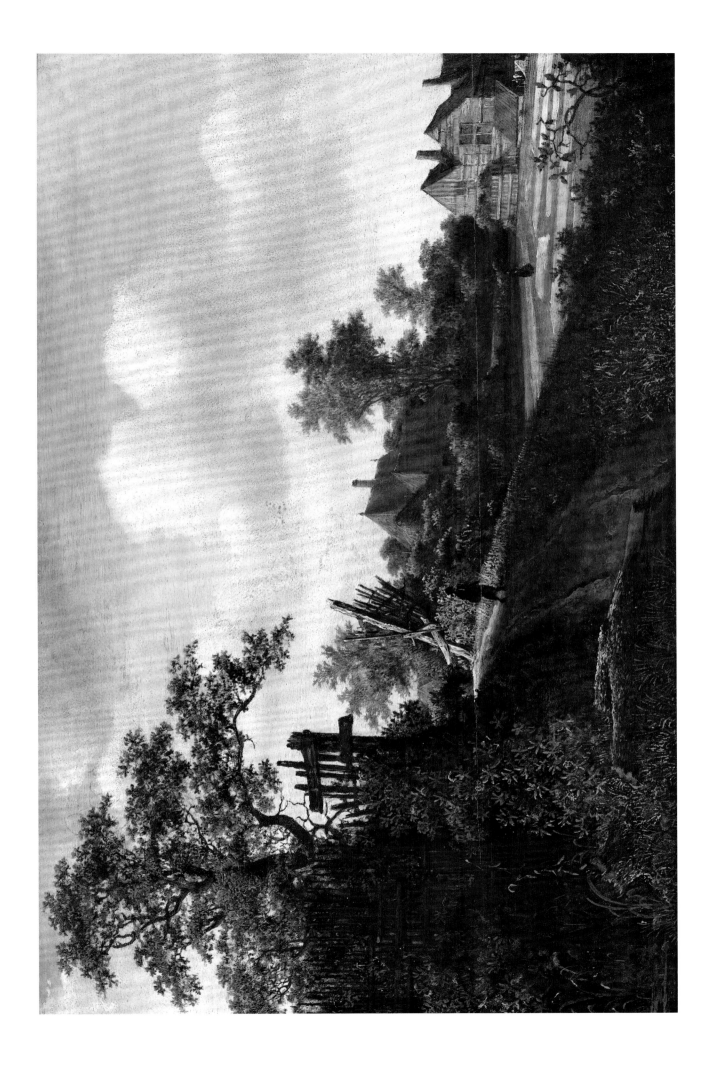

FREDERIK DE MOUCHERON

(Emden 1633 - Amsterdam 1686)

A Wooded River Landscape with a Traveller on a Track

signed 'Moucheron' (lower right, on the rock)
oil on canvas
61 x 78.1 cm (24 x 30¾ in)

Provenance: The Rev. Reginald Cholmondeley, Condover Hall;
(+) Christie's, London, 6 March 1897, lot 50 (28 gns. to Filper[?]).

FREDERIK DE MOUCHERON'S MAJESTIC LANDSCAPE, caught moments before the evening light dwindles into a brilliant sunset, inspires a serene and nostalgic atmosphere. The tranquillity of this bucolic ideal is brought to life by his exceptional contouring with its alternating bands of light and shade. The beautiful perspective of the work is created with a foreground interest of slender trees which act as a neat framing device. Both the winding river and the complementary curve of the dappled lowland with its mounted traveller, establish a broad and spacious view. Other human activity is evident on the curved path leading up to the castle ruins, where a shepherd tends to his small flock. There is also, in the middle distance, a modest dwelling place, its tall chimney positioned to the far left of the painting's centre point.

Strong Italianate influences can be detected in the luminous silvering of the tree trunks and their delicately highlighted leaves. Similar silvering

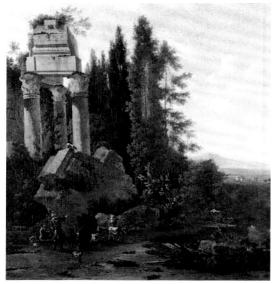

Frederik de Moucheron, *A Landscape with Classical Ruins*, c.1660, The National Gallery, London (Figure 2)

can be seen in another of de Moucheron's works, *An Extensive Wooded Landscape* (fig. 1).

De Moucheron was heavily influenced by the second generation of Dutch Italianate artists who numbered Jan Asselijn (after 1610-1652), under whom he trained, Jan Both (c.1618-1652) and Nicholas Berchem (1620-1683) (see Inventory for both) among others. These artists, active in Rome and the Netherlands from the 1630s onwards, incorporated classical architecture into their otherwise naturalistic scenery. Such a tendency is clearly apparent in the work of de Moucheron himself (fig. 2). De Moucheron's paintings are appreciated in the main for their decorative and hugely attractive picturesque qualities. Consequently, he was greatly in demand by the upper classes of Amsterdam who commissioned him to paint landscapes for the walls of their homes. Towards the end of his life he even painted the walls of a doll's house which was made and furnished in Amsterdam for Adam Oortmans and Petronella de la Court between c.1674 and 1690.

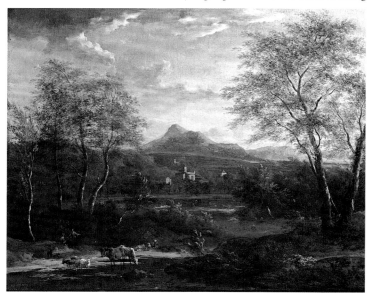

Frederik de Moucheron, *An Extensive Wooded Landscape*, Private Collection (Figure 1)

FREDERIK DE MOUCHERON
AND ADRIAEN VAN DE VELDE

(Emden 1633 - Amsterdam 1686)
(Amsterdam 1636 - Amsterdam 1672)

A Hawking Party at the Foot of an Ornamental Staircase,
with a Mountainous Landscape Beyond

signed and dated 'Moucheron f 1667' (lower right)
oil on canvas
86.3 x 72.7 cm (34 x 28⅝ in)

Provenance: with Thomas Agnew & Sons Ltd., London.

A HAWKING PARTY AT THE FOOT OF AN ORNAMENTAL Staircase, with a Mountainous Landscape Beyond presents an extravagant day of sport amidst a splendid classical landscape. At the foot of the staircase, an elegant lady dressed in blue sits side saddle on a horse, a hawk resting on her forearm. She speaks with a standing steward and points towards a horse clothed in red alongside, possibly suggesting that she has changed her mind over which mount she wishes to ride. Behind the lady an array of hunting dogs wait patiently in the courtyard, whilst stable boys and hawking aides sit or stand waiting for the party to depart. The landscape in the background appears verdant and lush, whereas the foreground is more densely forested as elongated, wispy trees grow amidst the rambling, ramshackle classical ruins.

At the foot of the staircase, upon two sculpted podiums, a colossal marble urn and a classical sculpture are placed. On the right the classical male figure, with a toga swept around his torso, plucks at a hand-held musical instrument, whereas the urn on the left is decorated with a frieze of dancing maidens. In the background another small classical sculpture is seen, leaving the viewer to suppose that the present work is set within an abandoned classical villa, presumably in Italy.

Frederik de Moucheron's paintings show the influence of the second generation of Dutch Italianate artists, particularly Jan Both (*c.*1618-1652) (see inventory) and Jan Asselijn (after 1610-1652), the latter with whom he trained in Amsterdam before settling in France for a few years. The second group of Dutch Italianates were active in Rome and the Netherlands in the 1630s and 1650s. Their work is characterised by the introduction of contemporary buildings and the depiction of low-life *bambocciate* scenes bathed in warm light.

The composition of a hawking party, set within a classical landscape, is clearly one that interested de Moucheron as an almost identical painting is held in the Louvre (fig.1). The staircase, landscape, placement of the figures and sinewy foliage is highly similar in both works, though de Moucheron has included some subtle differences; for example, in the Louvre version there are two colossal urns set atop the sculpted podiums, rather than the single urn and sculpture in the present work.

De Moucheron was born into a Dutch family of French descent. Together with his son Isaac, he specialised in Italianate, picturesque landscapes set within park-like settings, of which the present work is an excellent example.

We are grateful to Mr. Bart Cornelis for confirming that the elegant figures in this picture are by Adriaen van de Velde, who frequently collaborated with de Moucheron by contributing staffage to his paintings. He compares the execution of the figures with van de Velde's *A Hawking Party* of 1666.

Frederik de Moucheron, *Le Départ pour la Chasse*, The Louvre, Paris (Figure 1)

JOHANNES LINGELBACH

(Frankfurt am Main 1622 - Amsterdam 1674)

Peasants Resting Before an Inn

oil on canvas
49.6 x 38.7 cm (19½ x 15¼ in)

Literature: C. Burger-Wegener, *Johannes Lingelbach, 1622-1674*, Ph.D. diss., Freie Universität, Berlin, 1976, no. 106.

I N THIS WORK JOHANNES LINGELBACH HAS DEPICTED three peasants recuperating and refreshing themselves by an inn. These figures sit, eating and drinking, around a low table covered with a white cloth, on which a bowl and a chunk of bread have been placed. The eldest of the figures drinks deeply while clutching a flagon, ready to immediately refill his glass; this thirst suggests that they had a tiring journey. There is a lack of conversation between the figures, as they concentrate instead on rejuvenating themselves. Behind them, two horses water at a trough. The central group is meticulously depicted, particularly in terms of Lingelbach's use of light. The stark, white sunshine highlights the figures, models their faces, and picks out the folds in their clothing. This light also plays off various objects, such as the saddle, the large ceramic jug and the table top, giving an almost still-life aspect to the painting in this central, foreground section.

The inn dominates the canvas, so that there is a relative lack of depth to the *Peasants Resting Before an Inn*, although on the left-hand side a figure can be discerned, walking along a path and beyond him the outline of another building. In terms of composition the present work is reminiscent of other paintings by Lingelbach, such as *Roman Street Scene with Card Players* (fig. 1). Again a lack of recession focuses the work on a few leisurely foreground figures, the background details are indistinct. The scene is also illuminated by a similar stark light to the present work and these dramatic contrasts are reflective of

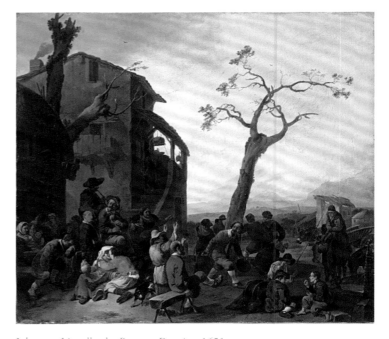

Johannes Lingelbach, *Peasants Dancing*, 1651,
The Metropolitan Museum of Art, New York (Figure 2)

Johannes Lingelbach,
*Roman Street Scene with
Card Players*,
1645-1650,
The National Gallery,
London
(Figure 1)

the time Lingelbach spent in Rome, where he was influenced by the fashion for precise but intense *chiaroscuro*.

Peasants Resting Before an Inn demonstrates Lingelbach's skill in depicting the human figure, something which is demonstrated on a greater scale in *Peasants Dancing* (fig. 2). In this painting we see a variety of figures, including musicians, dancers, drunks, lovers, workers and children. All these figures are treated in the same detailed and individualised manner which is employed in the present work. Lingelbach was part of the second generation of the *bamboccianti*, a group of, mainly Dutch, genre painters active in Rome during the seventeenth century, who chronicled the everyday life of the lower-classes. Having found commercial success through such works, on his return to Amsterdam Lingelbach helped develop the 'Italianate' genre that was imitated by Dutch artists who had never been to Italy. Such was his skill in painting genre figures, that Lingelbach was often invited to paint the staffage for prominent Dutch artists, such as Jacob van Ruisdael (1628/9-1682), Meindert Hobbema (1638-1709) and Jan Wijnants (c.1635-1684) (see inventory).

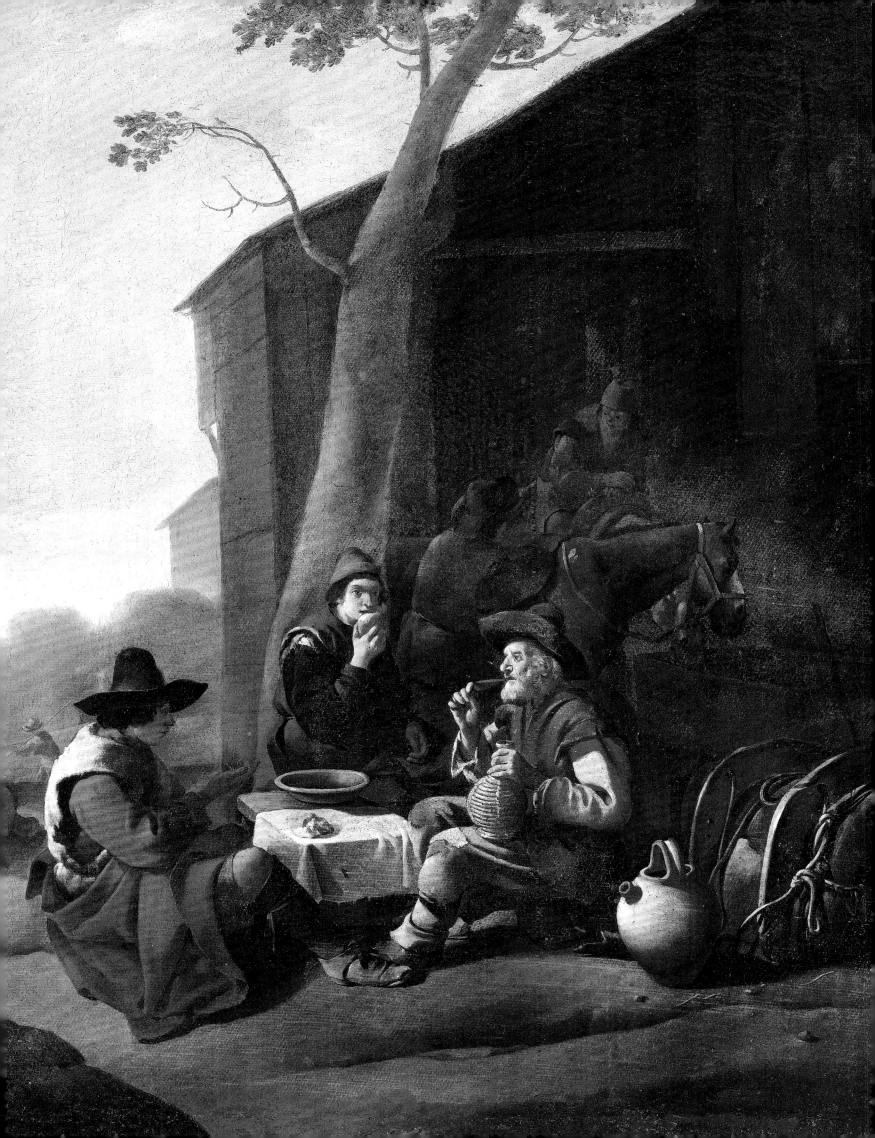

REINIER NOOMS, CALLED ZEEMAN

(Amsterdam 1623 - Amsterdam 1664)

Shipping before a Mediterranean Coast with a Fortified Town near a Cliff

signed 'R. Zeeman' (lower right)
oil on canvas
32.9 x 40 cm (13 x 15⅞ in)

Provenance: De Deckére (according to a label on reverse).

IN *SHIPPING BEFORE A MEDITERRANEAN COAST WITH A Fortified Town near a Cliff,* Reinier Nooms presents us with a bustling section of the rocky, undulating Mediterranean coastline. In the foreground, two rowing boats crammed full of passengers head for the shore, where a group of figures is seen guiding them in. Behind the two mooring boats is a larger vessel, possibly a form of xebec, an extremely popular boat of the period due to its fast speed and manoeuvrability - such qualities were particularly pertinent in areas like the Mediterranean which was constantly targeted by pirates. This ship is echoed by the silhouettes of similar vessels which disappear into the hazy horizon. On the right-hand side, a ship is being readied as a group of men are busily working to attach its sails. A fortified town is nestled under the cliffs, and various figures tend the surrounding land.

Throughout his career Nooms proudly identified himself by the surname 'Zeeman', which in Dutch means 'Seaman'. It was by this title that he regularly signed his works, and his paintings reflect a sailor's understanding and experience. For example, in the foreground of *Ships being Repaired,* a ship is seen lying on its side while being careened (fig. 1). This process involved hauling ships aground to allow their hulls to be scraped free of weed and barnacles. The men working on the upturned ship stand upon a floating raft. The unusual nature of this subject matter is reminiscent of the boat being readied in the present work. Nooms' inclusion of the everyday activities of sailors is typical of his work and hints at his time spent at sea.

Nooms' artistic output is not confined to paintings of ports and harbours as he also painted naval battle scenes, his *The Battle of Leghorn, 4th March 1653* being one such an example (fig. 2). This work depicts a famous Dutch victory over the English Navy that resulted in Dutch control of the Mediterranean. Despite a very different mood and subject to *Shipping before a Mediterranean Coast with a Fortified Town near a Cliff,* the works share several characteristics, such as the a focus on the technically accurate portrayal of the ships, and the similar repetition of the shapes of the vessels deep into the background

Nooms was probably self-taught as an artist, since much of his early career was spent as a sailor on Dutch merchant vessels travelling the trade routes to Paris, Italy and the North African coast. His work falls within the last two stylistic phases of seventeenth-century Dutch marine painting. Some of his paintings demonstrate the interest in light and atmosphere that typified his mid-century 'tonal' phase. Other works, such as Nooms' views of sea battles and Italian ports, have a romantic character that anticipates the more dramatic style of the late seventeenth century. Nooms' depictions of ships are full of accurate detail, demonstrating a keen eye and specialist knowledge in his delineation of features such as the hull or rigging. He often includes details of human activity in a harbour but this is rarely the focus of his work. Nooms was also a distinguished etcher, producing over one hundred and seventy plates.

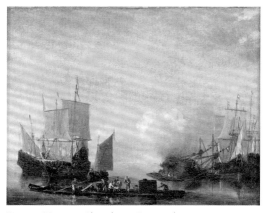

Reinier Nooms, *Ships being Repaired,*
The National Maritime Museum, London, (Figure 1)

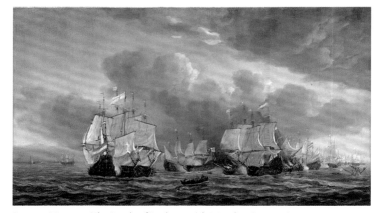

Reinier Nooms, *The Battle of Leghorn, 4th March 1653 c.*1653,
The National Maritime Museum, London (Figure 2)

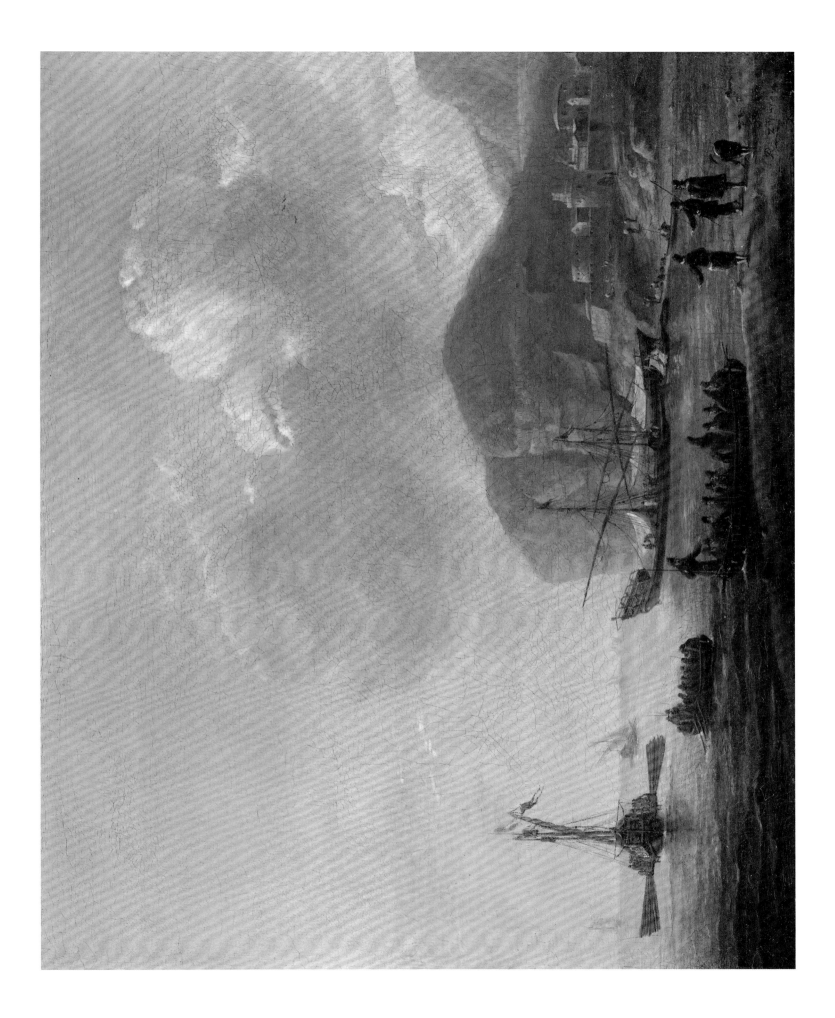

THOMAS HEEREMANS

(Haarlem 1641 - Haarlem 1697)

A River Landscape with Figures outside a Tavern and Yachts Moored alongside Houses

signed and dated on 'THMANS 1691' ('TH' in compendium) (lower right)
oil on canvas
102 x 143 cm (40 x 56¼ in)

THOMAS HEEREMANS' *A RIVER LANDSCAPE WITH Figures outside a Tavern and Yachts Moored alongside Houses* depicts a tranquil, but populated, riverside village. The main activity is condensed onto the far bank of the river, where a number of vessels are mooring up, behind them, a group of houses, a tavern and church line the water's edge. In front of the tavern, a cluster of figures stands around chatting, and even those who work in the boats do not seem particularly strained. In one boat, two men attempt to manoeuvre one of the large, awkwardly rounded wicker fishing baskets that are dotted about the picture, though even this does not appear to cause them particular strain. The peaceful, restful atmosphere is encapsulated by the two figures in the foreground, on the nearside bank. One sits in the sunshine, holding his fishing rod, as the other leans lazily against the bank.

The river, on which this village is obviously dependant, is perfectly still, and upon its glass-like surface Heeremans depicts the sunlight glistening off its gentle ripples. Many of the buildings, trees and boats are reflected in the water, with a marked tonal contrast between the darker reflections of the buildings on the left-hand side, and the predominant light blues and greys of the reflected sky, which make up most of the river. Underlined are the two distinct colour schemes that are dominant in the painting, the dark, earthy tones of the figures and the buildings, and the light, airy tones of the open river and sky.

Throughout his career Heeremans painted many similar riverside scenes, (though usually much smaller than this work), sometimes set in the summer but also often in the winter, such as the Rijksmuseum's *Winter Scene* (fig. 1). During the seventeenth century, an average of two out of three winters in Holland saw particularly extended periods of frosts and snow, with the level of snowfall increasing significantly during the 1660s. This perhaps helps explain the proliferation of winter scenes, not only in Heeremans' work but in seventeenth-century Dutch painting in general. *Winter Scene* portrays a frozen river running through a village, not dissimilar to the one depicted in the present work. Yet again Heeremans has depicted a mixture of work and leisure within the context of a happy community atmosphere. Various figures take advantage of the ice to go skating, whilst alongside them are people for whom work must continue. Sleds are being laden with heavy packages that still need to be delivered. A large group of people sit in a sled, and in the enforced absence of rowing boats the horse must try and ferry them across the ice. A couple of baskets, which have been cast aside, lie on the surface of the ice, a

reminder of the fishing which is not possible in such wintry conditions. Once more, the river reflects the colour of the sky, unifying the composition through a palette of grey and white.

Although previously very little was known about the Heeremans, recent research by Irene van Thiel-Stroman has shed more light on his life. Heeremans was born as the first of nine children and was baptised in the Reformed Church in Haarlem in May 1641. A notary's record from 1659 indicates that Heeremans may have studied under Van Everdingen. According to van Thiel-Stroman, this must refer to Cesar van Everdingen (1615/17-1678), as Allaert van Everdingen (1621-1675) had already moved from Haarlem to Amsterdam in 1652. No influence of the classicist painter can be found in the work of Heeremans, by whom no figure studies are known today. However, his style, particularly notable in his depiction of river scenes such as *A River Landscape with Figures outside a Tavern and Yachts Moored alongside Houses*, is very much influenced by the slightly older Haarlem landscape painter Klaes Molenaer (1630-1676), though Heeremans brings a greater vibrancy both in palette and movement to the rather melancholic scenes of Molenaer.

Also active as a dealer, Heeremans joined the Guild of St. Luke in 1664. He was buried in Haarlem at the Noorderkerkhof on 22 January 1694.

Thomas Heeremans, *Winter Scene*, 1675, Rijksmuseum, Amsterdam (Figure 1)

[1] See I. van Thiel-Stroman in *Painting in Haarlem. The Collection of the Frans Hals Museum*, Ghent, 2006, pp. 202-3.

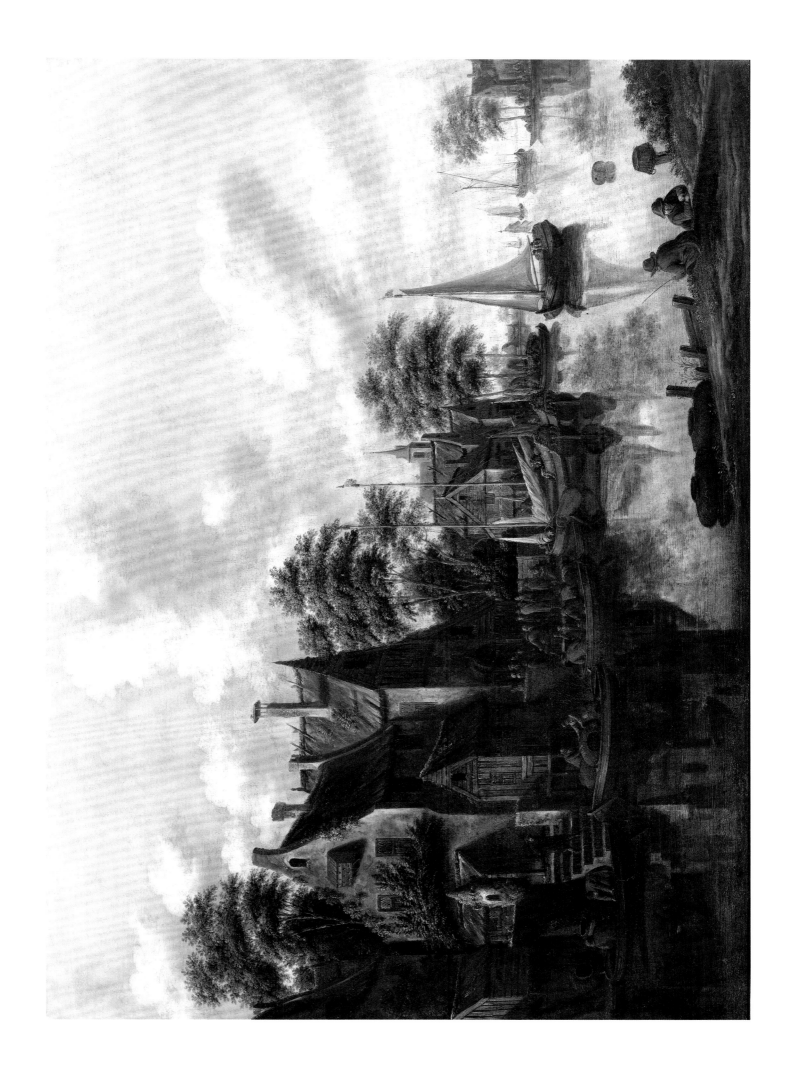

JAN ABRAHAMSZ BEERSTRATEN

(Amsterdam 1622 - Amsterdam 1666)

A Mediterranean Harbour with Men-o'War, Shipping and Merchants on a Quay by a Tower

signed and dated on a stone 'J. Beerstraaten 1664' (lower centre)
oil on panel
48 x 65 cm (18⅞ x 25½ in)

THIS DELIGHTFUL MEDITERRANEAN PORT, FILLED with men-o'war gallantly displaying the red, white and blue stripes of the Dutch flag, epitomises the mercantile success of the Dutch Republic in the seventeenth century. On the right, a resplendent man-o'war leaves the harbour with full sails, whilst to the left three further men-o'war are anchored in the harbour, their cargo presumably being tended to. In the foreground, figures standing on the quayside are seen gesturing towards the moored vessels. Two figures, most likely Dutch merchants, distinctively dressed with wide brimmed black hats and white ruffs, are in deep discussion under an arch. The arch forms part of a tower, with a bell perched on the top, clearly in a state of disrepair as creeping plants grow within the stonework. In the right foreground, a small wooden vessel can be seen unloading wares via a wooden plank. On the bow end of the boat, a man wearing a white turban and tunic converses with another man, suggesting that this port is a hub for international trade.

The background is dominated by a Mediterranean urban landscape. Though a *capriccio*, the visible fortifications in the harbour and towering mountain in the distance allude to Naples.

It is not known whether Beerstraten journeyed to Italy during his career, though his portrayal of dappled, southern light is particularly accurate. He may have copied drawings from Johannes Lingelbach (see catalogue no. 57), an Dutch-Italianate painter who had visited the Mediterranean. The so-called 'Golden Age' of the Dutch Republic in the seventeenth century was, in part, associated with the significant mercantile wealth accrued from their dominance of world maritime trade. The Mediterranean was the gateway between European and Eastern trade, and *A Mediterranean Harbour with-Men o'War, Shipping and Merchants on a Quay by a Tower* portrays the considerable presence of Dutch shipping on the trade route.

Beerstraten is thought to have been a pupil of the Flemish maritime painter Claes Claesz Wou (1592-1665) and is best known for his southern seaports, battle scenes and winter townscapes. His depictions of southern ports and seashores, such as *A Mediterranean Harbour with Men-o'War, Shipping and Merchants on a Quay by a Tower* were influenced by the Dutch Italianate painters Nicholaes Berchem (1620-1683) (see inventory) and Jan Baptist Weenix (1620-1660/1). Unlike his townscapes, Beerstraten's ports were entirely imaginary though sometimes well-known buildings were incorporated on the seashore.

Jan Abrahamsz Beerstraten, *A Mediterranean Harbour with Men o'War, Shipping and Merchants on a Quay by a Tower* (Detail)

Jan Abrahamsz Beerstraten, *A Mediterranean Harbour with Men o'War, Shipping and Merchants on a Quay by a Tower* (Detail)

LUDOLPH BACKHUYSEN

(Emden 1631 - Amsterdam 1708)

Shipping by the Dutch Coast

monogrammed on the barrel 'L.B.' (lower right)
oil on canvas
48 x 62 cm (18¾ x 24⅜ in)

Provenance: Rev. Elborough Woodcock;
Edmund C. Johnson, 20 Feb, 1916, No. 8;
Stuart Johnson, 4 Eaton Place, London SW1 (according to label on the reverse).

THE PRESENT WORK SHOWS A FISHING FLEET OFF the Dutch coast navigating choppy waters. In the far background, a Dutch man-o'war can be seen. In the rough water a wooden barrel floats on top of a wave, evidently lost from one of the nearby sailboats, and the underside of the cask is monogrammed with Ludolph Backhuysen's initials, 'L.B.'. The sky is dominated by low lying, thick dark clouds, intimating an approaching storm, which is further indicated by the full sails of the fleet, white capped waves and broken water. Backhuysen was an ardent student of nature, and frequently worked from an open boat in order to study the effects of storms. In *Shipping by the Dutch Coast,* one imagines the artist to be perched on the quayside, from which the broken wooden stilts of an earlier structure still visible, deftly recording the movement and fragility of the ships in the whipped and stormy waters.

Ludolph Backhuysen, *Shipping by the Dutch Coast* (Detail)

Backhuysen was a Dutch painter, draughtsman, calligrapher and printmaker of German origin, though he was primarily active in Amsterdam. Backhuysen was from Emden in north-west Germany and he trained as a clerk in his native town. Shortly before 1650 he went to Amsterdam to work for a wealthy merchant, and it was while working there that his fine calligraphy attracted attention. He also displayed skilled use of the pen in drawings, mainly of marine scenes, completed in black ink on prepared canvas, panel or parchment. He probably derived this technique and subject matter from Willem van de Velde the Elder's (1611-1693) pen drawings of the 1650s.

According to the Dutch engraver Arnold Houbraken (1660-1719), Backhuysen learnt to paint using oils from the marine painters Hendrick Dubbels (1621-1707) and Allaert van Everdingen (1621-1675) (see inventory). His earliest paintings utilise a silvery palate and are simply composed, echoing

the work of his forerunner, Simon de Vlieger (*c.*1600-1553) (see inventory). The present work, believed to have been completed *c.*1660-1665, demonstrates the features characteristic of Backhuysen's early works, such as the more subdued and limited colour palette in comparison to his later, more vibrantly colourful and charged works. Backhuysen did not join the Amsterdam guild of painters until 1663, after which his fame as a marine specialist rapidly grew. In 1665 he was commissioned by the burgomaster of Amsterdam to paint *View of Amsterdam and the IJ* (now in the Louvre, Paris), intended as a diplomatic gift for Hugues de Lionne, Louis XIV's Foreign Minister. After van de Velde the Elder and Willem van de Velde the Younger (1633-1707) moved to England in 1672, Backhuysen became the leading marine painter in the Dutch Republic. Unlike the van de Veldes, who were more concerned with representing the

Abraham Storck, *Review of the Dutch Yachts before Peter the Great*, 1697, National Maritime Museum, Greenwich, London (Figure 1)

technical aspects of sailing vessels and naval battles, Backhuysen concentrated on the ever changing climate and the magnificent skies of the Netherlands. Much of his work venerates Amsterdam and the mercantile trade that had epitomised its Golden Age.

Backhuysen's success won him important commissions from Cosimo III de' Medici, Grand Duke of Tuscany, Frederick I of Prussia, Elector of Saxony, and Peter the Great, Tsar of Russia. The artist exerted great influence upon a number of younger artists, including Abraham Storck (1644-1708) (fig. 1). The latter was particularly inspired by Backhuysen's pictorial treatment of sea and sky, as is clealy demonstrated in *Review of the Dutch Yachts before Peter the Great.*

DIONIJS VERBURGH

(Rotterdam c.1655 - 1722)

A Town in a Hilly Landscape with a River and Several Figures

signed with monogram 'Dvb' (lower left)
oil on panel
70 x 86 cm (27½ x 33⅞ in)

DIONIJS VERBURGH POSSESSED A DISTINCTIVE individual style that is particularly noteworthy in his landscapes. This scene is typical of his panoramas, which are often seen from a high viewpoint and always contain a plethora of landscape elements. Invariably, towns inhabited with tiny figures are situated by riverbanks and nestled between peaked mountains, as exemplified in his *A River Landscape with Figures Outside an Inn Beneath a Ruined Castle, a Town Beyond* (fig. 1). They are imbued with a peaceful, poetic atmosphere, which in the present work is achieved by the subtle tones, stippled foliage, calming influence of the church and quiet activities of the townsfolk.

Closer inspection of the painting reveals a masterly and charming attention to detail, from the swans on the lake to the clock on the church tower. The figures that fill his paintings demonstrate the skill of his brushwork as well as his playful imagination. In this painting, a man fishes, another removes his hat to greet two ladies, a boy plays with a dog and a woman leans out of her door to bellow commands at her husband.

The expression of spaciousness and atmosphere through subdued colour, which Verburgh achieves here, was a popular technique in seventeenth century art. Taking in the painting as a whole, the composition is a celebration of the countryside, which stems from a tradition of Dutch painting that looked to landscapes, townscapes and marine scenes as a means of expressing pride in their country. Such a desire developed out of the long struggle for independence from Spain, which was finally achieved in 1648 when the Peace of Münster was concluded. This was a significant cornerstone in Dutch history and was to condition and influence the nature of Dutch art in the seventeenth century.

Consequently, landscape views which served to celebrate the nation were often favoured over religious, mythological and historical works - themes which were a common tradition amongst their European counterparts. The reverence for nature and expression of heroic spirit in the works of Dutch landscape painters ensured their enduring popularity and significant influence on later art, most notably in England.

A landscape painter from Rotterdam, Verburgh was a follower of Gerrit van Battem (*c.*1636-1684). Notable for painting some of the figures in Salomon van Ruysdael's (see inventory) famous landscapes, in his personal work van Battem specialised in imaginary landscapes, painting mountain scenery, towns, winter views and woodlands. His preference for incorporating figures within a panoramic backdrop of mountains, rivers and woodlands shows the influence he exerted on Verburgh (fig. 2).

A Town in a Hilly Landscape reveals the influence of two notable Dutch painters on Verburgh's landscapes as well as his continuation of the nation's unrivalled endorsement of genre painting. An artist who was to be recognised in his own right for his superior portrayal of landscape scenes, Verburgh in turn attracted his own circle of followers.

Dionijs Verburgh, *A River Landscape with Figures Outside an Inn Beneath a Ruined Castle, a Town Beyond,* Private Collection (Figure 1)

Gerrit van Battem, *A Landscape with Travellers, c.*1670, The Royal Collection (Figure 2)

MATTHIAS WITHOOS

(Amersfoort 1627 - Hoorn 1703)

Capriccio of the Forum, Rome, with the Arch of Constantine

and the Coliseum in the Background

inscribed 'No 120 Withoos T BE' (on the reverse)
oil on canvas
98.1 x 135.4 cm (38⅝ x 53¼ in)

THIS ENCHANTING SCENE BY MATTHIAS WITHOOS, *Capriccio of the Forum, Rome, with the Arch of Constantine and the Coliseum in the Background*, combines elements of Roman architecture with highly naturalistic depictions of trees and flowers. The painstaking detail with which the flowering bushes in the foreground are rendered is of particular note. Morning Glory, thistles and wild flowers grow haphazardly around the base of a shady tree. A statue of Romulus and Remus as infants suckling from their wolf mother is nestled amongst the bushes. There are other statuary fragments scattered around the forest floor, such as a relief of a hunt with figures on horseback. An ancient fountain, overgrown with moss and foliage, is situated at the base of a hill, from which Cyprus and Pine trees grow. A majestic peacock sits on the edge of the fountain, looking exotic and other worldly amongst the classical remains.

The background of the painting is equally full of interest, as figures can be made out exploring the ruins of Rome. The architecture, reflecting the remains of actual buildings, is superimposed with fanciful elements to form an imaginary cityscape. The Arch of Constantine is most prominent near the centre of the composition, while the Coliseum stands to the right. Cyprus trees are interspersed between the buildings and architectural fragments, giving them a stately and sombre tone. The predominance of cool colours, and the bluish hue pervading the entire painting, adds to its mysterious and melancholy air, as does the overcast sky and the corresponding shadiness on the ground.

The foreground section of the canvas, dominated by flowers, could constitute a painting in itself as it appears to stand apart from the rest of the composition. Withoos is best known for his still life paintings, such as *Still Life* in the Indianapolis Museum of Art, see fig. 1, and it is evident that his foremost interest lies in the meticulous rendering of plants. In *Still Life*, cultivated flowers such as roses and lilies grow together with weeds and brambles, forming a dense patch of foliage, under which a hedgehog, lizard and mouse find shelter. In Withoos' still life paintings, the plants often have *vanitas* connotations; in *Still Life*, the roses and lilies symbolise the purity of the Virgin and the thistles and spiny plants represent Christ's crown of thorns. The inclusion of the flowering plants in the present picture may

have a similar purpose, with the Morning Glory making reference to the transience of life, as they flower in the morning and die in the afternoon.

Withoos studied under Jacob van Campen (1595-1657) and Otto Marseus van Schrieck (1619/20?-1678) (see catalogue no. 47). He accompanied van Schrieck and Willem van Aelst on a trip to Italy in 1648, where he became a member of the *Schildersbent* in Rome. His patrons, while in Italy, included Cardinal Leopoldo de' Medici. He had moved back to his birthplace, Amersfoort, by 1653 and lived there until 1572, when the French occupied the town, and he subsequently resettled in Hoorn. In addition to still lifes, Withoos painted views of Dutch ports. Five of his children became painters, specialising in landscapes, still lifes and insect studies in oil and watercolour.

Matthias Withoos, *Still Life*, *c*.1670,
Indianapolis Museum of Art (Figure 1)

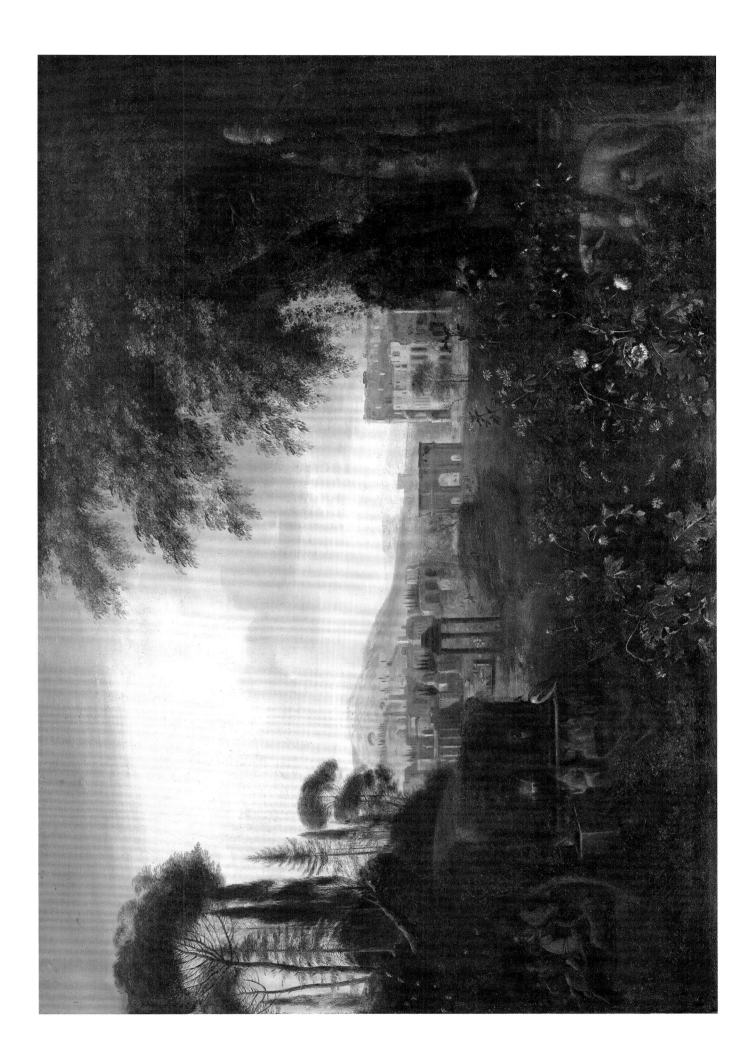

JAN SIBERECHTS

(Antwerp c.1627 - London 1703)

A Horse-Drawn Cart with Two Women Travelling down a Flooded Road at the Edge of a Wood

signed and dated 'J siberechts 1692' (lower centre)
oil on canvas
126.5 x 99.7 cm (49¾ x 39¼ in)

Provenance: Collection J. H. Leigh;
H. St. Barbe, Christie's, London, 7th July 1916, lot 76 (£94 10s. to Haggins (?));
with J. Goudstikker, Amsterdam, 1918, where brought by the family of the previous owners in 1919 (Dfl. 5,500).

Literature: T.H. Fokker, *Jan Siberechts: Peintre de la Paysanne Flamande*, Brussels, 1931, p.99.

JAN SIBERECHTS' *A HORSE-DRAWN CART WITH TWO Women Travelling down a Flooded Road at the Edge of a Wood* is a scene of the rustic English landscape. The water-logged path leads the eye across and back into the painting. On the far-side of the road is a wood, which encourages our eye further back into the distant landscape. Under the pink hue of the clouds, which suggests that it is dusk, a horse pulls a cart and two chattering women through the water at the end of the day. They have just passed cattle heading in the opposite direction, and a farmer riding alongside them. In the foreground, another peasant, lugging his heavy sack over a rickety bridge, follows his dog. As has been pointed out by Timon Fokker, Siberechts borrowed the distant landscape visible in the right background from an earlier picture now in the Museum of Fine Arts in Budapest that is signed and dated 1667.[1]

Siberechts painted the present painting in 1692, by which stage he had been living and working in England a number of years. This painting is, however, dramatically different from his usual work of this period. Instead, it follows in the tradition of the landscapes from his later Flemish period, which he occasionally still produced. By comparing *A Horse-Drawn Cart with Two Women Travelling down a Flooded Road at the Edge of a Wood* to a painting from his Flemish period, such as *Peasants Crossing a Stream*, which was executed over twenty years earlier, it becomes apparent that Siberechts has adopted the manner and style of the earlier work in the present painting (fig. 1). Both paintings include a stretch of water in the foreground on which Siberechts has indulged a clear interest in the glittering effects of light bouncing off the water's surface. In both works the dominant figures are female, and the inclusion of cattle wading through the water are a prominent feature. The employment of the expanding distant landscape which leads our eye deep into the background of the work, is also a technique apparent in both paintings.

This idea of Siberechts returning to an earlier style becomes all the more

Jan Siberechts, *Peasants Crossing a Stream*, c.1670,
Cleveland Museum of Art, Ohio (Figure 1)

apparent when one looks at work more typical of his time in England. Here he worked mainly for the English aristocracy and many of his commissions were,what came to be regarded as the first country house portraits, one of the most famous examples being his *View of Longleat*, see fig. 2, a work which seems to have very little in common with *A Horse-Drawn Cart with Two Women Travelling Down a Flooded Road at the Edge of a Wood*. The focus of the work is an accurate topographical depiction of the façade of the house at Longleat, still regarded as one of the finest examples of Elizabethan architecture in Britain. We are given a bird's-eye view of the house from a central position, which gives us the best possible view of the building and some of the surrounding estate. Here all the figures are minute, providing a sense of scale in relation to the house, and those that are distinguishable are

[1] T. H. Fokker, *Jan Siberechts: Peintre de la Paysanne Flamande*, Brussels, 1931, p.99.

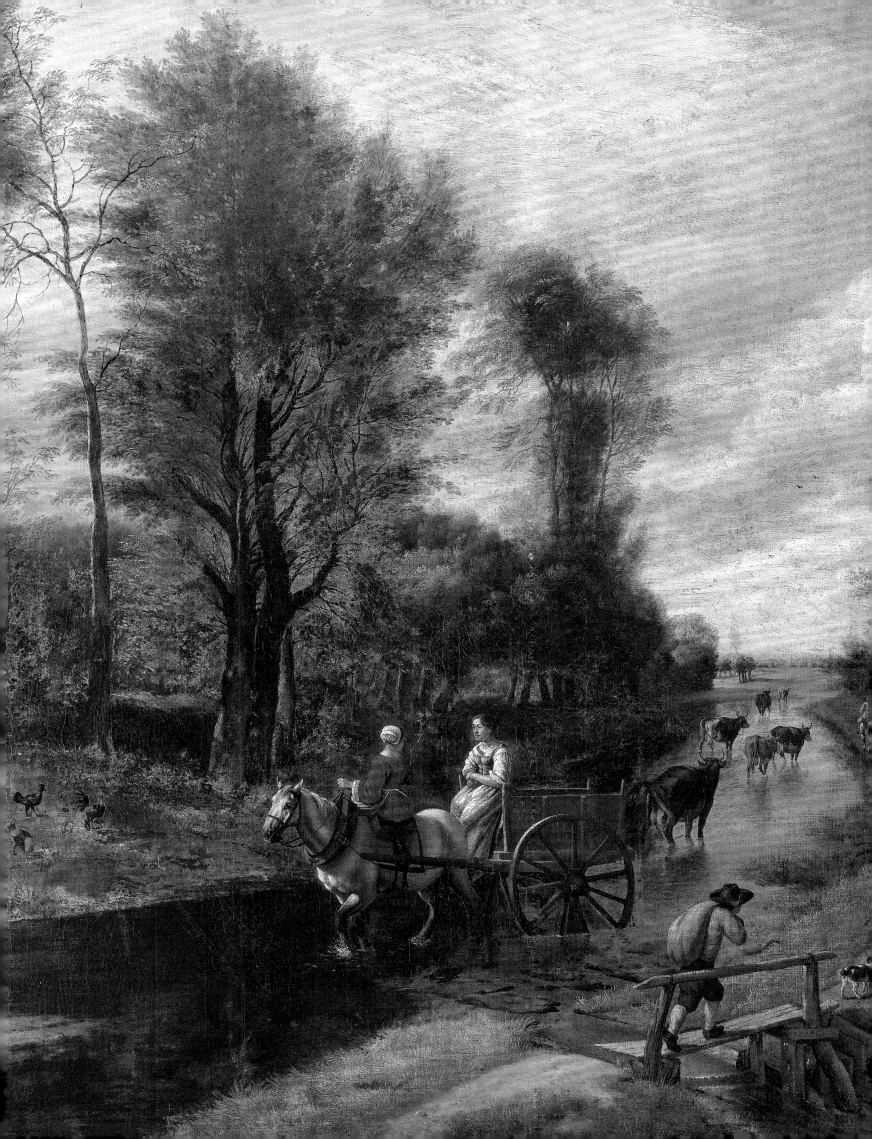

taking part in various leisure activities, such as walking about the grounds or hunting. This is in stark contrast to the focused images of peasant labour in the other two works thus far discussed. *View of Longleat* is an exercise in vanity on the part of Siberechts' patron, Thomas Thynn, who wished to celebrate the magnificence of his house, which served as a reflection on his status and fortune, whereas in *A Horse-Drawn Cart with Two Women Travelling Down a Flooded Road at the Edge of a Wood*, Siberechts has given us an appreciative view of rural peasant life.

The son of a sculptor, Siberechts was born in 1627 and baptised in Antwerp. He was apprenticed to the Flemish painter Adrian de Bie, and was elected to the Guild of St. Luke in Antwerp in 1648. His earliest dated works show the impact of Dutch Italianate painters like Nicolaes Berchem (1620-1683) (see catalogue no. 121) and in fact he probably visited Italy in the late 1640s. Siberechts became a master in Antwerp in 1648 and his earliest dated works are stylistically akin to those of the Dutch Italianate landscape painters. Around 1660, inspired by rustic life, he developed an individual style and started to paint Flemish scenes containing figures and animals. These landscapes, of which *Peasants Crossing a Stream* is an example, are regularly dominated by female figures dressed in simple clothing. Their bright whites, reds and yellows form colourful accents against the cool greens of the landscapes. Prominent rustic figures and animals are often further emphasised by patches of bright colour and dramatic lighting effects. Depicting figures with cattle crossing a stream bordered by large trees is one of Siberechts' recurring themes during this period. The backgrounds, which are generally cut off by an impenetrable, muted screen of foliage, emphasise the figures, animals and brightly lit road in the foreground. His works made until 1665 display an obvious interest in light effects. Thereafter, the representation of volume and shape became a predominant concern, expressed through, for example, more prominent figures placed sparingly in the foreground. He also opened up the curtain of trees characteristic of his earlier paintings, allowing trunks and branches to stand out as independently decorative features.

The main theme of Siberechts' work from this early period is his depiction of noble peasants, like those in *The Ford*, see fig. 3, which are often compared to those of France's Le Nain brothers. Siberechts possibly drew inspiration for his noble portrayal from the Brussels painter Michael Sweerts (1618-1664). Some of the motifs, such as the milkmaid carrying her heavy pail on her head, are reminiscent of counterparts in Rubens' (1577-1640) late landscapes. Rubens' influence was still keenly felt in Flemish landscape painting but Siberechts' work is generally more original than that of those artists who worked in Rubens' studio, such as Lucas van Uden (1595-1672) (see inventory) and Jan Wildens (1585/6-1653). In the 1630s Antwerp genre painting was dominated by the style encapsulated by Adriaen Brouwer's (1605/6-1638) work. This is extremely focused, with the emphasis on violent drama expressed by a small number of figures, generally rough peasant types symbolic of unacceptable behaviour. However, artists such as Siberechts changed this attitude towards

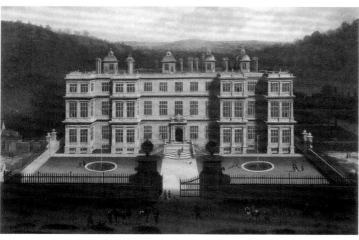

Jan Siberechts, *View of Longleat*, c.1675, Longleat House, Wiltshire (Figure 2)

Jan Siberechts, *A Horse-Drawn Cart with Two Women Travelling Down a Flooded Road at the Edge of a Wood*, 1692 (Detail)

the countryside and his statuesque, almost heroic, peasant girls reflected the increasing demand, also prevalent in literary circles, for idyllic and pastoral subjects. The woman following her cattle in *The Ford* has an almost classical pose, and a sculptural stateliness which is notable in Siberechts' figures, a reminder that his father was a sculptor. Marjorie Wieseman characterised the works of Siberechts in this period thus: 'As much figure and animal paintings as they are landscapes, Siberechts' views of watery highways are imbued with a quiet monumentality, expressed most cogently by the simple, solid forms of country folk and their livestock. With measured grandeur, they push against the resistance of the shallow water which slows and impedes their movement, raising the bright ripples and splashes which are a hallmark of the artist's work'.[2]

Siberechts arrived in England sometime between 1672 and 1674, apparently at the encouragement of George Villiers, 2nd Duke of Buckingham, who had seen some of Siberechts' landscapes in Antwerp in 1670, and Siberechts was immediately employed to help decorate the Duke's residence at Cliveden, Buckinghamshire. Many of Antwerp's leading artists emigrated during the seventeenth century and were not replaced, including David Teniers II (1610-1690) who left to become court artist in Brussels, and by around 1700 the Antwerp school no longer existed. This was symptomatic of a wider trend: Siberechts being one of hundreds of Dutch and Flemish artists who came to Britain in the seventeenth century. He travelled extensively throughout his adopted country though the majority of his oils of river landscapes which survive suggest that he concentrated on the topography of Derbyshire, the Trent and the Thames valleys.

It was on arrival to England from Flanders that Siberechts started his career as a topographical painter, for which he is most noted, and he has long been regarded as the leading topographical painter of his day. He also painted more generalised landscapes, particularly of the Peak District, merging his own style of Dutch influenced genre painting with the growing demands of

[2] Marjorie Wieseman, *The Age of Rubens*, exhibition catalogue, Boston 1993, p. 494, under no. 93.

Jan Siberechts, *The Ford*, 1670, Staatliche Museen, Berlin (Figure 3)

country house portraiture. It was his reputation that attracted the patronage of men of the standing of Thomas Thynn of Longleat, Sir Thomas Willoughby of Wollaton Hall, Philip Stanhope, 1st Earl of Chesterfield and William Cavendish, 1st Duke of Devonshire. As well as Longleat in 1675, his country house commissions included views of Chevely in 1681, Chatsworth in 1694 and Wollaton in 1695, creating topographically recognisable views of these buildings in more sober colour schemes than his earlier work. *Longleat House* is a fine example of Siberechts' ability to combine an accurate observation of topographical and architectural detail with a sensitive appreciation of the landscape of the extensive gardens and sweeping vistas of the surrounding countryside.

In these subjects, so much more aristocratic than his earlier work, Siberechts closely follows the form of composition which evolved earlier in France for military and topographical subjects and used repeatedly by painters such as Adam Frans van der Meulen (1632-1690). It comprises three main elements: a very soft and atmospheric distance, in which the natural features were sometimes slightly falsified for the sake of the composition; a meticulously accurate rendering of the house itself in the middle distance; and more freely painted groups of riders, coaches, dogs and huntsmen in the foreground, which was usually steeply and artificially raised in order to justify the high point from which the house was drawn. Such canvases, formal though they are, foreshadow the more sophisticated views of English houses by Richard Wilson (1713/14-1782) and Canaletto (1697-1768). Foreign artists exerted an enormous influence on English art of the period, in fact Siberechts' undated *View of Nottingham and the Trent* (Collection of Lord Middleton, Birdsall House, Yorks.) is possibly among the earliest of British landscape paintings. The bird's-eye view portrayal of houses with their estates, such as *Longleat House*, was introduced to England by Dutch artists and they dominated this new, fashionable style. Siberechts' compatriot Jacob Knijff (1639-1681), with his brother Leonard (1650-1722), embarked in the 1690s on an ambitious project of drawing and engraving the sprawling

piles of upper class English society, beginning with those of John Holles, Duke of Newcastle. In 1701, Leonard Knijff announced that he had drawn sixty seats to date and that his series of engravings would eventually total one hundred. A large number of them appeared in *Britannia Illustrata or Views of Several of the Queen's Palaces, as also of the Principal Seats of the Nobility and Gentry of Great Britain* (1707). This work was reissued in several volumes at various dates by a variety of publishers, sometimes with the title *Nouveau théâtre de la Grande Bretagne*, and the engravings were simultaneously marketed as independent prints. If we look at Leonard's engraving of *Longleat House*, which was made in the early eighteenth century, it is clear that whilst still strictly topographical, the depictions of these grand country houses became more inventive compared to the early works of Siberechts (fig. 4). The depiction is from a higher, more distant, less centralised angle than Siberechts' painting, with the result that as well as seeing more of the house, there is a greater emphasis on the extensive gardens and the estate as a whole. However, it is a work that owes a great deal to Siberechts initial explorations into the genre.

During this period Siberechts still painted the occasional rural scene or landscape, such as *A Horse-Drawn Cart with Two Women Travelling down a Flooded Road at the Edge of a Wood*. He continued to use the same style that had matured in Flanders and he invariable viewed the English countryside through Flemish eyes, although his style is quite independent of Rubens or the Brussels school. In these works and in Siberechts' few surviving watercolours he was particularly interested in portraying mighty trees and soft light on distant hills, making the figures less important than the landscape. The viewer's eye is drawn towards the broad, brightly lit vista in the background, while the foreground remains relatively dark. Siberechts' colour is cool and pleasant and his handling is broad. In England his subject-matter remained largely unchanged, but the distant scenery, which is used as a background for his troops of country folk with their horses, carts, and flocks, is recognisably English. Among the landscapes at Birdsall House, for example, which were painted for Sir Thomas Willoughby, is *Landscape with a Ford*, in which a team of horses pull a wagon through the stream against a distant view of Wollaton House.

Having established a lucrative career in England, Siberechts remained there until his death in 1703. One of his daughters was a lace-maker for the Queen and another married the sculptor John Nost. The influence of Siberechts can be seen in the work of a later generation of British landscape painters, including George Lambert (?1700-1765) and the early works of Thomas Gainsborough (1727-1788). According to Sir Ellis Waterhouse, he has a claim to be regarded as the 'father of British landscape'.[3]

Leonard Knijff, *Longleat House*, plate from Leonard Knijff and Jan Kip's *Britannia Illustrata or Views of Several of the Queen's Palaces, as also of the Principal Seats of the Nobility and Gentry of Great Britain*, 1708 (Figure 4)

[3] E. Waterhouse, *Painting in Britain, 1530-1790*, Harmondsworth, 1953, pp. 117-18.

SALOMON ROMBOUTS

(active Haarlem 1652 - Florence 1710)

A Torrent in a Scandinavian Landscape, a House Beyond

signed 'SRombouts' ('SR' linked, lower left)
oil on panel
36.5 x 32.2 cm (14⅜ x 12⅝ in)

THIS DRAMATIC COMPOSITION BY SALOMON Rombouts depicts a river rushing through a rocky northern landscape. The moving water exerts a dynamic presence, gathering speed as it diverts around a large boulder and cascades on either side, adding tension to the otherwise tranquil surroundings. Waterfalls were popular elements in the work of seventeenth-century Dutch masters such as Jacob van Ruisdael (1628-1682) and Allaert van Everdingen (1621-1675) (see catalogue no. 124), whose paintings clearly influenced Rombouts, and 'can be interpreted in Baroque terms as a symbol of man's transitory and ephemeral existence'.[1] *A Torrent in a Scandinavian Landscape, a House Beyond* brings to mind the power and unpredictability of natural phenomena, particularly if the movement of the water is contrasted with the mundane activities of the figures along the bank. On the left, two men attempt to shift the fallen tree trunks lying on the ground, and further along the path, a rider followed by a boy

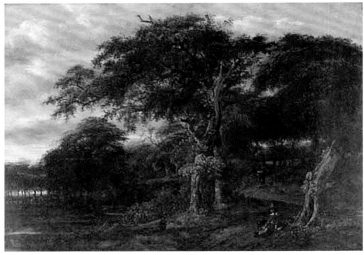

Salomon Rombouts, *Entrance to the Forest*, Louvre Museum, Paris (Figure 2)

leading two horses approaches. Another man crosses the bridge in the centre of the composition and his diminutive figure looks lonely and precariously balanced above the turbulent water.

Little is known about Rombouts' life and it has not been determined whether he visited high-mountain regions such as those depicted here. Like Ruisdael, he probably based the painting on examples by van Everdingen, who travelled to Norway and Sweden in 1644. Van Everdingen's *Forest Scene with Water-Mill*, executed *c.*1650, has many elements in common with the present work, including the rough timbered building, craggy rocks and brooding tonality (fig. 1). The addition of the castle in *A Torrent in a Scandinavian Landscape, a House Beyond*, parallels the fortifications often depicted in Ruisdael's landscapes, such as *Waterfall with a Half-Timbered House and Castle* in the Fogg Museum, Harvard, and heightens the romanticism of the scene. Rombouts' idyllic views were further inspired by Ruisdael's pupil, Cornelis Decker (1620-1678) (see catalogue no. 53), which is evident in his depiction of monumental trees and brooding skies in paintings such as *Entrance to the Forest* in the Louvre Museum (fig. 2).

Rombouts was the son of the painter Gillis Rombouts (*c.*1630-1678), with whom he may have initially studied, before being admitted to the Haarlem guild in 1678. He is recorded as having moved to Florence by 1690.

Allaert van Everdingen, *Forest Scene with Water-Mill, c.*1650, Wallraf-Richartz Museum, Cologne (Figure 1)

[1] Gabriele Groschner, Thomas Habersatter, Erika Mayr-Oehring (Ed.), *Masterworks*, Residenzgalerie Salzburg, Salzburg 2002, p. 28

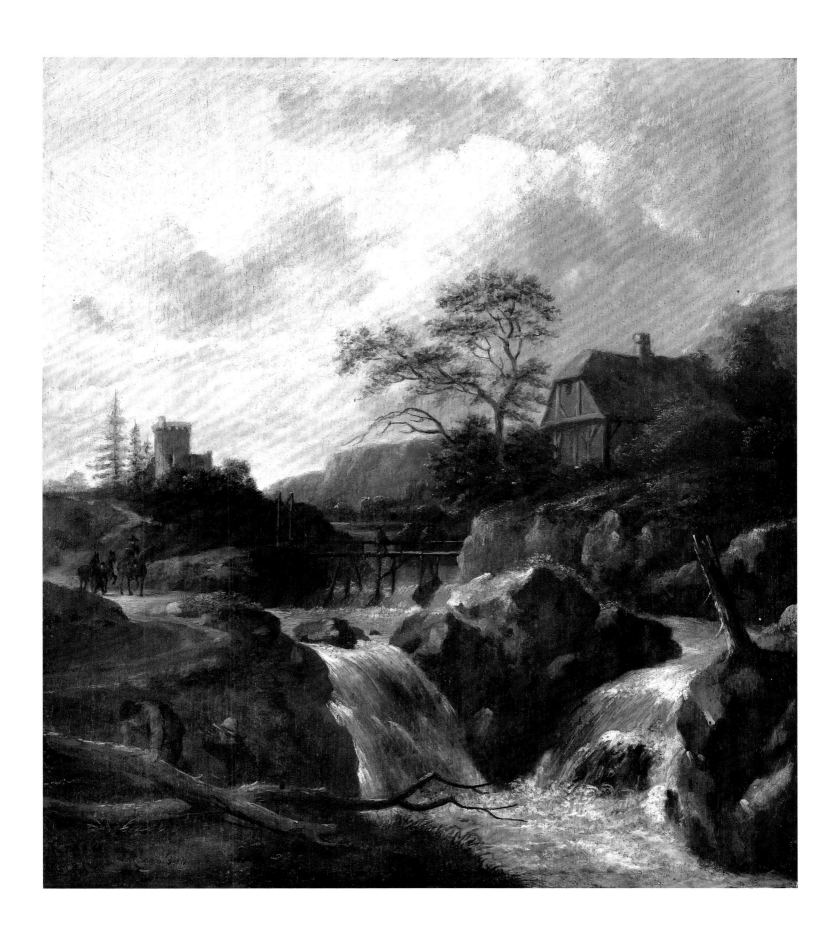

JAN FRANS VAN BLOEMEN, CALLED ORIZZONTE

(Antwerp 1662 - Rome 1749)

The Flight into Egypt

&

The Rest on the Flight to Egypt

oil on copper, a pair
26.7 x 43.8 cm (10½ x 17½ in) each

Provenance: Henry Huck Gibbs, by 1887;
thence by descent;
former Private Collection.

THE *FLIGHT INTO EGYPT* DEPICTS THE HOLY family making their way through an idealised classical landscape. Joseph leads his donkey, which bears mother and child, along a path which winds its way into the distance before disappearing behind a grove of trees. Beyond this, the painting opens up to a dramatic, undulating mountainous background, with a fortified town perched atop one of the peaks. On the left-hand side, a stream flows gently along and it is flanked, on the far bank, by a rocky wall. Acting as a *repoussoir*, we are drawn by the stream into the background, with the meticulously depicted tree on the right-hand side serving as a framing device.

In the accompanying picture, *The Rest on the Flight to Egypt*, Jan Frans van Bloemen, called Orizzonte, has painted a similar, Arcadian landscape. However, the most significant difference is the inclusion, on the left-hand side, of ancient artefacts, which help to contextualise the scene. The large stone urn on a plinth reinforces the sense of antiquity, with which both paintings are imbued; however the sphinx and the triangular structure behind it, the shape of which echoes the pyramids, specifically place this scene in ancient Egypt. This corner of the painting recalls the *capricci* of artists such as Giovanni Paolo Pannini (1691-1765), which were so popular with fashionable Roman society in this period. Again Orizzonte has used a precisely constructed composition that leads the eye from foreground figures through the landscape to a town set against a mountainous background.

The carefully constructed compositions evident in the present works are very much a feature of Orizzonte's work, a further example, in the Metropolitan Museum of Art, being his *Landscape with the Communion of Saint Mary of Egypt* (fig. 1). In this painting the diagonal line of the river guides our focus from the foreground figures, through the relatively lush Italianate landscape to the imposing background. The river is particularly reminiscent of that in *The Rest on the Flight to Egypt*, with Orizzonte delighting in displaying his skill in depicting the play of the bright Italian sunshine on the water's surface. In both *The Flight into Egypt* and *Landscape with the Communion of Saint Mary of Egypt* the prominent positioning of an overhanging tree serves, not only as a framing device, but also as a chance for

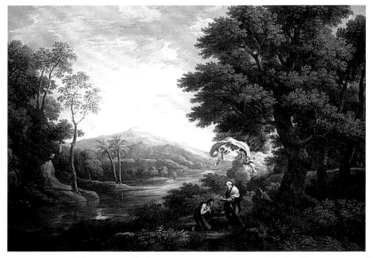

Jan Frans van Bloemen, called Orizzonte, *Landscape with the Communion of Saint Mary of Egypt*, The Metropolitan Museum of Art, New York (Figure 1)

Orizzonte to carefully record natural features. His scrupulous observation is especially evident in *The Flight into Egypt*, where the orange tinge of some of the leaves serve as the earliest signs of the coming autumn.

Orizzonte predominantly painted similar classical landscapes throughout his career, taking his inspiration from the Roman *campagna*. His landscapes, with their recession through a series of planes, soft, warm lighting and classical and religious subject matter, draw on the examples of artists such as Claude Lorrain (?1604/5-1682) and Gaspard Dughet (1613-1675). Orizzonte gained his moniker, meaning horizon, due to the wide panoramas found in his work. His paintings are exquisitely imbued with 'that difficult-to-define pastoral ambience' which helped to make him such a great painter in the eyes of his contemporaries.[1]

[1] Vernon Hyde Minor, *The Death of the Baroque and the Rhetoric of Good Taste*, Cambridge University Press, 2006, p. 69.

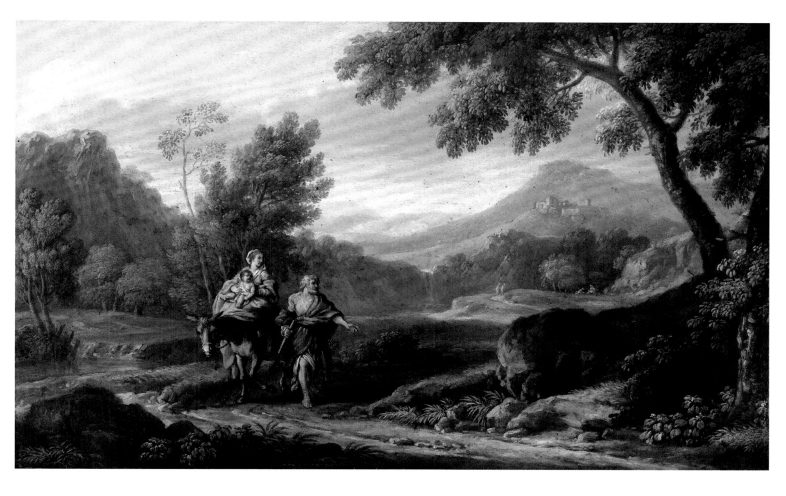

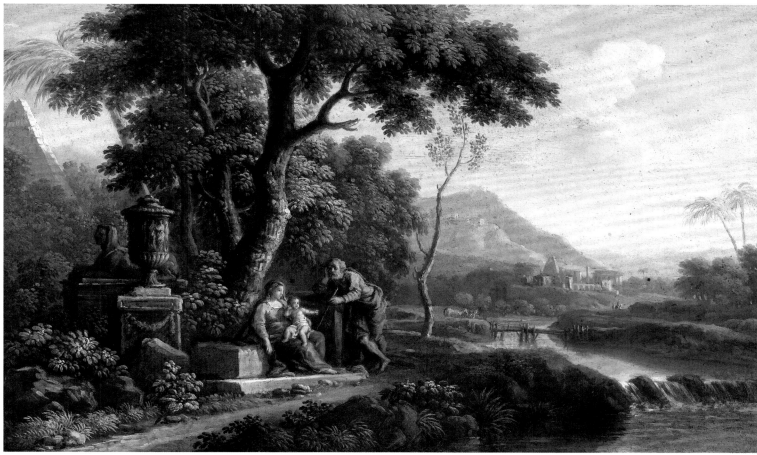

GERARD HOET

(Zaltbommel 1648 - The Hague 1733)

A Mythological Scene with Prisoners Kneeling Before a Queen

signed 'G. Hoet.' (lower right)
oil on canvas
54 x 64 cm (12¼ x 25¼ in)

Provenance: Acquired by the previous owner in January 1962.

I N THIS ELEGANT WORK BY GERARD HOET KNEELING prisoners are being presented before a queen as the royal court looks on. One of the prisoners is offering gifts to the queen, presenting a jug with his right hand whilst simultaneously drawing more objects from a sack, which glimmers with gold. This interaction is the focal point of the painting, with the courtiers looking curiously at the proffered gifts as the prisoners nervously try to gauge the queen's reaction. Just visible beyond the classical architecture of the court, is one of the evocative landscapes in which Hoet usually set his mythological subjects, and whole scene is lit with the warm light of dusk.

The painting shares many of the themes that are found elsewhere in Hoet's work. For example, in *The Banquet of Cleopatra,* we again see a queen as the dominant figure (fig 1). Cleopatra holds a glass of wine in which she is about to place a priceless pearl earring as an ostentatious sign of her indifference to wealth, an attitude reminiscent of the haughty, detached way in which the anonymous monarch inspects and discusses the sack of golden objects in *A Mythological Scene with Prisoners Kneeling Before a Queen*. Cleopatra is also being offered gifts, as Mark Antony presents her with Cyprus, Phoenicia, Coele-Syria and parts of Arabia.

A Mythological Scene with Prisoners Kneeling Before a Queen is a painting filled with contrasts. The left-hand side of the scene is made up of the male

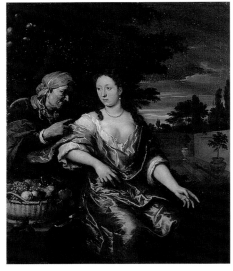

Gerard Hoet,
Vertumnus and Pomona,
The Hermitage, acquired
from the antiquarian I.
Gabikht, 1910
(Figure 2)

figures of the prisoners and their guards, whilst the right-hand side of the scene is dominated by the queen and her female courtiers. This split is emphasised by Hoet's use of light, with the men in shadow and the women illuminated by the evening sun. The vibrant, glimmering colours of the ladies' clothing also contrast with the polished armour of the guard nearest the viewer and the bare torso of the leading prisoner. This theme of contrasts recurs throughout Hoet's work, and is also present in his *Vertumnus and Pomona* (fig. 2). Here, Hoet depicts the story of how the Roman god Vertumnus seduced the goddess Pomona by disguising himself as an old woman and gaining entry to her orchard, warning her of the dangers of rejecting a suitor. The subject matter was popular among artists as it provided an opportunity to contrast the young female form of Pomona with the haggard, old one of Vertumnus.

Hoet trained with his father and with Waynard van Ryssen, a pupil of Cornelis van Poelenburch (1595-1667) (see inventory). In 1672, Hoet moved to The Hague, and then spent a year in Paris, returning to the Netherlands via Brussels. Settling in Utrecht, he founded a drawing academy in 1697. Seventeen years later he returned to The Hague, where he spent the rest of his life. He depicted mainly religious, mythological, or classical subjects set in landscapes, usually on a small scale. Less frequently, he painted these subjects in larger formats with multiple figures in an elegant, classicising style. Hoet also painted portraits and genre pieces, along with designing illustrations for bibles. His book on drawing was published in 1712.

This painting is accompanied by the certificate of Dr. Walther Bernt, endorsing the attribution to Hoet, dated 27 March 1973.

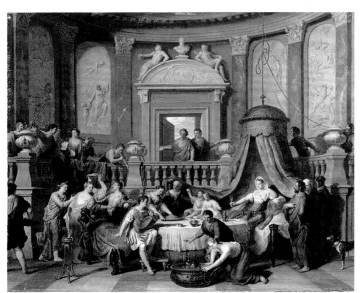

Gerard Hoet, *The Banquet of Cleopatra,*
J. Paul Getty Museum, Los Angeles (Figure 1)

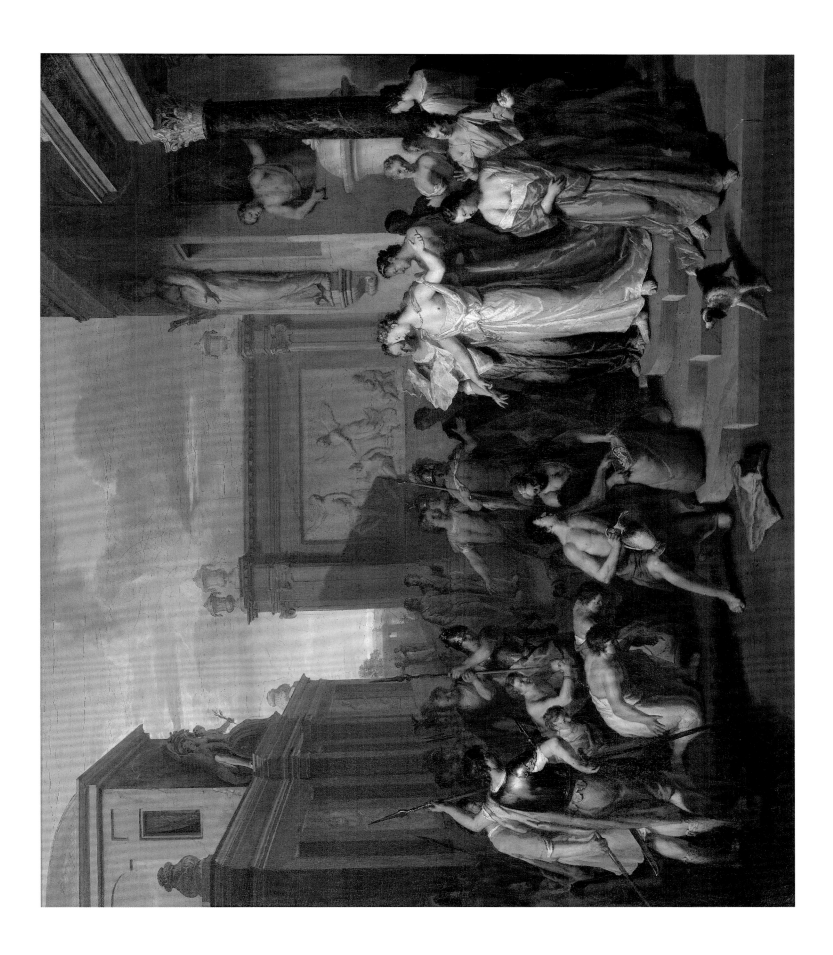

GERARD HOET

(Zaltbommel 1648 - The Hague 1733)

Paris Presenting Helen to the Court of King Priam

signed with initials 'I.B.G' (lower right)
oil on panel
53 x 66 cm (20⅞ x 26 in)

I N *PARIS PRESENTING HELEN TO THE COURT OF KING Priam*, Gerard Hoet presents us with a distilled moment in the build-up to the Trojan War. Paris has returned home to Troy, having stolen Helen, the most beautiful woman in the world, from her husband Menelaus, King of Sparta. Paris has entered the court of his father Priam, King of Troy, in order to present Helen to him. Paris and Helen stand, brightly lit, in the centre of the composition. With his right hand, Paris gently pushes Helen toward Priam, whilst with his left he gestures back towards the entrance of the court, where a slave brings in a chest, presumably filled with Menelaus' riches, which Paris also stole. Priam has rushed from his palace in his eagerness to greet his son, opening his arms to embrace him. Behind the king, rush his wife Hecuba and the rest of his court. Figures jostle in the crowd, crane their necks and lean out of windows in their eagerness to see the couple. Paris' gesture, along with that of the kneeling woman before him, also lead the eye towards the background, where Paris' boats are visible on the shore, reminding the viewer of the imminent arrival of the invasion that will gather on that same coast as a result of the prince's actions.

In deciding to depict the large, busy court, Hoet has given himself the opportunity to portray a wide variety of figures, and their differing responses to Paris' return. Men, women and children of varying ages are scattered about the scene. Amongst the rush of courtiers, emotions range from the contented faces of some individuals to those that are more restrained and concerned; the most extreme figure has flung himself to the floor behind Priam, covering his head with his arms, his muscular body taut with emotion. The painting, however, concentrates on the central interaction between the two main couples. Paris and Helen look nervous, waiting to see the king's reaction, whilst Priam and Hecuba have expressions of happiness and curiosity. The two couples also provide a contrast between the young and the old - contrasts being a recurring theme throughout Hoet's work, with this particular distinction being repeated in Hoet's *Vertumnus and Pomona*, which hangs in the Hermitage.[1]

Hoet's *Mercury and Herse*, see fig.1, also has several similarities with *Paris Presenting Helen to the Court of King Priam*. Compositionally, in both

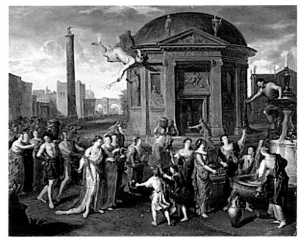

Gerard Hoet, *Mercury and Herse*, c.1710,
Norton Simon Museum, California (Figure 1)

paintings the main body of figures arrives onto the scene in a fluid stream that traces back around the corner, disappearing into the distance, creating a sense of a crowd much larger than that which is visible. In *Mercury and Herse,* again Hoet delights in painting figures in unusual poses, such as the men straining under heavy baskets, the man perched on the fountain, or Mercury, who hovers above the scene. It is a painting indicative of Hoet's delicate and decorative style of painting.

Hoet trained with his father and with Warnard van Ryssen, a pupil of Cornelis van Poelenburch (see inventory). Having lived in The Hague, Paris, Brussels and the northern Netherlands, he settled in Utrecht, where he became a member of the Guild of St. Luke. Whilst living in Utrecht he also founded a drawing academy in 1697 with Hendrick Schoock. From 1714 Hoet resided in The Hague. His *oeuvre* consisted of mainly religious, mythological or classical subjects set in landscapes, which were painted on a small scale in the style of van Poelenburch, but he also produced larger works, often with many figures, in an elegant, classicising style. He was also heavily influenced by French landscape painting.[2] In addition, Hoet painted portraits and some genre pieces. His book on drawing, with one hundred and three prints by Pieter Bodart, was published in 1712. He also designed many illustrations for bibles.

[1] See catalogue no. 67, fig. 1.

[2] For examples of this decorative painting, see Hoet's ceiling and wall paintings at the castle of De Slangenburg at Doetinchem.

PIETER GALLIS

(1633 - Hoorn 1697)

*A Swag of Flowers Hanging in a Niche, with Gooseberries,
Strawberries, Roses, Plums, an Iris, a Daisy and a Spider*

signed 'PGallis' (lower left)
oil on panel
35.6 x 43.8 cm (14 x 17¼ in)

Provenance: Lady Elizabeth Clyde;
anonymous sale, Sotheby's, London, 7 July 1976, lot 6;
with A. Brod, Ltd., London;
Private collection, Germany;
with Noortman, Maastricht, 1991;
anonymous sale [The Property of a Private Collector], Christie's, Amsterdam, 14 May 2003, lot 186, where acquired by the previous owner.

Pieter Gallis, *Still Life with Fruit*, 1673, Rijksmuseum, Amsterdam (Figure 1)

IN THIS DELICATELY NATURALISTIC COMPOSITION, Pieter Gallis demonstrates the immense technical skill that the still life genre of seventeenth-century Dutch art demanded. Unlike other paintings of a similar subject matter, Gallis' decision to present the flowers here in a swag enables an imaginative perspective and the opportunity to experiment in full with the advances made in botanical and optic sciences at this time.

Some of the objects depicted in Gallis' arrangement can be assigned symbolic meanings: the minutely patterned garden spider, for instance, can arguably signify death. Similarly, the dusky butterfly perched precariously on a leaf to the left of the ear of golden corn can be interpreted as a reminder of the carefree life of the soul after it has been freed from the burdens of life. The flowers and fruits, now plucked from their trees and plants are also designed to represent the transience and essential *vanitas* of nature. There are, however, other interpretations that ascribe far less weight to such suggestions.

Gallis' exquisitely accurate rendition of luscious strawberries, plump gooseberries and the painstaking clarity with which he delineates the structures and colours of the flowers, afford his composition an uncanny vitality. Gallis' skill is evident in another of his still lifes which is displayed in the Rijksmuseum (fig. 1). The fruits radiate a characteristic luminous quality that is emphasised all the more against a dark backdrop.

Before its place in the Golden Age of Dutch art was recognised, the genre of still life was not seen as one autonomous in its own right. Dutch fascination

Pieter Gallis,
*A Swag of Flowers Hanging
in a Niche with Gooseberries,
Strawberries, Roses, Plums, an Iris, a
Daisy and a Spider*
(Detail)

with horticulture and a keen affinity to their surroundings in general have been credited with the upsurge in creativity and artistry around previously mundane and un-extraordinary objects that became the subject of so many still lifes. Moreover, the translation into modern European languages from Latin of Pliny the Elder's *Natural Histories* may have encouraged artists including Ambrosius Bosschaert II (1609-1645) (see catalogue no. 36). Pliny makes specific mention of the pleasure that the Romans took in artistically translating images of nature onto the walls of their homes. He recounts one famous anecdote of birds coming to peck at grapes painted by Zeuxis (fl. late 5th-early 4th century BC) because they were so life like. Artists like Gallis, in his *A Swag of Flowers Hanging in a Niche with Gooseberries, Strawberries, Roses, Plums, an Iris, a Daisy and a Spider,* perhaps took the same pleasure in reproducing beautiful and exact replicas of nature in art.

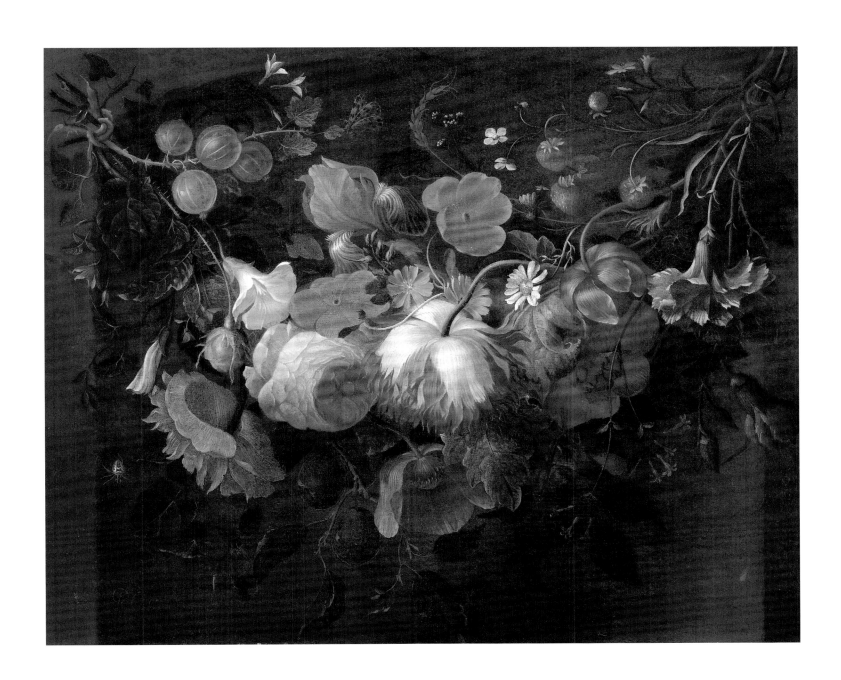

COENRAET ROEPEL

(The Hague 1678 - The Hague 1748)

Still Life of Grapes, Melons, Peaches, Plums and other Fruit with Morning Glory and Shafts of Wheat in a Stone Niche, with a Bunch of Grapes and Medlars Hanging Above

oil on canvas
85.1 x 57.8 cm (33½ x 22¾ in)

Provenance: Brig. Sir Geoffrey Hardy-Roberts;
by whom sold, London, Sotheby's, July 10, 1974, lot 23 (as by Cornelis de Heem);
Oppenheimer, Malmö, Sweden, 1986;
with Kunsthandel K. & V. Waterman, Amsterdam, by 1986, from whom acquired in 1990 by the previous collector.

Literature: R.J.A. te Rijdt, 'Een getekend portret van Coenraet Roepel door Richard vam Bleeck,'
Bulletin van het Rijksmuseum, 39, 1991, nr. 1, pp. 113-119, illus., fig. 3;
P.J.J. van Thiel, *All the paintings of the Rijksmuseum in Amsterdam*, Amsterdam 1976, p. 478, nr. A 337.

THE STUNNING VERISIMILITUDE AND QUALITY OF finish in *Still Life of Grapes, Melons, Peaches, Plums and other Fruit with Morning Glory and Shafts of Wheat in a Stone Niche, with a Bunch of Grapes and Medlars Hanging Above* exemplifies Coenraet Roepel's style. The artist, who was born and spent his career in The Hague, achieved prominence within a sub-genre of still life painting, depicting fruit and flowers assembled within a stone niche. Evidently, Roepel was so much associated with still life niche paintings that a portrait of the artist, by Richard (Risaert van) Bleeck (1670-1733), depicts him sitting at an easel with a palette in one hand and a brush in the other, applying the finishing touches to one of his characteristic works (fig. 1).

In the upper portion of the present painting, a lusciously heavy bunch of grapes is suspended with a gold ring from the top of the arched niche. Hanging with the grapes are medlars and carnations. Below, on the stone ledge, sit a profusion of ripe fruit including melons, peaches, plums, a pomegranate and green grapes. A trail of Morning Glory and a few shafts of wheat are interspersed with the fruit, and various insects feast from the abundance on display. A snail sits on one of the melons, a caterpillar inches along the Morning Glory, a butterfly hovers near the carnations and a spider lowers itself from the bunch of medlars. Although the pictorial representation is artificial, in that it brings together fruit and flowers that would never be found side by side in nature, there is exceptional realism in the way that each detail is depicted. Roepel's mastery of light effects and his skill in portraying reflections on each piece of the variously textured fruit is exceptional. His ability to capture the beauty of nature and preserve it through mimesis is a defining characteristic of Dutch still lifes and is highly evident in Roepel's work.

The arched niche framing the still life is a clever artistic device designed to deceive the eye into seeing an actual architectural feature. Roepel's use of shadowing and perspective gives the impression that the fruit is suspended from or positioned in a recessed space. In addition, the niche, according to Mariët Westermann, evokes 'a long tradition of devotional images, in which

Richard (Risaert van) Bleeck, *Portrait of the Painter Coenraet Roepel, Seated, Half-Length, Painting a Still Life with Flowers and Fruit*, c.1705, Private Collection (Figure 1)

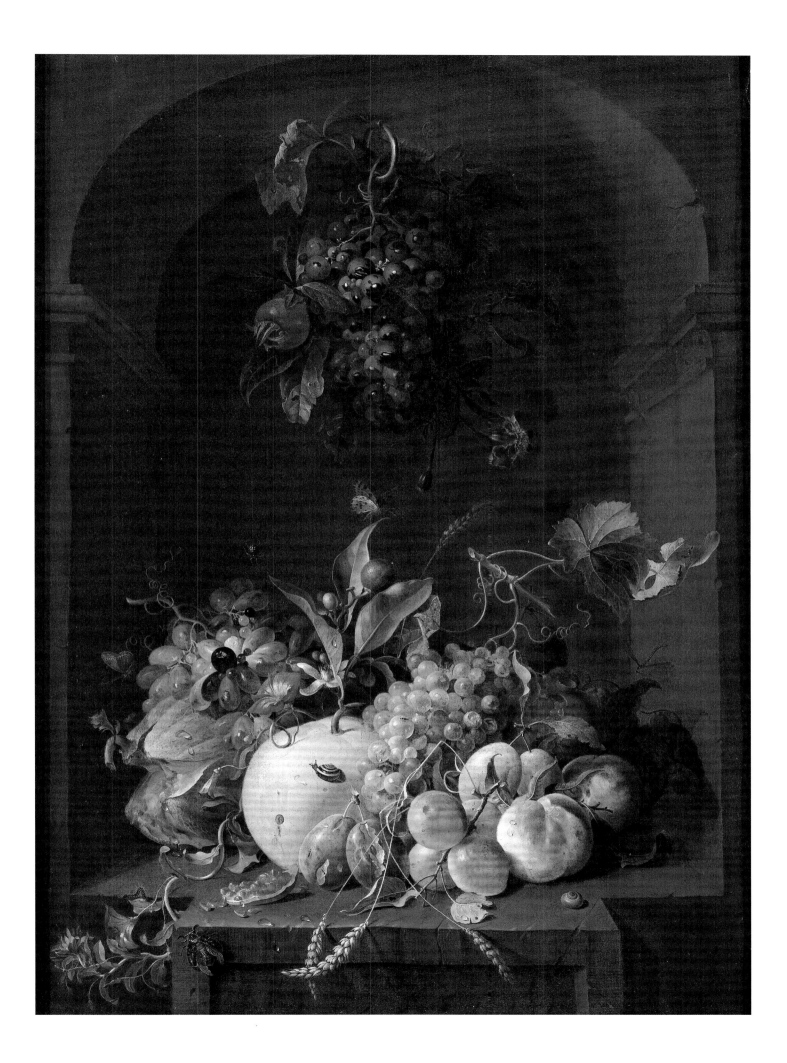

Coenraet Roepel,
*Still Life of Grapes, Melons,
Peaches, Plums and other
Fruit with Morning Glory
and Shafts of Wheat in a
Stone Niche, with a Bunch of
Grapes and Medlars Hanging
Above*
(Detail)

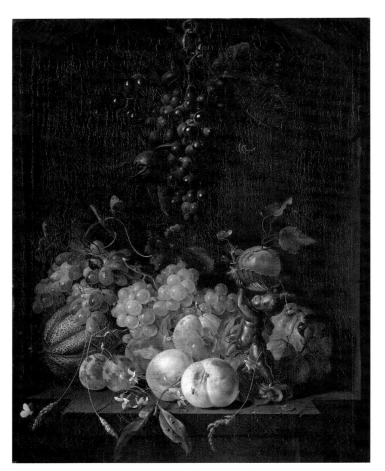

Coenraet Roepel, *Still Life with Fruit*, 1721,
Rijksmuseum, Amsterdam (Figure 2)

an isolated Madonna and Child or saint would invite viewers to meditation. Such imagery was no longer viable in Protestant cultures, but this particular mode of looking may well have survived'.[1] The still life, therefore, is designed for contemplation, both on an aesthetic level, in which the viewer appreciates the symmetry and veracity of the composition, and on a deeper spiritual level in which the choice of fruit and flowers is endowed with a symbolic significance.

What becomes most evident when examining the present work, apart from its striking attention to detail, is the overly ripe state of most of the fruit. One of the melons has burst open, revealing its seeds and soft sweet flesh. Dew drops linger on the surfaces of the melons, peaches, apricots and plums. Small holes have been bitten out of most of the pieces of fruit and a large chunk of the pomegranate has been removed, scattering its juicy red seeds. Many of the grapes appear soft and exude liquid. The plums beside them have been nibbled away by insects. One of the carnations hanging overhead has already fully bloomed and its petals are beginning to droop. The leaves of the medlars are not only chewed up but are turning brown.

The over ripeness of the fruit, their blemishes and signs of decay are indicators that Roepel's still life is not simply a celebration of nature's abundance but a reminder of the transience of life. The painting has a dual message, encouraging viewers to appreciate the beauty around them but simultaneously remember that it is short lived. For a seventeenth-century Dutch audience, reconciling the wealth of the republic with strict Calvinist morals could be problematic and a still life such as this illustrated this dilemma, both presenting an image of luxury and calling for moderation. The fruit that is beginning to rot, although not as obvious a *vanitas* symbol as a skull or an hourglass, is a reference to mortality and to the fragility of earthly pleasures. The dewdrops and insects gathering on the fruit are further representations of the fleeting nature of life. The morning glory is a particularly ephemeral flower, as it blooms in the morning and dies by the evening.

The choice of fruit displayed in S*till Life of Grapes, Melons, Peaches, Plums and other Fruit with Morning Glory and Shafts of Wheat in a Stone Niche, with*

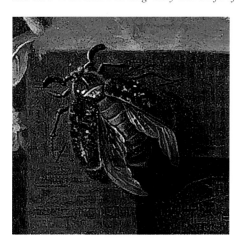

Coenraet Roepel,
*Still Life of Grapes, Melons,
Peaches, Plums and other
Fruit with Morning Glory
and Shafts of Wheat in a
Stone Niche, with a Bunch of
Grapes and Medlars Hanging
Above*
(Detail)

a *Bunch of Grapes and Medlars Hanging Above* is as significant as the way in which it is portrayed. The medlars are perhaps the most evocative of the fruit as they have unusual properties and would have had clear associations to contemporary viewers. Medlars require bletting to make them edible, a process that involves letting them decay and ferment for several weeks. After bletting, the skin rapidly becomes wrinkled and turns dark brown. This aspect of physical decay made the medlar a common literary metaphor, particularly in the sixteenth and seventeenth centuries, when medlars were often likened to human nature. In Shakespeare's *As You Like It*, Rosalind compares her interlocutor to a medlar tree, saying, 'for you'll be rotten ere you be half ripe' (III.ii.118). In the early Jacobean comedy, *The Honest Whore*, Thomas Dekker writes, 'I scarce know her, for the beauty of her cheek hath, like the moon, suffered strange eclipses since I beheld it: women are like medlars - no sooner ripe but rotten' (I.i.98).

Although the significance ascribed to types of fruit varies from source to source, an overarching religious theme in Roepel's selection can be traced. A most obvious metaphor is in the grapes and shafts of wheat that traditionally represent the blood and body of Christ. The carnation is known as the 'flower of God', signifying pure love, and in representations of the Virgin and Child, it is often a token offered by Mary to her son. The pomegranate, which has had multiple religious and metaphorical meanings throughout history, represents resurrection in the Christian faith, and also figures in a number of images of the Virgin and Child. The fruit, broken or bursting open, as in the present painting, is sometimes viewed as a symbol of the fullness of Christ's suffering and resurrection. The butterfly is similarly a symbol of resurrection and transformation. The religious message of the painting, therefore, could be interpreted as an uplifting one, suggesting the promise of life after death.

[1] M. Westermann, *The Art of the Dutch Republic 1585-1718*, The Orion Publishing Group, London 1996, p. 90.

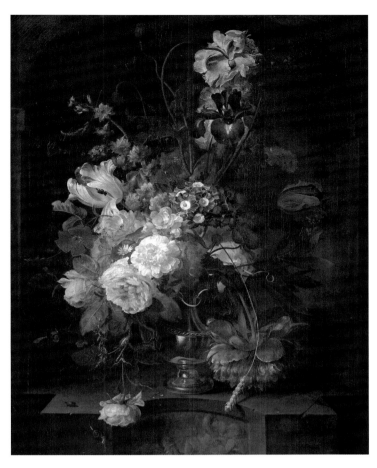

Coenraet Roepel, *Still Life with Flowers*, 1721,
Rijksmuseum, Amsterdam (Figure 3)

A still life painting of fruit by Roepel in the Rijksmuseum, Amsterdam, see fig. 2, is striking both in its similarities and its contrasts with the present work. A dark and beautifully luminous bunch of grapes intertwined with a medlar hangs in an identical fashion to the present painting, with the addition of a sprig of cherries. A melon, this time unopened, sits on the ledge, accompanied by grapes, peaches and different varieties of plums and small blossoming flowers. A bronze statue of a *putto* is nestled amongst the fruit, holding aloft a shell, on which sits a shiny nectarine. A fly buzzes near one of the peaches, a caterpillar eats its way through a leaf and two moths hover nearby; there are, however, fewer insects visible than in the present work. With the exception of a crushed grape and two split plums, the fruit is intact and there are no signs of its flesh spilling onto the stone ledge. Although both still lifes incorporate fruit and flowers that have been picked and are therefore dying, in the Rijkmuseum composition they are depicted before the signs of decay are rife. The mood of the painting, therefore, seems to be more a joyous celebration of the bountiful gifts of nature, directly referenced in the bronze *putto's* gesture of offering, than a moralistic chiding. Although there are subtle visual indications that the abundance will be short lived, and references to temporality, such as the dew drops and insects, one is not immediately aware of them, as in the present painting.

The extent of Roepel's virtuosity in depicting flowers as well as fruit is revealed in another still life painting in the Rijksmuseum, which like the previous example shows an image of nature suspended between life and death (fig. 3). Like the fruit, the flowers are not growing as nature intended but have been plucked and gathered in an artificial bouquet. They have not progressed

to a rapid state of physical decay, yet many of the blossoms are beginning to show signs of wilting. A full and heavy headed peony droops to the point of almost touching the stone ledge on which the vase sits. The stem of one of the pale pink roses has snapped and the blossom dangles off the ledge. These falling flowers are not only a means of displaying Roepel's talent for depicting the contrast between their soft velvety petals and the rough hardness of the stone, but bring to mind the transience of life, as do the insects that menacingly creep around ready to feast on the leaves and petals. The flowers on display are plentiful in variety and riotous in colour, evoking luxury, particularly in the inclusion of the rare and coveted tulip. Besides their aesthetic appeal and economic value, the choice of flowers, like the choice of fruit in the present work, no doubt has a rich symbolism, both religious and secular.

Roepel was a pupil of the portrait and genre painter Constantijn Netscher (1668-1723), whose influence can be discerned in the architectural elements and sculptures contained in his still lifes. Roepel was an avid gardener, which may explain his passion for painting fruit and flowers and his skill in portraying them with such detail and naturalism. The high quality and finish of his works attracted an international clientele, even though Roepel never left The Hague, apart from a brief stay in Germany. His patrons included the Elector Palatine in Düsseldorf, Lord Cadogan, Prince Williiam of Hessen and other members of the nobility. He also collaborated with Matthias Twerwesten (1670-1757), painting wall decorations in The Hague, some of which have survived. In 1718, he was inscribed in the Confrerie Pictura, eventually becoming deacon of the board. Johan van Gool, the painter and biographer, devoted eight pages of his book to Roepel and described him as sought after and well paid. He also mentions that the artist's patrons let him paint their own flowers.[2] Evidence from eighteenth-century collections and sale catalogues suggests that Roepel's works were held in high esteem and copied by his contemporaries.

We are grateful to Fred Meijer of the Rijksbureau voor Kunsthistorische Documentatie, The Hague, for endorsing the attribution to Roepel, based on photographs.

[2] Johan Van Gool, *De Nieuwe Schouburg der Nederlantsche kunstschilders en schilderessen: Waer in de Levens- en Kunstbedryven der tans levende en reets overleedene Schilders, die van Houbraken, noch eenig ander schryver, zyn aengeteekend, verhaelt worden*, The Hague, (privately printed), 1750-1751.

HENRI GASCARS

(Paris 1635 - Rome 1701)

Portrait of a Lady, Seated Three-Quarter-Length,

in a White and Gold Gown with a Blue Robe, a Garden Beyond

oil on canvas
in a painted oval
95.9 x 129.9 cm (37¾ x 51⅛ in)

Exhibited: New York, Wildenstein, *A loan exhibition of fashion in headdress, 1450-1943*, 25 April-27 May 1943, no. 33.

Literature: L. Nikolenko, *Pierre Mignard: The Portrait Painter of the Grand Siécle*, Munich, 1982, p. 104, no. 5, as 'possibly by Henri Gascars'.

THIS ELEGANT AND SENSUAL PORTRAIT BY HENRI Gascars can be compared to a highly similar example by Gascars of The Duchess of Portsmouth and Aubigny, held in a private collection. The sitter's relaxed pose within a feigned oval, reclining on one arm and gazing dreamily at the viewer, and informal and revealing gown, give the portrait a marked intimacy. Such displays of graceful feminine languor and negligent undress were highly fashionable in the English Restoration court and Gascars excels in appealing to his audience's voyeuristic inclinations. The opulence and refinement of the drapery, which is as integral to the image as the delicate modelling of the sitter's features, can be attributed to Gascars' Parisian training. A seventeenth-century critic described his portraits as 'made up with Embroidery, fine cloaths, lac'd drapery, and a great Variety of Trumpery, Ornaments',[1] which were clearly then, as now, the hallmarks of Gascars' success as a portraitist.

The style and format of the present work has distinct parallels with Gascars' *Portrait of a Lady with her Dog* (fig. 1). Both women display the requisite curled locks of hair bound with ropes of pearls as well as pearl earrings and necklaces. Their shifts are conspicuously visible under luxurious robes and drapery,

arranged in a voluptuous and titillating manner, and they are identically posed in front of lustrous red tasselled curtains, which are parted to reveal classically inspired landscapes.

Gascars is thought to have been the son of Pierre Gascar, an obscure Parisian painter and sculptor. He travelled to Rome in 1659 and was back in Paris by 1667, although he may have spent time in the Netherlands in the same year. In 1672, Gascars' *morceau de reception*, a portrait of Louis de Bourbon, the Grand Dauphin, was rejected by the Académie Royale, and two years later Gascars departed for England where he was better received. He worked at the Restoration court and found particular favour with Louise de Kéroualle, Duchess of Portsmouth and mistress to Charles II.[2] Gascars' portraiture reveals the influences of his contemporaries at court, particularly that of Sir Peter Lely (1618-1680), from whom he adopted the use of repeated poses for convenience. Catherine Macleod writes, 'At a time when Lely's own production was becoming even more repetitive, Gascars briefly threatened his dominance with the combination of a fashionable and powerful patron and French stylistic elements that must have had the glamour of novelty in the eyes of the court'.[3] Gascars returned to Paris in 1679, where he was received as a member of the Académie Royale the following year with portraits of Louis Elle the Elder and Pierre de Sève the Younger (both in the Château de Versailles). In 1681 he travelled again to Italy, visiting Modena and Venice and eventually settling in Rome. Gascars' *oeuvre* is best known by the large number of engravings made after his portraits.

We are grateful to Dr. Julia Marciari-Alexander for confirming the attribution to Gascars on the basis of photographs.

[1] Bainbridge Buckeridge, 'An Essay towards an English School of Painters' in R. De Piles, *The Art of Painting and the Lives of the Painters*, London, 1706, p.421.

[2] A portrait of a woman, similar to the present work, and presumed to be Louise de Kéroualle, formerly in the collection of William Randolph Hearst appeared at Sotheby's, New York, 18 June 1974, lot 126, as 'circle of Willwm Wissing.'

[3] Macleod, C., '"Good, but not Like": Peter Lely, Portrait Practice and the Creation of a Court Look' in Macleod and Julia Marciari Alexander, *Painted Ladies: Women at the Court of Charles II*, National Portrait Gallery, London, 2001, p.59.

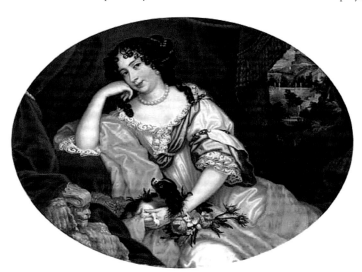

Henri Gascars, *Portrait of a Lady with her Dog*, Private Collection (Figure 1)

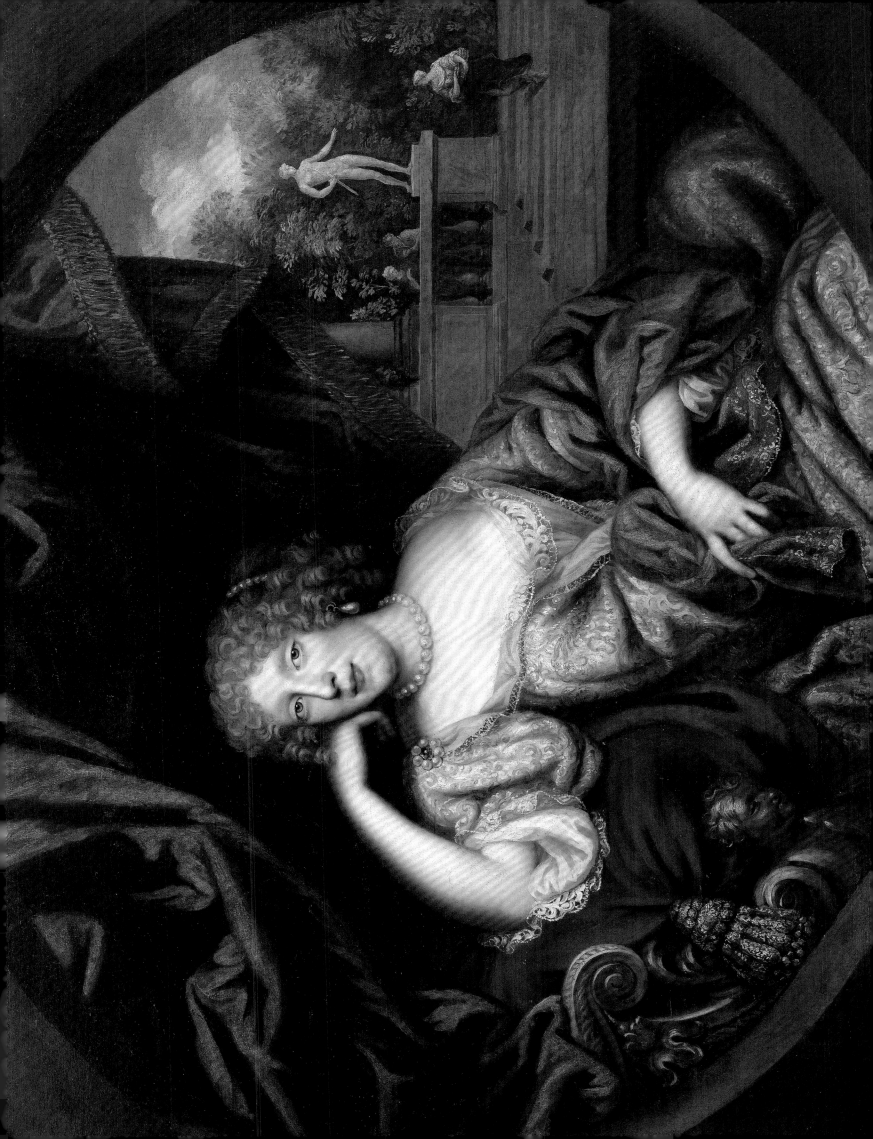

SIR JOSHUA REYNOLDS, P.R.A.

(Plympton, Devon 1723 - London 1793)

Portrait of a Lady, Bust-length, with Pearl Earrings, Unfinished

oil on canvas
59.7 x 45.4 cm (23½ x 17⅞ in)

IT HAS BEEN SUGGESTED THAT THIS BEAUTIFUL SITTER may have been an as yet unidentified member of Sir Joshua Reynolds' family. The deeply intimate nature of the painting supports the notion that the sitter may be one of Reynolds' sisters or a female relative. It is known that he lived with his devoted sister, Frances, herself an amateur painter. It is also thought that the work can be dated from *c.*1755 to 1760, a period when Reynolds' artistic career was firmly in its ascendency. Indeed, 1758 is recorded in his pocket book as a peak year with sittings noted for every day of the week.

This portrait, whoever the sitter may be, reveals a young woman gazing out enigmatically from the canvas, her eyes shyly meeting those of the viewer. The pearlescent quality of her skin and the precision of her features emphasise dark velvet eyes and a playful rosebud smile. Her upswept hair draws attention to a delicate, swan-like neck and her perfectly oval face; the inclusion of a single earring in her right ear creates a pleasing asymmetry to an otherwise carefully balanced composition. A gentle smile plays about her lips and her whole being radiates serenity and a quiet composure.

The roughly finished head stands in sharp contrast to the unfinished drapery and incomplete background. Just as Michelangelo's (1475-1564) incompleted figure sculptures for the tomb of Julius II demonstrate, Reynolds' *Portrait of a Lady, Bust-Length, with Pearl Earrings, Unfinished* (hereafter, *Portrait of a Lady*) embodies a purer idea of beauty as a direct result of its unfinished state. Above all, the unfinished nature of this portrait provides a fascinating insight into Reynolds' working technique and,

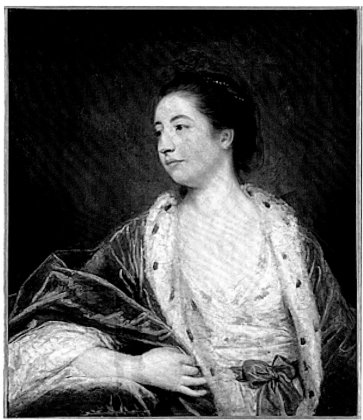

Sir Joshua Reynolds, *Portrait of Georgiana Spencer, Duchess of Devonshire,* *c.*1780-1781, Chatsworth House, Derbyshire (Figure 1)

Sir Joshua Reynolds, *Portrait of a Lady,* Metropolitan Museum of Art, New York (Figure 2)

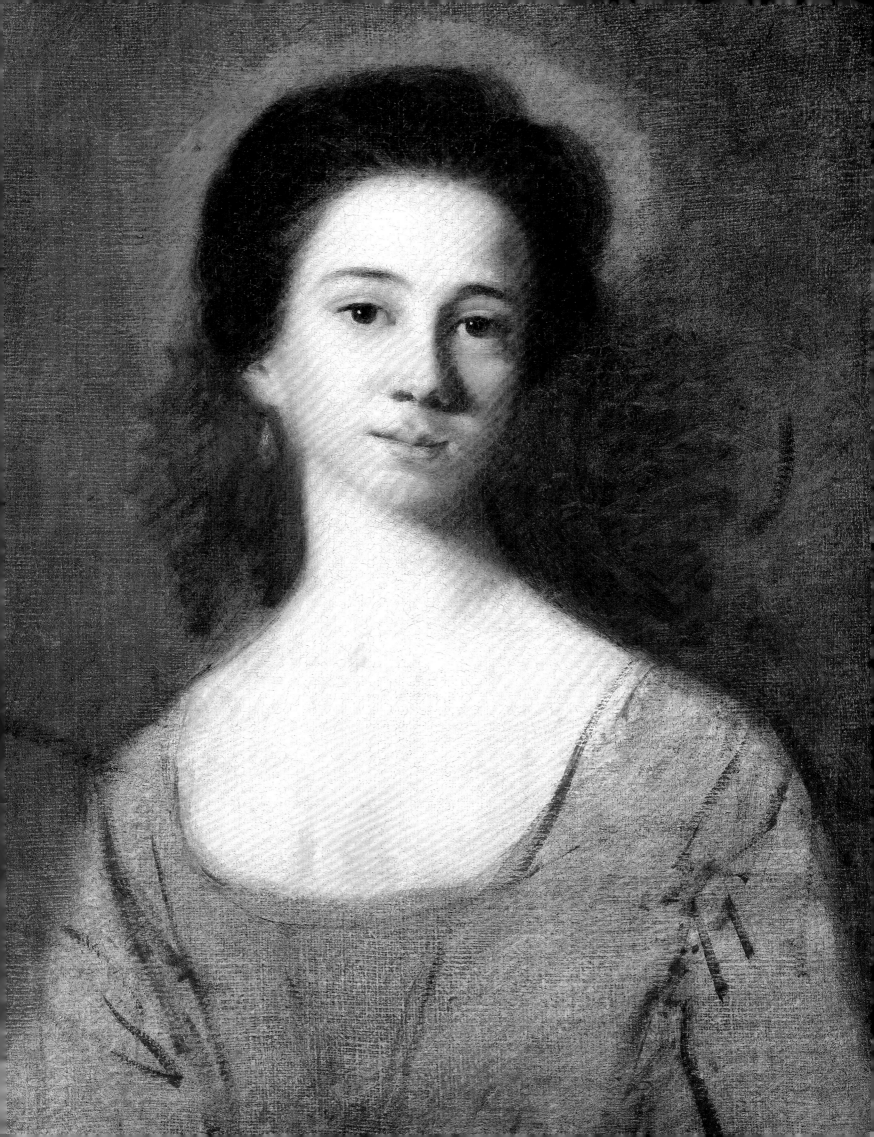

equally importantly, into his unique ideology concerning portraiture.

By the 1740s, Reynolds preferred to paint directly onto the canvas with no preliminary drawing, a methodology he applied throughout his career. When completing portraits, Reynolds tended to work on the head of the sitter present, whilst the costume and other details were completed later on. Such a process became standardised among portrait painters of this era and from Reynolds' own sitters' books it is clear that at the very least the artist needed an hour to capture an accurate likeness of his sitter's face. Other aspects of the finished product, such as pose and costume worn, could be completed using models, but the face was of central importance.[1]

In the studio of Sir Godfrey Kneller (1646-1723) who, like Reynolds, was a celebrated portraitist, the artist might only execute the portrait's head delegating to assistants the task of completing the body, drapery and background. Reynolds is known to have shared this approach, as can be clearly seen in the present work with the crude burgundy lines indicating where, at a later date, the folds of drapery would be formally painted in. Often he used a professional 'drapery painter' or one of his assistants. However, alterations show that Reynolds worked over these areas correcting outlines and enhancing particular details. The free handling of the paint and relaxed frontal pose of the sitter creates a sense of youthfulness, whilst remaining dignified in composition. In his fourth *Discourse* of 1771, Reynolds advised the 'historical painter' never to 'debase his conceptions with minute attention to the discriminations of Drapery...With him, the clothing is neither woollen, nor linen, nor silk, satin or velvet: it is drapery; it is nothing more.'[2]

Portrait of Georgiana Spencer, Duchess of Devonshire, (fig.1) which was executed between 1780 and 1781, presents an apposite comparison to *Portrait of a Lady.* (Unfinished portraits by Reynolds usually have the head completely finished whilst the background and drapery were left for his studio assistants.) Reynolds took on a number of assistants including

Sir Joshua Reynolds, *Countess Spencer and her Daughter,* 1759 to 1761, The Spencer Collection at Althorp, Northamptonshire (Figure 4)

James Northcote (1746-1831) whose recollections are particularly helpful in reconstructing the way in which Reynolds executed his portraits.

Reynolds wrote later in his *Discourses* that he viewed the role of the artist as much about representation as enhancement: '...If an exact resemblance of an individual be considered as the sole object to be aimed at, the portrait-painter will be apt to lose more than he gains by the acquired dignity taken from general nature. It is very difficult to ennoble the character of a countenance but at the expense of likeness, which is what is most generally required by such as sit to the painter.'[3] This attitude would explain the way in which he chose to represent a number of his sitters among them Lady Cockburn in *Lady Cockburn and her Three Eldest Sons* (fig. 3). As was his habit, Reynolds borrows much in compositional terms from the great portrait painter, Anthony Van Dyck (1599-1641) and it is virtually impossible not to detect unavoidable references to that artist's allegory *Charity. Lady Cockburn and her Three Eldest Sons* was painted at least twenty years after *Portrait of a Lady,* nevertheless it is instructive to note how, had Reynolds completed the present work, it might have looked.

Of arguably greater interest is the centrality of classical culture in his works. Lady Cockburn's husband objected to his wife being named publicly as the sitter and when, in 1791 Reynolds' work was engraved by Charles Wilkin, the title was changed to *Cornelia with her Children.* This is an allusion to the famous matron of Roman history, Cornelia, the mother of the Gracchi brothers who declared that her children were her only jewels. *Portrait of a Lady,* despite its unfinished nature could be said to bear a resemblance to portraits of Roman women preserved in fresco form in Pompeii.

From early on in his career, Reynolds attempted to master the female

Sir Joshua Reynolds, *Lady Cockburn and her Three Eldest Sons,* 1783, The National Gallery, London (Figure 3)

[1] Vaughan, W., *British Painting: The Golden Age* (1999) pp. 42.

[2] Reynolds, J., *Discourses on Art IV,* 1771 ed. R. Wark, New Haven and London, 1975.

[3] Reynolds, J. *Discourses, op. cit.*

portrait[4]. His ability to do so was questioned by Horace Walpole who remarked 'Mr. Reynolds seldom succeeds in women; Mr. Ramsay is formed to paint them'. But Reynolds, as this present work demonstrates, showed a deep artistic sensitivity when rendering the female. He also delighted in the range of poses and costumes his female subjects could support. His portrait of Mrs. Hartley, for instance, portrays his contemporary sitters as a nymph and Bacchus (fig. 5). He wrote in his *Discourses:* 'He...who in his practice of portrait-painting wishes to dignify his subject, which we suppose to be a lady, will not paint her in modern dress, the familiarity of which alone is sufficient to destroy all dignity...[he] dresses his figure something with the general air of the antique for the sake of dignity, and preserves something of the modern for the sake of likeness.'[5]

Reynolds was a prolific portraitist with estimates of his total output hovering around the three thousand mark. He has often been referred to as the 'father' of British painting, and the founder of a 'school' but later on in life he himself renounced such accolades, heaping them instead upon his nearest rival and contemporary, Thomas Gainsborough (1727-1788). His works greatly influenced the subsequent generation of painters that included Thomas Lawrence (1769-1830) and Henry Raeburn (1756-1823). He was a proponent of the 'Grand Style' of painting; his poses often inspired by classical sculpture or the Old Masters as he looked to enhance the dignity and classical virtue of his sitters.

Born in Devon in 1723, he received a classical education from his father, the Revd. Samuel Reynolds, who was also headmaster of Plympton Grammar School. His father had intended him to become an apothecary but the young Reynolds' desire to train as an artist led him, in 1740, to spend four years apprenticed to the fashionable London painter, Thomas Hudson (?1701-1779). He spent 1749 to 1752 in Italy studying the

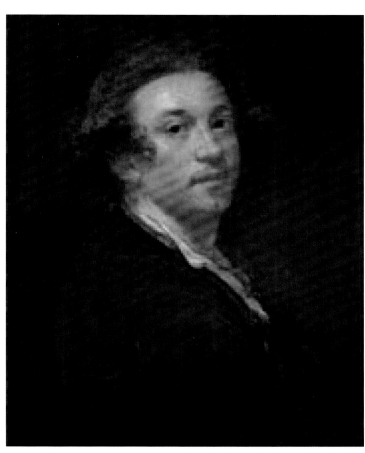

Sir Joshua Reynolds, *Self-Portrait, c.* 1750, The Yale Centre for British Art, Paul Mellon Fund (Figure 6)

Old Masters and developing his taste for the 'Grand Style' where he was greatly inspired by the works of Michelangelo, Giulio Romano (?1499-1546), Tintoretto (1519-1594) and Correggio(?1489-1534) among others.

He returned to London in 1752 and set up his first independent studio, first in St. Martin's Lane and then in Great Newport Street. As a keen intellectual, Reynolds socialised with a number of London's intelligentsia, including the author Dr. Samuel Johnson, Whig statesman Edward Burke and fellow artist Angelica Kauffmann (1741-1807). As well as receiving frequent royal and aristocratic commissions, Reynolds' rise to fame mirrored those whose fortunes were made through trade or on the stock exchange, for example, the portraits of Mr. and Mrs. Beckford (1755-1756; Tate Collection, London). His great popularity is evident in the remarkable inflation of his prices which rose from forty-eight guineas in the early 1750s to two hundred guineas by the 1780s.

Reynolds was one of the earliest members of the Royal Society of Arts, and alongside his almost exact contemporary, Gainsborough, he helped to establish the Royal Academy of Art in 1768, serving as its first president until his death. Between 1769 and 1790, Reynolds delivered to the Academy his *Discourses on Art* which to this day remain one of the most articulate panegyrics to the ideals of Western art grounded in the Italian Renaissance.[6] A year later he was knighted by George III and shortly afterwards he was forced into retirement having lost the sight of his left eye. He died in 1792 at his house in Leicester Fields and is buried in St. Paul's Cathedral.

We are grateful to Dr. Martin Postle for dating this work to *c.*1755-1760 and for suggesting that the sitter may be a member of the artist's family, as yet unidentified.

Sir Joshua Reynolds, *Mrs. Hartley as a Nymph with the Young Bacchus*, Exhibited 1773, Tate Gallery, London (Figure 5)

[4] Vaughn, W., *British Painting: The Golden Age* (1999) pp. 82.
[5] Reynolds, J. *Discourse on Art VII*, delivered at the Royal Academy, 1776.
[6] Langmuir, E. *The National Gallery, Companion Guide*, pp. 316 (1994).

JOHN HOPPNER

(London 1758 - London 1810)

Portrait of the Right Honourable William Pitt the Younger (1759 - 1806),

Three-Quarter-Length, in a Black Coat, Standing before a Column and Gold Brocade Drape

oil on canvas
114.5 x 144.5 cm (45⅛ x 56⅞ in)

Provenance: The Marquesses of Londonderry;
with Owen Edgar Gallery, London;
sale, Christie's New York, 11th January 1995, lot 235, where purchased by the previous owner.

I N THIS THREE-QUARTER-LENGTH PORTRAIT OF WILLIAM Pitt the Younger, John Hoppner has painted an image of restrained elegance. The cut of Pitt's clothing, his confident, upright bearing and the background column create a sense of reserved power that is heightened by the touch of opulence brought out by the gold brocade drape.

Pitt the Younger was one of Britain's preeminent politicians of the late eighteenth and early ninetieth centuries. He served as Prime Minister from 1783 to 1801 and then again from 1804 to 1806. His father, William Pitt the Elder, 1st Earl of Chatham, had also been Prime Minister. As a child, Pitt the Younger was extremely intelligent, though sickly, and is said to have expressed parliamentary ambitions at the tender age of seven. He attended Cambridge University at the age of fourteen and left three years later after taking advantage of a little used privilege available only to the sons of noblemen by choosing to graduate without passing any examinations. It was during his time at Cambridge that Pitt formed a lifelong friendship with the politician and leading protagonist for the abolishment of the slave trade, William Wilberforce (1759-1833). After the death of his father in 1778, Pitt received legal training at Lincoln's Inn and was called to the Bar in 1780.

Pitt's first unsuccessful foray into politics was during the General Election of 1780 where he contested, and lost, the University of Cambridge seat. However his second attempt proved more fruitful and, having gained favourable local patronage, he won the 'rotten' borough of Appleby in Cumbria during the 1781 by-election. Pitt came into his own as a politician, casting aside the withdrawn aloofness that had characterised his university days, becoming a respected parliamentarian and a talented debater. Like his father, he strongly denounced the American War of Independence and aligned himself with influential figures such as the prominent Whig statesman and radical, Charles James Fox, who would later become Pitt's lifelong political rival. He was made Chancellor of the Exchequer under Lord Shelburne in 1782.

At the age of twenty-four, having rejected the post three times previously, Pitt accepted George III's appointment and became Great Britain's youngest ever Prime Minister; a position many felt he was too young to carry out. A popular ditty commented that it was 'a sight to make all nations stand and stare: a kingdom trusted to a schoolboy's care'. In two separate ministries Pitt served as Prime Minister for almost twenty five years. He died in office from liver disease and was unmarried, having also accumulated debts of forty thousand pounds. Parliament agreed to pay the sum on his behalf, and granted Pitt the honour of burial in Westminster Abbey.[1] A patriot, his last words are said to have been 'Oh my country! How I love my country!'.

James Gillray, *William Pitt*, published by Samuel William Fores, 20th February 1789 (Figure 1)

Pitt's time as Prime Minister was certainly momentous as he led the country through major events, including the French Revolution and the Napoleonic Wars, regaining financial stability for Britain after the American War of Independence, and bringing about Union with Ireland. He also helped to define the role of the Prime Minister as the supervisor and co-ordinator of the various Government departments. Pitt resigned as Prime Minister in 1801 after he had lost the confidence of George III when the king refused to accept Pitt's Emancipation of

[1] After his death in 1833, William Wilberforce was also buried in Westminster Abbey, close to his friend William Pitt the Younger.

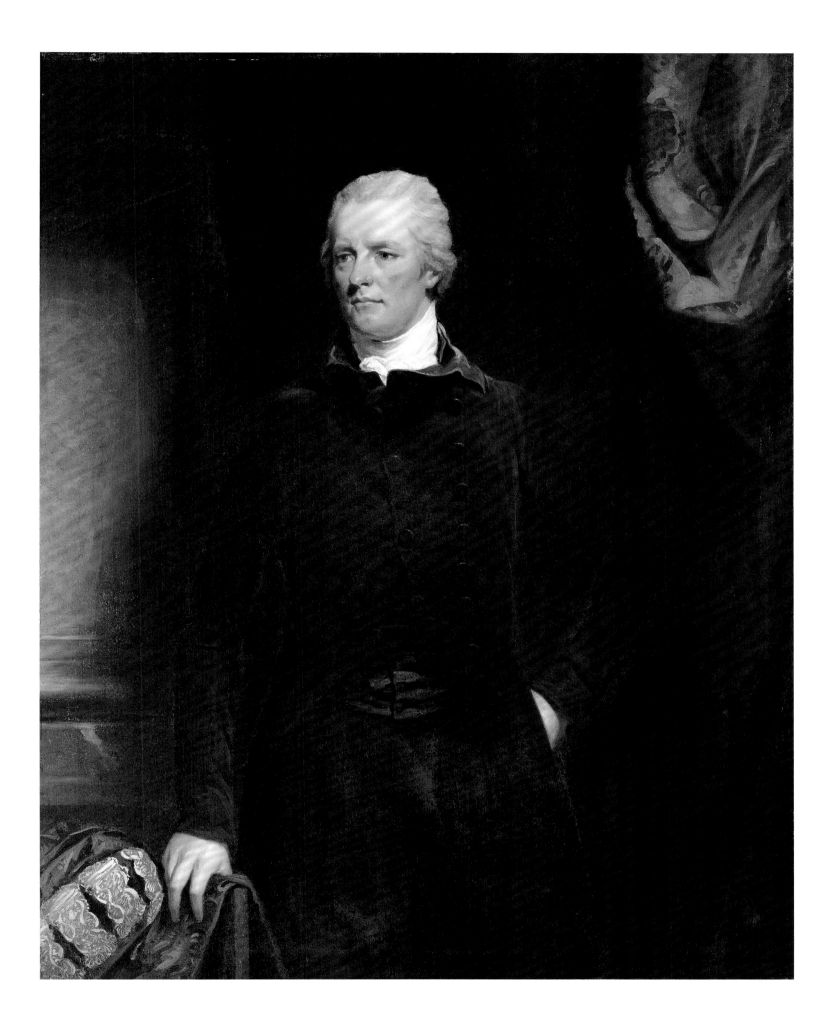

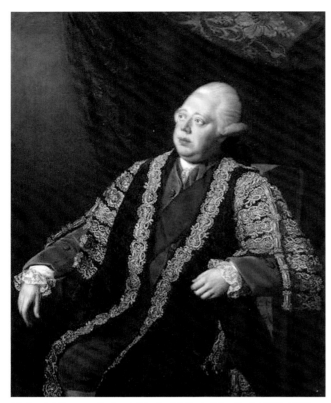

Nathaniel Dance, *Frederick North, 2ⁿᵈ Earl of Guilford, 1773-1774*, National Portrait Gallery, London (Figure 2)

Catholics Bill, saying that his assent would break his coronation oath of loyalty to the Church of England. However, Pitt resumed the position once again in 1804, when Napoleon threatened invasion, despite his failing health, possible alcoholism and limited support in the House of Commons.

The present portrait is one of several versions completed by Hoppner of Pitt the Younger. Hoppner's original portrait of Pitt (now at Cowdray Park) was commissioned by Lord Mulgrave and begun in 1804. It had not left Hoppner's studio when Pitt died in 1806 as it was being engraved in mezzotint by George Clint, and applications for copies were immediately submitted by Pitt's friends and colleagues. These were all made with the permission of Lord Mulgrave before the original left Hoppner's studio. The demand was considerable and Hoppner himself is said to have executed 20 versions, one of which is the present painting. Still further replicas were painted by Richard Reinagle (1775-1862), Samuel Lane (1780-1859), John Rising (1753-1817) and John Jackson (1778-1831)[2]

The provenance of the Marquesses of Londonderry is of particular note, given that Robert Stewart, first Marquis of Londonderry, was elevated to the peerage by Pitt as Baron Londonderry in 1789. He was later created Viscount Castlereagh on the 1ˢᵗ October 1795, Earl of Londonderry on the 8ᵗʰ August 1796, and then Marquis of Londonderry after Pitt's death. Lord Castlereagh played an important role during Pitt's attempts to reform the Irish Parliament and to bring about greater unity between Westminster and Dublin.

Interestingly, in this work, Hoppner has not focused on Pitt as a politician, rather he is presented as a distinguished and refined gentleman. His parliamentary status is subtly alluded to as his right hand rests on the black and gold gown of the First Lord of the Treasury; an office usually, but not always, held by the Prime Minister. However, one can only see a glimpse of this gown, which seems to have been flung onto the chair. When one compares this portrait to those of other eighteenth-century Prime Ministers, we see how understated it is. For example in Nathaniel Dance's (1735-1811) portrait of *Frederick North, 2ⁿᵈ Earl of Guilford* the Prime Minister wears the gown over an eye-catching red suit and blue sash, thus more overtly focusing on Lord North's affluence and his role as Prime Minister (fig. 2).

[2] see R. Walker, *National Portrait Gallery, Regency Portraits*, 1908, 1, pp. 392-3

Due to his position, Pitt was frequently portrayed by artists. However, the sober mood of Hoppner's work was a recurring theme in these depictions, as evidenced by James Gillray's (1757-1815) etching, *William Pitt* (fig. 1). Despite the fact that he invented, almost single-handedly, the genre of British political caricature, Gillray has provided a serious and sympathetic portrayal of Pitt. Although here Pitt is clearly much younger than in the present work there is still the same elegance in his demeanour, dress and surroundings. Pitt is shown looking into distance, possibly pondering on what is written on the paper in front of him. The writing desk and the paper are the most significant differences between this and the present work, and their inclusion reflects the image of austerity for which Pitt was renowned.

For a period, Hoppner was the most important portrait painter in England and the high status of his sitters reflects this reputation. During the 1790s, he was the principal painter to the Prince of Wales and produced works such as *George IV as Prince of Wales* (fig. 3). As in his portrait of Pitt, Hoppner has painted the prince as a gentleman in everyday dress, although his dark coat bears royal insignia. One major difference however, is that, whereas Pitt stands in a dark interior, the portrait of George IV as Prince of Wales is set within a landscape. This work is an example of how Hoppner's landscape portraits were often painted with an almost abstract vigour, hinting to the future work of Joseph Mallord William Turner (1775-1851) (see catalogue nos. 144 and 145). Indeed, Hoppner was instrumental in advising Turner at the beginning of the latter's career as an oil painter: Turner's first exhibited oil, *Fishermen at Sea* (Tate, London), owes more than a little to Hoppner's *Gale of Wind* (Tate, London).

However, not all of Hoppner's portraits employ this simplicity of dress, for example *George IV as Prince of Wales* (The Royal Collection) is a far more extravagant work (fig. 4). The prince is dressed in the ceremonial robes of the Order of the Garter, a highly exclusive medieval order of chivalry. This is an image that reflects the sitter's royal status. The huge velvet mantle, the hat's ostrich feathers, and the glitter of gold are signs of the opulence and extravagance that one would associate with the sitter. The classical columns, in front of which George IV stands, further exaggerate the notion of grandeur. This is an image of pomp, power and ceremony, themes which Hoppner only hints at in his *Portrait of the Right Honourable William Pitt the Younger (1759-1806), Three-Quarter-Length, in a Black Coat, Standing before a Column and Gold Brocade Drape* and *George IV as Prince of Wales.*

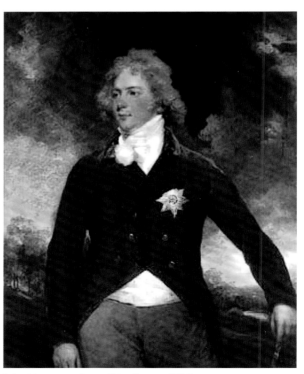

John Hoppner, *George IV as Prince of Wales*, Wallace Collection, London (Figure 3)

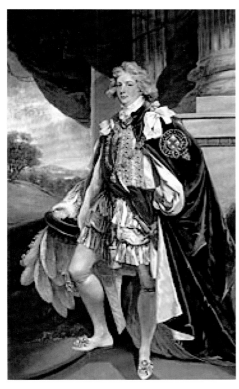

John Hoppner,
George IV (1762-1830),
when Prince of Wales,
c.1790-1796,
Royal Collection
(Figure 4)

Hoppner was born in Whitechapel to Bavarian parents. According to contemporary accounts, he was the most important portraitist in Britain in the period following the retirement of Joshua Reynolds (1723-1792) (see catalogue no. 72) in 1789. His mother was a lady-in-waiting to Queen Charlotte, the wife of King George III. During his time as a chorister in the Chapel Royal he was noticed by the King as a 'Lad of Genius' for his drawing ability. As a result he was sent to live with the keeper of the King's drawings and medals and given a royal allowance. This preferential treatment led to later speculation that he was an illegitimate son of the King, although there is no evidence for this. However, Hoppner, who was attuned to the value of publicity, never discouraged the rumours.

Hoppner entered the Royal Academy Schools in 1775, winning the Academy's silver medal for life-drawing three years later. He first exhibited at the Royal Academy in 1780 and two years later won the Academy's gold medal for history painting, with a now untraced scene from *King Lear.* His marriage in 1781 resulted in the withdrawal of his royal allowance and so he began to support himself by painting works that were suitable for engraving, such as portraits of beautiful women. His early pictures are well drawn and broadly painted, resembling Johann Zoffany's (1733-1810) life-size paintings.

By the mid-1780s, Hoppner's brushwork was beginning to take on some of the freedom that was to mark his mature work, as exemplified in *Portrait of the Right Honourable William Pitt the Younger.* A greater reliance on scumbling and impasto is evident, and his palette becomes purer. His paintings were noted for their colour and it was unfortunate for Hoppner that, due to fashion trends, clothes were often restricted in colour to black for men and white for women. By 1787, he was well established as the prime successor to Reynolds and Thomas Gainsborough (1727-1788). In the 1790s he began painting close friends, drawing upon early sixteenth-century Venetian examples, which resulted in portraits set against a rich, dark background, executed with a sensitive appreciation for the qualities of the paint. He made widespread use of *sfumato* for his treatment of hair, fur and, occasionally, foliage, and his whites are applied with considerable energy.

During the 1790s, Hoppner was the preeminent portraitist in England, as Thomas Lawrence (1769-1788) was struggling to maintain his own spectacular successes of 1790; a circumstance that continued to be the case until the end of his life. Hoppner painted most of the prominent figures of the day, including Pitt, several members of the royal family, Horatio Nelson and

Pitt's successor as Prime Minister, William Wyndham Grenville. Hoppner's portraits were known for their excellent likenesses; the faces of his sitters are almost anatomically and structurally built up with paint, while his treatment of costume indicates a similar appreciation and understanding of the texture of each fabric. His best portraits are simply constructed and brilliantly executed with vibrant brushwork and luscious colour, with some of his quarter-length portraits providing remarkable psychological insights. Hoppner took over the broad brushwork of the mature Reynolds, but followed the fashion of the 1790s and early 1800s for more restrained compositional structure and simplicity in dress.

Hoppner was a regular traveller and sketcher in England, Scotland and Wales and only once travelled abroad when, in 1802, he visited Paris during the Peace of Amiens. During this sojourn, his exposure to Napoleon's spectacular art collection in the Louvre profoundly affected his style. His work became simpler in composition and any exceptions to this stylistic modification are invariably due to the specific whims of his patrons. The masterpiece of his last years is *Sleeping Nymph* (1806, Petworth House, West Sussex), which depicts a reclining nude and an accompanying cupid in a lush landscape, is a picture that has been highly praised for its colouring.

The picture's provenance, originating as it did with the Marquesses of Londonderry is of particular note. Robert Stewart (1739-1821), the 1st Marquis of Londonderry enjoyed a close friendship with Pitt the Younger and was one of the few people to be elevated to the peerage without inheriting any titles prior to his creation (fig. 1). He had represented County Down in the Irish House of Commons earlier and was created Baron Londonderry in 1789, Viscount Castlereagh in 1795 and Earl of Londonderry in 1796. On reaching this rank, his son took Viscount Castlereagh as a courtesy title. Robert Stewart was not created Marquess of Londonderry by King George III until after the death of Pitt the Younger. He sat in the British House of Lords as one of the twenty eight original Irish Representative Peers from 1800 to 1821 and played a pivotal role in Pitt the Younger's attempts to reform the Irish parliament and in bringing about a greater unity between Westminster and Dublin. He was succeeded to the marquessate by his son from his first marriage to Lady Sarah Seymour. Stewart's son, also named Robert, was styled as Lord Castlereagh and was equally influential in the politics of his day (fig. 5).

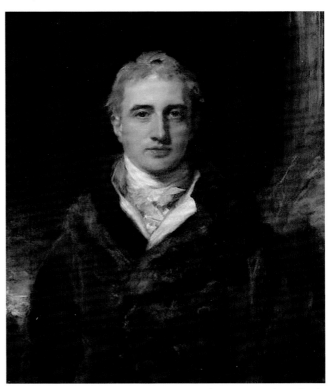

Sir Thomas Lawrence, *Robert Stewart, 2nd Marquess of Londonderry (Lord Castlereagh),* National Portrait Gallery, London (Figure 5)

WILLIAM HAMILTON

(London 1751 - London 1801)

Calypso Receiving Telemachus and Mentor in the Grotto

oil on canvas
202.7 x 158.8 cm (99½ x 62½ in)

Provenance: Sotheby's, London, 16 November 1983, lot 85.

Exhibited: London, Royal Academy, 1791, no. 133;
London, Heim Gallery, *The Painted Image: British History Painting 1750-1830*, May-June 1991, no. 95.

THIS STATELY AND ENCHANTING SCENE ILLUS-trates the initial encounter between Telemachus and Calypso narrated in Homer's *Odyssey*. Telemachus, who set out in search of his father Odysseus after the Trojan war, is accompanied by the goddess Athena disguised as Mentor, the young man's aged guardian. The pair were shipwrecked on an island belonging to the nymph Calypso who was immediately fell in love with Telemachus and tried to detain him. While there, Telemachus fell in love with Calypso's attendant Eucharis, which provoked the wrath of Venus who had been aiding Calypso in her own romantic designs. As a result, Mentor threw his love-struck charge into the sea where fortunately he was picked up by a passing vessel and taken to safety. A popular romance by the French writer Fenélon based on Homer's epic was published in 1699 as *The Adventures of Telemachus* and provided a source of inspiration for French and British artists during the eighteenth and early nineteenth centuries.

The statuesque figure of Calypso in *Calypso Receiving Telemachus and Mentor in the Grotto* dominates the canvas and she appears a powerful and seductive temptress in her classically inspired white dress, casually wrapped to reveal her voluptuous figure. She wears delicate sandals tied with white ribbons and fastened with gold clasps, matched by the ribbon in her golden hair and her pale blue silk mantle which heightens her ethereal air. Telemachus appears naive and vulnerable as he is led further into her lair and Athena, disguised as Mentor with scraggly white hair and a beard, warily watches the proceedings. They stand at the entrance to the grotto from which sharply angled rocks hang down intertwined with foliage, elevating its mysterious and somewhat menacing atmosphere.

A painting by William Hamilton in the Royal Academy of Arts, *Vertumnus and Pomona*, painted as a diploma work for the academy in 1789, parallels the present work stylistically and in its romantic narrative (fig. 1). The scene is taken from Ovid's *Metamorphoses*, in which the nymph Pomona is wooed by Vertumnus, the god of orchards, in the guise of an old woman. Pomona's features, pose and dress are classically inspired like Calypso's, and the choice of subject matter in both works reveals Hamilton's penchant for painting dramatic works of a mythological or historical nature.

Along with the present work, Hamilton exhibited *Aeneas Communicating to Dido the Necessity of his Departure from Carthage* at the 1791 Royal Academy exhibition. Interestingly, smaller oil versions of these two works, (23 x 15 in. each) entitled *Aeneas and Dido*, and *A Poetical Subject (Calypso Receiving Telemachus and Mentor)* were sold as a pair at Christie's on 19 November 1970, lot 172.

Hamilton, the son of an assistant to Robert Adam (1728-1792), trained in Rome as an architectural draughtsman. He studied under Antonio Zucchi (1726-1796) from *c.*1766 and again after returning to London from 1768. Hamilton attended the Royal Academy Schools from 1769, where he shifted focus to figure painting. He exhibited portraits and historical works at the Royal Academy from 1774 to 1801, becoming A.R.A. in 1784 and R.A. in 1789. Hamilton became a leading member of the second generation of British neoclassical artists, building on the foundations laid by predecessors such as Benjamin West (1738-1720) (see catalogue no. 138). Hamilton's *oeuvre* includes theatrical works, book illustrations, portraiture and historical and mythological scenes. Most notably, he painted twenty-three large-scale pictures for John Boydell's Shakespeare Gallery and contributed to illustrations for Bowyer's *History of England* and Thomas Macklin's Bible and *British Poets*. An accomplished draughtsman with an eclectic style, Hamilton was inspired by the work of artists such as Henry Fuseli (1741-1825), with whom he collaborated on various book illustrations. Fuseli's style of painting fantastical, theatrical themes with slightly elongated and distorted figures, appears to have influenced the present work.

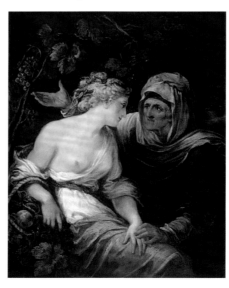

William Hamilton,
Vertumnus and Pomona,
*c.*1789,
Royal Academy of Arts,
London
(Figure 1)

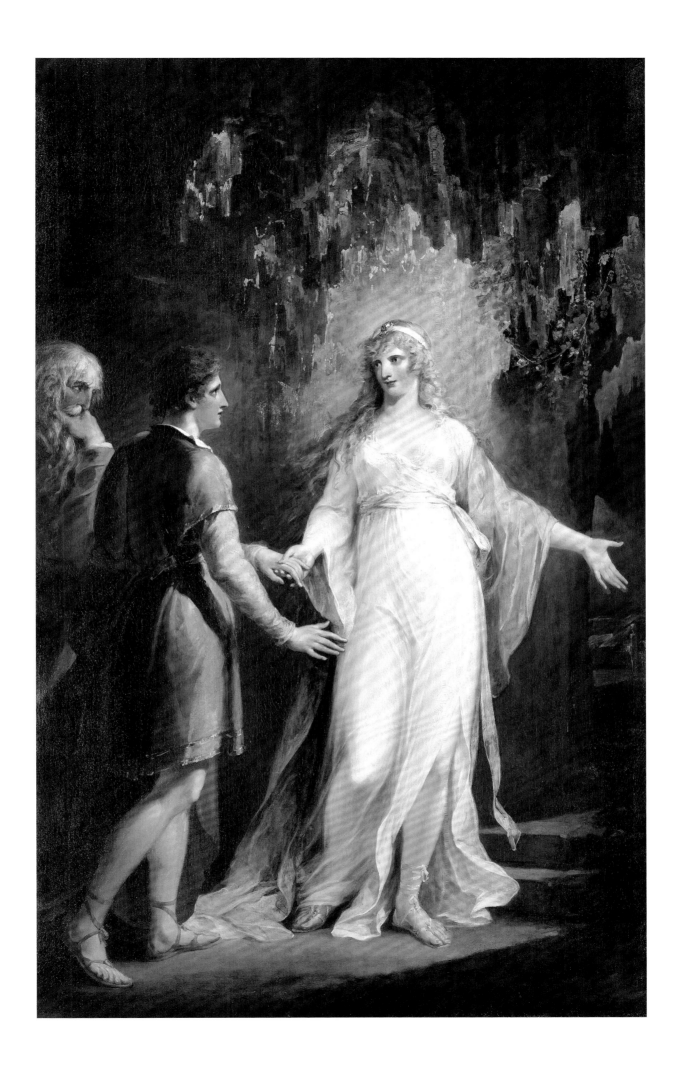

FRANCIS WHEATLEY, R.A.

(London 1747 - London 1801)

A Market Scene

oil on canvas
87.9 x 113 cm (34⅝ x 44½ in)

FRANCIS WHEATLEY'S *A MARKET SCENE* SHOWS A woman unloading baskets of peas from the back of a cart. A group of women, who have bought the produce, are preparing their baskets for the journey home, whilst children watch on. The abundant baskets, the young fresh faces of the women and children, and the soft sunlight contribute to this cheerful scene of lower-class urban living. Only the man looks anything other than contented, his evident fatigue suggesting he has driven the cart a long way, resulting in the aching neck he gently rubs.

A Market Scene is closely comparable with Giovanni Vendramini's (1769-1839) etching *Fresh Gathered Peas Young Hastings* (fig. 1). Vendramini's work is after a design by Wheatley that was part of a series of paintings, later engraved, called the *Cries of London* showing itinerant merchants selling their wares or services. The fourteen original paintings were immensely popular when exhibited at the Royal Academy between 1792 and 1795 and included images such as *Knives, Scissors, and Razors to Grind* or *Round and Sound, Fivepence a Pound, Duke Cherries*. In both *A Market Scene* and *Fresh Gathered Peas Young Hastings,* peas are being poured by the vendor into the customer's apron from the back of a cart. Moreover, in both works, a weary looking man watches on, whilst a child and dog are also present. However, *A Market Scene* is clearly a more refined work, with its street setting, additional figures and adept use of light. The repetition of subject matter is testament to the success and popularity of Wheatley's images of London life.

The son of a tailor, Wheatley was born in Covent Garden in 1747 and was trained at William Shipley's drawing school, as well as at the newly established Royal Academy Schools. He also won several prizes from the Society of Artists during the early phase of his career. His early work consists mainly of portraits and conversation pieces, which recall the manner of Johan Zoffany (1733-1810) and Benjamin Wilson (1721-1788), under whom Wheatley may well have studied. John Hamilton Mortimer (1740-1779), his friend and collaborator, also seems to have been an influence, particularly in the rendering of fabrics. In his youth Wheatley suffered financial difficulties due to a gambling problem and a love of the extravagant lifestyle of London high society. In 1779, with the help of a loan from Benjamin West (1738-1820) (see catalogue no. 138), he eloped to Dublin with the wife of J. A. Gresse (1740-1794), another artist. For four years Wheatley worked predominantly as a portrait painter, although he did complete a number of large-scale paintings depicting contemporary events. On his return however, he began to produce the sentimental genre scenes,

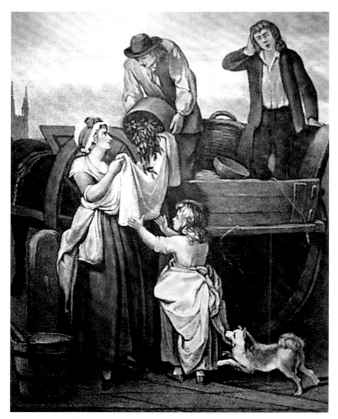

Giovanni Vendramini, *Fresh Gathered Peas Young Hastings*, published in 1795 by Colnaghi & Co, Fine Arts Museums of San Francisco, California (Figure 1)

inspired by Jean-Baptiste Greuze (1725-1805) for which he is best known, and of which *A Market Scene* is an excellent example. It was while he was in Ireland that Wheatley developed this particular style and his genre scenes of rural Irish life provide 'one of the most rewarding and appealing vistas on to the daily life of the common people of late eighteenth century Ireland'.[1] Upon his return to England he began to work for the print publisher John Boydell. This commission included producing works for the Shakespeare Gallery that were subsequently engraved and it was illustrations for novels and various genre subjects that formed Wheatley's lasting reputation, *Cries of London* being undoubtedly his most celebrated work. John T. Hayes has described 'the crisp handling of paint, the minute attention to detail in the costume, the lovely delicate tonality' as typical characteristics of Wheatley's work.[2] He was elected as a Royal Academician in 1791, but his last years were plagued by gout and continuing debt.

[1] Kelly, J. 'Francis Wheatley: His Irish Paintings, 1779-83', in Adele M Dalsimer (ed.), *Visualizing Ireland: National Identity and the Pictorial Tradition*, Faber & Faber, 1993, p. 160.
[2] Hayes, J. T., *British Paintings of the Sixteenth through Nineteenth Centuries*, Oxford University Press, p. 322.

WILLIAM JAMES

(active 1730 - 1780)

View of the Thames at Westminster

oil on canvas
69 x 115.5 cm (27¼x 45½ in)
in a Carlo Maratta style gilded frame

PAINTED IN THE MID-EIGHTEENTH CENTURY, THIS painting offers a vivid impression of the way in which the river Thames and its banks once looked and functioned, serving as a reminder of the river's evolving nature. Looking down the north bank towards Westminster Bridge, familiar sights are juxtaposed with the unfamiliar. From left to right, the buildings depicted include Westminster Hall, Westminster Abbey, the Small Beer Buttery with Whitehall Banqueting House behind, the Queen's Treasury, the Water Tower, York Stairs and the York Water Gate, the Office of the Commissioners of the Salt Tax, and finally the corner of the house of Sir Philip Botelier. The houses of prominent British figures of the time, including the Dukes of Richmond and of Montagu, the Countess of Portland, the Earl of Pembroke, Lady Townshend and Lord Grantham, lie between Westminster Abbey and the Buttery.

William James' vantage point appears to be a boat mid-river. The view is bustling and complex, incorporating various boats, buildings and people, the distinctive features of which James depicts in impressive detail. The use of bright and exaggerated colour, rather than a more natural and muted palette, is also striking.

Little is known about James' life. Paintings executed in the present style, and of similar content, have been grouped together under his name, with the present view of the Thames being repeated throughout the artist's active period. Cityscapes, particularly those which included rivers, were favourite subjects, and many Venetian scenes have also been attributed to James. It is thought that he may have been a pupil of, and assistant to, Canaletto (1697-1768). Famous for his landscapes of Venice, Canaletto also painted scenes of London, such as *Westminster Bridge* (fig. 1). Painted *c.*1747, there are clear points of comparison with *View of the Thames at Westminster*, not least in the plethora of activity on the river. Looking at the same view today noticeable differences evident paticularly in the absence of the Houses of Parliament, which were completed in the mid-nineteenth century, and Westminster Bridge itself. The bridge depicted by James in *View of the Thames at Westminster*, was constructed in 1750, but due to serious subsidence it had to be replaced in 1860 by the bridge that stands today. Similarly, the elegant York Water Gate, with steps down to the river, now stands detached from the bank some fifty metres away (fig. 2). Most striking however, is the hive of activity on the river. The assortment of boats involved in various tasks conjur up a vibrant image of how the river would have once looked when it served as the highway along which people and goods travelled through London.

The present painting was likely to have been executed shortly after the completion of Westminster Bridge in 1750. Certainly the light haze of smoke drifting from the chimneys of the York Buildings Waterworks, would suggest a date prior to 1755, when engines were abandoned in favour of horses. A charming work in a distinctive style, *View of the Thames at Westminster* provides a unique window onto the history of the river when it served as the main artery of the capital.

Canaletto, *Westminster Bridge, c.*1747,
Yale Center for British Art , Connecticut (Figure 1)

York Water Gate as viewed today (Figure 2)

DANIEL TURNER

(active 1782 - 1801)

View on the Thames with Blackfriars Bridge and St. Paul's Cathedral Beyond

oil on panel
25.4 x 40.7 cm (10 x 16 in)

Provenance: with the Parker Gallery, London;
Kleinwort Benson.

THE RIVER THAMES HAS PROVIDED POPULAR subject matter for artists over the centuries, and in their representations we have been left with a fascinating historical record of the river's past. Daniel Tuner's *View on the Thames with Blackfriars Bridge and St. Paul's Cathedral Beyond* is one such example. An assortment of boats occupies the foreground of the painting and to the left-hand side one sails into view. In the distance, Blackfriars Bridge can be seen extending to the north bank of the river where a variety of buildings and spires are overshadowed by the rising dome of St. Paul's Cathedral.

A seemingly well-known subject, the painting is a source of simultaneous familiarity and novelty. The recognisable presence of St. Paul's is unbalanced by more unusual sights, such as Watt's Shot Tower on the right-hand side of the painting, which no longer stands, and the open access to the Thames where a number of barges are congregate. At the time of painting this stretch of the south bank of the river upstream from Blackfriars Bridge was lined with timber yards, barge makers, the Lambeth Waterworks, and the occasional shot manufacturing tower, which produced shot balls for firearms by the freefall of molten lead. Blackfriars Bridge also appears in a different form from the bridge that stands today, which replaced the original in 1869. A similar view of the north bank of the Thames today reveals a more complex scene, where cranes replace spires and where the dominance of St. Paul's is overshadowed by new buildings like the 'Gherkin'.

In the current work, architectural detailing has been closely observed, and the painting is satisfyingly composed with the sailing boat and shot tower neatly framing the central focus of St. Paul's Cathedral. The boats in the foreground and the verticality of the shot tower, echoed in the distant spires, achieve a successful sense of proportion.

The river and her surrounding buildings are bathed in a warm light as the sun sets across London. The pink glow of the clouds that drift above is reflected in the stillness of the river, where barely a ripple disturbs its glass-like surface. Through the use of such soft tones, combined with a smooth and delicate application of paint, an atmosphere of serenity emanates from the painting.

The Thames was a focal point for much of Turner's career and his *oeuvre* contains various renderings of it from different viewpoints. This particular view of the Thames with St. Paul's and Blackfriars Bridge was one he repeated on several occasions (fig. 2). *View of London, with St. Paul's Cathedral* in the Courtauld is a graphite, pen and ink and watercolour sketch. Standing further back than in the present painting, Turner incorporates more of the immediate riverbank and a different building to the right, possibly a barge yard. Proportion and accuracy are not achieved as successfully here, as is apparent in Blackfriars Bridge and an uneven St. Paul's. Such details are corrected in the superior execution of the present work, which provides a unique insight into the ever-changing nature of the river and the city that lines its banks.

A view of the Thames with Blackfriars Bridge and St. Paul's Cathedral today
(Figure 1)

Daniel Turner, *View of London, with St. Paul's Cathedral,*
The Courtauld Gallery, London (Figure 2)

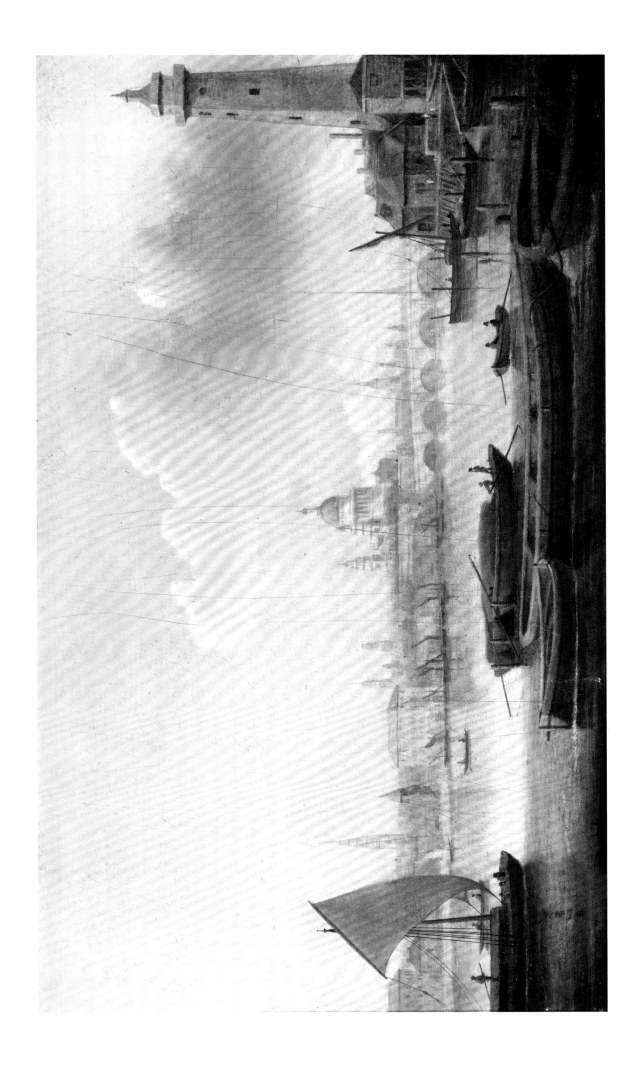

ATTRIBUTED TO

RICHARD WILSON, R.A.

(Penegoes 1713 - Colomendy 1782)

A River Landscape with Figures Dancing in the Foreground, Mountains Beyond

oil on canvas
35.9 x 43.3 cm (14⅛ x 17⅛ in)

Provenance: with J. W. Vokins, London.

Literature: Possibly 1851 Inventory, Dessert Room, *22 Paintings and 3 Prints - £35.0.0.*

I N THIS JOVIAL SCENE TWO PEASANTS DANCE TOGETHER, whilst a companion provides musical accompaniment. Two other figures sit on the ground watching this revelry. Beyond the wooded clearing is an old stone bridge fording a river and nearby a figure sits fishing. In the background a wide lake is flanked by mountains. The whole scene is bathed in a soft, hazy light.

A River Landscape with Figures Dancing in the Foreground, Mountains Beyond is attributed to Richard Wilson, and the compositional structure is one that Wilson used on several occasions, generally titled as *River Mouth with Peasants Dancing*. Examples of this are in the Neue Pinakothek in Munich and the Victoria and Albert Museum in London (fig. 1). Several similarities between the version in the Victoria and Albert Museum and this painting are notable. The eye is led from a similar group of foreground figures, along the river, to the lake and mountains in the background. The dancers are relaxing at the end of the day in the same dusky light. The major compositional difference between the works is in the use of the river. In the present work, the river veers quite sharply off, under the bridge and out of sight, while it holds a farmore dominant position in figure 1. Here, the river plunges straight back through the centre of the composition to the distant lake and Wilson clearly focuses on the reflection of the sky in the still water, contrasting it to the dark, shadowed waters on the left-hand side. The other significant difference is that the precision evident in *Landscape Composition; River Mouth with Peasants* has not been applied to the present picture where the brushwork seems much looser and more relaxed.

A River Landscape with Figures Dancing in the Foreground, Mountains Beyond shares qualities with much a number of Wilson's output, for instance *Holt Bridge on the River Dee* (The National Gallery, London). This painting also depicts figures relaxing whilst a companion plays a musical instrument. Below their elevated position, a river stretches away, towards a background made up of distant mountains. In *Holt Bridge on the River Dee*, Wilson has painted a landscape that exists: Holt Bridge joins Holt in Denbighshire to Farndon in Cheshire, although this is not a topographically accurate view. Instead, he has focused on depicting a unified landscape in the tradition of Claude Lorraine's (?1604/5-1682) paintings of the Roman *campagna*, which appear to have also informed the present work.

Having studied under Thomas Wright, Wilson began his career as a portrait painter in the 1740s. By 1750 he was travelling to Venice, and by 1752, he was in Rome, where he executed many drawings of the city and

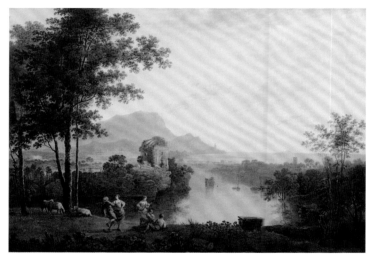

Richard Wilson, *Landscape Composition: River Mouth with Peasants Dancing*, The Victoria and Albert Museum, London (Figure 1)

the *campagna*, and where he studied the works of painters such as Lorrain and Nicolas Poussin (1594-1665). It was in Rome that Claude-Joseph Vernet (1714-1789) (see inventory), on seeing Wilson's work, expressed surprise that a landscape painter as talented as Wilson spent his time painting portraits. On his return to London Wilson established a successful studio with many pupils. His popularity lay in his ability to synthesise actual and idealised landscapes since the latter, firmly rooted in the Arcadian tradition, held a particular appeal for Wilson's classically educated clientele. From 1760, his work included historical landscapes in the grand style, along with Claudean depictions of English views. Wilson was a founder-member of the Royal Academy and enjoyed considerable success until the early 1770s but his last years were spent in poverty. With his reputation in decline and he retired to Wales in 1781. However, after his death his work began to be appreciated again and was a significant influence on the generation of J. M. W. Turner's. His significance is such that he 'fills much the same place in the development of a tradition of landscape painting in Britain that Reynolds does in the development of portraiture'.[1]

[1] L Ellis Waterhouse, *Painting in Britain, 1530-1790*, Penguin Books, London, 1953 p. 172.

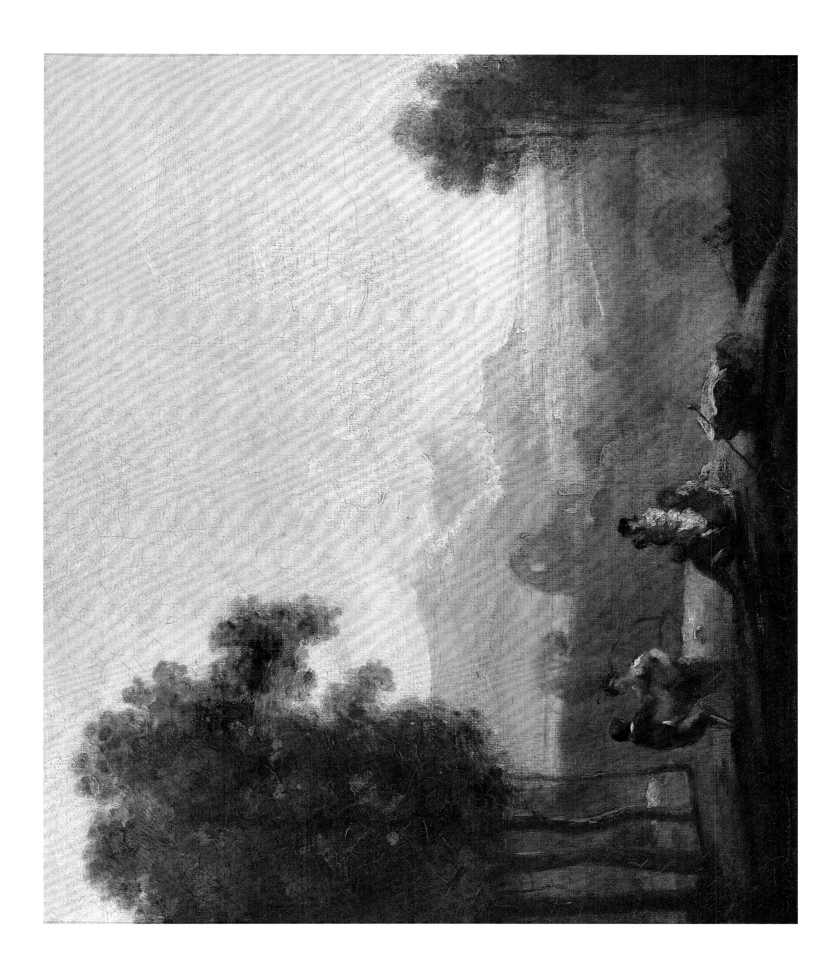

THOMAS LUNY

(London 1759 - Teignmouth 1837)

Ships in a Harbour with Fisherfolk in the Foreground

signed and indistinctly dated '18.7' (lower left)
oil on canvas
61 x 87 cm (24 x 34¼ in)

SHELTERED IN A BAY ON THE COAST, A GROUP OF fishermen are engaged in their daily tasks, observed by three women carrying baskets. On the right-hand side, as one fisherman tidies his boat, another loads a basket with fish, apparently in conversation with two of the women. A third fisherman sorts out his fishing net, signalling the end of the day's work. The figure on the far left is engrossed with his fishing rod, closely watched by one of the women. In the background, a harbour provides a place of rest for various boats and seamen, a number of whom have lit a fire on the beach. A large ship with billowing sails stands off the coast while on the horizon the sail of a much smaller boat is also evident. The sun disappears behind the sails of the main ship, yet the bright light radiating from it suggests some hours of day remain before what looks to be a tranquil evening sets in, indicated by the smoothness of the sea and only a veil of clouds.

Our attention in *Ships in a Harbour with Fisherfolk in the Foreground* is first drawn to the group of figures enclosed by the cliffs that surround them. The brightness of their clothes and distinctive features make them stand out from the hazy and neutral representation of the background details. The whole of this well-ordered composition is closely observed, from the foliage that extends from the cliffs to the rigging of the ships in the distance. The horizon sits low in the picture, with more space given over to the sky, yet this is broken up by the cliffs in the foreground which frame the painting and place the viewer on a par with the fisherfolk.

The use of a soft palette and delicate application of paint create the feeling of stillness in the painting, with the sea and sky virtually indistinguishable as the two planes blend into one another. Thomas Luny's careful attention to light and his success in rendering it lends the work its harmonious and accomplished presence.

Luny was an English painter whose expertise lay predominantly in seascapes and ship portraiture. He was best known for his dramatic representations of naval scenes exemplified by *Battle of the Nile, August 1st 1798*, and he received numerous commissions for such works, particularly from the British East India Company (fig. 1). In *Battle of the Nile*, the influence of Francis Holman (fl. 1760-1790), under whom Luny trained, is also evident. Holman was himself a marine painter and Luny worked with him until the early 1780s; his style came to closely resemble that of his master's, as can be seen in *Shipping off Newhaven,* notably in the depiction of the waves (fig. 2).

Luny was a member of the Thames group of marine painters around Deptford, following the tradition of the van de Velde family. In 1777, Luny first exhibited at the Society of Artists before becoming a regular exhibitor at the Royal Academy until 1793. From this date it is thought he served in the Royal Navy during the Napoleonic conflict. After his service he settled in Teignmouth, Cornwall - a move most likely prompted by the retirement of his naval patrons there and by the onset of rheumatoid arthritis. Luny continued to paint until his death, but his best work is generally considered to date from 1807 to 1817, before his physical disabilities took too firm a hold.

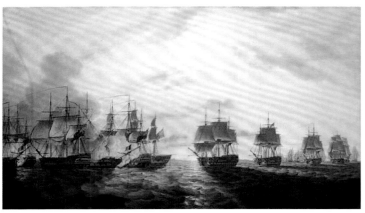

Thomas Luny, *Battle of the Nile, August 1st 1798*, National Maritime Museum, London (Figure 1)

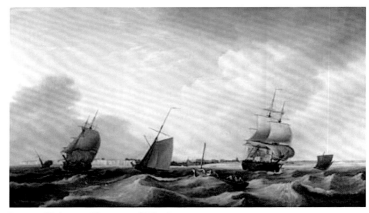

Francis Holman, *Shipping off Newhaven,* 1777, Government Art Collection (Figure 2)

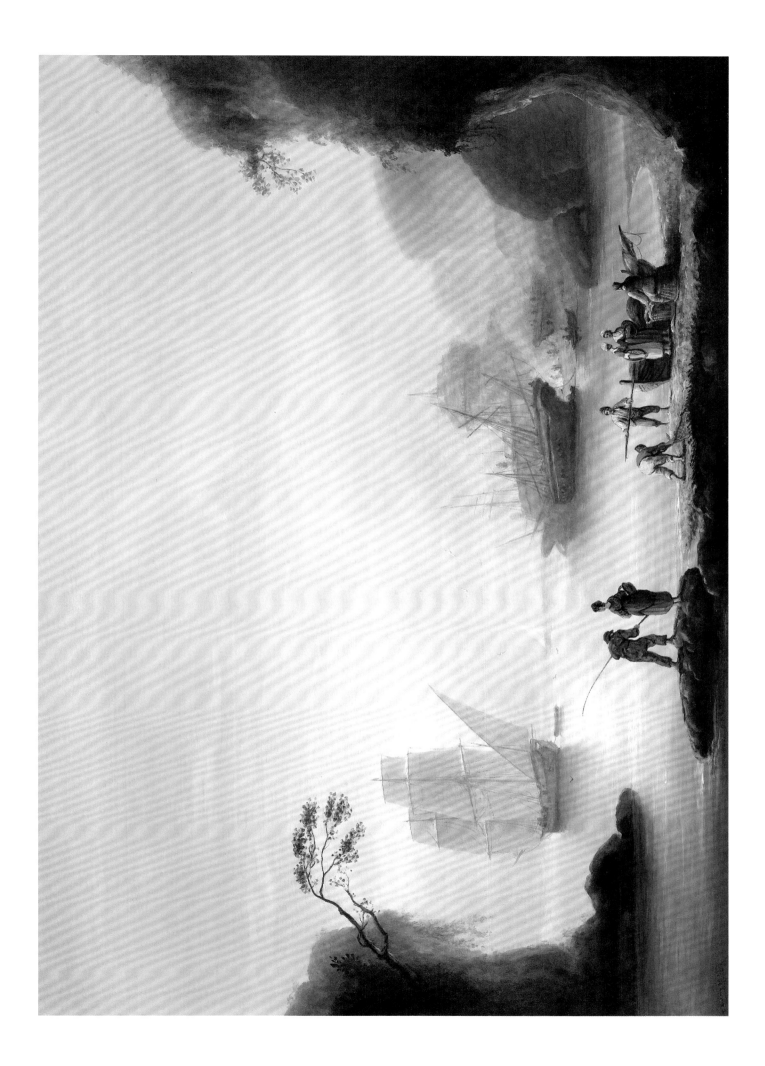

ALEXANDER NASMYTH

(Edinburgh 1758 - Edinburgh 1840)

A View of Loch Lomond with Figures and Boats in the Foreground

signed 'Alex. Nasmyth' (lower right)
oil on canvas laid down on board
63.5 x 88.9 cm (25 x 35 in)

'*By yon bonnie banks*
And by yon bonnie braes,
Where the sun shines bright
On Loch Lomond
Oh we twa ha'e pass'd
Sae mony blithesome days,
On the bonnie, bonnie banks
O' Loch Lomond.'
　- Traditional Scottish song

A *VIEW OF LOCH LOMOND WITH FIGURES AND BOATS in the Foreground* by Alexander Nasmyth delightfully encapsulates the beauty of the lake, the largest in mainland Britain. Loch Lomond, ever popular and exalted in traditional song and poetry, is here immortalised by Nasmyth in visual form. As is typical of the artist's work, the view is highly romantic and slightly idealised as Nasmyth often worked up his studies in the studio, modifying certain elements to achieve a harmonious balance in composition.

The sun has just dipped behind the rocky outcrop on the left of the painting and its late afternoon glow reflects on the surface of the water, the jagged faces of the surrounding hills and the luxurious clouds in the sky. The lighting has a soft Mediterranean feel, no doubt inspired by Nasmyth's travels through Italy, which enhances the poetic mood. In the foreground, a couple stands on the bank conversing, while a woman sits admiring the view and two men unload provisions from a rowing boat. At a slight distance, other sightseers alight from a boat and take in their surroundings.

Nasmyth's concern with atmospheric effects and his adherence to the ideals of the Picturesque, which were highly popular in his day, are in evidence in the present painting as well as in works such as *Dumbarton Castle and Town with Ben Lomond* (fig. 1). The two images have a number of compositional parallels, and are both marked by the brilliant rendering of the sky and weather conditions, features that have garnered Nasmyth widespread praise and distinguish his best works.

Nasmyth intended to train as an architect, but an early inclination towards painting led him to apprentice with James Cummyng (*c.*1730-1792), a house decorator and antiquarian. Nasmyth's talent impressed Allan Ramsay (1713-1784), who visited Crichton in 1774, and decided to take him on as an apprentice in London, where he spent four years. On his return to Edinburgh in 1778, Nasmyth set himself up as a portrait painter, initially following Ramsay's practice of painting his sitters bust-length against plain backgrounds, before gaining confidence and experimenting by placing his subjects in landscape settings. He soon developed an inclination towards landscape painting, and in 1783, an acquaintance loaned him £500 in order to broaden his artistic education on the Continent. His sketchbooks suggest that Nasmyth visited Rome, the Bay of Naples, Bolsena, Ancona and Tivoli, as well as Lakes Lucerne and Geneva in Switzerland. He returned to Edinburgh in 1784, now aged twenty-six, and resumed painting portraits, although in the following few years he increased his output of landscapes. Nasmyth's predominant theme was the Scottish landscape, and he soon developed a consistent style and compositional formula that he maintained with great success throughout his career.

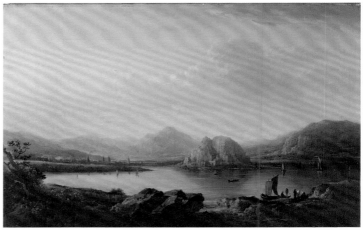

Alexander Nasmyth, *Dumbarton Castle and Town with Ben Lomond*, 1816, Hunterian Museum & Art Gallery, University of Glasgow (Figure 1)

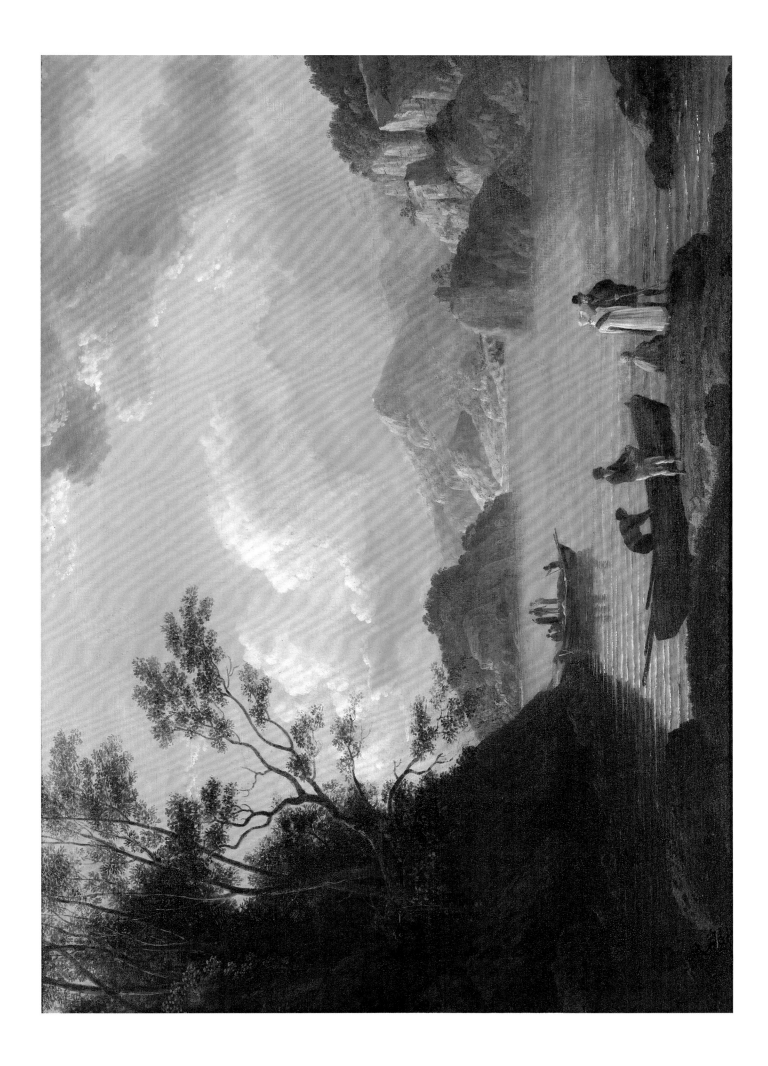

JOHN CROME

(Norwich 1768 - Norwich 1821)

A Wooded Landscape with an Oak

oil on panel
23.8 x 18.1 cm (9⅜ x 7⅛ in)

Provenance: Sotheby's, 20 November, 1985, lot 81.

A *WOODED LANDSCAPE WITH AN OAK* IS AS MUCH A tree portrait as a landscape study, as the sensitivity and naturalism of the painting imbues the subject with a great deal of character. The oak, 'half giant and half sage',[1] is portrayed as the guardian of the landscape, towering over the shrubbery and foliage around it and cutting a magnificent figure against the blue sky. John Crome, along with John Constable (1776-1837) (see catalogue no. 82), was one of the earliest English artists to represent identifiable species of trees, rather than generalised forms. His works, renowned for their originality and vision, were inspired by direct observation of the natural world combined with a comprehensive study of Old Masters.

A larger but essentially similar study of a tree by Crome is *The Poringland Oak* in the Tate, London (fig. 1). In this work, a group of bathers are depicted in the foreground; the subject of the painting, however, is undoubtedly the stately oak. Crome's later work reveals a growing interest in atmospheric effects, as indicated in the use of extensive shading in *The Poringland Oak,* which gives the impression of a slightly overcast afternoon, in contrast to the bright sunshine of *A Wooded Landscape with an Oak*. The differing tonalities have a marked impact on the overall mood of the paintings.

Crome was apprenticed to a coach and sign painter, Francis Whistler from the age of fifteen to twenty-two, after which he presumably continued to practise the trade as well as learning oil painting techniques. His early influences were the local artists William Beechey (1753-1839), John Opie (1761-1807) and Thomas Harvey. Harvey was a collector, as well as an amateur painter and had in his possession works by Dutch seventeenth-century masters such as Aelbert Cuyp (1620-1691), Jacob van Ruisdael (1628/9-1682) and Miendert Hobbema (1638-1709) as well as English eighteenth-century artists Thomas Gainsborough (1727-1788) and Richard Wilson (1713-1782) (see catalogue no. 78), all of whom influenced Crome's artistic development. Crome married in 1792 and soon afterwards established himself as a drawing teacher. He was one of the founders of the Norwich Society of Artists in 1803, and of the Norwich school of painters. Although during his lifetime his works were often criticised for their unfinished appearance, they became highly sought after following his death. In a letter written by the Rev. W. Gunn just weeks after Crome's death, he reports that people were 'crazy for his pictures'.[2] Crome was an art collector and etcher as well as a painter, and he is credited with having been at the forefront of the nineteenth-century etching revival in Britain. The large number of etchings that he produced help to establish a chronology for

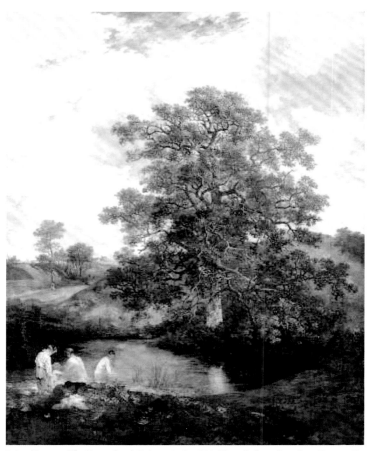

John Crome, *The Poringland Oak, c.*1818-1820, Tate Gallery, London (Figure 1)

his paintings, none of which were signed. Crome's sons, the most talented of whom was John Berney Crome (1794-1842), painted in his father's and continued his teaching practice, although they did not achieve the same success as their father.

[1] William Wordsworth, *The Oak and the Broom, a Pastoral.*
[2] Rev. W. Gunn to J. Flaxman, 4 May 1821; Cambridge, Trinity College Library.

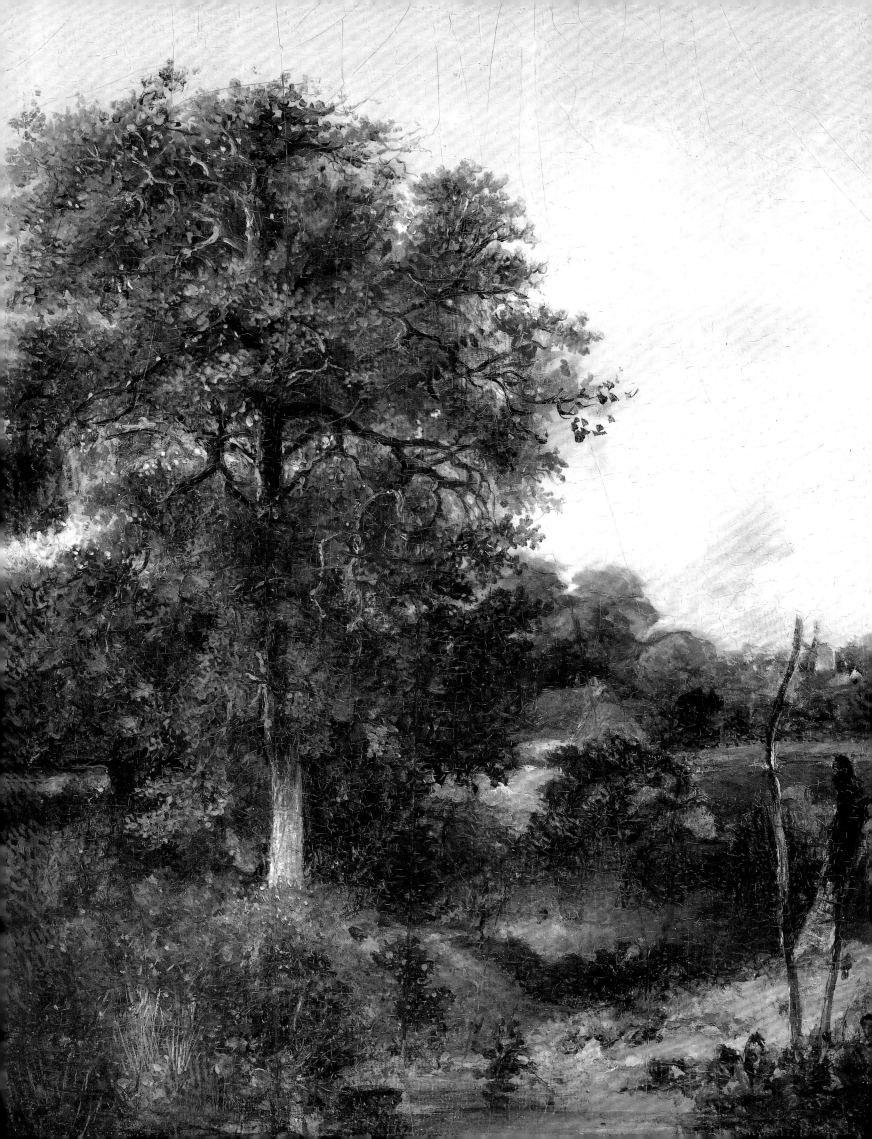

JOHN CONSTABLE, R.A.

(East Bergholt, Suffolk 1776 - Hampstead 1837)

View of East Bergholt House

oil on canvas
50 x 76.2 cm (19½ x 30 in)

Provenance: James Orrock;
Major C.R.C. Burton, MBE;
anonymous sale: Sotheby's, London, 19 July, 1978, lot 67.

Exhibitions: Oxford, Ashmolean Museum, 1963.

Literature: C.J. Holmes, *Constable,* London, 1902, pp. 118 and 242, plate facing p. 48;
Lord Windsor, *List of Constable's Chief Pictures,* London and New York, 1903, p.211;
M.S. Henderson, *Constable,* London, 1905, p. 22.

EAST BERGHOLT HOUSE, ABOUT WHICH JOHN Constable remarked, 'this place was the origin of my fame',[1] features frequently in the artist's work. The parish of East Bergholt in Suffolk was a place of great affection for Constable throughout his life, and as Leslie Parris and Ian Fleming-Williams write, 'when, after leaving home, Constable became a less and less frequent visitor to this richly cultivated landscape, his affection for the childhood he had spent in it grew into a nostalgia that became one of the driving forces of his art'.[2]

Constable was born in East Bergholt House, which his father had built two years earlier when Flatford Mill became too small for his growing family. The house no longer exists as it was pulled down *c.*1840, roughly twenty years after the family sold it; it is, however, a familiar site to Constable's audience as it has been memorialised in numerous paintings and drawings. The present work belongs to a small group of oil paintings that Constable executed between 1809 and 1811 showing similar views of the back of the estate from different proximities. Related examples can be found in the Mellon Collection, Yale Center for British Art, the Tate Britain and the Victoria and Albert Museum, London. These are part of a larger body of work painted between 1808 and 1817 when Constable focused his attention on recording *en plein air* his native landscape around East Bergholt. In a letter to a friend written while in London prior to returning home, Constable stated, 'for the last two years I have been running after pictures and seeking the truth at second hand... I shall shortly return to East Bergholt where I shall make laborious studies from nature... and I shall endeavour to get a pure and unaffected representation of the scenes that may employ me... there is room enough for a natural painter'.[3] His compositions of the period are noted for their intimacy, diversity of brushstrokes and adventurous colouring, in contrast to his earlier paintings of the English countryside.

John Constable, R.A., *View of East Bergholt House* (Detail)

[1] The accompanying inscription to a view of East Bergholt House included as the frontispiece of Constable's book *English Landscape Scenery,* 1832.
[2] L. Parris, C. Shields and I. Fleming-Williams, *Constable: Paintings, Drawings and Watercolours,* exh. cat., London, Tate, 1976, p.32.
[3] Larouse, *Dictionary of Painters,* Book Club Associates, London, 1981, p.70.

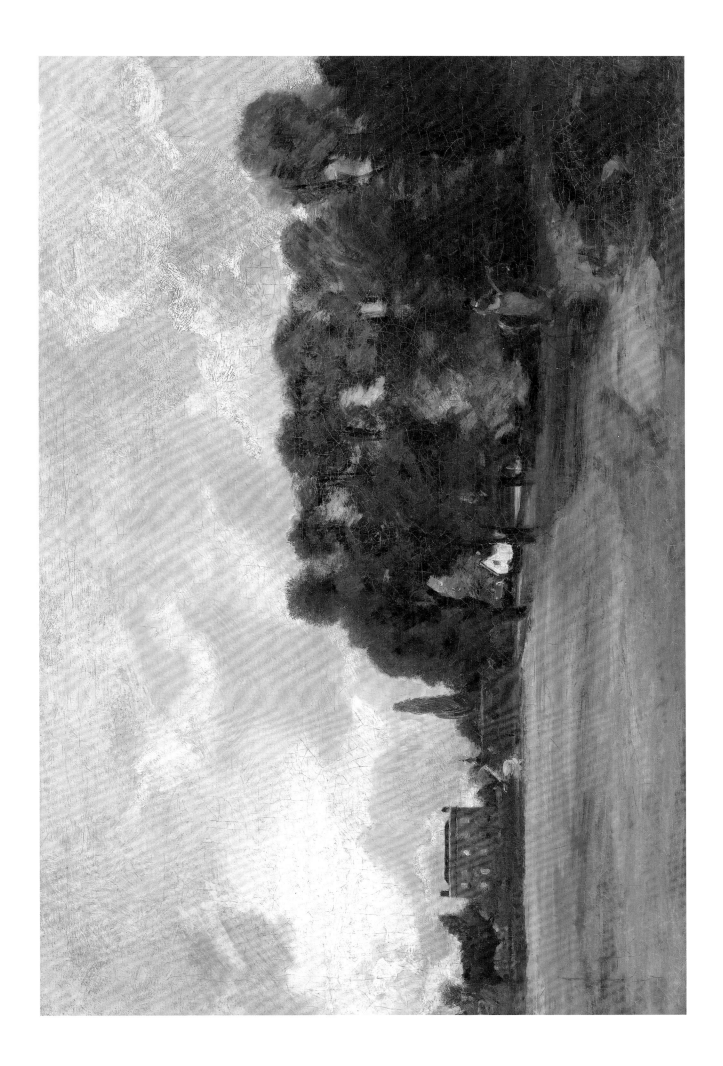

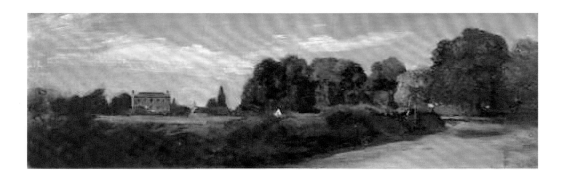

John Constable, R.A., *East Bergholt House*, c.1809, Tate Gallery, London (Figure 1)

In his book of mezzotints, *English Landscape Scenery*, Constable wrote of East Bergholt, 'the beauty of the surrounding scenery, the gentle declivities, the luxuriant meadow flats sprinkled with flocks and herds, and well cultivated uplands, the woods and rivers, the numerous scattered villages and churches, with farms and picturesque cottages, all impart to this particular spot an amenity and elegance hardly anywhere else to be found'.[4] This enthusiastic description resonates with the scenery depicted in *View of East Bergholt House*, and its charming and tranquil air. The house is a point of focus and at the same time recedes into the background in harmony with the horizontality of the landscape. The imposing trees on the right of the painting make up the densest part of the composition, while a female rider mounted side-saddle on a horse, stands out against them in a red shawl. The land through which she rides is part of more than thirty acres that were inherited by Golding Constable from his uncle Abram. The immediacy, sensitivity and atmospheric veracity with which Constable treats his subject make evident his fondness for the place.

The years in which Constable focused his studies on the back view of East Bergholt House corresponded with his meeting and falling in love with Maria Bicknell, whose grandfather was the rector of the parish. The fields around East Bergholt that are portrayed in the present work were no doubt given added significance to Constable's life as they were the location of his courtship, as well as his childhood games.

Of the comparable views of East Bergholt House in public collections, Constable's painting of the subject, dated c.1809, in the Tate Gallery is most related (fig. 1). The dense grouping of trees on the right takes up the majority of the canvas, as in *View of East Bergholt House*, and the colour palette of the two works is very similar. The Tate version presents a more expansive view of the countryside surrounding the house. Painted from a greater distance, the house and stables are diminished in importance within the landscape, while the hedge cutting across the fields diagonally forms the focal point of the composition.

Golding Constable's House, East Bergholt, painted c.1811, in the Victoria and Albert Museum, London, gives a less impressionistic view of the house from a much closer vantage point than either the present composition or the version in the Tate (fig. 2). The house is clearly the subject of the painting rather than a feature of the landscape, and it is rendered from an angle, rather than straight on, losing the symmetry of the present view. To the left, St. Mary's Church can be seen.

The addition of the female rider wearing red in *View of East Bergholt House* is of note, as there are similar figures in many of Constable's compositions, functioning as colourful accents against the landscape. *James Gubbins' House at Epsom*, painted c.1809, depicting the house belonging to Constable's uncle and aunt, is compositionally similar to the present work and also features a dab of red representing a female figure wearing a red shawl. A label on the back of the painting, written by one of the grandchildren of James and Mary Gubbins, reads, 'I asked about the red streak in the Picture of Epsom House – Burton says it was our aunt - she happened to pop out as Constable was painting it - in a red shawl - that induced him to put a dab to represent her - I should note it in Legendary Remarks on back of Picture'.[5] This anecdote relates to the advice give to Constable in his youth by J.T. Smith: 'Do not... set about inventing figures for a landscape taken from nature, for you cannot remain an hour in any spot, however solitary, without the appearance of some living thing that will in all probability accord better with the scene and time of day than will any invention of your own'.[6] These statements would suggest that the rider in the present work not only adds colour and liveliness to the composition, but may be someone associated with Constable or his family. Certainly, it seems that she is representative of a real person, and not simply a decorative element.

Hovering over the lush landscape of *View of East Bergholt House*, and taking up a large portion of the canvas, is a brooding and expressive sky, an element of the painting that was of great importance to Constable. 'That landscape painter', he wrote in 1821, 'who does not make his skies a very material part of his composition, neglects to avail himself to one of his greatest aids'.[7] Although at the time of writing Constable was living in Hampstead and devoting himself to series of cloud studies, his concern for conveying atmospheric effects and the light and movement of the sky is evident in his earliest oil paintings. *View of East Bergholt House* is a

[4] John Constable, *English Landscape Scenery: A Series of Forty Mezzotinto Engravings on Steel*, by David Lucas, London, Henry G. Bohn, 1855, Folio, pp.12-13.

[5] *Constable: Paintings, Drawings and Watercolours*, p.54.

[6] Charles Robert Leslie, *Memoirs of the Life of John Constable, Composed Chiefly of his Letters*, 1843, p.4.

[7] Joshua Charles Taylor, *Nineteenth-century Theories of Art*, University of California Press, 1989, p.301.

John Constable, R.A., *Golding Constable's House, East Bergholt, c.*1811, Victoria and Albert Museum, London (Figure 2)

particularly fine example of his attempts to capture the properties of shifting light and weather, and is a paean not only to the place but also to the time of day. The moody tonality of the clouds is similar to those depicted in *Dedham from Langham*, painted *c.*1813, in the Tate (fig. 3).

Constable was the second son of Golding Constable, a prosperous miller, merchant and Suffolk-born gentleman farmer. Constable was supposed to have continued his father's business but his artistic persuasions led him to cut short his apprenticeship. In 1799, he was granted permission to study at the Royal Academy Schools. The emphasis at the academy was on history painting, although the Academician Joseph Farington (1747-1821) and Sir George Beaumont (1753-1827) supplemented the curriculum with instruction in landscape. Constable copied a variety of seventeenth-century and contemporary landscapes, and developed a life-long reverence for the works of Dutch masters, such as Jacob van Ruisdael (1628/9-1682).

Early in his career, Constable focused on watercolours and graphite studies and it was not until 1806 that he turned his attention to oils painted from nature. In that year he produced a major body of landscape studies during a tour of the Lake District, which reveal his early concentration on the shifting effects of light and weather. In 1808, Constable began his campaign of oil sketching from nature around East Bergholt, of which the present work is an example. A year later he fell in love with Maria Bicknell and his need to acquire professional status and success became more urgent in order to provide a home for her. While some of his contemporaries and younger artists were achieving fame and fortune, Constable struggled to sell his work. Maria's family disapproved of the match, and the young couple were obliged to pursue a clandestine relationship. In the following years Constable began to attract critical notice; he was, however, unsuccessful in his attempts to be elected an Associate of the Royal Academy. In 1816, Golding Constable died, leaving his son with an assured income, which prompted him to marry Maria in October of that year. Soon afterwards, Constable moved permanently to London and searched for new subject matter, sketching in and around the city. He sold occasional landscape paintings but resorted to portraiture to supplement his income. His large painting, *The White Horse* (Frick Collection, New York), exhibited at the Academy, attracted critical approval, although the roughness of the brushwork was considered inappropriate in so large an exhibition piece. At the end of 1819, he was finally elected as an Associate of the Royal Academy. In the same year, Maria's tuberculosis prompted the family to settle in Hampstead, where Constable lived the rest of his life.

Constable's major work, *The Hay Wain* (National Gallery, London), painted in 1824, won a gold medal at the Paris Salon, but it was not until 1829, when he was over fifty, that he was made a full member of the Royal Academy. In 1833, Constable began lecturing on landscape painting. In his first lecture to the Royal Institution of Great Britain, he said about painting, 'I hope to show that ours is a regularly taught profession; that it is *scientific* as well as *poetic*; that imagination alone never did, and never can, produce works that are to stand by a comparison with *realities*'[8]. The honesty and accuracy with which Constable sought to represent nature, and the devotion he showed to portraying prosaic rural scenes, is powerfully illustrated in his studies of East Bergholt. *View of East Bergholt House* is, significantly, the last of four similar paintings of the house to have remained in private hands.

We are grateful to Graham Reynolds for confirming the attribution to Constable after inspecting the painting in the original.

[8] Introduction to Constable's Lecture 1 to the Royal Institution of Great Britain, notes taken by C.R. Lewis, 26 May, 1836.

John Constable, R.A., *Dedham from Langham, c.*1813, Tate Gallery, London (Figure 3)

JULIUS CAESAR IBBETSON

(Leeds 1759 - Masham 1817)

A Landscape with Travellers in a Horse Drawn Carriage and Figures Conversing by a Track

signed and indistinctly dated 'JIbbetson 1792[?]' (lower right)
oil on canvas
37.2 x 46.3 cm (14⅝ x 18¼ in)

Provenance: with Leggatt Bros., London.

IN THIS IDYLLIC RURAL SCENE, JULIUS CAESAR IBBETSON creates a fine contrast between the frenetic coachman, spurring his horses into a furious gallop and the leisurely exchange amongst the group of figures in the foreground of the work. So absorbed are they in their gossip that they seem almost oblivious to the noise and vigorous movement of the horses rushing past them. The motion of the horses is beautifully conveyed by their front hooves which scarcely skim the ground as they fly past. The two dogs flanking the stationary party emphasise this contrast all the more.

The pink-tinged clouds and the simple rural dwelling pictured, correspond to the output of other English landscapists in the later eighteenth century. with Ibbetson clearly demonstrating the influence that the joint authority of seventeenth-century Dutch and Italian landscape paintings still exerted.

Ibbetson was an English painter, print maker and writer. He began his career as a copyist, predominantly of Dutch works in London which gained him the nickname 'the Berchem of England'. By 1785 he began to exhibit landscapes, genre scenes and portraits at the Royal Academy where he continued to do so for the next thirty years. He travelled extensively which did much to influence his landscape painting. Between 1787 and 1788, Ibbetson was the personal draughtsman to Colonel Charles Cathcart on the first British mission to Beijing, which encompassed visits to Madeira, the Cape of Good Hope and Java. On his return to England, Ibbetson stayed with John Stuart, 3rd Earl of Bute at Cardiff Castle and also visited the Isle of Wight in 1790. The rugged beauty of the island evidently made a profound impact on the artist as he subsequently began to paint scenes of shipwrecks and smugglings. His bleak and evocative *A Storm on the Isle of Wight,* see fig. 1, stands in sharp contrast to the softly tranquil scene of this *Landscape with Travellers in a Horse Drawn Carriage and Figures Conversing by a Track.*

Julius Caesar Ibbetson, *A Storm on the Isle of Wight,* Cleveland Museum of Art, Ohio (Figure 1)

Equally significant in Ibbetson's artistic development was a visit to Wales and the surrounding area with the painter John 'Warwick' Smith (1749-1831). The visit resulted in the publication of a book of engravings: *A Picturesque Guide* (1793). Not long after his Welsh travels, Ibbetson was commissioned in 1794 by the 2nd Earl of Mansfield to decorate the library ceiling of Kenwood House. In 1803 he published *An Accidence, or Gamut, of Painting in Oils and Watercolours* which was part autobiography and part technical treatise. In it he cited Claude Lorrain (?1604/5-1682) and Albert Cuyp (1620-1691) as masters of landscape composition. The book also provides important insights into Ibbetson's own methods, one of which was modelling through 'inner light' achieved through the application of thin glazes.

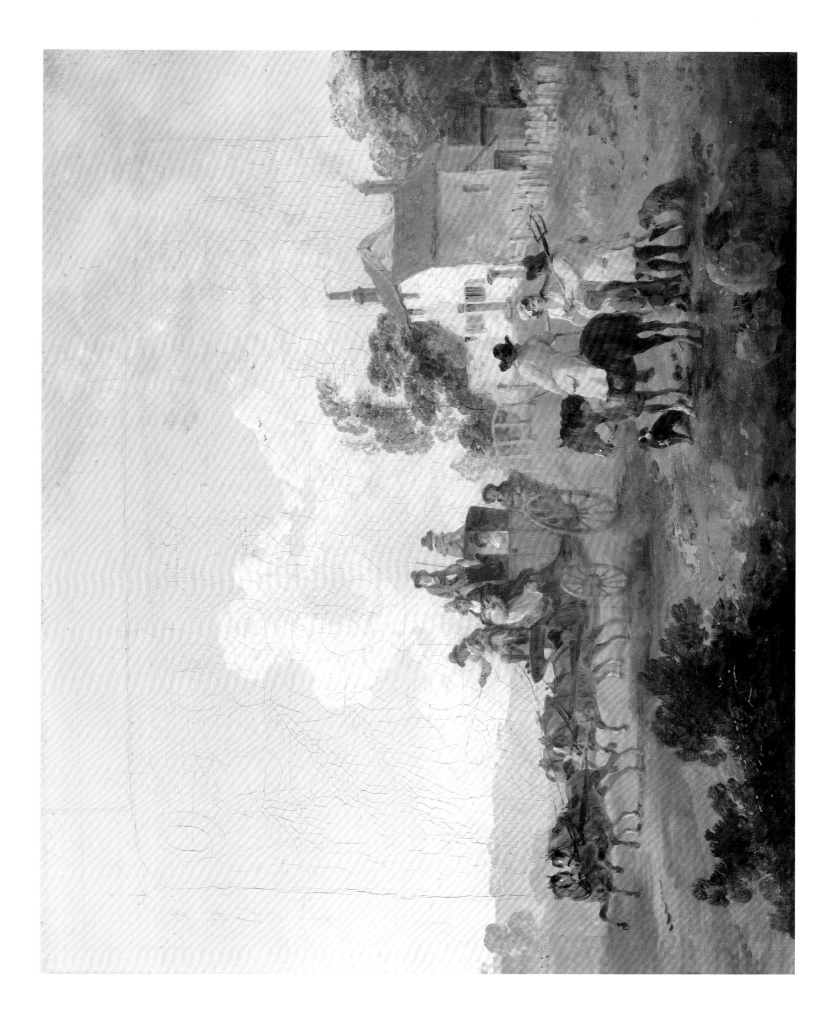

JAMES WARD

(London 1769 - Cheshunt 1859)

The Runaway Wagon

signed and inscribed 'I.WARD.x/Paddington' (on the wagon)
oil on canvas
61 x 76.2 cm (24 x 30 in)

AN EXHILARATING AND URGENT CHASE IS DEPICTED in *The Runaway Wagon* as a man desperately pursues his wagon pulled by two horses as they speed away in full gallop. James Ward is best known for his accomplished animal studies although he also expertly captured people and landscapes. In this composition, he brings all three components together to create an engaging scene. The tumultuous energy of the scene is heightened by the dark and stormy clouds in the sky and the shadowy ground beneath, and Ward's vigorous brush strokes and strong colours add further to the drama.

James Ward, *Studies of a Horse in Motion*,
The Fitzwilliam Museum, Cambridge (Figure 1)

Central to the composition are two horses showing off their powerful muscles and lustrous coats as they strain to escape the burden of the wagon. The lead horse is turned away but the second horse turns his finely formed head to challenge the viewer. Ward often painted animals in a state of agitation or movement and his preparatory drawings such as *Studies of a Horse in Motion*, see fig. 1, reveal his interest in capturing the specifics of anatomy and the range of movement that was necessary for the execution of a convincing animal painting.

Chaos abounds in *The Runaway Wagon*, and is evident in the details of the basket and bundles that are about to tumble to the ground, and the pigs scurrying from underneath the wagon in fright. A man, presumably the owner of the wagon, runs after it in a state of dishevelled frenzy, while on the left of the composition another man appears terrified as he hastens to close the gate and halt the oncoming horses. Down the path away from the village, a rider can be seen galloping by on his steed, which may explain the commotion that prompted the wagon horses to bolt. Meanwhile, the sky grows dark and threatening and the wind has picked up, suggested by the movement in the trees. In its heightened emotion and spirited portrayal of untamed nature, *The Runaway Wagon* exemplifies the ideals of Romanticism, as well as the Anglo-Dutch tradition of humorous imagery.

Ward had a lengthy and prolific career establishing himself as one of the most talented painters of animals, portraits and landscapes in Regency England. He frequently exhibited at the British Institution and at the Royal Academy of Arts, London. Ward was instructed in the art of engraving by his brother William Ward and John Raphael Smith (1752-1812) and developed a successful career as a mezzotinter before turning to oil painting around 1790. Traditionally, the first phase of Ward's painting career is thought to have lasted until *c.*1803 and consisted mostly of genre scenes, influenced by the work of his brother-in-law, George Morland (1763-1804) (see inventory). After 1803, a shift in Ward's style can be detected when his compositions began to emulate Peter Paul Rubens (1577-1640).

Shortly before 1810, Ward began painting characteristically proud and noble portraits of thoroughbreds and blood horses posed in expansive landscapes. He gained particular recognition for these works, leading the *Sporting Magazine* to describe him as 'the first of English animal painters now living'.[1] Following this success, Ward was elected to the Royal Academy in 1811. In the next decade, Ward completed a number of major paintings depicting landscapes and livestock. He devoted most of the years from 1815 to 1821 to executing the *Waterloo Allegory*, a composition of enormous size that had been commissioned by the British Institution. The work, now lost, was critically and financially unsuccessful and its negative reception may have added to Ward's increasing disillusionment with the art world. He retired to a cottage in Cheshunt, Hertfordshire, in 1830, although he continued to exhibit in London. His paintings of this latter period, although ostensibly still animal portraits, often have a religious subtext or incorporate moral commentary on the human condition. Ward continued to paint until 1855 when he suffered a stroke.

[1] *Sporting Magazine*, 1811, p.265.

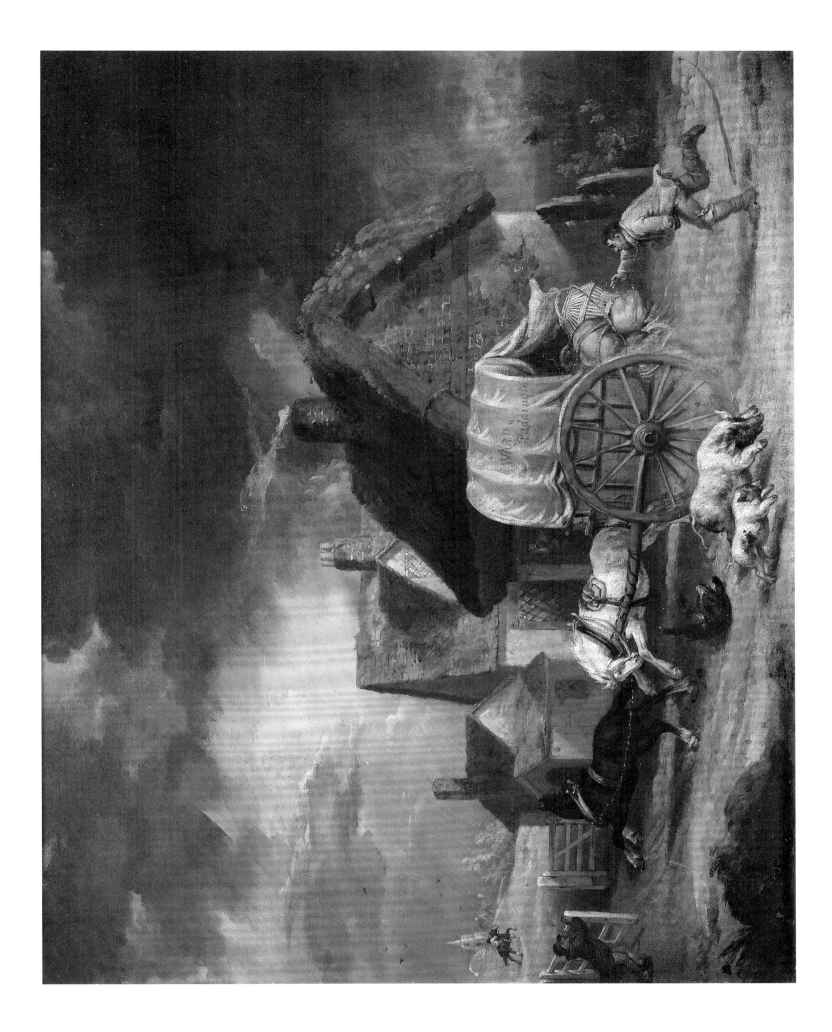

SPANISH SCHOOL, c.1529

Christ Washing the Disciples' Feet

indistinctly dated '1529 ...19' (lower right)
oil on panel
45.7 x 75 cm (18 x 29½ in)

THE SUBJECT MATTER OF THIS WORK RELATES TO the preparations for Passover (The Last Supper) and, in the Gospels, only John records these events. In Jesus' time, it was customary for people to have the dust washed off their feet before entering a house. It normally fell to the incumbent servants to perform such a lowly task. Here, however, Jesus himself washes the disciples' feet in order to teach them to serve one another just as he has served them. The positioning of the twelve disciples, with the group on his left mostly standing, and those on his right reclining above him, acutely emphasise the lowliness of his position.

With a gleaming copper basin brimming with water and 'with the towel wherewith he was girded', Jesus thus prepared them for priesthood. Only one of his twelve disciples, Simon Peter, perhaps pictured seated in a blue robe, protested at his master carrying out such an act. In reply, Jesus told him: 'If I wash thee not, thou hast no part of me'. Peter then said, 'Lord, not my feet only, but also my hands and my head'.[1] Jesus then contradicts him and, addressing him personally, adds: '... you are clean, though not all of you ...' hinting at the imminent betrayal of Judas Iscariot, who is pictured here clutching a bag of money.

Spanish School,
*c.*1529,
*Christ Washing the
Disciples' Feet*
(Detail)

Judas, the archetypal betrayer, is depicted with a bag of money which could be in reference to the following event: when the Jewish chief priests and elders were plotting to have Jesus arrested and put to death, Judas asked them what they would give him to betray Jesus. They promptly offered Judas thirty pieces of silver. Here he is holding either that promised silver or the disciples' money, of which he was the treasurer. Judas is often accompanied by a demon, or some other creature, and it is possible that the little cat detailed by his feet alludes to this.

Renaissance Spain never developed secular imagery on the scale seen in Italy, as princely patrons were more interested in funding military ventures than in commissioning art. From the marriage of Isabella of Castile and Ferdinand of Aragon in 1469 onwards, the subject matter of Spanish art was overwhelmingly Catholic. Particularly during the *siglo de oro* or Golden Age from the reign of their grandson Charles I (1516 - 1556) to the end of the Habsburg dynasty in 1700, Spanish art continued in this vein.

Spanish School,
*c.*1529,
*Christ Washing the
Disciples' Feet*
(Detail)

[1] John 13:9

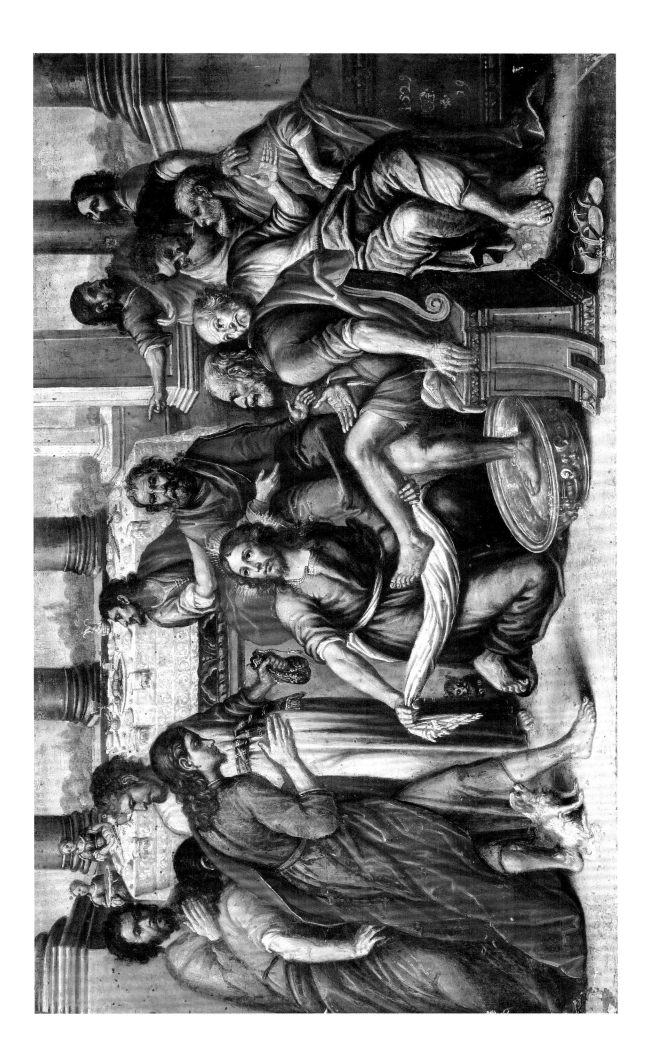

SPANISH SCHOOL, SEVENTEENTH CENTURY

The Crucifixion

oil on canvas
88.8 x 60.5 cm (35 x 23⅞ in)

I N THIS HIGHLY ATMOSPHERIC AND POWERFUL IMAGE of *The Crucifixion,* night has fallen on Golgotha and the figures of Christ and two criminals are illuminated by the ghostly light of the moon. Christ is depicted in the centre of the composition, His pale quiescent body and upturned face glow in the moonlight, giving Him a serene and ethereal air. Behind Him to the right and left are two other crucified men, fully naked, writhing in agony. Their facial expressions and contorted bodies express the gruesomeness of their torture; one figure struggling to break free has lifted himself up and slung his arms over the horizontal beam of the cross. Christ maintains a stoic disregard for His suffering, and in his pose and straightened body, gives the impression of already having transcended the physical pain and humiliation of His punishment.

The desolate site of the crucifixion is called Golgotha, an Aramaic word meaning 'the skull' the Latin form of which is Calvary. The appropriately named execution ground is littered with human remains. According to biblical accounts, Golgotha, although not precisely located, was supposed to be on high ground outside the city walls of Jerusalem (Mark 15:40). The area just visible in the left background, and seemingly full of tombs, may be the garden where Christ was buried, which was recorded as being near the place of crucifixion (John 19:41).

The physicality of *The Crucifixion* is overtly signalled and the naked limbs of the two criminals, while agonising to look at, draw attention to the sensuality of the image. The figure on the right, who appears to be in the last throws of death, evidenced by his clenched fist and the strained backward thrust of his body, appears to have reached a state of rapturous abandon through the intensity of his pain. As common criminals, crucified for their thievery, they are representative of worldly sin in contrast to Christ's divine nature. This is signified, in part, by the loincloth, which differentiates Christ's nudity from the criminals' nakedness, as well as the distinction in lighting on the three figures, which has a celestial quality where it falls on Christ and a more terrestrial normality throughout the rest of the composition. 'The nude image of the crucified Christ in art is usually kept from being overloaded with erotic suggestion by the force of its devotional meaning' writes Ann Hollander in *Seeing Through Clothes*, 'In crucifixion scenes the nudity of the two thieves, however, is often startlingly erotic by contrast, since they do not need to assume the ritual pose'.[1] This difference in presentation, exemplified in the present work, heightens the dramatic force of the image and emphasises the fundamentals of the narrative. Such a result would have satisfied Counter-Reformation doctrine regarding art, which demanded images that were instructive through their emotional content and ability to move the public.

Although the painter of the present work and its exact date are unknown, its dramatic tension, intensity of expression and highly developed form bring to mind a range of influences. In the slightly elongated forms of the figures of the two criminals flanking Christ, there can be detected hints of Mannerism. Christ's figure however is painted with a greater degree of naturalism, however, that suggests that the artist was receptive to the Baroque style. The theatricality and religious fervour of the composition and tenebrist lighting are further hallmarks of Baroque painting, examples of which would have been available in Spain by the early 1600s through the Spanish rule of the Neapolitan kingdom, as well as through the many Spanish practitioners of the movement. The spirited brushwork and colour palette is reminiscent of El Greco's (*c.*1541-1614) paintings of an earlier period, or those of his pupil Luis Tristán de Escamilla (*c.*1585-1624). While the artistic precedents for *The Crucifixion* are open to interpretation, it is evident that the spiritual fervour, emotional intensity and visual impact of the work distinguish it from other Spanish School paintings of its type.

Spanish School, Seventeenth Century. *The Crucifixion* (Detail)

[1] Anne Hollander, *Seeing through Clothes,* University of California Press, Berkeley, 1993. p.182

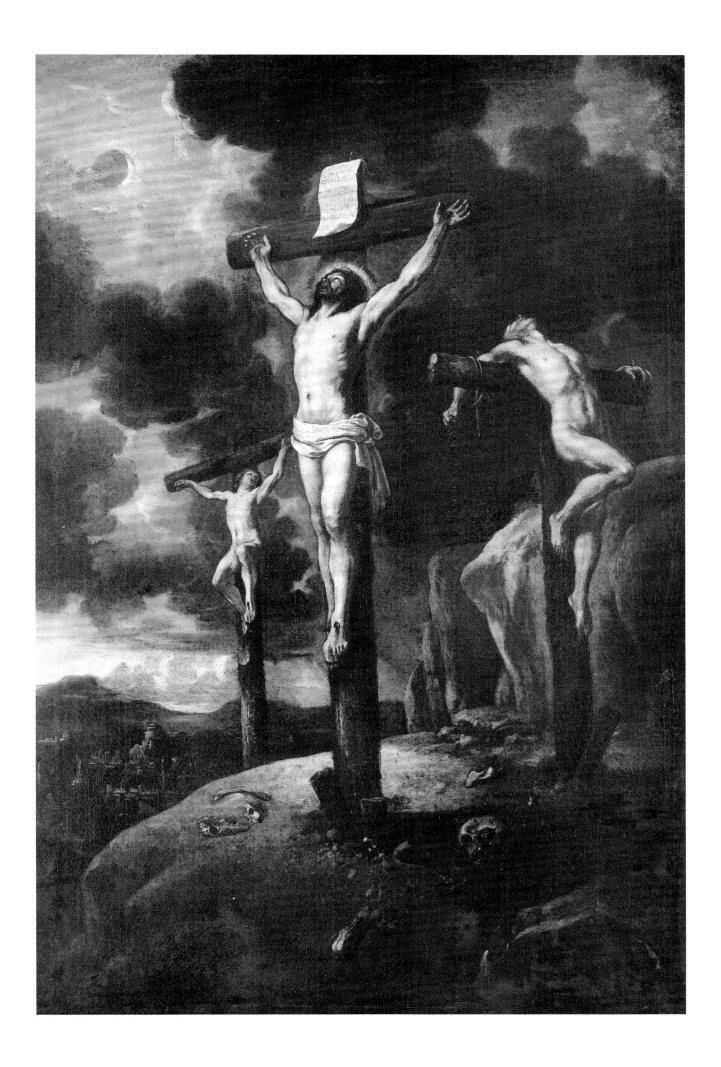

FOLLOWER OF
MARTIN SCHONGAUER

(Breisach 1430 - Colmar 1491)

The Crucifixion

tempera on wood
105 x 75.8 cm (41¼ x 29⅞ in)

*T*HE CRUCIFIXION IS PAINTED AFTER AN ENGRAV-ing by Martin Schongauer, *c.*1475, one of his largest and most detailed depictions of the subject, see fig. 1, by one of his followers, and is thought to have been executed *c.*1500. The painted version, although slightly different from the engraving, reflects the balance and harmony of Schongauer's composition. In the painting, there is most noticeably the addition of the figure of a donor, and parts of the landscape have been simplified. Christ's crown of thorns has been replaced by a halo. Although *The Crucifixion* by necessity loses some of the complexity of the original etching, the addition of colour and painterly technique heightens the dramatic power of the image.

In both works, at the centre of the composition is Christ on the cross. At his head is the inscription I.N.R.I., from the Latin *Isvs Nazarenvs Rex Ivdæorvm*, meaning 'Jesus the Nazorean, King of the Jews' (John 19:19). Flanking him is the Virgin Mary on the left and St. John the Evangelist on the right. In *The Crucifixion*, the donor kneels in a supplicant pose next to the Virgin, with words rising above him on a scroll and a crest with three mallets at his feet. Perhaps the most captivating element of the work is the depiction of four angels hovering around the cross, each holding a golden chalice to catch the drops of Christ's blood. The voluminous flowing robes and drapery of the angels and saints, and the loincloth worn by Christ, are masterfully conveyed in Schongauer's engraving, as well as in the present painting with a combination of expressive line, shadowing and highlights.

Although Schongauer is best known as an engraver, and his works were widely disseminated and copied throughout Europe, in his time he was also famous as a painter.[1] His practise as an engraver gave his paintings greater refinement in draughtsmanship and visual depth. There are only a small number of paintings that can be attributed with certainty to Schongauer, while the majority once considered to be by him are now thought to be products of his workshop. One such work is *Noli me Tangere* in the Musée d'Unterlinden in Colmar, France (fig. 2). Interestingly, the painting bears a number of stylistic similarities to the present picture, particularly in the way that Christ's emaciated figure and pronounced facial structure are depicted. Whether the painter of *The Crucifixion* may have come into contact with Schongauer's workshop, or the master himself, is unknown; however, the artistic parallels between the two works are striking.

We are grateful to Ludwig Meyer of the Munich History of Art Archive for proposing that the painter of *The Crucifixion* had knowledge of Schongauer's engraving .

[1] John M Jeep, *Medieval Germany: An Encylopedia*, Routledge, 2001, p 631.

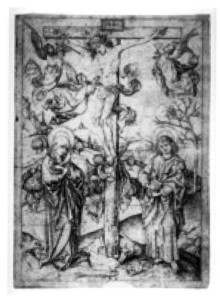

Martin Schongauer,
Christ on the Cross with Four Angels,
Fine Arts Museums of San Francisco
(Figure 1)

Martin Schongauer,
Noli me Tangere,
Musée d'Unterlinden, Colmar
(Detail) (Figure 2)

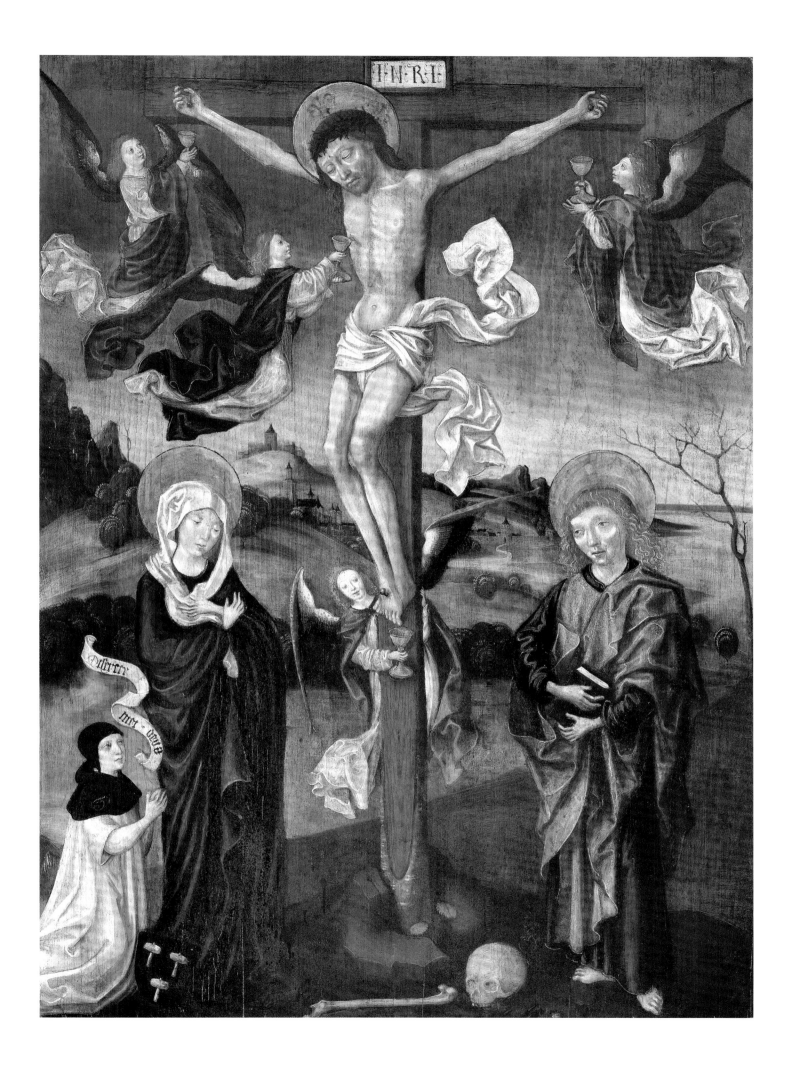

BARTHOLOMÄUS SPRANGER

(Antwerp 1546 - Prague 1611)

The Sufferings of Christ

oil on copper
29.5 x 22 cm (11⅝ x 8⅝ in)

BARTHOLOMÄUS SPRANGER'S EMOTIVE DEPICTION of Christ, surrounded by the instruments of His torture, unites the Italian Mannerist style of Parmigianino (1503-1540) with the naturalism of his native Netherlands. In the centre of the painting, outlined against a burst of golden light, an angel supports Christ's lifeless body. Towering on either side and framing the pitiful figure, are the cross that was used to crucify Him and the stone Corinthian pillar to which He was tied before being flayed. The jagged nails are still visible sticking into the cross and a whip is held by a classically modelled figure standing by the column. The lance that pierced His side can also be seen, its point resting near the foot of the cross. Spranger creates a unique perspective with the deliberately diagonal slant of the pillar and the crucifix, which exposes and centralises the exaggerated curve of the dead Christ.

In form, the figure of Christ bears a striking resemblance to the elegant and lengthened subjects that dominate Parmigianino's work. The angels detailed here represent a supreme example of Spranger's skill at combining the Flemish and Italian styles. The iridescent wings of the central angel resemble those of birds and are rendered in a typically Flemish naturalistic way. And yet, the wings of the standing angels to the left of the composition are far more reminiscent of early Renaissance Italian painters such as Fra Angelico (c.1395/1400-1455). The little *putto* hovering above and bearing the *sudarium* of St. Veronica, has wings that seem almost like peacock's feathers. The cloth which he holds aloft is an allusion to the cloth which Veronica, a pious woman of Jerusalem, gave to Jesus on His way to Calvary. Moved to pity as she witnessed Him carrying His cross to Golgotha, she gave Him her veil so that He might wipe his forehead. Jesus accepted the offering and when He returned it to her, His face had miraculously imprinted itself onto it. Veronica's sense of wonderment is beautifully depicted in El Greco's (c.1541-1614) *Saint Veronica Holding the Veil* (fig. 1).

Bartholomäus Spranger, *The Sufferings of Christ* (Detail)

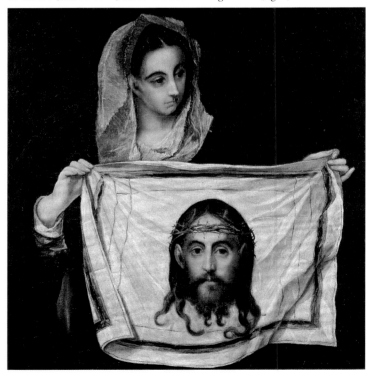

El Greco, *Saint Veronica Holding the Veil*, c.1580, Museo de Santa Cruz, Toledo (Figure 1)

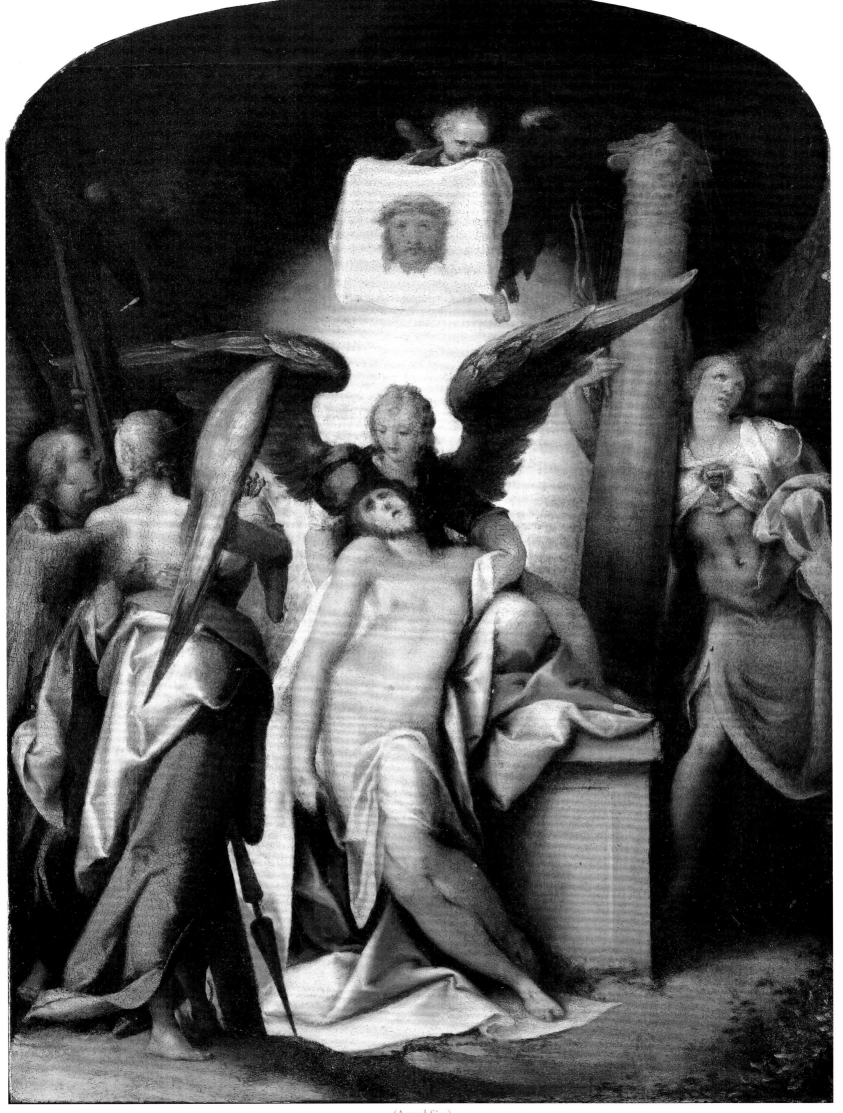

(Actual Size)

El Greco treated the theme of St. Veronica several times. Despite their different backgrounds and nationalities, El Greco and Spranger are curiously linked by Giulio Clovio (1498-1578), an Italian painter and illuminator of Croatian descent. When Spranger was in Rome during the summer of 1566, Clovio introduced the promising artist to Cardinal Alessandro Farnese who became an important source of patronage. In total, Spranger's travel to Italy spanned a period of ten years, from 1565 to 1575, with most of his time in Italy being spent in Rome. Clovio equally supported El Greco in a similar fashion persuading the Cardinal in the 1570s to provide the young artist with lodgings in his Palazzo so that he could concentrate on his work. El Greco's period in Rome, from 1570 to 1576, coincides with that of Spranger, as such it is quite possible that the two would have met through Clovio during this period, which is also when the present painting is believed to have been executed.

The climactic moment of the Passion story is the crucifixion itself. Paintings of this subject were usually intended to foster meditation on Christ's self sacrifice and this present work is no exception. Its relatively small size

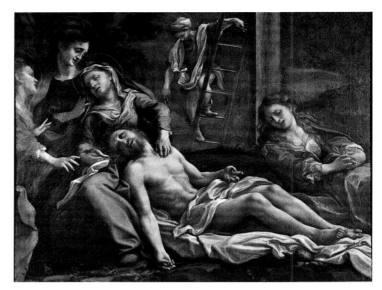

Correggio, *Deposition from the Cross*, 1525, Galleria Nazionale, Parma (Figure 3)

Whilst a great deal of Spranger's later output gave prominence to the playful subject matter popular at the imperial courts of Prague and Vienna, see figs. 4 and 5, his *Adoration of the Kings*, see fig. 2, is alike in its religious subject matter to the present work. It is interesting to note the extensive stylistic differences in the course of the intervening twenty years between the execution of *The Sufferings of Christ* and his *Adoration of the Kings*. The mannerist style that pervades *The Sufferings of Christ* has been replaced here by a distinctly more courtly and artificial atmosphere, showing influences of El Greco in the figures of the Virgin and Child. The composition is carefully arranged so that the two kings in the foreground are mirror images of each other just as their pageboys, too, imitate their balletic stance. There is none of this in Spranger's more serious depiction of Christ's suffering in all its intensity. Similarities can be identified in the richly vivid colours of the cloaks adorning the three kings and those worn by the two angels in the left hand corner of *The Sufferings of Christ*.

Spranger is renowned for his unique ability to fuse his native Netherlandish tradition with the Italian Mannerist influences of his extensive European travels. Along with his fellow countrymen, Hans von Aachen (1552-1615) and Joseph Heinz I (1564-1609), Spranger was one of the most important artists at the court of Rudolf II in Prague. Early in his career he travelled to Italy, studying fresco painting in Milan and then, in the spring of 1566, he worked in Parma as an assistant to Bernadino Gatti (*c*.1495-1576) where he painted the dome

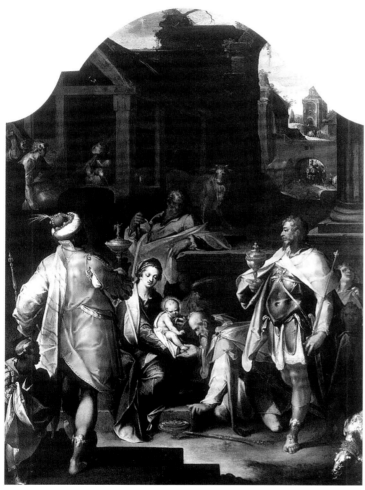

Bartholomäus Spranger, *Adoration of the Kings, c.*1595, The National Gallery, London (Figure 2)

suggests that it was a devotional image used for private prayer. Devotional literature from the thirteenth century, such as the *Little Book on the Meditation of the Passion of Christ*, suggests: 'It is necessary that when you concentrate on these things in your contemplation, you do so as if you were actually present at the very time when he suffered. And in grieving you should regard yourself as if you had our Lord suffering before your eyes, and that he was present to receive your prayers.'[1] Other small-scale works executed by Spranger include the *Lamentation*, which now hangs in the Alte Pinakothek, Munich.

[1] Sturgis, A., *Understanding Paintings: Themes in Art Explored and Explained*, p. 48.

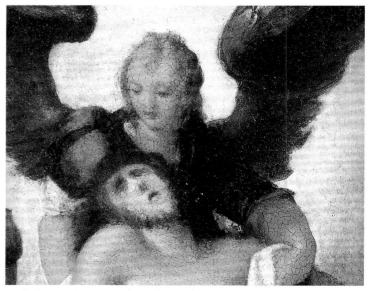

Bartholomäus Spranger, *The Sufferings of Christ* (Detail)

Bartholomäus Spranger, *Maia and Vulcan*,
Kunsthistorisches Museum, Vienna (Figure 4)

of S. Maria della Steccata. Whilst in Italy, the works, particularly, of Correggio (?1489-1534), see fig. 3, and Parmigianino, made a deep impression on him.

Indeed, he had taught himself some of their artistic methods by copying engravings after Frans Floris (1519/20-1570) and Parmigianino. Following his time spent in Milan and Parma, Spranger journeyed to Rome. It was here that Clovio introduced him to Cardinal Alessandro Farnese for whom he worked and where he also became an assistant to Federico Zuccaro (1540/2-1609) in the Villa Farnese in Capraola where he produced landscape frescoes. Distinguished patronage followed when he was taken into the service of Pope Pius V, for whom he worked for two years, in 1570. In 1575, the celebrated sculptor and Spranger's compatriot, Giambologna (1529-1608), was instrumental in introducing him to the Emperor Maximilian II's court in Vienna.

Spranger's *The Resurection with Portraits of Nicholas Müller and his Family* - which was painted for Maximilian - is clearly influenced by Roman Mannerism in its almost pastel colours. Some features have been borrowed from Michelangelo (1475-1564) and there is the characteristic rear view of a figure derived from similar representations by Zuccaro. After Maximilian's death in 1576, Spranger painted for his successor, Rudolf II and moved with the imperial court to Prague. Less than a decade later, in 1584, the artist was awarded the title 'painter by royal appointment' to the Hapsburg monarch.

Rudolf was one of the great collectors of curiosities and rarities in the arts. He patronised predominantly secular, refined and often erotic art, favouring representations of the female nude or as it has been called, 'silken titillation couched in mythclogical or allegorical guise.'[2] Thus Spranger's early work for Rudolf has bright colouring and a Mannerist feeling for form. He painted mythologies and learned allegories including, *An Allegory of Rome* and *Mercury Leading Psyche into Olympus*. His works, especially renditions of his female nudes, owe much to the elegant figure drawing of Correggio and

[2] Langmuir, E., *The National Gallery Companion Guide*, pp. 154-155.

Parmigianinc. One of his most famous works for Rudolf II was the *Triumph of Wisdom* (c.1591, Kunsthistorisches Museum, Vienna). Despite this Spranger continually produced works on religious themes including, *The Three Marys at the Tomb* (1598, Vienna) and a series of saints and biblical scenes.

It is very difficult to appreciate fully Spranger's great achievements as a painter without taking into account his abilities as a sculptor. Throughout his career, Spranger was engaged with sculpture. The complicated embraces of his couples and the extreme *contrapposto* of many of his painted figures would be unthinkable without the example of contemporary sculpture, including works by his friend, Gimabologna. It is thought that Spranger acquired his first practical knowledge of sculpture when working with Hans Mont (c.1545-after 1582).

Whilst in Rome, Spranger had made the acquaintance of his countryman, Karel van Mander (1548-1606). In 1577, Spranger invited van Mander to Vienna to assist him with some of his works. In recognition of his help, Spranger gave him a number of his drawings which van Mander in turn took back to Haarlem. He showed them to his new friend and associate Hendrick Goltzius (1558-1617) over whom they exerted a profound influence. It could be said that this exchange formed the basis of Haarlem Mannerism. Through the many reproductive prints after his work Spranger also influenced Matthäus Gundelach (c.1566-1654) in Bavaria.

Thomas Da Costa Kauffman, the author of *The School of Prague, Painting at the Court of Rudolf II*, recognises this present painting as an original in agreement with M. Foucart, curator at the Louvre who says '*que le tableau serait par le main de Spranger, je crois que l'artiste l'aurait fait pendant les anées 1570 avant son arrive à Vienne ou à Prague*' ['The painting is by the hand of Spranger, I believe that the artist would have painted it during the years 1570 before his arrival in either Vienna or Prague'].

Bartholomäus Spranger, *Angelica and Medor*, 1600,
Alte Pinakothek, Munich (Figure 5)

CIRCLE OF
BARTHEL BRUYN THE ELDER

(Wessel 1493 - Cologne 1555)

Portrait of a Gentleman

oil on panel
45.7 x 38 cm (18 x 15 in)

Provenance: William Beckford;
his sale, Fonthill Abbey, October 2, 1822, lot 11 (as Holbein), withdrawn;
thence by descent to Susanna Euphemia, Duchess of Hamilton;
thence by descent to William Douglass-Hamilton, the 12th Duke of Hamilton;
his sale, Christie's, Hamilton Palace, June 17, 1882, lot 8 (as Holbein);
E.F. White, London;
Alice Woodhams Gregg, Temple Grafton Court.

PREVIOUSLY ATTRIBUTED TO HANS HOLBEIN (?1460/65-1534) in a sale at Fonthill Abbey in 1822, *Portrait of a Gentleman* is now viewed to be by an artist from the circle of Barthel Bruyn the Elder, as suggested in communications by the Rijksbureau voor Kunsthistorische Documentatie, The Hague. The painting depicts a gentleman set against a plain background, his left hand looks to be in motion, extending out of the picture, intensifying the connection felt between sitter and viewer. Key features of the face, such as his nose and eyes, are exaggerated allowing for greater expression. The detailed dress of the sitter dominates the work, and the fur, necklace and signet ring serve as indicators of the sitter's wealth, thus informing the viewer of the individual's status. The painting is typical of portraiture of the period and shares many characteristics with portraits by Bruyn the Elder (fig. 1).

A German painter active in Cologne, Bruyn the Elder founded an important school of painting, bringing to an end the Gothic tradition of portraiture, which focused on generic representations, by introducing Italianate-Flemish Renaissance forms that heightened the engagement between sitter and viewer, and gave greater attention to individual identity than a mere natural representation. Such techniques, apparent in *Portrait of a Gentleman*, suggest that the artist was exposed to these new methods of portraiture, introduced by Bruyn the Elder, whilst preceding the more extensive characteristics of Mannerist portraiture.

The painting has a fascinating provenance, having been housed in two of the country's most impressive residences. Its first recorded appearance is at Fonthill Abbey, the largest private house ever built in Britain, famous for its ninety-metre octagonal tower. A building of incredible magnitude and opulence, it was built by the exceedingly wealthy and eccentric William Beckford at the turn of the eighteenth century. However, due to mounting running costs of £30,000 a year, Beckford sold Fonthill Abbey and many of its artefacts in 1822 - the present work being withdrawn from that sale. The tower collapsed

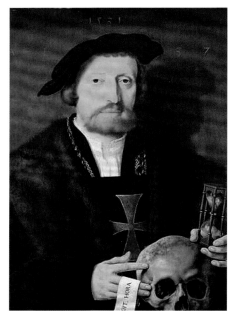

Barthel Bruyn the Elder,
Portrait of a Knight,
Gemäldegalerie,
Kunsthistorisches Museum,
Vienna
(Figure 1)

in 1825 and by 1858, the remaining parts of the abbey were destroyed.

The painting, along with other fine works from Fonthill Abbey, such as a portrait of Philip IV of Spain by Velasquez, now in the National Gallery, London passed into the hands of the prestigious Hamilton family, who lived in Hamilton Palace. Built in 1695 in Scotland, Hamilton Palace was a grand and ostentatious building before its decline and eventual demolition in 1965. In 1882, in order to raise funds, William, the 12th Duke of Hamilton, organized a great sale, through Christie's, of the family's substantial collection. It comprised of 2213 lots, in which *Portrait of a Gentleman* was sold as a Holbein, although it is now recognised as belonging to the circle of Bruyn the Elder.

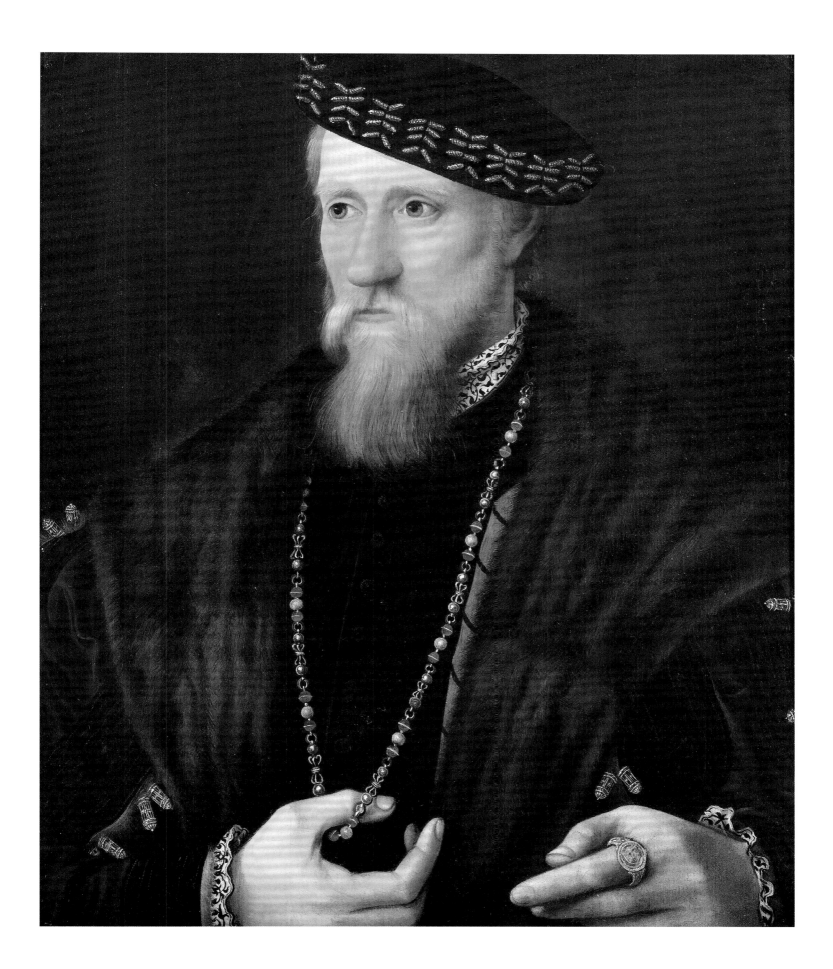

ATTRIBUTED TO

GEORG PENCZ

(Leipzig c.1500 - Nuremberg 1550)

Lucretia

oil on panel
104 x 74 cm (41 x 29⅛ in)

*'Taking a knife which she had concealed beneath her dress, she plunged it into
her heart, and sinking forward upon the wound, died as she fell.'*
- Livy *Ab Urbe Condita* I.58

T HIS ARRESTING FULL-LENGTH PORTRAIT OF
Lucretia, the epitome of virtue and chastity, is memorable
not only for the carefully depicted pose but also the
strikingly opulent surroundings in which she has been
placed. Seated in the foreground against an elaborately
draped green, velvet canopy, Lucretia balances tentatively on the edge
of what is, presumably, her marital bed and the scene of her violent
assault at the hands of Tarquinius. Her hand rests awkwardly upon
an intricately carved wooden figure atop a fluted Ionic column. The
combination of this strange nude statuette and the luxuriousness of
the crimson damask at the foot of the bed with the golden tassel of
a cushion, lends an otherwise tragic scene a peculiarly charged air of
sensuality.

The story of Lucretia's fate was integral to the history of Rome's
foundation and became a powerful moral fable in the Roman psyche.
Retold in Livy's *Histories*, it provided countless opportunities for
artists, poets and musicians from the Renaissance onwards to exploit
its dramatic and didactic potential. According to Roman mythology,
Lucretia's rape by the unscrupulous son of the last king of Rome, Sextus
Tarquinius, was the cause of the overthrow of the Roman monarchy and
the consequent birth of the Roman Republic.

Lucretia was married to Lucius Tarquinius Collatinus and her father
was Spurius Lucretius Tricipintinus. Livy tells us that in 509BC, the
violent Tarquinius desiring to violate the legendary chastity and moral
rectitude for which Lucretia was famed, planned to rape her. Telling
her that if she refused to acquiesce to his demands he would kill her
and place her body next to that of a slave, she tearfully complied with
whatever he forced her to do. That she would be accused of committing
adultery with a lowly slave engendered far greater shame than anything,
however terrible, Tarquinius would have her do.

Once Tarquinius had left, she summoned her father and husband
to her and when they arrived she told them of Tarquinius' evil actions.
Despite their reassurances and attempts to comfort her distress,
Lucretia made them promise to avenge her violation. Feeling that this
would not be enough, however, she took a sword and plunged it into
her heart, uttering to them the words which secured her reputation
as the archetypal Roman matrona: 'It is for you to determine what is

Georg Pencz, *A Sleeping Woman (Vanitas)*, 1544,
Norton Simon Museum, California (Figure 1)

due to him, for my own part, though I acquit myself of the sin, I do
not absolve myself from punishment; nor in time to come shall ever
unchaste woman live through the example of Lucretia.'[1]

Attributed to Georg Pencz, *Lucretia* recalls a number of strikingly
similar female nudes by Pencz. A depiction of a sleeping woman, based
heavily on the Venetian artists whom he so admired, notably Giorgione
(*c*.1477-1510), resembles *Lucretia* in terms of form (fig.1). The exact and
realistic draughtsmanship of the sleeping woman is typically northern
European, as are the still life elements that can be seen beyond in a
niche in the background. The same elements and meticulous attention
to detail are to be found in the bed post upon which Lucretia's hand
rests, as well as in the highly realistic imitation of fabrics and marble
inlay.

The subject of Lucretia's suicide is also treated by Lucas Cranach
the Elder (1472-1553), as well as by Pencz's master, and Cranach's
contemporary, Albrecht Dürer (1471-1528), and both artists' respective
interpretations of the subject shed a great deal of light on the present
rendition of Lucretia. Cranach the Elder was preoccupied by Lucretia
throughout his lifetime with more than thirty-five other compositions
attributed to him and his circle. In a number of his extant compositions,

[1] Livy *Ab Urbe Condita* I.57-60.

Albrecht Dürer, *Lucretia*, 1518, Alte Pinakothek, Munich (Figure 2)

Attributed to Georg Pencz, *Lucretia* (Detail) (Figure 3)

Lucretia is shown either full-length or half-length and partially clothed or entirely nude apart from a beautifully delicate veil that coils sinuously around her body. The present work alludes to such presentation with a flimsy, transparent wisp of gauze provocatively encircling Lucretia's waist. In Cranach's conception of the story, as in his 1533 version in the Staatliche Museen, Berlin, the rape itself is never depicted, as in this present composition. Rather, it is the abject figure of Lucretia preparing to take her own life, in order to salvage her honour and dignity, that captures both artists' attention. Given the subject matter, it is remarkable too, just how devoid of violence Cranach's Lucretias tend to be. At most, as in Dürer's ominous version, there will be a discreet stream of blood drawn by the superficial piercing of the sword (fig. 2). Yet, there is not even a hint of violence in this painting attributed to Pencz. The surreal atmosphere seems wholly at odds with the tragic end that befalls Lucretia. Dürer, despite the heavily criticised composition of his Lucretia, does manage to imbue the work with an atmosphere of great solemnity and foreboding that seems to be curiously absent in both Cranach's version and the present work.

It is likely that Cranach viewed Lucretia as he did the other heroines whom he frequently depicted such as Judith, the Old Testament heroine, and Salome, the wife of King Herod: as an iconic figure and the embodiment of virtue rather than one based in historical myth, or indeed reality. This is perhaps in no small part due to the erotic nature of Cranach's nudes and this idea can certainly be transposed onto the present *Lucretia*.

Whilst not as flamboyantly dressed as some of Cranach's versions, the present work shows a woman surrounded by luxury and dripping with ornate and precious jewellery (fig. 3). The intricate detailing of her pendant and bracelets bear a distinctly Northern European flavour and have far more in common with versions by Cranach. Arguably, the artist's decision to clothe his subject in little else but jewellery reveals a startling contradiction: on the one hand, she historically embodies the wifely virtues that Lucretia herself exemplified, while in the other, she is presented to us in a suggestive pose. It is highly similar in this respect to Pencz's female nude previously discussed (fig. 1). Such playful eroticism is entirely missing from Dürer's 1518 version. Interestingly, however, the backdrop of Lucretia's bedroom, which is not included by Cranach, is borrowed in the present work from Dürer's careful intimation of drapery.

Georg Pencz,
Lucretia,
Private Collection
(Figure 4)

Georg Pencz,
Paris and Oenone,
1539,
Dallas Museum of Art
(Figure 6)

Pencz himself evidently derived much inspiration from the story as he painted at least one other version of Lucretia on the point of suicide (fig. 4). In addition, as part of a selection of engravings from Roman history, Pencz includes the scene when Tarquinius surprises the sleeping Lucretia, threatening her with his sword if she makes a single noise (fig. 5). The stylistic similarities between the present work and Pencz's engravings are exemplified in his rendition of the story of Paris and Oenone from 1539 (fig. 6). The voluptuous figure of Oenone and the luxurious drapery that conceals very little are strongly reminiscent of the figure of Lucretia. The facial expressions of the two women are highly similar even though Oenone is composed in profile.

Pencz was a German draughtsman and painter who was active in the workshop of Dürer. He arrived in Nuremberg in 1523 and subsequently entered Dürer's workshop. Imprisoned, together with the Beham brothers, for allegedly disseminating the radical political and religious views of Thomas Müntzer, he was eventually pardoned and free to carry on with his painting. Heavily influenced by his master, Pencz's prints of

Georg Pencz, *Tarquin and Lucretia, c.*1546-1547,
University of Virginia Art Museum, Charlottesville (Figure 5)

the 1520s include copies after prints by Dürer, employing the fashionable northern Italian style. Pencz was probably in northern Italy and Venice in the late 1520s and returned to Nuremberg in *c.*1529. Works by Venetian artists exerted a great deal of influence upon him. Similarly, a painting of *Judith* (Alte Pinakothek, Munich) shows a half-length figure in the manner of the early work of Palma Vecchio (?1479/80-1528) or Titian (*c.*1485/90-1576).

In the years following 1533, Pencz made several large ceiling pictures on canvas and was one of the first in Germany to conceive of ceiling pictures as a continuous whole. He was commissioned by Hirschvogel to do a ceiling painting of the *Fall of Phaethon* (preparatory drawing, Nuremberg), for the main room of the Bolognese Renaissance-style house built in his pleasure grounds. Peter Flötner (1485/96-1546) provided the interior decoration, and Pencz's painting was clearly influenced by the furnishing and decoration by Giulio Romano (?1419-1546) of the Palazzo del Te, Mantua, which he saw when he visited Italy in the late 1520s.

Pencz completed a prestigious commission from King Sigismund I of Poland to paint scenes from the Passion (1538) for the silver altarpiece in the Jagiellonian chapel in Wawel Cathedral, Kraków (*in situ*), unfinished after the death of the court painter Hans Dürer (1490-?1538).

Between 1539 and 1540, Pencz seemingly made a second journey to Italy, going as far as Rome. There are many indications of this in his surviving drawings and engraved prints from the period. A revisit to Mantua is indicated by the large engraving of the *Capture of Carthage* after Romano's work of 1539. This second Italian journey also affected Pencz's religious and mythological paintings, which mostly contain a few figures shown half-length in the Venetian style.

In September 1550 the Prussian Duke Albert sent for him to come to Königsberg as a court painter, at the instigation of the preacher Andreas Osiander, whose portrait Pencz had painted in 1544. He set out but died *en route.*

We are grateful to Mr. Jan de Maere for the attribution of the work to Georg Pencz.

FRANZ DE PAULA FERG

(Vienna 1689 - London 1740)

A Classical Landscape with a Family Resting by the Ruins of a Fountain, a Man with a Pack-Donkey Passing by

&

A Classical Landscape with a Family Resting by the Ruins, a Boy Struggling with an Obstinate Pack Mule

oil on copper, a pair
inscribed 'AP.No83' and 'AP.No84 ' ('AP' in monogram, on the reverse of each)
21.6 x 17.5 cm (8½ x 6½ in)

WITH THIS PAIR OF PAINTINGS FRANZ DE Paula Ferg presents us with two delightful figurative mountainous landscapes set amongst classical ruins. In *A Classical Landscape with a Family Resting by the Ruins of a Fountain, a Man with a Pack-Donkey Passing by* a mother, father and child rest on a rocky mound. The child, open-mouthed, excitedly stretches out his hand towards the donkey. The adult figures, turned towards the toddler, delight in his reaction, the two female figures looking on with considerable affection. The family have stopped by a fountain decorated with classical heads of satyrs or fauns, and the foliage that grows on the top of the fountain reinforces the impression of age and antiquity. The viewer's eye falls back to the gentle, mountainous landscape beyond, through which we imagine the group have travelled.

The accompanying work, *A Classical Landscape with a Family Resting by the Ruins, a Boy Struggling with an Obstinate Pack Mule* is set in a similar Arcadian landscape. A classical ruin again provides a backdrop under which a family rest, the head of a faun appearing once more, this time carved into the stone under the right-hand scroll. This scene is however animated by the vigorous stubborness of the pack mule, which a young boy struggles to control. Both arid landscapes are lit with a soft gentle light and the rich colours of the figures' clothes brighten the scenes. The two paintings are clearly a pair, unified in size, setting, subject matter and palette.

Ferg painted many of these types of Italianate landscapes. Although *Italian Landscape* depicts a more panoramic view than the present pair, it is set in a similar dry but idealised landscape, dotted with ruins and infused by the same soft, golden light. (fig. 1). In terms of the composition once again Ferg's landscape recedes through a series of carefully composed planes to a hazy and mountainous background. On the left-hand side of *Italian Landscape* is a similar family group, replete with mules, whilst in the shadows on the right-hand side a couple of shepherds watch their small flock. Like the present works it is a charming scene of rustic life, set in a brilliantly depicted Arcadian landscape.

A prolific artist, Ferg specialised as a painter of small-scale landscapes and genre scenes in the manner of the Dutch seventeenth-century masters, particularly Philips Wouwerman (1619-1668) (see inventory). Ferg studied landscape painting under his father, Adam Pankraz Ferg (1651-1729), and Josef Orient (1677-1747), studying staffage painting with Johann (Hans) Graf (1653-1710). He also studied the engravings of Jacques Callot (1592-1635) and Sébastien

Leclerc (1637-1714). His early works show subjects such as harbours, markets and villages as wide vistas with many figures, trees and buildings, such as his *Fair with Temple and Maypole* (Vienna, Belvedere). These scenes incorporated both landscape and genre painting and are characteristic examples of early eighteenth-century Austrian panel painting, showing the influence of Dutch, Flemish and Italian models. The colours are dark, and the staffage figures, in the manner of Graf, are slender, with petite heads.

In 1718, Ferg left Vienna and went to Franconia, Bamberg, and Leipzig. There he met Johann Alexander Thiele (1685-1752) whom he accompanied to Dresden. Later Ferg travelled to Lower Saxony, and from about 1724 he lived in London. In 1726, he created a series of eight etched *capricci* (Fine Arts Museum, San Francisco), which help to date many smaller pictures to the London period. His late cabinet pieces contain fewer, clearly drawn figures, set in Italianate landscapes with ruins; their Arcadian mood, brilliant colour and Rococo manner are particularly pleasing. The current pair of works are very much in the style of this late period. Filled with charm, Ferg's pictures found a ready market amongst collectors who sought after the dwindling supply of Dutch masters that would not be returned to the market until the upheavals of the French Revolution. Ferg's principal patrons were the Elector of Saxony at Dresden, and after his move to London in 1718, the Duke of Brunswick.

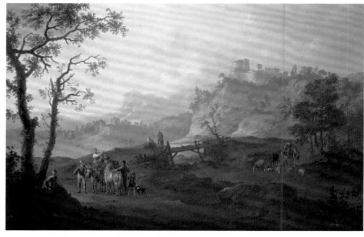

Franz de Paula Ferg, *Italian Landscape, c.*1730, Belvedere, Vienna (Figure 1)

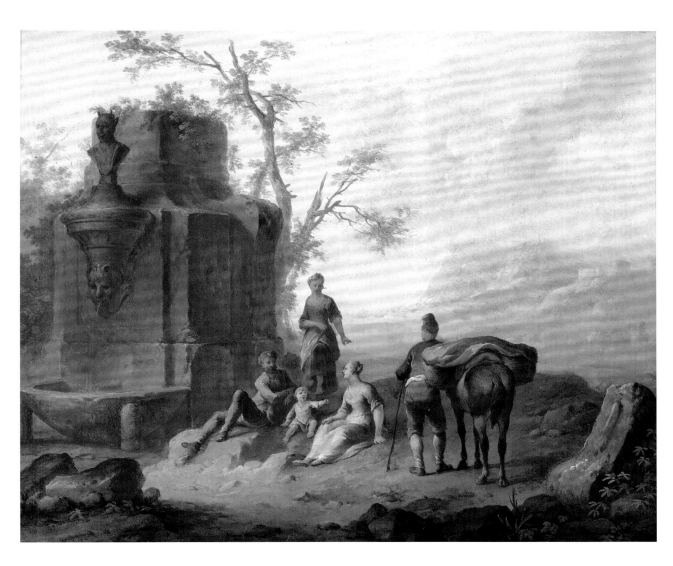

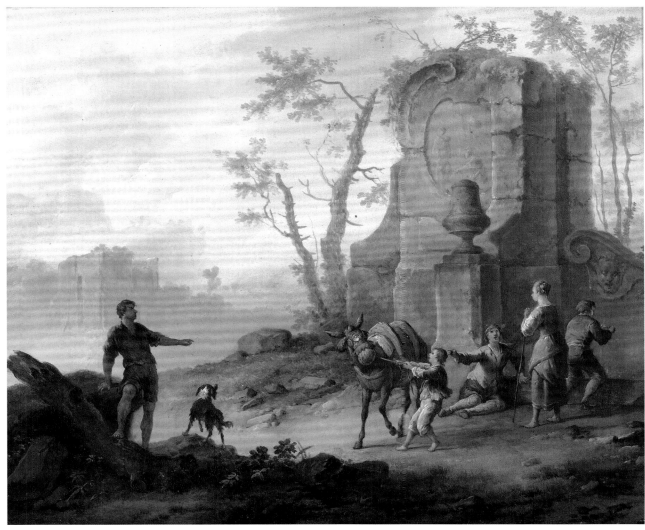

ATTRIBUTED TO

ANGELICA KAUFFMANN

(Chur 1740 - Rome 1807)

Portrait of a Lady, Three-Quarter-Length, Wearing a Gold Dress and Red Shawl,

with a Pearl Headdress, Holding a Dove

oil on canvas

76 x 64 cm (30 x 25¼ in)

Provenance: Sale, New York, Christie's, 6 April, 2006, lot 319 (as Angelica Kauffmann).

THE DOVE, WHICH RESTS WITH WINGS OUT-stretched in the arms of the elegant lady pictured here, is a symbol of Venus, thus likening the sitter's beauty and grace to that of the goddess. The inclusion of the bird, depicted on such a large scale, was no doubt intended to give the portrait an allegorical dimension; the choice of the dove, in particular, is significant not only for its associations with Venus but alternatively with prudence, innocence, simplicity, peace and matrimonial harmony. The multiplicity of possible interpretations serve to exalt the sitter and make the portrait more enigmatic and engaging.

The lady is positioned in a dignified manner, with her hair fashionably upswept and decorated with a strand of pearls. Her garments are of rich gold and red fabrics that shimmer in the gentle light cascading over her. Her dress, ornamented at the neck with luminous beadwork and at the shoulder with a delicate clasp, is simple in cut and reveals her shift underneath, giving the costume a classical, timeless appeal.

Portrait of a Lady, Three-Quarter Length, Wearing a Gold Dress and Red Shawl, with a Pearl Headdress, Holding a Dove is attributed to Angelica Kauffmann, the distinguished Swiss neo-Classical painter. The portrait is very similar stylistically and in costume detail to Kauffmann's *Portrait of Mme. La Touche*, the pendant to her portrait of John La Touche, both formerly in the Schloss Kevenig bei Trier collection (fig.1). The informal sketchiness of the work, the soft lighting effects and the plain background resemble that of the present painting, as does the sitter's refined pose and simplicity of dress, with voluminous sleeves and elegant detailing around the neck, a red shawl wrapped artfully around her left shoulder, and her hair carefully arranged and bedecked with pearls. Mme La Touche is portrayed in a contemplative manner with one hand supporting her head and the other resting on a book, signifying her scholarly or poetic nature. In many of Kauffmann's portraits of women, she makes a point of depicting the sitter with a meaningful object, such as a book or as in the present work, a dove, suggesting that the woman's identity transcends the traditional role of faithful wife or mother. Likewise, Kauffmann's self-portraits often show her with a paintbrush and palette in hand, emphasising her position as an artist over that of a woman.

Kauffmann was initially tutored by her father, Joseph Johann Kauffmann (1707-1782), a painter of portraits and ecclesiastical murals, and grew up assisting him with commissions in Switzerland, Austria and Northern Italy. In 1762, they arrived in Florence, where Kauffmann was introduced to early neo-Classicists, such as the American artist Benjamin West (1738-1820) (see catalogue no. 138). In 1763, she travelled to Rome and then briefly to Naples before returning to Rome, where she painted portraits and studied Classical sculpture. At the same time time, she ventured into history painting, a prestigious branch of art that had long been closed to women. Three years later, Kauffmann travelled to London, where she associated more closely with the neo-Classicists and rapidly became acknowledged as a leading artist of her day. In 1768, she and Mary Moser (1744-1819) were selected as the only two female founder-members of the Royal Academy of Art. Kauffmann enjoyed a glittering reputation as a portraitist in London, which proved the most lucrative aspect of her career, although she was also highly praised for her history and subject painting, which was noted for its innovative iconography. In 1781, Kauffmann married her second husband, Antonio Zucchi (1726-1796) (see catalogue no. 101), and returned to the Continent, settling eventually in Rome, where she painted some of her finest works and was a prominent figure in the city's artistic society.[1]

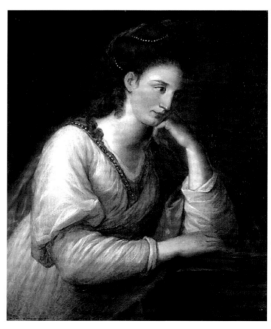

Angelica Kauffmann, *Portrait of Mme. La Touche*, Private Collection (Figure 1)

[1] David Piper, *A-Z of Art & Artists*, Guild Publishing, London, 1984.

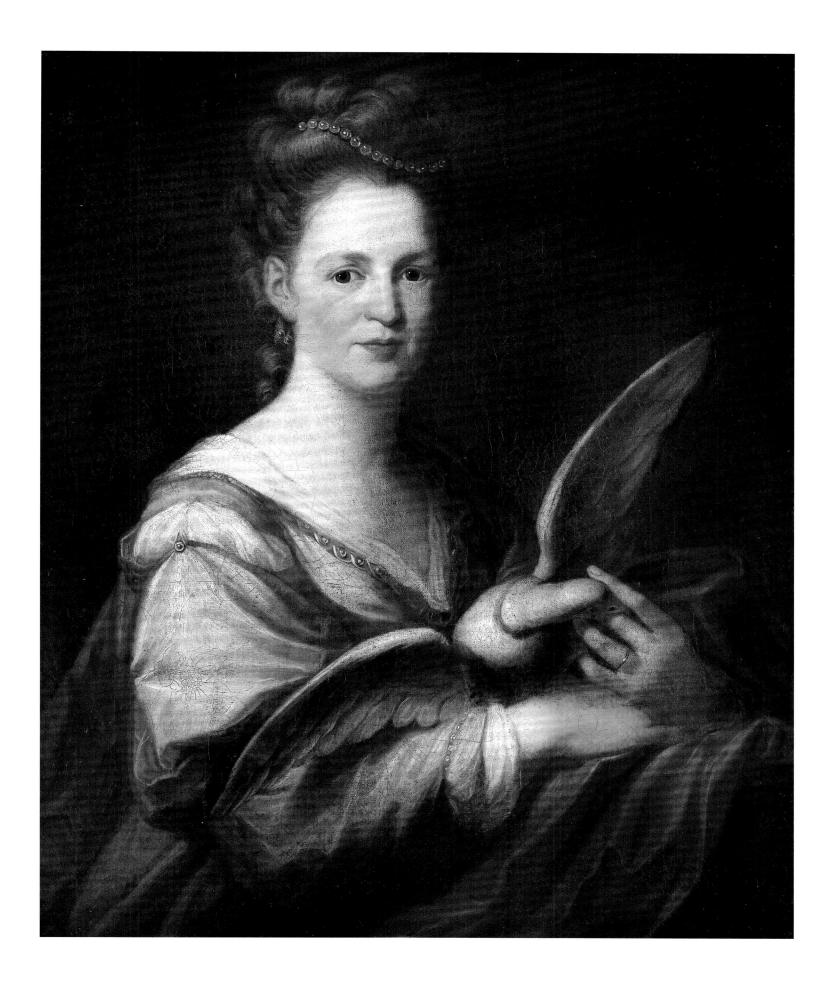

FOLLOWER OF

JACQUES CALLOT

(Nancy 1592 - Nancy 1635)

A Sultan Riding a Camel Led by a Driver, Accompanied by a Dignitary

oil on panel
36 x 46 cm (14⅛ x 18⅛ in)

Provenance: Viennese private collection.

A SULTAN RIDING A CAMEL LED BY A DRIVER, ACCOM-panied by a Dignitary is a whimsically delightful composition by a follower of Jacques Callot. Callot, best known for his etchings chronicling the lives of soldiers, clowns, gypsies, beggars and aristocrats whom he encountered in the streets or at court, also depicted figures in eastern dress, which reflected the European taste for Orientalism. His compositions often included elements of the exotic, such as the camels in *An Army Leaving a Castle*, which give the work an undoubtedly foreign feel (fig. 1).

The present painting may be influenced by Callot's illustrations for *Il Solimano*, a play centring on the intrigues of the Ottoman court of Suleiman I the Magnificent, which was published in 1620 as a tribute to Grand Duke Cosimo II. *Il Solimano* prefigured the works of Jean Baptiste Vanmour (1671-1737), a French-Flemish painter who devoted his career to depicting life in the Ottoman Empire during the Tulip period. A series of engravings made after Vanmour's paintings were published in 1708 under the title *Recueil de cent estampes représentant différentes nations du Levant*, and had enormous influence in Western Europe. Vanmour's portrayal of oriental dress, although less flamboyant, is clearly related to Callot's style of illustration, and the present work.

In *A Sultan Riding a Camel Led by a Driver, Accompanied by a Dignitary*, the sultan is depicted in the centre of the scene, exotically caricatured in a red sleeved tunic, gold boots with turned up toes and a white turban with a feather. He rides a stately camel, whose head is decorated with a spray of feathers, and

Jacques Callot, *Franca Trippa and Fritellino in Balli di Sfessania*, 1621, Private Collection (Figure 2)

shelters under a red and black fringed canopy adorned by a crescent moon. The sultan's dramatic appearance is heightened by the long blue cloak with a scalloped edge that hangs behind him, held up by a dignitary. The dignitary is richly clad in a full-length red vest and matching turban. Leading the procession is the camel driver, whose unusual headdress has two protuberant horns and a large upright feather. The ground where each figure treads is spot lit while the rest of the composition fades into darkness, emphasising its theatricality. Birds, with colourful plumage and stylised wings and tails and the occasional cloud stand out against a mysterious black background.

The men's beards in *A Sultan Riding a Camel Led by a Driver, Accompanied by a Dignitary* are exaggeratedly pointed in a fashion reminiscent of those belonging to Pantalone and other male characters in the *Commedia dell'Arte*. The Italian comedy fascinated Callot, and one of his most notable series of engravings, called the *Balli di Sfessania*, depicts its most popular entertainers. These highly caricatured and grotesque figures bear a resemblance to the sultan and his entourage, particularly the camel driver with his pointed headdress (fig. 2). The present work combines something of the comical absurdity of Callot's depictions of *Commedia dell'Arte* characters, with the fanciful magnificence and exoticism of his figures from the Ottoman court.

Jacques Callot, detail of *An Army Leaving a Castle, c.*1632, J. Paul Getty Museum (Figure 1)

ALEXIS GRIMOU

(Argenteuil, near Paris 1678 - Paris 1733)

Portrait of a Gentleman, Half-Length, Wearing a Cuirasse, a Hat and a Red Cape

signed 'Grimou / .f.' (centre left)
oil on canvas
48 x 39.5 cm (19 x 15½ in)

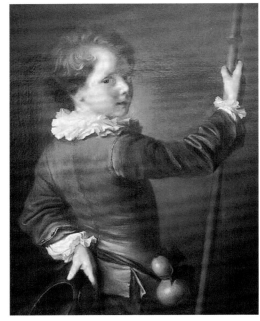

Alexis Grimou,
Young Male Pilgrim,
The Uffizi Gallery,
Florence
(Figure 1)

I N ALEXIS GRIMOU'S *PORTRAIT OF A GENTLEMAN, HALF-Length, Wearing a Cuirasse, a Hat and a Red Cape* a young man looks back over his shoulder towards the viewer. Dressed in a cuirasse, the armour of a heavy cavalry officer, he holds an armed pole, which is complemented by the elegance of his cape, collar and hat. The rich red, blue and yellow hues of his clothing enliven the picture, despite its shadowed background.

Portrait of a Gentleman, Half Length, Wearing a Cuirasse, a Hat and a Red Cape has many of the characteristics of a typical Grimou portrait. This is evident if we compare the work to one of his best-known works, the Uffizi's *Young Male Pilgrim* (fig. 1). The similarity in pose of the two figures, with their heads turned back over their right shoulders, and staff clasped in their right hands is immediately evident. Their poses create a sense of intimacy, as if the sitters have only just become aware of the viewer's presence, a technique used repeatedly by Grimou in his portraits. The faces of the sitters in both paintings are also intensely illuminated, lifting the figures out of the canvas, from their dark shadowy backgrounds.

One of the most distinctive features of Grimou's portraits is the different costumes that worn by his sitters. Although he painted many conventional portraits, Grimou is at his best and most original in his many 'fantasy portraits'. He depicted his sitters dressed as Armenians, as Pilgrims, as Savoyards, as Spaniards or, as in his *Portrait of Jean Bart* (1700, Louvre, Paris), as Poles. He even portrayed himself as a Greek god in *Self-Portrait as Bacchus* (1728, Museum Magnin, Dijon).

In 1704 Grimou married a niece of the tavern-keeper Procope, whose house in Paris was a meeting-place for artists and intellectuals. The following year he was approved by the Académie Royale de Peinture et de Sculpture. Although instructed by the Académie to paint as his *morceaux de réception* portraits of the sculptor Jean Raon (1630-1707) and the painter Antoine Coypel, he failed to present either picture and in 1709 the commission was annulled. As a result he joined the Académie de St. Luc.

Grimou was a pupil of François de Troy (1645-1730), from whom he learnt to use a palette of unusually warm colours and to work with uncomplicated pictorial formats in the tradition of rigorous seventeenth-century classicism. Certain audacities in his handling, however, place him well into the eighteenth century. The significance of Grimou's portraits for the development of early eighteenth-century French art has not yet been fully appreciated. Many of them are half-lengths, and they clearly stimulated the fantasy portraits later sketched by Jean-Honoré Fragonard (1732-1806) (see catalogue no. 96), who, moreover, painted pastiches of Grimou's manner, such as *Portrait of a Girl*, (Dulwich Picture Gallery, London), although this attribution has been questioned.[1] Grimou's influence can also be discerned in the work of Charles Eisen (1720-1778), Joseph Ducreux (1735-1802) and Jean-Baptiste Greuze (1725-1805). For this reason it can be said that by introducing into France northern formulae for improvised portraits, Grimou played a role not unlike that of Antoine Watteau (1684-1721), who was responsible for introducing the *fête galante* into French art.

In terms of style as well as iconography, Grimou was influenced by Dutch seventeenth-century masters, notably Rembrandt van Rijn (1606-1669), almost to the point of pastiche, and because of this he was often confused with his contemporaries Jean-Baptiste Santerre (1651-1717) and Jean Raoux (1677-1734). His characteristic warm, earthy palette and golden *sfumato* reveal his close study of Dutch art and demonstrate why he was known to his contemporaries as *le Rembrandt français*. In addition to the aforementioned Santerre and Raoux, many artists from the French Académie, such as Hyacinthe Rigaud (1659-1743), worked in the style of Rembrandt in the first decades of the eighteenth century, all considering Rembrandt to be their true master. Certainly the deep *chiaroscuro* of the works discussed reflects Grimou's debt to Rembrandt as well as to the work of George de La Tour (1593-1652).

[1] Donald Bruce, 'The Dulwich Gallery Restored' in *Contemporary Review*, 1st December 2000.

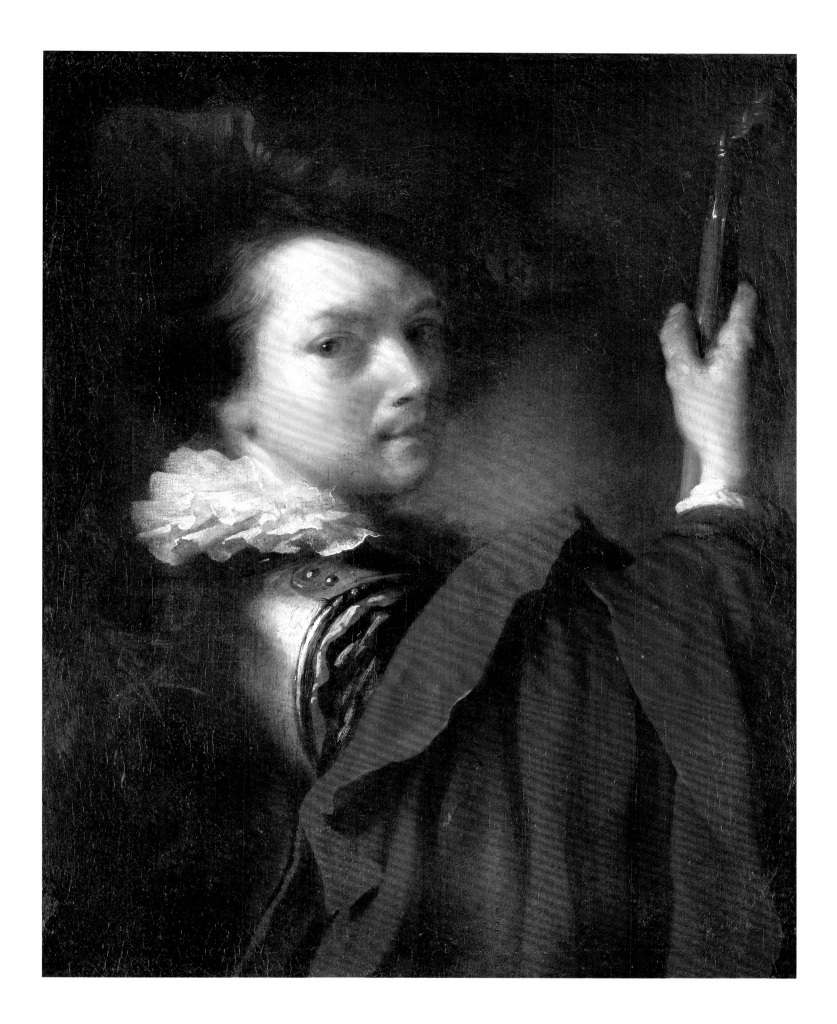

LOUIS-GABRIEL BLANCHET

(Paris 1705 - Rome 1772)

The Four Seasons

two signed and dated 'L.Blanchet / 1759' (lower right), all inscribed 'blanchet a Rome / 24 piese' (on the reverse)
oil on panel
tondos; each diameter 22 cm (8⅝ in) (4)

'Therefore all seasons shall be sweet to thee
Whether the summer clothe the general earth
With greenness, or the redbreast sit and sing
Betwixt the tufts of snow on the bare branch
Of mossy apple tree...'
- Samuel Taylor Coleridge, *Frost at Midnight* (1798)

EACH PORTRAIT IN THIS SET OF FOUR, DEPICTS THE vibrant paraphernalia of the four seasons: spring, summer, autumn and winter. Spring is the first season of the four tondi to be illustrated and with the radiant promise of sun and plenty after a long winter, the *putto*-esque figure is painted with delicate ears of corn inter-woven with her blonde curls. In her arms she clasps a golden bundle of freshly scythed corn, the positioning of which frames her rosy face with its wistful smile. Spring's dimpled hands and child-like features stand in remarkable contrast to the mature figure that Louis-Gabriel Blanchet painted ten years later, *Allégorie de l'Été / Allégorie de l'Hiver* (fig. 1). It is possible that he used this tondo portrait as an initial basis for it.

Spring unfurls into summer in the second of the four portraits, and an intensely arresting child gazes out with an abundance of exotic flowers pressed to her chest. The flowers, denoting summer, could be anemones. The sinuous curves, created by both her blonde curls and the blue ribbon woven through them is a characteristic distinctive of the Rococo style that Blanchet absorbed both from France, as well as from his adopted home of Italy. The pastel shades of the clothes worn by at least three of his sitters are also a unique feature of French Rococo artists.

The child representing autumn clutches a bunch of succulent, dark purple grapes and, with vine tendrils playing about his hair, bears a significant resemblance to the young Bacchus, Roman god of wine. Autumn was commonly the time for the grape harvest and festivals celebrating the 'grape-gatherer', Bacchus were widespread.

Autumn gives way to winter in the last of the tondi: a figure, wrapped tightly in a fur-trimmed scarlet coat with a tasselled cap fitting snugly around his head, attempts to ward off the cold. In stark contrast to the other scantily clad *putti*, winter is suggested too by the figure's shiny nose and ruddy complexion. As in the other three paintings where each season can be identified by various props, 'winter' poses with a glazed ochre urn filled with glowing embers

Louis-Gabriel Blanchet,
Allégoie de l'Été /
Allégorie de l'Hiver,
1769,
Private Collection
(Figure 1)

to keep him warm. In subject matter and composition, this portrait is similar to the second of the twinned allegories, *Allégorie de l'Été / Allégorie de l'Hiver.*

Principally a painter of portraits, it seems only natural that Blanchet should use people as the *modus operandi* for his allegorical portrayals. On his arrival in Rome he enjoyed the patronage of such distinguished persons as Nicolas Vleughels, Director of the Academie de France and the Duc de Saint-Aignan, who was also the ambassador to the Holy See. Under their auspices, Blanchet was certainly influenced by the prevailing Italian style as the *putti*-like appearance of these four figures demonstrates. He was fond of painting allegories and some of his works bear similarities to that of his Roman contemporary Pompeo Girolamo Batoni (1708-1787).

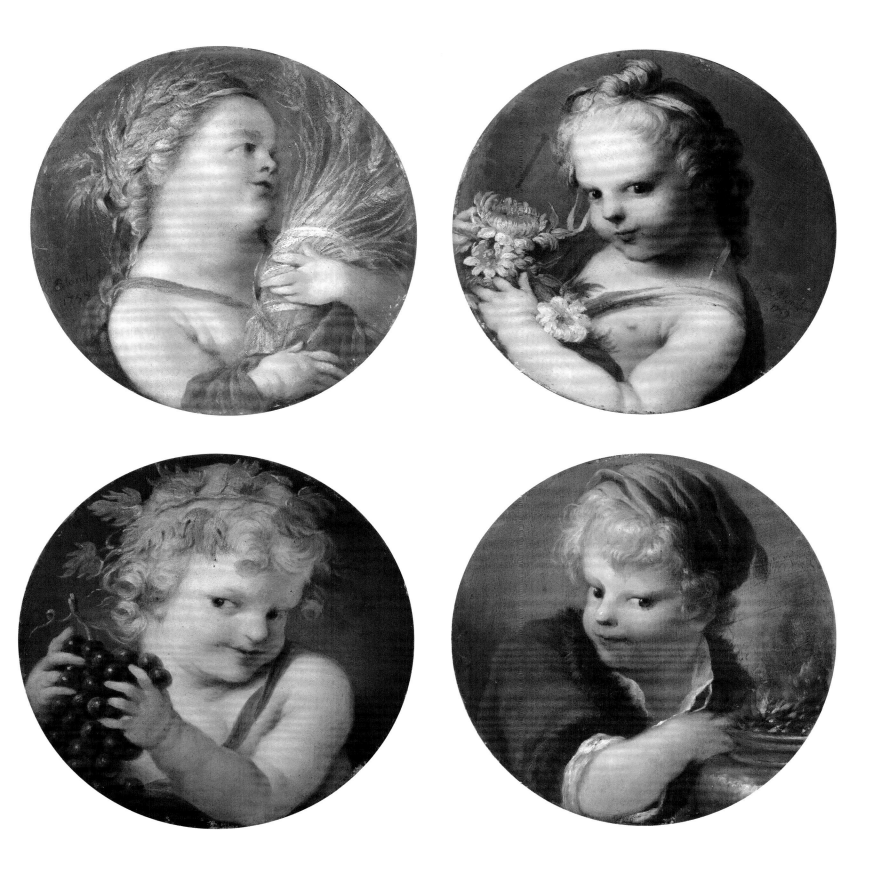

JEAN-HONORÉ FRAGONARD

(Grasse 1732 - Paris 1806)

Landscape with a Youth by a Pond

oil on canvas
24.3 x 32.8 cm (9⅝ x 12⅞ in)

Literature: Jean Pierre Cuzin and Dimitri Salmon, *Fragonard, Regards Croisés*, Editions Mengès, Paris 2007.

I N THE FOREGROUND OF THIS SMALL AND CHARMING pastoral landscape, a youth stoops down to gather water from a pond into a pan. Beyond him, his companion sits demurely on the crest of a hill, her hands folded in her lap, before the gnarled and venerable old trees which dominate the skyline. Her red skirt adds a vivid, masterly dash of colour to the predominant green and brown tones of the painting. To the left of the youth, a flock of sheep gather to drink from the pond, while above him, cattle amble down in procession from behind the crest of the hill to the watering place. Broken branches are strewn across the ground to the right of the youth and beyond them, a little path circumventing the hill leads the eye to the distance at the right, where a peasant couple can be glimpsed walking in a field. The lush green foliage of the trees lines the horizon of the painting. A few freely painted, grey and white clouds scud across a luminous sky, its white radiance reflected in the highlights of the cow in the mid ground.

Although Jean Honoré Fragonard is famous as a painter of amorous genre subjects and mythological scenes, the landscape was equally significant in his *oeuvre*. The subject of the recently discovered *Landscape with a Youth by a Pond* was previously known in another version of similar dimensions in a private collection, dated by Rosenberg and Cuzin on a stylistic basis to between 1766 and 1770;[1] in comparison, the present painting demonstrates a more packed composition with extensive detailing, in particular on the level of the herds of sheep and cows and vegetation. It is most likely, therefore, that *Landscape with a Youth by a Pond*, would also have been painted during these years at the height of maturity.[2] Since the artist painted primarily for private collectors, rather than executing formal commissions, the majority of his paintings can only be tentatively dated.

In 1758, about ten years prior to painting these landscapes in France, Fragonard met the landscape painter Hubert Robert (1733-1808) during his five-year sojourn in Rome. It was Robert who introduced Fragonard to the art of sketching landscapes in the open air. Both artists sketched prolifically *en plein air*, Fragonard producing the famed and highly evocative red chalk drawings of the gardens of the Villa d' Este at Tivoli in the summer of 1760, where he resided as the guest of Robert's patron, the Abbé de Saint-Non.[3] It is known that Fragonard used preparatory sketches made on the spot as a basis for oil paintings such as *Le Petit Parc*, c.1762/3 (Wallace Collection, London), for which he had made preparatory drawings at the Villa d'Este, Tivoli, as well as an etching.[4]

Jean-Honoré Fragonard, *Landscape with a Youth by a Pond* (Detail)

[1] P. Rosenberg, *Tout l'oeuvre peint de Fragonard*, Paris, 1989, no. 144; J. P. Cuzin, *Jean-Honoré Fragonard, Life and Work*, Fribourg, 1988, no. 131.
[2] See J.P. Cuzin and D. Salmon, *Fragonard, regards croisés*, Editions Mengès, Paris 2007.
[3] Ten drawings by Fragonard of the Villa d'Este are situated at the Bibliothèque Municipale, Besançon.
[4] See P. Rosenberg, *Fragonard*, Exhib. Cat., Paris, Grand Pal; New York, Met.; 1987-8, no. 66.

Having developed the practice of drawing directly from nature in Italy, it is highly likely that Fragonard would have based *Landscape with a Youth by a Pond*, executed after his return to Paris, on a drawing made *en plein air*. Indeed, the freshness and verve of the work attest's to testifies the artist's direct observation of nature, and exemplifies his virtuosity as a painter of naturalistic landscapes.

Fragonard's naturalistic treatment of the clouded but radiant sky, and the presence of the statuesque, ancient trees on the crest of the hill in *Landscape with a Youth by a Pond*, demonstrate the profound influence on the artist of the great Dutch seventeenth-century landscapist, Jacob van Ruisdael (1628/9-1682). On Fragonard's return to Paris from Italy in 1761, he had the opportunity to view Dutch seventeenth-century landscapes belonging to the wealthy collectors and patrons for whom he had worked. These Dutch landscapes were highly sought after by the French collectors of the second half of the eighteenth century. Fragonard's contact with van Ruisdael's paintings in particular resulted in a series of landscapes, culminating in *The Watering Place* of *c.*1762/4, see fig. 1, which is strongly related in theme and treatment to *Landscape with a Youth by a Pond*. In *The Watering Place*, a herdsman leads his cattle and sheep to a watering hole beneath a grassy outcrop of rock, on which a seated young couple can be glimpsed in the distance, the young woman wearing the same red skirt as that is portraied in the present painting.

Landscape with a Youth by a Pond, painted a few years later between 1766 and 1770, revisits the theme of *The Watering Place*. Here, Fragonard combines the marked influence of van Ruisdael's dramatic naturalism with his own vision of a pastoral idyll on a summer's day. There is an engaging quality to the depiction of country people and animals alike, slaking their thirst in the heat of the day, the abundant foliage of the trees lining the horizon evoking summer at its height. Moreover, there is a subtly implied courtship between the youthful couple, the young man appearing to be in the act of fetching water for his modest young companion who awaits him on the hill.

The impact of van Ruisdael's dramatic realism was most fully realised in works such as Fragonard's masterly painting *Landscape with a Passing*

Jean-Honoré Fragonard, *Landscape with a Passing Shower, (La Clairière)* *c.*1665-1675, Detroit Museum of Arts, Michigan (Figure 2)

Shower (La Clairière), see fig. 2, dating to between 1665 and 1775, approximately in the same period as *Landscape with a Youth by a Pond*.

Landscape with a Passing Shower, depicting a herdsman with sheep and cattle dramatically highlighted in a sombre landscape, beneath darkening, raining skies, is unusually solemn for the artist. Like *Landscape with a Youth by a Pond*, Fragonard's magnificent, highly finished red chalk drawing, *A Gathering at Woods' Edge* of *c.*1773, see fig. 3, combines the impact of van Ruisdael in its depiction of the imposing, mature trees, with a lighter, more playful note. The statuesque trees flank an opening to a shady wood, where elegant groups of figures, partly submerged in shadow, engage in courtly dalliance. Much of the charm of *Landscape with a Youth by a Pond* lies in the lowly and rustic character of the setting and the figures, the couple's courtship very delicately implied. In both works, Fragonard creates a benevolent vision of nature offering sustenance, whether water or shade, to its inhabitants.

In his *oeuvre* Fragonard developed his own exuberant, spontaneous interpretation of the Rococo style, established by Antoine Watteau (1684-1721) and François Boucher (1703-1770) (see catalogue no. 114). Fragonard's genius lay in his extraordinary versatility; the artist turned his hand with equal mastery to subject matter ranging from grand history paintings to such intimate pieces as *Landscape with a Youth by a Pond*. Alongside his painted masterpieces, he created some of the finest drawings, in chalk and wash, of the eighteenth century.

Fragonard was the only son of François Fragonard and Françoise Petit, both from shop-keeping and glove-making families in the Provençal town of Grasse. In 1738, when Fragonard was six years old, the family moved to Paris, where Fragonard entered the studio of Jean-Siméon Chardin (1699-1779), on the advice of Boucher. Fragonard then entered Boucher's own studio at the young age of seventeen, in about 1749, where he probably remained for a year. During Fragonard's period there, Boucher was at the height of his fame, and it is highly probable that Fragonard assisted him in such large-scale commissions as tapestry designs. At the age of twenty, the brilliant young artist successfully entered the competition for the

Jean-Honoré Fragonard, *The Watering Place, c.*1762/4, Private Collection (Figure 1)

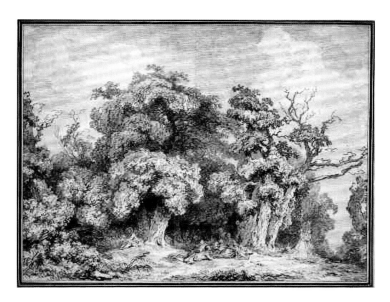

Jean-Honoré Fragonard, *A Gathering at Woods' Edge*, c.1773,
Metropolitan Museum of Art, New York (Figure 3)

Prix de Rome in 1752 with the painting *Jeroboam Sacrificing to the Idols*
(École Nationale Supérieure des Beaux-Arts, Paris), painted in the grand
manner of Carle Vanloo (1705-1765) (see inventory). This was despite
not having been a student at the Académie, as stipulated for entrants to
the competition.

The following year, in 1753, Fragonard entered the École Royale des
Elèves Protégés, under the directorship of Vanloo, where he remained
until 1756. It was here that Fragonard established his reputation as a
history painter, producing the documented *Psyche Showing her Sisters
Cupid's Presents* of 1754 (National Gallery, London), and *Christ washing
the Disciples' Feet* of 1755 (Grasse Cathedral, *in situ*). Fragonard also
established his career as a decorative painter in his early twenties,
producing four scenes from country life, *Harvester, Woman Gathering
Grapes, Gardener* and *Shepherdess* (Detroit Institute of Arts, Michigan),
themes which had been previously treated by Boucher.

In 1756, at the age of twenty-four, Fragonard travelled to Rome,
where he remained for five years. Here the artist was deeply impressed
by the Italian artists Federico Barocci (*c.*1535-1612), Pietro da Cortona
(1596-1669), Francesco Solimena (1657-1747) (see catalogue no. 30),
and Giambattista Tiepolo (1696-1770) (see catalogue no. 113). It was
in Italy that Fragonard painted his first amorous subject, *Kiss Won (The
Stolen Kiss)* of 1756 to 1761 (Metropolitan Museum of Art, New York)
for the Ambassador to Rome from Malta, the Bailiff of Bréteuil. Towards
the end of 1758, the artist met Hubert Robert, with whom he made
prolific red chalk drawings of the Roman *campagna* and the Villa d'Este,
Tivoli, in the open air. Towards the end of Fragonard's stay in Italy, in
1761, Fragonard joined Robert and his patron, the Abbé de Saint-Non
on their tour of Italy, visiting Naples and the North.

Fragonard returned to Paris in the same year, 1761, and it was
four years later, when the artist was thirty-three, that he achieved
official success with his grand-scale, neo-Baroque *morceau d'agrément*
(acceptance piece), *Coresus and Callirhoë*, for the Académie Royale. The
painting was received with grand acclaim and Fragonard quickly became
the new figurehead for the French School and history painting in the

grand manner. However, Fragonard rejected 'high art' and the promised
glory of a career as *Peintre du Roi*, choosing instead to produce rapidly
painted, intimate genre scenes, decorative works and landscapes, an
approach which was more suited to his spontaneous temperament. The
celebrated painting, *The Swing* (The Wallace Collection, London) is a
prime example of the kind of small-scale easel painting executed for a
private collector, painted with exuberance and spontaneity. During the
1760s Fragonard also produced a masterful new genre of portrait with his
Figures de Fantaisie, including the consummately painted portrait from
life of the *Abbé Richard de Saint-Non* (Louvre, Paris).

In addition to the small-scale easel paintings, Fragonard executed a
number of decorative commissions for prestigious patrons, culminating in
the greatest decorative ensemble produced in eighteenth-century France,
The Progress of Love of 1771/1772 (Frick Collection, New York). This series
was commissioned by Madame du Barry, the official mistress of Louis XV,
for the salon *en cul-de-four* of her new pavilion at Louveciennes.

In 1773, Fragonard set off on his second journey to Italy with the
financier Jacques-Onésyme Bergeret de Grancourt, Saint-Non's brother-
in-law, where he started to sketch with brown wash. He returned to
Paris in 1774, where he continued to produce small paintings for private
collectors. It was during this period that he produced a series of large-scale
decorative landscapes, which continued the theme of the *Fête Champêtre*
established by Antoine Watteau.

During the 1780s Fragonard turned increasingly to mythological
subjects, and to portraits of his own family, including the delightful
portrait of his son, Alexandre Evariste Fragonard, dressed as Pierrot,
*c.*1785-8 (Wallace Collection, London).

In 1789, the year of the French Revolution, the Fragonard family moved
to the artist's home town of Grasse, returning however to Paris in 1792.
In spite of Fragonard's association with the Ancien Régime, he escaped
imprisonment and emigration, and on the recommendation of Jacques-
Louis David (1748-1825) was appointed as a member of the Conservatoire
des Arts in 1794, an institution created to oversee the creation of a national
museum at the Palais du Louvre. The following year he was put in charge of
the new museum, which was expanding swiftly with paintings looted from
churches and private collections. In 1797, Fragonard was given the title
Inspector of the Transportation of Works of Art and oversaw the creation
of a new museum of the French school at Versailles. He continued in this
post until 1800, ending his life six years later in obscurity.

The death of Fragonard, the last Rococo painter (and the most
versatile and flamboyant genius of eighteenth-century France,) heralded
the end of an age. Of Fragonard's two pupils, his sister-in-law Marguerite
Gérard (1761-1837) and his son Alexandre Evariste Fragonard (1780-
1850), the latter went on to pursue a career as a decorative painter and
sculptor during the Empire, producing designs for the Sèvres factory.
However, the artist had no direct influence on the evolution of French art,
which was now dominated by the neo-Classical style of David, *Premier
Peintre* to Napoleon. It was not until the 1840s that the freedom of style
and imagination exemplified by the Rococo became championed by such
left wing intellectuals as Théophile Thoré. The paintings of Fragonard,
Watteau and Boucher were soon in demand by such wealthy collectors
as the Rothschilds. In the wake of the De Goncourt brothers' researches,
scholars have attempted to establish a chronology for the artist's *oeuvre*.

This recently discovered work by Fragonar will be published in the
forthcoming book by Jean-Pierre Cuzin and Dimitri Salmon.

JEAN-BAPTISTE PILLEMENT

(Lyon 1728 - Lyon 1808)

A Mountainous River Landscape with Figures Fishing below a Cascade

oil on canvas
50 x 61 cm (19¾ x 24 in)

Literature: M. Gordon-Smith, *Pillement*, Cracow, 2006, pp. 254-5, 257, fig. 249.

IN THIS LIVELY LANDSCAPE JEAN-BAPTISTE PILLEMENT has depicted a gushing torrent of water emerging from a rocky setting. The water flows down from the distant mountains and as it crashes against boulders it explodes into a mound of foam and spray. However, the tumultuous cascade quickly transforms into the calm, still water that is visible in the foreground. On the left of the composition, the charming figures are in keeping with the relaxed mood of the foreground. The figures lounge and chat in the sunlight, their fishing basket discarded to one side. To the right two further figures can be seen, one of whom is casting his rod into the water. The river is flanked by rising walls of rock topped with trees, bushes and a circular tower teetering on the edge; its small size providing a sense of perspective in this image of the sublime in nature.

In *A Mountainous River Landscape with Figures Fishing below a Cascade* there is a stark contrast between the magnificence and power of nature, seen in the craggy mountains and cascading water, and the tranquillity experienced by the relaxed figures in the foreground. This was an artistic device frequently employed by Pillement, for example in *Landscape with Washerwomen* (fig. 1). Here, the ferocious force of water, which in this work is in the form of a waterfall crashing down behind the figures and the brilliant white of the foam catch the viewer's eye. Behind the waterfall, a wide mountainous landscape expands and Pillement's loose palette gives the impression that the peaks are being submerged by cloud. However, the frenetic energy of the waterfall and background is contrasted with a peaceful, pastoral foreground. Washerwomen are working on a sunlit grassy spot on the bank of the river, whilst other figures, sheep and goats graze nearby. As in *A Mountainous River Landscape with Figures Fishing below a Cascade* the figures create a charming and idealised depiction of rustic life.

Pillement was a fashionable eighteenth-century artist and major contributor to the spread of the taste for the Rococo and, in particular, for *chinoiserie*. Under the tutelage of Daniel Sarrabat (1666-1748), who had been a pupil of Pillement's grandfather, he became proficient in painting genre scenes, in the Rococo style of Antoine Watteau (1684-1721) and François Boucher (1703-1770) (see catalogue no. 114). Early in his career he worked as a designer at the Gobelins, a Parisian tapestry factory patronised mainly by the French royal family. From 1745 to 1748 he worked in Madrid and although he was there for only three years, he returned regularly due to the popularity of his work. Having worked for some of the most important patrons in Spain he was eventually offered the title of Painter to the King, a position which he declined saying, 'it was not sufficient reason to dissuade him from the desire of learning

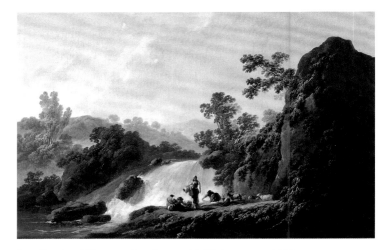

Jean-Baptiste Pillement, *Landscape with Washerwomen*, 1792, Musée des Beaux-Arts, Bordeaux (Figure 1)

through travel'. Instead, he moved to England in order to take advantage of the booming art market and, in particular, the fashion for landscapes. He stayed in England for ten years developing a style of brightly coloured landscapes that drew on the work of Nicolaes Berchem (1620-1683) (see catalogue no. 121) and Claude-Joseph Vernet (1714-1789) (see inventory).

Pillement was enormously successful during this period and his work is a testament to his great versatility. His landscape, genre, and decorative drawings were frequently engraved and published, the most important and influential of which was a collection entitled *One Hundred and Thirty Figures and Ornaments and Some Flowers in the Chinese Style*, which was published in 1767. After leaving London he worked for the Prince of Liechtenstein and was made *pictor regius* by the King of Poland. Later in his career he was also appointed personal painter to the French queen Marie-Antoinette. His *oeuvre* is characterised by its prolific nature, as well as by its versatility, inventiveness and novelty, which helps to explain why he was so sought after throughout his career. He painted and drew genre scenes, *chinoiserie*, flowers, landscapes, and marine subjects in many media, always in the same rococo style. As Maria Gordon-Smith writes 'he infused each work to which he set his hand with a boundless imagination, an unbridled spirit, and a tireless pursuit of beauty'.[1]

[1] Maria Gordon-Smith, *Pillement*, introduction, Cracow, 2006.

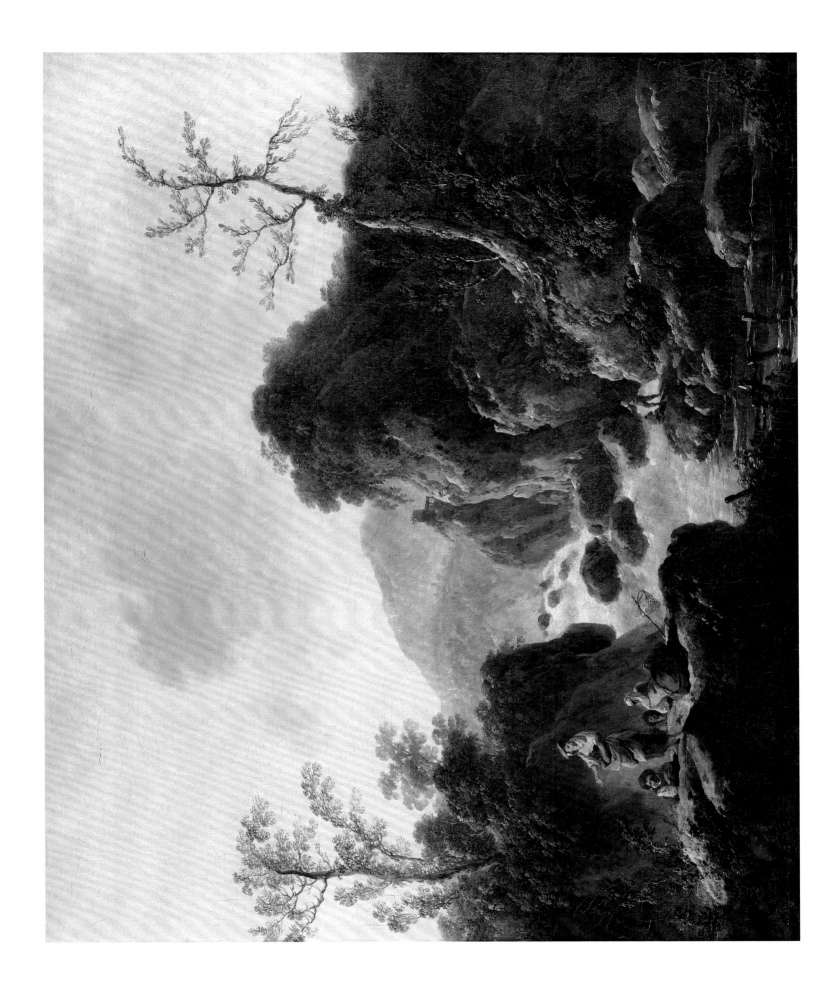

ATTRIBUTED TO

JEAN-BAPTISTE LALLEMAND

(Dijon 1716 - Paris 1803)

View of the Tiber, Rome, with the Castel Sant'Angelo and St. Peter's Beyond

oil on canvas
44 x 69.2 cm (17¼ x 27¼ in)

THIS BEAUTIFUL RENDITION OF A TYPICALLY NEO-Classical subject matter evokes a mauve twilight slowly descending over the serene River Tiber. In the foreground, two fishermen inspect their daily catch whilst another couple lazily recline in the blue flowers that dapple the left bank. On the far side, a herd of cattle drink thirstily as the summer evening draws in. The graceful arches of the bridge with their softly glimmering reflection in the silvery water create a strikingly spacious perspective.

The composition is dominated by the magnificent silhouette of the Castel Sant'Angelo, originally a mausoleum built by the Roman Emperor Hadrian. The bridge detailed, the Pons Aelius, was also built by Hadrian in order to span the Tiber from the city centre to his newly constructed mausoleum.

Landscape painting of this time was continually engaged with the representation of the constancy of nature versus its ephemeral passing, as was the role of humans and their artefacts. The glory of nature is a characteristic theme; the counter theme is the appropriate presence of humans. To include manmade edifices like the Castel Sant'Angelo Agrippa's tomb, or a château, see figs. 1 and 2, perhaps tacitly suggested the transient quality of human achievements when pitted against the permanency of the River Tiber and the essence of nature evident in the perpetual and cloudless sky.

View of the Tiber, Rome, with the Castel Sant'Angelo and St. Peter's beyond, attributed to Jean-Baptiste Lallemand, bears striking similarities in composition and in its imitation of light effects, to Lallemand's *Veduta di Ponte Emilio, Roma* (fig. 2). In both images, the immense sky expressively conveys the mellowness of

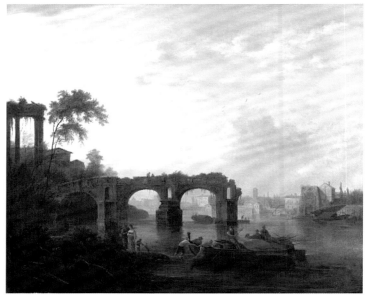

Jean-Baptiste Lallemand, *Veduta di Ponte Emilio, Roma*
Private Collection, Italy (Figure 2)

early evening, whilst the monumental buildings are both positioned prominently.

Lallemand was a French painter and draughtsman who specialised in architectural, landscape and marine scenes. He moved to Paris in 1739 to study art, possibly with Giovanni Niccolò Servadoni. In 1745, Lallemand was appointed a member of the Académie de St. Luc where he exhibited landscapes and figures of animals. He travelled then to Rome where he remained for the next fourteen years. Whilst in Italy, he came into contact with a number of prominent artists including Etienne Parrocel (1696-1775) and Claude-Joseph Vernet (1714-1789) (see inventory). The latter, particularly, may have influenced Lallemand with his favoured Italianate style (fig. 2). The artist was also inspired by the works of Giovanni Paulo Panini (1691-1765) and fascinated by antique ruins and Baroque buildings. A number of his works therefore made much of their inherently artistic properties. Lallemand often frequented the Académie de France at a time when architectural draughtsmen such as Louis-Joseph Le Lorrain (1715-1759) were there. In 1755 he taught Robert Adam (1728-1792) landscape drawing, giving some idea of his own eminent standing in this sphere. At around the same time, he worked on frescoes in the Palazzo Corsini, as well as executing four large paintings of antique architecture for the Anichkov Palace, Russia. Lallemand attempted most 'minor' genres including rural subjects and village scenes inspired by the work of the Dutch painters Jan Baptist Weenix (1621-?1660/61) and Jan Wijnants (c.1635-1684) (see inventory). Pre-eminent in his work, however, are his views of imaginary ruins, architecture, landscapes and topographical views.

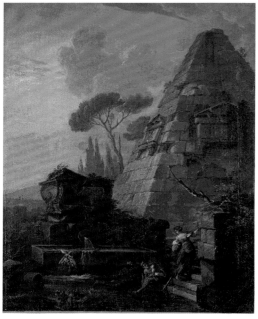

Jean-Baptiste Lallemand, *The Tomb of Agrippa and the Pyramid*, Musée des Beaux Arts, Caen, (Figure 1)

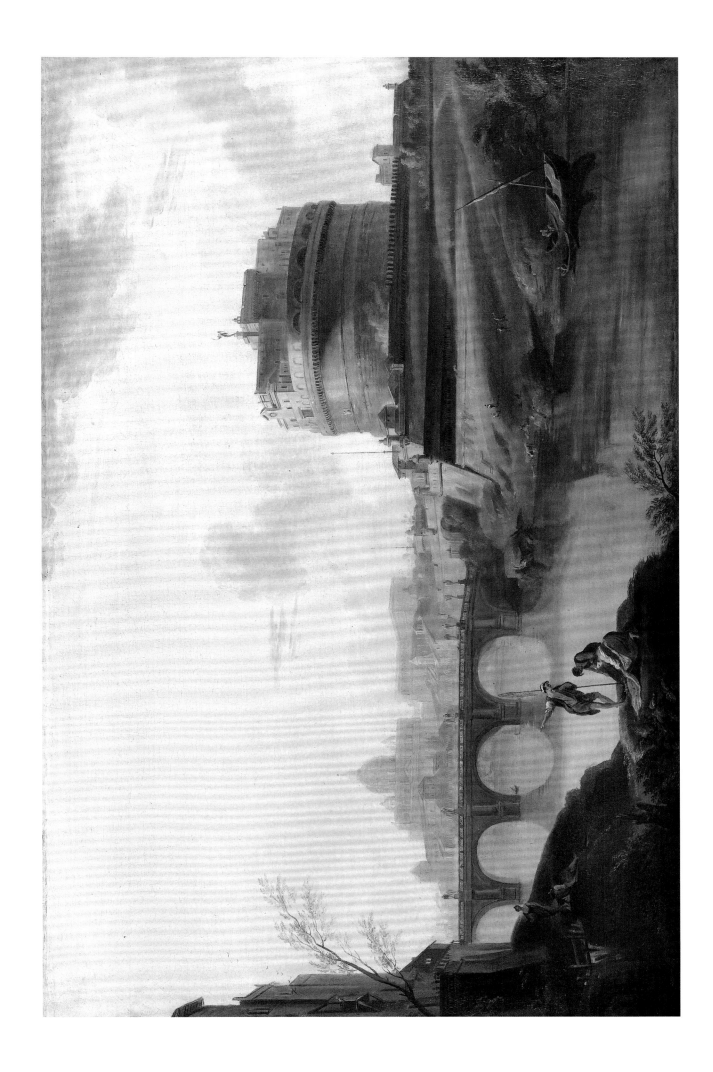

HENRI-PIERRE DANLOUX

(Paris 1753 - Paris 1809)

Portrait of a Man, Half-Length, in a Grey Coat

oil on canvas
64.7 x 54.8 cm (25½ x 21⅝ in)

THIS INTENSELY STRIKING PORTRAIT REVEALS A powerful man, fixing his concentrated gaze defiantly away from the viewer. His upraised profile with its prominent bushy eyebrows, aquiline nose and high forehead endows him with an outwardly unshakeable authority. The sombre background tones and the subdued hue of his grey coat serve to further accentuate his startlingly pale face. On closer inspection, the translucent quality of his skin, with its faintly bluish hue, lends him a fleeting air of fragility, despite his commanding features. His silvered hair, swept back hurriedly, stands in contrast to the powdered wig, so fashionable in more aristocratic days.

The sitter's entire posture and outfit stand in stark contrast to the previously exotic and frivolous Rococo-style costumes beloved of the French aristocracy. His heavy linen cravat and simple, though still luxurious greatcoat, usher in a new stylistic departure which perhaps suggests that the painting can be attributed to the latter period of Henri-Pierre Danloux's career during the French Revolution, when costume witnessed a decisive and sudden shift. The artist's far freer brushstrokes, notably in the detailing of the sitter's hair also suggest that this portrait maybe a more mature work.

Danloux was a highly successful painter and draughtsman. Brought up by his architect uncle, he was apprenticed, in 1770, to Nicolas-Bernard Lépicié (1735-1784). Three years later he was admitted into the studio of Joseph-Marie Vien (1716-1809) with whom he travelled to Rome in 1775. Interestingly, his Italian journeys - he also visited Naples, Palermo and Florence - provoked more of an interest in landscape and portrait craft than in antiquarian ruins prized by so many of his contemporaries. In this, his early period, Danloux specialised in the intimate genre scenes of his first mentor, Lépicié, as well as in the execution of small-scale portraits.

In 1783, Danloux returned from Italy and settled in Lyon and Paris. In Paris he made the acquaintance of the Baronne d'Etigny who was instrumental in obtaining the young artist a number of important portrait commissions. During the French Revolution Danloux exhibited at the 1791 Salon but, loyal to the French royal family, he emigrated to London in 1792 where he temporarily made his home, executing portraits such that of 1st Viscount Duncan that same year (fig. 1). His diary reveals that he also cultivated relationships with French *émigrés* and obtained portrait commissions from them.

Danloux was influenced by fashionable English portrait painters including Thomas Lawrence (1769-1830), John Hoppner (1758-1810) (see catalogue no. 73) and, in particular, George Romney (1734-1802) (see inventory). In 1793 he exhibited at the Royal Academy in London which

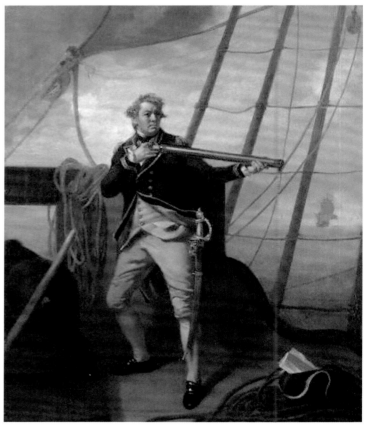

Henri-Pierre Danloux, *Adam Duncan, 1st Viscount Duncan*, 1792, National Portrait Gallery, London (Figure 1)

resulted in commissions from a number of British patrons. Among others, he painted the Comte d'Artois, as well as a beautiful portrait of the family of the Duke of Buccleuch.

In 1801 Danloux returned to Paris. Throughout his final years in London, he had begun to work on large subject pictures, and this he continued to do. When his history painting *The Flood* (Saint-Germain-en-Laye, Musée Municipal) was badly received at the 1802 Salon, however, he subsequently only painted occasional portraits, among them that of the writer the Abbé Delille and a few oil sketches of historical genre scenes.

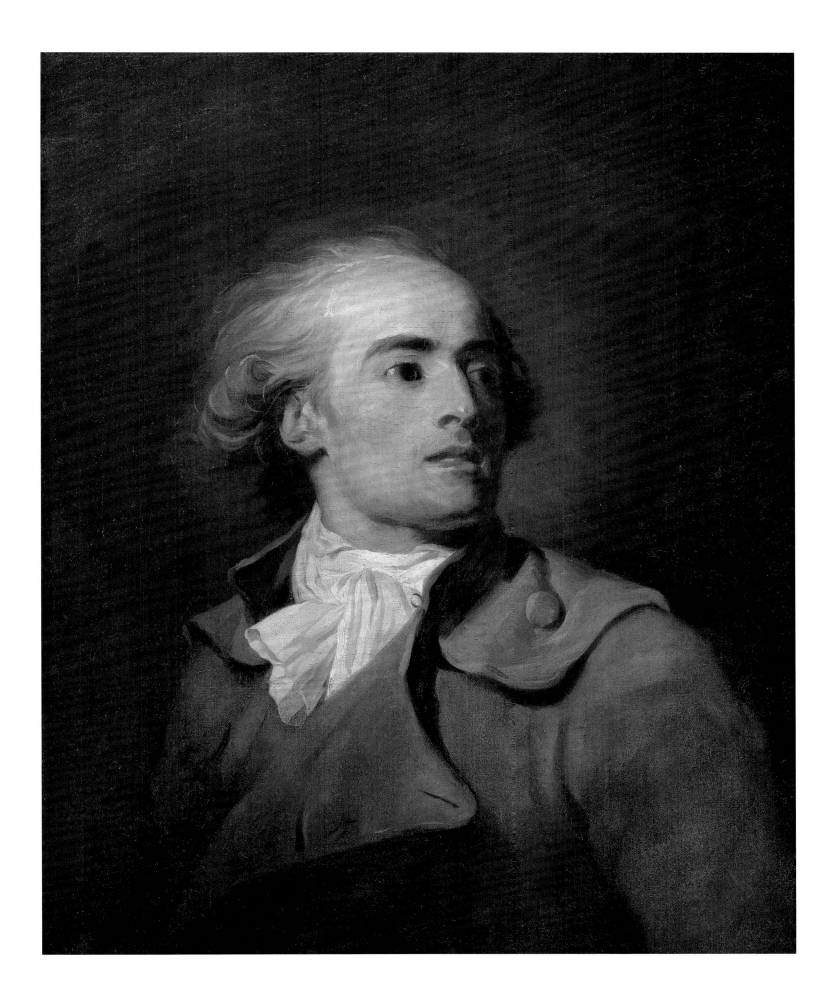

JEAN-BRUNO GASSIES

(Bordeaux 1786 - Paris 1832)

A View of Loch Lomond, Scotland, with Figures on a Path in the Foreground

signed and dated 'Gassies./1824' (lower left)
oil on canvas
25.2 x 32.5 cm (9⅝ x 12¾ in)

Provenance: Marquis de Cypierre, 1824;
his deceased sale, Paris, M. Bonnefons Delavialle, March 10, 1845, lot 58, for 108 francs;
anonymous sale, Paris, Neret-Minet Scp, March 15, 2002, lot 52.

Exhibited: Paris, Salon, 1824, no. 720.

A VIEW OF LOCH LOMOND, SCOTLAND, WITH FIGURES on a Path in the Foreground presents the famous Scottish loch moments before a storm moves in. Jean-Bruno Gassies has paid particular attention to light in order to evoke the storm-whipped atmosphere looming nearby; in particular there are patches of bright sunlight strewn across the foreground and shallow waters where the cloud cover has not yet reached, whereas in the background the ominous, dense storm clouds are evidently moving over the terrain casting dark shadows as they approach.

In the foreground two figures lit by a shaft of light gesticulate towards the impending storm clouds. A gentleman wearing a top hat and blue tailcoat stands next to a pointing male figure who wears a vibrant tartan coat. On his head he wears a traditional Scottish blue bonnet, the Tam o'Shanter, so named after Robert Burns' 1790 poem of the same name. Beyond these two figures, a shepherd can be seen standing holding a long staff, his flock beyond grazing at the water's edge. Further down the path, two figures wander towards a small hut situated on the edge of the loch.

Gassies has framed the composition, and delineated the fore and backgrounds, by introducing a line of large, irregular boulders along the bottom-left edge of the present work. In the far left corner, a dimly lit cascading waterfall snakes its way down the mountain side; only the whipped, white surface water identifying its true activity.

The majesty of Loch Lomond and surrounding Trossachs are evident in Gassies' interpretation of the iconic Scottish loch. By detailing the mist moving across the water, trees growing out of the teetering edges of rock faces and the rising Highland peaks in the far distance, Gassies has deftly created a sense of mountainous mysticism in an verdant, expansive landscape. Loch Lomond is the largest lake in mainland Britain, and lies between the western lowlands of Central Scotland and the southern Highlands, and can now be found within the Trossach National Park.

The 1824 Paris Salon, at which *A View of Loch Lomond, Scotland, with Figures on a Path in the Foreground* was exhibited, marked the triumph of Romanticism and included works by such great artists as Eugéne Delacroix (1798-1863) and Horace Vernet (1789-1863) (see inventory). Stendhal, a literary pseudonym of Marie-Henri Beyle, commented on the landscape paintings in the 1824 Salon, saying: 'An epidemic is sweeping through the landscape painters this year at the Salon. Many of these gentlemen have attempted to do views of Italy, but they have all given their landscapes a sky from the valley of Montmorency'.[1] One can only assume that Stendhal would have been less disparaging of Gassies' present work, having been unmistakably executed by applying his own direct knowledge of the highlands.

Gassies was a member of the French navy who was subsequently captured and imprisoned by the English. It is thought that it was after his release from captivity that he had the opportunity to explore England and Scotland, and developed a love for the British landscape. He was greatly taken by the English School of painting of the early nineteenth century, and he returned several times to visit, in 1821, 1824 and 1826. It was during his this last visit that he painted *Paysage d'Ecosse* (now in the Musée Rolin, Autun). Gassies was a pupil of the neo-Classical French artist Jacques-Louis David (1748-1825) and, after the 1822 Salon, was decorated with the Legion d'honneur.

[1] Stendhal, *Oeuvres Complètes, Mélanges III. Peinture*, new edition, Geneva 1972, pp. 51-4.

SPHINX · FINE · ART

Edward Strachan • Roy Bolton

Fifty
Old Master Drawings

125 Kensington Church Street
London W8 7LP • United Kingdom
Tel: +44 20 7313 8040 • Fax: +44 20 7229 3259
info@sphinxfineart.com
www.sphinxfineart.com

C O N T E N T S

No. 131	**Roelandt Savery** (Kortrijk 1576 - Utrecht 1639)	*A Rocky Landscape with Two Huntsmen and a Dog by Fallen Fir Trees*
No. 132	**Abraham Storck** (Amsterdam 1644 - Amsterdam 1708)	*Shipping at Anchor*
No. 133	**Attributed to Cornelis Pietersz. Bega** (Haarlem 1631/2 - Haarlem 1664)	*A Standing Soldier, seen from Behind*
No. 134	**Jan van Goyen** (Leiden 1596 - The Hague 1656)	*A Village on the Banks of a Canal with Cattle and Fishermen*
No. 135	**Jan van Goyen** (Leiden 1596 - The Hague 1656)	*A Group of Covered Wagons and Horsemen before a Country Inn*
No. 136	**Willem van de Velde II** (Leiden 1633 - London 1707)	*A Dutch Flagship at Anchor Attended by Small Boats, the Fleet Seen Beyond*
No. 137	**Esaias van de Velde** (Amsterdam 1587 - The Hague 1630)	*A River Scene with Rowing Boats, Cottages on the Shore and a Windmill in the Distance*
No. 138	**Benjamin West, P.R.A.** (Pennsylvania 1738 - London 1820)	*Studies for the Ascension: Christ Ascending*
No. 139	**Joseph Mallord William Turner, R.A.** (London 1775 - London 1851)	*The Bridge at Vernon, from Vernonnet*
No. 140	**Joseph Mallord William Turner, R.A. and Thomas Girtin** (London 1775 - London 1851) (London 1775 - London 1802)	*Arno, a Villa Among Trees and Bushes*
No. 141	**Thomas Rowlandson** (London 1756 - London 1827)	*A Landscape with Monks*
No. 142	**Thomas Rowlandson** (London 1756 - London 1827)	*A Passing Flirtation*
No. 143	**Thomas Rowlandson** (London 1756 - London 1827)	*A Wagon and Horses Passing a Family on a Wayside*
No. 144	**Thomas Rowlandson** (London 1756 - London 1827)	*Taking the Water*
No. 145	**Thomas Rowlandson** (London 1756 - London 1827)	*Travellers on the Road*
No. 146	**George Morland** (London 1763 - London 1804)	*Travellers Returning Home*
No. 147	**Philippe-Jacques de Loutherbourg, R.A.** (Strasburg 1740 - Chiswick 1812)	*Two Men, One Sleeping*
No. 148	**Philippe-Jacques de Loutherbourg, R.A.** (Strasburg 1740 - Chiswick 1812)	*Smugglers on the English Coast*
No. 149	**Attributed to Christoph Schwarz** (Munich c.1545 - Munich 1592)	*The Raising of Lazarus*
No. 150	**Johann Heinrich Roos** (Otterburg 1631 - Frankfurt am Main 1685)	*A Peasant Family and their Animals by Ruins*

CATALOGUE OF DRAWINGS

ATTRIBUTED TO

ANTONIO ZUCCHI

(Venice 1726 - Rome 1795)

Landscape Animated with Musicians, Shepherds and Fishermen

quill and brown ink with grey and brown wash
46 x 67 cm (18⅛ x 26⅜ in)

UNDER A VAST SUMMER SKY, THE RURAL SCENE laid out beneath seems the embodiment of easy tranquillity. The towering trees on the right-hand side of the composition dominate the landscape but also provide welcome penumbra for the dwarfed humans who idle beneath their boughs. With the exception of the two men casting their fishing nets by the river, which runs through the landscape, the figures are clustered together in groups of two or more. The viewer's eye is drawn in a sweeping curve first to the group of four in the centre of the composition and then to the charming couple watched over by an inquisitive dog as they sit together on a rocky ledge.

The boy languidly plays a flute-like instrument while the girl leans over eagerly to hear him play and a flock of sheep stand lazily by. There is a distinctly amorous overtone to the whole vignette. The artist's careful clustering of the figures opens up an enormous vista for the viewer and the delicate contour accents, accomplished by skilled *chiaroscuro*, contributes to an overall atmosphere of mellow calm.

This drawing, which is attributed to Antonio Zucchi, recalls, in both the composition of the figures, and exploitation of light and shade, works such as Zucchi's *Classical Ruins with Figures* (fig.1).

Zucchi was the brother of Giuseppe Carlo Zucchi (1721-1805) and studied first with Francesco Fontebasso (1707-1769) and then with Jacopo Amigoni (1682-1752), who exerted upon him a profound influence. A number of his early works displayed clear signs of Amigoni's artistic style and hazy colouring notably in *Male Saints Surrounded by Female Franciscan Saints* (untraced). His *Fourteen Stations of the Cross* (1750, Venice, S. Giobbe) also shows Amigoni's influence as well as a willing acceptance of Francesco Guardi's (1712-1793) innovations. In 1756 Zucchi was elected a member of the Accademia di Pittura e Scultora in Venice, and from the evidence of two canvases depicting angels, it is clear that he began to develop a more academic style which imbued his figures with a greater plasticity. He undertook several study trips, probably after 1759, in the company of Robert Adam (1728-1792) to Rome and Naples, where he gained a deeper knowledge of the neo-Classical style propounded by Adam.

Zucchi settled in Rome in 1766 from where he painted the altarpiece depicting the *Incredulity of Thomas* for the church of S. Tomà, Venice (*in situ*). In that same year he journeyed to London to visit Adam, to exhibit his work in 1771. Two years later, he had painted five frescoes for Home House in London in collaboration with Adam, who had designed the building. Zucchi worked on the decoration of other large houses and in 1781 married the artist Angelica Kauffmann (1741-1807). In 1784 he was elected a member of the Royal Academy.

Antonio Zucchi, *Classical Ruins with Figures*, Courtauld Institute of Art (Figure 1)

Antonio Zucchi, *Capriccio with Buildings and a Tower around a Lake, Figures in the Foreground*, Private Collection (Figure 2)

GIOVANNI DAVID

(Gabella, Liguria 1743 - Genoa 1790)

The Discovery of Romulus and Remus

bears partly erased old attribution: 'Giovanni Battista Pittoni, Venezia 1687 - 1767' (lower right of backing sheet)
pen and grey ink and brown and grey wash, over black chalk
32.2 x 45.4 cm (12⅝ x 17⅞ in)

Literature: M. Newcome, 'Drawings by Giovanni David' in *Master Drawings,* 1993, vol. 31, no. 4, p. 479, figs. 11-12.

THE MYTH OF ROMULUS AND REMUS AND THEIR subsequent foundation of Rome was of acute interest to Italian artists and their patrons. The scene, captured in this exquisite drawing by Giovanni David, focuses on the discovery of the twins by a shepherd. The sons of Rhea Silvia and Mars, the god of war, Romulus and Remus calmly suckle from the she-wolf that became irrevocably linked in legend to Rome's origins.

The twins' great-uncle, Amulius, had dethroned their grandfather, Numitor, the rightful king of Alba Longa - which would become Rome. Fearing that his niece Rhea Silvia's children could threaten this position, Amulius compelled her to become a Vestal Virgin and swear an eternal vow of chastity. The god Mars, however, is said to have seduced Rhea Silvia in a wood and by him she became pregnant with the twins. In fury, Amulius ordered that she be buried alive, following the conventional punishment meted out to a Vestal Virgin for subverting her sacred oath, and that the twins be killed. The servant who was ordered to undertake this deed could not bring himself to kill such innocents and instead settled them into a basket, which floated down the River Tiber. The river god Tiberinus protected the twins and eventually set them down in the roots of a fig tree where a she-wolf, *Lupus*, nursed them. They were then discovered by a shepherd, Faustulus, depicted here in the background.

This tranquil scene radiates blissful solitude and displays a rare harmony between the natural world and its human inhabitants. The glassy river reflects the gently curving arches of a stone bridge as a shepherd quietly tends his flock by the water's edge. An female figure leans against the tree in the foreground. This pairing of two sinuous shapes underlines the intentional dominance of the figure as he stumbles upon the wolf suckling her human young. She holds her hand to her mouth in surprise and the incline of her head meets that of the startled wolf in a strong diagonal.

Classical subjects such as this one feature prominently in David's work, although this sheet does not appear to be preparatory for a known painting or engraving. The myth of Perseus and Andromeda form the subject matter for one of his etchings and display the same carefully modelled characters (fig. 1). A 1775 etching also exploits the artistic potential of mythical subject matter with a rendition of Daedalus and Icarus. The highly finished style of *The Discovery of Romulus and Remus* perhaps places it in the later part of the

Giovanni David, *Perseus and Andromeda,*
The Metropolitan Museum of Art, New York (Figure 1)

artist's career, as it is comparable with a sheet depicting the *Temptation of Saint Agnes* in the Bibliothèque, Rouen which is preparatory for the painting of the same subject in the church of S. Maria del Carmine, Genoa, dated to circa 1789.[1]

David worked extensively for Giacomo Durazzo (1717-1794) who had been the Venetian ambassador to Vienna. David's main activity was in Genoa where he painted vast panoramic canvasses of battles in the 1780s. His work marked a sharp contrast to the academic tradition of Raphael Meng which was at that time prevalent in Liguria. David's last period was devoted largely to the decoration of the church of S. Agnese, Genoa. This was characterised by a more dramatic and visionary style that is also evident in his drawings and engravings from those years, including the present example.

[1] Newcome, M. 'Drawings by Giovanni David' in *Master Drawings,* 1993, vol. 31, no. 4, p. 479, figs. 11-12 .)

ATTRIBUTED TO

GIOVANNI MARIA MORANDI

(Florence 1622 - Rome 1717)

A Processional Feast with Musicians and People in Costume, a Woman on a Horse at the Centre

pen and brown ink, brown wash, heightened with white, irregular shape
20.5 x 30.5 cm (8⅛ x 12 in)

IN *A PROCESSIONAL FEAST WITH MUSICIANS AND PEOPLE in Costume, a Woman on a Horse at the Centre*, which is attributed to Giovanni Maria Morandi, we are presented with an image of joyous celebration in a spirited and expressive manner. The scene takes place in an Italian square and the party of revellers is centred on an elaborately dressed woman riding a horse. Her dramatically spiked headdress and flowing drapery echoes the frenzied movement around her of barefoot men in oriental dress and women with garlands in their hair. The men blow on horns while the women strike tambourines and cymbals, forming a procession reaching horizontally across the paper. From the open windows and on the roof of a loggia in the square, people have assembled to watch the spectacle, which appears to be either a fashionable masquerade or a festival.

The work exhibits a painterly spontaneity and freedom in the application of pen and brush marks that equals the subject in its vitality. The combination of dark outlines around the forms of the figures and the white heightening of the costume folds add to the drawing's depth and texture, while the use of *chiaroscuro* intensifies its dramatic impact. The sense of movement and theatricality and the hasty, informal draughtsmanship of *A Processional Feast with Musicians and People in Costume, a Woman on a Horse at the Centre* are in harmony with Morandi's style.

Morandi was born in Florence and was mainly active in his native city and Rome, although he also worked in Venice. He trained under Giovanni Biliverti in Florence. In Rome, he became a member of the Accademia di San Luca in 1657 and was elected *principe* twice in the following years. He painted numerous altarpieces in Rome, including the *Death of Mary* in the church of Santa Maria della Pace and pieces in Santa Maria in Vallicella and Santa Maria del Popolo. In Siena, he painted the *Annunciation* in the church of Santa Maria della Scalla. The Prado,

Attributed to Giovanni Maria Morandi, *A Processional Feast with Musicians and People in Costume, a Woman on a Horse at the Centre* (Detail)

Madrid, and several Italian collections house examples of his religious works. Morandi was also a portraitist and several of his portraits can be seen in the Kunsthistorisches Musem in Vienna. Although works by Morandi are now rare, there is evidence that he was a sought-after artist in his time, for as Paolo Bellini notes, 'the abundance of etchings after Morandi is testimony to his contemporary success'.[1]

A drawing by Morandi with similar subject matter is in the Louvre, Paris.[2]

[1] Paolo Bellini, *The Illustrated Bartch*, 47 (Vol. 1), commentary, p. 12.
[2] *De la Renaissance à l'Age baroque. Une collection de dessins italiens pour les musées de France*, exhib. cat., Paris, Louvre, 2005, no. 113.

LUIGI SABATELLI

(Florence 1772 - Milan 1850)

Dante and Virgil Watching Charon Ferrying Souls to Hell

pen and brown ink over traces of black chalk
44 x 62 cm (17⅜ x 24⅜ in)

Provenance: Sale, London, Christie's, 21 November 1996, lot 6.

Literature: Barbara Brejon de Lavergnée, *Catalogue des Dessins italiens, Collection du Palais Des Beaux-Arts de Lille*, Paris/Lille 1997, p. 209, no. 598, reproduced; Beatrice Paolozzi Strozzi, *Luigi Sabatelli*, exhibition catalogue, Florence, Uffizi, 1978.

'And here, advancing toward us, in a boat,
an aged man - his hair was white with years -
was shouting: "Woe to you, corrupted souls"'.
　　　- Dante, *Inferno*, Canto III

THE SUBJECT OF THIS PRESENT WORK IS TAKEN from Dante's *Inferno*, Canto III. Dante, as well as Milton and other Romantics provided Luigi Sabatelli with a treasure trove of inspiration that suited his imaginative artistic personality. Other drawings by Sabatelli that illustrate scenes from Dante are known, and can be dated to his last Roman period from 1789 to 1794. Indeed, another version of this same subject is displayed in the Castello Sforzesco, Milan.[1] A further drawing of Dante and Virgil is in the Palais des Beaux-Arts, Lille, but may be dated stylistically to earlier in the artist's career.[2] Beatrice Paolozzi Strozzi, in her catalogue of the Sabatelli drawings exhibition at the Uffizi, comments on the renewed fascination with selected episodes from Dante, an interest which Sabatelli shared with contemporary artists such as Giuseppe Cades (1750-1799) and Felice Giani (1758-1823), and which can probably be traced to the influence of John Flaxman (1755-1826), a contemporary English artist who helped to popularise the concept of the Sublime.[3]

The ostensibly complete nature of this present drawing seems to suggest that it was designed to stand as a work in its own right rather than as a preparatory sketch for a painting. Sabatelli was a widely respected draughtsman as well as a fresco painter and he produced a number of independent, highly finished drawings for sale to collectors. Trained in the neo-Classical tradition in Florence, he took his inspiration from Ariosto's *Orlando Furioso*. Arguably, however, his pictorial representation of Dante's words, are among his most powerful and innovative drawings. The very composition of *Dante and Virgil Watching Charon Ferrying Souls to Hell*, with its swarm of massed, despairing humanity, is depicted with all the intensity of their wretched plight. The terrifying figure of Charon, beautifully described in Virgil's epic *Aeneid* as well as by Dante, glowers over his charges with crazed eyes and an unkempt, flowing beard. His impressively detailed musculature bears the hallmarks of Michelangelo's (1475-1564) influence on Sabatelli and perhaps also conjures up the figures of William Blake (1757-1827). On the far shore, the delicately rendered figures of Dante and Virgil can be seen gesticulating and conversing with each other. Whilst Charon is represented in a strikingly different fashion in

Luigi Sabatelli, *Charon*, c.1795, Private Collection (Figure 1)

figure 1, the presence of Dante and the great classical poet is the same. They can be seen on the far left, and in both drawings the two poets wear crowns of laurel leaves to symbolise a supreme mastery of their literary craft.

Sabatelli was regarded by some as the most talented of Tuscan painters after Pietro Benvenuti (1769-1844). After studying in Florence he settled in Rome and in 1808 he accepted a professorship of painting at the Academy of Fine Art in Milan. One of his finest achievements was his series of frescoes based on Homer's *Iliad* that now adorn the walls of the Picture Gallery in the Pitti Palace, Florence.

[1] Collection F19/2.
[2] Brejon de Lavergnée B., see lit., p. 209, no. 598, reproduced.
[3] Paolozzi Strozzi, B., see lit..

DOMENICO PIOLA

(Genoa 1627 - Genoa 1703)

Bathsheba Attended by Two Women

pen and brown ink and wash, over traces of black chalk; squared in black chalk
28.2 x 42.1 cm (11 x 16 ½ in)

Provenance: J.A. Gere;
with Hazlitt, Gooden and Fox, Ltd., London;
acquired in 1994 by the previous owner

'And it came to pass in an eveningtide, that David arose from his bed, and walked upon the roof of the king's house: and from the roof he saw a woman washing herself; and the woman was very beautiful to look upon.'
- II Samuel 11:2

MARRIED ORIGINALLY TO URIAH THE HITITTE, the story of Bathsheba's seduction by King David is told in II Samuel. While walking on the roof of his house, the King caught sight of her bathing and sent messengers to bring her to him. He then seduced her and made her pregnant. In an attempt to conceal his sin David summoned Bathesheba's husband, Uriah, back from the army that he was away commanding in the hope that he would re-consummate his marriage to Bathsheba and assume the child already conceived to be his own. Uriah, however, elected to stay with his men rather than return home to his wife. After repeated efforts to convince Uriah to lie with Bathsheba, the king gave orders to his general Joab that Uriah be abandoned in the midst of a fierce battle and left to die at the hands of the enemy. Ironically, David had ordered Uriah himself to bear the message that ultimately led to his death. With Uriah dead, David made the now widowed Bathsheba his wife.

In his characteristically detailed style, see fig. 1, Domenico Piola has captured the moment at which Bathsheba is completing her toilet with the assistance of her two handmaidens. He has faithfully transposed the well-known biblical scene into a contemporary Italian palazzo. Bathsheba, correspondingly, is portrayed as a high-born Italian woman reclining back on a plump, tasselled cushion. The accoutrements of her toilet, the perfume bottle and jewellery, lie casually on an ornate Baroque table decorated with gargoyles. Dominating the left foreground of the composition is an opulently carved urn filled with flowers. In faint outline, a building can be seen in the distance which, in many other renditions of the same subject matter, represents the roof from where David spied her. Often he is pictured, but in this drawing he is absent. It is possible that if this were a preparatory sketch for further work, David would be added in later. Indeed a painting of this subject with many of the same elements, but differing in composition, is in a private collection in Genoa.[1]

Piola, a prolific draughtsman, designed many prints and frontispieces for books. He was also an outstanding painter and the leading artist in Genoa

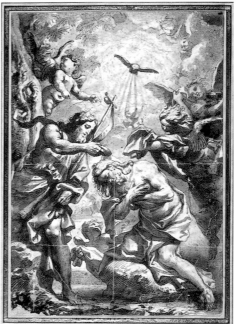

Domenico Piola,
The Baptism of Christ,
1670s,
The Hermitage,
St. Petersburg
(Figure 1)

in the second half of the seventeenth century, designing and executing ceiling frescoes for an astonishing number of Genoese churches and palaces. He derived his mature style in part from Giovanni Benedetto Castiglione (1609-1664), whose influence is very much in evidence from the undulating figures and diagonal composition of this present drawing. Piola also responded to the echoes of Parmigianino's (1503-1540) style that he found in the works of Valerio Castello (1624-1659).

[1] Sanguineti, D., *Domenico Piola e i pittori della sua 'casa'*, Soncino 2004, vol. II, pp. 318, 408, no. I.94, reproduced pl. XLVIII.

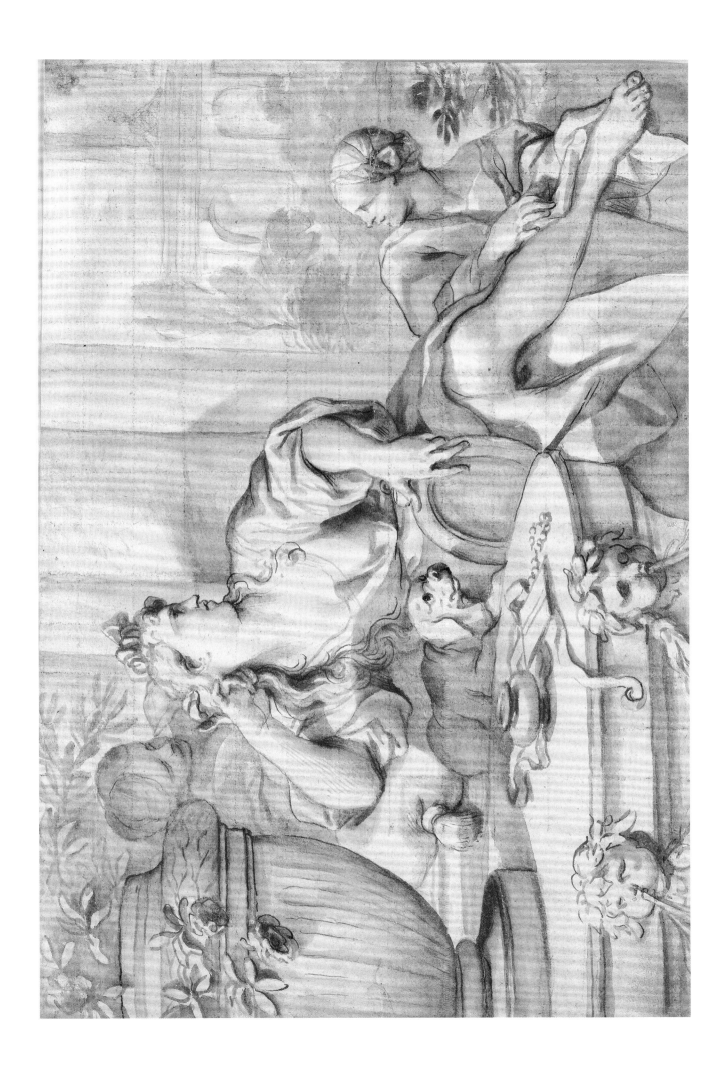

GIUSEPPE MARIA CRESPI

(Bologna 1665 - Bologna 1747)

Study of a Model Posed as a Nude Hercules

Verso: Study of a Male Figure

red chalk (recto); black chalk (verso)
29 x 35.3 cm (11⅜ x 13⅞ in)

Provenance: Mastai Ferretti Collection, Rome.

THIS SOLIDLY MUSCULAR STUDY OF A FIGURE masquerading as Hercules inevitably owes much to the time that Giuseppe Maria Crespi spent at a life-drawing academy, as well as to the figure drawings of Michelangelo. The seated Hercules' pose allows the artist to experiment with perspective, as the figure's enormous hand shows.

Jacob Bean has noted that Crespi's drawings and paintings often have little in common: 'it was only with brush in hand that he took those liberties that give his work its particular savour.'[1] This is in spite of the sometimes identical subject matter; Crespi did, for instance, fresco part of the Palazzo Pepoli in Bologna with *The Triumph of Hercules.* As a draughtsman, Crespi seems to have been a diligent *professore del disegno* working in an established Bolognese tradition. His *Hercules Holding a Club (Recto); A Nude Tracing a Circle with a Compass (Verso)* (fig.1) provides a useful comparison to the present work, especially the standing Hercules figure wielding a club. The style, both of this work, and of the present *Study of a Male Nude Posed as Hercules,* recalls the artistic style of one of Crespi's tutors, Maria Canutti (1625-1684).

The attribution to Giuseppe Maria Crespi was proposed by Donatella Biagi Maino, who has suggested that the present work must be a rare example of the artist's early style. In his youth, Crespi frequented the workshop of the Bolognese Carlo Cignani (1628-1719) and in the mid 1680s he attended a drawing academy headed by Cignani. When his master left for Forli, Crespi took over his studio with Giovanni Antonio Burrini (1656-1727).

Donatella Biagi has associated the present sheet with Crespi's assiduous studies made in life-drawing academies, which he was attending at that time in the Casa Ghisilieri. She makes an interesting comparison with the red chalk standing academy, now in Stuttgart,[2] although that seems closer to the tradition of the Accademia Carraccesca degli Incamminati.[3] The present study shares some similarities also with the work of Burrini.

Crespi was born in Bologna and, according to Waterhouse, his work represents, 'the last flash of genius in a dying school' and 'a deliberate reaction to all that was solemn and academic in the Bolognese tradition.'[4] In his youth he copied the frescoes of the Carracci family and the early altarpieces of Guercino (1591-1666). He was also heavily influenced by the Venetian school of artists including Correggio (1489-1534), Titian (c.1485/90-1576)

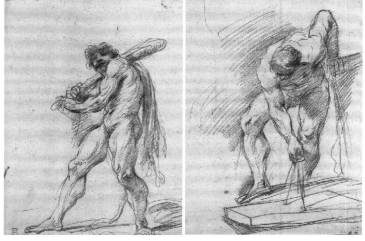

Giuseppe Maria Crespi, *Hercules Holding a Club (recto); A Nude Tracing a Circle with a Compass (verso),* Private Collection (Figure 1)

and Paolo Veronese (1528-1588). Crespi later drew artistic inspiration from north of the Alps, in particular in his commissions in Florence for Prince Ferdinand of Tuscany. In general, Crespi's *oeuvre* plays on several registers. He is known on the one hand for his genre scenes that depict every-day life, and the intimacy of which frequently carried over into his religious works, full as they are of tenderness and domestic details; at the same time, however, when depicting religious, antique or mythological themes, he produced works of a far more monumental and dramatic character, often with a decidedly tragic slant.

[1] Jacob Bean *Drawings by Giuseppe Maria Crespi, Master Drawings iv,* 1966, p. 419.
[2] Sammlung Freiherr Koenig-Fachsenfeld; see M. Pajes Merriman, *Giuseppe Maria Crespi,* Milan 1980, p. 73, reproduced fig. 32.
[3] M. Pajes Merriman, *Giuseppe Maria Crespi,* Milan 1980, p. 73, reproduced fig. 32.
[4] E. Waterhouse, *Italian Baroque Painting* (Second Edition), 1969.

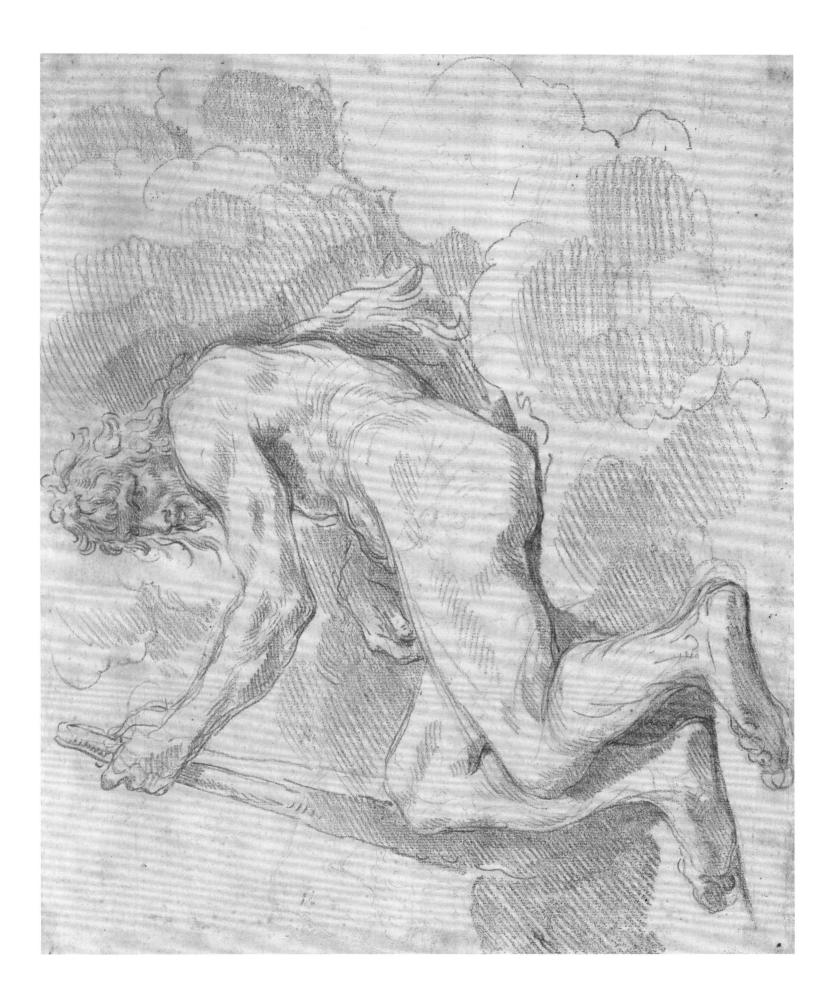

ANTONIO DOMENICO GABBIANI

(Florence 1652 - Florence 1726)

The Rape of the Sabine Women

bears inscription in pen and brown ink: 'P. Berretini'
pen and brown ink and wash over black chalk
24.1 x 33.7 cm (9½ x 13½ in)

Provenance: Sale, London, Sotheby's, 13 December 1973, lot 29 (as Ciro Ferri);
Herbert List (bears his collector's dry stamp twice, not in Lugt);
Flavia Ormond, London; acquired in 2000.

Literature: C. Monbeig Goguel, *Dessins Toscans XVIe-XVIIe Siècles 1620-1800*, vol. II, Paris 2005, p. 260, cat. no. 340.

THE RAPE OF THE SABINE WOMEN WAS A THEME popular from the Renaissance onwards as a story which championed the centrality of marriage for the continuity of families and cultures. The legend, narrated by both Livy and Plutarch, became an important foundation myth in the Roman psyche. The rape is said to have occurred shortly after Romulus founded Rome when his men found themselves without wives. The Romans attempted, ultimately unsuccessfully, to negotiate with the neighbouring Sabines but when they refused to allow their women to marry Romans, a plan was hatched to abduct the unsuspecting Sabine women. Inviting whole Sabine families to a festival venerating Neptune, Romulus ordered his men, at a signal, to seize the women and fend off their men folk[1].

The scene captured here by Antonio Domenico Gabbiani shows a mass of writhing bodies and Roman soldiers lifting them up. It is perhaps worth noting that the reference to rape in this context comes from the Latin *rapere* which means 'to seize'. Livy is very clear on the matter stating that Romulus offered the Sabine women free choice and promised them civic and property rights: 'They would live in honourable wedlock, and share all their property and civil rights, and - dearest of all to human nature - would be the mothers of free men.'[2]

The old attribution inscribed on this drawing is a testament to the pervasive influence that the works of Pietro da Cortona (1596-1669) exerted on Gabbiani, after he first saw them in Rome. Although his debt to Cortona's celebrated painting of the same subject, now in the Pinacoteca Capitolina, Rome, is obvious here, Gabbiani has imbued the composition with his own rhythm and energy (fig. 1). The arms of the women in Cortona's work owe much to the influence of Gian Lorenzo Bernini (1598-1680), particularly his *Apollo and Daphne*. Gabbiani absorbs this too and the influences of the two are readily apparent.

Carlo Maratti (1625-1713) and Pietro da Cortona were both strong influences on Gabbiani, who studied in Florence and Venice, and travelled extensively around Europe. He is chiefly known for his magnificent frescoes for the *palazzi* of the Italian aristocracy including the Strozzi-Ridolfi (1694), Corsini (1695), and Medici-Riccardi (1690-97) among many others. A large number of preparatory drawings survive for these decorative schemes and can be seen in the Uffizi, Florence.

Gabbiani received a number of commissions from the Medici family including requests to depict religious subjects. His *Christ Giving Communion to St. Peter of Alcantara in the Presence of St. Teresa of Avila* (1714, Schleissheim, Neues Schloss), which shows the influence of Sebastiano Ricci (1659-1734), was possibly commissioned by Cosimo III for his daughter Anna Maria Luisa de' Medici. Other religious commissions include those for the *Assumption of the Virgin* and the *Virgin and Child with the Symbols of the Passion* (both 1720-22, Florence, Uffizi). These paintings, and many of his later works, reflect both the paintings of Ricci (see inventory) and the classicism of Maratti.

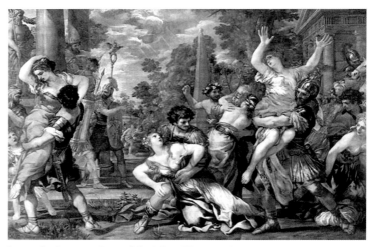

Pietro da Cortona, *Rape of the Sabine Women*, 1629,
Pinacoteca Capitolina, Rome (Figure 1)

[1] Livy, *The History of Rome* 1.9.
[2] Livy, *The History of Rome* 1.9.
[3] Anna Lo Bianco, et al., *Pietro da Cortona*, exhibition catalogue, Rome, Palazzo Venezia, 1997-98, no. 36.

GIOVANNI FRANCESCO GRIMALDI, IL BOLOGNESE

(Bologna 1608 - Rome 1680)

Landscape near Viterbo

annotated 'Bolognese' (lower left)
annotated on the reverse 'Veduta presso Viterbo di Giovi Francesco Bolognese'
quill and brown ink
21.5 x 36.5 cm (8½ x 14⅜ in)

GIOVANNI FRANCESCO GRIMALDI'S *LANDSCAPE near Viterbo* is a brilliantly constructed composition containing a plethora of landscape elements. In the foreground is a river, which winds its way through the undulating Italian landscape to the background of the work, where a towering mountain dominates the horizon. In the foreground, the work is dotted with several medieval buildings of this hamlet near Viterbo, an ancient city in the Lazio region of central Italy. A stone bridge on the right-hand side leads to a fortified building, whilst on the left-hand side there is a Romanesque church, as well as various other buildings dotted along the riverbank. In the foreground, a dense variety of trees, plants and shrubs create delicate patterns across the work.

Grimaldi uses long, thin quill marks to portray this landscape, varying the density of these marks in order to create some tonal distinction and a sense of the different textures. Whereas the bare stone bricks of the buildings are lightly treated, the hatching used to portray the surrounding foliage is denser and the line occasionally thicker. Grimaldi unifies these styles to create a landscape which is bright and airy and enhanced by the white of the paper, which he allows to shine through.

The same relatively sparse use of line can be found in the majority of Grimaldi's drawings, an example being *Path Leading to a Fortress, near a Pond*

Giovanni Francesco Grimaldi, *Path Leading to a Fortress, near a Pond*, The Louvre, Paris (Figure 1)

(fig. 1). In this drawing different types of line are used to indicate various surfaces, with heavy hatching and thick line predominantly used on the trees. Overall the scene is imbued with the same bright sunshine, with only the faintest hint of cloud in the sky, giving the work an airy and still atmosphere.

In terms of composition, the two works are very similar and reflective of the techniques used by Grimaldi in much of his work. The eye is led from the foreground through the picture by a clear progression of planes culminating in a mountainous background. His landscapes are spacious and tranquil and the scenes are usually animated by figures or large fortified buildings, their heavy bulk contrasting with the numerous natural features. Often, as is the case in the works illustrated, a body of water is included in the foreground, and the reflections off the still water accentuate the sunny atmosphere.

Grimaldi was both an architect and painter, and was known as il Bolognese from the place of his birth. He was a relative of the Carracci family, under whom it is presumed he was first apprenticed. He went to Rome, and was appointed architect to Pope Paul V and also patronised by succeeding popes. In Rome, Grimaldi regularly collaborated on public decorations with other artists, including Alessandro Algardi (1598-1654) and Gaspard Dughet (1615-1675). His landscapes were popular with many of the most important Roman families, such as the Santacroce, the Pamphili and the Borghese. In 1648, he was invited to France by Cardinal Mazarin, and for roughly two years he was employed in building projects for the minister and for Louis XIV, in addition to fresco painting in the Louvre. He executed history paintings and portraits, as well as landscapes, but it was this last genre that seems to have favoured, especially in his later years. He often produced engravings and etchings from his own landscapes and also from those of Titian and the Carracci. Returning to Rome, he was made *principe* of the Accademia di San Luca. He made many drawings, mainly in pen and ink with brown wash, often on blue paper, which demonstrate an accomplished variation on the Bolognese tradition, established by artists such as Annibale Carracci (1560-1609) and Domenichino (1581-1641). His many etchings and drawings spread the influence of the Bolognese landscape throughout Europe. In both his paintings and engravings he was assisted by his son Alessandro. His mistress was Elena Aloisi, daughter of the painter Baldassare Aloisi (1577-1638).[1] It was in Rome that Grimaldi died, in high repute not only for his artistic skill but for his upright character and charitable deeds.

[1] Charles Dempsey, 'The Carracci Postille to Vasari's Lives', *Art Bulletin* 68 (1), March 1986, pp. 72-76.

FRANCESCO GIUSEPPE CASANOVA

(London 1727 - Brühl 1803)

A Shepherd's Family Travelling with their Flock

signed 'F. Casanova.' (bottom right)
lead pencil and sepia wash
56.5 x 41.5 cm (22¼ x 16⅞ in)

Provenance: Veil-Picardy Collection, Paris.

FRANCESCO GIUSEPPE CASANOVA'S DRAWING SHOWS A group of travellers making their way through a rocky landscape. The path, up which the travellers make their way, is framed by a wall of rock and a withered tree, so that the viewer's eye is led back into the extensive background. The group of people file through the scene, surrounded by their animals. The sheep suggest that they are shepherds, though their group of animals also includes a dog, horses and two heavily-laden mules. The heavy and full parcels they are carrying with them suggest that they are nomadic, perhaps moving to higher fertile grounds to graze their livestock over the summer months. On the left-hand side a figure kneels to pick something off the ground whilst to his right, another guides one of the mules. He points at something, perhaps warning the young family who follow of some uneven ground. At the back of the group another shepherd waits patiently for the flock, who slowly amble along behind the others.

In *A Shepherd's Family Travelling with their Flock,* Casanova has placed his figures in the type of rugged, rocky landscape that recurs throughout his work. The ground is uphill, barren and uneven. There is a wall of rock on the left-hand side, and the few trees that are in the scene are relatively bare with snapped branches. Casanova often depicted this sort of rough landscape, for example in *The Waterfall* (fig. 1). This drawing is characterised by the torrent of water spewing out from the craggy rock. It is a depiction of a nature which is wild and untamed. Despite being focused around the water it is in a similar vein to that of *A Shepherd's Family Travelling with their Flock.* Both drawings also demonstrate Casanova's tonal variation. In *A Shepherd's*

Francesco Giuseppe Casanova, *Resting Herdsmen with Donkey and Herd,* Albertina, Vienna (Figure 2)

Family Travelling with their Flock the area where the family are is illuminated, whereas the surrounding ground is cast in shadow. Similarly, in *The Waterfall* a bright light shines on the water and the top of the rock and other parts of the drawing remain untouched by the intense sunshine.

Although born in London, where his actor parents had been touring, Casanova was raised in Venice and the art of that city was an important influence on his career. According to the *Mémoires* of his brother, Giovanni Giacomo (1728/30-1795), Casanova studied drawing with Gianantonio Guardi (1699-1760) (see catalogue no. 26) for ten years in Venice. In 1757 Casanova began working in Paris and quickly became a much sought after court painter of battle, hunting and equestrian scenes and his work was critically well received when exhibited at the Salon. In addition to numerous military paintings he also painted many landscapes, which are often dotted with rural figures such as farmers or shepherds, as seen in both *A Shepherd's Family Travelling with their Flock* and other works such as *Resting Herdsmen with Donkey and Herd* (fig. 2). By about 1772, he had begun to design tapestry cartoons for the royal factories in Beauvais and Aubusson whilst continuing to exhibit publically until 1783 when he returned to Venice. Other significant patrons from the latter stages of his career included Prince Nicolas Esterházy of Hungary, Ferdinand IV, the Bourbon King of Naples and Catherine the Great of Russia.

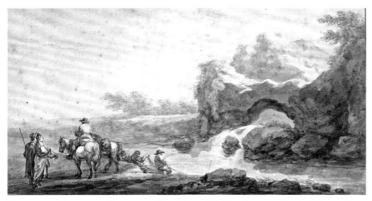

Francesco Giuseppe Casanova, *The Waterfall,* The Louvre, Paris (Figure 1)

TOMMASO MARIA CONCA

(Rome 1735 - Rome 1822)

The Rest on the Flight into Egypt

signed with the artist's abbreviated first names in black chalk on the fallen stone 'TÙM. / MAP / V.D.' (lower right)
black chalk, within black chalk framing lines
45.9 x 51.8 cm (18⅛ x 20⅜ in)

Provenance: with Crispian Riley-Smith, London, acquired in 2001;
Jeffrey E. Horvitz.

THE PRESENT DRAWING DEPICTS A MOMENT IN the Holy Family's escape from the infanticide of King Herod. The figures have obviously been resting and are now preparing to set off again. Joseph hails a boatman whilst gathering their belongings and Mary picks up her son. Details, such as the sphinx, hieroglyphs and distant obelisk, create a setting which is overtly Egyptian, whilst the Grecian style signature reflects a general interest in the ancient world on the part of Tommaso Maria Conca. This interest is confirmed by another treatment of the same subject by the artist, which is in the collection of the Accademia Nazionale di San Luca, Rome, although here the family are amongst Roman, rather than Egyptian relics.[1]

The Rest on the Flight into Egypt, although one of the few works that Conca attempted with a biblical subject matter, is characteristic of his work in its concision and balance of composition, a prominent feature of his other drawings such as *The Finding of Moses* (fig. 1). In the present work the Virgin and Child are bathed and highlighted by a soft light. The inward movement of both Joseph and the boatman helps direct our attention to mother and child. Similarly, in *The Finding of Moses,* the figures, which are arranged in a frieze-like manner, create a sense of movement which leads to, in this case, Bithiah, daughter of the Pharaoh of Egypt, who receives the infant Moses in her arms. The narrative, although slightly more complicated, is immediately discernable. The baby has clearly been lifted from the basket that lies on the ground, and the attention given to the child by the surrounding figures confirms his importance. In both works, the figures have a similar sculptural solidity; their movements and contours are firm and definite, with heavy drapery, defined by deep, shadowed folds. In *The Finding of Moses,* again the setting is conveyed with Egyptian architectural detail.

Conca was the pupil of both his father Giovanni Conca (b. *c.*1690), as well as his more famous uncle Sebastiano Conca (1728-1779) (catalogue no. 33). By 1770, Conca was in Rome and working in the orbit of Anton Raphael Mengs (1728-1779), and possibly on the decoration of the Coffee House in Villa Albani. Conca went on to become one of the better known decorators of the late eighteenth and early nineteenth centuries. His early works reflect a degree of research which gained him a prominent position as a late Rococo artist and exponent of nascent neo-Classicism. In 1775, having been commissioned by Prince Marcantonio Borghese, he started working at the Villa Borghese, notably in the Sala Egizia which is concerned with the evocation of ancient Egypt. In 1786 he decorated the Sala delle Muse at the Museo Pio-Clementino in the Vatican Palace, and the dome of the cathedral of Città di Castello. These important fresco cycles established Conca as one of the most outstanding figures in the sphere of Roman neo-Classicism. His work was usually of mythological subjects, treated in the tradition of the Carracci, whose influence is evident in the head of the boatman in *The Rest on the Flight into Egypt*. In 1770 Conca was elected to the Accademia di San Lucca, and in 1793 he became *principe*. His son Giacomo was also a painter, and executed his designs for the Egyptian Room in the Palazzo Lignani-Marchesani.

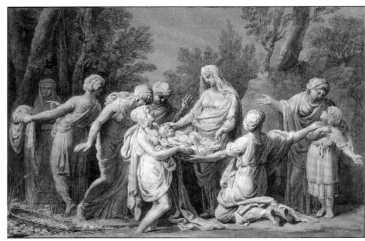

Tommaso Maria Conca, *The Finding of Moses,* 1810-1820,
Philadelphia Museum of Art, Pennsylvania (Figure 1)

[1] See S. Rudolph (ed.), *La pittura del 1700 a Roma,* Milan 1983, no. 199.

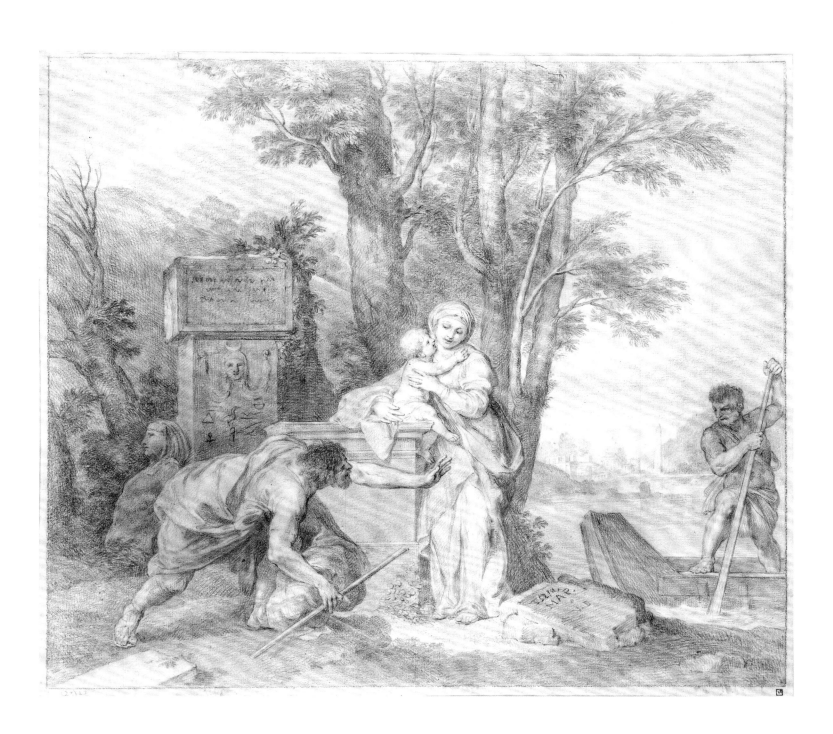

PIETRO GIACOMO PALMIERI

(Bologna 1737 - Turin 1804)

A Peasant Family and their Animals among Classical Ruins

signed 'Palmieri. In. fe cc.' (lower centre, on a rock)
black chalk, pen and brown ink, brush and grey and black ink, grey, black and brown wash, heightened with white
36.2 x 54.6 cm (14¼ x 20½ in)
and a drawing attributed to Pietro Giacomo Palmieri, *Landscape with Peasant*

PIETRO GIACOMO PALMIERI'S DRAWING SHOWS A crumbling architectural ruin set in a slightly wild and overgrown landscape. An old lady and child are standing beneath one of the archways whilst a man on a horse, who is guiding sheep and accompanied by a dog and a donkey, looks down on them. The building is short, squat and carved from huge lumps of stone, its imposing form dominating the scene. The ruined state of the structure creates a worn and dilapidated air to the scene, its base is cracked and crumbling, the remnants of the tower above are barely standing, and creepers and plants have begun to take over. The surrounding landscape also contributes to this mood; huge boulders, bare and windswept trees and a dark and stormy sky suggest an atmosphere of untamed nature. This type of rugged and weathered landscape is typical of Palmieri's work.

One of the most prominent aspects of *A Peasant Family and their Animals among Classical Ruins* is the range of tonal contrasts that Palmieri has applied to the work. This is a recurring characteristic of Palmieri's drawings, as evidenced by *Landscape with Three Woman Dressing to Leave the Bath* (fig. 1). In this work the strong *chiaroscuro* of the women and animals in the centre of the drawing, achieved by the use of a bright light, is mediated by the variety of tone in the surrounding shadows. Although in *A Peasant Family and their Animals among Classical Ruins* these contrasts are perhaps not as stark, there is, however, greater variety to them on account of Palmieri's use of different washes.

Palmieri was born in Bologna, where he studied at the Accademia Clementina di Bologna with Ercole Graziani (1688-1765). He was invited to Parma by Guillaume du Tillot, a leading minister who was trying to make the court a cultural centre. It was in Parma that Palmieri developed his style of landscape, for which he was later to become recognised. His works generally reveal a strong debt to seventeenth-century Dutch art, Italian painters, such as Salvator Rosa (1615-1673) and Guercino (1591-1666), and contemporary French works, particularly those of Claude-Joseph Vernet (1714-1789) (see inventory). Typically, a few rustic figures, possibly with accompanying animals, are often dotted about rugged, isolated landscapes, which have clearly been moulded by the passing of time; a group of these landscapes were engraved and published as *Il Libro dei paessaggi* in 1760. Having lived in Paris for eight years Palmieri moved to Turin in 1779, where he worked for the Savoy court as an advisor for the royal collection of prints and drawings. He also produced witty *trompe l'oeil* drawings and accomplished compositions consisting of assemblages of prints.

A Peasant Family and their Animals among Classical Ruins is accompanied by *Landscape with Peasant*, a drawing attributed to Palmieri (fig. 2)

Pietro Giacomo Palmieri, *Landscape with Three Women Dressing to Leave the Bath*, The Louvre, Paris (Figure 1)

Attributed to Pietro Giacomo Palmieri, *Landscape with Peasant*, accompanying drawing (Figure 2)

JEAN-ANTIONE JULIEN, CALLED JULIEN DE PARME

(Cavigliano 1736 - Paris 1799)

The Marriage of Alexander to Roxana

signed and dated 'julien I [Invenit]. 1768, à Rome' (lower right)
black chalk, pen and brown ink, brown and grey wash, heightened with white
on lightly washed paper, watermark encircled fleur-de-lys
33.2 x 45.9 cm (13⅛ x 18⅛ in)

Provenance: An unidentified collector's mark PBR *(verso)*.

ROXANA WAS THE FIRST OF ALEXANDER THE GREAT'S wives. Daughter of Oxyartes, a baron from Bactria, a region which now encompasses Afgahistan, Uzebekistan, Taijikistan, she was betrothed to Alexander on the capture of Sogdiana. Robin Lane Fox writes on Alexander's nuptials, 'Roxana was said by contemporaries to be the most beautiful lady in all Asia. She deserved her Iranian name of Roshanak, meaning "little star". Marriage to a local noble's family made sound political sense. But contemporaries implied that Alexander, aged twenty-eight, also lost his heart. A wedding feast for the two of them was arranged high on one of the Sogdian rocks. Alexander and his bride shared a loaf of bread, a custom still observed in Turkestan. Characteristically, Alexander sliced it with his sword.'[1] Alexander fell passionately in love with Roxana, and was determined to raise her to the rank of his consort. She accompanied Alexander all the way to India, and bore him a child, Alexander IV, six months after Alexander the Great's death.

Jean-Antoine Julien, known as Julien de Parme, is now recognised as one of the precursors of neo-Classical painting. Born in Switzerland, he settled in Rome in 1760, after a short sojourn in Paris. In Italy his main patron was Guillaume-Léon du Tillot, Marquese de Felino (1711-1774), Prime Minister of the Duchy of Parma. Each year, du Tillot would commission a large historical picture from the artist, who, as a sign of his gratitude to the court of Parma, decided to adopt the name Julien de Parme. When du Tillot fell from power in 1772, de Parme followed him into exile in Paris. Whilst there, his works did not meet with the success he was expecting, and his career ended in obscurity and poverty. His *Journal* as well as his published correspondence with the Belgian painter André-Corneille Lens (1739-1822) serve as invaluable documents of artistic life in Rome and Paris at the end of the eighteenth century.

This drawing is a study for *The Marriage of Alexander to Roxana* painted in 1768 for the court of Parma, now in the Palazzo Pitti, Florence.[2] The present work was followed by another developed composition, closer to a work now in a French private collection,[3] which demonstrated de Parme's equal interest in both antiquity and in the great masters of the Renaissance, as is typical of de Parme's work. It has often been noted that the initial source of inspiration for de Parme's composition was a fresco of the same subject, executed in 1512 by the Italian Mannerist painter il Sodoma (1477-?1549) at the Villa Farnesina. The influence of Sodoma's fresco is evident in de Parme's *The Marriage of Alexander to Roxana*, where the placing and the postures of the main protagonists of the scene are directly borrowed from il Sodoma's composition. The version in the Pitti is closer to the now lost composition by Raphael (1483-1520) on which Sodoma based his fresco, and which de Parme would have known through an engraving by G.J. Caraglio (*c*.1500/05-1665).

Interestingly, de Parme acquired a drawing at the sale of the famous collection of Pierre-Jean Mariette, then considered to be Raphael's study for his Marriage of Alexander to Roxana. Long regarded as having been executed by one of the members of his studio, it has recently been reattributed to the master himself.[4]

The son of a stone-mason, de Parme received his initial training in Craveggia under a local artist, Giuseppe Borgnis, with whom he spent two years. By 1760 he was in Rome, where he threw himself into the study of the antique. He quickly proclaimed his scorn for such contemporaries or immediate predecessors as Gian Lorenzo Bernini (1598-1680) and Carlo Maratti (1625-1713) in Italy, and François Lemoyne (1688-1737) in France, though he was full of praise for Raphael, Polidoro da Caravaggio, Carracci and Domenichino (1581-1641). Indeed, Domenichino's work was to exert a very strong influence on him. De Parme's earliest known extant picture is a life size painting of *Cupid* (1762), currently in the Barbieri private collection in Parma, which exemplifies the main features of his style. It is inspired by classical sculpture, and the effect of the careful composition is heightened by the subordination of colour to line.

De Parme travelled to Venice in 1771 but was unimpressed by what he saw there, preferring instead the work of Giulio Romano (*c*.1499-1546) at the Palazzo del Te in Mantua, through which he passed on his return to Rome. In May 1773 he left Italy for Paris. He did not enter the Académie Royale but enjoyed the patronage of du Tillot. After du Tillot's death in 1775 de Parme found another patron, Louis-Jules-Barbon Mancini-Mazarini, Duc de Nivernais (1716-1798), for whom he was to work for the next twenty years.

[1] Robin Lane Fox, *The Search for Alexander*, 1980, p.298.
[2] P. Rosenberg, in *Julien de Parme 1736-1799*, exhibition catalogue, Rancate, Pinacoteca Cantonale and Parma, Fondazione Magnani-Rocca, 1999-2000, no. 20.
[3] P. Rosenberg, ibid., no. 21.
[4] *Roma e lo Stile Classico di Raffaello*, exhibition catalogue, Mantua and Vienna, 1999, no. 81.

GIOVANNI BATTISTA TIEPOLO

(Venice 1697 - Madrid 1770)

Death of Seneca

pen and brown ink and grey wash over black chalk
42.8 x 28.2 cm (16⅞ x 11⅛ in)

Provenance: sale, London, Christie's, 5 July, 1983, lot 128;
Private Collection.

CHARGED WITH CONSPIRACY BY EMPEROR NERO, Seneca chose to commit suicide rather than face the humiliation of execution. This narrative tale was a popular subject in Italy in the 1700s and reflected the revival of interest in Stoicism. Stoic philosophers, like Seneca, argued for the control of the emotions, and his suicide embodied this repression of feeling. Having slit his own wrists and taken poison, Seneca slips into unconsciousness and is helped into a warm bath of water by some compassionate friends in order to hasten his death.

Giovanni Battista Tiepolo's dashing, fluid manner of drawing has its origins in the work of Luca Giordano (1634-1705), whose influence is readily apparent in this early drawing dating from the 1720s. Soon after this, Tiepolo began to seek inspiration from the works of artists from his native Venice, particularly Giovanni Battista Piazzetta (1682-1754), but here the theatrical poses, intense characterisation and narrative clarity, as well as the use of broad, relatively evenly applied washes, all indicate the importance of the earlier influence of Giordano.

The rapidity of execution that Tiepolo used, which was also derived from Giordano, enabled him to produce a very substantial number of drawings during the course of his career, but early drawings of this type are, in fact, rather rare. The most comparable studies to the present work include *The Decapitation of a Bishop* (Civici Musei di Storia e Arte, Trieste), and *Roman Sacrifice* (Fogg Art Museum, Harvard University). The latter may be linked with Tiepolo's Ca' Dolfin decorations of 1728.

Also known as 'Giambattista', Tiepolo was one of the most brilliant and sought after Italian painters of the eighteenth century, and embodies the ultimate achievement of the Venetian tradition of decorative painting in the Grand Manner. He also painted numerous large-scale oil paintings and a wide repertory of oil sketches, and he was an accomplished draughtsman as well as a successful and original etcher. He had trained in Venice and been brought up to admire the achievements of the great Venetian Renaissance masters, above all Tintoretto (1519-1594) and Veronese (1528-1588). Thus Tiepolo was not inhibited by the more restrained classical tradition of ancient Rome and the legacy of the Renaissance, Baroque and neoclassical artists active there, from Raphael (1483-1520) and Michelangelo (1475-1564) to Pietro da Cortona (1596-1669). Yet through his interest in prints he was well aware of the inventive imagery of a wide range of seventeenth-century Baroque artists active outside Venice, including the Genoese artist Castiglione (1609-1664), Salvator Rosa (1615-1673), Stefano della Bella (1610-1664), and Rembrandt (1606-1669), all of whom exercised a strong influence on the range of his visual vocabulary. *Death of Seneca* exemplifies how Tiepolo, through rhetorical gesture and facial expression, created a theatrical sense of composition and design, and an imaginative appreciation of the physical context in which his work would be seen. Tiepolo became extremely successful at projecting narrative and telling a story with dramatic effect, whether of religious or secular subject matter. Above all, he could enrich and embellish historical and mythological themes by transforming them into poetic fiction. Invariably, in his response to both the natural world and the artistic tradition he inherited, he displayed a sense of fantasy and humour, and an exhilarating feeling of joy that had been conspicuous by its absence from so much art of the preceding Baroque era.

His early oil paintings, influenced by Piazzetta, Federico Bencovich (1677-1753), and Sebastiano Ricci (1659-1734) (see inventory) are notable for their expressive vigour, contorted figures, angular movement, dark and often murky tonality, dramatic lighting and crowded compositions; for example the *Sacrifice of Isaac* (Ospedaletto, Venice) and the *Madonna of Mount Carmel* (1721-22, Pinacoteca di Brera Milan). A decisive turning point, and the beginning of Tiepolo's career as a decorator, came with a commission from the Patriarch Dionisio-Dolfin (1663-1734) for his palace at Udine. Here he worked with the *quadratura* specialist Girolamo Mengozzi-Colonna (1688-1766). The resulting frescoes, of *c.*1726, are notable for their brilliant colouring and the juxtaposition of elegant figures in sixteenth-century dress within a sunny pastoral landscape.

When the present drawing was sold in 1983, the attribution was confirmed by Professor George Knox, after first-hand inspection.

FRANÇOIS BOUCHER

(Paris 1703 - Paris 1770)

Diana and Callisto

pen and brown ink over black chalk with touches of grey-brown wash, on paper washed pink,
within brown ink framing lines, with some retouching by a later hand
28.5 x 41.4 cm (11½ x 16⅓ in)

THE NYMPH CALLISTO WAS A FAVOURITE companion of the virgin goddess Diana. Callisto had vowed to remain chaste and to follow in the ways of Diana and she loyally accompanied Diana hunting as her constant companion. However, once Jupiter had caught a glimpse of the beautiful Callisto, he fell in love with her. Knowing that Diana had warned Callisto of the deceitful ways of men and gods, Jupiter cleverly disguised himself as Diana, *Jupiter in the Guise of Diana and the Nymph Callisto,* also by François Boucher, illustrates this scene (fig. 1). Once disguised, Jupiter then seduced Callisto and consequently she conceived a child. The subject of Diana and Callisto was drawn by Boucher on a number of occasions, but none of the studies appear to be preparatory for a painting or print. An elaborate *Diana and Callisto* in black chalk was sold in London at Christie's, in 1976, and another, executed in a similar technique to the present drawing, was previously in the Veil-Picard collection and sold in Paris, Artcurial, 19 December, 2006. The delicate, and highly distinctive combination of brown pen and wash over a paper washed pink was used by Boucher in a small group of drawings which date from the 1740s to the mid 1760s: see, for example, the *Young Garden Girl, c.*1760-5 in the Musée du Petit Palais, Paris, or the *Nativity, c.*1761.

Since the publication in the mid-nineteenth century of Edmund and Jules de Goncourt's famous essays, including *L'art du Dix-Hutieme Siécle,* Boucher has been considered by many to be the quintessential painter of eighteenth-century France. His voluptuous mythologies and elegant pastorals have been greatly admired as typical of the Rococo style. Boucher worked successfully in several genres: he treated mythological themes in different ways either with a delicate and very modern eroticism, as in *The Bath of Diana* (1742, Louvre, Paris); or otherwise with robust splendour, as in *The Rising of the Sun* (1753, Wallace Collection, London). He also painted scenes of contemporary fashionable life, including the delightful *La Marchande de odes* (1746, National Museum, Stockholm). He was a stylish portrait painter and his images of his most famous patron Mme de Pompadour are widely considered his best. He also painted landscapes in a sweetened version of seventeenth-century Dutch style. He occasionally painted devotional subjects, among them the graceful *Nativity* painted for Mme de Pompadour's chapel at Bellevue (1750, Musée des Beaux-Arts, Lyon). In all of these modes the predominant atmosphere is one of happy escapism, supported by an easy grace of style, a luscious touch, and shimmering, nacreous colouring.

In a career supported by wealthy private patrons, such as Louis XV and Mme de Pompadour, Boucher produced not only easel paintings but also cartoons for the Beauvais and Gobelins tapestry factories, made designs for Sèvres porcelain, painted decorative schemes for Versailles and Fontainebleau, and designed sets for theatre and opera. By his own reckoning he made more than 1,000 paintings and oil sketches, many of which are in the Wallace Collection, London. Boucher was granted the title of *Prem'er Peintre du Roi* on the death of Carle van Loo (1705-1765) (see inventory).

Boucher was born in Paris and trained with the engraver L. Cars, contributing to the scheme to engrave the works of Antoine Watteau (1684-1721), whose art exercised a formative influence. He also worked in the studio of François Lemoyne (1688-1737), one of the chief protagonists of the colouristic, Rubéniste tendency in France. In 1723, Boucher won the Académie Royale's *Grand Prix,* but it was not until 1727 that he left for Rome, at his own expense and in the company of Carle and Louis-Michel van Loo. There he fell under the spell of the decorative painters of the Baroque: Albani (1578-1660), Pietro da Cortona (1596-1669), and Luca Giordano (1634-1705). Returning to Paris in 1731, he was received as a member of the Academy in 1734 on his presentation of *Rinaldo and Armida* (Louvre, Paris). By 1736 his mature style was fully formed, altering little during his long and successful career.

François Boucher, *Jupiter and Callisto,* Pushkin Museum, Moscow (Figure 1)

FRENCH SCHOOL, EIGHTEENTH CENTURY

Four Views of Ports

black ink and grey wash
18 x 34.5 cm (7⅛ x 13½ in)
a set of four (4)

FOUR VIEWS OF PORTS SHOWS FOUR DENSELY POP-ulated port scenes buzzing with maritime and harbour-side activity. Some figures are engaged in heavy labour as they unload wares from the docked ships, whilst others are clearly leisurely strolling along the classical promenades. The dress worn by the figures indicates their differing social status; some are shown in torn and tatty clothing, while others appear in the elegant finery of the eighteenth-century upper classes. The artist has paid much attention to the varying activities of the figures to interest and attract the viewers' attention, for example the construction workers extending a dock, the architect consulting his drawings, the couple relaxing and drinking together in the sunshine and the figures seen firing cannons out to sea. The ports are jam-packed with ships further highlighting their importance as hives of local mercantile and social activity.

The drawings are reminiscent of the port scenes produced by Claude Lorrain (?1604/5-1682), for example *Port with Villa Medici* (fig. 1). Claude, by framing the scene with buildings and boats, forces the viewer's eye to the horizon and a similar technique has been used in *Four Views of Ports*. Furthermore, the dockside architecture in *Four Views of Ports* is in the same imposing classical style as the buildings that recur in much of Claude's work. Claude also populates the foreground with scenes of the day-to-day activities found in port cities.

Scenes of port life were popular in France during the eighteenth century and artists, such as Claude-Joseph Vernet (1714-1789) (see inventory) and Nicolas Ozanne (1728-1811), often produced similar marine landscapes. In

Claude Lorrain, *Port with Villa Medici*, 1637, The Uffizi, Florence (Figure 1)

the case of Vernet, whose work was also heavily influenced by Claude, his series of the *Ports of France* was one of the most important royal commissions of Louis XV's reign. Like *Four Views of Ports*, the *Ports of France* are also notable for the considerable detail used to imaginatively bring to life the multitude of activities taking place.

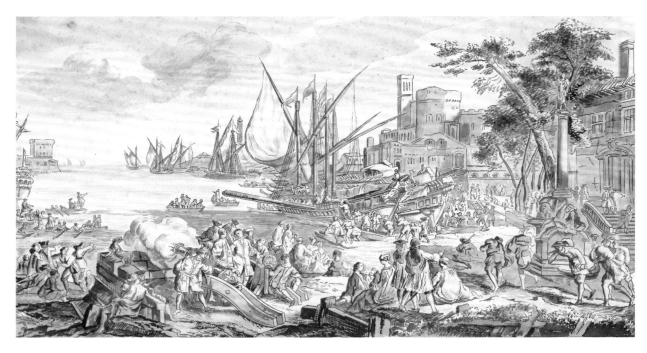

JEAN-BAPTISTE HUET

(Paris 1745 - Paris 1811)

A Shepherd and a Shepherdess Resting

watercolour on traces of black and sanguine chalk
19 x 24.5 cm (8 ½ x 9 ¾ in)

Provenance: Albuquerque, his stamp (lower right)

IN THIS CHARMING DRAWING, A YOUNG SHEPHERD reclines elegantly upon the lap of a young shepherdess, who appears to be about to place a garland of pink roses upon his head. She smiles at a small dog who regards her eagerly, his forepaws resting on her lap. The pretty couple have cheeks as pink as the roses, and seem to be barely more than children. A basket of roses is set beside them, while a few sheep lie placidly about. This happy gathering rests in a clearing before a tree and a stone ruin. The artist's use of rubbing to the background creates a bluish, hazy effect, suggesting the depth of the woods.

A Shepherd and a Shepherdess Resting is an example of the pastoral genre in the *petite manière,* in which a shepherd and shepherdess are presented as lovers, a genre popularised by Jean-Baptiste Huet's contemporary, the great Rococo artist François Boucher (1703-1770) (see catalogue no. 114). These pastorals were inspired by comic operas produced for the Théâtre de la Foire by Boucher's friend, Charles-Simon Favart (1710-1792). In our present pastoral, the young couple act out a scene of pastoral love in embellished costumes, in the spirit of Boucher. Huet also treated the pastoral theme in the medium of the print, creating such lyrical and dreamy scenes as *Shepherdess with Flock,* in which a lone shepherdess, seated by a ruined arch, appears lost in a reverie (fig.1).

Huet, both painter and engraver, trained with his father, Nicolas Huet, before being apprenticed to Charles Dagomer (fl.1762-1764), the animal painter. It was at this time that he began making prints and became acquainted with the print maker Gilles Demarteau (1722-1776), who subsequently made coloured chalk-manner engravings of Huet's and Boucher's works, replicating the effect of their drawings in chalks. It has been established that Huet collaborated with Boucher and Jean-Honoré Fragonard (1732-1806) (see catalogue no. 96) on a decorative scheme for

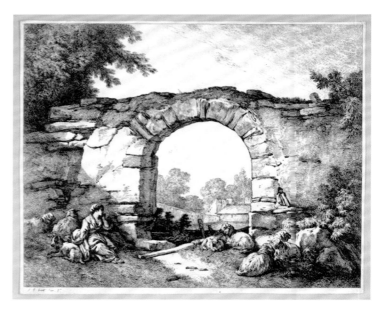

Jean-Baptiste Huet, *Shepherdess with Flock*, etching,
Harvard Art Museum / Fogg Museum, Cambridge, Massachusetts (Figure 1

Demarteau's house in Paris (Carnavalet, Paris).[1]

At the age of nineteen, Huet entered the studio of Jean-Baptiste Le Prince (1734-1781) (see inventory), who had trained with François Boucher. He was *agrée* (approved) by the Académie Royale, and in 1769 he was *reçu* (received) as an animal painter. He first exhibited paintings at the Salon in 1769, his *morceau de reception* (reception piece), *Fox in the Chicken Run*, being one of his most important works. When the French Revolution broke out in 1789, Huet became captain of the town militia at Sèvres, where he owned a country residence. He exhibited twice more at the Salon in 1800 and 1801, ten years before his death.

[1] J. Wilhelm: 'Le Salon du graveur Gilles Demarteau peint par Francois Boucher et son atelier avec le concours de Fragonard et de Jean-Baptiste Huet', *Bull. Mus. Carnavalet*, I (1975), pp. 6-20.

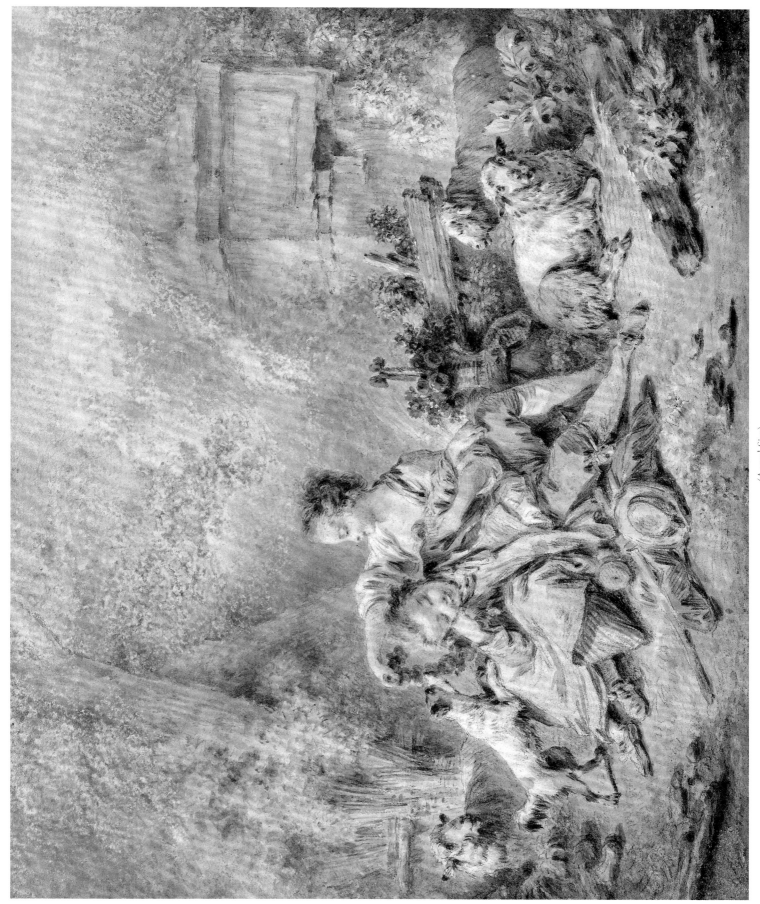

(Actual Size)

CLAUDE-LOUIS CHÂTELET

(Paris 1749 - Paris 1795)

View of Manfredonia in Puglia

inscribed in a later hand 'Stadt Ansicht von Manfredonia in Appulien/Cassas' (on the verso)
pen and black ink and watercolour over black chalk
20.9 x 33.5 cm (8¼ x 13¼ in)

Provenance: H.W. Campe (L.1391).

THIS BEAUTIFUL MONOCHROME DRAWING framed in a delicately structured composition seethes with activity. The diagonal line of the mountains fades out to highlight the stark outline of a Corinthian column, evidence of Manfredonia's classical heritage. A parallel line of clustered dwellings draws the eye to the horizon with its small flotilla of boats bobbing up and down. The composition is bilaterally divided by the central mound of rocks in the foreground, which creates a pleasing symmetry. In the far left foreground, an energetic man in blue pantaloons chivvies his oxen as they struggle with a load of wooden barrels. In contrast, a couple perch in tranquil repose at the base of the pillar whilst in the viewer's most immediate space a donkey pauses with its laden panniers as the two mounted upon it stop to converse.

The inscription on the *verso* is helpful in identifying the location of the view. The drawing is similar to views made in connection with the Abbé de Saint-Non's (1727-1791) *Voyage Pittoresque ou Description Historique des Royaumes de Naples, et de Sicile* which appeared in five volumes between 1781 and 1786, but the composition does not appear in that publication. On stylistic grounds, an old attribution to Louise-François Cassas (1756-1827) seems less convincing than one to Claude-Louis Châtelet, although both artists were involved in the project.

Principally a landscapist, Châtelet rapidly acquired a reputation as a talented young artist. Inspired by the drawings of Italy by Jean-Honoré Fragonard (1732-1806) (see catalogue no. 96) and Hubert Robert (1733-1808), he journeyed to Italy in the 1770s accompanied by the architect Louis-Jean Desprez (1743-1804). Together they undertook a series of sketches for a book commissioned by Saint-Non: *Voyage Pittoresque ou Description Historique des Royaumes de Naples, et de Sicile*. Fragonard made a second trip to Italy and it is thought that he met Châtelet and Desprez during his tour of 1773-1734. Whilst in Italy Châtelet executed a number of pieces depicting the elegant disintegration of the Tivoli Gardens that so moved his contemporaries. The gardens at the Villa d'Este, Tivoli were laid out in the 1560s and are famous for their ancient plantings of cypress trees (fig. 1). By the 1700s they were valued by artists for their air of romantic neglect.

On his return, Châtelet attracted the attention and royal patronage of Queen Marie Antoinette and became one of her favourite painters.

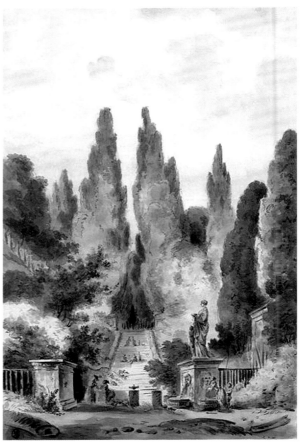

Claude-Louis Châtelet, *Les Grand Cypres de la villa d'Este, Tivoli*, Private Collection (Figure 1)

She commissioned him to record the Petit Trianon gardens and he also recorded many other picturesque parks in and around Paris including Bellevue and the Folie Saint-James, Neuilly. Despite this aristocratic patronage, Châtelet became seduced by revolutionary ideals and became a member of the Revolutionary Tribunal. He was sent to the guillotine in May 1795.

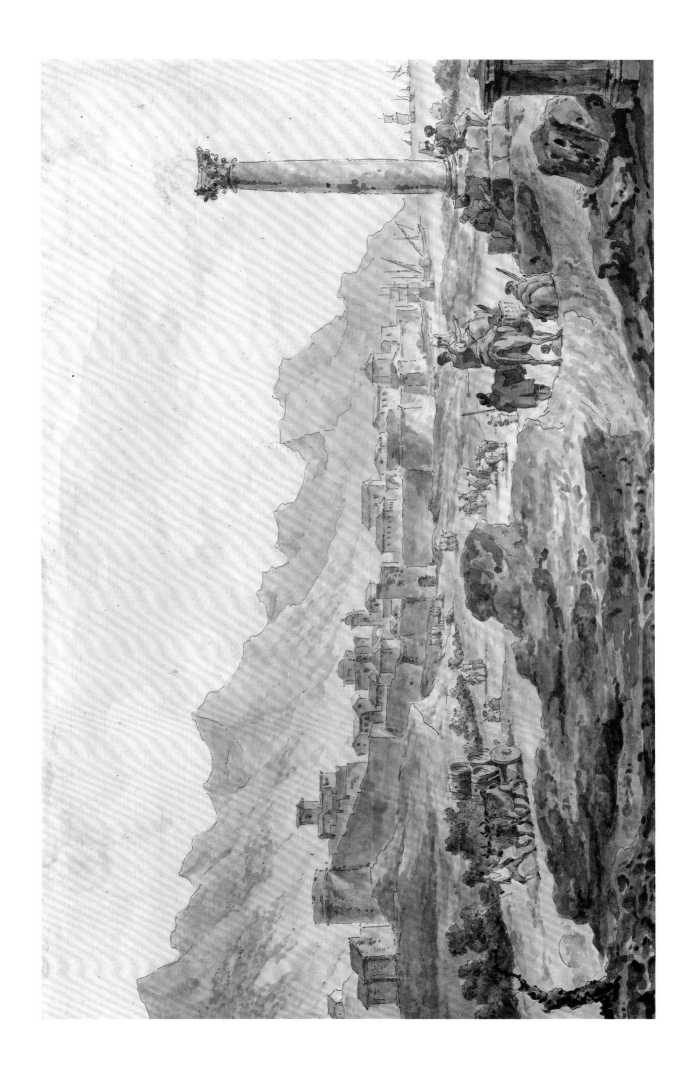

ATTRIBUTED TO

LOUIS-JOSEPH WATTEAU

(Valenciennes 1731 - Lille 1798)

The Bivouac

watercolour, gouache and oxidised white gouache
14.5 x 24.5 cm (5¾ x 9⅝ in)

Provenance: Anonymous sale, Paris Drouot Hotel, on June 4, 1947, Room 9, no. 90.

THIS CHARMING SCENE, ATTRIBUTED TO LOUIS-Joseph Watteau, combines the atmosphere of a *fête-galante* with the martially orientated themes that run throughout Watteau's works. A delicate, essentially monochromatic, background underlines the action at the fore of the work, which immediately captures the viewer's attention.

At the entrance to a low-slung tent, a moustachioed officer is seated, holding a glass in his right hand whilst his left elbow props him up, giving him the air of a man embarking upon some serious relaxation. He seems almost impervious to the palpably joyous couple frolicking nearby: a magnificently attired officer, complete with plumed hat and a splendid blue uniform with brass buttons, affectionately clasps his female companion around her waist. The little dog capers about in clear delight, evidently enjoying the couple's very public intimacy.

Standing placidly by, two horses relish the chance to rest, though that

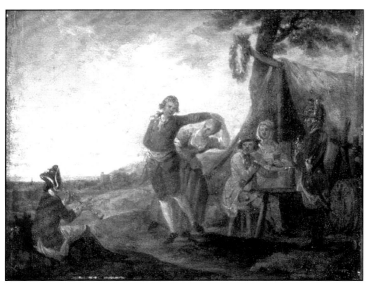

Louis-Joseph Watteau, *Scène de Camp*, Musée des Beaux-Arts, Valenciennes (Figure 1)

they are still fully saddled up suggests it will not be for long. The three figures trotting gently forward in the left-hand middle ground further enhances the notion that this foreground grouping is enjoying only a temporary respite and the bivouacs themselves were designed simply as interim encampments during military manoeuvres.

The artful figure arrangement of *The Bivouac* lends a remarkable sense of depth to the work. The main focus of the action is on the right-hand side of the composition which at once attracts the viewer's attention. In compositional terms, whilst this present work is attributed to the artist, a painting of a military scene by Watteau bears astonishing similarities to this exquisite watercolour (fig. 1). The same raised perspective of foreground action can be seen, as well as an almost identical grouping of figures outside a similarly detailed bivouac.

Watteau, also known as Watteau of Lille, was a nephew of the renowned artist Jean-Antoine Watteau (1684-1721) and borrowed much from his ancestor's whimsical rococo style. He trained under Jacques Dumont in Paris as well as at the Académie Royale. In 1755, he settled in Lille and became a teacher at the school of drawing though he was dismissed for introducing the then scandalous innovation of the study of the female nude. Over the course of his career he became a prolific draughtsman. Having returned to his home town, Valenciennes for fifteen years, Watteau succeeded Louis-Jean Guéret to the directorship of the school of drawing in Lille and established an annual salon in 1773, where he himself exhibited.

One of the more colourful aspects of his life played out in 1795 when he was asked to draw up an inventory of all works of art seized from religious foundations and the property of a huge number of aristocrats during the French Revolution. Ultimately, Watteau played a decisive role in the foundation of what would become the Musée Lillois des Beaux-Arts, which opened in 1803.

Watteau is chiefly remembered as a highly skilled genre painter who adapted the style of other family members to produce his own uniquely romantic and informal painting manner. He was a highly prolific artist, described by his contemporaries as *un peintre besogneux* ('a hard-working painter') and between 1773 and 1798, he exhibited around two hundred works in the Lille Salon. He exerted a great influence on his son, Francois Watteau (1758-1823) so much so that it is often exceptionally difficult to tell apart the work of father and son.

JEAN-BAPTISTE PILLEMENT

(Lyon 1728 - Lyon 1808)

Peasants Resting and Dancing to a Piper beside a Farm

signed and inscribed 'Jean Pillement l'an 4. D. La. R. [1795-6]' (lower left)
black chalk, stumping, grey wash, brown and black ink framing lines
35.5 x 48.3 cm (14 x 19 in)

THIS DRAWING BY JEAN-BAPTISTE PILLEMENT shows a group of peasants relaxing in the sunshine by the side of a farmhouse. On the left-hand side two men sit on a grassy bank, each talking earnestly to a woman. In the centre of the composition, another couple are dancing on the tips of their toes. The man is trying to take his partner's arm but she is distracted while in conversation with the group of figures who sit on the ground nearby. Musical accompaniment is provided by the young piper perched on a large barrel and beyond him another weary figure looks on. The landscape itself is uneven and grassy, dotted with rocks, shrubs and small piles of logs that are presumably used by the farm. The background is faint, although the occasional tree and contour of the mountains are still discernable. The whole scene is cast in light and bright sunshine.

Much of Pillement's work depicts groups of peasants within similar idyllic rural settings, an example being The Louvre's drawing *Group of Shepherds* (fig.1). Although this drawing does not have the same festive atmosphere as *Peasants Resting and Dancing to a Piper beside a Farm*, there is a comparable relaxed feel to the work. The three shepherds may be at work but one figure leans casually on his staff, another sits, while one is dozing. The two women, one of whom cradles an infant, are also sitting. There is no sense that the figures' lives are strenuous and the appearance of two sheep is the only evidence of any work taking place. The landscape appears slightly dry and rocky, although, as in *Peasants Resting and Dancing to a Piper beside a Farm*, it is covered with a thin layer of vegetation and bathed in a warm sunlight. It is another idealised vision of rural life, a genre in which Pillement specialised.

Stylistically, both drawings are executed in a similar manner, for instance in the sensitive treatment of the figures. They all share a broad solidity and the variation of poses demonstrates the artist's interest in the human figure. In *Peasants Resting and Dancing to a Piper beside a Farm*, for example, some figures are flamboyantly dancing while others are hunched on the ground; another lies on his stomach. Similarly, in *Group of Shepherds* the poses of the three male figures are deliberately contrasted. Much attention has been paid to the figures' clothing, which is baggy with deep folds. Pillement's focus has clearly been on the foreground landscape. This is treated carefully, with quick, precise lines, the thin grass dotted with individual plants and rocks. There is considerable tonal variety, with careful modelling of both the setting and the figures. While in contrast, only the faintest outline of the background is discernable and nothing more than an impression is provided.

Even in a drawing such as *Summer*, where the subject is very different, characteristic traits of Pillement are clearly evident (fig. 2). The setting provides a contrast between rock and foliage, both depicted through a precise use of line. His application of light remains paramount - bright sunshine set against dark shadow - and with the reflections visible in the calm river, light plays an even more pivotal role. Furthermore, the scene is relaxed, tranquil and happy. As in *Peasants Resting and Dancing to a Piper beside a Farm*, it is an exemplary illustration of Pillement's *oeuvre*, which led him to become a major contributor to the spread and taste for the Rococo throughout Europe.

Jean-Baptiste Pillement, *Group of Shepherds, c.*1772, The Louvre, Paris (Figure 1)

Jean-Baptiste Pillement, *Summer, c.*1759-1760, The Louvre, Paris (Figure 2)

JEAN-BAPTISTE MARIE PIERRE

(Paris 1714 - Paris 1789)

A Bacchanal: Naked Maenads Decorating a Herm

red chalk
22.3 x 17.8 cm (8¾ x 7 in)

Provenance: Sale, Paris, Hôtel Drouot, Maître Ader, 29 November, 1976, lot 21.

Literature: O. Aaron, *Cahiers du Dessin Français no.9, Jean-Baptiste-Marie Pierre,* Paris n.d., no's. 27, 29.

IN GREEK MYTHOLOGY, *MAENADS* WERE THE INSPIRED and frenzied female worshippers of Dionysus, the Greek god of mystery, wine and intoxication, known to the Romans as the god Bacchus. Their name translates literally as 'raving ones', as the mysteries of Dionysus inspired the women to ecstatic frenzy. The *Maenads* were entranced women, wandering under the orgiastic spell of Dionysus through the forests and hills. They were usually pictured crowned with vine leaves, clothed in fawn-skins, carrying the thyrsus and dancing with wild abandon. The *Maenads* are the most significant members of the *Thiasus*, the retinue of Dionysus (Bacchus in the Roman pantheon). The maddened Hellenic women of real life were mythologised as the mad women who were nurses of Dionysus in Nysa.

In early ancient Greece, Hermes was a phallic god of boundaries. His name, in the form *herma*, was applied to a wayside marker pile of stones, later with a square or rectangular pillar of stone or bronze topped by a bust of Hermes, and an erect phallus rose from the base. In the more primitive Mount Kyllini or Cyllenian herms, the standing stone or wooden pillar was simply a carved phallus. In Athens, herms were placed outside houses for good luck.

This extremely delicate and refined drawing is characteristic of Jean-Baptiste Marie Pierre's style, as also seen in two further works by him in The Louvre (figs. 1 and 2). The high level of finish in *A Bacchanal: Naked Maenads Decorating a Herm* suggests it was intended as a complete work on its own, but Pierre may have made a print after it, as he did of several of his drawings.

Highly talented, Pierre was a French painter, printmaker and draughtsman. The pupil of Charles-Joseph Natoire (1700-1777), he studied at the Royal Academy of painting and sculpture. Pierre won the *Grand Prix* of painting at the Academy in 1734, which enabled him to study in Rome. He became an Academician in 1742 and later became director of the Academy in 1778. He painted a ceiling in the new apartments of the Palais Royal representing *The Apotheosis of Psyché*. In 1754, he decorated the private theatre of the Duke of Orleans. In 1761, he was made Knight of the Order of Saint-Michel and, in 1770, he became the first painter to the King of France, replacing François Boucher (cat. no. 114). He was director of the Gobelins, and the Musée des Gobelins has many tapestries made after his cartoons. Although he painted a number of rustic genre scenes and was an occasional designer of vases and picture frames, he was principally active as a painter of large scale history and religious works. In this aspect of his output he forms a link in the eighteenth century tradition of French history painting that runs from Jean Jouvenet (1649-1717) to the neoclassicism of Jacques-Louis David (1748-1825). Pierre died on 15 May, 1789, just before the French Revolution.

M. Nicolas Lesur has kindly confirmed the attribution from a photograph and suggests a dating around 1755.

Jean-Baptiste Marie Pierre, *La Colère de Neptune,* The Louvre, Paris (Figure 1)

Jean-Baptiste Marie Pierre; inspired by Jean François de Troy, *Aman and Mardochee,* The Louvre, Paris (Figure 2)

(Actual Size)

NICHOLAES BERCHEM

(Haarlem 1620 - Amsterdam 1683)

A Peasant Couple by a Tree with Cattle and Sheep

pen and brown ink, brown wash, incised for transfer, pen and brown ink framing lines
11.1 x 14.9 cm (4⅜ x 5⅞ in)

Provenance: J. van Haecken (L. 2516).

NICHOLAES BERCHEM'S DRAUGHTSMANSHIP ranges from meticulous preparatory studies for etchings to a looseness of line verging on the abstract. *A Peasant Couple by a Tree with Cattle and Sheep* is a charming and elegant example of his free and more expressive drawing style. The most well-defined elements of the work are the sheep in the foreground, appearing contented and lethargic as they rest on the grassy hillside. Two are nestled together and a third sits on its own, with several others grouped nearby. A goat, clearly the most energetic member of the group, makes a vigorous attempt to climb a gnarled tree. A young woman sits at the base of the tree and next to her a man gestures with an outstretched hand towards the distance, perhaps indicating the next stop on their journey. A hefty cow stands at his side. The various elements of the composition are depicted with an economy of line that is impressive in its ability to express the mood and vitality of the scene. With a minimal application of brown wash, Berchem brilliantly captures the Italianate lighting effects that his work was famed for.

The image of a peasant couple tending their flocks is one that Berchem delighted in and used repeatedly in his paintings and drawings. *Cows Crossing a Ford with a Couple and a Dog* in the J. Paul Getty Museum, see fig. 1, has a number of compositional elements that correspond to the present work, not only in the presence of a man and woman with cows and sheep, but in the tree that anchors the group's movement. Although *Cows Crossing a Ford with a Couple and a Dog* is more fully worked up than *A Peasant Couple by a Tree with Cattle and Sheep*, it still retains a delightful informality akin to the present work. The medium of both works is primarily pen and ink and brown wash, and the style of execution is similar, particularly in the dashes that form the grass and the foliage of the tree in the present drawing, and which make up the background details of the Getty image.

Berchem was initially taught by his father, Pieter Claesz (*c.*1597-1660), who instructed him in drawing. According to Arnold Houbraken (1660-1719), Berchem went on to study with Jan van Goyen (1596-1656)

Nicolaes Berchem, *Cows Crossing a Ford with a Couple and a Dog*, 1656, J. Paul Getty Museum (Figure 1)

(see catalogue nos. 134 and 135), Claes Moeyaert (1591-1655), Pieter de Grebber (*c.*1600-1652/4), Jan Wils (*c.*1610-1666) and Jan Baptist Weenix (1621-?1660/61). Although he may not have had formal training with these artists, there are a number of parallels in their work. Berchem joined the Haarlem Guild of St. Luke in 1642 where he quickly acquired pupils. Although there is no documentary evidence that he ever visited Italy, the atmosphere and light in his work is distinctly Mediterranean in inspiration and Berchem was a prolific member of the second generation of Dutch Italianate artists. He is credited with over three hundred drawings and fifty etchings as well as more than eight hundred paintings. His work, which seems to foreshadow the Rococo style, was highly influential, particularly amongst French pastoral painters of the eighteenth century.

(Actual Size)

ATTRIBUTED TO

JAN PORCELLIS

(Ghent, before 1584 - Zouterwoude 1632)

Navy with Boat and Sailing Ships

black chalk with brown pen and ink, grey wash, heightened with white, on light brown paper
with traces of a frame in brown pen and ink, watermark Arms of Amsterdam
18.3 x 30.1 cm (4⅞ x 12 in)

Provenance: H. Hamal, with his inscription (Lugt 1231).

IN THE FOREGROUND OF THIS SMALL AND ATMOS-pheric drawing, a rowing boat with fishermen lurches in the waves as a standing fisherman steadies himself to catch two large fish with his rod. Beyond the fishing boat, a sailing boat lists to the right in the wind, along with the distant fleet of sailing ships on the far horizon and at the far left, the outline of a remote town can be glimpsed. While the nearer vessels and figures are drawn with pen and brown ink - the thick, defined lines evoking their proximity - the vessels further out to sea are sketched lightly with black chalk, creating an impression of a distant fleet vaguely seen. By depicting vessels diminishing in size and clarity, the artist achieves an illusion of a vast distance. Great emphasis is given to the expanse of sky, which occupies over two-thirds of the sheet; with grey washes forming billowing clouds, drifting in the wind. Touches of white in the sky and on the horizon evoke a pale sunlight, which catches the sails, while white highlights form the crests of the waves. Sky and sea merge in this monochromatic drawing, the light brown tone of the paper forming the mid tone for both.

Navy and Boat with Sailing Ships has been attributed to Jan Porcellis by Peter Schatborn, bringing this work closer to one outlined on a signed document in respect of the Frits Lugt Collection, Fondation Custodia, Paris.[1] Porcellis, who owned a small yacht which he sailed on the Dutch waterways, found his artistic inspiration in the atmosphere of sea and sky.[2] After settling in Haarlem in 1622, Porcellis pioneered a new, more naturalistic approach to convey the atmosphere of sea and sky through the adoption of a near monochromatic palette of light grey and brown tones, highlighted with white to evoke light and sea spray. This entirely fresh approach represented a radical break from the colourful, graphically detailed portraits of vessels of the Dutch fleet practised by Hendrick Vroom of Haarlem (*c*.1563-1640) and his generation. By 1624, the artist had not only painted the first atmospheric seascapes in muted, monochrome

colours, but had also become the first of the sky painters in Dutch art, evoking as he did the Dutch weather with its shifting changes in mood (fig. 1). His work was to have a profound impact on the art of the great landscape painters of the seventeenth century, Jan van Goyen (1596-1656) (see catalogue nos. 134 and 135) and Salomon van Ruysdael (1600/03-1670) (see inventory).

Porcellis was the son of the Flemish Captain Jan Pourchelles or Porcellis, who escaped Spanish persecution by emigrating to the Northern Netherlands. The family settled in Rotterdam, where Porcellis married in 1605. Porcellis is first cited as a painter in Antwerp, where he moved in 1615 following his bankruptcy in Rotterdam. He became a Master of the Guild of St. Luke there in 1617. The artist achieved success after his move to Haarlem in 1622, where his artistic innovations altered the course of Dutch marine and landscape painting. The artist's last few years were lived in Zouterwoude near Leiden, where he owned several properties.

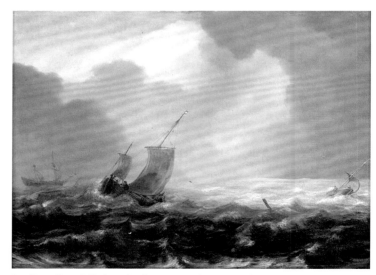

Jan Porcellis, *A Fishing Pink on a Windy Day*, *c*.1632, The National Maritime Museum, London (Figure 1)

[1] See the exhibition catalogue, *Eloge de la Navigation hollandaise au XVIIe siècle*, Dutch Institute, Paris, 1989, cat no. 41, pl. 19.

[2] Bob Haak, *The Golden Age, Dutch Painters of the Seventeenth Century*, Stewart, Tabori & Chang, New York, 1996 (originally published 1984), p. 268.

CORNELIS VISSCHER

(Haarlem 1628/9 - Amsterdam 1658)

Portrait of a Young Man, Head and Shoulders

black chalk on vellum, within black ink framing lines
18.5 x 16.2 cm (7¼ x 6½ in)

Provenance: F. Seymour Haden (L.1227);
Adalbert, Freiherr von Lanna (L.2773);
Arthur Feldmann, Brno;
consigned by him for sale, Lucerne, Gilhofer and Ranschburg, 28 June 1934, lot 318, reproduced plate XXIII (unsold);
looted by the Gestapo during the Nazi occupation of Czechoslovakia;
sale, London, Sotheby's, 16 October 1946, lot 61 (together with another);
Gusta Stenman, Stockholm;
Prof. Dr. Einar Perman, Stockholm;
Arthur Feldmann collection.

Exhibited: Stockholm, Nationalmuseum, *Dutch and Flemish Drawings in the Nationalmuseum and other Swedish Collections,* 1953, cat. 254; Laren, Singer *Museum, Oude Tekeningen uit de Nederlanden, verzameling Prof. E. Perman, Stockholm*, 1962, no. 127, reproduced fig. 48.

CORNELIUS VISSCHER'S MOST TYPICAL WORKS, including this present example, are portrait drawings on vellum, drawn with a fine technique that indicates his apprenticeship to Peter Soutman (*c.*1580-1657), himself a pupil of Peter Paul Rubens (1577-1640). Visscher's larger, more elaborate portrait drawings are often fully signed but there are also a number of less formal studies, such as this drawing, which are not. The delicate hatching on the sitter's cheek and forehead as well as his refined features are both hallmarks of Visscher's impeccable draughtsmanship.

Visscher had a relatively short career as a draughtsman, considering his prolific output: he is generally thought to have started drawing only in 1651 and he did so until his early death at the age of about thirty. In this period he was incredibly active producing as many as two hundred prints and drawings. He is most appreciated for his distinctive style which emphasised delicate shading and sensitivity of expression. Typical of Visscher is the soft hatching in different directions as demonstrated here, and his ability to model drapery so successfully. The latter skill is more evident in his *Portrait of a Seated Gentleman,* where he combines this with his characteristic softness (fig. 1). His technique is thought to have been influenced by Anthony van Dyck (1599-1641).

The present drawing originates from the outstanding collection formed from around 1922 by Dr. Arthur Feldmann of Brno, Czechoslovakia. It was one of several hundred of his drawings looted by the Nazis shortly after the German invasion of Moravia in 1939, and passed through various hands, before the generous co-operation of a private collector resulted in its recent re-acquisition by Dr. Feldmann's heirs[1].

Visscher can be considered the pioneer of the detailed yet highly atmospheric style of chalk figure drawing that was subsequently practised by a number of his fellow Haarlem artists.

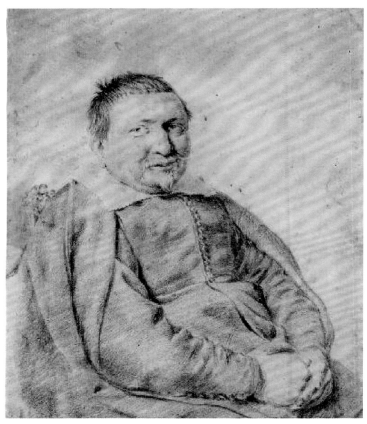

Cornelius Visscher, *Portrait of a Seated Gentleman,* Private Collection (Figure 1)

[1] For a fuller account of the Feldmann Collection, see sale catalogues, London, Sotheby's, 6 July 2005 (pp. 20-75) and 4 July 2007 (pp. 31-35, 214-215)

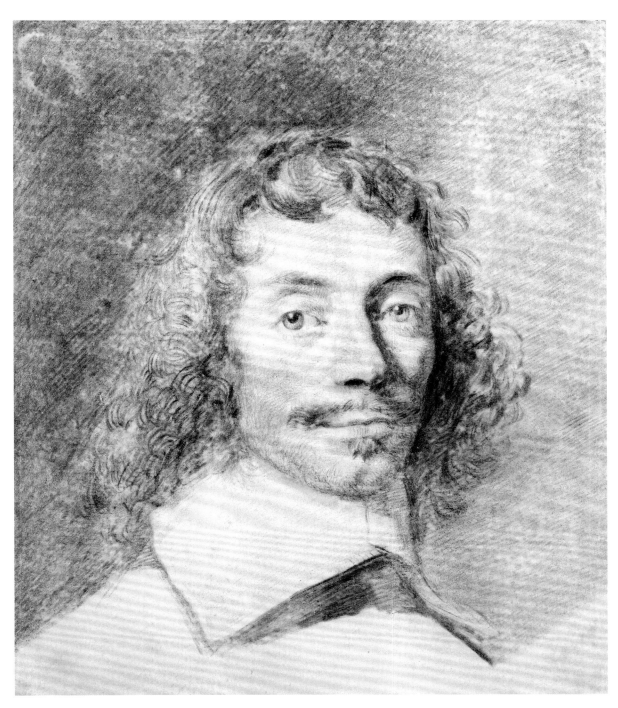

(Actual Size)

ALLAERT VAN EVERDINGEN

(Alkmaar 1621 - Amsterdam 1675)

The Month of August (Virgo): The Harvest

brush and grey and brown wash
11.1 x 12.8 cm (4⅜ x 5 in)

Provenance: Jacob van Rijk, Amsterdam;
sold by him in 1694 to Sybrand I Feitama (1620-1701), Amsterdam;
Isaac Feitama (1666-1709), Amsterdam; Sybrand II Feitama (1694-1758), Amsterdam,
his sale, Amsterdam, de Bosch, 16 October 1758, lot O.18 (as part of a set of the twelve months, lots O.11-22, later dispersed, f 155, to Yver);
possibly Nicolaes Tjark; probably sold by him, Amsterdam, de Leth, 10 November 1762, p. 24, under nos. 15-26 (12 months, f. 2)0, to Fouquet);
Henry Oppenheimer, London, his sale, London, Christie's, 13 July 1936, in lot 243 (four landscapes, this one 'C')
Ernst Goldschmidt, Brussels, 1936; by descent, until sold Paris, Ader Tajan, 28 October 1994, lot 14 (to Peck);
Sheldon and Leena Peck, Boston.

Literature: Feitama NdT 469 (as part of series of the months, NdT 462-473);
Broos 1985, pp. 118, 128-29, no. 66;
Broos 1987, pp. 191-92, 202, note 153, 206, nos. 462-73;
A. I. Davies, *The Drawings of Allart van Everdingen*, Doornspijk 2007, pp. 102-3, 373, no. 546, reproduced.

T*HE MONTH OF AUGUST (VIRGO): THE HARVEST* has an extended and fascinating provenance. Sold as part of a complete set of the twelve months in 1694 to the famed Amsterdam writer and translator Sybrand I Feitama (1620-1701), it was passed down through the literary Feitama family who were avid collectors of seventeenth-century Dutch works on paper.[1] The present work was separated from the other months after their 1758 sale and most likely stayed in private collections until 1936 when it appeared in Christie's London saleroom as part of the Henry Oppenheimer sale.

Allaert van Everdingen was an exceptional draughtsman who was particularly skilled at making sets of drawings depicting, with appropriate images and activities, the twelve months of the year.[2] This tradition was rooted in medieval manuscript illumination, but became increasingly popular in the context of paintings, drawings and prints in the sixteenth century.[3]

In the seventeenth century, the popularity of such themed sets of images began to wane, and van Everdingen's devotion to the concept was strikingly unusual. He seems to have made at least eleven sets of drawings of the months, not as one might have imagined, as designs for prints, but as artistic creations in their own right. Six of these sets remain intact, while Davies (see lit.) has reconstructed the others, on the basis of their stylistic and physical characteristics, and clues from the early provenance of the drawings.

The present drawing originates from a series now dispersed known as the

'Zodiac set', in reference to the astrological sign that the a-tist placed in the sky of each composition - a device familiar from earlier prints, but by this time much rarer. Ten of the twelve drawings from this set are known today, or have been recorded in relatively recent times: five are in the Fitzwilliam Museum, Cambridge, two in the Boijmans van Beuningen Museum, Rotterdam, and two are currently untraced. As Davies has noted, the other known drawings from the series are all somewhat broader than this, with the sign of the Zodiac in the centre of the sky, suggesting that the present drawing may at some point have been cut on the left. The distinctive orange-brown wash seen here is not present in the other drawings, but is found in both *The Month of April*, see fig. 1, and *November* (Rotterdam).

Allaert van Everdingen, *The Month of April (Taurus)*,
Fitzwilliam Museum, Cambridge (Figure 1)

[1] Their collection included *View of Delft after the Explosion of the Gunpowder Arsenal on October 12, 1654* by Herman Saftleven, II (now in the Metropolitan Museum of Art, New York).
[2] Davies, A. I., *The Drawings of Allart van Everdingen* pp. 97-109.
[3] For example, in the 1550s and 1560s, Pieter Brueghel the Elder executed a series of paintings and print designs with seasonal subject matter.

(Actual Size)

ATTRIBUTED TO

CORNELIS DE MAN

(Delft 1621 - Delft 1706)

Two Men, One Elaborately Dressed, before a Fireplace, a Woman in a Kitchen Beyond

(verso) A Woman Bending forwards in Work, and a Dancing Putto

pen and brown ink and wash, over black chalk (recto); black lead (verso)
13.2 x 17.7 cm (5¼ x 7 in)

Provenance: Count M. von Fries (L.2903);
Jacobus A. Klaver, Amsterdam.

THIS DISTINCTIVE AND ANIMATED DRAWING IS attributed to Cornelis de Man, on the basis of its stylistic and thematic similarities with paintings by the artist, whose drawings are rare. Although he sometimes painted Italianate landscapes and church architecture, de Man is best known for his depictions of middle-class Dutch domestic interiors, for which he took inspiration from Jan Vermeer (1632-1675) and Pieter de Hooch (1629-1684). One of his most celebrated paintings, *Man Weighing Gold*, depicts, like the present composition, a man wearing an ornate cap (fig. 1). The man's exotic appearance in both works is most striking in that it contrasts with the ordinary domesticity of his surroundings, a visual juxtaposition that is typical of de Man's paintings.

Two Men, One Elaborately Dressed, before a Fireplace, a Woman in a Kitchen beyond was purchased by the previous owner as an illustration of the story of 'Jacob and Joseph', although it is unclear what biblical episode it is thought to depict. In the corner of a humble Dutch home, two men are seated on low chairs warming their feet at the hearth. One, the elder of the two, and perhaps therefore representing Jacob, learns forward holding a ladle to taste the contents of the pot suspended over the flames. He wears a simple doublet and breeches with a brimmed hat. His companion, seated with his back turned to us, wears a more elaborate costume and a conspicuously decorative hat that gives him a foreign and mysterious air. His dress could be explained by his identity as Joseph; perhaps he is wearing the legendary robe that Jacob made for him.

Framing the two figures is the large mantelpiece of the fireplace; behind is a window and to the right a doorway, through which a woman can be seen attending to her household chores. The multitude of differing angles used to represent the furnishings and proportions of the room, typical features within de Man's work, displays an expert understanding of perspective. The hasty, energetic pen and ink strokes give the drawing a liveliness that is particularly evident in the curlicues of smoke spiralling up towards the chimney and the

Cornelis de Man, *Man Weighing Gold* (detail)
Hornstein Collection, Montreal (Figure 1)

dashes used to indicate the facial features and clothing of the figures.

Little is known about the details of de Man's life. Now a celebrated artist, he was almost forgotten until 1903, when the art historian Hofstede de Groot (*c.*1863-1930) rediscovered his work. De Man may have come from a family of jewellers and he certainly had relatives in the clergy, which would have given him an elevated social rank. In 1642, he entered the Delft Guild of St. Luke. Subsequently, he worked in Paris, Florence, Rome and Venice, before returning to Delft in 1654 and settling there. At the age of thirty-six, he was appointed regent of the guild, a position that he held repeatedly through the years, suggesting that he was a person of notable stature in the artistic community.

(Actual Size)

DIRK LANGENDYK

(Rotterdam 1748 - Rotterdam 1805)

Elegant Figures in Conversation at a Quay, Boats being Loaded to the Right

signed and dated in pen and black ink 'Langendyk Fecit 1784' (lower left)
pen and black ink and grey wash over black chalk
29.5 x 47 cm (11⅝ x 18½ in)

Provenance: Sale, 'J. L.L.', Paris, 19 March, 1925, lot 39.

THIS DRAWING OF A BUSTLING QUAY ILLUSTRATES Dirk Langendyk's skill as a draughtsman. On the left-hand side three dock workers sit and slouch on boulders chatting. They stand in contrast both in pose and dress to the group of three elegant figures in the centre of the composition. This group are stiffly formal and their comparatively elaborate costume and hairstyles catch the eye. Just beyond them, two figures survey the loading of the boats from horseback. A procession of mules is being led down to the edge of the water, where the animals are relieved of their heavy loads, which are being transferred onboard the docked vessel. The tower looming over the workers helps to ground the work and draws the eye to the classical architecture and mountainous landscape beyond. The busy composition on the left-hand side is contrasted on the right by the calm sea that stretches away towards the horizon, where the faint outlines of ships and the setting sun can be made out.

Langendyk was a prolific artistic and he often depicted military scenes, such as *An Embarkation of Soldiers; Marching from behind a Building at Left down towards Ships in the Harbour at R, more with Packages and Trunks in the Foreground, a Woman Talking to One Soldier at Centre* (fig. 1). Despite the military theme, there are notable similarities between the British Museum work and *Elegant Figures in Conversation at a Quay, Boats being Loaded to the Right* not least in that the mood of both works is of busy activity. Despite the fairly populous foregrounds, the figures in both drawings interact in small, clearly defined groups. Again the figures in the British Museum work display a variety of poses and costume, from the peasants who lug heavy burdens on their backs, to the formal and elegant officers who oversee proceedings. Both drawings are also characterised by a sophisticated use of light. The modelling of light on the figures and the landscape is constantly, but subtly, varied. Therefore although the tonal contrasts are not extreme, Langendyk's drawings are characterised by a lively use of light.

Langendyk was a pupil of Dirck Anthonie Bisschop, an interior decorator and a painter of coats of arms and coaches. From the beginning of his career Langendyk depicted primarily military scenes and this is evident in the skilled depiction of horses and soldiers in both of the illustrated works. As his career progressed he drew inspiration for these military scenes from the Dutch

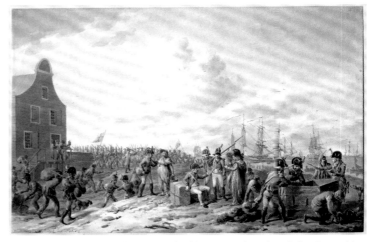

Dirk Langendyk, *An Embarkation of Soldiers; Marching from behind a Building at Left down towards Ships in the Harbour at R, more with Packages and Trunks in the Foreground, a Woman Talking to One Soldier at Centre*, 1800, The British Museum, London (Figure 1)

conflict between the Patriots and the Orangists, and from the invasions of the Dutch Republic by the French and Anglo-Russian armies in 1795 and 1799 respectively. Langendyk's style is characterised by a concentration on crowds rather than individuals, as is evident in the present work. In his military scenes, we typically see the interaction between groups of officers and soldiers before and during battle. However, as well as military scenes, Langendyk also depicted many scenes of coastal life, such as the Courtauld Gallery's *Shipping in a Storm off the Coast*. He executed many of his works without pencil and pen, often just drawing with a brush.

Langendyk was primarily a draughtsman and he was greatly admired in his lifetime, particularly for his detailed rendering of equestrian combat scenes. He was also, to a lesser extent, a painter and etcher, although dated paintings by him are only known from the period of 1771 to 1772 and from 1780. These generally depict the daily life of soldiers and landed gentry.

HENDRIK VERSCHURING

(Gorinchem 1627 - Dordrecht 1690)

A Horse Market with Arabian Merchants in the Campo Vaccino, Rome

signed with a monogram in brown ink 'HVS. f.' (lower left)
pen and brown ink and grey wash with touches of black chalk, within brown ink framing lines
31 x 41.5 cm (12¼ x 16¼ in)

HENDRIK VERSCHURING MADE HIS REPUTATION with equestrian drawings, of which *A Horse Market with Arabian Merchants in the Campo Vaccino, Rome* is a fine example. The fair in the Campo Vaccino was a subject that the artist clearly favoured, perhaps as it provided an opportunity to highlight the magnificence of his horses, by portraying them surrounded by noble and timeless remnants of classical architecture. Several of his drawings show the same setting from different vantage points, one of which is in the Royal Collection at Windsor.[1]

The Campo Vaccino was a name designated in the Middle Ages to an area of the Roman Forum located between the Capitoline Hill and the Colosseum that was traditionally used as a cattle market. During Verschuring's time, some of the Forum's most impressive ruins would have been covered with several metres of eroded soil, much of it created by the new building projects in the Baroque period, and it was not until the Napoleonic regime that excavations of the city began. Many of the monuments that define the Forum today do not appear in the artist's drawings, perhaps out of artistic preference, but most likely because they were as yet undiscovered. The column at the centre of the present drawing is distinctive in its free-standing isolation and is probably the Column of

Photograph of the Roman Forum with the Column of Phocas and the Temple of the Dioscuri

Phocas, a landmark often depicted in vedute and engravings. The column was the last addition to the Forum erected in honour of the Byzantine emperor Phocas in 608 AD.

Another drawing of the Campo Vaccino by Verschuring, from a different angle, prominently features the three columns of the Temple of the Dioscuri (fig. 1). This ruin of antiquity, like the Column of Phocas and the classical statue in the present work, gives the composition greater definition and elevates the subject matter. The crowded lower ground of both works is typical of Verschuring, as is the fluidity and hasty expressiveness of his pen and the dashes of grey wash that so dramatically indicate shadow. In both examples, he further punctuates the lines with touches of black chalk.

Verschuring was a pupil of Jan Both (c.1615-1652) (see inventory) in Utrecht before travelling to Italy in c.1650. He remained in Rome for a considerable length of time, only returning to Holland in 1662. In his maturity, he achieved considerable renown for his paintings of Italianate equestrian and battle scenes in a style similar to that of Philips Wouwerman (1619-1668) (see inventory).

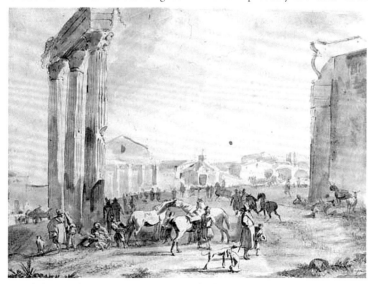

Hendrik Verschuring, *A Horse Fair in the Campo Vaccino*, Private Collection (Figure 1)

[1] See C. White and C. Crawley, *The Dutch and Flemish Drawings of the Fifteenth to the Early Nineteenth Centuries in the Collection of Her Majesty the Queen at Windsor Castle*, Cambridge 1994, p. 351, cat. no. 488.

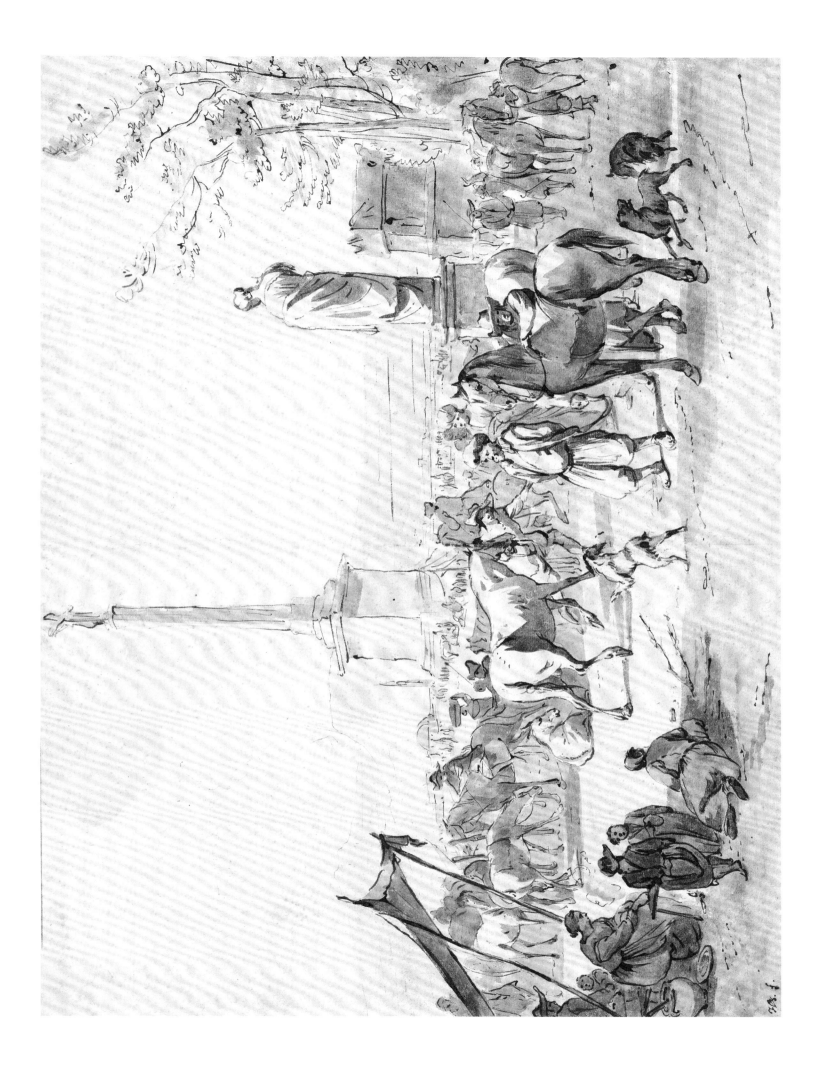

JACOB CATS

(Altona 1741 - Amsterdam 1799)

Winter Landscape with Peasants with a Sledge by a Farm, a Town Beyond

signed, dated, and numbered in brown ink '664 / J: Cats Ao 1795' (verso)
black chalk and grey and brown wash, and touches of white heightening, within brown ink framing lines
27.2 x 35.9 cm (10⅝ x 14 in)

Provenance: Sale, Amsterdam, Sotheby Mak van Waay, 2 May 1984, lot 22;
sale, Amsterdam, Christie's, 18 November 1985, lot 156;
Jacobus A. Klaver, Amsterdam.

Literature: L.A. Schwartz, 'The 'Thoughts' ('Gedagten') of Jacob Cats (1741-1799).
Inscriptions on the numbered drawings of a prolific eighteenth-century draughtsman.
An addition to the list of Jane Shoaf Turner (1990),' in *Delineavit et Sculpsit*, 31 December 2007, p. 73.

IN ITS LARGE-SCALE, ATMOSPHERIC SUBJECT MATTER and fine execution, *Winter Landscape with Peasants with a Sledge by a Farm, a Town Beyond* is an outstanding drawing by Jacob Cats. Cats was a leading draughtsman and watercolourist in late eighteenth-century Holland, a reputation confirmed by his engaging and highly detailed studies, a further example of which can be found in catalogue number 129. In the present work, the figures treading across the landscape, the undulating snow-covered roofs of the houses and the bare trees and darkening clouds, exemplify Cats' talent for pictorial expression.

Of particular interest in this drawing is the numbering on the *verso*, which is in the artist's own hand. According to Jane Shoaf Turner, between a quarter and a third of his drawings have such numbers, and the works are predominately less finished monochromatic sketches, either in black chalk or with grey wash, such as this work.[1] Turner suggests that the

Jacob Cats, *Papeneiland*, 1785,
Amsterdams Historisch Museum, (Figure 2)

numbered drawings may have been used to assemble a pattern or sample book, from which potential clients could select compositions or motifs that they would like worked up into finished drawings and watercolours. In the present case, there exists a watercolour of the same subject painted by Cats in the same year (fig. 1). The two versions differ somewhat in the representation of the trees and the positioning of the background staffage but are virtually identical. The upright figure by the sledge, which has been erased but is still just visible in the drawing, does not appear in the watercolour.

A drawing by Cats depicting the *Papeneiland* in Amsterdam also depicts figures pulling and pushing a sledge with a dog following behind, a motif that bears a marked resemblance to that in this drawing (fig. 2). This is further evidence that Cats reused his most popular motifs, thereby contributing to his artistic prolificacy and commercial success.

Jacob Cats, *A Winter Landscape with Men and a Sledge near a Farm, People on the Ice Beyond*, 1795, Private Collection (Figure 1)

[1] Turner, J.S., 'Jacob Cats and the Identification of a "Pseudo-Goll van Franckenstein" Numbering System', in *Master Drawings*, XXVIII, no. 3 (Autumn 1990), pp. 323-331. See also Leslie A. Schwarz, *op. cit.*, pp. 57-77.

JACOB CATS

(Altona 1741 - Amsterdam 1799)

A Swineherd with Three Pigs on a Track, a Windmill Beyond

&

A Peasant Watering his Animals at a Ford

signed, dated and inscribed 'Bij Heemskerk J: Cats Ao 1772' (verso, 1)
black chalk, pen and grey and brown ink, grey wash, pen and grey ink framing lines, a pair (2)
16.2 x 21.3 cm (6⅜ x 8⅜ in); 17.6 x 24.5 cm (6⅞ x 9⅝ in)

Provenance: Colonel H.A. Clowes; Christie's, London, 17 February 1950, lot 3 (to Clowes) and thence by descent

A SWINEHERD WITH THREE PIGS ON A TRACK, A WINDMILL Beyond and *A Peasant Watering his Animals at a Ford* are classic representations of the idyllic landscapes executed by Jacob Cats. In contrast to *Winter Landscape with Peasants with a Sledge by a Farm, a Town Beyond* (catalogue no. 128), the present drawings depict summer scenes, characterised by atmospheric tranquillity, the abundant foliage of the trees, and the well-nourished contentment of grazing animals.

The first of these representations of pastoral harmony, *A Swineherd with Three Pigs on a Track, a Windmill Beyond*, depicts an unmistakably Dutch landscape with a windmill, gnarled oak trees, thatched cottage and a peasant herding his pigs along a well-kept path. Cats' expert ability in capturing the appearance of the sun-dappled leaves of the trees and the texture and tonality of the scene is evident. A drawing executed three years prior to the present one, *Landscape with Cottage and Figures at the Side of a Road*, in the Courtauld Gallery, London, depicts similarly engaging compositional elements and a concern with spatial depth and the effects of light and shade (fig. 1).

The second of the two drawings, *A Peasant Watering his Animals at a Ford*, is equally expressive in its depiction of a hillier and wilder landscape with rugged rocky outcrops. Another version of the work is housed in the Fogg Museum at Harvard. The two drawings, while strikingly similar, also bear perceptible differences. The present one appears heavier and more confident in its use of line and shading then the Harvard version. Details such as the shadowing on the path, the delineation of the foliage on the trees and the positioning of the animals in relation to the landscape differ between the two images, although Cats' ability to imitate his own work is impressive. Cats is known to have been amenable to reworking past compositions as he is believed to have presented clients with a sample book of his drawings, from which they could choose their favourite subjects, motifs or whole compositions for him to replicate.[1] The works in his existing sample books are numbered on the *verso* in the artist's hand and the Harvard drawing

bears such a number. Perhaps, therefore, it was executed first, and a client who liked the result then commissioned *A Peasant Watering his Animals at a Ford*.

Cats, the son of the Dutch book dealer Johannes Cats, was trained as a bookbinder and engraver. He studied first under Abraham Starre, then with Pieter Louw (d.1800), and finally with the pattern designer Gerard van Rossum (*c.*1690-1772). For three years following, he became a wallpaper painter in the Amsterdam factory of Jan Hendrik Troost van Groenendoelen. At the age of twenty-one, Cats established his own business painting wall-hangings, and was considerably successful until the fashion began to decline. He then took up drawing, specialising in topographical views and landscapes, and also began executing copies of famous paintings by artists such as Rembrandt (1606-1669) and Gerrit Dou (1613-1675). Cats' drawings were reproduced in prints by some of his contemporaries such as Isaac Jansz. de Wit (1744-1809), Cornelis Ploos van Amstel (1726-1798) and Jan Evert Grave (1759-1805).

Jacob Cats, *Landscape with Cottage and Figures at the Side of a Road*, 1768, The Courtauld Gallery, London (Figure 1)

[1] Turner, J.S., 'Jacob Cats and the Identification of a "Pseudo-Goll van Franckenstein" Numbering System', in *Master Drawings*, XXVIII, no. 3 (Autumn 1990), pp. 323-331.

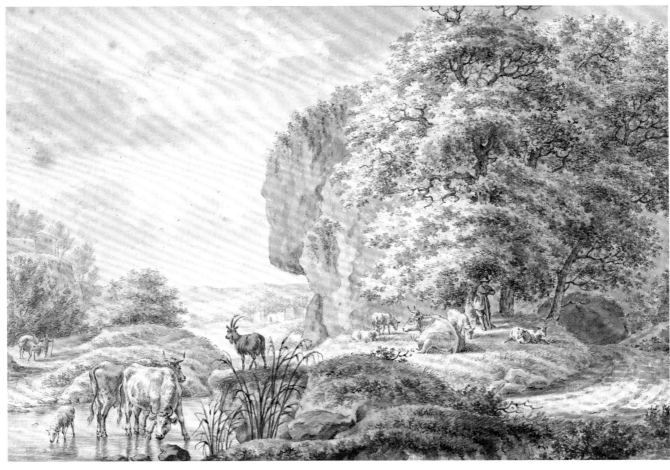

JAN GOEREE

(Middleburg 1670 - Amsterdam 1731)

Study for an Illustration to Jacob Cats' 'Eighty-Two Years Old'

pen and brown ink and two shades of brown wash, with touches of red wash, over black chalk,
indented and blackened on the reverse for transfer
13.8 x 14 cm (5⅜ x 5½ in)

Provenance: Sale, (E. van Aelst *et al*), Amsterdam, Paul Brandt, 24-28 November 1975, lot 698;
Jacobus A. Klaver, Amsterdam (bears his mark, not in Lugt, on the backing), his sale, Amsterdam, Sotheby's, 10 May 1994, lot 103.

Exhibited: Amsterdam, Rijksprentenkabinet, *Tekeningen van oude meesters. De verzameling Jacobus A. Klaver*, 1993
(catalogue by Marijn Schapelhouman and Peter Schatborn), no. 101.

THIS DYNAMIC AND CROWDED COMPOSITION IS A design for an illustration by Jan Goeree for the 1712 edition of *The Complete Works of Mr. Jacob Cats*. The passage depicted here, from Cats' verse autobiography *Eighty-Two Years Old* relates how the author's ownership of a piece of polder land in Biervliet was the source of his fortune. In the foreground of the drawing, *putti* hold the coat of arms of Biervliet, a small fishing village in the Dutch province of Zeeland. Behind them is an image of soldiers from Biervliet, a reminder of their crucial role in the siege of Constantinople in 1204. The scene of military splendour is framed within a circle and adorned with further *putti* who hold a fishing net above their heads. A plaque resting above the frame is decorated with two fish and a gutting knife and surrounded by grape vines. Numerous allusions to fishing, the town's main industry, appear throughout the drawing. On the right, a market seller holds up a fish for a lady's inspection; on the left, a man points towards the vessels bobbing on the sea; in the foreground, a *putto* is absorbed in gutting a fish; a stealthy cat creeps around the corner of the crate to paw at the fish strewn on the ground.

Goeree's monumental style and show of pomp and theatricality, is similarly revealed in his design for a frontispiece entitled *An Allegory of the Decline of Classical Civilisation* (fig. 1). Both works feature compositions tightly packed with figures and activity, and yet they achieve a sense of harmony and balance. Antiquity, the main subject matter of *An Allegory of the Decline of Classical Civilisation*, is also referenced through the multitude of *putti* that throng *Study for an Illustration to Jacob Cats' 'Eighty-Two Years Old'*, giving the work a degree of nobility and timelessness that no doubt would have pleased the book's author.

Jacob Cats (1577-1660) was a poet, moralist and statesman who is best remembered for his emblem books reflecting Calvinist philosophy. He studied law at Leiden and Orléans and became a successful lawyer specialising in witchcraft trials. While living in The Hague, he contracted a debilitating fever and for two years searched in vain for a cure, until he was mysteriously healed by a travelling doctor. During an interlude in the Eighty Years War, Cats and his brothers achieved great prosperity through draining and reclaiming land that had been flooded during the conflict, thus explaining his reference to

the fortune he made in Biervliet. Cats became a prominent political figure in Middleburg and Dordrecht, serving as Grand Pensionary of Holland from 1636 to 1651, and was sent on at least two diplomatic missions to England. Cats was extremely popular and influential in his day, and his emblem books, poetry and autobiography were reprinted and translated repeatedly.

Goeree was a painter, draughtsman, engraver and etcher. He was the son of Willem Goeree, a Dutch art theorist who undertook a comprehensive survey of the various techniques necessary to make a great artist: drawing, architectural knowledge, perspective, anatomy, composition, imagination, colour and shading, all of which his son evidently mastered.

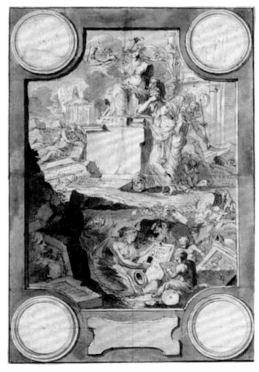

Jan Goeree,
*Design for a
Frontispiece: An
Allegory of the Decline
of Civilisation*,
Private Collection
(Figure 1)

(Actual Size)

ROELANDT SAVERY

(Kortrijk 1576 - Utrecht 1639)

A Rocky Landscape with Two Huntsmen and a Dog by Fallen Fir Trees

inscribed and dated 'In pariis. 1625.' (upper right)
black chalk, pen and grey ink, grey wash
19.7 x 27.6 cm (7¾ x 10 ⅞ in)

Provenance: An unidentified collector's mark G (*verso*);
with Gebr. Douwes Fine Art, London.

ROELANDT SAVERY'S INTRICATE AND BEAUTIFULLY complex composition challenges the viewer at every turn, not least with the sheer amount of detail and unconventional perspective generated by the skewed, perpendicular fir trees. The peculiarly surreal atmosphere that Savery often conjured up, in his favoured subjects of Orpheus and the Garden of Eden,[1] is no less vivid in this drawing; twining ivy tendrils are wrapped around a protruding fallen tree and give the landscape an exotic, jungle-like feel. The same can be said for the rocky promontory itself. Seemingly unconnected to anything else, it imbues the scene with a sense of isolation and mystery. A harmonious contrast is achieved between the darker foreground figures.

Savery settled in Haarlem in about 1585 having fled from the Spanish occupied Southern Netherlands. Initially he was taught by his elder brother, Jacob (*c.*15650-1603) as well as by Hans Bol (1534-1593). His best known association, however, was with the court of the Hapsburg emperor, Rudolf II, through which Savery made contact with a group of international artists including Bartholomäus Spranger (1546-1611) (see catalogue no. 88) and Hans von Aachen (1552-1615). Savery particularly enjoyed drawing the emperor's impressive menagerie of wild animals from life, which even included a dodo, as well as the stags in Rudolf's hunting fields. A number of his finest paintings incorporate a staggering array of wildlife as a result of these preparatory studies.

An equally important contribution to his works from the Prague court came from Rudolf II's first commission, when he sent the artist to complete sketches of the Tyrol between *c.*1606 and 1607 (fig.1). The resultant drawings, depicting majestic jagged mountain peaks, rivers and dense forest served as invaluable reference material for Savery's later, large-scale works. Savery made his early travel drawings using the same materials that he often combined, namely black chalk and coloured wash, as is the case in *A Rocky Landscape with Two Huntsmen and a Dog by Fallen Fir Trees*. As in the present work, the overall impression is one of the vast scale of nature in relation to humankind; the human figures on the track in *Alpine Landscape*, just like the two huntsmen, are miniscule against the ineffable forces of nature.

The artist's preoccupation, in the tradition of Gillis van Coninxloo (1544-1607) and Paulus van Vianen (*c.*1570-1613), with transcribing nature exactly as he saw it and his predilection for bizarre rocky landscapes are clearly

Roelandt Savery, *Alpine Landscape, c.*1606-7, The British Museum (Figure 1)

reflected in this present work. Perhaps more accurately, Savery saw no reason why nature itself could not serve as the main point of dramatic departure in a work. This certainly explains elements of the present composition in which the two huntsmen and their dog are almost entirely obscured in the face of powerful elemental forces.

Savery returned from Amsterdam in 1613 and settled eventually in Utrecht. Besides his fantastical compositions of rocky scenery and exotic animals, he is remembered as one of the first flower painters to introduce the genre, and his works became highly influential on Dutch artists of the next generation. Savery had made the acquaintance of Ambrosius Bosschaert I (1573-1621) and Balthasar van der Ast (1593/4-1657), and his pupils included Allaert van Everdingen (1621-1675) (see catalogue no. 124).

In the 1620s, Savery was one of the most sought after and highly paid artists in Utrecht; some of his pieces commanded prices that were usually reserved for large, historical paintings.

[1] Examples include his *Orpheus* in the National Gallery, London, and his *Garden of Eden,* in the Farringdon Collection, Buscot, Oxon.

(Actual Size)

ABRAHAM STORCK

(Amsterdam 1644 - Amsterdam 1708)

Shipping at Anchor

black chalk, pen and brown ink, grey wash, pen and brown ink framing lines
20.3 x 31 cm (8 x 12⅛ in)

Provenance: L.H. Philippi (L. 1335);
B. Jolles (L. 381);
Fürst von Hohenzollern-Hechingen (?) (L. 2087).

ABRAHAM STORCK, HELD IN GREAT ESTEEM FOR HIS accurately detailed and often dramatic maritime works, exhibits his consummate skill as a draughtsman in *Shipping at Anchor*. Two intricately realised vessels dominate the foreground as they cut through a choppy sea. The strength of the wind can be gauged from the taut sail and tilting keel of the ship most immediately to the left of the composition.

The formation of the ships and overall layout of the present drawing is strikingly similar to one of Storck's paintings, *Sea Piece with Dutch Man-of-War*, especially in the lower left quadrant (fig.1). It is possible that a drawing such as this could have been a preparatory sketch for his large-scale paintings. Another drawing by the artist (fig. 2), demonstrates the immense detail that would later be translated into oil: the shaded sails on the ships are similar to the careful *chiaroscuro* Storck employed to accomplish the highly realistic perspective in the present drawing.

Storck, a prolific painter of maritime landscapes and other genre paintings was described in 1708 as an artist of 'tempestuous and tranquil

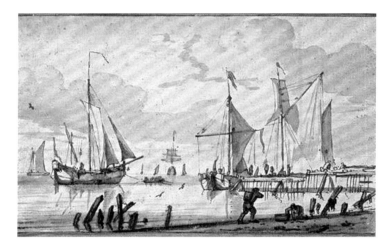

Abraham Storck, *Voiliers près d'un débarcadère*, The Louvre, Paris (Figure 2)

seascapes.'[1] Storck's output was extensive, encompassing sea battles, river scenes and townscapes. His river and coastal scenes were greatly influenced by Ludolph Backhuysen (1631-1708) (see catalogue no. 61) in their pictorial treatment of sea and sky. Storck also absorbed influences from other leading Amsterdam marine painters including Willem van de Velde the Younger (see catalogue no. 136). It is thought that van de Velde, in particular, inspired Storck's great technical accuracy in his depiction of ships and other sailing vessels.

Storck was born in Amsterdam in 1644, the youngest son of the painter Jan Jansz Sturck, who was also known as Sturckenburch. It is likely that Abraham Storck and his brothers were trained and educated by their father and the painter Jan Abrahamsz Beerstraten (see catalogue no. 60) who was a friend of the family. From Beerstraten, Storck adopted his artist's densely packed compositions. By 1688 Storck was a member of the Guild of St. Luke in Amsterdam and enjoyed a reputation as a highly skilled artist during his lifetime.

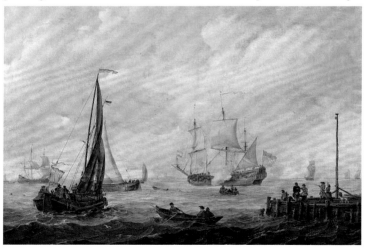

Abraham Storck, *Sea Piece with Dutch Man-of-War*,
Fitzwilliam Museum, Cambridge (Figure 1)

[1] A. Houbraken, *De groote schouburgh* (1718-21.)

(Actual Size)

ATTRIBUTED TO

CORNELIS PIETERSZ. BEGA

(Haarlem 1631/2 - Haarlem 1664)

A Standing Soldier, seen from Behind

red chalk, within black chalk framing lines
26.7 x 14.4 cm (12⅝ x 9⅞ in)

IN *A STANDING SOLDIER, SEEN FROM BEHIND,* THE SUBJECT is depicted standing at ease. The soldier's left hand is raised to his hip and he leans his weight on the object he holds in his right, possibly an arquebus, a forerunner to the musket. His sword is also prominently displayed, so that the viewer is left in no doubt over the man's identity. The figure is turned slightly to the left so a glimpse of his face, replete with enormous moustache, is visible.

A drawing showing exactly the same figure from a fractionally different viewpoint was sold in the 1960s as by Cornelis Pietersz. Bega.[1] It seems that these two drawings must have been made by two different artists, who happened to have been working alongside one another in the same studio. The survival of such a pair of drawings, clearly made at the same time from the same posed model, is rare, especially amongst seventeenth-century Dutch drawings. There are a few examples from Rembrandt's studio, and many others have survived from the eighteenth and early nineteenth centuries, when numerous semi-amateur life-drawing societies sprang up throughout Holland. However, this may be the only known extant example from the close-knit artistic community of Haarlem.

Of the two drawings, the present work looks more like the work of Bega, although it is often difficult to distinguish his drawings from those of some of his Haarlem contemporaries, notably Gerrit and Job Berckheyde (1638-1698 and 1630-1693), and Leendert van der Cooghen (1632-1681). Attribution is made particularly difficult because the Haarlem school shared models and traded drawings. Moreover, in Bega's case, none of his studies which were drawn *naer het leven* (from life), seem to relate to a painting or etching. Despite the stylistic similarities, as Peter Schatborn has observed, 'From the whole group of Haarlem artists Bega is the one who has gone the furthest in developing this characteristic manner into a firm style'.[2]

When compared to other examples of Bega's single-figure studies, for which he is particularly noted, *A Standing Soldier, seen from Behind* has some similarities in its execution with his work (fig. 1). Bega's drawings are executed mainly in red chalk on white paper, such as the illustrated works, or in black and white chalk on blue paper. Both *A Standing Soldier, seen from Behind* and *Milkmaid Seated* are of anonymous figures, whose identities are indicated simply and concisely. Both works have regular and precise parallel shading and

well defined forms, which are characteristic of Bega's drawings, and indeed the Haarlem school in general. Both drawings also suggest the folds of drapery in a subtle, yet precise way.

Figures in the type of military uniform seen in *Standing Soldier, seen from Behind* are rather rare in the work of the artists thus far mentioned, although they do appear more frequently in the compositions of Italianate artists such as Jan Both (*c.*1618-1652) and Karel Dujardin (1626-before 1678) (see inventory for both artists). The handling of the present drawing, however, would suggest it is a product of the Haarlem school.

Bega was born into prosperous circumstances; his mother, Maria Cornelis, inherited half the estate and all of the red chalk drawings of her father, Cornelis Cornelisz. van Haarlem (1562-1638), who was a renowned Mannerist artist. Having studied with Adriaen van Ostade (1610-1685), Bega joined the Guild of St. Luke in Haarlem in 1654.

Bega painted, drew, etched and made counterproofs in a wide variety of media on different types of small-scale supports and he may have been the first Dutch artist to make monotypes, (but this remains controversial.) Bega's principal subjects were genre representations of taverns, domestic interiors and villages. He often depicted nursing mothers, prostitutes, drunks, smokers, gamblers and fools such as quack doctors and alchemists. Although *A Standing Soldier, seen from Behind* depicts a respectable figure, as is *Milkmaid Seated*, both figures correlate with the recurrent subject matter of lower class Dutch life that the artist employed. It seems that Bega remained and worked in Haarlem until the end of his short life when he was probably killed by the plague.

Cornelis Pietersz Bega,
Milkmaid Seated,
The Courtauld Gallery,
London,
(Figure 1)

[1] London, Sotheby's, 10 December 1968, lot 155, from the collection of Dr. N. Meyer (L.1812)

[2] P. Schatborn, *Dutch Figure Drawings from the Seventeenth Century,* exh. cat., Amsterdam, Rijksmuseum, and Washington, National Gallery of Art, 1981-82, p. 105

(Actual Size)

JAN VAN GOYEN

(Leiden 1596 - The Hague 1656)

A Village on the Banks of a Canal with Cattle and Fishermen

signed with initials and dated 'VG 1652' (lower right)
black chalk, grey wash, pen and brown ink framing lines, watermark foolscap
11.3 x 19.2 cm (4½ x 7½ in)

Provenance: E. Cichorius; C.G. Boerner, Leipzig, 5 May, 1908, lot 535, (sold before the sale);
O. Huldschinsky; Berlin, 3 November, 1931, lot 46a (130 Marks);
with Galerie Rosen, Berlin, 1962.

Literature: H.-U. Beck, *Jan van Goyen 1596-1656, Ein Oeuvreverzeichnis, I*, Amsterdam, 1972, p. 108, no. 304b.

JAN VAN GOYEN WAS AN ACCOMPLISHED DRAUGHTS-man and painter, and his drawings are testament to his capabilities. He travelled widely throughout the Netherlands recording details of landscape, topography and everyday life in chalk, wash and ink sketches, filling many sketchbooks with his daily observations. Though primarily a landscape artist, van Goyen frequently animated his composition with genre scenes of everyday life, and painted many of the canals in and around The Hague as well as the villages surrounding the countryside of Delft, Rotterdam, Leiden and Gouda. After compiling these preparatory sketches *in situ*, of which the present drawing, *A Village on the Banks of a Canal with Cattle and Fisherman*, is a charming example, he used them to form and shape the final painting carried out in the studio (fig. 1). Drawings survive for every year of van Goyen's creative life, see figs. 2 and 3, and he was particularly prolific

Jan van Goyen, *Snowball Fight*, 1625, The Hermitage, St. Petersburg (Figure 2)

when he speculated in tulips in 1637, at the height of 'tulip mania' when contract prices for bulbs of the newly introduced tulip reached extraordinarily high levels and then suddenly collapsed. At the peak of this tulip mania, in February 1637, tulip contracts sold for more than twenty times the annual income of a skilled craftsman. It is generally considered the first recorded speculative bubble. Despite being a prolific artist, van Goyen was unable to cover his debts and in 1652 and 1654 he was forced to sell his possessions at public auction, and subsequently moved to a smaller house. He died in 1656, sadly still heavily in debt, forcing his widow to sell all their remaining assets, including their home.

Jan van Goyen, *Village at the River*, 1636, Alte Pinakothek Munich (Figure 1)

from 1631 to 1653. Indeed, of his surviving body of work approximately 1,200 paintings have been documented.

Van Goyen was born in Leiden, the son of a shoemaker who, reportedly, from the tender age of ten, was apprenticed to several artists before training in Haarlem for a year, in 1617, with Esaias van de Velde (1587-1630) (see catalogue no. 137). In 1632, at age thirty five, he established a permanent studio in The Hague. Two years later he acquired rights of citizenship and served as head of the Guild of St. Luke (1638-40). An artist with business acumen, van Goyen recognised that income gained solely from his artistic output was insufficient, and he worked intermittently as an art dealer and collector, auctioneer, estate agent and picture valuer to further his prosperity. He lost a great deal of money

Jan van Goyen, *Cottages Amid Leafless Trees*, c.1625-1630
Rijksmuseum, Amsterdam (Figure 3)

(Actual Size)

JAN VAN GOYEN

(Leiden 1596 - The Hague 1656)

A Group of Covered Wagons and Horsemen before a Country Inn

signed with initials and dated in black chalk 'VG 1653' (lower left)
bears pencil numbering, No 9 (*verso*)
black chalk and grey wash, within grey ink framing lines
17 x 27.3 cm (10¾ x 6¾ in)

Provenance: F. C. Th. Baron van Isendoorn à Blois, his sale, Amsterdam, C. F. Roos, 19 August 1879, lot 56 (25 fl, to Muller);
W. Pitcairn Knowles, his sale, Amsterdam, Frederik Muller & Co., 25 June 1895, lot 278 (18 fl, to Coblenz);
sale, Paris, 11 April 1924, lot 96, reproduced (3,000 fr);
H. E. ten Cate;
with C.G. Boerner, Düsseldorf, December 1964, cat. No. 53.

Literature: D. Hannema, *Catalogue of the H. E. ten Cate Collection*, Rotterdam 1955, p. 132, no. 237;
H.-U. Beck, *Jan van Goyen 1596-1656*, Amsterdam 1972, vol. 1, p. 145, no. 424, reproduced.

IN THIS ENCHANTING DRAWING JAN VAN GOYEN HAS vividly captured the sense of activity that surrounds a remote roadside inn. Three covered wagons, each pulled by a pair of horses, stand in the centre of the composition. Their drivers are ready to continue their journey, having refreshed themselves at the low thatched inn. Accompanying this convoy are four horsemen, who are preparing to depart. One of these wields a musket, to protect the convoy from wily highwaymen. By the inn a family group is visible, and on the near side of the path two travellers who have thrown their walking-sticks to the ground to rest on the grassy bank can be seen. The variety of figures suggests that this inn enjoys a brisk trade, despite its isolated position, and indeed the wagon, which appears in the distance, may well be also about to stop.

A Group of Covered Wagons and Horsemen before a Country Inn depicts a quiet scene of simple rustic life set within a recognisably Dutch landscape. It is the sort of humble subject which van Goyen delighted in depicting throughout his career, as did many of his contemporaries, including Claes Jansz Visscher (1587-1652) and Esaias van de Velde (1587-1630) (see catalogue no. 137). According to Mariët Westermann these artists 'helped constitute a sense of the local landscape as plain but productive, as the rightful preserve of a population dedicated to such burgher values as hard work and a frugal, God-fearing life'.[1]

A further charming example of this genre by van Goyen is the British Museum's *Landscape with Cottages set in a Bank by a Road; a Group of Figures on the Bank to Right and a Horse-Drawn Cart below to Left,* (fig. 1). It is not only the subject matter which makes this work comparable to the present drawing, but also the techniques that van Goyen has employed. The black chalk used in both works was ideally suited to his fluid technique, and short quick dash marks are a feature in the foreground of both works. The slightly frenzied and spontaneous nature of these strokes contrasts beautifully with the otherwise gentle air of both landscapes. Languid undulations animate the flat Dutch scenery, which is lit by warm sunshine, and despite both works being reasonably populated, there is a tangible sense of tranquillity. The figures themselves appear sketchy, and these outlines convey a sense of vivacity and movement.

Van Goyen ranks as one of the leading Dutch seventeenth-century landscape artists. The present work is dated to 1653, one of van Goyen's most creative periods as a draughtsman and today his drawings are as well regarded as his paintings. His legacy to Dutch landscape painting was considerable; van Goyen's influence extended to Aelbert Cuyp (1620-1691), Nicolaes Berchem (1620-1683) (see catalogue no. 121) and Jan Steen (1626-1679), the latter being two of his pupils.

Jan van Goyen, *Landscape with Cottages set in a Bank by a Road; a Group of Figures on the Bank to Right and a Horse-Drawn Cart below to Left,* 1649, The British Museum, London (Figure 1)

[1] Mariët Westermann, *The Art of the Dutch Republic 1585-1718*, London, 1996, p. 178.

(Actual Size)

WILLEM VAN DE VELDE II

(Leiden 1633 - London 1707)

A Dutch Flagship at Anchor attended by Small Boats, the Fleet seen Beyond

black chalk, pen and black ink, grey wash
27.4 x 51.5 cm (10¾ x 20¼ in)

Provenance: Anonymous sale (possibly M.O. Brenner, Berlin);
Amsterdam, R.W.P. de Vries, 14 December 1911, lot 1502, perhaps bought by de Vries for Dfl. 150;
with R.W.P. de Vries, Amsterdam, 1917.

Exhibited: R.W.P. de Vries, Amsterdam, 1917, *Dessins anciens et modernes: marines et paysages rivérains*,
p. 24, no. 1509 (offered for Dfl. 300,-).

THIS FINELY EXECUTED PEN AND INK SKETCH with grey wash by Willem van de Velde II, depicts a Dutch fleet off the coast of Holland. The flagship dominates the composition, while in the foreground many smaller vessels are seen swaying in the swell of the sea. In the distance, the ghostly figures of the other ships are just distinguishable. According to the sale catalogue of 1911, this scene might depict the Dutch war council on board the flagship the 'Gouden Leeuw' under the command of Admiral Cornelis Tromp, who served in the Anglo-Dutch Wars throughout his naval career.

Although van de Velde's reputation rests on his highly regarded representations of coastal scenes and ships in the medium of oil, such as his *The Gouden Leeuw before Amsterdam* (fig. 1), the present work nevertheless demonstrates his technical expertise, executed with apparent ease and freedom of touch. His best productions remained faithful to a vessel's structure and rigging and here, despite its fleeting impression, neither proportion nor accuracy is compromised. Closer inspection reveals a mastery of form and detail, evident in the flagship's ornamentation, its guns and sails, as well as the movement of figures and oars aboard the smaller boats. The delicately drawn ships, careful placing of each vessel, and soft tones achieve a satisfying composition and serene atmosphere - trademark qualities of van de Velde that led to his fame as an artist. Successful in his renderings of the sea, painting calm and storm with equal ability, he proved more than adept at capturing the rich and evocative atmospheres of seascapes, whether in a subtle, refined work such as this, or in a large-scale oil painting.

Van de Velde was born in the Netherlands in a family of artists. He received his training from his father Willem van de Velde I (1611-1693), and from Simon de Vlieger (*c.*1600/1-1653) (see inventory), both accomplished marine artists. He learnt the qualities of detailed realism from the former, who provided extraordinarily comprehensive records of ships, (fig. 2). From de Vlieger he adopted atmospheric effects from the latter and his influence can be seen in van de Velde's oil paintings (fig. 1).

In 1673, van de Velde and his father settled in England where they became a formidable team, producing a vast amount of work, now of historical significance. He was commissioned by Charles II, at a salary of £100, to aid his father in 'taking and making draughts of sea-fights'. Van de Velde I, provided eyewitness drawings of warships and naval actions, which van de Velde II then used to inform his paintings. After his father's death, it became necessary for van de Velde to be present himself at maritime events; his works began to show a freer approach, being unbound by his father's scrupulous attention to detail. Demand for the van de Velde's work was considerable, and they received commissions from the Duke of York and other members of the nobility. The influence of their studio established the van de Veldes, to all intents, as the founders of the English school of marine painting.

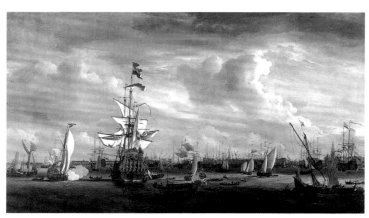

Willem van de Velde the Younger, *The Gouden Leeuw before Amsterdam* 1686, Historisch Museum, Amsterdam (Figure 1)

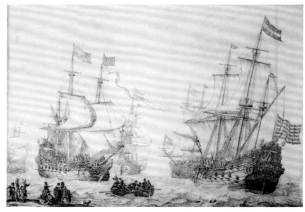

Willem van de Velde the Elder, *Two Dutch Merchant Ships under Sail near the Shore*, National Maritime Museum, London (Figure 2)

ESAIAS
VAN DE VELDE

(Amsterdam 1587 - The Hague 1630)

A River Scene with Rowing Boats, Cottages on the Shore and a Windmill in the Distance

bears inscription in black chalk, (lower left), either partial van Goyen monogram: 'VG', or partially effaced 'VELDE' signature
black chalk and grey wash
18.4 x 30 cm (7¼ x 11¾ in)

A QUIET VILLAGE AND ITS INHABITANTS ARE DEPICTED in *A River Scene with Rowing Boats, Cottages on the Shore and a Windmill in the Distance.* In the foreground, one boat carries passengers away from the river bank while in another, a figure prepares to depart, loading his possessions as a dog looks on from the shore. In the far left of the composition, two gentlemen are engaged in relaxed conversation. Behind them, a hamlet of rustic cottages stand, against which lean a wheelbarrow and other gardening tools. In the distance, a sailing boat, a bridge and a windmill are faintly illustrated.

An atmosphere of serenity pervades Esaias van de Velde's depiction of the gently flowing river and the unhurried activities of the villagers, which is enhanced by his soft handling of the chalk. The low horizon and landscape, articulated by a diagonal river course framed by vertical groups of trees and horizontal elements, as well as the employment of uniform, simple colouration are characteristic of van de Velde's compositions. Such stylistic techniques signified his desire to realistically recreate the Dutch landscape and marked his departure from the work of his late Mannerist predecessors, Gillis van Coninxloo (1544-1607), David Vinckboons (1576-1633) and Roelandt Savery (1576-1639) (see catalogue no. 131), whose work was defined by extreme stylisation and a preference for fantastic views and motifs.

Van de Velde's drawing of a *Farm by a River in a Wooded Landscape* in the Museum of Fine Arts, Boston, is similar to the present work in the artist's distinctive representation of the trees and shrubbery and charmingly unpretentious thatched cottage (fig. 1). Both scenes are simple and informal, and marked by a uniform tonality in draughtsmanship, giving the subject a pleasant familiarity. They are also unmistakably Dutch views, especially with the addition of the sailing craft and windmill in *A River Scene with Rowing Boats, Cottages on the Shore and a Windmill in the Distance.* In the realism, clarity of line and heavy use of *chiaroscuro* in both drawings, the influence of the German artist Adam Elsheimer (1578-1610) can be detected. Elsheimer's work was widely reproduced through prints in Holland and featured straightforward compositions, incorporating a pronounced diagonal format and use of outline. Van de Velde furthered Elsheimer's concepts, cultivating a realistic representation of the natural world and exerting a profound influence on the stylistic direction of landscape painting in Holland.

Born in Amsterdam, van de Velde is likely to have received his initial training from his father Hans and, later, possibly trained with Coninxloo and Vinckboons. He worked in Haarlem from 1610 to 1618, becoming a member of the Guild of St. Luke in 1612, together with Willem Buytewech (1591/2-1624) and Hercules Segers (1597-1639). During this period he had two students, Pieter de Neijn (1589/90-1633/8) and notably, the landscape painter Jan van Goyen (1596-1656) (see catalogue nos. 134 and 135). By 1618 he had moved with his family to The Hague, where he once more joined the Guild of St. Luke, and became court painter to the Prince Maurits and Frederick Henry. Also an engraver, etcher and painter of genre and military scenes, van de Velde is best-known for his landscape paintings, which contributed to the redefining of the subject and established early conventions for naturalistic depictions of the Dutch countryside. He left an extensive *oeuvre* of over 180 paintings, 117 of which are landscapes. A cousin of Jan van de Velde the Younger (1593-1641), he was not related to the family of Willem van de Velde (1611-1693).

Having examined this work at first hand, Dr George Keyes has confirmed the attribution to Esaias van de Velde, but suggests that some of the grey wash may be by another hand.

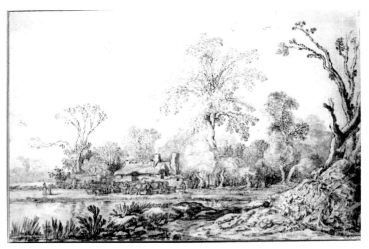

Esaias van de Velde, *Farm by a River in a Wooded Landscape*, Museum of Fine Arts, Boston (Figure 1)

(Actual Size)

BENJAMIN WEST, P.R.A.

(Pennsylvania 1738 - London 1820)

Studies for the Ascension: Christ Ascending

Verso: Studies of Heads

black and white chalk, on grey paper
25.4 x 19 cm (10 x 7¼ in)

Provenance: The artist's family, and by descent to Mrs. P. Howard;
Sotheby's, London, 22 March 1979, lot 33.

Literature: H. von Erffa and A. Staley, *The Paintings of Benjamin West*, New Haven and London, 1986, no. 380, note 6, p. 376.

STUDIES FOR THE ASCENSION: CHRIST ASCENDING (Recto); Studies of Heads (Verso) are loose and confident in manner, revealing Benjamin West's chief concern with the expression of movement. The figure of Christ is roughly delineated, with bold black lines, heightened by white, indicating the swirl of drapery around him. The brashness of execution powerfully evokes the upward motion of the figure, which appears ready to rise off the page.

The studies were drawn by West in preparation for a painting of *The Ascension*, which was to be the focal point of the Chapel of Revealed Religion that King George III had intended to build at Windsor. The chapel's construction was never realised and the painting remained in West's possession, accompanied by a monochrome sketch for the work that now belongs to the Tate Gallery (fig. 1). The depiction of Christ in *Sketch for 'The Ascension'*, although more finished, is only slightly modified from West's initial conception indicated by the present studies.

The Ascension was displayed in West's posthumous exhibition and sold in his studio sale in 1829, after which it was presented to Harrow School where it remained until 1854. It is now in the gallery of the Bob Jones University in Greenville, South Carolina.

West, who is often recognised as 'the father of American painting', grew up in rural Pennsylvania and was largely untutored in academic painting. At the age of twenty-two, he was sponsored by two wealthy Philadelphia families to travel to Italy, where he studied for three years. This move has been described as an act of profound significance to American art, as West was the first of his kind to move away from the colonialist portraiture tradition and embrace new European styles of painting and subject matter[1]. In Rome, he was taught by Anton Raphael Mengs (1728-1779), and influenced by Gavin Hamilton's (1723-1798) early neo-Classical works. Afterwards he moved to London, where he soon made his mark as a painter of historical and religious scenes and was a social as well as artistic phenomenon. His patron William Allen wrote enthusiastically, 'he is really a wonder of a man, and has so far outstripped all the painters of his time [in getting] into high esteem at once… If he keeps his health he will make money very fast'.[2]

In London, West began painting in the neo-Classical style, but became more experimental with his most famous painting, *Death of General Wolfe*, which was acclaimed for its depiction of a historical subject in contemporary dress. The painting was exhibited at the Royal Academy in 1771, where West was a founder member. A year later he was appointed official history painter to George III. In 1792, West succeeded Joshua Reynolds (1723-1792) (see catalogue no. 72) as president of the Royal Academy, a post that he held, albeit with a brief interlude, until his death. As scholars have commented, West's remarkable and innovative place in history made him stand out: he was the 'first American to achieve an international reputation and was an inspiration to many of his countrymen'.[3] West taught three generations of American artists, including Gilbert Stuart (1755-1828), Joseph Wright (1756-1793), John Trumbull (1756-1843) and Robert Fulton (1765-1815), as well as his own son Raphael Lamar West (1769-1850).

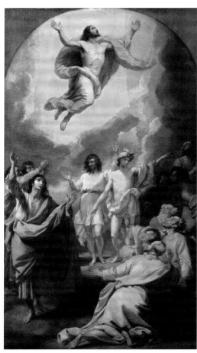

Benjamin West,
Sketch for 'The Ascension',
*c.*1782,
Tate Gallery,
London
(Figure 1)

[1] E. P. Richardson, *Painting in America: The Story of 450 Years* (New York, 1956).
[2] D.A. Kimball and M. Quinn, 'William Allen–Benjamin Chew Correspondence, 1763–1764', PA Mag. Hist. & Biog., xc (1966).
[3] *The Concise Oxford Dictionary of Art and Artists*, 3rd edition, ed. Ian Chilvers, Oxford University Press, Oxford, 2003.

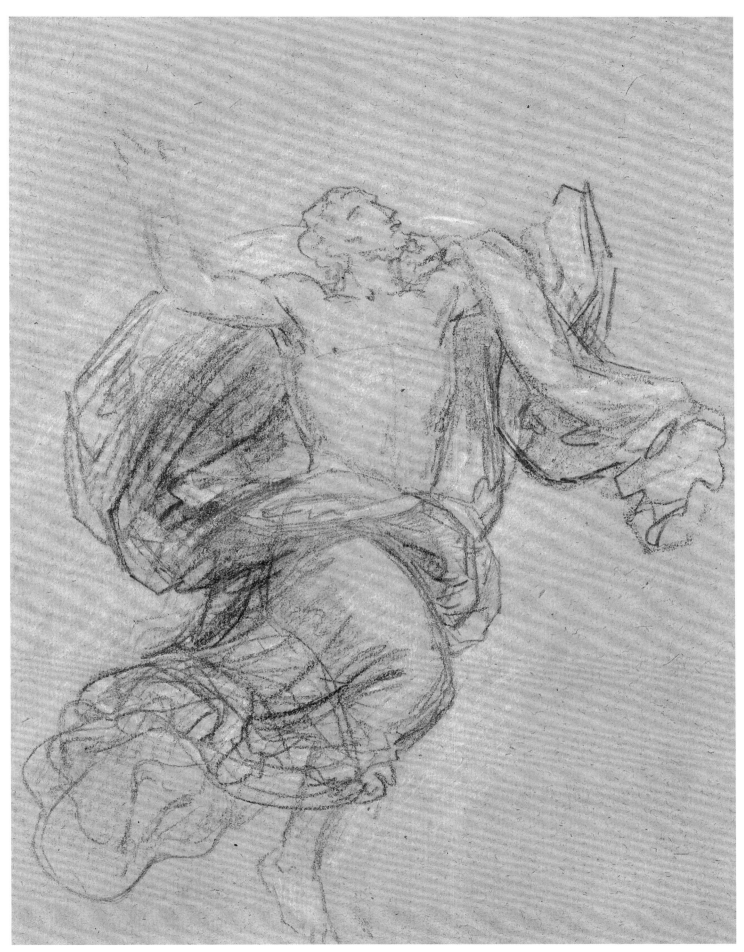

(Actual Size)

JOSEPH MALLORD WILLIAM TURNER, R.A.

(London 1775 - London 1851)

The Bridge at Vernon, from Vernonnet

pen and brown ink with pencil on blue paper
13.6 x 19.2 cm (5⅜ x 7½ in)

Provenance: John Ruskin; A. J. Finberg; Dr. Charles Warren;
with Andrew Wyld; Agnew's, London; The Fine Art Society as a *View of Angers.*

Exhibited: Cotswold Gallery, 1931, no. 6; Cotswold Gallery, 1932, no. 95;
London, Royal Academy, *Turner Bicentenary Exhibition*, 1974-5, no. 150 (As *View of Angers*);
London, Tate Gallery, *Turner on the Seine*, June-October 1999, no. 37 (illus. fig. 189, p. 204).

Literature: N. J. Alfrey, M.A. report, University of London, 1977, p. 20;
Ian Warrell, *Turner on the Loire*, 1997, p. 209, no. 118;
Ian Warrell, *Turner on the Seine*, 1999, cat. No. 37, p. 204, fig. 189.

THIS SMALL AND EVOCATIVE PEN AND INK STUDY depicts the village of Vernon, which lies on the River Seine between Rouen and Paris, as seen from the *fauborg* of Vernonnet on the other side of the river. Rising above the turrets on the left is the Church of Nôtre Dame; to its right the Tour des Archives. In the left foreground a figure, standing on a bulwark flanking the gateway to the bridge points towards the River Seine. The river is conjured up by the paper itself, while shading in pencil and a little white heightening create reflections of the arches of the bridge. Below the bulwark a group of figures line the shore of the river: they appear to be bent and straining, and are perhaps hauling in fish. These figures are rendered with thick and summary strokes of the pen, becoming an almost abstract series of pen and ink notations. The bridge rises from the left foreground and spans the Seine, the outlines of the bridge and the village being delineated with the same thick, strong strokes of the pen. Mill wheels are suspended from its structure at its far end, harnessing the fast currents flowing through the narrow channels. Sunlight is evoked by the tone of the paper itself, while shadow on the bridge and buildings is conveyed by shading in pencil.

This drawing, dated by Ian Warrall to between 1827 and 1829, is a preparatory sketch made by Joseph Mallord William Turner, R.A., on his walking tour of the Seine, for a famous series of views in watercolour and gouache made on the same blue paper. John Ruskin (1819-1900), who owned *The Bridge at Vernon, from Vernonnet,* referred to these as Turner's 'blue drawings.' Turner's finished watercolour views were engraved by other artists to illustrate the book *Turner's Annual Tours: Wanderings by the Seine* compiled by Leitch Ritchie and published in two volumes, in 1834 and 1835. A previous volume, published in 1833, was devoted to views of the River Loire. For *Wanderings by the Seine* the illustration of Vernon

which was selected for engraving and publication was based on another of the artist's works, *Vernon* (fig. 1). This was one of Turner's finished watercolours on blue paper, a medium which he used devotedly from the late 1820s onwards. The eye is guided by the flow of the river, over the human activity on the right-hand side to the bridge in the background, a completely different perspective of Vernon to that in the present work The other existing view of Vernon by Turner is a pen and ink drawing entitled *The Bridge at Vernon from the West*, which is stylistically close to the present drawing and is dated to the same period of *c.*1827 to 1829.[1]

As a young man, Turner took up the tradition of landscape painting in watercolour that had evolved in the eighteenth century, and developed it into a masterful art form. He went on to create an entirely new way of rendering the effects of light, water and atmosphere in oil paint as well as in watercolour, producing sublime visions of nature.

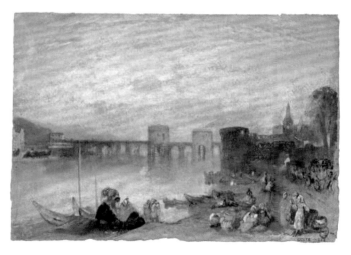

Joseph Mallord William Turner, *Vernon, c.*1833, Tate Britain (Figure 1)

[1] Ibid., *The Bridge at Vernon from the West and (upside down) a view of the Seine near Vernon?* Pen and ink fig. 186, p. 202 (T.B. CCLX 24).

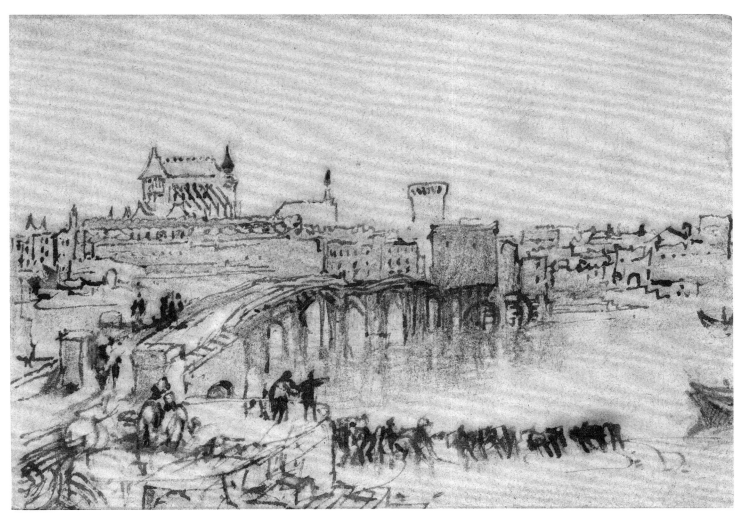

(Actual Size)

JOSEPH MALLORD WILLIAM TURNER, R.A. AND THOMAS GIRTIN

(London 1775 - London 1851)
(London 1775 - London 1802)

Arno, a Villa Among Trees and Bushes

pencil and watercolour
18 x 23.5 cm (7⅛ x 9¼ in)

Provenance: Thos. Agnew & Son;
The Leicester Galleries, March 1953;
H.M. Langton;
Spink & Son;
private collection.

ARNO, A VILLA AMONG TREES AND BUSHES PRESENTS an imposing Tuscan farmhouse framed by sprawling verdant vegetation. The light terracotta tones of the tiled roof and walls blend harmoniously with the subtle colouring of the surrounding landscape. The blue sky is dappled with light cloud cover that hints at muted summer warmth, while the varying palette of greens applied to the trees and bushes highlight their lusciousness and the fertility of the local soil.

The present work, like figure 1, was completed for the physician and watercolour enthusiast Dr. Thomas Munro. The young Joseph Mallord William Turner, R.A. and Thomas Girtin worked for Munro for three years copying the watercolours of John Robert Cozens (1752-1797), amongst

others, in Munro's collection.[1] The present work bears a label which reads: 'Italian villa with trees 7½ inch by 9¼ Bought from Agnews as a copy by Turner from Cozens. Original sketch in pencil is in Vol. vi. of the Beckford Sketch Books, now owned by the Duke of Hamilton. Volume vi. contains J.R. Cozen's sketches made between Sept 15th and Oct 10th 1783 and the sketch for the above drawing is dated "Arno Sept 25th" and is on page 14 of the volume. There are five other sketches of the same date, one of "Villa Salviate on the Arno", another of the Grand Dukes Palace.'

In 1794 Girtin first visited the home of Dr. Thomas Monro to study and produce work with Turner. 'Girtin drew the outlines and Turner washed in the effects. They were chiefly employed in copying the outlines or unfinished drawings of Cozens of which they made finished drawings.'[2] The present work was executed *c*.1795 and is typical of Girtin's and Turner's work for Monro.

As early as 1780 Cozens started making watercolours of Italian subjects for William Beckford (1760-1844) who was a friend and patron of his father, the artist Alexander Cozens (1717-1786). In 1782/1783, Cozens made his second trip to Rome, via Germany and Austria and he travelled as far as Naples accompanied by Beckford who was, at the time, one of the wealthiest men in England. During this sojourn Cozens filled his sketchbooks with small studies, which he later worked up into finished watercolours. There are seven Beckford sketchbooks containing Cozens' work from this trip. *View from Isola Borromea, Lago Maggiore* in The Tate Gallery, is one of the finished watercolour series commissioned by Beckford on their return.

Joseph Mallord William Turner and Thomas Girtin, *View from the Corsini Gardens, Rome,* Private Collection (Figure 1)

[1] Munro had cared for Cozens during his last illness, as well as treating the insanity of King George III (1738-1820).
[2] Susan Morris, *Thomas Girtin* (Yale, 1986), p. 12. Turner and Girtin told Joseph Farington of their activities at Dr. Monro's house.

(Actual Size)

THOMAS ROWLANDSON

(London 1756 - London 1827)

THOMAS ROWLANDSON, 'ONE OF THE FOUNDERS and supreme characters of the English caricature tradition',[1] excelled in depicting his subjects with gentle satire and exuberance. His comedic characters, although quintessentially English, are portrayed with an elegance and fluidity of line that is reminiscent of the French Rococo style. The five drawings and watercolours presented here, varying in subject matter and their degree of satire, are all excellent examples of Rowlandson's distinctive style of draughtsmanship.

Rowlandson, whose portrait painted by George Henry Harlow (1797-1819) can be seen in figure 1, was the son of William Rowlandson, a wool and silk merchant. Early in Thomas' childhood, his father went bankrupt and he was sent away to live with relatives. He attended the reputable school of Dr Barwis in Soho Square. At the age of sixteen, he entered the Royal Academy Schools, first exhibiting there three years later. During this period he also visited Paris where it is thought he may have been introduced to the Rococo manner, although he no doubt would already have been familiar with French works of art through prints. In 1777, he received a silver medal from the academy and in the following year, set up independently in Wardour Street, London.

William Hogarth, *A Rake's Progress* (plate 3), 1735, The Tate Gallery, London (Figure 2)

Early in his career, Rowlandson painted attractive portraits in the manner of Francis Wheatley, R.A. (1747-1801) (see catalogue no. 75) and John Raphael Smith (1752-1812). He was also inspired by Thomas Gainsborough (1727-1788), whose works were among those he engraved in *Imitations of Modern Drawings* (1788). Rowlandson's humorous drawings are indebted to the works of John Hamilton Mortimer (1740-1779), many of which he owned. Rowlandson also collected engravings after the artists he most admired, ranging from Rubens (1577-1640) to William Hogarth (1697-1764), who not only played a crucial role in establishing an English school of painting but became famed for his satirical works depicting low-life scenes of the period, such as *A Rake's Progress* (fig. 2).

Rowlandson undertook the first of several sketching tours in 1784, travelling from Salisbury to Portsmouth accompanied by his friend, the amateur caricaturist Henry Wigstead. Throughout his career, Rowlandson toured many parts of England and Wales, recording the landscapes and people he encountered. As all the drawings presented here are rural in subject matter, it is likely that they were created on one or more of these study trips. His landscapes drawn from life are often devoid of human activity and are therefore not illustrative of Rowlandson's most humorous commentary. They are, however, imbued with character and expressiveness, as the landscape elements of the works here attest to.

In 1784, Rowlandson, who was not politically inclined, also produced a

George Henry Harlow, *Thomas Rowlandson*, 1814, National Portrait Gallery, London (Figure 1)

[1] *The Concise Oxford Dictionary of Art and Artists*, 3rd edition, ed. Ian Chilvers, Oxford University Press, Oxford, 2003.

James Gillray, *A Voluptuary under the horrors of Digestion*, 1792,
The British Museum, London (Figure 3)

rare series of political prints ridiculing Georgiana, Duchess of Devonshire,
in her canvassing of votes for Charles James Fox. His cartoons are not
as abrasive as those of his contemporary James Gillray (1756-1815), who
specialised in political satire, exemplified by his attack on the notoriously
dissolute Prince of Wales, later Prince Regent and George IV (reigned
1820-1830) in *A Voluptuary under the horrors of Digestion* (fig. 3). Neither
are they morally conclusive, like those of Hogarth. In general, Rowlandson
favoured a mild form of caricature as evident from the present works, and
his most cutting satirical prints are modelled on ideas originally conceived
by Wigstead, Henry William Bunbury (1750-1811) and Job Nixon (1784-
1815).

Rowlandson achieved considerable prestige and popularity in the
1780s and his patrons included the Prince of Wales (later George IV).
In 1787, however, he abruptly stopped exhibiting at the Royal Academy,
perhaps because of the substantial legacy left to him on the death of his
aunt. Instead, he spent the following years travelling through Europe and
gambling excessively, quickly depleting his fortune. By 1793, he was back in
London and poverty-stricken, and was forced to survive on the proceeds of
his drawings and prints. Fortunately, in 1797 he was employed by Rudolph
Ackermann (1764-1834) who owned a print shop in the Strand, and his
works for the next twenty years were mostly produced for Ackermann,
featuring some of his most celebrated characters, such as Dr. Syntax.

In 1798, Rowlandson visited Bath with the amateur caricaturist Nixon

² Fiona Haslam, *From Hogarth to Rowlandson: Medicine in Art in Eighteenth-
century Britain*, Liverpool University Press, 1996, p.180.

Thomas Rowlandson, 'The Pump Room' from *The Comforts of Bath*, 1798,
Victoria Art Gallery, Bath (Figure 4)

and published his series *The Comforts of Bath*, satirising all the essential
elements of a fashionable person's stay in the city, such as attending balls,
gambling and taking the waters. In each print there is always present
the figure of the bewigged invalid gentleman, overweight and suffering
from gout, which Rowlandson considered the typical visitor to Bath. The
scene depicted in *The Pump Room*, see fig. 4, bears many similarities to
that of *Taking the Water* (no. 144), the most obviously scornful of the five
drawings presented here. In both works, Rowlandson treats his subjects
with undisguised mockery, depicting a cross section of fashionable society
afflicted with all manner of ailments.

Thomas Rowlandson, *The Parson and the Maid*, Private Collection (Figure 5)

The composition of *Taking the Water* is crowded with men, women and children, of different shapes and sizes, some debauched and careless in appearance and others more image conscious. They have assembled in this countryside location to benefit from the healing properties of the water, which was thought to ease disorders such as melancholia, consumption and gout, and of which the physician George Cheyne wrote: 'I have often observ'd, with admiration, the Wisdom and Goodness of Providence, in furnishing so wonderful an Antidote to almost all the Chronical Distempers of an English Constitution and Climate'.[2] A young woman carries around a tray with glasses, from which the visitors guzzle voraciously. A number of elderly gentlemen with canes in hand and sour expressions on their faces have come to the spa to sooth their afflictions. The exceedingly rotund gentleman sitting on the bench at the right wears slippers to relieve his gout. The women appear generally jovial and enjoy the opportunity to socialise while benefiting from the medicinal effects of the water. Rowlandson revels in the opportunity to depict their light clinging Regency dresses, which although fashionable, are inappropriately revealing and look unbecoming on the older and stockier women.

A recurrent theme in Rowlandson's work is that of physical, economic and sociological contrasts. His drawings often place side by side the elderly and young, rich and poor, ugly and attractive, virile and impotent, drawing attention to the inequalities inherent in human nature and society. These differences are particularly noticeable in *Taking the Water* although they are also alluded to in some of the other works presented here. *Travellers on the Road* (no. 145), which appears to be primarily an impartial narrative image, is overtly class conscious in its depiction of a poor family overtaken on a country path by a gentleman and lady riding their horses. The female rider is noticeably plump, indicating her comfortable lifestyle, in contrast to the mother with her children who labours up the hill. The human pathos is evident in Rowlandson's interpretation of the scene and gives the image a greater significance.

A Passing Flirtation (no. 142) is a charming small-scale depiction of a gentleman and a lady trotting by each other on horseback. The lady glances downwards with blushing cheeks as the gentleman turns in his saddle towards her. As is common in Rowlandson's drawings, even those that are not obviously satirical, there is an element of gentle caricature in the modelling of the figures and evident mischief in the indelicate way in which the horse's rear is turned towards the viewer. The drawing provides a refreshing contrast

Thomas Rowlandson, *The Horse Dealer*, Private Collection (Figure 6)

Thomas Rowlandson, *Market Cart*, c.1805, The Courtauld Gallery, London (Figure 7)

to many of the artist's works featuring lascivious elderly men leering at pretty young women, such as *The Parson and the Maid* (fig. 5).

Naturally, horses and wagons frequently feature in Rowlandson's country scenes. With a few dashes and squiggles of the pen and brush, Rowlandson expertly conveys the anatomy and movement of the animals. In drawings such as *The Horse Dealer*, see fig. 6, which is the same size as *A Passing Flirtation*, there is a corresponding immediacy, vitality and naturalness to his depiction of the steeds. His treatment of trees is similar, always quick and economical in his use of line to convey foliage. The extensive landscape in *A Wagon and Horses Passing a Family on a Wayside* (no. 143), clearly sketchy and not intended as a highly finished drawing, exemplifies Rowlandson's vigorous and emphatic draughtsmanship. A more fully worked up watercolour in The Courtauld Gallery, London, *Market Cart*, reveals not only the same basic elements within the composition but also a corresponding hasty and dynamic handling of the trees, animals and figures (fig. 7).

A Landscape with Monks (no. 141) also portrays an expansive landscape enlivened by the grouping of figures to the right of the composition. A portly monk, with a distended belly showing beneath his robes, looks unwieldy as he stands at the bottom of the steps leading to the chapel, revealing that not even men of God can escape Rowlandson's sharp wit. In his landscapes, (such as the present one,) Rowlandson owes something to the works of Francis Towne (1739-1816), who similarly outlined landscape elements before filling them in with broad pale washes of colour. The delicate colouring and curvilinear rhythms of Rowlandson's watercolours are evidence of the Rococo influence on his work.

The accessibility of Rowlandson's images and the ease of interpretation that they invite have no doubt contributed to the artist's popularity throughout generations. Ronald Paulson writes, 'for the most part Rowlandson is content with the surface appearance of things, he is easy to live with, calling for no special preparation of mood, his meaning plain and instantaneously conveyed to the observer'.[3] There is no doubt that the facility and devotion with which Rowlandson communicates and caricatures the peculiarities of English scenery and society, and the gusto and vitality with which he records them on paper, have affirmed his significance within the English artistic tradition.

[3] Ronald Paulson, *Rowlandson: A New Interpretation*, New York, Oxford University Press, 1972, p. 13.

THOMAS ROWLANDSON

(London 1756 - London 1827)

A Landscape with Monks

pen and ink and wash
24.5 x 35 cm (9¾ x 13¾ in)

THOMAS ROWLANDSON

(London 1756 - London 1827)

A Passing Flirtation

pen and grey ink and watercolour
12.8 x 14 cm (5 x 5½ in)

(Actual Size)

THOMAS ROWLANDSON

(London 1756 - London 1827)

A Wagon and Horses Passing a Family on a Wayside

pen and ink
19 x 26.7 cm (7½ x 10½ in)

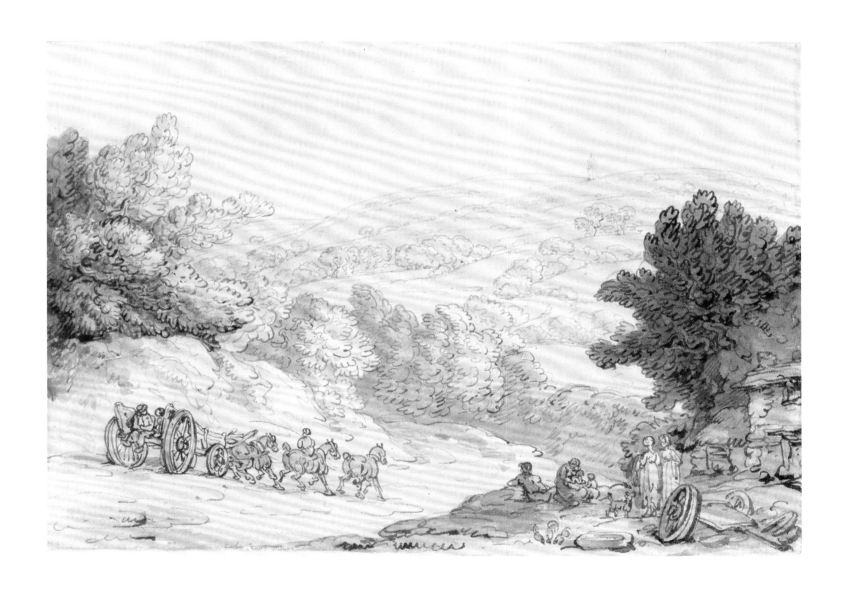

THOMAS ROWLANDSON

(London 1756 - London 1827)

Taking the Water

pen and ink and watercolour over pencil
24 x 38 cm (9½ x 15 in)

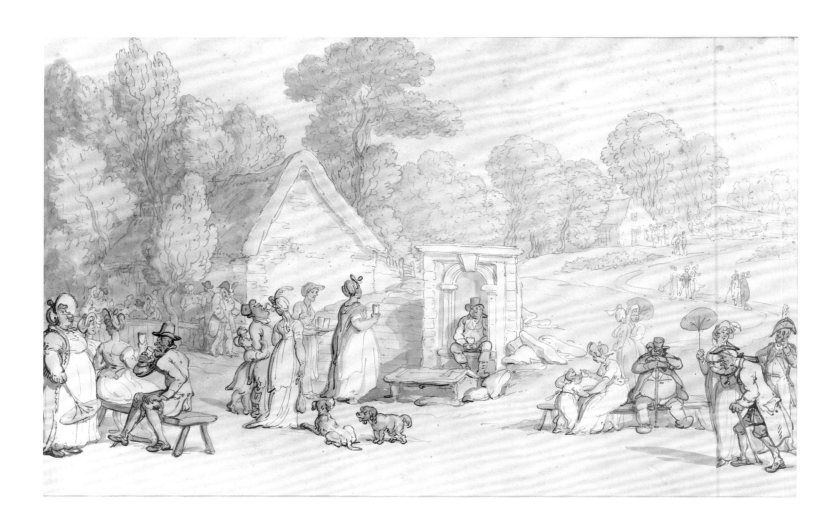

THOMAS ROWLANDSON

(London 1756 - London 1827)

Travellers on the Road

pen and ink with wash over pencil
15 x 23.5 cm (6 x 9¼ in)

GEORGE MORLAND

(London 1763 - London 1804)

Travellers Returning Home

signed and dated 'G. Morland 1795' (lower right)
pencil
16.5 x 21 cm (6½ x 8¼ in)

Provenance: Lord Overstone.

Literature: G. Redford, *Descriptive Catalogue of Works of Art at Overstone Park, Lockinge House and Carlton Gardens*, 1878
(Lord Overstone's collection), no. 181 (5 drawings);
L. Parris, *The Loyd Collection of Paintings, Drawings and Sculptures*, 1967, no. 108, p. 42.

THIS PENCIL DRAWING BY GEORGE MORLAND shows two travellers nearing a thatched cottage. The image is one of isolation, set in a rugged landscape. There are no other signs of human life apart from the two figures and the single dwelling, and the deep recession of the drawing emphasises the remoteness of the setting. The cottage is set against a towering rock face, which sets the tone of this slightly wild landscape.

The scene is typical of Morland's work, with its characteristic depiction of rustic peasant life; his *Carters with a Load of Slate*, another representative example of his *oeuvre*, draws several similarities in its setting and composition to *Travellers Returning Home* (fig. 1). Once again, the motif of a thatched cottage on the right-hand side looms in the shadows of a cliff, providing a backdrop for the work; in front, a path leads off into the mountainous distance. Although the work does not have the same feeling of desolate isolation as *Travellers Returning Home*, the landscape nevertheless feels remote and untamed, the side of the road and the thatching are overgrown with moss and lichen, and dark clouds hover above. It is another image of anonymous rural life.

Morland turned his hand to more rural subject matter from 1791, and whilst some of his works would often highlight the distinctions between the classes, *Travellers Returning Home* instead appears to represent an almost idyllic paradigm of rural society, concealing the turmoil within Morland's life at the time of its execution. By 1789, Morland was in serious debt, his mounting arrears had accelerated to such an extent that from 1794, the year before he produced *Travellers Returning Home*, he had begun moving from home to home in an effort to evade his collectors. His return to London in 1793 also spelled the start of great difficulties within his marriage, with Morland often leaving for periods of time, choosing on occasion to seek the company of gypsies.

Born in 1763, Morland was a precocious talent, first exhibiting at the Royal Academy at the age of ten. Morland was an apprentice under his father but his chief employment during this period lay in copying and forging paintings, particularly seventeenth-century Dutch landscapes. As soon as his apprenticeship was over, Morland escaped the confines and respectability of the family home and embarked on a life of prodigality. He valued his independence in both his life and work, preferring to sell finished work to dealers rather than undertaking commissions, and he even declined an invitation to supply Carlton House with 'a room of pictures' for the Prince of Wales (later George IV). Morland's lifestyle meant that he was often in debt and in 1789 he is thought to have made the first of several trips to the Isle of Wight in order to evade his creditors. The rest of his life was spent in various stages of debt and alcoholism, and he spent some time in prison. Despite the unrest in his personal life he worked at an astonishing rate and it is thought that in the last eight years of his life he produced eight hundred pictures.

George Morland, *Carters with a Load of Slate*, Museum of Fine Arts, Boston
(Figure 1)

(Actual Size)

PHILIPPE-JACQUES DE LOUTHERBOURG, R.A.

(Strasburg 1740 - Chiswick 1812)

Two Men, One Sleeping

with inscription 'J. Loutherbourg' (on the mount)
pen and black ink, grey wash
13.6 x 12.4 cm (5⅜ x 4⅞ in)

Provenance: An unidentified collector's mark (L. 1718).

IN THIS DRAWING PHILIPPE-JACQUES DE LOUTHERBOURG has shown a robbery in process. One man is fast asleep; the spilt flagon suggesting that he is either drunk or has possibly been drugged. The second man looms over the sleeping figure, his arm outstretched. It appears that he is about to steal whatever the sleeping figure cradles in his arms. The thief is dressed in torn, ragged clothing, has a straggling beard and long, unkempt hair. His appearance suggests that he is an impoverished street thief and his sly, gleeful grin confirms his wickedness. The prominently positioned flagon is decorated with an oriental text, thus the present work possibly shows the robbery of a naive foreigner.

In *Two Men, One Sleeping* the robber's clothing strongly reflects his character. His costume quickly establishes his role in the image and the focus on costume is a feature in several of de Loutherbourg's drawings, such as *Man in Uniform* (fig. 1). Although this drawing has no narrative, as it is a study of the figure of an officer in his uniform, like the figure of the thief in *Two Men, One Sleeping*, the viewer gains an immediate, concise and clear insight into the officer's character. His tight-fitting jacket accentuates his rather portly figure, and as it clings to his large stomach, the buttons seem on the verge of popping off. It creates a slightly comical appearance although the man is clearly well-off. His chubbiness, confident upright bearing and his jolly, round face creates an image of a well fed, upper class man that is ever so slightly mocking. This is an example of the characteristic humour found in de Loutherbourg's work.

De Loutherbourg's father, Philipp Jakob (1698-1768) was an engraver and miniature painter to the court of Darmstadt. In 1755, he took his family to Paris, where de Loutherbourg became a pupil of Carle van Loo (1705-1765) (see inventory). At this early stage he specialised in landscape painting but the focus of these works was often on the foreground figures, which are framed by natural formations that occasionally fall away to reveal distant horizons. His original style was extremely popular with the French public but in 1771 he went to London, intending to take advantage of the wealthy English market. Here he met the English actor and manager David Garrick, who employed de Loutherbourg as his chief scene designer at the Drury Lane Theatre. De Loutherbourg became the most inventive set designer in eighteenth-century Europe. His lighting and sound effects, use of puppets and models, introduction of painted act drops between scenes and the diversity of his stage pictures set a precedent for all future attempts at theatrical illusion. *Two Men, One Sleeping* is itself a very theatrical drawing, with the dramatic gesture of the thief and the clarity of the narrative.

De Loutherbourg's work became characterised by its variety from landscape to caricature and he often adapted his art to suit the market. De Loutherbourg was also a prolific illustrator, contributing twenty plates to John Bell's second edition of Shakespeare (1786-1788), as well as publishing his collections of engravings, *The Picturesque Scenery of Great Britain* (1801) and *The Picturesque and Romantic Scenery of England and Wales* (1805).

Philippe-Jacques de Loutherbourg, *Man in Uniform*, The Courtauld Gallery, London (Figure 1)

(Actual Size)

PHILIPPE-JACQUES DE LOUTHERBOURG, R.A.

(Strasburg 1740 - Chiswick 1812)

Smugglers on the English Coast

pen and brown ink, brown and grey wash, oval
22.8 x 31.7 cm (9 x 12½ in)

Engraved: Victor-Marie Picot, January 1776.

I N THIS DRAWING PHILIPPE-JACQUES DE LOUTHERBOURG depicts a clandestine meeting of smugglers on the English coast. The drawing centres on two men who argue quite heatedly, presumably in relation to the quality or quantity of the smuggled goods, over which they stand. A figure is on his knees taking a closer look at the goods, whilst two men watch the argument play out. One smuggler is exhausted from the voyage and is slumped on the ground, his sword a reminder of the dangerous and dark side of these activities. A group of men are waiting in a rowing boat, and in the background is the faint outline of a much larger ship, although whether this is the smugglers' or a customs' ship, that they have outwitted, is uncertain.

Smuggling was a major business in Britain during the eighteenth century. Illegal trade across Britain's coastline grew at an incredible rate as an inevitable result of the heavy taxation imposed by a series of governments seeking funds to pay for costly European wars; the tax for tea alone was nearly seventy percent of its initial cost by the middle of the century. In response to this, contraband was smuggled into the southern counties of England in huge quantities. It was not unheard of for a smuggling trip to bring in three thousand gallons of spirits. Illegally imported gin was sometimes so plentiful that the inhabitants of some Kentish villages were said to use it for cleaning their window. Some estimates reckon that four-fifths of tea drunk in England had not paid duty. So widespread was the practice that Daniel Defoe wrote of the port of Lymington 'I do not find they have any foreign commerce, except it be what we call smuggling and roguing; which I may say, is the reigning commerce of all this part of the English coast, from the mouth of the Thames to the Land's End in Cornwall'.[1]

George Morland, *The Smugglers*, 1792,
The Fitzwilliam Museum, Cambridge (Figure 2)

De Loutherbourg seems to have been fascinated by this lawless life and he depicted smugglers on several occasions, as well as bandits in a manner recalling Salvator Rosa (1615-1673). *The Smugglers Return* is one such example, and depicts a group of figures struggling to push their boat onto the shore, amid the stormy weather and crashing seas (fig 1). The painting accentuates the perils associated with the business of smuggling, as these figures had to contend with the unpredictable forces of nature in order to accomplish their mission.

The subject matter of *Smugglers on the English Coast* was not an unusual one for artists, such was the prevalence of this business in the eighteenth century. For example George Morland's *The Smugglers* also shows contraband being unloaded onto the English coast, the wagon ready be filled with the barrels which they are unloading, (fig. 2). Although the scene does not take place at a legal port, the figures do not seem especially furtive or isolated. It is broad daylight and several other vessels can be seen in the background.

Smugglers on the English Coast was engraved in aquatint by de Loutherbourg and published by Victor-Marie Picot in January 1776. The aquatint was dedicated to the actor and theatre manager David Garrick, who employed de Loutherbourg as a stage designer in his Drury Lane Theatre, although it is unclear why de Loutherbourg chose this particular topic as a tribute to his friend.

Philippe-Jacques de Loutherbourg, *The Smugglers Return*, 1801,
Joslyn Art Museum, Nebraska (Figure 1)

[1] Daniel Defoe, *A Tour Thro' the Whole Island of Great Britain*, Letter III, London, 1724

ATTRIBUTED TO

CHRISTOPH SCHWARZ

(Munich c.1545 - Munich 1592)

The Raising of Lazarus

numbered '24' and with inscriptions 'B' and 'Marto Wi...' (verso)
red chalk, pen and brown ink, brown wash, watermark serpent (twice), on two joined sheets
41.2 x 106.5 cm (16¼ x 42 in)

Provenance: Anonymous sale, Sotheby's, Amsterdam, 1 December 1986, lot 9 (as Matthias Kager);
L. Houthakker, his mark (not in Lugt);
with Hazlitt, Gooden and Fox, London, 1993, no. 17 (as Matthias Kager).

Literature: P. Fuhring, *Design into Art: drawings for architecture and ornament, the Lodewijk Houthakker Collection,* I,
London, 1989, p. 243, no. 275 (as Matthias Kager).

THE RAISING OF LAZARUS, TOLD IN THE GOSPEL of John, is often seen as a foreshadow of the Resurrection. His miraculous return to life provided highly popular subject matter for Renaissance artists and its dramatic potential is no less exploited in this present composition. Lazarus' two sisters, Martha and Mary, had hurried to Jesus to tell him that their brother was ill and that he should come immediately. Jesus, on hearing this, stayed where he was and only arrived at Bethany, where Lazarus lived, four days after he had been entombed. Martha, reproached him, and Jesus assured her replying, 'I am the resurrection, and the life: he that believeth in me, though he were dead, yet shall he live: And whosoever liveth and believeth in me shall never die'.[1] In the presence of a crowd of mourners, Jesus ordered the stone to be removed from the tomb and for Lazarus to come out. This he did, still wrapped in the cloths in which he had been buried.

This drawing, attributed to Chrisoph Schwarz, shows Lazarus being gently lifted up from his tomb by two onlookers. The acute precision of the pen and ink technique and the artist's employment of a muted wash, establishes a skilful contrast between light and shade as the limbs of the various figures are carefully accentuated. The sisters of Lazarus can be seen, one flanks Jesus, who is made clearly identifiable by the halo above his head, and the other sister stands immediately behind him. Anxiously whispered conversations take place amongst members of the crowd as they stand in awe at the miracle taking place before them.

The present drawing represents a study for a tomb dated 1598 in the Church of St. Anne, Augsburg. A drawing of the same composition, also attributed to Schwarz, is in the Narodwe Museum, Warsaw, and a copy is in the Staatsgalerie, Stuttgart.[2],[3]

Schwarz was a pupil of Hans Bocksberger II in Munich for six years from *c.*1560. When he subsequently travelled to Italy, he spent the majority of his time in Venice, where he became a pupil of Titian (*c.*1485/90-1576). On his return to Germany, he was appointed court painter to Duke Albert

IV, a post which he held until his death in 1592. He was responsible for decorating several public buildings in Munich including the Senger Brewery in Burgstrasse and a merchant's house at Kauffingerstrasse 4. During the reign of William V, however, Schwarz focused more closely on smaller devotional images and became the Bavarian court's favoured painter. He was also commissioned to decorate the interior of the Duchess' private oratory at the Residenz in Munich. Drawing on his exposure to Venetian artistic techniques, Schwarz used canvas panels to create the ceiling pictures.

In 1585, Schwarz visited Augsburg where he painted the altarpieces of chapels in S.S. Ulrich und Afra and as a result of his great reputation, Emperor Rudolf II attempted to poach him to work in his own court. William V refused but Schwarz was permitted to work in Munich on pieces for Rudolf's *Kunstkammer* in Prague - several pictures by him are mentioned in early inventories.

A number of Schwarz's works were engraved by Jan Sadeler (1550-1600), examples of which can be seen in the Fitzwilliam Museum, Cambridge. Aegidius Sadeler II (?1588-1665) and Lucas Kilian (1579-1637), among others, ensured that the reputation which Schwarz had enjoyed during his lifetime was perpetuated into the eighteenth century. He exerted considerable influence on the Bavarian artists who came after him - Hans Krumper (*c.*1570-1634), Georg Pecham (*c.*1568-1604) and others. He is primarily remembered as one of the main practitioners of the Venetian manner in south German painting, making him a forerunner of the Baroque style of Johann Rottenhammer the Elder (1564-1625).

[1] *John* 11.25-26.

[2] inv. no. 5987.

[3] For other drawings by Christoph Schwarz see *Zeichnung in Deutschland. Deutsche Zeichner* 1540 - 1640, exhib. cat., Stuttgart, Staatsgalerie, 1979-80, nos. D9-12.

JOHANN HEINRICH ROOS

(Otterburg 1631 - Frankfurt am Main 1685)

A Peasant Family and their Animals by Ruins

signed 'JHRoos [JHR in ligature] fecit', with a subsidiary study of child in black chalk (verso)
pen and brown ink, brown and grey wash, pen and grey ink framing lines
26.1 x 19.8 cm (10¼ x 7¾ in)

Provenance: Sir Thomas Lawrence (L. 2445);
W. Esdaile (L. 2617), his partial mount with attribution 'J.H. Roos' (recto and verso)
and inscription 'Formerly in the colln of Sir Thos Lawrence J-H-Roos' (verso);
Christie's, London, 22 June 1840 (4th Day's Sale), probably lot 821 as
'Roos: Peasants, with cattle and sheep near some Roman ruins, pen and ink; very spirited' (with lot 820, also by Roos, 11s. to Tiffin);
Colonel H.A. Clowes, and by descent

THE CRUMBLING STONE ARCH THAT FRAMES THE precisely drawn peasant family is a familiar motif throughout Johann Heinrich Roos' work. In both his paintings and drawings, he became highly skilled at incorporating antique ruins within scenes of everyday rural life and placing animals in idealised southern landscapes. The comparison between the faintly etched surroundings and the more polished peasant figures, complete with their customary dress, is echoed in a work in the Crocker Art Museum (fig.1). Here, as in the present work, it is the animals and the humans that engender Roos' particular artistic fascination, the ruins merely providing an aesthetically pleasing backdrop.

Roman Landscape with Cattle and Shepherds, see fig. 2, provides an indication of how Roos' drawings might have been used as preparatory sketches, for paintings with his animals taking on a glossy, almost photographic effect.

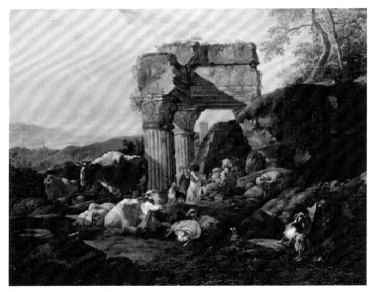

Roman Landscape with Cattle and Shepherds, 1676,
Minneapolis Institute of Arts, Minnesota (Figure 2)

Johann Heinrich Roos,
A Roman Landscape
c.1661,
Crocker Art Museum,
California
(Figure 1)
Johann Heinrich Roos,

Roos was the pre-eminent painter of animals in Germany. He is noted for his realistic depictions of cattle, goats and sheep and often included them in what are known as his 'pastoral idylls'. Numbering at least two hundred, and dating from 1657 until his early death in 1685, he took great pleasure in featuring the Italianate landscapes favoured by artists such as Karl Dujardin (1622-1678) (see inventory) and Nicolaes Berchem (1620-1683) (see cat. no. 121). The influence of the latter, in particular, can be seen clearly in this present work, as well as that of one of his tutors in landscaping, Cornelis de Bie (1627-1711/16).

Roos' pastoral idylls perhaps allude to a longing for a return to the natural harmony ordinarily linking mankind and animals to their natural landscape after the devastation caused by the Thirty Years War from which he and his family fled in about 1637.

(Actual Size)

389

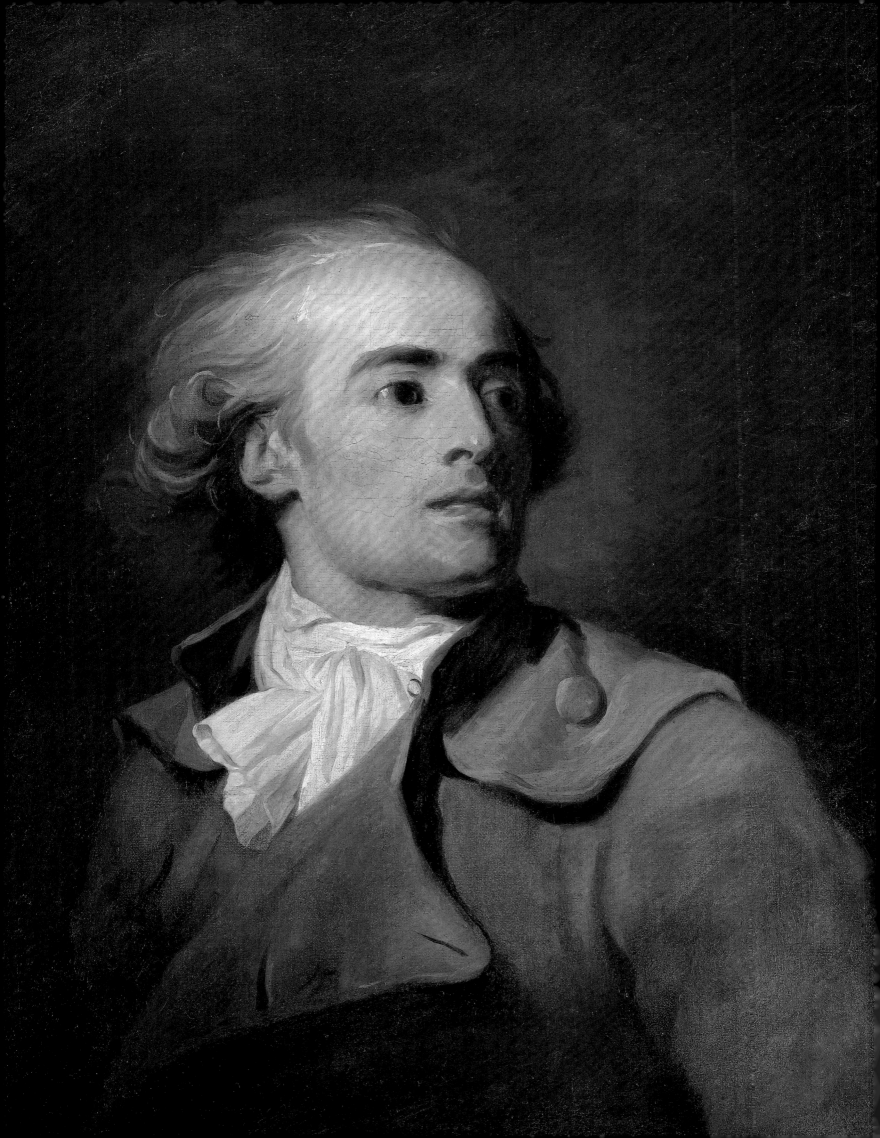

SPHINX · FINE · ART
Edward Strachan · Roy Bolton

ACKNOWLEDGMENTS

CATALOGUE

Editor: **Roy Bolton**

Sub-Editors: **Jon Goad & Ann Stirling**

CONTRIBUTORS

Roy Bolton

Edward Strachan

Ann Stirling

Olivia Westbrook

Lydia Hansell

Petra Lescht

Ed Beer

Charlie Minter

Natasha Broad

Clementine Musson

Design: **Jon Goad**

Printing: **Steve Rose, BAS Printers**

Photography: **Andy Johnson, A.J. Photographics**

Edward Strachan and Roy Bolton would like to heartily thank everyone who has worked so hard to create this publication. The contributors have made a herculean effort in researching the paintings; Ann Stirling, Olivia Westbrook, Lydia Hansell, Petra Lescht, Ed Beer, Charlie Minter and Natasha Broad have contributed so much to the ideas within this work that we could not have come close to putting this together without their invaluable dedication. Jon Goad's design work has also turned a rough diamond into an impressive work. We would also like to thank Henry Gentle, Simon Gillespie, Matthew Goldsmith, Philip Elletson, Susanna Bell, Andy Johnson, Steve Rose, Nina Jones, Paul Raison, James MacDonald, Susanna Pell and Alyona Kadatskaia for all their support throughout.

GALLERY · SERVICES

*Sphinx Fine Art has a wealth of experience in Old Master
and Russian pictures, Roy Bolton and the gallery team are always pleased
to advise in any specialist art capacity.*

OUR SERVICES ALSO INCLUDE:

Fine Art Consultation to help build your collection.

•

Advice on adding to your collection
with an eye to investment as well as enjoyment:
Old Master paintings have long proved a steady investment, unswerving in the winds
of sudden market changes, while the Russian art market has grown immensely in the last few years.

•

We are happy to give evaluations of paintings brought
to the gallery for our team to appraise.

•

We gladly advise on art insurance matters
and the care of your collection.

•

Our experience is always at hand when it comes to restoration
and framing advice for your paintings.

•

We offer complimentary UK delivery and picture hanging,
we also provide lighting and hanging consultations at your home.

•

The gallery provides a discreet way of selling our paintings,
matching your art works with that of our clients needs.

•

Our full equipped gallery space is available
to friends of the gallery for private and corporate events and gatherings.

HISTORY

Maxim Vorobiev (1787-1855) *Neva Embankment near the Imperial Academy of Arts,* 1835, Russian State Museum, St. Petersburg

Edward Strachan and Roy Bolton

Sphinx Fine Art, named after the fourteenth century BC sphinxes outside the Russian Academy of Arts in St. Petersburg, opened in London with its exhibition *Russia & Europe in the Nineteenth Century.* The gallery has a dual focus, specialising in Russian and Russian Orientalist paintings from the eighteenth to early twentieth centuries and Old Master pictures from the fifteenth to the early nineteenth centuries. We draw our core paintings from a collection built up over many years and we continue to add to this when the right opportunities are found. All works are available for sale so the collection is in a constant state of flux. However, it is our intention to hold a solid platform of works from which to build on our exciting exhibition programme. Over the coming months and years we hope these exhibitions will bring Western European and Russian artistic interplay to a wider audience.

Edward Strachan joined forces with that of Roy Bolton to create Sphinx Fine Art. Edward's fascination with Russian art began early and has been strengthened year on year since his time reading Soviet and Russian Studies at the School for Slavonic and East European Studies in London (UCL). Basing himself in Russia since 1991 Edward has spent the years travelling extensively and living throughout the countries of the former Soviet Union; from Kazakhstan to Azerbaijan, Uzbekistan, Turkemenistan and the Ukraine; applying his knowledge of Russian culture and history to make artistic discoveries. His interest in the idea of Eurasia

and Russia's historic role at the crossroads of civilisations is reflected in the many topographical, ethnographic and military subjects he has chosen for the collection. Edward's empathy with earlier Russian art collectors, as exemplified by the collections at the Hermitage, led to his evolving expertise in Old Masters.

Meanwhile Roy Bolton, then head of a Christie's Old Master paintings department for seven years, was becoming increasingly involved in the Russian art market and acutely aware of its growing internationalism over the last decade. After living in Ireland and California Roy began his vocation in art while studying at Oxford University. By the mid 1990s he was an arts writer and columnist. Beginning his auction house career as a paintings specialist at Phillips, his passion for Old Masters led him to specialise in that area by the late 1990s. Continuing to write, his growing appreciation of Russian paintings led him to publish, in Moscow, his history of world painting Живопись. От первобытного искусства до XXI века in 2006.

The trajectory of their careers inevitably brought Edward and Roy together. In 2007 they founded Sphinx Fine Art to pool their complementary areas of expertise in Russian and Old Master pictures. Now they jointly curate this gallery devoted to the correlating relationship between Western European and Eurasian painting. Two other Sphinx publications on Russian and European art are pictured below and available from the gallery.

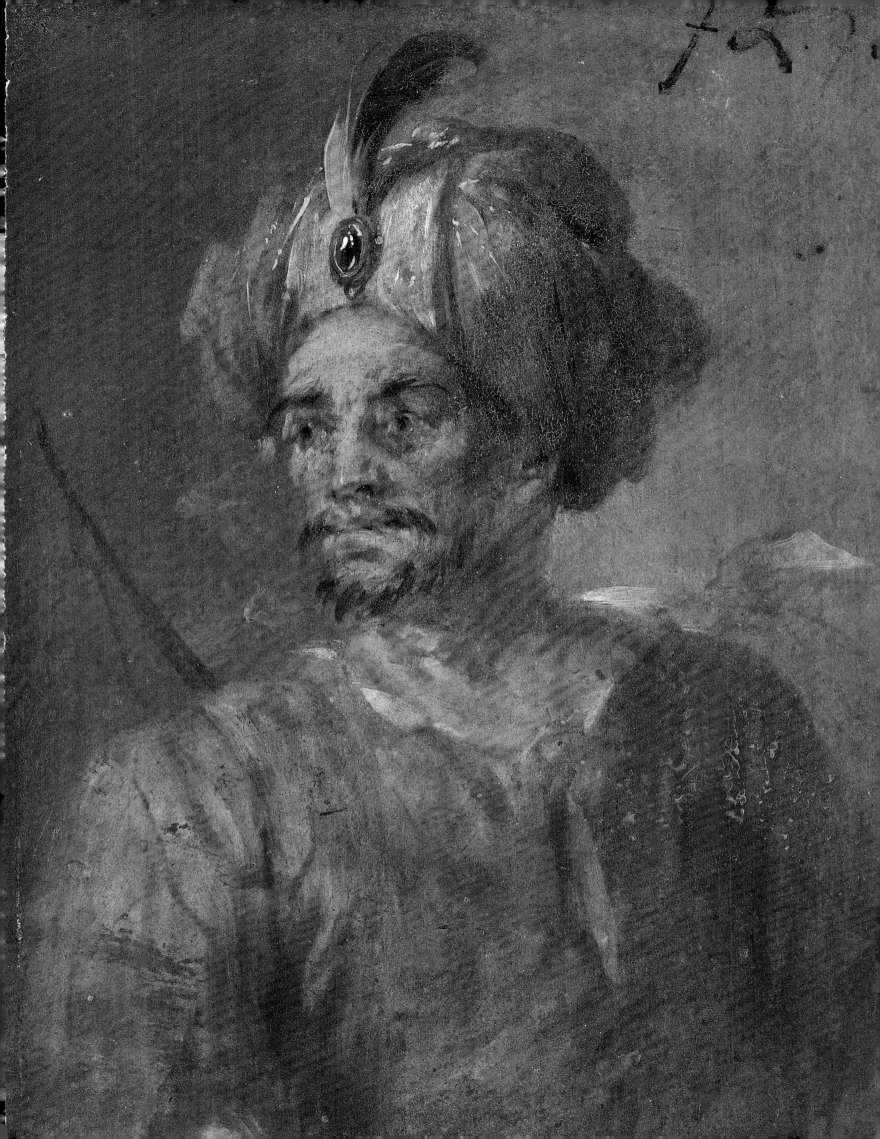

INDEX·OF·ARTISTS

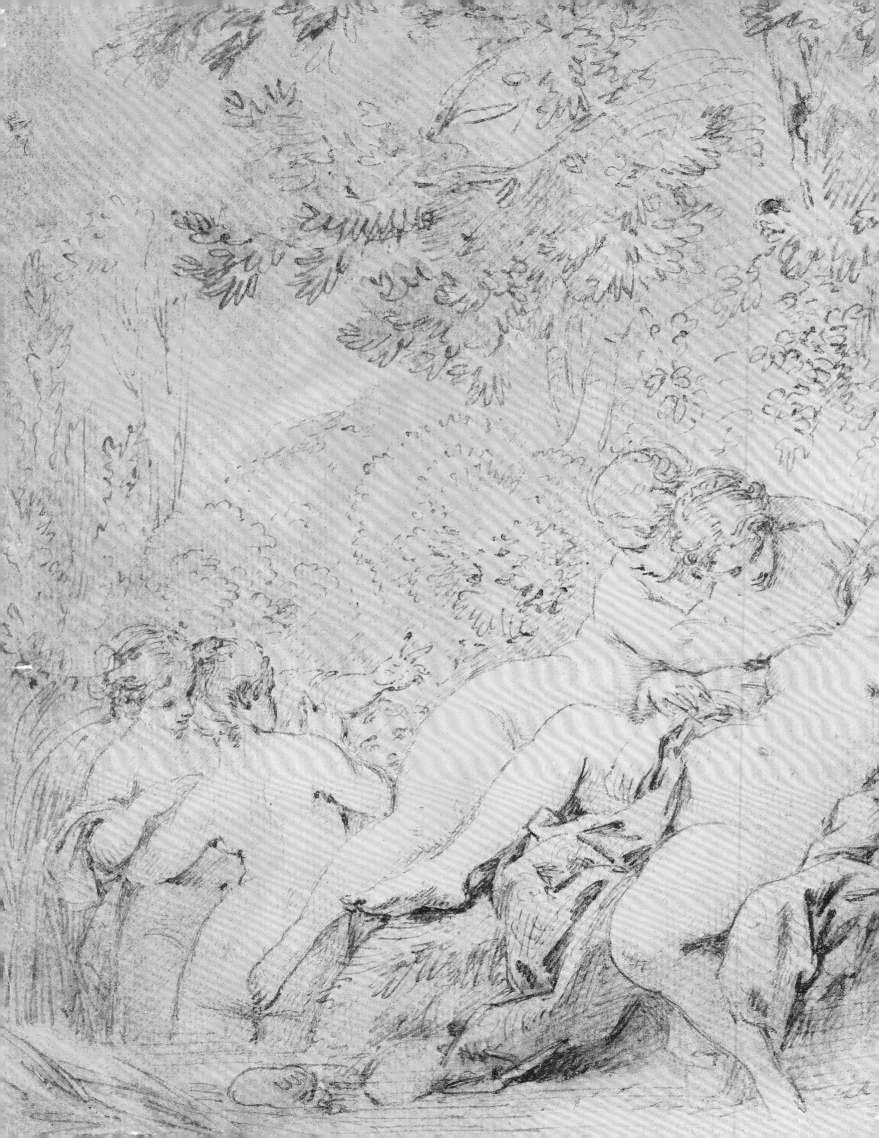